The Ghosts of Harlem

The Ghosts of Harlem

Sessions with Jazz Legends

**Photographs and Interviews
by Hank O'Neal**

Foreword by Congressman Charles B. Rangel

VANDERBILT UNIVERSITY PRESS / NASHVILLE

13 12 11 10 09 1 2 3 4 5

Revised and expanded from *The Ghosts of Harlem (Les Fantômes de Harlem): L'Histoire du Quartier Mythique du Jazz*, published by Éditions Filipacchi, Société Sonodip, Levallois-Perret Cedex, France (1997)

Printed on acid-free paper
Manufactured in China
Jacket design: Paul Bacon
Text design: Dariel Mayer

Library of Congress Cataloging-in-Publication Data

O'Neal, Hank.
[Ghosts of Harlem. English]
The ghosts of Harlem: sessions with jazz legends /
photographs and interviews by Hank O'Neal.
p. cm.
Includes discography and index.
ISBN 978-0-8265-1627-5 (cloth : alk. paper)
1. Jazz musicians—New York (State)—New York—Interviews.
2. Jazz musicians—New York (State)—New York—Biography.
3. Harlem (New York, N.Y.)—Social life and customs—
20th century. I. Title.
ML394.O5413 2009
781.65092'27471—dc22
[B] 2008022128

Contents

The Ghosts of Harlem

Foreword

by Congressman Charles B. Rangel

In 1930 there was more great music to be heard and places to be entertained in Harlem than anyplace in the world. In fact, no place else was even close. Every night of the year great jazz could be heard up and down all the avenues and the cross streets in between. You could hear a band led by Benny Carter at the Alhambra Ballroom; a few blocks up Seventh Avenue (now Adam Clayton Powell Jr. Boulevard) you'd find Fletcher Henderson at Connie's Inn; and if you wanted to walk a few blocks more, Charlie Johnson could be found holding forth at Small's Paradise. You could listen to Luis Russell at the Capitol Palace on what was then Lenox Avenue (now Malcolm X Boulevard), dance all night with Chick Webb across the street at the Savoy Ballroom, or see an incredible stage show with Cab Calloway at the Cotton Club a few blocks north. And these were just the big ballrooms; there was dozens of smaller places on the side streets with great pianists, vocalists, and small bands. There was nothing like it anyplace else in the world.

I was born in Harlem in 1930 and it has always been my home. I may not have been conscious of the music when I was a child, but it didn't take long for me to realize that music, particularly jazz music, was an integral part of my community. The first jazz I ever heard was on records by Fats Waller. My uncle Herb looked and could sing like Fats, and I'm sure he played many others, but I remember hearing "Ain't Misbehavin'" on the wind-up Victrola. It was then I began to absorb jazz, not just because I heard it on a record, but also because it was everywhere—on the radio, the street corner, and jukeboxes.

As a young man in my late teens, I enlisted in the U.S. Army and was ultimately shipped to Korea (my only extended stay away from Harlem), but not before I'd heard Chick Webb, Count Basie, Jimmy Lunceford, and Duke Ellington at ballrooms like the Savoy or at the Apollo Theater, and other terrific artists at exciting clubs like Minton's Playhouse, Celebrity Club, Hot-Cha Bar and Grill, or the Silver Dollar Café. All these great musicians made a lasting impression on me and shaped my musical interests.

When I returned home after being gone from my beloved Harlem, I had missed out on much of the jazz migration downtown to clubs on Fifty-second Street and Greenwich Village that had been going on but, fortunately, my buddies from schooldays Arthur Barnes and Norman Howard had kept up and led me through the times I had missed. It was a sad day when the Savoy Ballroom closed in 1958, but by that time, none of the big ballrooms and theaters that were active the year I was born were still in business, and even though a few clubs held on into the 1960s, by the time I was elected to Congress in 1970, there was very little live jazz in Harlem on a regular basis. The legendary Apollo Theater still staged shows, but not with the regularity that made it such an exciting place in years past.

A case in point: In the early 1970s, Clyde Bernhardt, a wonderful trombonist who'd played in Harlem in bands led by everyone from King Oliver to Claude Hopkins and Joe Garland, formed the Harlem Jazz and Blues Band. Other members of his band were legendary players, artists like Doc Cheatham, Cozy Cole, Tommy Benford, Happy Caldwell, and Charlie Holmes. Over

the next thirty years the lineup changed as often the Yankees' lineup, but for almost thirty years, there was one constant: The band never played in Harlem. There was no place for a band like this to play. Happily, that is no longer the case, but it was for much too long.

I knew—and in a few cases, still know—many of the musicians who appear in *The Ghosts of Harlem*. The roster of musicians is wide ranging, from journeymen like Greely Walton and Gene Prince, to exceptional sidemen like Al Casey and Jimmy Hamilton, and big-band leaders such as Erskine Hawkins and Andy Kirk. There are also star entertainers like Cab Calloway and Joe Williams, and giants such as Dizzy Gillespie and Benny Carter, two of the finest American musicians of the twentieth century. In these pages can be found the voices and photographs of some of the men and women who created the most enduring and influential American art form, America's classical music, and much of this creation was centered in a small enclave of New York City known as Harlem. There are many reasons why Harlem is so well known and has such iconic status all over the world, and one of the most important is the music created by the men and women chronicled in *The Ghosts of Harlem*.

Except for one new artist included in this English-language edition—my good friend, the wonderful pianist Dr. Billy Taylor—all these interviews and photographs date from the years 1986 through 1996. At that time, many of the musicians were understandably upset with what they saw happening in Harlem, particularly the lack of opportunity to perform. Benny Waters's description of coming out of the subway after many years abroad and bursting into tears is very moving. Sy Oliver's comments about driving across 125th Street are equally disturbing, but I'm happy to report that in one short decade there have been remarkable changes; music—jazz music—is once again alive and well in Harlem. In this case, almost everyone was wrong when asked if jazz would return to Harlem.

The Apollo Theater is freshly refurbished and now presents events on a regular basis, as well as special all-star concerts sponsored by organizations as diverse as Time Warner, Jazz at Lincoln Center, and the Jazz Foundation of America, as well as the theater itself. The Jazz Museum in Harlem will soon be a reality and have a home on 125th Street, and there are nearly a dozen clubs in Harlem that present jazz and related music on a nightly basis. I only wish that all these wonderful musicians who made Harlem such a vital place for so many years were still here to see how vibrant the streets of Harlem have once more become, and how much more is planned for the future.

I don't know if Harlem will ever be like it was when I was born, but maybe it will be something even better. Much is made of the Harlem Renaissance of the 1920s; but someday they'll be talking about the renaissance that occurred in the first decade of the twenty-first century. Perhaps we will never see the likes of Dizzy Gillespie and Cab Calloway again, but there will be others who are equally exciting, young men and women who, as they move forward into the future, can look back and reflect on the stories and portraits presented in *The Ghosts of Harlem*.

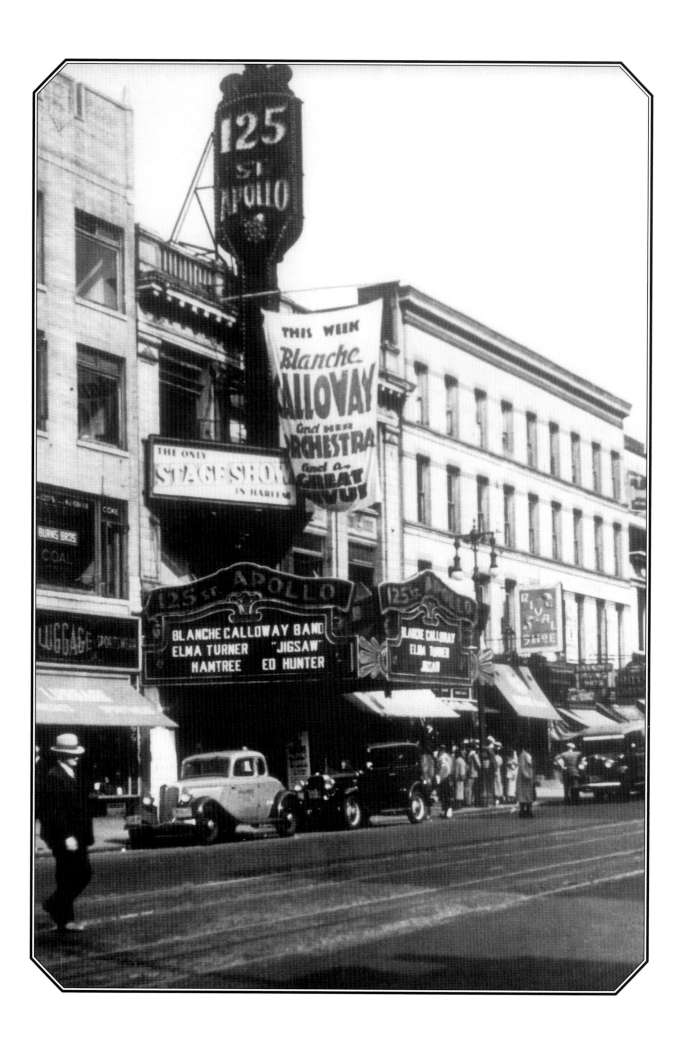

Introduction

Harlem 1985

I once asked Sammy Cahn, the noted lyricist, a question he'd heard many times: "What comes first, the words or the music?" Sammy replied, not in jest, "The telephone call," and it was much the same with the project I was later to call *The Ghosts of Harlem*. The telephone call came from my longtime friend, the noted record producer/talent scout and social activist John Hammond. The day was 4 March 1985, and John wanted to go on a short journey into the past.

The destination was the basement of Small's Paradise at 135th Street and Seventh Avenue (now Adam Clayton Powell Jr. Boulevard), where, on Monday evenings in the spring of 1985, it was still possible to hear a big jazz band uptown. Al Cobbs's C&J Orchestra played two sets each Monday; Al wanted John to hear his band and had repeatedly asked that he come by and audition the group.

When John Hammond first visited Harlem in the 1920s, he was an enthusiastic teenager on the verge of discovering music and people that would change his life and music in America. For those who've never heard of John, think Billie Holiday, Benny Goodman (his brother-in-law), Count Basie, Charlie Christian, and in later years Aretha Franklin, Bob Dylan, George Benson, Bruce Springsteen, and Stevie Ray Vaughan. John discovered and launched the careers of these and many other artists over a period of fifty years.

In the 1920s, thrilling new music and exciting nightlife were evolving in front of his eyes and in his ears. Six decades later, in 1985, John was in failing health and, like Harlem, had seen better days. He knew he didn't have the energy or wherewithal to do anything with Al's band, but he did want to check it out, because he said he would and perhaps because he wanted to have one last look.

John knew that I was always game to go hear a jazz band with him, no questions asked; that I knew Al and some of the men in his band; and, most important, that I had a car, a perfectly inconspicuous go-to-a-rough-neighborhood kind of vehicle that could be left on any street in New York City and still be there when I returned.

In those days the band played only two sets, and they were early sets. The first one may have been at 8:00, the second at 9:30. Everyone in the band was a pensioner: The days of jamming until dawn were behind them, and they didn't want to be out on the streets too late.

Opposite: The Apollo Theater, 125th Street, September 1935

1

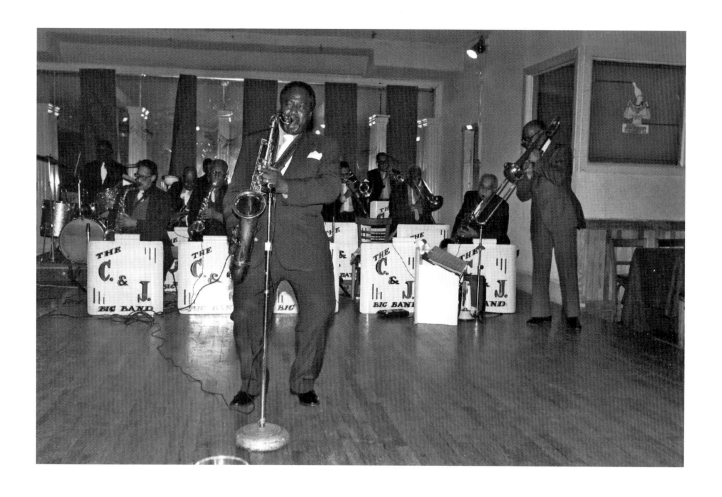

Eddie Martin with Al
Cobbs's C & J Big Band,
Small's Paradise, April 1985

The same was true for John, and he had permission from his wife to stay for the first set.

Shelley Shier, my business partner and wife, and I arrived at 444 East Fifty-seventh about 7:15, picked John up, and headed north. He said we should take the park drive, which was how he always liked to go to Harlem. Shelley was excited; it was her first trip uptown to hear live music. I was excited as well because it was the first time I'd ever been to Harlem with John, a man who'd been there in the early 1920s, who'd seen the development of jazz during its formative years.

John was in a reminiscing mood. We made the light at 110th Street and as we sped through the intersection he said, "One night I was taking Art [Tatum] home and I ran a red light at this corner and Art said, 'You missed that one, John.' You know, he could see a little." As we headed north John pointed out landmarks along the way: "See that window over there, the one with the light? That's where Fats [Waller] lived." Or "That building, the big grocery store, was Connie's Inn." He was clearly having fun, and we were, as well.

We arrived at 135th Street. I made a U-turn and parked the car on the corner at 134th. The only lights on that side of the street streamed from Small's and an inconspicuous diner next door. We went in, followed the buoyant sounds of warmly pulsating music down a flight of stairs, and found a crowded basement room of people enjoying themselves. Much to our regret, we'd missed the beginning of the first set. The band was playing, and, to paraphrase Fats Waller, whose window we'd passed under earlier,

the joint was already jumping. People were dancing and listening to the music, picnic baskets that had been groaning with food were becoming rapidly depleted, and the single refreshment concession, which dispensed soft drinks and potato chips, was enjoying brisk sales.

I know John Hammond has a few detractors—people who say he really didn't discover this person or that, or didn't do all the things that were claimed in the books and magazines (usually by people other than John)—but that night, when many of the older musicians in Al's band caught sight of him, their faces looked as bright and enthusiastic as a bunch of kids on Christmas morning. He was an old friend, one who'd done much as a social activist and a talent scout, and he'd come out for them.

We found three seats, I secured

some potato chips and soft drinks, and we enjoyed the remainder of the set. It was spirited music, miraculously resurrected from another time. Was the C&J Orchestra a world-class big band like those led by Duke Ellington or Count Basie, or even a lesser band like the Mills Blue Rhythm Band? Of course not. But the C&J was full of live musicians making music that might have rattled some of the ghosts out of the nooks and crannies of Small's Paradise, and that was good enough for me and for everyone else in the room.

I took a few snapshots of the band, and at the conclusion of the set I photographed John with some of the guys to commemorate the occasion. I'd promised John's wife, Esmé, that I'd have him home before 9:30, and the promise was one I wanted to keep.

From left: Max Lucas, Howard Johnson, Marion Davis, John Hammond, and Shelley Shier, Small's Paradise, April 1985

We bid everyone good-bye, climbed the stairs, and made our way to the street.

My leave-it-anywhere car was still parked under the bright light at the corner. I unlocked the doors for John and Shelley, helped Shelley in, and turned to help John, to find him standing quietly, staring at a sad-looking building. He seemed lost in reverie. The building was little more than a derelict shell. A rusting sign that had once been lit with colorful neon proclaimed Bar HOT-CHA Grill, but it hadn't glowed in years and now it seemed as though it might crash to the street at any moment.

I asked John what he was looking at and he said softly, "That's where I first heard Billie [Holiday]." We headed downtown, but our conversation was not so animated. John had heard some good music, seen some old friends and acquaintances, done his duty, but this last look wasn't such a good one. He died a little more than two years later in July 1987, and he never visited Harlem again.

This brief uptown musical episode both fascinated and puzzled me. I became interested in the question of how the vibrant musical scene that had permeated pre–World War II Harlem could vanish in less than two decades.

How did it happen? This question was mixed with the outrage I always felt, when I visited Harlem from the mid-1960s onward, at the sight of this once wonderful neighborhood in such a state of decay. How could otherwise intelligent people—the residents of the neighborhood and the city government—allow such urban blight to occur? This was, after all, the place Duke Ellington once described as something as glittering as a scene out of the Arabian Nights. At the same time, I knew I was treading on sensitive ground because I was from the

outside; I'd lived in New York City for the past seventeen years, but 135 blocks south of 135th Street.

There were any number of men and women I could question who were intimately involved with the uptown music scene—people I knew well, like Benny Carter, Maxine Sullivan, Buck Clayton, Doc Cheatham, and Cab Calloway. In 1985 there were a few people still living who had performed in Harlem prior to 1920, but there were hundreds of men and women who'd worked in theaters, ballrooms, clubs, and corner bars prior to World War II and many more who had made music uptown as conditions worsened in the 1950s and 1960s.

Many of the older musicians were longtime friends and acquaintances I had worked with and planned to work with again. They had lived and worked

From left: Benny Carter, Maxine Sullivan, and Doc Cheatham, Floating Jazz Festival, 1985

in Harlem during the golden prewar years, and I knew they could not only bear witness to Harlem's musical decline, but also offer firsthand reasons for its demise. If anyone might have answers to my questions, it would be the men and women who made the music while hundreds of thousands of happy people stomped at the Savoy, wobbled at the Paradise, or shuffled along at Connie's Inn.

The idea to interview and photograph some of the surviving musicians who had performed uptown prior to World War II came upon me one day, from wherever ideas come from, but I didn't begin the project immediately. I first began making notes and assembling lists of musicians who I felt might have interesting observations. I also discussed my potential project with two people who I felt might provide me with suitable historical and photographic guidance—John Hammond and my photographic mentor, Berenice Abbott.

John was very encouraging. In fact, he made suggestions as to whom I should interview first and even asked that I let him know when I would be with certain people. He was increasingly confined to

his home due to illness and wanted me to telephone him during the interviews and photo sessions so that he might have a chat with some of these older musicians, men and women who were very dear to him.

Berenice was less enthusiastic, at least initially, but that was her nature. The ultimate realist, she knew how much work would be involved for the photography alone. She told me it sounded like a good project, but if I undertook it I should take the photographs with a large-format view camera—nothing less would do—and I should be very careful with the portraits. Lighting was critical, she said, because black faces absorb so much more light than white ones do.

As my project developed, she became more and more enthusiastic. Berenice loved the Savoy Ballroom—she'd not only danced there when she returned from Paris in 1929 but had taken the first photograph of a band in live performance at that legendary ballroom in the same year. This was a remarkable achievement, given the circumstances. She danced many nights away at the Savoy and sometimes went there with her friend

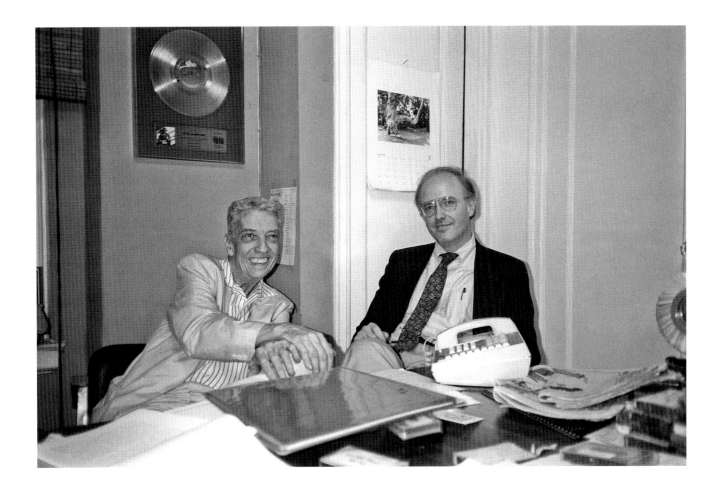

the legendary Lelia Walker, whom she photographed in the late 1920s.

I've always been partial to the statement "He was in the studio at the time," which simply means that someone was present when something happened. If there was a question about a recording that couldn't be determined by merely listening to the music, then I've always felt it best to discuss the circumstance with someone who was there in the studio at the time—in the band, making the music, or working as a producer or technician. In the same way, I felt the older musicians who'd played uptown would offer better ideas than those put forward by jazz critics, most of whom weren't in Harlem when the music happened.

In the beginning, I had no plans to assemble the results of my efforts into book form; I simply planned to photograph and pose a few questions to some of the musicians I worked with on a regular basis. The basic questions I wanted to ask were:

1. Where did you first work in Harlem, either for pay or just jamming? Where was it located and what was the year? Describe the general ambiance.
2. Who were the other players in the band?
3. Describe the audience. Was it black, white, or mixed?
4. In your experience in Harlem, where did you most enjoy working?
5. When you weren't performing, where did you hear the best music and who was your favorite band?
6. When did the jazz scene in Harlem really peak for you?

John Hammond, *left,* and Hank O'Neal at Hammond Music Enterprises office, New York City, 1983, photographed by Allen Ginsberg

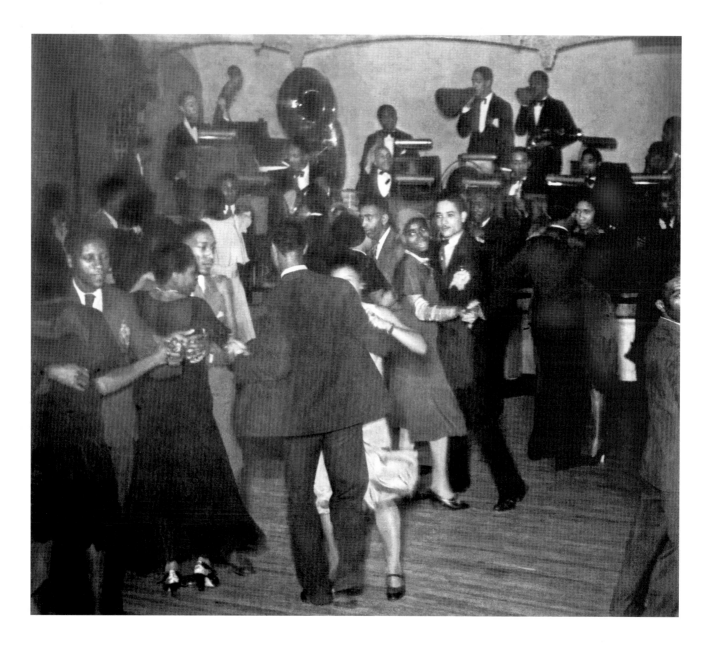

Dancers with Chick Webb and His Orchestra, Savoy Ballroom, New York City, 1929, photographed by Berenice Abbott, © Berenice Abbott/ Commerce Graphics, NYC

7. Were you active in the after-hours music scene?
8. When did you notice the music scene beginning to fade? Were you regularly performing uptown when this occurred?
9. When was the last time you worked uptown? What was the name of the location? What was the difference between your first job in Harlem and the last time you performed there?
10. What do you think killed the music scene in Harlem?
11. What do you miss about it the most?
12. Do you think music will ever come back to Harlem on a large scale?

I tried out these questions with a handful of musicians during the 1985 Floating Jazz Festival. The 1985 festival was more leisurely than most, spread out over four weeks at sea, and there was time to take advantage of an afternoon at sea with some of the potential "ghosts" on board the ship. These first conversations—with Buddy Tate, Joe Williams, J. C. Heard, and Major Holley—were tentative, testing their reactions to the questions. I discovered in these first interviews that everyone knew the music was gone—long gone—but few had ever really thought about why. They had just kept working and moving on.

After a conversation with Buddy Tate and his wife, Vi, I also discovered that the answers to what seemed fairly simple questions might be more complex than I initially imagined. The Tates suggested one reason the music vanished that I hadn't even considered: integration. Later, back in New York, I mentioned Buddy's and Vi's comments to John Hammond, and he agreed with everything they'd told me on the ship.

In early 1986, I began to conduct more interviews and took the first portraits with my large-format camera. One of the first people I interviewed and photographed was a longtime friend, Milt Hinton. Much of what he said helped put my project in perspective and was very encouraging. The excerpt from the interview that follows illustrates this. It is not typical of the interviews that I present for each musician, because I have retained all my remarks, whereas in the others I have generally condensed my remarks to a single question.

Milt was not only a wonderful musician and raconteur but a fine photographer as well. He had conducted a number of interviews with many of the well-known and less well-known first-generation jazz musicians who'd been active in Harlem and clearly understood the importance of the interviews I planned to conduct and the photographs I wanted to take. When I asked about the many interviews he'd conducted with older musicians, some on behalf of the Smithsonian Institution and some for himself, Milt replied:

> That's right, I've got hundreds of tapes here, with Eubie Blake, Perry Bradford, Jerome Richardson, Jo Jones, Ben Webster, and people like that. Mona and I would have them over for dinner and then after dinner, maybe Eubie and the guys and the

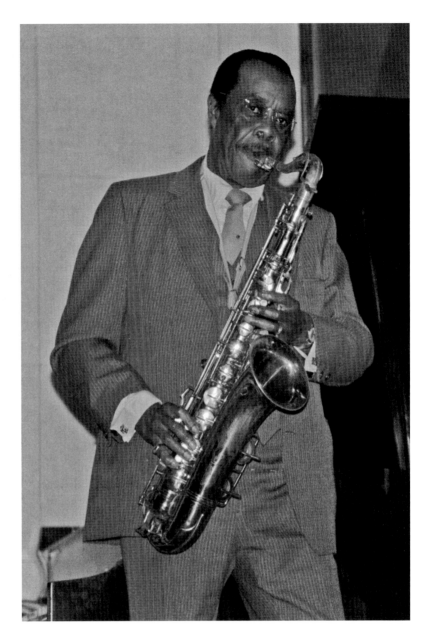

Buddy Tate, Floating Jazz Festival, 1985

ladies would come down here to my basement and have some coffee with some brandy and somebody would stick one of those questions in. I had an old upright piano over there in the corner. Somebody would hit Eubie Blake with one of those questions or maybe Marion Evans, the great genius of orchestration, would say something to Eubie and Eubie would say, "Now, you're using that trick harmony on me," and we'd get this thing going and it was just fabulous the information that would come out

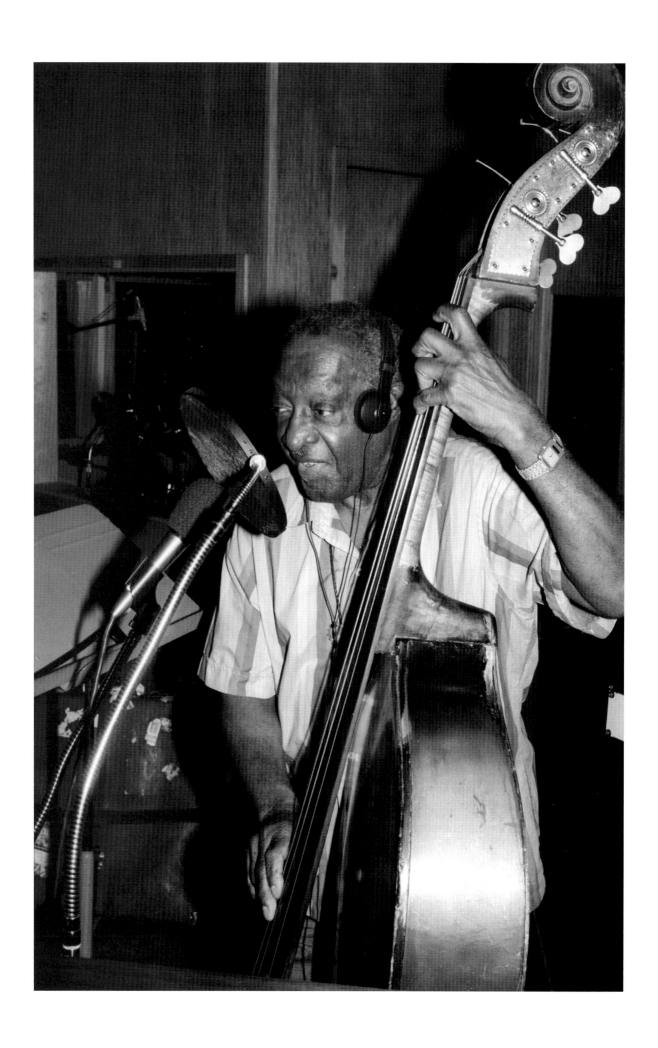

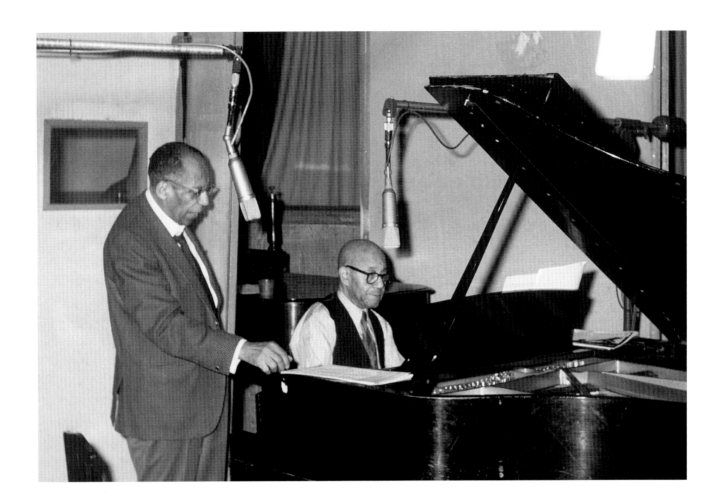

of these get-togethers. Eubie would say, "There ain't no sense in me telling you. I'll have to show you," and he'd go to my old piano and he'd start hitting on something.

This basement is the last place Ben Webster lived when he was in the United States. Right here. He slept right on this couch. Things were bad for him, and he was my dearest friend. Mona loved him. She tried to save him, tried to show him how to save himself, to take care of himself. You know, she's a magician with money and she has a real estate license.

Mona said to Ben, "You're such a star, such a famous person, if you'll just give me five thousand dollars, I'll make a down payment on a house, a two-family house, where you can rent the upstairs. I'll rent the upstairs for you and you can get enough money

from the rent to pay the mortgage. Then I can get a nice elderly lady that needs a home to stay in one of your extra bedrooms in the downstairs apartment and just keep it clean for you and keep it so you can live there when you come back to the United States." But we could never get him to even do that. We would sit around and play duets; I took two mikes and hung them overhead and I'd set up a tape recorder. I've got so many tapes of just Ben and I playing. The last place he lived was right here. Then he finally had to go to Europe, and when he was gone I'd get a call at four o'clock in the morning on Sunday—I knew it was ten o'clock in Copenhagen—and Ben would be drunk and lonesome and he would call and talk to me, my wife, and my daughter. It was so sad.

Noble Sissle, *left,* and Eubie Blake at Columbia studios, New York City, February 1969

Opposite: Milt Hinton, Van Gelder recording studio, Englewood Cliffs, New Jersey, 1990

Hank:

Well, you see, that's one reason why the title of the book is *The Ghosts of Harlem*. A giant like Ben Webster was treated with so much more dignity in Europe than in the United States. He had so many more places where he had an opportunity to work, to record. The same was true of so many of the mainstream black musicians who were shut out of work when the big-band era died, when the music changed, and when venues in neighborhoods like Harlem simply vanished. I don't know exactly when it started, but certainly by the 1950s, even the late 1940s, there was an exodus of musicians to Europe, and later Japan, where they were treated as exceptional artists. Then they'd return to the United States, where there was limited work, and simply vanish like ghosts—like Ben Webster living in your basement. It's a disgrace. Some of them just gave up before they had any chance to play overseas where they were appreciated. In the 1970s, John Jeremy shot a major portion of a fine film at my recording studio. It is called *Born to Swing*, and one of the things in the film is a section on Dicky Wells. In those days he was working as a messenger for some company on Wall Street.

Milt:

It breaks my heart. You see, I was lucky. I was lucky to be in the right place at the right time and be fortunate enough for someone to be kind enough to give me a job in the studios and have common sense to behave myself and do the job right. I made a couple of bucks, but while I was working I saw my dear friends, my dearest friend, Paul Webster, a fine trumpet player with Cab, working in a subway. I saw Hilton Jefferson—one of the finest saxophone players, a man that Benny Carter worships—I saw him messengering for a bank. Any number of them. Greely Walton worked for a brokerage. All of these great, great musicians were out of work because there were no more big bands and no place to play. All these hotels in New York and all these people playing in these hotels and you have a hard time finding a black musician these days. It was even worse in the 1950s, and it ruined a lot of people. As I say, it just makes me sad about all the ghosts we've lost, so many of these gentlemen you've mentioned. Some of the happiest days I had in my life was listening, talking, and playing cards with these gentlemen, and they were mostly gentlemen. It seems as if we in music—and I'd say music, not just black or just white—that if you were eccentric or a little odd and had talent, you'd probably be successful, but just to be a nice guy, save your money, go to church, and go home wasn't enough. I tell people all the time I've never gotten any publicity because I've been a deacon at my church for five years. They don't understand a jazz musician that's a deacon. Sure, I drink. My friends come over and have a taste with me, but you don't catch me laying in the gutter or something like that. It's not good copy for a musician to do that, to be a good guy.

Now, show me the names on your list. Gene Mikell, he was in Cab's band, but his father taught Benny Carter and Russell Procope.

His father was really the leader of James Europe's band. Gene can tell you about that. Sammy Lowe, Sy Oliver—I'm sure they'd be happy to talk to you. Make sure you talk to Beverly Peer, but don't be surprised if he is a little leery of you. Some of these guys are white-shy. Just be careful; and if it helps, you just mention my name. Say something like, "I was talking to Milt, and he said I should call you"—this might help. My concern is that the information gets out and to make sure it doesn't blow. I'm into blackness, and I go into one of my classes and the students just look at me when I mention someone like Will Vodrey—black kids who should know their heritage, and they just look at me.

Hank:

I think it's very important. You interviewed a lot of people, but you didn't get them all, and I know I can't either. My scope is also narrow, but I'll do what I can. I have a small family, very few relatives, and my parents died young. I have boxes full of family photographs and don't know who these people are, and there's no one to ask. I thought about this when I was organizing this project. One of these days all the people who played uptown will be dead—they'll all be real ghosts, and if some of it isn't set down, no one will remember. It's hard enough to get people to remember them when they're alive.

I refer to the men and women on my interview list as "ghosts" partly because the word is featured in the working project and the proposed book

titles. All of these people were very much alive and, indeed, all but two were working musicians. Yet, as Milt Hinton suggested, the word seemed to fit. These were men and women who once lived and worked in Harlem and then simply vanished, leaving a handful of memories and traces behind—photographs in the lobby and halls of the Apollo Theater, the occasional street sign, or even a name on an apartment house. (I would mention the proposed title to most of those I interviewed and the reaction was positive; it made sense to them.)

Milt's comments encouraged me about the importance of doing the interviews, but I was concerned about a number of things. Would I get straight answers? Would the musicians look on me as just another pesky fan asking a lot of questions, wasting their time, and going over things that happened many years before? Would they simply make up stories they thought I would like to hear? This was certainly a possibility. I knew then, and know now, that much of jazz history is anecdotal, made up on the spot by musicians just to get someone to leave them alone or to have a little fun with a gullible questioner. Indeed, this was a subject discussed during some of the interviews, and many people suggested that almost everyone at one time or another passed on spurious information.

There was another complication. I was asking people to let me invade their homes with a tape recorder and cameras, record their thoughts, and take a formal portrait. It's one thing to ask someone to let you take a snapshot at a club or after a concert, but quite another to ask them to sit around while you set up an old wooden view camera in their home. Fifteen seconds to take a snapshot is an inconvenience; an hour to organize a portrait is an imposition.

It turned out that the time it took to

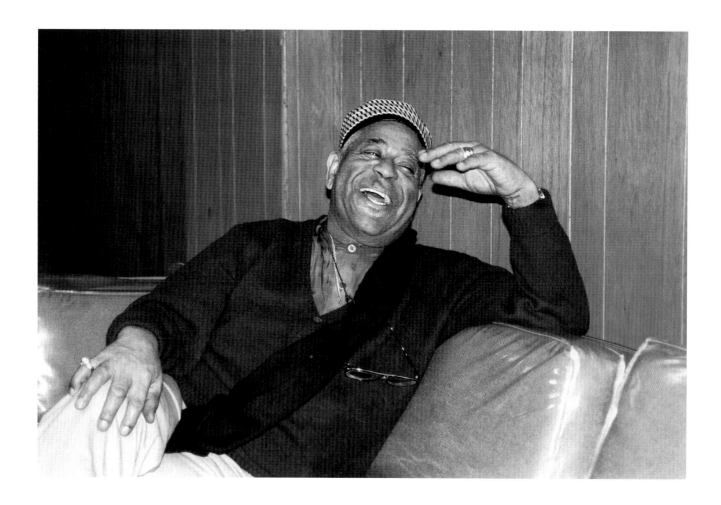

Dizzy Gillespie at home,
Englewood, New Jersey,
1990

take a portrait and the use of my ancient camera probably had a very positive effect and taught me a valuable lesson. The only reason I got away with taking so long was because the process amused the men and women on the other side of the lens, as I unfolded the old camera, arranged my modest fill light, and fumbled under my focusing cloth.

A serious camera does have an effect on most people, and all my subjects were old enough to remember when—either in their childhood or later—this was the way everyone had their portraits taken. That old camera was a trip back in time for most of them. When I'd take it out of its case, the usual reaction was, "Look at that! I haven't seen one of those in years." Then I'd make them promise not to laugh at me while I was trying to get the photograph set up. The focusing cloth always messed up my hair, and since I

had to use special glasses for focusing on the ground glass, I usually had the appearance of someone wearing glasses made from the bottoms of Coca-Cola bottles who'd just put his finger in an electric outlet.

All my subjects were amused. Some of them laughed out loud. Dizzy Gillespie actually howled, but when he got over it, he went to a locked cabinet and retrieved some of his special cameras so we could compare notes. The old camera was my secret weapon, and people who had moved around a great deal for most of their lives happily held still for the one- or two-second exposures that were required for indoor portraits.

In its simplest form, my project was to ask my questions and take some photographs. It continued along these lines until mid-1986, when it became something else. My former editor at St.

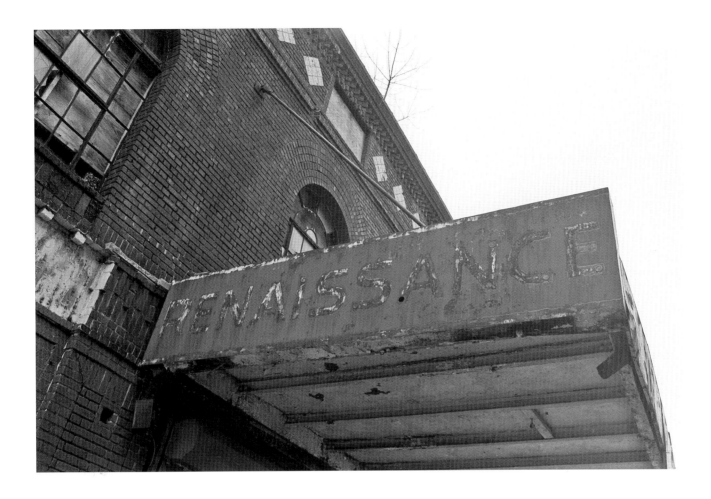

Martin's Press, Les Pockell, telephoned in April and said he was now at Doubleday and was looking for good projects. I told him I might have just the thing. I offered up my working title, *The Ghosts of Harlem*, a long list of potential ghosts complete with telephone numbers, and a three-page outline. My idea was accepted, and on 6 June I signed a contract with Doubleday. Les later told me he could have sold the book on the title and list of names and telephone numbers alone. The contract called for a book with sixty photographs and 100,000 words of text. I took the first official photographs for the book four days later, when I visited and interviewed Jimmy Hamilton in St. Croix in the Virgin Islands. I worked steadily for the next year taking photographs and conducting interviews.

Searching for the Ghosts

My first step in *The Ghosts of Harlem* project was to identify the people I wanted to contact. I knew it couldn't be an all-inclusive list; in fact, it would be very narrow, restricted to musicians. If I'd had the time to be completely thorough, I would have asked my questions of musicians' wives, dancers in the chorus, stagehands, and nonmusical entertainers, such as jugglers and comedians. I would have also sought out individuals who'd owned ballrooms and nightclubs, almost all white, and those who'd owned smaller clubs and neighborhood bars, mostly black, where there was music on a fairly regular basis.

I knew the names, backgrounds, and addresses of most of the men and women I wanted to contact, but I needed

The Renaissance Ballroom, 150 West 138th Street, 1996

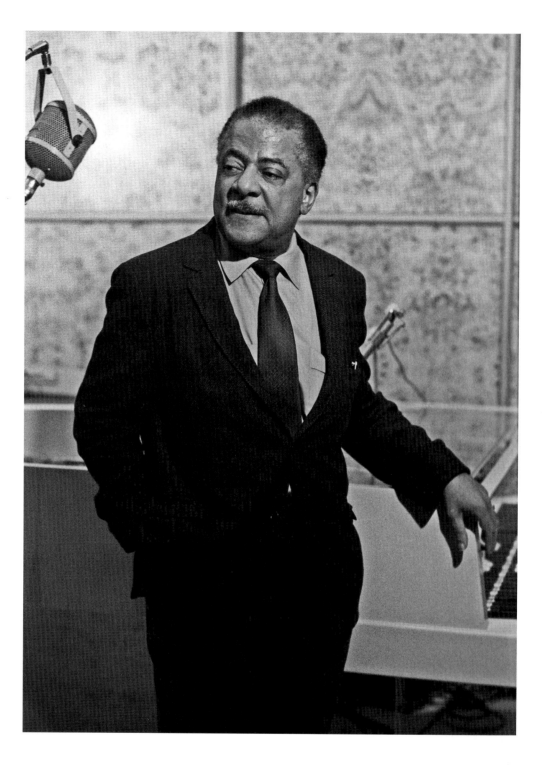

Teddy Wilson at the home
of Sherman Fairchild, New
York City, 1971

help with some of the less well-known
players. I turned to Stanley Dance for
advice on the big-band swing players
of the 1930s and to Dr. Al Vollmer for
information on the older men, many
no longer active, who had performed
uptown in the 1920s and 1930s. Each
man came up with names and addresses
of long-forgotten players, who were often

not even included in standard reference
books.

My list of potential ghosts grew
to 112 men and women; two of these,
Teddy Wilson and Clyde Bernhardt,
died as I was assembling the list, which
made me realize time was my enemy.
By the beginning of August 1987, I
had managed to conduct thirty-four

interviews (denoted by *) among the 110 possibilities listed here. In 1991 I interviewed Dizzy Gillespie, and in 1996, I reinterviewed Al Cobbs and conducted six additional interviews (denoted by †). I photographed four other ghosts but for one reason or another didn't conduct an interview with these men (denoted by ‡). In 2007 I conducted the final interview for this book, with Dr. Billy Taylor. (The names of all forty-two ghosts interviewed for this book are in boldface.)

William Alsop
Ovie Alston*
Harold Ashby
Harold Austin
Eddie Barefield*
Danny Barker*
Mario Bauzá
Aaron Bell
Tommy Benford*
Sammy Benskin
Skeeter Best
Lester Boone
Herman Bradley
Ed Burke
Jacques Butler
Jimmy Butts
Cab Calloway*
Nelson Cannon
Thelma Carpenter†
Leslie Carr
Benny Carter*
Al Casey†
Eddie Chamblee
Doc Cheatham*
Arthur Clark
George Clark
Buck Clayton*
Al Cobbs*†
Rupert Cole
Harry Dial
Bill Dillard*
Eric Dixon
Bill Doggett
Eddie Dougherty
Eddie Durham*
Harry Edison*
Roy Eldridge

Mercer Ellington
Brick Fleagle
Bernard Flood
Panama Francis*
Charlie Frazier
Carl Frye
Dizzy Gillespie
Freddy Green
Clarence Grimes
Tiny Grimes
Al Hall
Jimmy Hamilton*
Erskine Hawkins*
J. C. Heard*
Horace Henderson
Haywood Henry
Eddie Heywood
Milt Hinton*
Major Holley*
Franz Jackson*
Milt Jackson‡
Illinois Jacquet†
Howard Johnson
Jonah Jones*
George Kelly†
Andy Kirk*
Johnny Letman
Jimmy Lewis
Sammy Lowe*
Lawrence Lucie†
Calvin Lynch
Dave McRae
Teddy McRae
Jay McShann‡
Gene Mikell
Freddie Moore
Peck Morrison

Fred Norman
Sy Oliver*
Beverly Peer
E. V. Perry
Gene Porter
Sammy Price*
Gene Prince*
Roger Ram Ramirez
Red Richards*
Gene Rodgers
Ivan Rolle
Al Sears‡
Arvell Shaw
Cliff Smalls
Jabbo Smith‡
Perry Smith
Alberto Socarras
Ted Sturgis
Maxine Sullivan*
Buddy Tate*
Billy Taylor
Clark Terry*
Joe Thomas
Louis Thompson
Norris Turney
Greely Walton*
Benny Waters*
Laurel Watson
Frank Wess†
Crawford Wethington
Doc Wheeler
Bobby Williams*
Joe Williams*
Johnny Williams*
George Winfield
Booty Wood

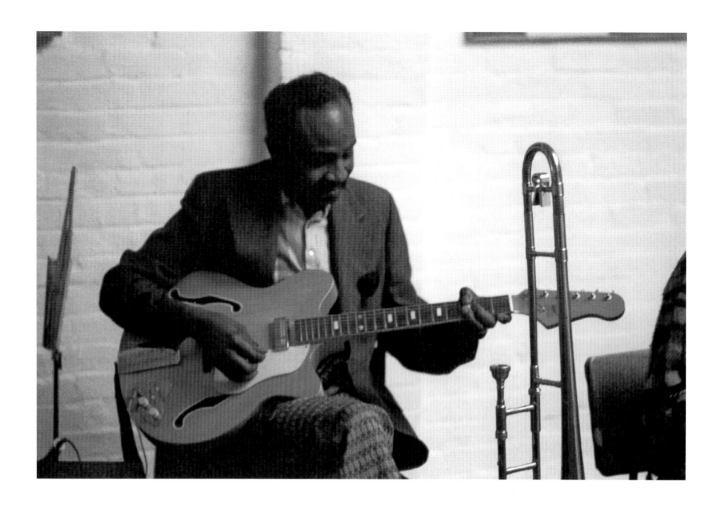

Eddie Durham, WARP
studio, New York City, 1973

As the list of names grew, even a casual glance at the addresses and telephone numbers made something very clear: Harlem may have been where these musicians first played in New York, but it was, as I had suspected, no longer where many of them lived, and it certainly wasn't where any of them, with a few exceptions, performed on a regular basis. Ultimately, I conducted only five interviews uptown; of those five, only three people actually lived in Harlem—Andy Kirk, Sammy Price, and Greely Walton. I interviewed and photographed Eddie Durham and George Kelly in Harlem, but both men lived in Brooklyn; they simply preferred to meet me in the apartments of lady friends who lived uptown.

I felt it was important to conduct the interviews in the musicians' homes or wherever they were most at ease. The most important factor to me was to make the musicians comfortable. I felt this would lead to better interviews.

I handled the photographs in the same way. I wanted the men and women at ease, in their own homes, surrounded by familiar objects, or at least in their neighborhood, if they wanted to be photographed outside. I had no interest in a portrait of anyone with a horn in his mouth, even though, in some instances, the musicians wanted to hold their instrument or perhaps sit at a piano. Milt Hinton, for instance, felt most comfortable holding his bass, which he was doing when I photographed him in his basement.

There were no performance portraits—no one dressed up, no one was styled, and nothing was set up or

fabricated. The best remark any of the musicians made to me about the setup of the photographs came from Maxine Sullivan, when, at the conclusion of the interview, I told her I wanted to take a photograph. Maxine looked at me and said simply, "Well, what you see is what you get." She hadn't fixed herself up; she was wearing a dark blue jumpsuit and her infectious smile. This was the way she was around the home she'd shared for so many years with her husband, the legendary Harlem stride pianist Cliff Jackson. This was, of course, exactly what I wanted. The photographs simply depicted the way these people appeared at the conclusion of our interview.

Between June 1986 and July 1987, I conducted thirty-two interviews. I photographed twenty-nine of the musicians with a large-format view camera and three with a medium-format camera—in St. Croix (Jimmy Hamilton), New Orleans (Danny Barker), and Oslo, Norway (Benny Waters). I was thrilled; the interviews were consistently informative and the photographs were equally interesting. I felt it was time to get some critical feedback and decided to show a representative sample of an image of each musician to my sternest critic, Berenice Abbott.

In those years I always spent at least one week a year with Berenice in northern Maine, and I made it a point never to miss her birthday in mid-July. The timing was perfect. Her birthday was just around the corner, and I spent a good deal of time in the darkroom making certain I had decent prints to put before her always critical eyes.

I think she was surprised I'd managed to take so many portraits in such a short time. She complimented me on some of the images—high praise indeed from someone so reserved and

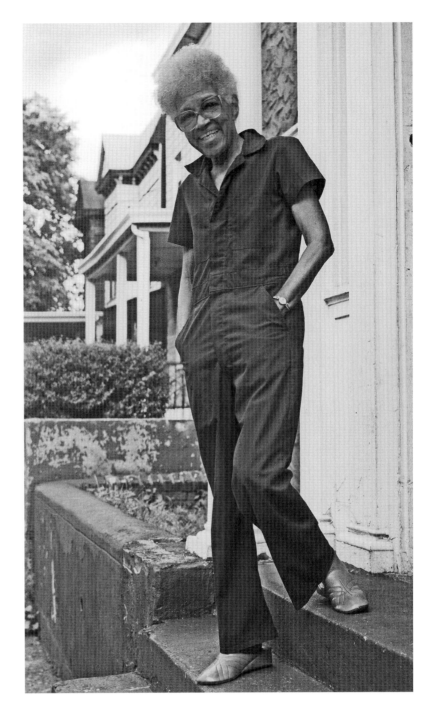

normally not effusive. She told me once more of the difficulties she'd had with men and women like Claude McKay, Lelia Walker, and Buddy Gilmore in the 1920s, when she had only modest natural light and one artificial light, and of how she'd had even more trouble with Leadbelly in the 1940s, when she had decent studio lighting, because he was *so* dark. I told her I had many advantages

Maxine Sullivan at home, Bronx, New York, 1986

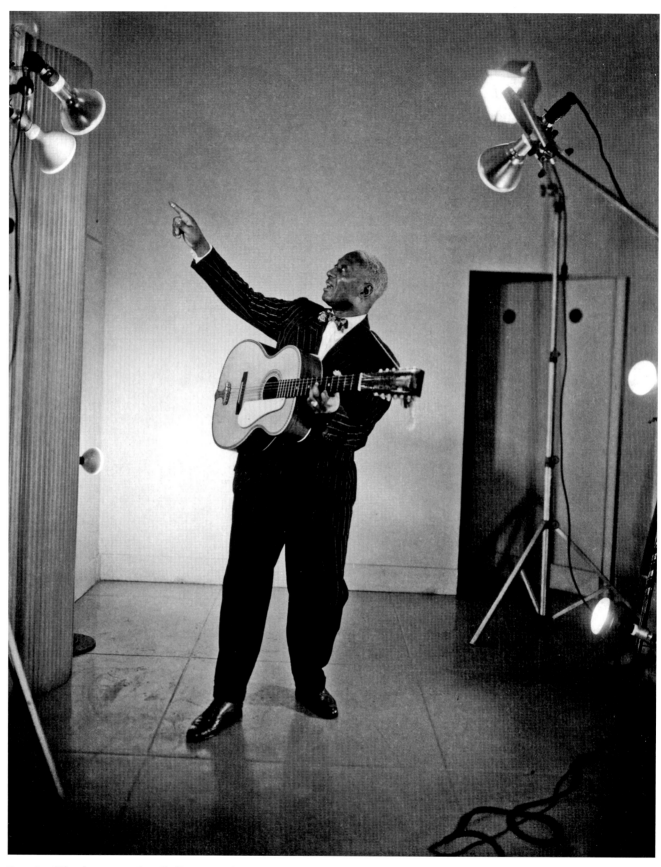

Berenice Abbott's portrait of Leadbelly, New York City, 1945,

© Berenice Abbott/Commerce Graphics, NYC

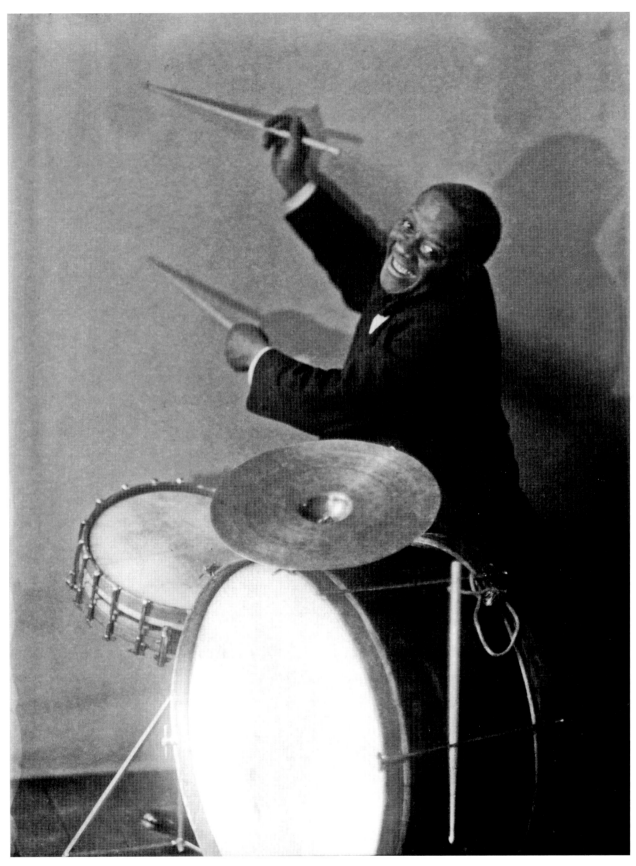

Berenice Abbott's portrait of Buddy Gilmore, Paris, 1927,

© Berenice Abbott/Commerce Graphics, NYC

The Harlem Blues and
Jazz Band and film crew
outside Van Gelder studio,
Englewood Cliffs, New
Jersey, 1990

unavailable to her: My film was possibly
five or six times faster than her glass
plates in the 1920s or even the sheet
film she used in the 1940s; my portable
halogen light was very strong, to use for
either fill or for better illuminating dark
rooms; and my subjects were always
willing.

Berenice encouraged me to continue
with the project. She approved of *The
Ghosts of Harlem* because it was concrete,
a project that would have a logical
ending—in this case, the publication
of a book. She always felt that a project
needed to have an original concept
and a logical conclusion. Nothing was
more useless, in her opinion, than a
photographer who just went about, to use
her words, "taking pictures willy-nilly."

I should have been suspicious,
because everything was going so well
with the interviews and photographs.
Then, while I was on my way to Maine,

John Hammond died on 10 July. I'd
last seen him in June, knew he wasn't
getting any better, but didn't expect him
to leave us so quickly. I'd been able to
show John a handful of finished prints,
and I'd hoped to go over as much of the
book with him as possible. All he'd been
able to do was look at a few images and
occasionally talk to the musicians when
I telephoned him from their homes. The
last, as I recall, was Bill Dillard.

I returned to New York and pushed
on with the project. I contacted Ovie
Alston in Washington, D.C., and asked
if I could visit with him. He seemed
shocked that anyone remembered him
and was very agreeable. When I met
with him at the end of July and took
photographs, I didn't know these would
be the last portrait for *The Ghosts of
Harlem* project for many years.

When I returned to New York City,
Les Pockell telephoned and suggested

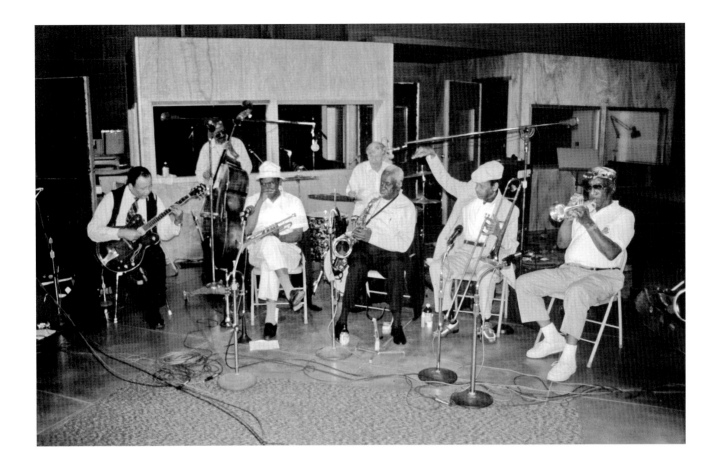

a meeting. When we got together the next day, he told me he had good news and bad news. The good news (for him) was that he was going to Japan to head a publishing company in that country. The bad news (for me) was that no one else at Doubleday understood anything about *The Ghosts of Harlem* and the project was officially dead.

I had only one other friend at Doubleday, Jacqueline Onassis, who'd been my first editor on the book that was published as *Berenice Abbott— American Photographer* in 1982. She was sympathetic but bogged down and unable to take on a new project. I was out of luck.

I didn't have the time to go casting about for another publisher because of the press of other business. In the summer of 1987 we had purchased all the assets of Chiaroscuro Records, the company I'd founded in 1970 but sold in

1978, and I was now back in the record business, often recording musicians who were prominently listed on the chart of ghosts tacked to my door. My festival production company, HOSS, Inc., was producing at least six festivals a year, and my reconstituted record company meant I had two full-time jobs and any number of part-time demands. As much as I regretted it, the taped interviews, never transcribed, sat on a shelf, and the photographs I'd so enthusiastically shown to Berenice Abbott a few weeks earlier remained in the box, filed away in my darkroom.

I didn't officially abandon *The Ghosts of Harlem*, but I didn't do any new work on it until 1990, when I helped the Swiss-based filmmaker Erwin Leiser produce a three-part television documentary. He'd sold the idea to Swedish and German public television using *The Ghosts of Harlem* as his title. We roamed all over

The Harlem Blues and Jazz Band, with, *from left,* Lawrence Lucie, Johnny Williams, Johnny Letman, Johnny Blowers, George Kelly, Candy Jones, and Erskine Hawkins, Englewood Cliffs, New Jersey, 1990

Ahmet Ertegun, New York
City, May 2004

Ghosts of Harlem. When I told him about the project, he looked at a few other photographs in the series and said simply, "We'll publish this book under the same terms as the Charlie Parker book."

In March 1996 I signed a contract with Filipacchi to issue *The Ghosts of Harlem* in a French-language edition. Filipacchi was interested in a substantial book, and ultimately the manuscript contained in excess of 150,000 words and more than 350 photographs and illustrations.

I soon interviewed and photographed Thelma Carpenter, Frank Wess, George Kelly, Al Casey, Lawrence Lucie, and Illinois Jacquet. I also conducted a new interview with Al Cobbs and photographed him for the first time. The old Deardorff camera was still just as effective, and new DAT technology made recording the interviews much easier.

Florence Paban translated my American-language text, a skilled design team in Paris organized 350 photographs and illustrations, and in the fall of 1997, a beautifully designed and well-printed edition of *The Ghosts of Harlem* was published. It was very successful in France but was never licensed to a publisher in the United States.

Harlem with his camera crew. Erskine Hawkins and Johnny Williams were our guides to the Apollo Theater, Sylvia's, the Audubon Ballroom, and other locations.

Les Fantômes de Harlem

In late 1994 I undertook a book project with the noted French editor Nicholas Hugnet, and in October 1995 Editions Filipacchi published *Charlie Parker–Norman Granz Jam Sessions.* Nicholas visited New York shortly after the book was published, and at one of our meetings he inquired about a photograph of Jonah Jones he saw in my studio. The photograph was from *The*

Despite their being in French, copies of *The Ghosts of Harlem* circulated in the United States—in jazz specialty shops, upscale bookstores, and on various Internet sites. In late 2004, an old friend, Ahmet Ertegun, obtained a copy and asked why there was no English-language edition. I told him the Doubleday story and said Filipacchi now had world rights. He made a telephone call to Daniel Filipacchi and within a few months, I was informed that Filipacchi had "ceased commercialization" of the book and the rights had reverted to me. This enabled me to pursue an English-language edition.

Decline of the Harlem Music Scene

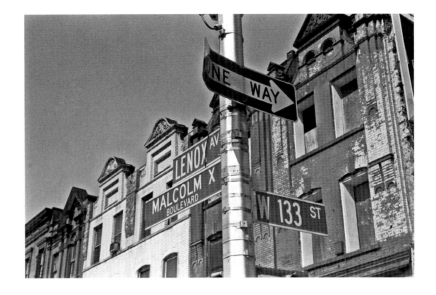

Early on in the project I asked one of the members of the Harlem Blues and Jazz Band if the group ever played in Harlem. He shook his head. "No, nobody has ever hired us." This now thirty-plus-year-old band is not unlike the New Orleans–based Preservation Hall Jazz Band; both are made up of a rotating group of older musicians. These men play distinctly old-fashioned music in an infectious manner all over the United States—in fact, all over the world. The difference is that the Preservation Hall Jazz Band performed regularly in its own hall in the heart of the French Quarter in New Orleans, at least until Hurricane Katrina interrupted things. In 1985, when my project began, the Harlem Blues and Jazz Band had never performed in Harlem, and it never did until the mid-2000s.

As the project developed, my title, *The Ghosts of Harlem*, seemed more and more appropriate. The men and women on my list hadn't exactly vanished like ghosts, for their whereabouts were well known, but they'd certainly slipped out of uptown, seemingly unnoticed, and they never, or rarely, returned to perform or even to visit old friends. It also appeared that none of the current inhabitants of Harlem, at least not anyone under fifty, missed them.

Ultimately, I encountered many musicians who hadn't been in Harlem in years because there was simply no reason to go, just as there was never any reason for me to visit the small Texas town in which I was born in 1940. A visit to Kilgore, Texas, would just make me sad; a trip back to Harlem often had the same effect. Sy Oliver confessed to driving across 125th Street after a ten-year absence and being so depressed he never

went back, and Benny Waters, who'd lived in Europe since the early 1950s, reported coming out of the subway at 125th and Lenox Avenue after an absence of many years and bursting into tears. These were strong reactions and, I suspected, not uncommon.

Even though all the ghosts I interviewed lived through the Depression, none recalled it as a matter of consequence. It may have been too painful. The repeal of Prohibition, however, was clearly a factor in Harlem's decline. An argument could be made that the decline of Harlem as a jazz entertainment mecca began on 5 December 1933, when the Twenty-first Amendment repealed the Eighteenth. In 1932, an after-hours joint on West 133rd Street, known to some as Jungle Alley, or even a big, brassy place like the Cotton Club on Lenox Avenue—places certainly selling illegal alcohol—was far more likely to be tolerated in Harlem than the same kind of venue would have been downtown. With repeal, it was easier for many people to drink closer to home, and the excitement of going to after-hours clubs, the appeal of doing

Malcolm X Boulevard (Lenox Avenue) and 133rd Street, 1996

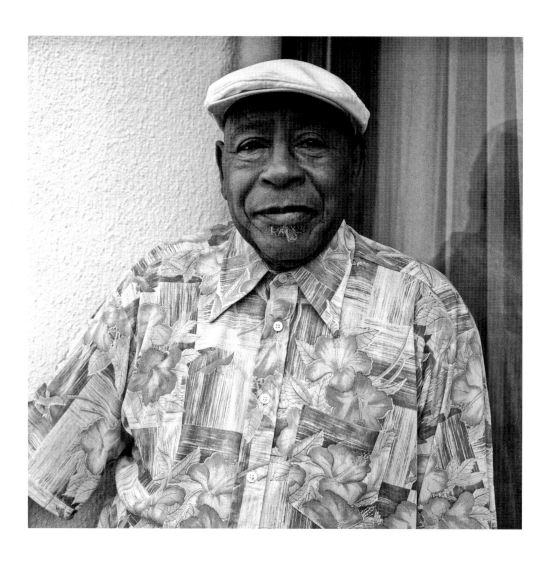

Benny Waters, Oslo,
Norway, 1986

something slightly illicit, maybe even a little dangerous, diminished. Many of the dictys—members of the black upper classes—who used to glide on polished dance floors in Harlem chose to dance elsewhere. The Cotton Club remained uptown a few years after repeal but finally moved downtown in 1936. At its location in the Times Square area, its luster seriously tarnished, it never again enjoyed the same kind of success. In 1931, "The Thrill Is Gone" moved high on the pop-music charts; a few years later the title described entertainment uptown.

World War II's impact on the Harlem music scene was also profound. Many musicians were drafted, depleting the ranks of bands, large and small, and the quality of the music often suffered. In 1996, by which time most of the

interviews had been completed, the age range of the ghosts was 72 to 98, but on December 7, 1941, it was only 17 to 43, and anyone born after 1905 was fair game to be drafted for military service.

Apart from artistic considerations, it was also harder for the bands to travel, with gasoline and tires rationed. By the time of full-scale mobilization, there were fewer young men to take young women to dances, and there was less transportation available to take them there. There were fewer records available, because shellac was needed for the war effort. It's hard to imagine today, but there was a time when you had to hand in an old record to buy a new one.

Panama Francis said the competition between bands and musicians was just like that in sports, an apt analogy. The

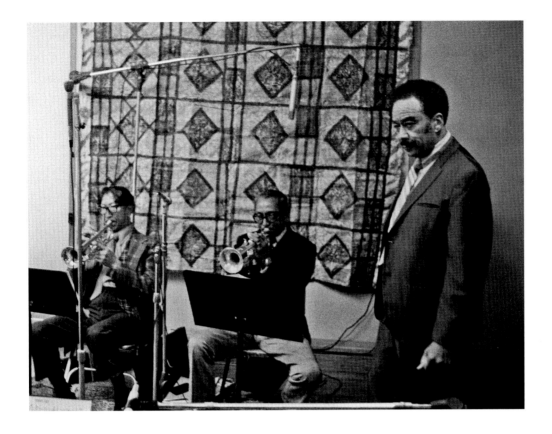

men who made up most of the jazz bands were about the same age as the men who made up the major league baseball teams, and everyone knows how the quality of baseball suffered during the war. Buck Clayton was just as important to Count Basie's Orchestra as Bob Feller was to the Cleveland Indians. The bands still made music, just as the teams still played baseball, but the quality of the product was diminished. The difference was that when World War II came to an end, the rules for baseball were still the same; Ted Williams could come home to Fenway Park without missing a stride. But for the returning musicians, the rules had changed—not only the rules of the marketplace, but also the musical rules.

At least half the big bands no longer existed and would never be formed again. Even the music had changed. World War II is widely recognized as a distinct dividing line in the evolution of jazz. The sound of the music before 1941 was very different from that which prevailed in many quarters after 1945. When jazz began to change in Harlem at the legendary encounters at Minton's and Monroe's in the early 1940s and finally emerged full-blown on Fifty-second Street, the uptown music scene was never the same. This musical revolution was one of crucial importance, not only to the development of jazz, but also to the ultimate demise of live music in Harlem.

Only three of the ghosts included in this survey actually lived in Harlem at the time of these interviews, as I've indicated. Living in Harlem, walking to and from work or taking the bus, was at one time not unusual. Many of those I interviewed fondly recalled walking to and from their jobs—presumably on a lovely spring or summer night, not in a howling blizzard in January. Some even volunteered that there was a time when there was no need to leave Harlem for any service they might require. It was a city unto itself; there was no need to go downtown for anything. Then things began to change,

From left: Doc Cheatham, Joe Newman, and Buck Clayton, WARP studio, New York City, March 1974

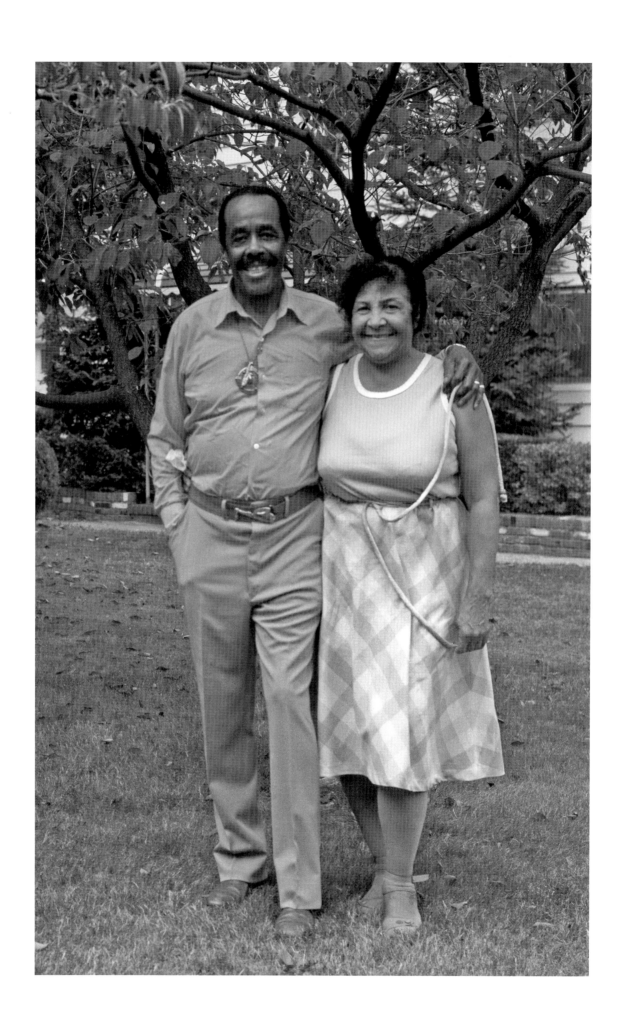

and the changes seem to have occurred, at least in the minds of most of the musicians, in the mid to late 1940s.

In discussions with Vi and Buddy Tate, it was clear their feelings were that the makeup of the population in Harlem changed when increasing numbers of unskilled workers from the South came north during World War II. Many settled in Harlem and didn't return to their homes after the war. As Vi Tate said:

> Let me tell you something. During the war, we had a lot of people move to New York from Virginia, South Carolina, North Carolina—places like that. I think they came for work in the factories and plants. Well, after the war they didn't go back home; they stayed. When we moved into our apartment in 1939, it was so nice and quiet, and all of a sudden you saw so many strangers on the street. I thought, Who in the world are these people? You couldn't walk the street; there were strangers in town. After the war it was worse. I'd come downstairs and there were people all over, strangers I didn't want to know, and many of them were a bad element. That's why we moved away. This was all over Harlem.

Others, who said the clientele of the Savoy Ballroom began to change about the same time, suggested the same kind of thing. There were increasing numbers of ignorant people who didn't know how to handle themselves in certain kinds of social situations.

Red Richards commented:

> I think the war brought an influx of the wrong kind of people to cities like New York, Chicago, and Philadelphia. People that came to make, maybe, two or three hundred dollars a month—which to them was a fortune—and these people couldn't cope. I used to see things in the Savoy; the bouncers had to throw these people out. These people would come up to the Savoy looking for fights; the ordinary people, the regulars, only wanted to drink and dance, but these low-class people wanted something else. The bouncers would be polite and ask them, "Why don't you go home?" But they didn't go home; they would look for a fight or pester women coming out of the ladies' room. They figured that since they paid their admission, they had the right to bother anyone. The wrong element was creeping in, and as years went by there were more and more people who just couldn't cope. Instead of having fun, these people wanted to cause trouble.

Many suggested that integration was the single most important factor in the demise of the uptown music scene. Today, no one doubts that jazz was extremely good for race relations. The first mixed-date recordings occurred in the 1920s—Jelly Roll Morton with the New Orleans Rhythm Kings, Eddie Condon with Fats Waller and His Buddies, and Coleman Hawkins with the Mound City Blue Blowers. Jazz musicians and the serious devotees of their music were light-years ahead of the rest of the United States in terms of race relations. In an era of back-door entrances and service elevators; no places to eat, sleep, or relieve oneself; plus all the other demeaning limits that white America imposed on all blacks, jazz was a field in which black and white men and women not only worked together,

Opposite: **Buddy and Vi Tate at home, Massapequa, New York, 1986**

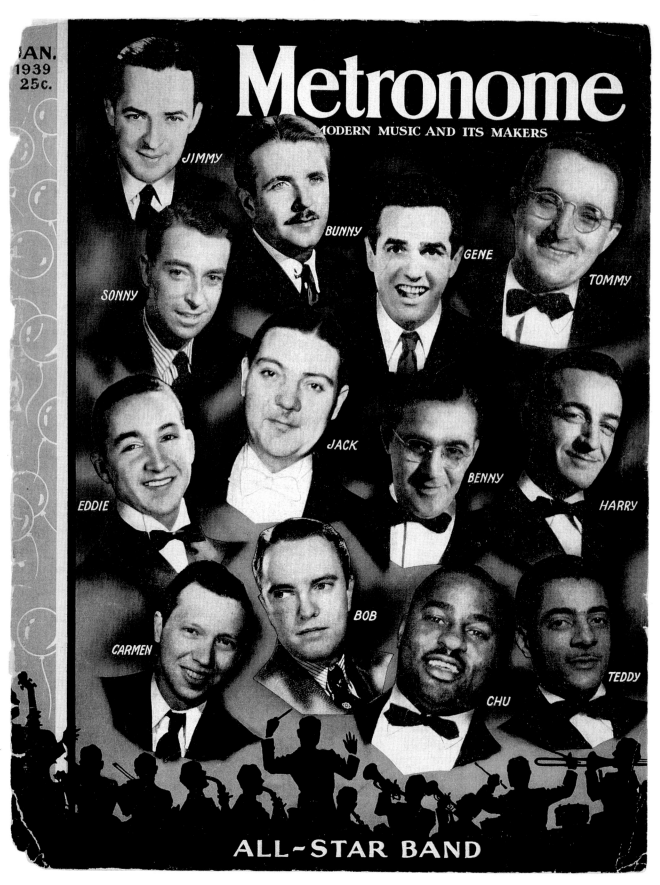

Metronome Magazine, January 1939

but also socialized. Teddy Wilson joined Benny Goodman *ten years* before Jackie Robinson joined the Brooklyn Dodgers and, given the popularity of Benny Goodman at the height of the swing era, the presence of Wilson, Lionel Hampton, Charlie Christian, and Fletcher Henderson in Goodman's band was just as important in furthering the positive growth of race relations as were the later contributions of Robinson, Larry Doby, Monte Irvin, and Roy Campanella.

In the ten years leading up to the end of World War II, many celebrated black performers toured with white jazz bands. Mixed bands appeared regularly on New York's Fifty-second Street and in Greenwich Village, and these bands toured nationally and performed on the radio, in theaters, and even occasionally in films. There was no doubt in the mind of any thinking jazz musician, black or white, that the giants among them were Duke Ellington, Louis Armstrong, Art Tatum. The music magazines of the day—*Metronome* and *Downbeat*, to name just two—reflected these feelings and, to a lesser degree, so did the results of the various popularity polls sponsored by these publications. Yes, in January 1941 it was perhaps a little strange to see Tex Beneke sitting next to Coleman Hawkins at the Metronome All Star Band recording session, but the point is that Coleman Hawkins was in that all-star band and so were five other black faces, men voted in by a largely white electorate.

With integration, however, more and more black jazz stars began to go downtown, both as featured soloists in white orchestras and as leaders of their own bands, and there was less need for whites from downtown to go uptown to see them. If someone could see Cab Calloway at the downtown Cotton Club, why go uptown to see a possibly lesser

show at Small's Paradise, even if it did cost less? Unlike the time when you didn't need to leave Harlem for anything, it became necessary to leave it for musical reasons, and the integration of musical establishments downtown created this situation.

Another threat to the Harlem live entertainment scene was the jukebox. Legend has it that the first one was installed in a little rib joint called the Barbecue, located at 131st Street and Seventh Avenue, above the basement that housed Connie's Inn and later the Ubangi Club. The jukebox could provide a greater variety of entertainment than could a pianist or a trio. It was also a novelty, and one that people would pay to play. It was very cost effective; a jukebox took up less room than a bandstand, and you didn't have to pay it—it paid you. Your only expense was the modest protection money you had to pay to whoever installed the machine.

Cab Calloway was right when in the late 1940s he said to one of the men in his band, "Television is going to knock us out"—but it didn't knock only him out, it KO'd all kinds of live entertainment. Television was a hundred times worse than a simple jukebox. Initially, it too was just a novelty, a box that glowed from the end of the bar at every corner saloon. Within a short time, however, it was no longer a novelty. Now, not only was there no piano player or trio, but also the jukebox was silent, as the omnipresent television set was everywhere, spewing forth everything from variety entertainment to sporting events.

As more and more people acquired television sets, live entertainment diminished all over the country, but Harlem was not like most parts of the country. There was always much

more live entertainment along its broad avenues and side streets than in a comparable-sized section of most American cities. Harlem had much more to lose from the free entertainment offered by television. If the 1950s was the golden age of television, it was also the decade that saw the total collapse of Harlem's entertainment industry. By 1956, the twenty-year-olds who came uptown and danced at the Savoy Ballroom to the music of Chick Webb in 1936 were forty, living comfortably in the suburbs with their two children, two cars, two television sets, a dog and cat. If they wanted to hear a big band, well, Tommy and Jimmy Dorsey were the summer replacement for Jackie Gleason, and Lawrence Welk was on one night a week. Within a couple of years, no one was stomping at the Savoy, and by 1960 almost no venues with live jazz remained uptown.

Television was not particularly friendly to black performers in that supposed golden age. Individual artists who were well-known Harlem personalities appeared infrequently on television. There was a short-lived show in the early 1950s called *Showtime at the Apollo*, but it was not successful or even very well conceived, just assorted soundies clipped together, interspersed with comedy and variety acts.

A number of other more localized factors played a part in the destruction of the music scene in Harlem and in many ways contributed to the decline of the area in general. The reasons cited by the ghosts were a laundry list of the kind of social ills that plague most large inner-city neighborhoods.

If, as they say in the real estate business, the three most important factors are location, location, and location, in the eyes of most of the ghosts, drugs, drugs, and drugs were Harlem's biggest problems, and by drugs they meant the advent of heroin. There had always been modest abuse of cocaine and opium, but neither of these caused serious social upheavals. These drugs were material for funny songs—"Viper Mad" didn't have anything to do with being annoyed at snakes, "Minnie the Moocher" wasn't just about a nice girl living off someone, and "Wacky Dust" wasn't about the cleaning lady. In later years, cocaine was no laughing matter, but the devastation caused by cocaine and its derivatives were far in the future. Marijuana was, of course, of no consideration whatsoever. Heroin was the problem. It was the drug that killed both musicians and listeners, destroyed neighborhoods, led to serious, well-organized crime, made for dangerous streets, and changed Harlem's reputation forever.

There finally came a time when reality overtook the fantasy that was Harlem. The myths weren't enough to sustain the illusion, and there were no more rent parties or Saturday night functions, no more chorus lines and speakeasies. The fantasy Harlem—the one shown over and over in black soundies and feature films of the 1930s and 1940s, the one that still attracts buses loaded with hungry tourists to Sylvia's or gospel lovers to countless churches on Sunday morning—never really existed. As noted so pointedly by Benny Carter, "I think it is important to remember that Harlem was never the heaven that some people claim it to have been nor was it the den of iniquity that others have suggested."

During World War II attitudes about what *really* went on uptown began to

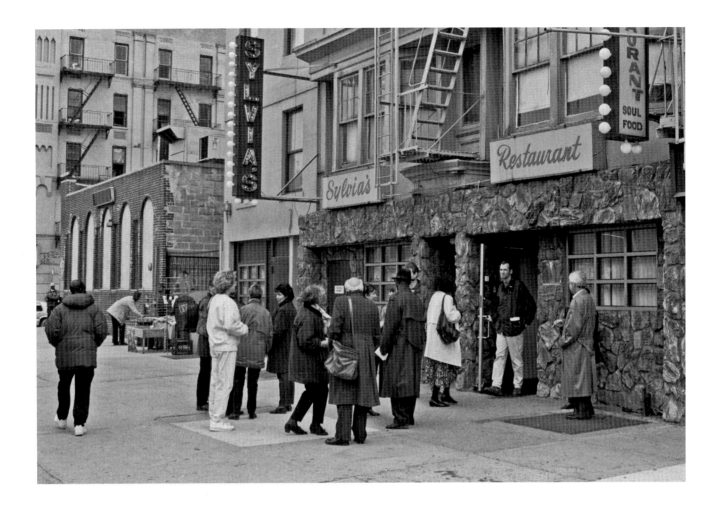

change, and any number of ghosts said they'd seen signs posted downtown that warned, "You go to Harlem at your own risk." Maxine Sullivan said that during the war everything north of 110th Street was declared off-limits for white soldiers in uniform. Maxine said, "Harlem was slowing down a long time before it closed down completely." If it had not been slowing down, the distribution of handbills downtown and quasi-official military restrictions probably would have been of no consequence to anyone who wanted to go to the Apollo Theater for a show or to dance at the Savoy Ballroom.

But there came a time when you did go to Harlem at your own risk—when there was crime on the streets. Danny Barker's description in "I'se a-Muggin" of a 1930s mugging seems almost quaint compared to what later was to transpire

on the same streets. Danny even felt the seemingly nonsensical song "gave hoodlums the idea to mug people."

One of the more interesting explanations for the decline of jazz in Harlem was that as time passed and the black population changed, many differing black cultures emerged, each with its own popular music, some of which had little relationship to jazz. Milt Hinton pointed out that there was cultural dissension among blacks of different ancestry. People from the Caribbean had very different musical tastes from those who had lived in Harlem for generations. Indeed, the music of those from the Caribbean varied considerably from island to island. U.S.-born blacks often viewed blacks from the Caribbean with suspicion and in the 1920s and 1930s treated them with scorn. Two of the ghosts even referred to them as "monkey-

Crowd outside Sylvia's Restaurant, Malcolm X Boulevard (Lenox Avenue), 1996

Sammy Price, 1987

huggers." Indeed, it was suggested by some of the ghosts that degrees of blackness sometimes determined the makeup of certain bands.

New immigrants from Africa had their own music and, of course, young black teenagers from all cultures had their own idea of what was suitably hip music and what was old-fashioned and unacceptable. There was a time when the music presented on a given evening at the Apollo—big bands, vocalists, comedians, and novelty acts—would appeal to the vast majority of the residents of Harlem. Later, this became less and less the case, particularly if the primary music presented was big-band jazz or the kinds of variety acts that the big bands accompanied.

The vanishing from Harlem's neighborhoods of the middle class and of the musicians was a highly debilitating factor in the area's demise. It was something mentioned by many of the ghosts, and they were, in fact, talking about themselves. No one except Sammy Price found this middle-class flight disconcerting, but it left Sammy outraged, as his comments clearly indicate: "If you go to Pennsylvania Station or Grand Central at 5:00 and see who's catching the 5:15, the black guys with the *New York Times* and four buttons on their sleeves. They're on their way home to Westchester or Long Island. If you ask them, they'll tell you they live in New York, but Westchester and Long Island isn't New York City and it sure ain't Harlem."

The lack of places to perform was a reason frequently cited for the decline of music uptown, but the lack of venues was not so much a cause of the problem as it was a result. Hordes of people thronging to the Renaissance Ballroom

Clark Terry, The New
School, New York City, 1995

would probably have kept it open forever. It was kept open for dances and social gatherings long after places like the Savoy Ballroom and the Cotton Club were demolished, but finally there was simply no one who wanted to use it. Today it stands forlorn and abandoned.

Some of the ghosts cited the lack of positive publicity previously noted as a contributory factor in the decline of music in Harlem. There is undoubtedly a good deal of truth to this charge, but, like the lack of venues, it was probably a result as opposed to a cause. In the late 1920s, newspapers ran stories about what was going on uptown, about the exhilarating social scene that could be found in nightclubs and speakeasies above 125th Street, because it was both exciting and it was news. The *New York Times* and the *Daily News* couldn't care less about jazz. They had music critics, but the exciting music and the clubs

presenting it uptown were as much a cultural phenomenon as a musical one.

In contrast, read the issues of *Downbeat* magazine for any year in the mid-1950s; it is rare to find a mention of an event in Harlem in the "Music News" or "Strictly Ad Lib" sections. Music uptown was simply no longer a factor, and this remained the case until the late 1990s. In recent years, however, there have been remarkable changes, and there are now listings in the *New Yorker, New York Magazine*, and various music publications.

Some of the ghosts mentioned racism as a debilitating factor, at least as the music scene was struggling in the 1960s. This phenomenon was less one of whites being antiblack than of blacks being antiwhite. These are the people who proclaim that jazz is the "black man's music"; who believe black musicians shouldn't play the music of white "jazz-

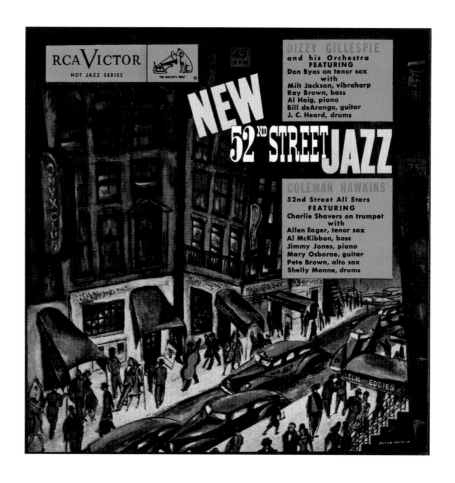

First RCA bebop album cover, 1946–47

oriented" composers; who denigrate or ignore white jazz musicians, regardless of their ability; and who certainly don't want to be taught by white teachers. Clark Terry experienced this with a school he started on 125th Street in the 1960s. The social factors cited by the ghosts as contributing to the decline of the music industry in Harlem were overshadowed by explanations that were strictly musical: The primary reason most of the ghosts gave for the decline of music and musical opportunity in Harlem was simply that the music changed. In saying "the music changed," they were referring to the advent of bebop; their general feeling was that the changes in jazz led to the demise of swing and big bands.

Benny Carter condensed many of the reasons to a few sentences when he said: "I don't know what killed Harlem and the music other than changing tastes. The music the kids started dancing to after the war had a beat. The beat was there, whereas bebop lost it. Absolutely lost it. Some of the music was a little too cerebral." A number of the most skilled musicians were able to change, chameleonlike, between bebop, swing, and, in some instances, cool jazz, but the post–World War II years were particularly hard for the older musicians who'd emerged in the 1920s and up through the mid-1930s.

Many of the ghosts showed genuine hostility toward the new music. They didn't understand it when it was first emerging, and they didn't like it once it burst full-blown upon Harlem and Fifty-second Street during and after World War II. They liked it even less when the music business began to change and jobs dried up, and bebop and modern music were easy to blame for the musical misfortune

that was affecting many of the older swing players.

The musical revolution that grew up and spread from Harlem in the early 1940s caused a serious schism in the jazz world that, though radically diminished, still existed in the minds of some of the ghosts when I interviewed them forty years later. Panama Francis described the main creative forces in the evolution of bebop as "rejects," men who couldn't make it as big-band musicians:

> If you sit down and pay strict attention to the music they made at Minton's, the music that became bebop, you'll see it's rebellious music. The reason why it was rebellious music is because the guys who created that music were rejects from big bands. Dizzy [Gillespie] had just had a run-in with Cab, so the other leaders didn't want him. Charlie Parker, who the white musicians idolized—since they're mainly technicians, they could relate to what he was doing—had such a bad sound that black players at the time didn't relate to him. So he was a reject. [Thelonious] Monk was a reject. He came into Lucky's [Millinder] band and lasted exactly one set. They were all rejects. One of the bass players that hung out with that group, somebody they never even talk about, was a guy named Nick Fenton. He'd stay high all the time—he used to get high off of nutmeg and anything else he could get his hands on.

Others echoed Panama Francis's complaint. As Bill Dillard put it:

> With some musicians it's very difficult to accept the idea of being an entertainer, and I guess in many cases their objective is to satisfy and

please themselves, instead of pleasing the audience and listeners. I recall quite a few years ago when bebop or progressive music became in, and that was the new music being projected by individuals and groups. Quite often a soloist would leave the bandstand and not return except to go out to the microphone and take a solo. At the end of the solo, he wouldn't smile. He wouldn't bow. He wouldn't acknowledge the audience at all. He would finish and just walk back to his seat with practically no expression. He might even walk off the stage, depending on where he came from. This sort of thing left me cold. I'd come up in an earlier time when the performer and the music they made was supposed to please the audience. When the music and the musicians stopped doing this, part of

Bill Dillard, 1987

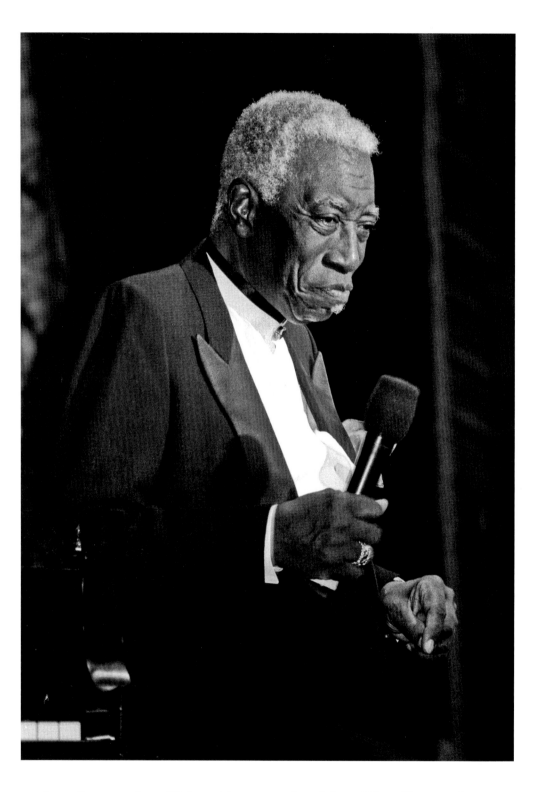

Joe Williams, Floating Jazz
Festival, 1998

the audience was lost. All these things hurt the clubs and places in Harlem.

Louis Armstrong put it another way, as Al Cobbs reported: "Let me tell you something. The kind of music I'm playing makes people feel good—the folks come in and they buy steaks. But some of the things people are playing make people sad, and these folks will just sit there, drink a Coca-Cola, and stay all night." On the surface, Armstrong's statement was about music, but it was really about economics and why the clubs failed.

The new harmonies and technical demands made by bebop—and later, even more advanced forms of music—coupled with the perceived lack of entertainment

value were only part of the problem. The main problem with the new music, in the eyes of the ghosts, was its lack of a danceable beat. The rhythm was simply wrong, as far as they were concerned; the drummers didn't use the bass drum except, as Panama Francis said, "to drop bombs all over the place."

The ghosts saw this lack of an immediately perceptible beat, a groove, an easily danceable rhythm, as one of the main culprits that caused the uptown musical audience to vanish. Yet bebop musicians didn't really lose the beat; it was there, but sometimes the rhythms were so complicated, ordinary people who wanted to dance couldn't figure them out. At least they couldn't get the beat in the same way they could at the Savoy Ballroom, dancing to Chick Webb or Erskine Hawkins.

I fully understood what various ghosts were telling me, but I also remembered an LP I'd had since the 1960s entitled *Bird at St. Nick's*. It was a technically poor recording of a dance Charlie Parker and a quintet played at the St. Nicholas Arena on 18 February 1950. Interspersed with the obligatory "Scrapple from the Apple," "Hot House," and other bebop anthems are soulful renditions of "Embraceable You," "I Cover the Waterfront," "Out of Nowhere," "What's New," and "Smoke Gets in Your Eyes." Maybe the Lindy Hoppers and jitterbugs would have been annoyed by Parker's new compositions, but *anybody* could have danced to the ballads the group played that night. There's no easy resolution to this issue.

There was something else happening, however, that the ghosts occasionally mentioned, but only in passing. By 1940 there were too many big bands, some of which were the size of symphonic ensembles, and many of the big band vocalists were becoming

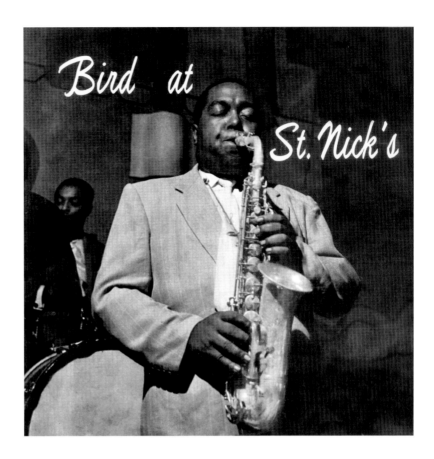

Album cover from Charlie Parker live recording, 1950

more popular than the bands with which they sang. It didn't take the booking agencies long to realize they could sell a star vocalist with local musical support easier and more efficiently than they could sell a twenty-piece band *and* a star vocalist.

Billy Eckstine and all his musicians may have loved his big band, even though not many people danced to it, but what the public really loved was the romantic Mr. B., Frank Sinatra, Sarah Vaughan, or any of the other star vocalists who came out of the big bands. Simply look at the primary vocal stars of the 1950s; almost all came out of big bands. It is also interesting to note that of the few big bands that survived into the 1950s and beyond, as well as those formed in the late 1940s and 1950s, few had strong vocalists who later became stars, with the possible exception of Joe Williams, who helped rejuvenate Count Basie's Orchestra. It was perhaps a little late, but the leaders learned their lesson.

Al Sears at home, 1987

Back to the beat. It was incorporated in different kinds of music, and the young people who wanted to dance had rhythm and blues and rock 'n' roll from which to choose. All the ghosts talked about this: This was the music that replaced swing dance bands, large and small, and a number of musicians, particularly black musicians, cut their musical teeth in rhythm and blues bands of the 1940s and 1950s. It's not widely discussed, but such distinguished jazz artists as John Coltrane, Stanley Turrentine, Benny Golson, Blue Mitchell, Jaki Byard, Jimmy Cobb, and Keter Betts, along with many others, were associated with Earl Bostic in the 1940s and 1950s. Many great jazz musicians who emerged in the 1950s and 1960s paid their youthful dues with local and national rhythm and blues bands, even avant-garde figures like Ornette Coleman.

Many of the New York–based swing and mainstream musicians played with rhythm and blues bands, as well as with more conventional popular musical groups, primarily in recording studios. Milt Hinton became a studio mainstay, Panama Francis probably made as many rhythm and blues and rock 'n' roll sides as anyone in the 1950s, and many of the ghosts settled into recording studios and Hollywood soundstages and worked with dozens of pop and rock stars. The pictures on Sammy Lowe's wall attest to this history, and Al Sears was prominently featured in the movie *Rock, Rock, Rock.* This music, however, did not fare well in Harlem, except at venues such as the Apollo, where it frequently was very successful. Almost all the ghosts confessed they played jazz when they could but played something else when it was necessary. Those who couldn't adapt to changing times and tastes suffered with nonmusical employment of the sort outlined earlier by Milt Hinton.

When the jazz and big-band business in Harlem was at its peak, many contemporary musicians looked down on a form of music now closely associated with jazz: the blues. One rarely heard in Harlem the music performed by blues singers and the musicians who usually accompanied them. As Sammy Price said: "In Chicago, there were places where blues artists could work, but it seemed the people who controlled things in New York didn't want to feature blues singers. Blues singing was not a musical style that was generally popular in Harlem." There were, of course, a few exceptions, and blues singers were occasionally part of stage shows; Bessie Smith performed at the Apollo Theater as late as 1935. But by and large, Harlem was not a blues singer's paradise. Its sophisticated residents felt blues singers were old-fashioned, and they didn't want to be associated with the kind of material featured in the standard blues repertoire.

None of the ghosts suggested that the lack of blues singers had anything to do with the demise of music in Harlem. Yet the attitude that the music was old-fashioned was symptomatic of something that also may indicate trouble for uptown jazz in the future. Blues were judged to be old-fashioned in the 1930s, but by the 1950s, so were jazz and big-band swing. Any number of ghosts said that Harlem residents, particularly the younger ones, looked down on the music they usually played. It wasn't hip. Cab Calloway, once the ultimate hipster and always one of America's greatest entertainers—a man who, in his striking yellow zoot suit was just right for the Blues Brothers in 1980 or a Janet Jackson video in the 1990s—was considered a cornball in the 1950s, when the music scene was dying uptown. Many other outstanding jazz

musicians were equally unfashionable and some of it remains unfashionable to this day, at least in some quarters.

Harlem was already full of exciting music when first-rate jazz bands, large and small, began to emerge in the 1920s. The music these bands made was an integral part of Harlem's culture and economy until World War II; then the music began to change and, for the most part, migrated south from 125th Street. The big-band era sputtered along for many years after the war. When it officially died, with Duke Ellington in 1974, it hadn't been vital in years. Big bands, even Ellington's, had long been absent from Harlem, and the unpleasant experience in the 1960s with the black power advocates that Clark Terry relates in his interview points this out succinctly. The same is true of small-group mainstream jazz; it wasn't just the Harlem Blues and Jazz Band that didn't play in Harlem. After 1970 almost no one played uptown; there were no clubs that could afford the first-division players, and no one would come out to see those who were less famous.

There are, of course, still big bands and mainstream groups, but the ranks are thinning. The few big bands that still exist are often just fronted by a third- or fourth-generation leader and filled out by younger, college-trained musicians playing in the style of another era. Today, there is not a single big jazz band fronted by an original leader from the 1940s. Illinois Jacquet, who died in 2004, was the last leader of a big jazz band that worked regularly.

All the others are ghost bands with new leaders, and anyone who has heard an original band in person or even on record—one led by a Count Basie or Duke Ellington—can tell the difference immediately. Mainstream jazz bands, large and small, were performer driven, and that was the difference. The Lincoln Center Jazz Orchestra can play Duke Ellington or Thelonious Monk compositions for the next fifty years, and even though the pieces may be well played and often very exciting, they will not have the vitality they had when groups led by Ellington or Monk played them. The compositions remain as unique and elegant as ever, but sometimes you need Lester to leap in the right way or Cootie to play the concerto correctly.

Rebirth

There is still a great deal of exceptional jazz being played uptown today—it's just a different kind than the jazz that made Harlem sizzle once upon a time, and it's played by different, mostly younger, players. A handful of older players perform occasionally, but they are well into their eighties or older. A decade ago it was still possible to hear some of the older ghosts in concert or in clubs all over the world—men like Benny Carter, Benny Waters, and Doc Cheatham. Today there are venues in Harlem where they might play, and it's unfortunate that they were not able to be part of the new Harlem renaissance.

On a good night, remarkable younger players can make you imagine what it must have been like in Harlem in the 1920s or early 1930s. Music—all kinds of music, not just mainstream jazz and big-band swing—is a remarkable thing. It is a simple key to time travel that allows you to go home again, if only for a moment, and the uptown home to which it is returning these days is looking better and better.

As of January 2009, of the original

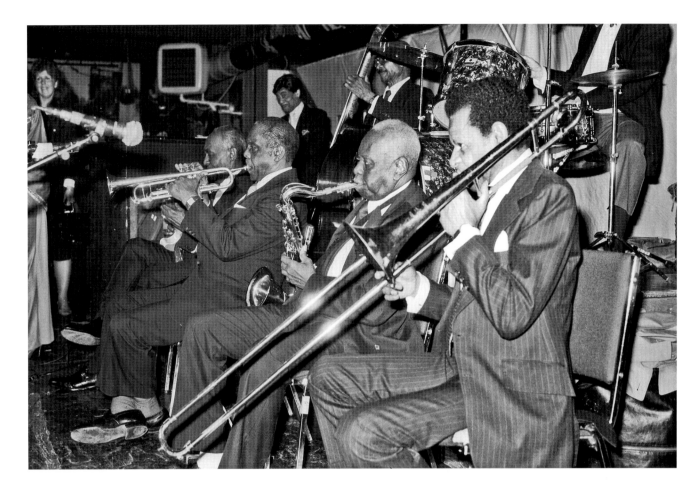

ghosts, only Lawrence Lucie (101), Clark Terry (88), and Frank Wess (86) are left, along with the more recently interviewed Dr. Billy Taylor (87). There may be fewer ghosts walking the streets in Harlem these days, but the streets are a great deal more fun to walk than they were when I initiated this project more than twenty years ago. Many of the men and women I interviewed said they felt music would never return to Harlem. They were wrong. There are many places that feature live jazz uptown nightly, and the trend seems to be very positive.

To help prove the point, I include an updated and expanded selection of photographs, as well as text, in the "Discovering Lost Locations" section, contrasting 1996 with 2007. The buildings that housed the Renaissance Ballroom, Small's Paradise, Connie's Inn, and other musical landmarks still stand, as do the brownstones and apartment buildings in the block of West 133rd once known as Jungle Alley. A decade can make a big difference, and the positive changes in Harlem since I last photographed Jungle Alley and other streets are remarkable. Where ten years ago there were only ghostly musical echoes of the past, today there's music in the air along the streets and avenues—not as much as in 1935, but it's definitely there.

The Harlem Blues and Jazz Band, the Cat Club, 1989

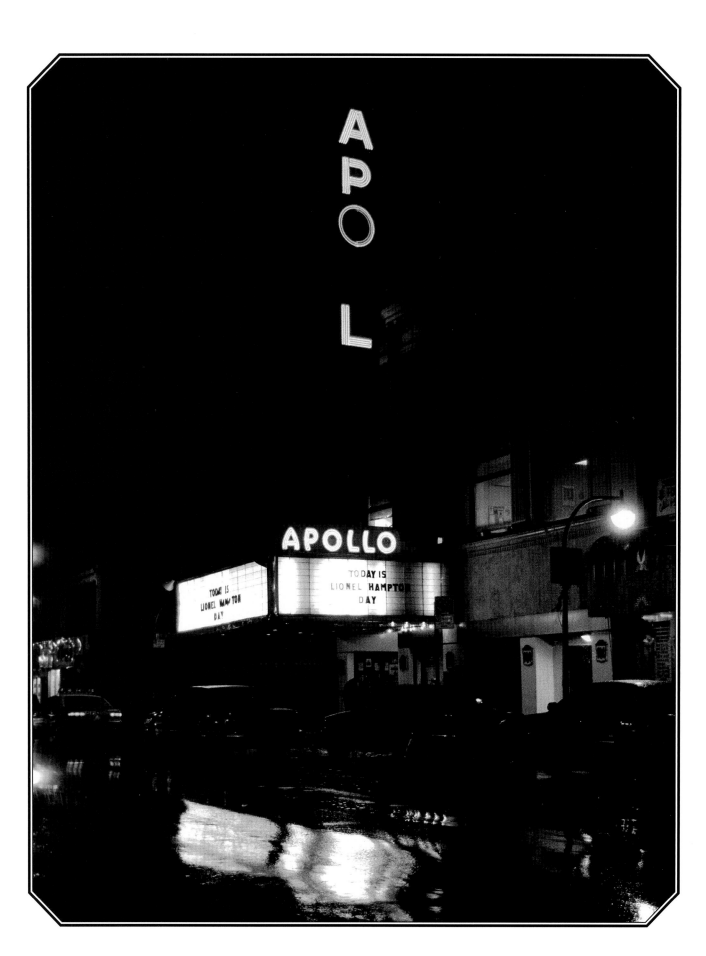

Discovering Lost Locations

(1996 and 2007)

On the Avenues

On Lenox Avenue

Lenox Avenue (also known as Malcolm X Boulevard) was never overrun with jazz clubs, but it once was home to the two most prominent jazz and big-band establishments in Harlem, if not in New York City: the Cotton Club and the Savoy Ballroom. In 2007 the single most popular address in Harlem was also on Lenox Avenue: Sylvia's Restaurant.

The Savoy Ballroom, the "home of happy feet," was arguably the heart and soul of the music scene in Harlem. The best bands, the biggest crowds, an integrated audience, and the finest hostesses to be found in any ballroom were part of the Savoy legend. It was simply the best there was at the time, and its demise in 1958 was justifiably lamented, as it spelled the end of the forty-year joyride of music uptown.

The Cotton Club has been celebrated in song, literature, and more recently in a feature film, *The Cotton Club*. Even though it was located in Harlem and headlined the finest jazz to be heard anywhere, it did not necessarily reflect the best aspects of jazz or of African American culture because, except for the entertainers onstage, for most of its existence it was as segregated as a plantation in the Deep South. This scenario changed marginally when the club moved downtown to the Times Square area. There is currently a nightclub on West 125th Street called the Cotton Club, but any similarity to the uptown original is purely coincidental.

When urban renewal projects came to dominate the east side of Lenox Avenue in the 1950s, enormous apartment blocks replaced hundreds of buildings, including those that housed these two institutions.

Opposite: The Apollo Theater, March 1996

1996

1996

2007

288 Lenox Avenue: Lenox Lounge (1939–present). This perfectly restored time capsule was not known for its music when it opened seven decades ago. It was an upscale gathering place for the celebrated and their associates, but in 2007 it adopted a nightly jazz policy that is among the best in Harlem, attracting high-level performers as well as the eye of every location scout on the East Coast. The joint is jumping and features outstanding music nightly, as well as a jazz and gospel jazz brunch on Sundays.

328 Lenox Avenue: Sylvia's (1962–present). From its modest beginnings as little more than a luncheonette in 1962, Sylvia's Restaurant has grown substantially and now occupies the better part of a city block. It can handle about 450 diners and is so popular it spawned Sylvia's Also to handle the overflow, as well as the many tourists who arrive for a Sunday brunch of soul food. It remains a New York City as well as a Harlem landmark, with its own line of food that can be purchased all over the country.

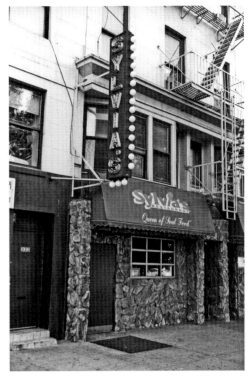

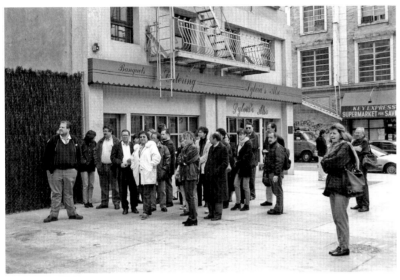

1996

2007

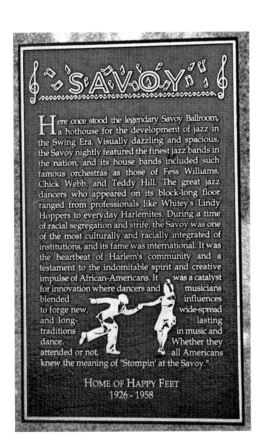

2007

596 Lenox Avenue: formerly the Savoy Ballroom (1926–58). The "hip and historic" Savoy Park, a historical marker, and a massive apartment complex are now on the site once occupied by the ballroom.

2007

644 Lenox Avenue: formerly the Cotton Club (1918–36). There are no markers for the Cotton Club. Apartment complexes, including the Minisink Town House, occupy the site.

On Seventh Avenue

Celebrated in jazz classics such as Eubie Blake's "Dicty's on Seventh Avenue" and in songs like the "Seventh Avenue Express," as well as an inspiration to such writers as Langston Hughes, Seventh Avenue was home to more jazz spots than was any other street in Harlem.

Many of the buildings that once housed famous clubs and theaters are still standing, some abandoned, others used for a variety of purposes. Real ghosts probably haunt the abandoned buildings, such as the Renaissance Ballroom. There was music at Small's Paradise as late as 1986, but the last notes the Renaissance heard were almost a decade earlier. The building at the corner of Seventh Avenue and 131st Street housed a series of wonderful clubs. It was first Connie's Inn, then Club Harlem, and finally the

Ubangi Club. The only music heard there these days is from the iPods carried by some of the shoppers, but I wonder if on still nights the faint notes of Fletcher Henderson's orchestra might drift among the groceries stored in the basement of C-Town Supermarket for Savings.

The Tree of Hope used to stand proudly in front of Connie's Inn at 131st Street, a living good-luck talisman. When Seventh Avenue was widened, Bill Robinson made certain the tree was replanted, but the passing years were not kind to it and the original tree was probably reduced to ashes in someone's fireplace. Today a metal Tree of Hope stands in the median between the uptown and downtown lanes on Seventh Avenue, now named Adam Clayton Powell Jr. Boulevard.

2007

2110 Seventh Avenue: the
Alhambra Ballroom (1929–45).
The ballroom on the top floor
still exists. Unused in the 1990s,
it is now refurbished and can be
rented for private functions, with
or without music. In its heyday,
the Alhambra featured Benny
Carter, Luis Russell, and other
big-band leaders, but today most
people bring in smaller groups, as
well as catered food. There is also a
bowling alley on another floor.

1996

2007

2221 Seventh Avenue: formerly Connie's Inn,
Club Harlem, and the Ubangi Club (1921–40).
The building has been a C-Town Supermarket
for as long as I can remember, but it has been
nicely remodeled since I photographed it in
1996.

Seventh Avenue and 131st Street: the Tree of Hope. The colorful enamel Tree of Hope is unchanged, although it seemed to look a little brighter in 2007.

1996

2007

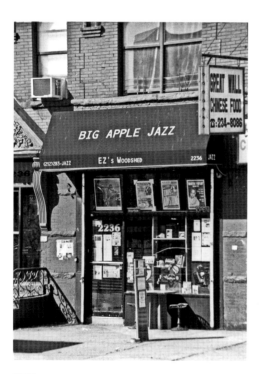

2007

2007

2236 Seventh Avenue: Big Apple Jazz and EZ's Woodshed (2007). This inspired joint venture is a combination jazz emporium and performance space. CDs, LPs, literature, and assorted jazz memorabilia are for sale seven days a week at Big Apple Jazz, and there are regularly scheduled performances at EZ's Woodshed in the back room on weekends.

2007

2245 Seventh Avenue: formerly Basie's Lounge (1955–late 1960s). The building now houses a new restaurant, Doug E.'s, which promises to be a chicken and waffles joint once construction is complete.

Wells Lounge, 1996

Harlem Grill, 2007

2247 Seventh Avenue: formerly Wells (1940–2000). In 1996 Joe Wells was still in business. The Harlem Renaissance Orchestra was advertised as appearing every Monday night. Various types of entertainment were presented at Wells in those years; there was even a karaoke night that was broadcast from the club on public access television. Joe Wells closed the club in 1999 after a sixty-year run. The location morphed into the Harlem Grill in the 2000s, a supper club with music, and was successful for a while. It had a sporadic music policy but closed in the spring of 2007. The Harlem Renaissance Orchestra continues as an active and vital big band.

1996

2007

2280 Seventh Avenue: formerly the Hot-Cha Bar and Grill (1930–60). This building was abandoned in 1985 and 1996. It is now refurbished; a floor has been added, and the Migdol Organization, a real estate company, occupies the ground floor.

1990

2007

2294 Seventh Avenue: formerly Small's Paradise (1925–86). Abandoned in 1990, this building has been completely transformed. The Thurgood Marshall Academy, a charter school that has been achieving remarkable results, has been built on top of it. Ed Small would probably have preferred that the new ground-floor tenant be International Chicken and Waffles.

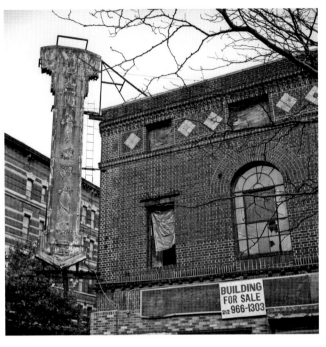

1990

2007

150 West 138th Street at Seventh Avenue: formerly the Renaissance Ballroom (1923–early 1970s). In 1990 the ballroom's sign at the corner of Seventh Avenue was still in place, as was the marquee; by 2007, all the signs had fallen and trees were growing out of the building's roof. The property is owned by the Abyssinian Development Corporation, which has professed plans to turn it into a cultural space. More recently there has been talk about refurbishing it for use as an area for a minor league basketball team. There is precedent for this. The old Harlem Rens played there in the 1930s. What it looks like inside today is anyone's guess, but it seems certain there'll be no breakfast dances in its immediate future.

1996

2007

2389 Seventh Avenue: formerly the Bamboo Inn, later the Dawn Casino (1923–late 1960s). Currently the entire block between 139th and 140th Streets is a drive-in McDonald's and a seafood restaurant.

2007

2007

2361 Seventh Avenue: formerly Lickety Split (1996). In 2007 the Palace advertised live entertainment, but on a Saturday night it was not open for business. Its status in 1996 was also unclear; the sign said "Live Jazz and Blues," but one of the ghosts, George Kelly, who spent a good deal of time around the corner on 139th Street, said that it was just a corner bar and there was rarely ever any live music. This still seems to be the case.

2456 Seventh Avenue: formerly the Yeah Man (1925–60). The longtime home of pianist Donald Lambert is currently Paula's Place, a cosmetics emporium, but perhaps only temporarily, because scaffolds went up the week after this photograph was taken.

1996

2007

773 St. Nicholas Avenue: formerly
Poosepahtuck Club (1930–40) and
Luckey's Rendezvous (1940–50), now St.
Nick's Pub. As Luckey's Rendezvous, this
spot was a noted piano room up to about
1950 and the home of Luckey Roberts,
Donald Lambert, and Marlowe Morris. In
the 1990s informal jam sessions began to
take place, and in 2007 it is a full-blown
jazz club featuring music every evening.
It is a major part of the revitalized
Harlem music scene.

2007

721 St. Nicholas Avenue: formerly
the Silver Dollar Cafe (1925–1960s).
This venue was first a speakeasy and
then the 721 club, which featured small
jazz groups until it finally became just
a neighborhood bar. Later it became
Promised Land and by 2007 was
abandoned, looking for another owner.

1996

2007

94 St. Nicholas Place: formerly
Bowman's Grill (1955–late 1960s). The
grill later became Braker's Lounge, which
featured live jazz from its inception. It
morphed into Mama's Fried Chicken by
1996 and in 2007 was still offering fried
chicken but was known as Maximum's
Halal.

Cross Streets

On 118th Street

Efforts are occasionally made to preserve or restore Harlem musical landmarks, and in the early 1990s, I met with a number of public-spirited citizens who were intent on restoring Minton's Playhouse to its former glory. I said I'd help however I could, to just let me know what I could do. I never heard anything, and I thought the project had been abandoned. Imagine my surprise when I turned the corner on 118th Street and saw a new sign on the old Playhouse building! The playhouse itself was still unused in 1996. On the day I took the photograph, I had a conversation with an elderly man who lived in the old Cecil Hotel building, where the club is located. When I asked about the Playhouse, he said he thought maybe it would be back in business in five or six years. It took a little longer, but in 2007 there was music presented in Minton's on most nights and many weekend afternoons. It was hard to take an up-to-date picture because the small tree that appeared in the 1996 photograph has prospered, as has the surrounding neighborhood.

1996

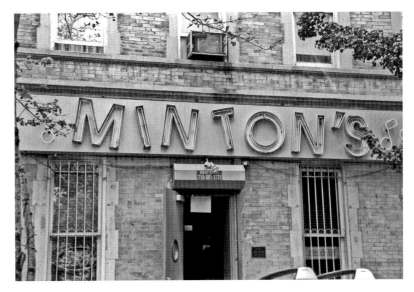

2007

210 West 118th Street: Minton's Playhouse (1938–present). Minton's is now back in business, featuring good jazz nightly. Its colorful sign is the finest bit of outdoor advertising to be found uptown.

On 125th Street

125th Street has always been the emotional and geographic heart of Harlem as well as its most important thoroughfare. Its significance in 2007 cannot be underestimated in terms of commerce, culture, and development. There were many good jazz establishments along 125th Street, some of which, like the Celebrity Club, flourished into the 1960s, but most of them were taken over by retail establishments or urban renewal projects. The only place the word "jazz" appears on the street is at a clothing outlet, Jimmy Jazz.

2007

1996

125th Street and Seventh Avenue: the Hotel Theresa. A Harlem landmark managed by Andy Kirk in its later years, the Theresa is no longer a hotel but is used as office space. In 2007, it was undergoing renovation, with scaffolds surrounding the building.

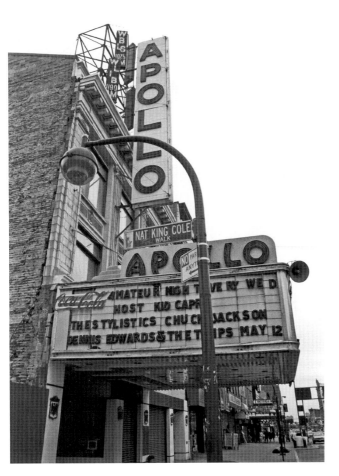

1996

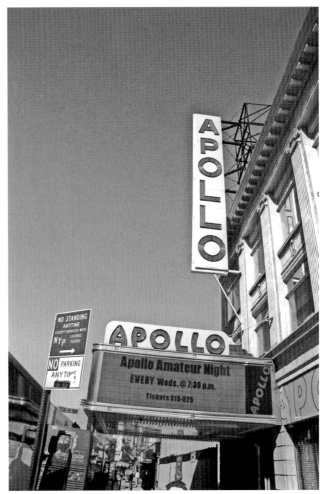

2007

253 West 125th Street: the Apollo Theater (1910–present). This legendary theater, which will soon celebrate its centennial, is nearly 100 percent restored. The lobby has been remodeled, new seats have been installed throughout the auditorium, a new electronic sign is in place, and the imposing APOLLO sign is always lit, with letters that never burn out. It still presents live music on a semi-regular basis; in 2007, groups as diverse as Jazz at Lincoln Center, Jay-Z, and the Jazz Foundation of America presented evenings at the theater.

1996

2007

319 West 125th Street: formerly the Baby Grand (1945–1970s). Once the home of comedian Nipsey Russell and small combos, this address in 2007 housed a Radio Shack. Perhaps the iPods have some good jazz programmed on them.

1996

2007

354 West 125th Street: formerly the Mayfair Lounge (1945–55). Vocalists and small groups worked in this modest lounge after World War II. A McDonald's Express that had taken over in 1996 still held the lease in 2007; fast food is long-lived on 125th Street.

1996

1996

375 West 125th Street: Showman's (1942–present). Showman's Cafe, temporarily located at 2321 Eighth Avenue, offered jazz two or three nights a week in 1996, more than any other venue in Harlem. The club even attracted tour buses, but the owners were just waiting for the club's original 125th Street location to be rebuilt after a fire. The new Showman's at 375 West 125th Street has been up and running for some while and presents music on a regular basis; jazz, blues, or soul might happen on a given night.

2007

Along Jungle Alley, 133rd Street

The block on 133rd Street between Lenox and Seventh Avenue was once known as Jungle Alley. At least seven identifiable clubs could be found in that one block between the years 1925 and 1950. All seven locations were active simultaneously for five years, between 1928 and 1933. By the 1990s, the block had changed remarkably, in a negative way, but by 2007, it had improved remarkably.

This was Jungle Alley in the early 1930s: Fats Waller was a regular at Tillie's Chicken Shack (134 West); when it moved locations it was of sufficient importance to be memorialized by a recording, Bud Freeman's 1935 release "Tillie's Downtown Now." There was less entertainment at the Clam House (136 West), usually little more than a vocalist, but it was a moderately popular establishment. Mexico's (140 West) was more a speakeasy with irregular entertainment, but a few doors west a number of fine performers worked regularly at Covan's (148 West)—Monette Moore, Garland Wilson, and, in the club's later stages, Slim Gaillard and Slam Stewart were on hand. Basement Brownie's (152 West) was a modest piano room that featured a number of exceptional artists, primarily stride men like Willie "The Lion" Smith, James P. Johnson, and Fats Waller. Pod's and Jerry's (168 West) was actually the Categonia Club, but most people referred to it using the names of its owners. Billie Holiday and Bobby Henderson appeared there together. After repeal it became known as the Log Cabin, when a small log cabin–like structure was added to the front of the street-level entrance.

The Nest Club (169 West) presented exceptional artists for five years until it closed in 1930; Elmer Snowden's band and Luis Russell began there. When it closed, it became Dicky Wells's Shim Sham Club, with the Rhythm Club #2 meeting in its back room. A year or so later the Rhythm Club took over the entire facility.

In 1996 these seven locations presented a very different face. There was no indication anywhere that this was once a bustling street full of exciting nightclubs and exotic speakeasies. There was no plaque—not even a street sign. There was a vacant lot, residences, bricked-up buildings, a church, what seemed to be a church residence, and an office facility. The block was in rough shape at the eastern end but improved as one traveled west.

By 2007, Jungle Alley, since renamed in honor of a fallen firefighter, Keith Glascoe, had been reconstructed. The vacant lot that was once 152 West is unchanged; 168 West is still the Bethlehem Moriah Baptist Church; and the little wooden structure from its days as the Log Cabin survives. But the facades of the other buildings that were in such disrepair in 1996 have all been rebuilt, abandoned buildings have been rehabilitated, and the entire block seems to have come to life. Music is beginning to find its way back onto the block—in the church and at Bill's Place (148 West)—and urban renewal seems to have been very successful.

1996

2007

134 West 133rd Street: formerly Tillie's Chicken Shack (1928–35). This was primarily a piano room that in its early years featured Fats Waller, among others.

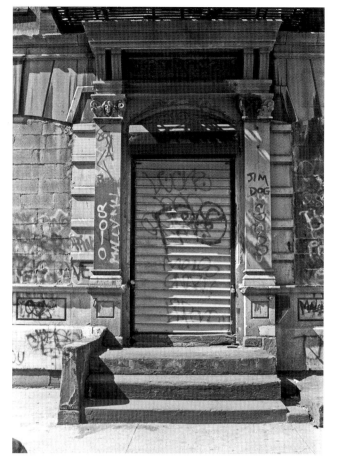

1996

2007

136 West 133rd Street: (*above left and right*) formerly the Clam House (1925–33). The oldest establishment on the block was a late-night spot, best known for risqué entertainment.

140 West 133rd Street: formerly Mexico's (1928–36). There was little structure here; the place featured impromptu entertainment and was little more than a speakeasy.

1996

2007

1996

2007

1996

2007

148 West 133rd Street: formerly Covan's Club Morocco (1930–40). The club featured Garland Wilson in the early 1930s and later was the home of Slim Gaillard and Slam Stewart. In 2007 it had become Bill's Place, where good jazz could be heard on a regular basis. Perhaps the trend will spread along the block.

152 West 133rd Street: formerly Basement Brownie's (1930–35). This was a piano room that featured all the greats for a few years. It has been a vacant lot for well over a decade.

1996

168 West 133rd Street: formerly Pod's and Jerry's/the Categonia Club/the Log Cabin (1925–35). A great piano room, Pod's and Jerry's was also known as one of the first places that hired Billie Holiday.

2007

1996

169 West 133rd Street: formerly Nest Club/Dicky Wells's Shim Sham Club/the Rhythm Club #2 (1925–30). This location had many names and owners, but it was always one of the most popular locations on 133rd Street. It is now for sale.

2007

Other Streets:
131st Street–165th Street

A number of buildings that once housed clubs are scattered around Harlem. Two now house churches; Fatman's Café was the Tioga Carver Democratic Club in 1996 and remains so. The building in which the Heat Wave was located has been torn down and a new industrial facility is in its place. From Lenox Avenue and 134th Street, one can see the silhouette of the Lincoln Theater, where a thousand people could listen to Fats Waller play a mighty Wurlitzer organ; the old theater is now the Metropolitan African Methodist Episcopal Church, undergoing renovation. (I wonder if the old organ is still in working order. One never knows, do one?) Wrecking balls dispersed all the ghosts from the Audubon when it was razed in 1992.

2007

161 West 131st Street: formerly the Band Box (1920–35). Once an informal jam session club with no regular entertainment, the building housed Christ Temple Baptist Church in 1996 and in 2007.

1996

1996

2007

1996

58 West 135th Street: formerly the Lincoln Theater (1915–mid-1960s). What is today the Metropolitan African Methodist Episcopal Church was the Harlem showcase for much early black vaudeville, such as the TOBA (Theater Owners Booking Association) circuit performers. It was built in 1915 and was transformed into a church in the mid-1960s. It still presents musical entertainment, but of a slightly different sort. It is undergoing renovation but is essentially unchanged.

1996

1996

2007

1996

2007

138 West 136th Street: formerly the Tempo Club (1914–50). This was not a nightclub with an entertainment policy, but an organization that conducted booking activities and presented occasional concerts and social gatherings. In 2007 it appeared to be private residences, the Temple of Joy.

266 West 145th Street: formerly the Heat Wave (1940–47). An exciting club before, during, and after World War II, the Heat Wave featured bebop and swing stars. Marlowe Morris was frequently the house pianist. The building, rented in 1996, now houses a medical establishment.

1996

2007

450 West 155th: formerly the Fatman's Café (1935–late 1960s). A restaurant and hangout for musicians, the Fatman's had no regular music policy. Now the Tioga Carver Democratic Club, it has been refurbished since 1996.

1996

One of the finest uptown addresses in Harlem was **555 Edgecombe Avenue**, at the top of Sugar Hill. You could watch Willie Mays run down fly balls if you lived on the upper floors. Andy Kirk, one of the last legendary jazz artists to live at 555, remembered watching the baseball games from his living room window. It remains a very desirable address and is currently undergoing renovation.

2007

1990

1990

1990

2007

In 1990 the Audubon Ballroom stood abandoned on the small, oddly shaped block where **Broadway, St. Nicholas Avenue, and 165th Street** converge. Efforts to preserve it were to no avail. It was razed, and a scientific center, bank, bookstore, restaurant, and parking lot now occupy the site.

There are far more sites where jazz used to be played in Harlem than sites where it is played today, but the same can be said of any location in the world. Jazz could still be found in a few places uptown in 1996, but only one club presented jazz on anything approaching a regular basis. In 2007, the situation was much better. Most places that present music must appeal to various audiences—jazz on one or two nights, soul or rhythm and blues on another, karaoke and even a taste of Latin on others.

The music most regularly presented in and around Harlem is played on Sunday mornings, when some of the best choirs ever assembled shout forth their sanctified messages. In fact, there is a minor controversy brewing that pits the churches that invite tourists to their Sunday morning services against those who do not. On any Sunday morning in Harlem, double- and triple-parked cars line the streets and avenues around every church. As long as choirs continue to present outstanding gospel performances in Harlem's churches, they will undoubtedly continue to attract downtown tourists. Some people have even suggested that Sunday is the best day for tourism in Harlem—church services followed by brunch at Sylvia's or a similar restaurant.

On a Saturday night in October 2007 there were nightly performances at the Lenox Lounge, EZ's Woodshed, Minton's, St. Nick's Pub, Showman's, and the Apollo. Their signs lit up the night. Sylvia's patrons were inside and outside, with cars double parked along the avenue. There was probably good music at other, less well-lit locations—perhaps music better than that to be found at the more noted spots. Bill's Place on West 133rd Street is starting to get a reputation, and there are regularly scheduled jazz presentations at Harlem Stage on Convent Avenue.

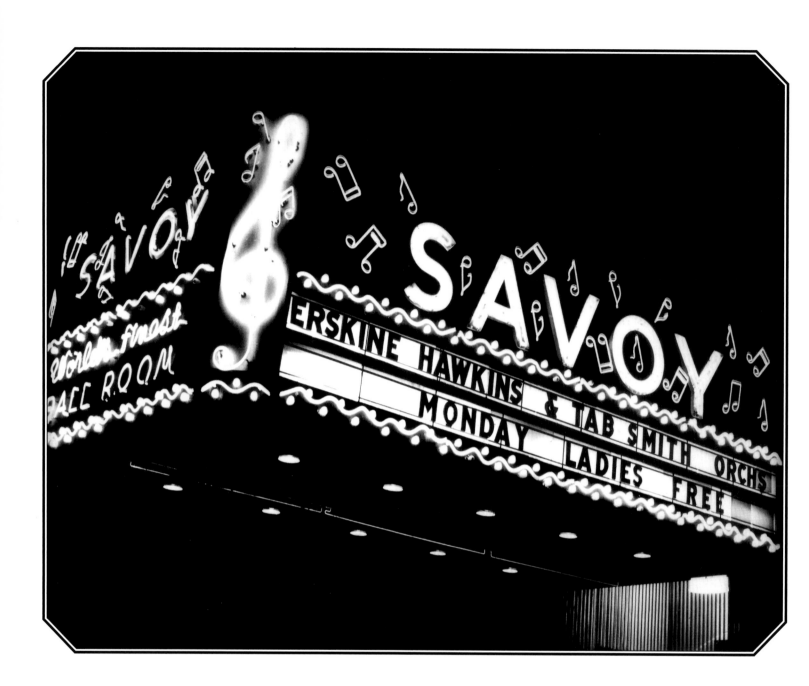

A Guide to the Interviews

Each of the forty-two interviews presented in this book is a compilation of the words and ideas offered by the participating musician. They are not exact transcriptions of the conversations that took place, but rather condensations of the pertinent information I was able to elicit from my subjects. Exact transcripts of the interviews exist, but they are often lengthy, full of redundant matters, repetitions, and commonplace information that, while possibly interesting, is utterly foreign to the subject matter of *The Ghosts of Harlem*.

The original transcription of Sy Oliver's interview, for instance, ran more than twenty-five pages; I condensed it to twelve. I didn't normally send these condensations to the ghosts for approval, but at her request, I did send a copy of the edited version to Lillian Oliver, Sy's widow, and she told me she was astounded because the printed words sounded so much like her late husband. I hope the others sound like the men and women who spoke the words and entrusted me with their thoughts.

I'm reasonably knowledgeable about the history of jazz and the men and women who made the music. In the editorial process, my assumption was that if something came up that was totally unknown to me, something I sensed might be important, then there were any number of other people who didn't know about it as well. Some of the musicians with whom I spoke, such as Sy Oliver, had not been extensively interviewed; if they began talking about something I felt might be of more than passing interest, I let them talk and, where appropriate, incorporated their comments into the finished interview, even if they strayed from my basic questions. An example of this is Thelma Carpenter's remarks regarding the background, recording, and subsequent performances of Coleman Hawkins's classic "Body and Soul."

The interviews appear in chronological order by age, from the oldest ghost, Andy Kirk, to the youngest, Major Holley. In some instances the musician's comments begin without my asking a question. In all circumstances I asked a question first, but if the speaker's initial comments made sense without including my question, I presented them that way. The musicians often quote others, and even though I'm certain virtually all these quotes are nothing more than generalizations of forty- or fifty-year-old remarks, I have put them in quotation marks.

Opposite: The Savoy Ballroom, late 1940s

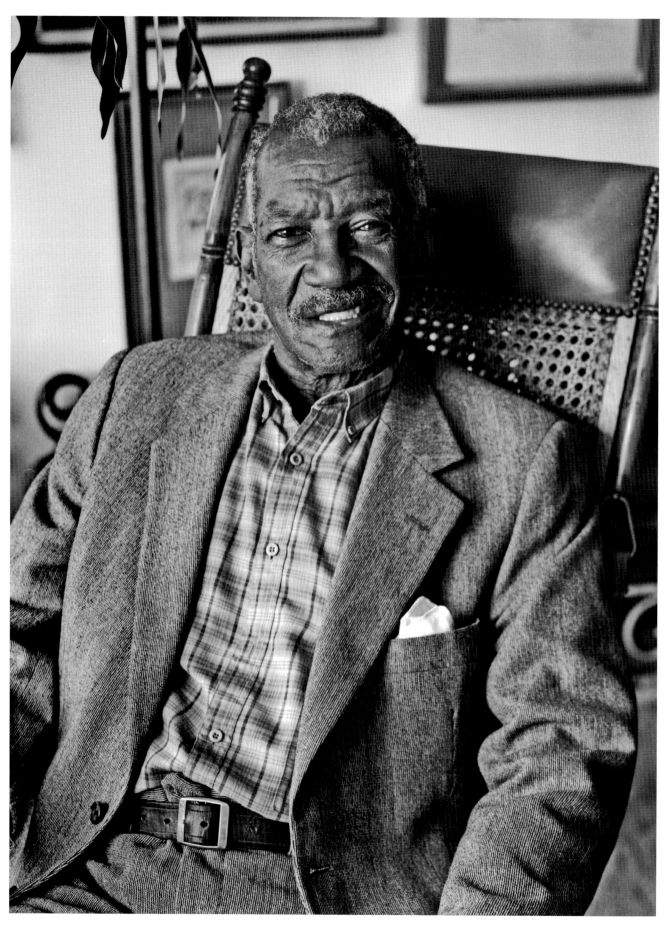

Jabbo Smith, Lorraine Gordon's apartment, New York City, 1987

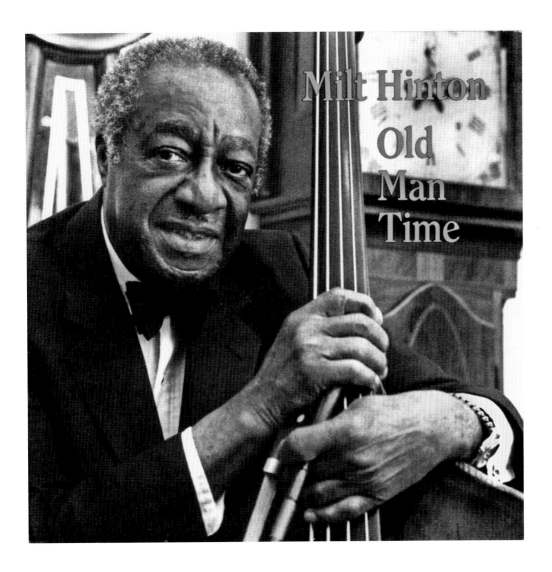

The date on each interview indicates the day on which it took place and—except in one instance, Al Cobbs—the day on which the portrait was taken. I do not remember why I was unable to take Al's portrait on the day of the first interview. I took his portrait on the day of the second, nine years later, but the changes in Al between 1987 and 1996 were visually imperceptible.

There are four ghosts whom I photographed with no interview. Jabbo Smith couldn't talk because of the effects of a stroke; Al Sears wanted to speak but couldn't because of laryngitis; Milt Jackson couldn't talk because of the stipulations of a contract he had with Warner Books; and Jay McShann was late coming to our meeting and there was no

time for an interview because of his travel plans.

One group interview I've included was not conducted as an interview at all; it was a conversation recorded at the conclusion of one of the sessions for Milt Hinton's musical biography, *Old Man Time*. The participants were Milt, Cab Calloway, Eddie Barefield, and Doc Cheatham. The conversation was released on the two-CD set, but I felt it might be of interest to those who have not heard the recording. This interview is included on the CD that accompanies this edition of *The Ghosts of Harlem*. The four men were part of a band we assembled for the 1990 recording session, which we jokingly called the Survivors because the minimum age for membership in the

Booklet cover, *Milt Hinton: Old Man Time* CD, 1990

From left: Doc Cheatham, Eddie Barefield, Milt Hinton, and Cab Calloway, "The Survivors" recording session, Englewood Cliffs, New Jersey, 1990

group was seventy-five. The others in the ensemble were Buddy Tate, Al Casey, Red Richards, and Gus Johnson. Buck Clayton wrote the arrangements. All the Survivors, except Gus Johnson, are part of this book.

In virtually every instance I trusted the memories of the men and women I interviewed. I know as well as anyone that selective memory often distorts facts, but the interviews reflect how these people remembered the past. There may

be instances where dates are slightly off—perhaps someone joined a band earlier or later, or the name of a club might not be exactly correct—but when I read all the interviews in sequence it is interesting to note in how many instances one ghost corroborates the comments of another. As far as I'm concerned, most facts are only memories, things that happened in the past that cannot be documented in any way. People remember things—facts, if you will—and when the people who

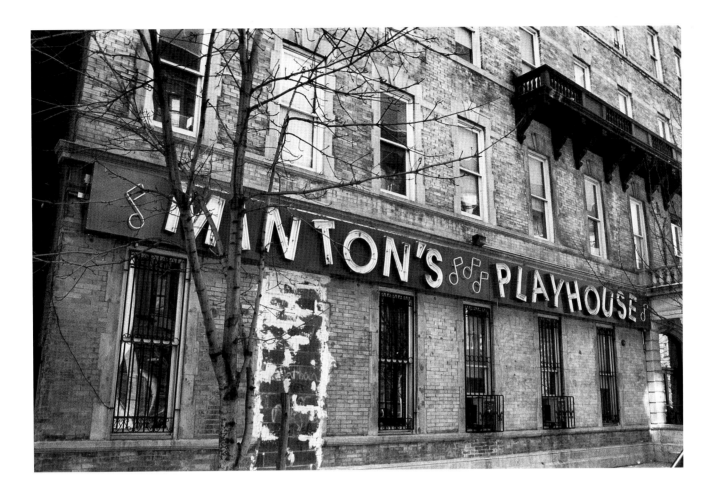

Minton's Playhouse, 210
West 118th Street, 1990

remember these things die, many of these undocumented facts simply vanish. Since much of the history of jazz is anecdotal, the memories of the ghosts and the resulting anecdotes are as good as any others, and once in print they may live a little longer.

I trust these interviews will not cause any scholarly confusion or discomfort, but I was not interested in tampering with anyone's memories. If someone said the jam session took place at Minton's in 1941, I was not prepared to dispute it. *The Ghosts of Harlem* is not a book of ultimate scholarship—far from it. Books of that sort both bore and terrify me. No, this is a book of memories, both verbal and visual, a search for answers to some questions and photographic images to illustrate these answers. My feeling is that the words of those who sat on the bandstand, who made the music night

after night, are far more important than the words of those who only listened, observed, or danced the night away and on another day wrote about what they experienced. I should add, however, that if someone did, inadvertently, make a mistake that was easily verifiable, such as perhaps suggesting the Savoy Ballroom was on Seventh Avenue, I corrected it.

Street names like Lenox Avenue were a matter of possible confusion in the interviews because some Harlem street names have changed. None of the musicians with whom I spoke referred to any of the major Harlem streets and avenues by anything other than their original names, and I retained the older names in the interviews. In fact, Illinois Jacquet had a good time joking about the new street names and how confusing they

The Lionel Hampton House, 410 St. Nicholas Avenue, 1996

are to him. In 2009, even though in some places both old and new names are used, the names are officially as follows:

125th Street
 Martin Luther King Jr. Boulevard
Lenox Avenue
 Malcolm X Boulevard
Seventh Avenue
 Adam Clayton Powell Jr. Boulevard
Eighth Avenue
 Frederick Douglass Boulevard

A final point: I have noted the year of birth of each of the musicians but, even though many of them are now deceased, I've made no mention of the year in which they died. I felt there was no need to do so. One of the wonderful aspects of being a creative artist is that as long as the work you've created lives on, so do you, at least in the minds and memories of others. An artist's contemporaries may die, and there

will come a time when there won't be a living soul who experienced any of these ghosts in person, but their music and personalities will live on in audio and video recordings.

One of the ghosts recently told me how often he thinks of Coleman Hawkins and how, even though he's been dead for over three decades, he doesn't think of him as anything other than a glorious musician, blowing everyone away at the Golden Gate Ballroom. Hawkins is very much alive for this man, as he should be for anyone with an interest in jazz and American music. Some of these ghosts are more important than Coleman Hawkins, some are less significant, but I hope in three decades all will be equally alive. Lionel Hampton is now gone, but everyone remembers his music, and his name will also live on emblazoned on the Harlem apartment building that bears his name.

African Square at Adam Clayton Powell Jr. Boulevard (Seventh Avenue) and Martin Luther King Jr. Boulevard (125th Street), 1996

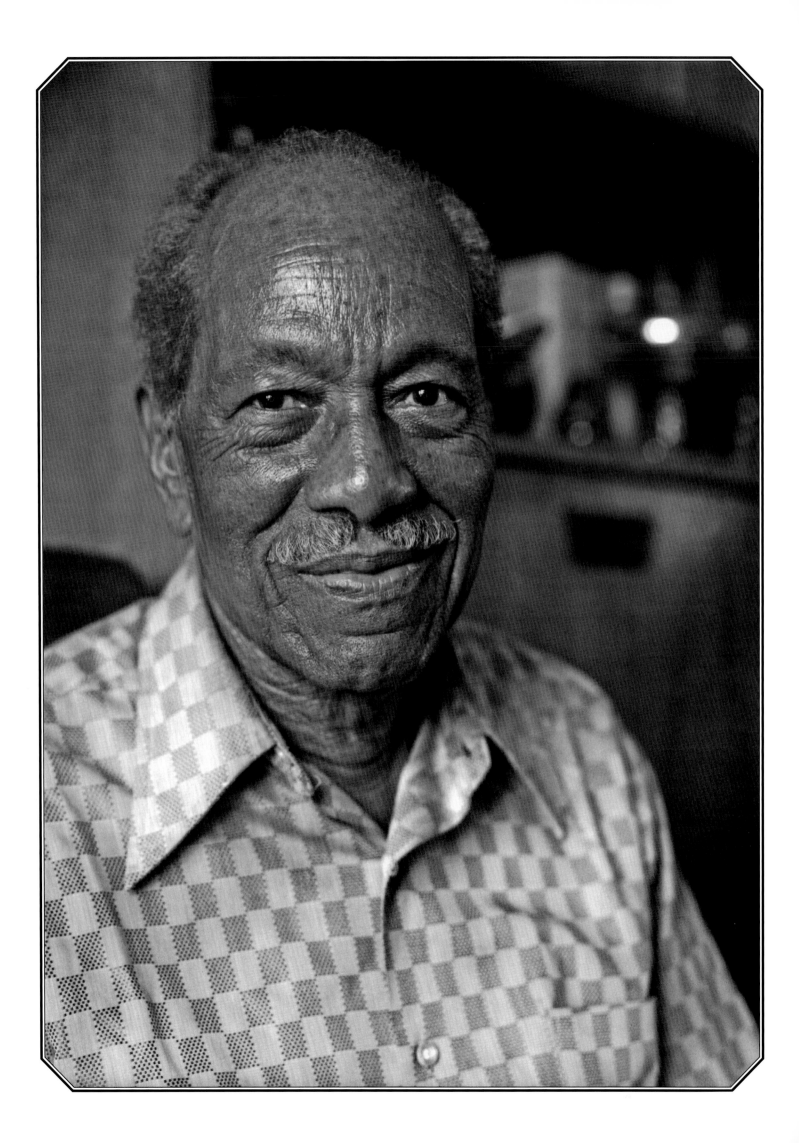

Andy Kirk
(b. 1898)

Hank: *I spoke with Buddy Tate this morning and told him I planned to see you this afternoon, and he said to make certain I gave you his best regards.*
Andy: I've known Buddy for many years; he played for me many, many years ago, after I left George Morrison. We might have even played together in Texas, with Terrence Holder—we called him Tee Holder.

H: *Tell me about George Morrison. I recall you were with Morrison when you first came to New York City.*
A: That's right. Morrison was a fine violinist and he had no competition in Denver, no competition at all. There were wonderful orchestras there, but he had no competition because he was such a fine musician. He not only played jazz but could play society music and had the best musicians in the city. One time I remember, Jimmy Lunceford was home from college. He was on alto, I was on tenor, and my wife, Mary, on piano, and some other fellows filled out the band. It wasn't unusual for Morrison to have a couple of jobs at the same time—one at the country club with his violin, playing all these classical things, and another where he'd play jazz for dancing somewhere else. I came up that way; I

learned to play it all. I was close to all kinds of music and that's the best way. You know, I wasn't supposed to make "Until the Real Thing Comes Along," but I did because I knew about all kinds of music. When I recorded that song in 1936, we were just a band making race records. But it became a hit, and everybody listened to it.

H: *Tell me about your first trip to New York. What was Harlem like in 1920?*
A: We came in the spring of 1920. We were supposed to make some records, and then we were to go to Europe because Morrison found out we'd just be part of another band. We made the records but he didn't want to go to Europe, so we just made the records and played at a hotel for a few weeks. I think Tim Brymn had arranged for us to come to New York, and he got us the hotel job. It was a place on Broadway, at about 100th Street, called the Carleton Terrace. I think there's a grocery store there now. Brymn probably had worked out the recording, and when we weren't recording we were playing at the hotel. I don't really know the inside story—I was just there, part of the band, playing tuba and saxophone, sometimes string bass. I remember the string bass didn't

Opposite:
Andy Kirk, 1986

sound very well on the recordings, and I decided to stick to playing saxophone. The tenor sax became my main instrument. The first instrument I played was the piano, but I thought I couldn't do that—a piano was for girls. My wife, Mary, is a piano player.

H: *Tell me about those records.*
A: I don't remember much about them. I think they were for Columbia, but I don't remember more than that. They probably weren't very good. Someone told me they issued one called "I Know Why."

H: *What was Harlem like in 1920?*
A: Well, we lived in Harlem. We worked at 100th Street and they fed us one meal a day there, but we lived uptown on 137th Street in a little black hotel. W. C. Handy lived on 138th Street, and we got to know him and his family. We got to know a lot of people in the neighborhood, but we only stayed in New York a few weeks. I went back to Denver, but I made up my mind to stop delivering mail. I'd been a mailman, you know, and I carried the mail for a while after I went back, but I knew I just had to stop because music was in my blood.

H: *When did you get back to New York City?*
A: Not for many years. I played with many bands—in Denver, all over the Midwest, around Kansas City, as far west as California, down in Texas. All over. I heard Tee Holder—Tee was short for Terrence—in Texas. Maybe that's where I first met Buddy [Tate]. Anyway, this was a fine band, and I began to listen carefully to how they played after I joined them. I liked the way they played, and it wasn't too much later when

Holder left the band and I was asked to take it over, and we became Andy Kirk and His Dark Clouds of Joy. I didn't like the "dark" part and changed it to Andy Kirk and His Twelve Clouds of Joy. It was a good name; it stuck, and we got work throughout the Midwest. One night we were playing at the Clayborn Hotel in Kansas City, and Fletcher Henderson came in as an added attraction. He heard the band and must have enjoyed it, because through Henderson we got our first job in New York City, at Roseland. It was late 1929 or early 1930. We had about six weeks, alternating with Casa Loma and some others.

H: *Did your band play uptown during this first trip?*
A: Yes, the first place we played was where Chick Webb always played, the Savoy Ballroom. I think we played there once or twice, but we didn't stick around very long because we were on tour. I was booked from Kansas City to Boston, and New York was just one of the stops.

H: *Mary Lou Williams was in the band by this time, wasn't she?*
A: Oh, yes. Mary Lou joined the band in 1929. We had a real important audition for a record contract in Kansas City and our regular pianist hadn't shown up. He was a ladies' man named Marion Jackson. Mary Lou was with Lunceford at the time. Her husband, John Williams, had already left Lunceford and was in my band, and as soon as Mary Lou had finished up her obligations with Lunceford in Memphis, she came to Kansas City. So now she was in Kansas City and my piano player hadn't shown up, so I asked John to call Mary Lou and see if she would come to the audition. I liked what I heard,

and so did the recording people. I had to fire Jackson, because from that point on Mary Lou was in the band. We got a two-year contract and Mary Lou stayed with me for a dozen years, until about 1942. I was sorry to see her leave the band. She was a great pianist and a wonderful person. We had some good pianists after Mary Lou—Hank Jones, Kenny Kersey—but there was only one Mary Lou.

H: So you were in and out of New York for many years?
A: Well, I didn't just come and go out of New York; it was well-organized travel, because I was working for Joe Glaser out of Chicago.

H: That's Little Joe from Chicago?
A: Yes. He was a tough customer. He killed a black man one time. He shot him in Chicago—killed him—and the lawyers got him off it, then got him out of Chicago and moved him to New York. I didn't know that in my early days with him, but he was something. Once we had a problem in his office on Fifty-ninth Street, and I said, "Look, Joe, I'm sitting right here. You don't have to holler unless you just want to show off in front of your employees." You know what he did? He calmed down and realized what I said was something that he should think about. He changed right away, and he started talking sensibly—didn't say another word out loud. He was sure a character, but I never was really angry with him because I knew he was a hustler and he had spent time in jail. He killed a man, but I didn't know that until later. If I'd known, I might not have spoken that way to him. I stayed with Joe until I disbanded the Clouds of Joy.

H: When you played at the Savoy in the early '30s, were you alternating with other bands?

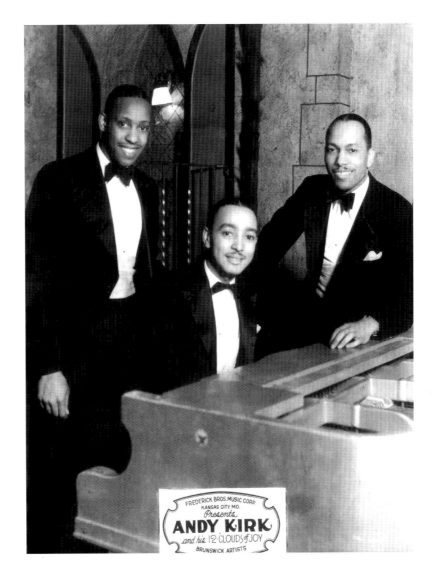

A: Oh, yes, and sometimes it was Chick Webb, my favorite band. There were other good ones, but I liked Chick's best.

From left: Pha Terrell, Earl Thomas, and Andy Kirk, Kansas City, 1934

H: Where else in Harlem did the band play?
A: Almost everywhere—the Golden Gate, the Apollo, the Alhambra, private parties at the Renaissance Ballroom. I remember playing at the Golden Gate opposite Teddy Wilson. Ben Webster was with Teddy then, and, remember, Ben had been with me in the early 1930s and even after he left we remained friends. One night Ben played with Teddy and then when I came on he played with my band. But we played almost everywhere in Harlem—private affairs for clubs, at Small's, wherever there was a good job.

If we were in New York and there was an opportunity, we'd play. There were many places to play, and I played them all.

H: What was your favorite one?
A: Well, I think the Savoy, because I could hear Chick Webb. He had the best band, the best style. No other orchestra sounded like his. It was in a class by itself.

H: Did you ever have a battle of bands with Chick Webb?
A: No, but we did with others, right in the Savoy, and then someone booked a tour where we went on the road and did battles in a chain of ballrooms. But we didn't just play battles; we also played pretty things for dancing. Remember, "Until the Real Thing Comes Along" was a big hit. We started making records for Decca in 1936, but most of them were tunes for the black market. Maybe they'd sell fifteen thousand copies. They'd never sell very many. We started playing "Until the Real Thing Comes Along" at dances, and the response to Pha Terrell singing this pretty ballad was terrific. I told the record people they should let me record it. The record guy said, "What's the matter with you fellows? Every time you get something going for yourselves, you want to do what the white boys are doing." I told them there was no color in my music. They let me do it and I had a hit. Instead of a few thousand, a hundred thousand. The next time I came to record with some jazz things, they've got ballads for me. Money talks.

We recorded those things and kept touring. The band eventually played in every state except Vermont and Montana. I made marks on a big map and kept a log. We played in 368 different cities. And some places were rough. I remember playing in Durham, North Carolina—it

was a black dance. The kids from the University of North Carolina and Duke were up in the balcony; that's the way everything was controlled in those days. Now, on Pha's vocal, he'd sing the song and then we played sixteen bars and then he would come and sing the last sixteen bars. After he sang a chorus, I noticed there was a big husky black guy with a big scowl standing right down front. We were only a couple of feet off of the floor. So I take the mike and put it back where the scowling guy can't reach it, just in case. Pha comes and sings his last sixteen—he takes the mike and puts it right in front of this guy's face, and this guy's trying to shove it but Pha had a good grip on it and he bowed, but this big cat jumped up onstage, went for him. Pha decked him. All the white kids in the balcony started shouting. Pha was the hardest-hitting little man I ever saw. He was working for the mob as a bouncer when I got him. This guy in Durham was a head taller than Pha, but he had no business jumping onstage and Pha took him down. The kids in the balcony all shouted for more.

H: Did you ever have any incidents in a ballroom in Harlem like you did down in Durham when someone tried to hit somebody on the stage or something like that?
A: No. People were better controlled in Harlem, and this was one of the few times anything like this ever happened to the band.

H: When did you finally settle in New York?
A: I moved to New York in 1939, right here to 555 Edgecombe, but most of the time I was on the road. I was only in New York a small part of the time; I was in 368 other cities the rest of the time.

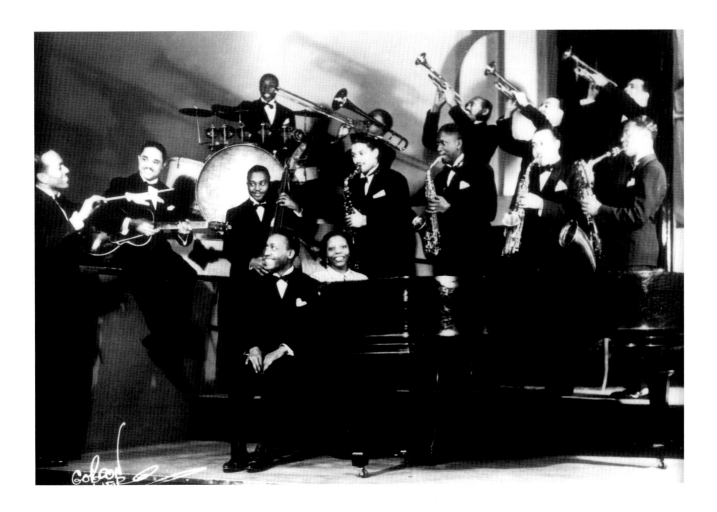

H: *Do you remember what was the last place that you played in Harlem? What was the last job that you played uptown with the band?*

A: Well, you see, when I broke up the Clouds of Joy, I didn't do what some others did. I didn't trim it down to a small band. Joe asked me to do that, and I wouldn't do it. I liked the way the big band sounded. So I would sometimes put the band together if there was a special function or to make a record—things like that. So I don't remember the last time I led the band uptown. It was probably at one of the ballrooms somewhere, but I just don't remember.

H: *You did a lot of things in Harlem other than lead a band. Tell me about some of those things.*

A: 1950 or 1951 was my last year of road tripping and I became the manager of

the Hotel Theresa on 125th Street. I was the manager for many years. There wasn't enough room for a band there. Sometimes there would be a little combo or something, but never a big band. I was there the day President Truman visited the hotel, and many years later when Castro stayed in the hotel. The man who owned the hotel, Mr. Wood, was determined to make the Theresa the uptown Waldorf-Astoria. He thought I was just afraid of losing my job, but I told him he shouldn't do it because there already was a Waldorf-Astoria. But his plans didn't work out. The black organizations who could have used the hotel went downtown to other places, and the hotel failed. So did Mr. Wood. The community just didn't support him. He lost all his money, and finally all he had left was one little whorehouse on 123rd Street. The old Hotel Theresa is

Andy Kirk and His Twelve Clouds of Joy, 1937

Andy Kirk outside 555 Edgecombe Avenue, 1986

still there, but it's just an office building now. And you know, for a few years I had a barbecue place at 129th Street but this was in the 1940s. We even had a cook from Kansas City.

H: If you could point to one thing, what hurt the music business in Harlem more than anything else?
A: I know World War II did a lot to everybody, and those men who fought in World War II had a different way of thinking. They'd think, "When I get home, it's going to be different." But prior

to that everybody wanted to just snap their fingers and have a ball. The music changed. It wasn't so easy to dance to, and people starting going downtown. I kept playing, leading the band for private functions, into the 1960s but mostly downtown. I even used smaller eight-piece bands on occasion. If it was a bigger affair, I'd use a twelve-piece band. But I haven't had the band out in years, and I haven't heard anyone else play anywhere in almost as long.

15 September 1986

Hotel Theresa, 125th Street and Adam Clayton Powell Jr. Boulevard (Seventh Avenue), 1996

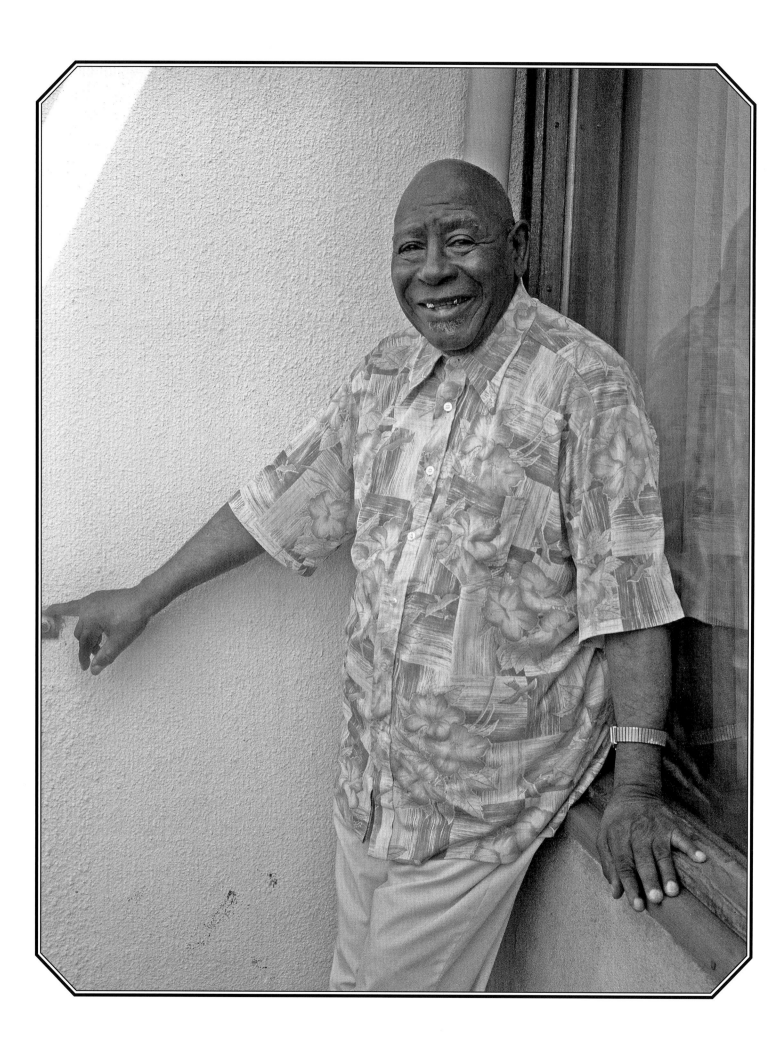

Benny Waters

(b. 1902)

Benny: The first time I played in Harlem was in 1924, at the Lafayette Theater, but I was really based in Boston. I didn't come to New York City to stay until I joined Charlie Johnson in 1925.

Hank: *Why were you in Boston?*
B: I was studying at the Boston Conservatory and gigging around town. In fact, I played all over New England, up in Maine and Vermont. I was part of a show with singers and dancers that did pretty well all over New England. That was the show that went into the Lafayette Theater in 1924—it got so good, they brought us in for two weeks. I even did some teaching while I was in Boston, and Harry Carney was a student. I first met Johnny Hodges in Boston; he was very young but already a fine player I admired very much. I left Boston and went back to Philadelphia about 1924 and was playing there when I was recommended to Charlie Johnson. I joined Charlie in Atlantic City and went to New York with him. I stayed with the band until the early 1930s, maybe as late as 1932. I worked with Charlie again a few years later.

H: *Tell me about the Charlie Johnson Orchestra.*

B: We opened at Small's Paradise in the fall of 1925 and were the house band there until I left. I think Charlie may have continued there after I left, but I'm not sure. It was hard work at Small's because the shows changed all the time; a show would last a few months, maybe three or four, and then we'd have another show. I remember one of the most popular shows was written by Jimmy Johnson; it was the show that featured "Charleston," and they based the whole show around that song. I had the privilege of writing the arrangement for that song. Charlie's band and his shows were very popular; that's why he stayed at Small's for so many years. Other clubs tried to get him to leave. The Cotton Club wanted the band, but they wouldn't pay Charlie as much as he was getting at Small's and they wouldn't let him run the show. The Cotton Club had more prestige than Small's, but Charlie liked to run things and they wouldn't let him do that at the Cotton Club.

H: *Describe Small's in those days. What did it look like?*
B: It was just a club; there were no fancy decorations like the Cotton Club. Just a stage for the shows, but there were

Opposite:
Benny Waters, 1986

a lot of people in the shows, sometimes as many as thirty-five or forty—singers, dancers, comedians, acrobats. The shows at Small's specialized in talent, all kinds of talent. Bojangles [Bill Robinson] worked there, and so did Ethel Waters. We really had the talent. I remember Bill Bailey worked at Small's when he was young. Small's charged an admission; if you paid it, you could come in and stay as long as you wanted, but most people only stayed for one show because the shows were all identical. The people came and went, and we were packed all the time, even on Monday nights. That's why the Cotton Club wanted Charlie: Small's was always full. Like I said, we specialized in entertainment. The Cotton Club dancers were prettier than our girls, but we had much better dancers. The girls at the Cotton Club were all dressed up in those fancy costumes—much fancier than our girls— but we could outdance them anytime. The main thing, though, was that the band was great. Charlie always had a great band, even in Atlantic City before Benny Carter joined. We also had other fine arrangers— Edgar Sampson wrote for the band. He wrote great arrangements, and it was very sad about him, what happened to him. While I was spending all that time drinking whiskey, smoking cigarettes, chasing girls, and doing everything, Edgar was like an angel, almost like a preacher, and he didn't have to chase those chicks, the chicks liked him. I don't know what happened but things changed, and he had such a bad time before he died.

H: Did the Charlie Johnson band double up and take jobs around town or on the road when it wasn't working at Small's?

B: We were always working somewhere. Sometimes we'd go out of town to play a dance, and we played at the Lafayette Theater. We made records in Camden [New Jersey], and once, I remember, we made records in the daytime. Played at Small's all night until three or four in the morning and then played a breakfast dance somewhere, probably the Lenox Club, the place they called the Breakfast Club.

H: With a schedule like that you probably didn't have too much time for after-hours jamming.
B: I used to hang out—I liked to drink; I liked those chicks. I'd go to those clubs with the girls and I jammed a little at Minton's and places like that, but I didn't do it much. I liked those chicks—that's where I spent most of my time—but I heard some great playing at some of those after-hours places, those jamming places.

H: Give me an example of a really good one you remember.
B: Well, people sometimes jammed at Small's at the end of the evening. There wasn't any jamming at the Cotton Club, but you could jam at Small's. By the end of the night we'd all be tired or drunk, and we'd be happy to have someone come up there and play, to give us a little rest. It was hard playing those shows night after night. But most of the jamming went on at other places, little out-of-the-way places that didn't have a regular band. Piano players played at Reuben's. I heard some great sessions there. And there was one night when Benny Carter, Johnny Hodges, and Jimmy Dorsey hooked up. I don't remember the name of the place where it was, maybe it was at the Melody Club, but it was a fantastic night. Benny just blew everybody out. Johnny did pretty well, but he wasn't as musical as Benny, and Jimmy was out of place entirely. I could

Opposite:
Small's Paradise,
circa 1920s

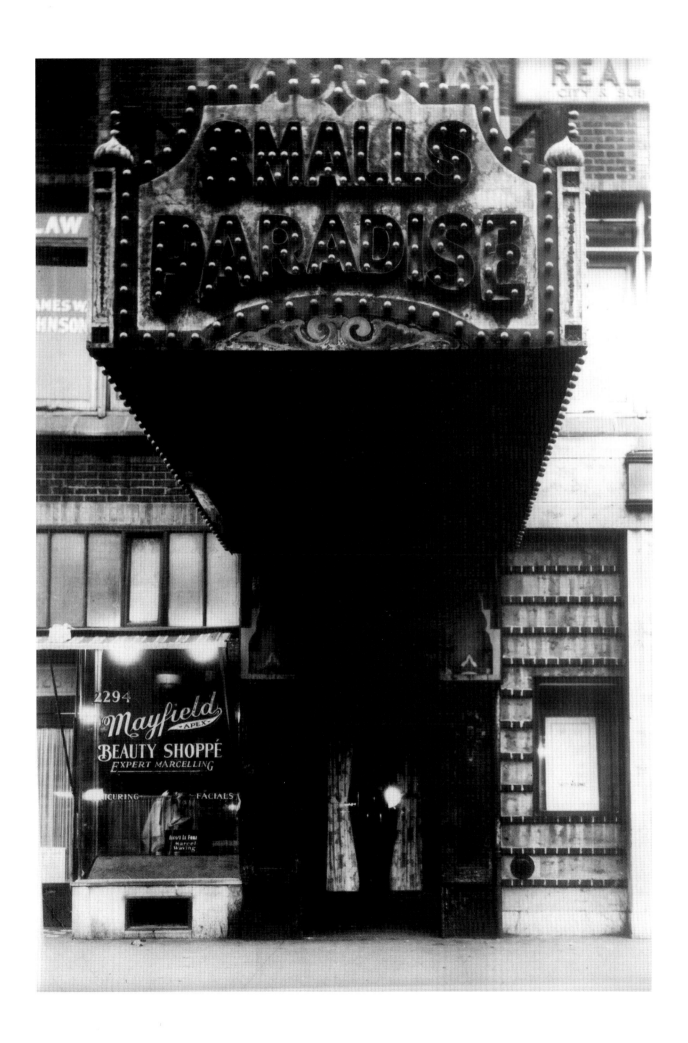

Benny Waters and young
fans at the Grand Hotel,
Oslo, Norway, 1986

have done better than Jimmy. He was just out of place. Now don't get me wrong, Jimmy Dorsey was a great saxophone player—but he wasn't *that* great. His idea was to come to Harlem and blow us out of there. Well, Benny Carter put a stop to him thinking he could do that. I think Benny knew he was going to try and do that and had it in for him. Benny is very dangerous, you know. He goes along real quiet, but don't wake him up—I mean, with that saxophone. I don't mean he's tricky, someone like Earl Bostic, he isn't someone with tricks and high notes; he just plays the saxophone, and that night he played so damn much saxophone that Jimmy Dorsey never came back. After that session, I'm told, Jimmy never came back to play in Harlem, and I'm pleased that Benny played so well because when Jimmy was coming at you, he wasn't very nice.

H: Who was the rhythm section—do you remember any of the other players or the year it took place?

B: I don't remember exactly when it took place, maybe 1929, 1930, something like that, but I'll bet the piano player was probably somebody Benny brought with him, somebody who could play in all those funny keys. Maybe it was Freddy Johnson. That's one reason why Jimmy probably lost; he couldn't switch keys as fast as Benny, and he got lost. Now, Johnny Hodges didn't get lost—he could play in any key he could hear. Johnny was a gifted musician; he could play in any key without knowing what key he was in. I remember, I tried to trick him up in Boston. We were playing "Runnin' Wild"—the tune had only been out a little while, and we're racing through it. I was playing it in D-flat, the original key, and then I get smart and changed it to B-natural, which

is hard as hell. I figure it was a key he didn't know, but he went right along with me—he didn't know what key he was playing in, he was just doing it. Johnny did pretty well when Benny was changing those keys—he was a gifted player—but Benny just knew more music. You can always tell who is a better musician with certain songs. I used to work with Johnny all the time in Boston. He could always play and had that distinctive tone, but he couldn't play a number until he'd learned it. Benny Carter could just play it. When we were together with Charlie Johnson, Benny and I would both work on the same songs; if there was a new song, we could both just play it with no trouble, or maybe I'd show Benny a new song, play it for him, and once he heard it and thought about it, he'd play it a whole lot better than me.

H: You mentioned piano sessions at Reuben's. Were any particularly memorable?
B: There was one night when I heard Fats Waller, Art Tatum, Earl Hines, and a modern guy who died young—I don't remember his name. He was like an early Thelonious Monk. I never heard so much piano playing in all my life—and, oh, yes, the man with the cigar was there, Willie the Lion [Smith]. They all played on one piano—somebody would be playing, and then Willie the Lion or somebody would say, "I got it," and sit down and take over.

H: You mentioned Monk; did you ever encounter him or any of the early bebop musicians in Harlem?
B: I remember Monk when he first started. I saw him at some of those after-hours parties, at places where they had chicks and sold pigs' feet, marijuana, and all kinds of stuff—places that were private, where you had to have a card or where you were known. Musician places.

Those are the kind of places I first heard Monk. Dizzy [Gillespie] used to come to places like that, and that's where he got a lot of his ideas—some pretty crazy ideas. Monk was always crazy, you know. He wasn't studied, and sometimes he wasn't even very musical, but he was certainly gifted and a pioneer of modern jazz. Where some guy might be looking for the correct chord, he was looking for something else.

H: You played with and arranged for many different bands, large and small, in the 1930s and 1940s. Did you have any favorites?
B: I was with Fletcher Henderson, Jimmy Lunceford, and Claude Hopkins and wrote arrangements for all of them. I also arranged for some bands I didn't play with, like Charlie Barnet. I spent a year with Hot Lips Page in the late 1930s and enjoyed it. He was a terrific player, a very underrated player. We played at Small's and the Savoy Ballroom, and sometimes I'd sneak out of his band to take another job, but we were good friends and when I'd come back he'd always hire me. I think he even fired people to put me back in his band. I'm sorry he never got the recognition he deserved, but he died young on account of worry. He used to worry about his success. Some musicians have that disease, the disease of worrying about success. They see some musicians who they don't think are as good as they are, raising hell, making money, and having a lot of success and they worry about it. If you do that, it'll kill you—and it killed Lips Page. I never worry about who is making how much. Don Byas used to worry like that, and it hurt him just like it hurt Lips Page. Don Byas was a wonderful musician but he worried himself to death worrying about his success. Stress did it, and I don't want any stress.

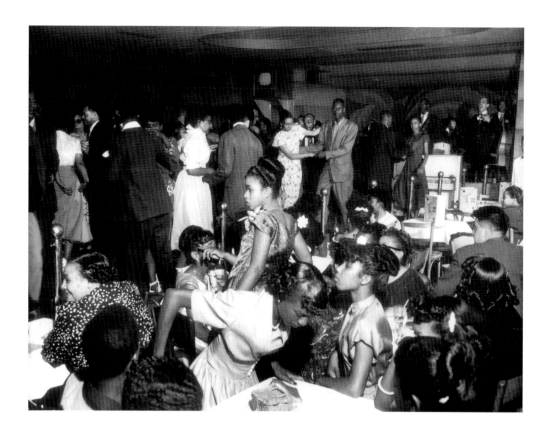

Dancers and patrons,
Small's Paradise, 1945–46

H: I know you've been in Europe for years; do you remember the last time you played in Harlem?

B: I was with Jimmy Lunceford and we were playing at the Renaissance Ballroom. That was the only place Jimmy played in Harlem. I was with the band a little over a year—wrote a few arrangements and was on the road with them. We went all over, as far as California and then back to New York. I fired myself from the band. We opened at the Renaissance but I only played one night; I got drunk the next day and fired myself. Jimmy came to my house looking for me, but I was drunk. I used to drink a lot, you know, but I stopped in 1969.

H: When was the last time you visited Harlem?

B: I've lived in Europe for about thirty-five years but recently I've started to come back for visits. I always kept a small account at a bank on 125th Street, and when I was in New York City last year, I went to visit the bank. I hadn't been to Harlem in about seven or eight years. I took the subway up, and when I walked up the stairs and looked around I began to cry. It had gone down so far; it was so different from what I remembered, tears came to my eyes. I took all the money out of that bank and moved it downtown so I don't have to go to Harlem anymore and see all that sadness.

9 August 1986

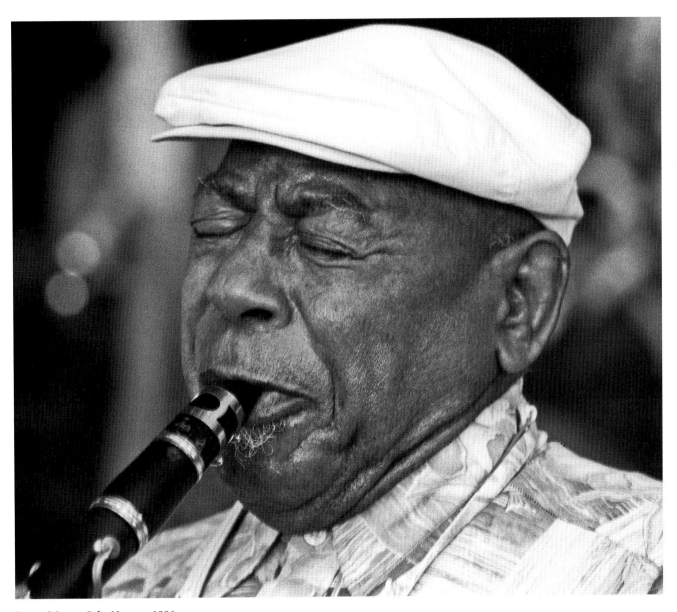

Benny Waters, Oslo, Norway, 1986

Greely Walton

(b. 1904)

Greely: I was born in Alabama in 1905, but I wasn't raised there. My father died when I was ten and we moved away, first to St. Louis and then to Pittsburgh. We were in a lot of different places before that because my father had tuberculosis and we moved around to different places hoping he'd get his health back. We would stay in one town and then try another but always go back to Mobile. It didn't bother me. I was happy. I had a very beautiful childhood, in a way. I came to New York from Pittsburgh in 1926, and I've been here ever since.

Hank: *When you were in Pittsburgh, did you know Earl Hines?*
G: I played with him in Pittsburgh. Benny Carter came to Pittsburgh in 1925 and he was working with Earl Hines at the Paramount Inn, a place in one of the black neighborhoods. I worked down there with them for a little while. Before that, Earl had been with the famous band in Pittsburgh led by the singer Lois Deppe. I didn't work there long, but that's where I first met Benny Carter, and we've been friends for a long time. About that time some of us organized a band with guys from around Pittsburgh. Joe Eldridge was on saxophone—Roy [Eldridge] was still a little boy at this

time. The trumpet player was R. T. Johnson, a fine musician. He's somewhere in New York, but I haven't seen him for years. We called the band the Elite Serenaders, with an emphasis on the *E.* We were all very young musicians, but we did well around Pittsburgh.

H: *How did you manage to come to New York with that band?*
G: Benny Carter was the one who got us the job. He'd come back to New York and told a man he knew we were pretty good. He came to see us and then brought us to NY to play at the Renaissance Casino, at 138th Street and Seventh Avenue. We started in July or August and worked up there for six months. Then I went with Elmer Snowden at the Nest. He had a fine band. Walter Johnson was drummer, and Preacher—Wardell Jones (we used to call him Preacher)—was on trumpet. He was a hell of a trumpet player. He worked with Benny Carter the same time I did, but that comes later. The pianist was Charlie Lewis, a graduate of Pace University. He was very fair, had blonde hair, and was really a concert pianist. He went to Europe later on and stayed over there. A fellow I just remember as Cuppie was on trombone, and Joe Eldridge was the other saxophone. We used to play

Opposite:
Greely Walton, 1987

at theaters, and when we weren't at the Nest, we'd be at another cabaret on Lenox Avenue, the Bamville Club. When we were at the Bamville, Otto Hardwick was in the band—he'd quit Duke at the time. Duke had just started the big band, had just come up from the Kentucky Club, and Otto got mad about something and left Duke. In fact, Snowden brought them here. Let me tell you something about Otto Hardwick. He could put his instrument down for weeks, not even touch it, and all of a sudden come to work, pick it up, wet the reed, and play exactly like he did when he left. It was remarkable to see him do this, because I had to practice every day.

About that time I started working in the pit of the Lafayette Theater. Garvin Bushell was the one who hired me. I was young, but I was a good reader. Will Vodrey was in charge of scoring all the music for the shows, and I remember Bushell came and got me to audition. They'd been trying out a lot of tenor players, but the music was very hard and Vodrey was hard to please. Bushell took me down there, and Mr. Vodrey looked at me and said, "Bushell, why are you bringing this kid here, this kid can't play my music." I said, "I can play it. Do you have it all marked properly and everything?" He said, "Yeah, and he's a cocky kid too." I guess I was a little cocky. And then he said, "Do you want me to take you upstairs and run over some of it?" I asked him if he was conducting and he said he was, so I said, "We don't have to do that." I went right in the pit, played the show, and it went right down beautifully. When we came off the stage after the first show I played—it was the second or third show of the day, we used to do three a day—Vodrey says, "You know, I'm slipping. Anytime some kind of kid like you can come in here

and play my music, then I'm slipping. I've got to try and do something else." Anyway, that started it.

H: Do you remember what the show was?
G: No, but it wasn't a jumping show. A lady I think was related to Vodrey was singing. Will Marion Cook was in the show, and his wife was a singer in the show as well. It was a real production, similar to what happened in Broadway theaters, only shorter. After two weeks the show went out, but I stayed on to work in the pit. I was doubling, playing the pit and the Nest. At this time Fats Waller was playing the organ in the theater, and he was such a beautiful guy. Not many people know this story because it was just between Fats and me. There was a little alley that led to the stage entrance, and next to the alley was a little place selling booze called Blackie's. Now, Blackie's was a terrible place; it was greasy and awful. You'd never stayed there to drink, you just went in, got what you wanted, and got out. Fats would ask me to go out and buy a half a pint of scotch for him while he's on and I'm off. I'd go to Blackie's to get a half a pint of scotch for him and then sit with him in the pit while he's playing the organ. Now, there might be a funeral or something going on in the movie but he'd take a couple of drinks and say, "Hey, Greely, listen to this!" He'd cut loose right in the middle of a picture. He was a wonderful guy and a real character. He'd send me out to get his whiskey and then entertain me during the picture.

H: Did you ever spend any time at the Rhythm Club? Do you remember Jelly Roll Morton?
G: When I was a young man, just in town, I spent a lot of time at the Rhythm

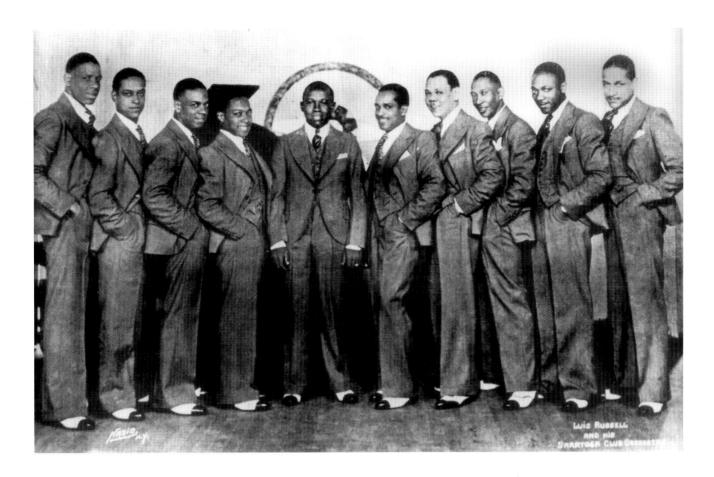

Club and used to see Jelly all the time. He was always there ragging the guys. He even ragged me sometimes. He was a nice guy but was always ragging you about something. He'd brag about this and that, but I always just thought he was kidding. I never heard him play the piano at that place.

H: Tell me about those early clubs like the Bamville and the Nest. Which did you enjoy most?

G: They were both a lot of fun because I was playing with the same guys, it was the same group—we'd come out of the Nest, somebody else would go in, and we'd go to the Bamville, and then maybe go back to the Nest. It was while I was working at those places that I was young enough to spend some time jamming at other places. Not after I finished work but during intermission. I worked at the Nest until maybe five o'clock in the morning and I'd have a theater show at eleven

o'clock. I might sneak out during an intermission, down the street to Mexico's. We didn't have much time off—only a half hour, forty-five minutes at the most. I didn't lead that kind of life very long. The last time I jammed at Mexico's, Johnny Hodges was there. And I didn't stay with Snowden all that long either; I left and worked with many different bands. I worked with Benny Carter a few weeks at the Savoy but only for about six weeks. I hadn't been married very long and when Benny took the band on the road, I stayed behind. I loved that band; most of the arrangements were by Benny, and how that man could write an arrangement and how he could play! He's a beautiful player, but he was an even better writer and leader. He wrote hard music, but Benny's band was the most interesting I ever played with. I even played society dances with Luckey Roberts's band. We played for J. P. Morgan at Tuxedo Park.

Greely Walton with Luis Russell and His Saratoga Club Orchestra, 1930

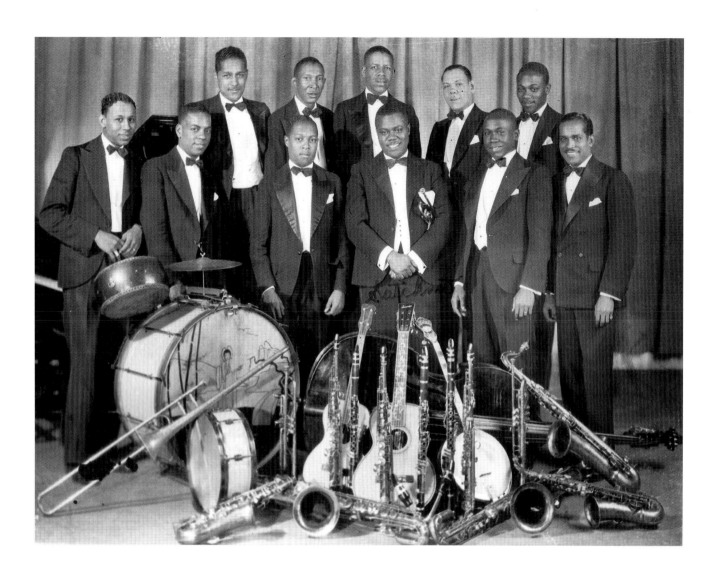

Louis Armstrong with the
Luis Russell Orchestra, 1930

H: *You were with Luis Russell for many years. Tell me about that band.*

G: I joined the Russell band about 1930. It was a fine band, and we were in the Saratoga Club on Lenox Avenue, at least when Louis Armstrong wasn't fronting the band. When Armstrong came in from Chicago, he took over the band. He eventually took over the band and kept it, and I stayed with it until 1937.

H: *You played for a series of big bands after you left Armstrong. Did you have any favorites?*

G: I went with Horace Henderson, a marvelous musician, in some ways like Benny Carter. He could organize a band very well. I worked with Cootie Williams and then joined

Cab Calloway in 1943. I enjoyed Cootie Williams very much; he was a wonderful player and an exceptional sight reader. He also had a beautiful tone and played the hell out of first [trumpet]. He was the most versatile trumpet player I ever worked with. Another thing was that he had access to Benny Goodman's repertoire. He could get anything he wanted, and he'd bring in Benny's arrangements. He'd pass them out and show [Ermit] Perry how he should play first trumpet. Not that Perry couldn't play it, but Cootie would show him how he thought it should be played. And boy could he play!

H: *Who wrote most of the arrangements for that band?*

VICTOR
V–38058–B

For best results
use Victor Needles

SARATOGA SWING—Fox Trot
(*Ritmos de Saratoga*)
(Barney Bigard)
Duke Ellington and His Cotton Club Orchestra

G: Everybody, but most of the book was Benny's stuff when I was there. Don Redman wrote some, I believe. It didn't make much difference, because the band wasn't a success. Cootie was such a good-hearted guy, and the guys in the band took advantage of him. After I left to join Cab, I think the band got better, and later I heard they went out on tour with the Ink Spots; but when it came back, it just disintegrated. The next time they went out it was with Eddie ["Cleanhead"] Vinson's band, and I left Cab and became the conductor for the Ink Spots' part of the show. I stayed with them a couple of years and there were no problems.

H: What are some of your memories of Cab Calloway?
G: Cab's band was terrific. He had fine musicians in it, and working with Cab at that time was just like working with the government. It was run just like the government, in a way, because it was so well organized. I remember I used to catch it pretty badly when Dizzy Gillespie and Charlie Parker started playing downtown. When we'd have a night off, all the guys would go listen to Dizzy and Charlie, but I'd go to Carnegie Hall to hear a symphony. You see, I was also a violin player. When I was a kid, I had to go to pop concerts in St. Louis with my teacher. When I'd come back from one of those concerts, the guys would ride the daylights out of me. They'd say, "And where did you go, Lord Fauntleroy?" That's what one of the guys called me, Lord Fauntleroy. One of my favorite people in Cab's band was Hilton Jefferson. I remember one funny thing. When we were on stage, Milt [Hinton] sat behind Jeff and I, back behind the reeds. He said that Jeff and I had the dirtiest glasses of anyone he had ever seen in his life. He used to hit me or Jeff with the bow and say, "Hey, clean your glasses! I

Greely Walton at home, 1987

can't see a thing!" I spoke with Milt about three or four months ago. I was sitting in here looking at the television and realized my glasses were so dirty I could barely see. I called Milt up and I said I had some dirty glasses. I broke him up!

We had wonderful times together. We'd be on tour, and you can believe we didn't just sit in our seats or sleep all the time. I remember distinctly one night when we were on a train and two soldiers came in the men's room of our car and there was a crap game going on. Illinois Jacquet was cleaning everybody. These two lieutenants wanted to get in the game. Cab had rules about that—he didn't want anybody outside the band in any of those crap games. He thought it was all right if the fellows gambled

among themselves because each guy would have the chance to get his money back if he lost. Strangers were something else—somebody just passing through that you might not ever see again—he didn't think that was a good idea at all, but these guys wanted to shoot dice so bad. This time Cab said, "OK, if you want to, but we won't be responsible for any of your losses or anything." Jacquet was shooting. The guy said, "What you shooting?" Jacquet said, "A hundred dollars—there it is down there." The guy threw his hundred-dollar bill in and almost before it had hit the floor, Jacquet had hit a seven on him. Right up against the wall. Nobody was cheating or anything. He did that about three times on the guys before they folded up and left. I never gambled. I don't know why I'm not a gambler. I used to take care of my house and everything. My wife was sick to begin with, and that's where my money went. I didn't want to chance it out there like that.

H: I've heard you spent some time teaching saxophone.
G: I didn't teach much. I did teach some blues, but I only wanted to teach professional guys. I taught some after I stopped playing professional in the early 1950s. I don't have the patience to teach children, but I used to teach Jeff, Charlie Holmes, and Hilton Jefferson. Jeff didn't want anyone to teach him but me, and I said, "Jeff, I don't want to teach." He said, "You gotta teach me." So I did. I gave lessons to George Dorsey, and I taught Charlie Holmes. These were professional guys. They were beginners on blues, but they were musicians and could read just as well as I could. Charlie was with me in the Cootie Williams band, and George and I were together in the Marcelino Guerra band, a Machito-like band. Most

of the guys in the band were Cubans but Doc Cheatham and Mousie Randolph were also part of it.

H: What was your favorite band, just for listening, and where did you enjoy listening to them?
G: The dance halls and ballrooms were the most fun for listening, and I think the Savoy was more fun than, say, the Renaissance, because at the Renaissance there was usually only one band. The Savoy had two bands all the time, and on Sundays there were sometimes three or four. Big bands are what I enjoy most; I'm strictly a big-band man. I still listen to them on the radio. I enjoyed Don Redman a great deal, and Chick Webb was very good, but to me he wasn't the best. During the years he played there, I think Benny Carter was the best. Yes, if you were there and really listened to Benny's music, well, I just thought he was the best. He was a great saxophone player. There was nobody who could touch him. The nearest thing to him to me was Willie Smith. Willie copied him, and Willie could play! But he wasn't Benny Carter. Benny had such beautiful ideas when he played. Gene Mikell [Jr.] could tell you this better than I. Benny used to study under Gene's father. I've heard Benny was one of the slowest students he had, but when he finally caught on, look what he did with it! He sure took it, believe me! I didn't study with Mr. Mikell but I was friendly with him and I used to visit him at his home.

H: In your opinion, why did the music scene in Harlem change?
G: There came a time when there was no place left to play. The people who used to sustain the places tapered off; they stopped coming. When Connie's Inn was running, and places like the

Cotton Club, the Savoy, the Renaissance, and all the others were running every night, there was a lot of music—Harlem was a club place. The Renaissance would run every night for six months with a different club every night, that's how many bands there were. One problem was that most of the other places had to depend on mostly the white people who came uptown. Of course, the young people went to the Savoy to dance— young people, white and black—but when the white people stopped coming uptown, it started going down. This is because the money just wasn't there. I don't know what made some of the places go down, because I wasn't there, I was out on the road. When I came back, I spent a lot of time playing with Latin bands, so I didn't play that often in Harlem. By the time I stopped playing in the mid-1950s, everything had just petered out.

Greely Walton, 1987

2 February 1987

Tommy Benford
(b. 1905)

Hank: When was the first time you played in Harlem?

Tommy: In 1917. I was brought up in an orphanage, the Jenkins Orphanage in South Carolina. We had a brass band and played all over the world. Sometimes we played concerts; other times we just played in the streets and passed a hat. We had to raise money to support the orphanage. I learned drums there; my brother, Bill, learned tuba—he was also in the band. I never saw my mother; my father and sister put us in the orphanage when we were very young, and I stayed there until I was about sixteen.

H: Did you visit Harlem every year?

T: Most of the time but, as I said, we played all over the world against some of the best bands—[John Philip] Sousa, Arthur Pryor. We played for the king and queen of England. We even got trapped in England during the war. We were stranded there in 1914, but we finally came back.

H: When you left the orphanage, what did you do?

T: First, I went to New York because I had some relatives there, but then I moved on to Chicago. I didn't start playing again until I got to Chicago and I played with some little bands there. I was playing in Chicago in 1921; I even heard King Oliver and Louis Armstrong. I only stayed in Chicago four or five months and then came back to New York at the end of the year. My brother and sister were with me.

H: Tell me about your first job uptown.

T: It was with a guy named Bob Fuller— he played clarinet—and it was at a spot on Seventh Avenue called the Garden of Joy. It was a kind of open-air dance hall, and all the dance freaks used to go there. They hadn't built the Savoy Ballroom in those days, and this was a place for the people who really wanted to dance. Eccentric dancers, people who wanted to be entertained. I heard some fine players there. Mamie Smith worked there; I heard Bubber Miley and Ward Pinkett. That was the first place I heard Benny Carter. He was just a kid, maybe a year or two younger than me, but I'll never forget one thing about him. He was living downtown in the sixties somewhere and he'd come up with his saxophone, and the first time I heard him play, he was wearing a rope around his neck to hold his horn. I'd never seen anything like that!

H: If the Garden of Joy was an outdoor dance hall, it must have closed in the winter.

Opposite:
Tommy Benford, 1986

T: I don't know, but I moved on to another dance hall with Bob Fuller, a place down on 125th Street between Lenox and Seventh Avenue.

H: Rose Danceland?
T: No, that was an upstairs place on the corner of 125th Street and Seventh Avenue. We went to a dance hall further in the block. I don't remember the name of it—it's over sixty years ago. I was working in there when Prohibition started. You could bring your own stuff, but they wouldn't let you get drunk. They were tough on you; they'd put you out in a minute.

H: You worked in many different bands in the 1920s. Tell me about some of the more enjoyable groups.
T: My brother, Bill, had a nice band. He'd taken over Charlie Skeets's band, and it was the same band Jelly Roll Morton used to make some of those Red Hot Peppers records. Jelly Roll never played with that band outside the recording studio but the band stayed together, and we played in dance halls all over the city, uptown and downtown. I've been in the business a long time, and I think I've probably played in every dance hall and club in this town—uptown and downtown, maybe in the Bronx and Brooklyn too—at least once or twice. I just worked with many different people over the years, and I played wherever they were booked to play.

H: Did you have a favorite club uptown?
T: I had no particular favorite; I played in them all, starting with the Garden of Joy through theaters like the Apollo and everything in between. The Alhambra, the Bamboo Inn, the Baby Grand, all those places. At one time or another I got to play with almost everybody—I was even with Duke Ellington for a month. The one guy

I never worked with was Cab Calloway. I just couldn't see that man. He wanted to tell me how to play my drums, and he didn't know anything about drumming. I used to tell the guys, "You guys are really suckers to let a man like that tell you what to do." I never could understand about Cab Calloway.

H: Did you ever visit Small's Paradise and listen to Charlie Johnson?
T: Sure, but I also worked at the first Small's, the one over on Fifth Avenue. Now that was a fine place. I remember they had dancing waiters, who were terrific, and a good band. June Clark led the band. He was a wonderful trumpet player, but he drank too much and practically killed himself. They had a stride pianist named Charlie Smith, who was very good. There were some good places on Fifth Avenue in those days; I remember I first heard Ethel Waters at one of them in the early 1920s. There was another place I used to visit on Fifth Avenue up at 135th Street. I remember they had terrific pianists. I don't remember its name.

H: Was it Leroy's?
T: Yeah, that's the place. I don't think it lasted very long; none of those early places lasted. Everything moved over to Lenox and Seventh Avenue.

H: Do you remember the last time you played in Harlem?
T: It was just a few years ago. I played for somebody at Small's, the one on Seventh Avenue. But I don't remember much about it.

H: Tell me about your favorite band to work with.
T: The one I'm in right now with Al Hall.

5 September 1986

Opposite: Tommy Benford, recording session at Downtown Sound, 1978

Doc Cheatham

(b. 1905)

Hank: *I want to talk about Harlem and your impressions of it, from when you first experienced it up until today.*
Doc: I'd been around a lot—all over the country and in Europe—before I spent any time in Harlem.

H: *What had you been doing in music just before you first arrived in Harlem?*
D: Well, I did play a night or two in New York very early on with Chick Webb. I think it was just a one-nighter in the mid-1920s, maybe about 1927 or so. He was just getting organized at the time. Freddie Jenkins was in the band and so was Johnny Hodges. He was getting this band together for a social club in a hotel. I don't remember too much about it. I just played with him for one night, and then Sam Wooding came into town and put out the word he needed a trumpet player. I originally planned to stay with Chick but when Sam offered me the spot in his band, I took it. I left with Sam and went to Europe. We traveled all over Europe for almost three years. It was a pretty good band for those days, and I enjoyed it. Since I was overseas, I missed what was going on in Harlem in the late 1920s.

H: *You were with Cab Calloway's band for many years. Did you join Cab when you returned from Europe?*
D: No, when I returned, the first band I joined was Marion Hardy's Alabamians. I played with this band in Chicago and New York. In fact, the first time I played uptown, in Harlem, was with Marion Hardy at Small's Paradise. This was probably about 1930, and I think that some of the players from this band wound up going with Cab a while later.

H: *What was Small's like when you played there in 1930?*
D: It was very different from the way it is today [1986]. It was well run, very clean, a first-class cabaret. Now it's just a bar—a dump, really. In those years they had chorus girls, a big revue. Ed Smalls, the owner, was always there and made sure the place was run right, and it had a mixed audience.

H: *Were there ever mixed audiences at the Cotton Club?*
D: Not in the early days, but sometime during Cab's run the policy started to change a little. I think Cab helped break down some of that prejudice, and so did Bill Robinson. He was always coming to the club.

Opposite:
Doc Cheatham, 1986

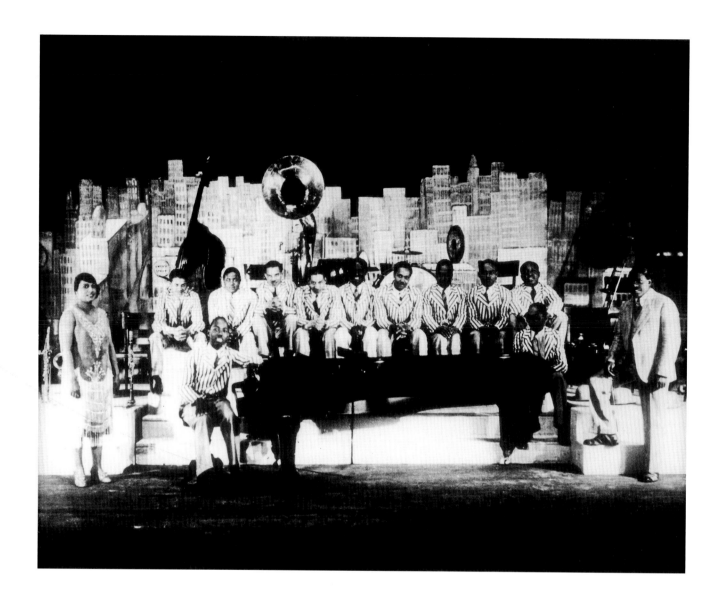

Doc Cheatham with Sam Wooding and His Orchestra, Schumann Theater, Frankfurt, Germany, 1928

H: Tell me about playing with Cab Calloway.

D: I loved that band. It was a wonderful organization. A first-class band in every way. And it was a hard band. By that I mean we worked hard and Cab demanded a lot of us. The best players, fine uniforms, always paid on time. You know the story about Cab having his own train when we were on the road?

H: Yes, I think everyone's heard about that, but maybe you could tell me what it was like playing a show with the Calloway band at the Cotton Club.

D: Oh! That was an experience. We started each show like it was the final number in a big revue, with all the singers and dancers on stage with Cab and the band. Everyone was on stage—all those beautiful girls on stage with the band. Lena Horne worked in the chorus for a while when she was attending Brooklyn High School. Everyone came out and did something, all at once; Cab was featured doing some solo thing and then in an ensemble number. There was no pause until everything was over. The singers, the dancers, everyone. Then when the opening was over we'd go into acts—the other singers, the dancers, the other soloists. Dancers like Bill Robinson, the Cotton Club Boys, Pete Pizzas and Paul Mills, the tap dancers. There were

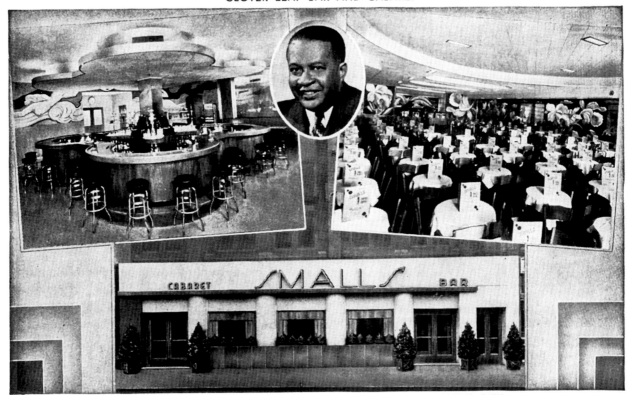

CLOVER LEAF BAR AND CABARET

SMALL'S PARADISE, 135th STREET and 7th AVE., NEW YORK CITY

singers like Adelaide Hall, Ada Ward, Anita Hill, and Catherine Perry—I think she was Earl Hines's first wife—people like that. I don't remember any men who were featured vocalists—that was left for Cab. He was the big star of the show, and each show would usually end with him singing about a dozen numbers. When he finished his last number, then everybody returned to the stage for a final production number that was even better than the opening. The whole thing took about two hours. It was a hard show. When we finished, we'd be off for about half an hour, maybe forty-five minutes, and then we did it all over again. It was over about four in the morning.

H: Then what happened?
D: Well, I didn't go hang out anywhere. I lived uptown and went home to get some sleep because I knew I was going to have to play in some theater or a benefit or some concert the next morning. When we were at the Cotton Club, we were also at a theater playing shows, and sometimes we'd have to start as early as nine in the morning—and not just in Harlem but downtown, or out in Jamaica, or out on Long Island somewhere. Sometimes there would be a movie at the theater and they showed the movie and then we'd play a show. Other times we'd be the show and they'd run some shorts after the band played and then we'd have to play again. Cab was so popular that the theater owners figured more people would come for Cab than a movie, so they just played shorts. If there were movies, we didn't have so many shows; if they just had shorts, we'd do seven or eight shows a day at the theater and then go to work at the Cotton Club that night. Oh, we worked so hard. Some of the theaters kept iron cots in the basement so we could rest between shows when they

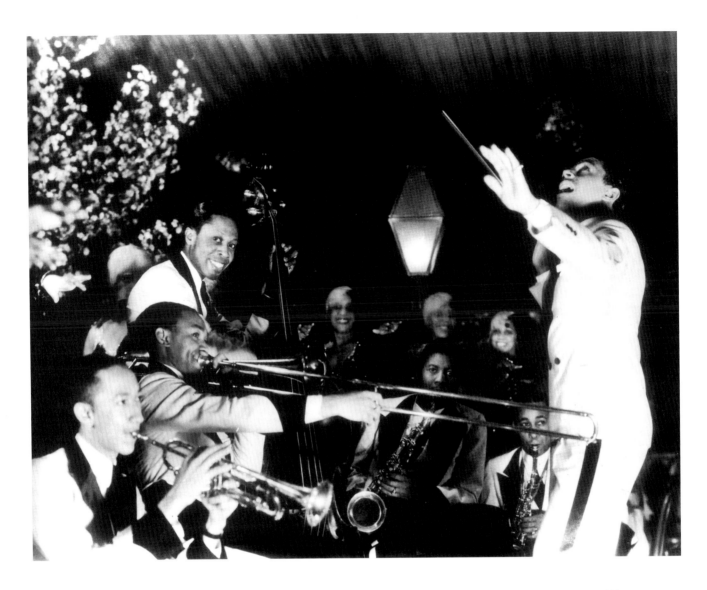

Doc Cheatham with Cab
Calloway and His Orchestra
at the Cotton Club, 1932

were playing the movie. Cab's was a hard band.

H: Was it always like this for nine years with Cab, or were there some things that were out of the ordinary?
D: Oh, yes, we did some unusual concerts. Sometimes we played for some of the people who were associated with the Cotton Club. The concerts were held at Sing Sing prison. The boss or the bosses had been sent to jail, so we went up there and played a concert to entertain him. It seems when we weren't at the Cotton Club or in a theater, we were on a bus going to play a concert for a politician or a gangster. Or a benefit for someone. We played a lot of benefits. Sometimes we'd be coming back from

a concert or a benefit and still have our uniforms on, jump right off the bus, and jump right onstage.

H: Am I safe to say it was a relief to go on the road?
D: It was so much easier. It might not have been easier for some bands, but it was much easier for me. I looked forward to it.

H: Of course, Cab was right there, working with you just as hard, maybe harder. I once asked him how he did it and he just shook his head and said he doesn't know, he just did it.
D: That's right! That's right! We just did it. It was hard work. We were well paid and we did it night after night. We even could

bank some money. We didn't have any chance to spend any of it. You know, all that extra work I was talking about—we got paid for everything we did. But it was easier when we were on the road because we didn't have to play the Cotton Club show. You know that these were shows that were written for us with set numbers, and sometimes when we were playing theaters during the day we'd play a lot of the Cotton Club numbers; we might even have some of the singers and dancers with us. It was like an advertisement for the show. When we were on the road playing one-nighters, we just played for dances, and that was a lot easier.

Sometimes I don't know how I did it. I guess I could do it because I always got some sleep. I enjoy sleeping.

H: Have you seen Cab recently?
D: Oh, yes, I worked with him in England a short while ago. We did a television show. It was a Cotton Club show at the Ritz in London. They put together a band of English musicians. They may have been good players but they didn't want to rehearse very much, and they were always drinking a lot of beer and stuff when they weren't playing. They hired me because someone told them I was the oldest living trumpet player who had

Doc Cheatham with Cab Calloway, Van Gelder recording studio, 1990

Doc Cheatham, Floating Jazz Festival, 1985

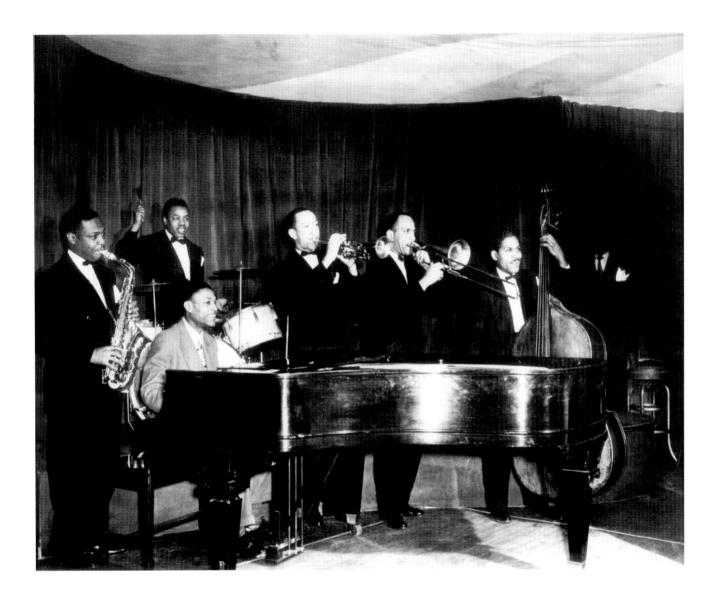

played at the Cotton Club. They asked me to play with the band so I sat in for one song, but they hadn't rehearsed enough. They were bad, and Cab had a fit. He came up to me and asked me what kind of band I had, and I said I had nothing to do with the band, that they wouldn't rehearse. He was mad. It wasn't a very good show, but I had nothing to do with it. Cab was so mad, he wouldn't let me explain anything to him.

H: When you left Cab in the late 1940s, what was your next stop?
D: I had a little time off, but then I went with Teddy Wilson's big band. It was a wonderful band and, except for a few things and the time I spent with Latin

bands in the 1950s, playing with Teddy was about the last time I played regularly in Harlem.

H: Where did the Teddy Wilson Orchestra work uptown?
D: The main place we played was the Golden Gate Ballroom. He was the house band there for a while. It was a very nice place, well run by a man named Jay Faggen, and was located at Lenox Avenue and 142nd Street. The people who owned it tried to build it up, but they couldn't. We never had a full house up there. They tried to run it right, but they couldn't compete with the Savoy. They even had two bandstands right next to each other, and there were always two bands

Doc Cheatham with Eddie Heywood's Orchestra, Café Society, 1944

booked. We worked opposite Andy Kirk
and Coleman Hawkins. We had battles
of the bands, but I don't think anybody
really won the battles because all the
bands were so good. I just remember the
Golden Gate only lasted about a year or
so. They couldn't compete. I think the
people from the Savoy bought them out
and closed the place down. The Savoy
didn't want Teddy Wilson's band, which
was more sophisticated; they wanted a
jitterbug band like the Savoy Sultans
or Lucky Millinder.

*H: Tell me about Teddy's big
band. I've heard the records and
it sounded terrific.*
D: I think the band was a little
too good, and it got very little
recognition. It was the most musical
band I ever played in. Cab's band was
great; he had terrific players—Chu

Berry, Ben Webster, Milt Hinton,
people like that—but the band was all
Cab. That's what the people came to
hear. With Teddy Wilson it was more a
musical band, the only band I was ever
with where everyone worked together,
everyone played with the same quality
with good singers and nice arrangements.
They didn't do that very much then and
they never do it now. It's too bad it lasted
for such a short time.

*H: You played with some fine bands
in Harlem in those days, but of all the
bands you heard uptown, which one was
your favorite?*
D: I didn't have a lot of time to listen
to the other bands, but when I did I
liked Chick Webb better than any of the
others. Chick created a lot of things, like
drummers playing the same licks as brass
players. He was always doing something

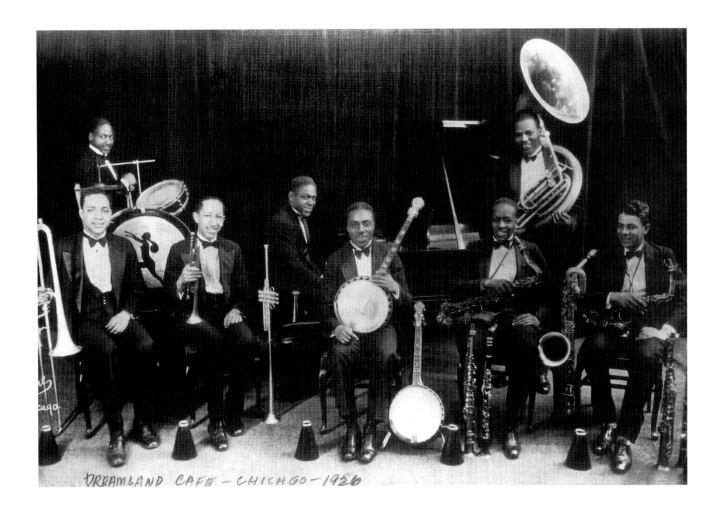

DREAMLAND CAFE — CHICAGO — 1926

new, something great that made his band sound terrific. All the figures that drummers play today, he started them. And his drumming could drive his band. No other band was like that, sometimes smooth but always driving. He created the style of drumming that's being played today, and it made his band sound like no one else. Chick was what made his band sound so good. After he died and Ella took over, it was a nice band but it wasn't the same.

H: Did you play with any other bands uptown after you left Teddy Wilson?
D: Oh, yes, there were some others, but just for a short while. I was with Benny Carter's band in 1941 and with Fletcher Henderson a little later. Fletcher was taking a band into the Savoy, and I was part of that. It was about the last band

Fletcher had before he became ill. I also played with Teddy Hill at the Apollo. We just played the regular shows—the comedians and the dancers. They had dressing rooms at the Apollo, but we didn't have much time to dress. A lot of the guys shot craps in the basement; they even brought in outside shooters to run the games down there.

H: Tell me about the nightlife in Harlem in those days—the after-hours places and the jam sessions.
D: I never had the time to hang out, to go and sit in. I just never had the time. I was tired. I was always the lead trumpet player in the band, did all the lead parts, and after that I was tired. I wanted to get some sleep, so I didn't hang out at all. I would go by those after-hours joints and peep in sometimes, but I knew if I

Doc Cheatham's Orchestra, Dreamland Café, Chicago, 1926

went in the door I'd have to drink, and I wasn't drinking. That's all they did in those places, drink and play. Sometimes they wouldn't even let you out; they'd keep you there drinking and playing until daylight. Forget about that. I had a hard job to do every day.

H: Tell me about the Latin bands you played with uptown.
D: That was in the 1950s. I was with Machito for a few years, and I also played with Prez Prado. I played with Machito at the Savoy Ballroom. That was really the last time I played in Harlem. He had a wonderful band and I enjoyed it. There was a lot of vitality in his music, and that kind of music is still the same today. It doesn't change very much—all the same songs. Maybe the arrangements are a little more modern, but that's about all.

H: Do you ever go uptown these days?
D: No. I lived there many years ago, on 145th Street, but today I live just where Spanish Harlem begins. Harlem is awful today, and I don't think it will ever come back. Everything's torn down. I'll never see any of it again. It just fell apart.

H: Did you see this happening?
D: Yes, after the war. That's when it started. The big bands started disbanding—one, two, three, one after another. And then the ballrooms and places where people danced started closing, and when they closed, a lot of little places around them also closed. Pretty soon there was no place to listen to music, no place to dance. People started to go downtown more, bebop started to come in, people went to places

like Birdland. A lot of people went to Birdland to see what it was all about. Some of the kids didn't like what they heard down there; they couldn't dance to it. The bands stopped going out on the road because all the ballrooms around the country were closing. It seems like it all happened about the same time, and then the music was gone uptown.

H: Was there anything else that helped kill the music in Harlem?
D: I think something else that killed the music uptown was the same thing that wiped it out in Chicago. When they got rid of the mobs, the music was hurt because they had all the money. It you wanted to put on a show at the Cotton Club or Connie's Inn, it took a lot of money. No owner could afford to have shows like that unless the places were run by the mob—people who had money, people who had their own whiskey and beer, that kind of thing. When the mob was gone, so were those big clubs and most of the little clubs. The Hot-Cha, the Big Apple, places like that. Some hung on for a while, like Dicky Wells's after-hours spot, but pretty soon they were all gone.

H: Small's is the last place, it seems.
D: Yes, but it's not the same Small's, and they only have music once a week. Al Cobbs plays in there with a band, but I've never been up there to see it. I don't have time—I'm playing all the time, and I like my sleep. I never did hang out, drinking and talking. I just wasn't strong enough. I went home and went to bed because I knew I had a job to play the next day.

18 September 1986

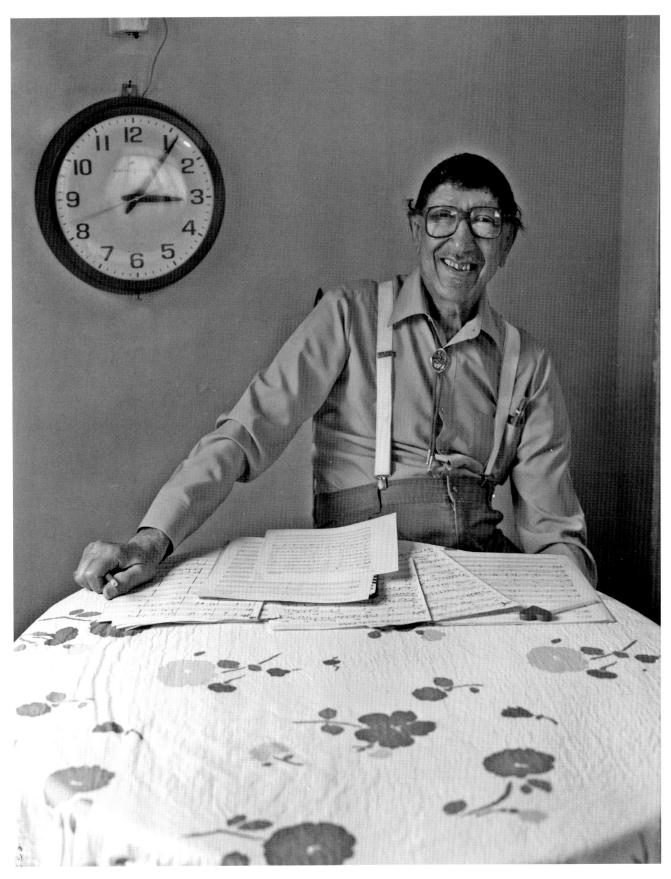

Doc Cheatham, 1986

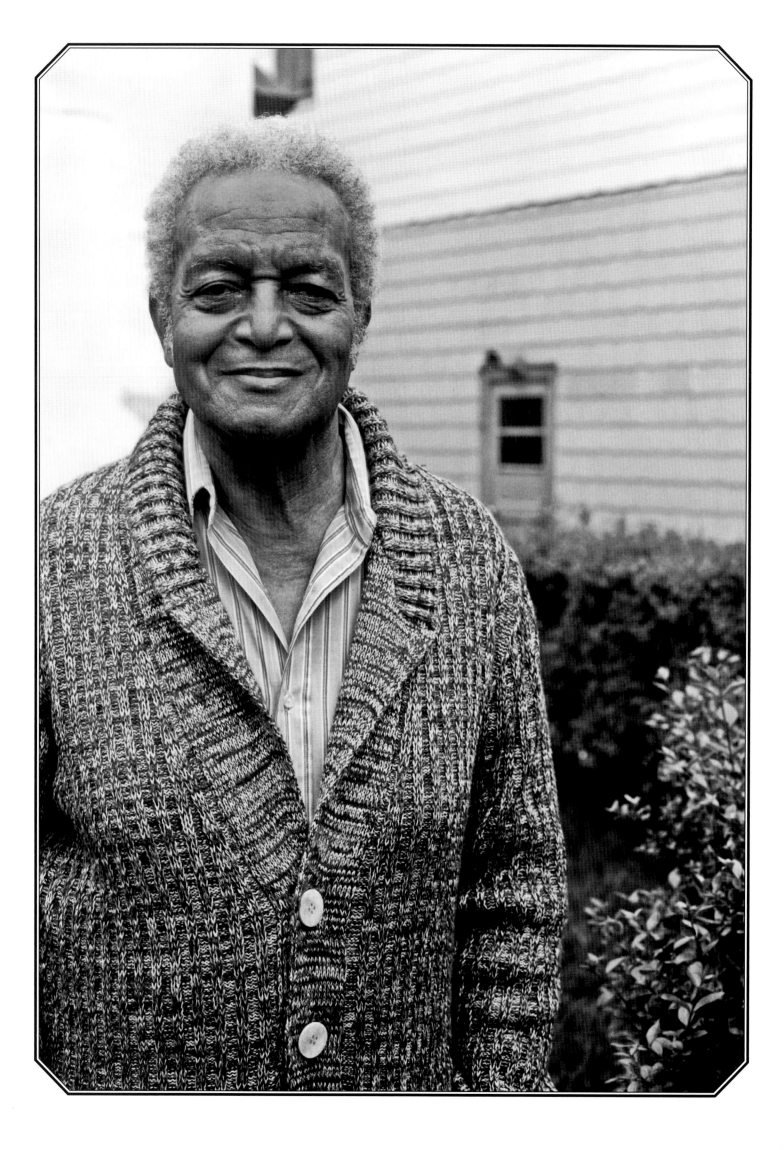

Gene Prince

(b. 1905)

Gene: I was born February 1, 1905, and was mostly raised in St. Joseph, Missouri. Coleman Hawkins was from St. Joseph, he was maybe a year older than I and we went to the same school. I knew him from about the age of nine or ten. St. Joseph didn't have many black people in it, and the schools were separate. We had a little school band—Coleman and one of the mathematics teachers and a couple of other teachers were in it, and a few other kids. Coleman was playing a little saxophone, but I seem to remember his first instrument was cello. There was a lot of music in St. Joseph. There was a coronet player who used to come to church and play solos, and then there was a man who came through St. Joseph wanting to teach violin. He went around to different families trying to get the children to take up the violin. I said I want to play the violin, but my mother went to this cornet player and told him I wanted to play an instrument, and naturally he told her I should play cornet. He told her I could fit into any band with a cornet. About the same time, Coleman Hawkins got a saxophone, which was a new thing to me. I'd never heard of a saxophone until he got one. Another fellow there was named Matthew Dennis; he was also a fine violinist. The music teacher at the school lived in the Hawkins's house—they rented her a room—and she's the one who gave him his first lessons. He and some of the other fellows used to play dances in another part of town, but my father wouldn't let me go there, so I never played with him. I only played little school functions like graduations and with the ROTC band. I played mellophone the first year and then played trumpet the next. When I was in the eleventh grade, Mamie Smith came to town and sang in a big auditorium. All the kids went to see her, including Coleman Hawkins, and she took him away with her and I never saw him again until years and years and years later. In fact, the next time I saw him was in Kansas City, playing with McKinney's Cotton Pickers. I rarely ever saw him after that; I never ran into him in New York.

Hank: *When did you leave St. Joseph?*
G: I came to Washington, D.C., in the early 1920s and went to Howard University, which is where I began playing regularly. I got to know a lot of musicians from Washington. One of my best friends was Harry White, a trombone player, who played with quite a few bands like Cab Calloway and

Opposite:
Gene Prince, 1987

the Mills Blue Rhythm Band. In those days he was playing in a little band in Washington called the White Brothers. Arthur Whetsol played with this band and so did Harry's brothers and cousins. Duke Ellington hired Arthur away, but I started playing in this band while I was still at Howard, when I was still learning how to play jazz. I was also working in little nightclubs in Washington; I remember a little speakeasy, Louis Thomas's place, where two schoolmates and I got a job. I was going to school but I'd also work in that speakeasy until three o'clock in the morning, but I mainly worked with the White Brothers. Harry and his brothers were from Bethlehem, Pennsylvania, and they had a wonderful little band. They all learned more than one instrument. One of the brothers [Willie] played saxophone and trumpet. Harry, who was my friend, played trombone and saxophone, and another brother [Eddie] was the piano player. There was a banjo player and a drummer named Tony Miles. We played all the proms at the school and dances at the fraternities and sororities. In fact, we played a lot of nice functions in Washington and then toured a little. We went to Atlantic City and then to Philadelphia and Saratoga. I just kept playing after the summer and finally just eased out of school. I didn't have any clear idea of what I wanted to pursue in college. I knew I didn't like cutting up animals in class, but I liked music so much and I began to play more and more.

H: When did you first play in New York City?
G: It was with Andy Kirk at Roseland, in late 1929, near the end of the year, I think, and we played at Roseland.

H: How did you manage to hook up with Andy Kirk?
G: I had spent some time in Denver after I left Howard and played in a band led by a violinist named George Morrison. We even toured a little around the Midwest. The band that I later joined led by Andy Kirk had originally been led by a man named Terrence Holder, but Kirk took it over from Holder. He'd been voted in; it was a cooperative band. Everybody in the band had to vote on everything. I was in Texas when they called me; I was recommended by the saxophone player Johnny Harrington. I joined the Kirk band in Oklahoma City. We also played in Tulsa and were so successful a scout from Kansas City heard about us and wanted the band to come to Kansas City to record and play in a new ballroom. We got to make the record but never did play in the ballroom. There was some kind of union trouble about us playing in Oklahoma City, Tulsa, and Kansas City. A few months later we came to New York. At that time Fletcher Henderson was the only black band that played at Roseland. We were very popular—played there about three or four months. The management wanted to keep us over the summer but some of the guys didn't like New York; they were lonesome for Kansas City. This was still a cooperative band and since management didn't want to keep us at the same salary, some of the guys went back to Kansas City. I stayed here and went from band to band. I played in so many different bands. That's why I'm not on so many records—I just jumped from band to band and then finally joined up with Fess Williams.

H: Was he really as terrible a player as he sounds on records?
G: He was awful. You'd sit up on the stand and you'd be embarrassed all night long. What he did on that clarinet! He

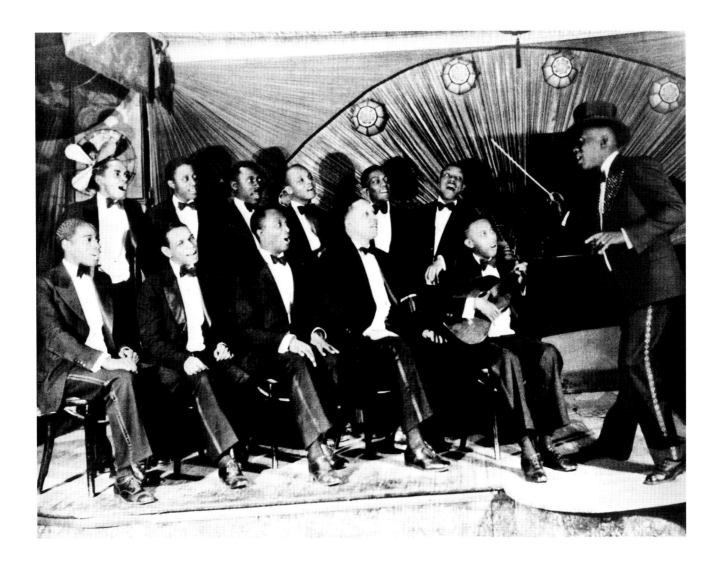

chirped like a bird. When I was with him, he decided to reorganize the band, so he got Benny Carter to write some things for him. They were good arrangements, but he didn't play the arrangements. He'd be up there in front of the band and always take two or three solos on his clarinet and ruin everything. He was always out in front of the band playing, and it was terrible. It didn't matter who wrote the arrangements. Fess was very liberal. He paid us a salary—we'd go out on the road and play three nights in New England or Pennsylvania and come back to New York, still on salary. That's one of the nice things about him. I suppose Fess wanted to be the black Ted Lewis. The most embarrassing thing about it was what you had to wear in that band. We had

purple uniforms with rhinestones down the side, lapels with rhinestones, and Fess wore a coat covered with rhinestones and a top hat, like Ted Lewis. I suppose he just wanted to be different. He was very, very different. At that time Fess was at his peak and had gone about as far as you could go as a black bandleader. When I joined him, he'd been the best seller of all the Victor artists on records, except for some classical people, but he was no longer recording for them. He played the Regal Theater in Chicago and the Savoy Ballroom in New York. Fess was one of the first bands to play at the Savoy. Sometimes he'd go to Chicago alone and leave the band in New York under the leadership of Jelly James, the trombonist. He had another band in Chicago. I

Gene Prince with Fess Williams and His Orchestra, **1930**

usually just played in the New York band but I traveled to Chicago a few times. I liked Jelly James and enjoyed the band when he was the leader. Fess Williams thought he was so big, he decided to book himself.

When I joined him, as I said, he'd just left Victor but he had three big cars—a Pierce Arrow, a Packard, and some other big car. He could take the whole band around in those cars. He was very popular in New England and Pennsylvania, over in the coal-mining section— he was king over there. Even as late as 1935, when I came back to New York from out west, I met him on the street one day and he said, "You're just the guy I'm looking for. I'm going up to Boston if you want to go." We went up there and they were still crazy about him then. He had his clientele, the people loved him, and he made a lot of money. I still don't know what it was people liked about Fess. He was an entertainer; he used to do little skits with Stoney, a little bald-headed guy that played saxophone in the band—he was a regular comedian. In fact, he had me doing a skit one time out in Chicago. My song was "I'm a Big Man from the South with a Big Cigar in My Mouth." I only did it once or twice. I had a lot of fun with him. He was quite big.

H: Would he wear those purple rhinestone outfits in the Savoy?
G: Oh, yes! They loved him there too. Fess was still playing old-fashioned music, almost what you might call ragtime, but he was so popular he could get away with almost anything. Fess never changed, and as the other bands came in, they passed him by. I only stayed with him about a year, but I don't think he kept that band going for too much longer on a regular basis, on salary. Williams kept doing the same thing over and over, and time was passing by.

H: Tell me about Jelly James; I've never spoken with anyone who knew him.
G: We were good friends. I wasn't married yet and neither was Jelly. When we'd go out with Fess on the road and play three or four days and we'd come back, we didn't have anything to do. So we'd go down to the gin mill, down to Pete's, and drink top and bottom. That was a ball.

H: What's top and bottom?
G: Top and bottom was bad whiskey— one-half wine and one-half whiskey. Bad wine and home brew. I drank so much whiskey, and I've had so many buddies who turned out to be really bad, so far as whiskey is concerned, I don't know how I managed. During the time of the Prohibition, top and bottom was the thing. You know, you go into Pete's and order a top and bottom because it was so strong. Homemade corn whiskey that tasted so bad you had to have something to make the bad taste go away. So you put wine with it. If you didn't have any wine, you put salt on the back of your hand and you'd lick it, use it as a chaser for that bad corn whiskey. Jelly and I were buddies in the band until Fess just messed himself up with that ancient music. I remember one time when Fess got involved with a man from France who wanted to put on a show. This guy was some kind of an angel who was behind Fess, and his idea was to make a little theatrical play with animals. He dressed the band up in monkey suits. There were three boys, dancers, who used to do somersaults over chairs—two chairs, then three chairs, then four chairs, things like that. They were very good acrobatic dancers, and it must have been

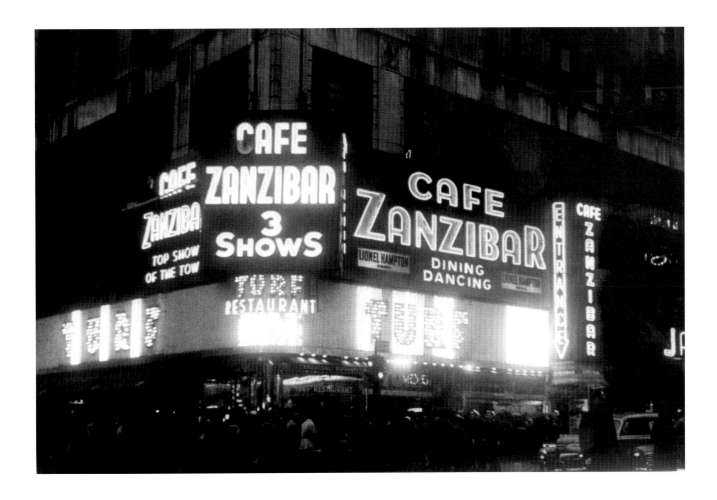

hard because they were dressed as tigers. Shelton Brooks, who was the composer of "Some of These Days," was a lion, I believe.

H: Was he part of the band?
G: No, he was an actor and a songwriter. There was a woman who was featured, and she was a lioness. And there were three girls, a trio, who sang beautiful, dressed as animals. Everybody was an animal, and we did this show all over the New York circuit. The man from France spent all this money to make these costumes and get the show together, and just as we were getting ready to go to France, he pulled out. Then we jumped out to Chicago where Fess had been so popular; the same guy from France was backing him but now the people were ready to hoot at him. We jumped to Kansas City, and there were more

people on the stage than in the audience. There I was, back in Kansas City, and we were stranded. I went back to Chicago; I was married by then and my wife was in Chicago. I didn't come back to New York until 1935, when I was part of a band Louis Armstrong had put together in Chicago. We played around the world: the four theaters—Philadelphia, Washington, Baltimore, and New York. We played the Apollo, my first time there, and then Joe Glaser wanted to book the band at a club downtown but the New York union wouldn't let us play because we were a Chicago band. We all got our salary, but most of the band went on back to Chicago. I stayed here along with a saxophone player named Scoville Brown and the piano player, but he finally went back as well. I stayed in New York and played with different bands, like Willie Bryant. I was back with Louis Armstrong

The Café Zanzibar on Broadway, 1945

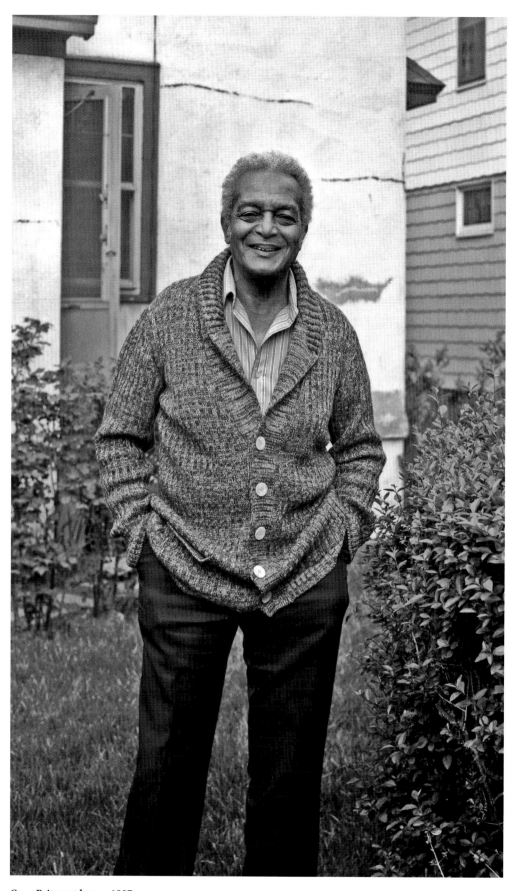

Gene Prince at home, 1987

in 1941 but that's when I started to get sick, just at the beginning of the war. We were out on the road in the Midwest and I don't know how I made it. We came back and went into the Apollo but I only lasted one week. I went into the hospital and stayed twenty-two months. I lost two years of music, and thing really began to change while I was away. I knew Dizzy Gillespie because he used to come up and sit in with Willie Bryant's band while I was there. He was playing with Teddy Hill when I was with Willie, and sometimes both bands would be at the Savoy. He'd sit in with us during intermission. Dizzy and Willie were both after the same girl, as I recall. I wasn't so active in music when I came out of the hospital. I took a few jobs but while I was in the hospital all that time, I began studying electronics. My last job was at the Zanzibar in 1946 or 1947. I left music and worked in electronics—radio and television.

H: You left music before the uptown music scene failed, and I'm sure you have wonderful memories of it. Which was your favorite big band?
G: Chick Webb, without a question. When he was playing the right music, he was the best. He had such marvelous players. How I loved Hilton Jefferson! I also enjoyed Claude Hopkins. He played downtown at Roseland. Chick was usually always at the Savoy. They were such wonderful ballrooms. I swear, you could stand in the middle of the Savoy or Roseland and close your eyes and you couldn't tell where you were. The music sounded so good in those ballrooms, but Chick Webb's band had the best sound I ever heard. I even tried to listen to them on the radio—they'd make half-hour broadcasts from the Savoy—but I don't think they ever got a full-time sponsor.

18 May 1987

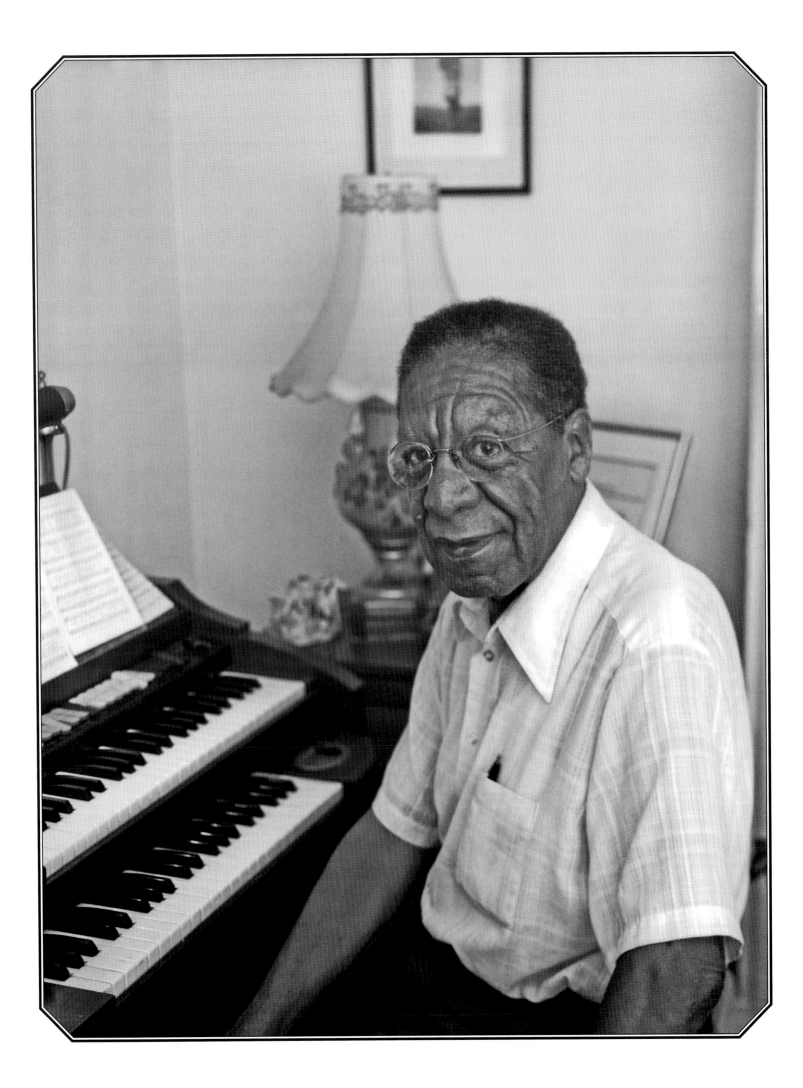

Ovie Alston

(b. 1906)

Hank: *When and where did you first start playing trumpet?*
Ovie: Right here in Washington in 1922 or 1923. I went to New York in 1926 with Billy Taylor [the bassist]; we were the same age and used to work together. Rex Stewart called Billy and said we should come to New York. We were all young men in our early twenties and thought we could do anything. Billy left town first and then a month or two later he called and said I should join him. I did and we got jobs right away because we were fairly good in our trade. We could read and we could play. I played with local bands led by people like Charlie Skeets and Johnny Montagu and then hooked up with Arthur Gibbs for a while. I played in some dance halls downtown—I remember one was called the Star Ballroom. Andy Kirk was in the band. We both hated it and said we'd never set foot in that place again, and neither one of us ever did. Later, when he had his own band, it was one of the best there was, so smooth. I loved Andy's band. By 1929 I was with Bill Brown and His Brownies. He was a good trombone player and a nice guy, a few years older than I was. John Kirby was in that band, and we even made some records. They were my first and I sang on one of them. Sometimes I sang with the band. I stayed with Brown until Claude Hopkins called for me. He was from across the river, over in Alexandria, and he'd gone to New York before me and was already well established when I came to town. I must have joined Claude about 1930 or 1931.

H: *Do you remember the first places you worked in Harlem?*
O: The first places we worked were at the Alhambra Ballroom and then, a little later, the Savoy Ballroom. Then the Roseland sent for us and asked us to make an audition in 1931. They liked the band; it was just eleven pieces with a vocalist, but we were very good and they liked us. We went into Roseland and stayed four or five years and made records for Columbia and Brunswick. This was late 1931, and then we became very popular in 1932.

H: *You recorded a good deal with Claude as I recall.*
O: Yes, we made "(I Would Do) Anything for You" at the first session, and from that point on Claude was gone. I sang a song on that first date, "How'm I Doin'?"

Opposite:
Ovie Alston, 1987

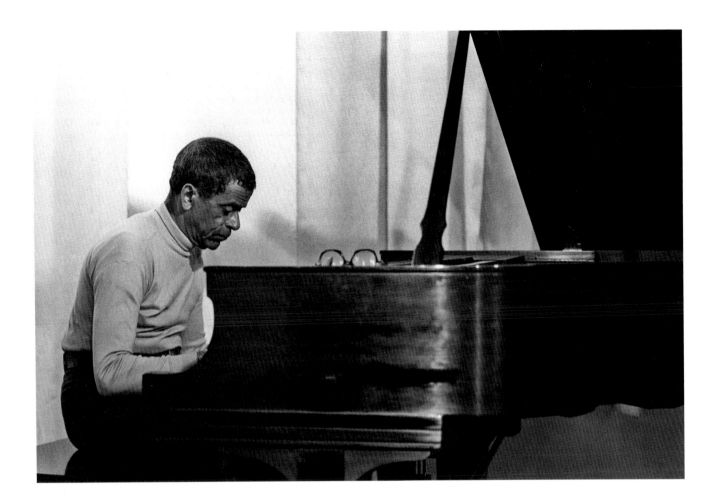

Claude Hopkins, recording session at WARP studio, 1972

H: Were you a featured vocalist with the band?

O: Yes, I started out as a first trumpet player but then switched to hot trumpet and novelty vocal. The sweet vocalist with the band was Orlando Roberson. Those were good days. It seemed every night was just like a one-night stand, we were so popular. We might go out on a short tour but then we'd be right back at Roseland; when we did a summer tour, they'd have us back in when we got back. I left Claude in 1936 and put my own band together, a small band about the same size as Claude's first band. There were no hard feelings with Claude about my leaving; when I made my first records for Vocalion a few years later, Claude was on piano for some of them. There were a couple of guys from Claude's band that went with me into my group.

H: Did you ever play in Harlem with your band?

O: Not very much, but one of my first jobs with the band was at the Apollo Theater. You see, Claude was out on tour and Roseland liked the sound we had, so I went into Roseland with the band and stayed almost five years. When the war broke out, I did a lot of USO camp shows. When I went out, I had nine or eleven pieces, alternating with a big featured band that would have seventeen or eighteen pieces. When I came back from the USO tours, I went back into Roseland for four or five more years, until about 1947, but with a smaller group, maybe eight or nine men. We played opposite all the best big bands—Harry James, Tommy Dorsey, Woody Herman, Joe Venuti— everybody came into Roseland at one time or another.

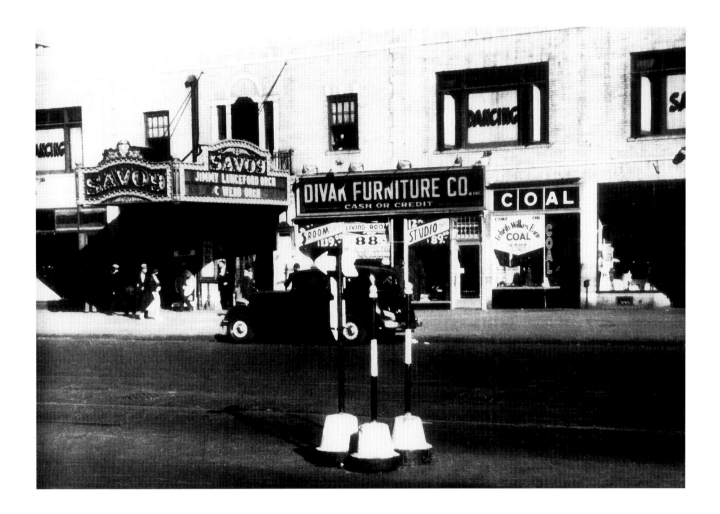

H: During your early days at Roseland with Claude, did you ever play opposite Count Basie?

O: I first met Basie in Kansas City when Claude's band was on tour. It was about 5:30 in the morning when we got to town; all those guys were in the street waiting for us. Claude's band was hot, and they wanted to meet us. Basie had just taken over the band in Kansas City and most of his guys hung out with us for the whole weekend. A couple of years later they came to New York, came into Roseland, and made some records. Their records were jumping!

H: It seems you didn't play much uptown.

O: Not as much as downtown, but with Claude we sometimes played the Savoy, and it was wonderful. When Claude's band went into the Cotton Club in 1934 and 1935, we were uptown all the time.

H: Give me some of your memories of the Savoy. When you weren't playing somewhere else, did you ever go there to dance or listen to the other bands?

O: No, we never had that much of a break. I wasn't interested in hanging out, but sometimes when we were off, I'd go to the Savoy just to dance.

H: Who were your favorite bands?

O: I liked Erskine [Hawkins] and Chick [Webb], but I also enjoyed the Savoy Sultans. They stayed there a long time. You know, when I first came to New York, Fess Williams was tops in the Savoy. He had the Savoy like that! He wasn't much of a player, but he had something the people liked—he was a show. I

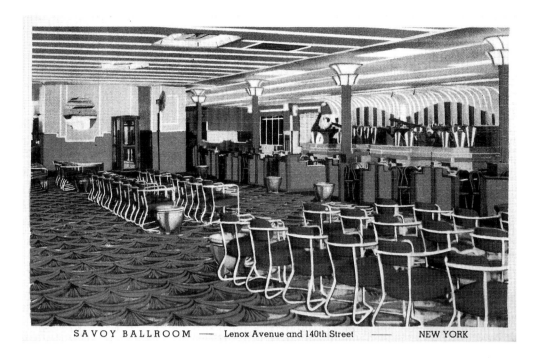

SAVOY BALLROOM —— Lenox Avenue and 140th Street —— NEW YORK

remember one time when he played the Savoy Sultans down to *nothing*. When he played that day, all you could hear were the feet. He had some beat, and the band had a lot of showmanship. He could get the people right in that mood; then he would soften it down and ask them, "You got it? Keep it, now! While you got it, hold it right there!" Then you'd just hear feet. Boy, he'd tear it up. He'd do it with a tune like "Four or Five Times," songs like that. When a good band was playing, that floor used to rock. I used to think it would rock up and down like ten or twelve inches. I always thought the floor would fall into the stores underneath—merchant stores, furniture stores, dress stores, candy stores. You know, the Savoy took the whole block. But it never did fall, and people came from everywhere to dance at the Savoy—from New Jersey, the Bronx, and Brooklyn. After Ella [Fitzgerald] made "A-Tisket, A-Tasket," the place would be packed. After Hawk made "Tuxedo Junction," it was jammed for him.

H: Tell me about working at the Cotton Club with Claude.

O: As I recall, we were uptown at the Cotton Club off and on for almost two years. It was the real thing! The Cotton Club was Cab's [Calloway] home, but when he went out on the road, we came in. If you saw the picture, you knew what the place looked like—it was a replica. The tables used to sit around the dance floor; you could almost put your elbow on the floor, but you knew you shouldn't do that. They had big lampposts and a log cabin effect all around the windows. The tables around the windows were elevated so everyone could see, and there was red carpet everywhere. The movie was very accurate about the look, except they said the Savoy was in the next block. That wasn't so; the Savoy was two blocks away. Of course, the gangsters didn't act that way. They had plenty of money and pretty women, but they weren't at ringside; they were back in the corner and you never knew they were there. By the time Claude's band played at the Cotton Club, there was some integration. I remember Joe Louis coming in after he

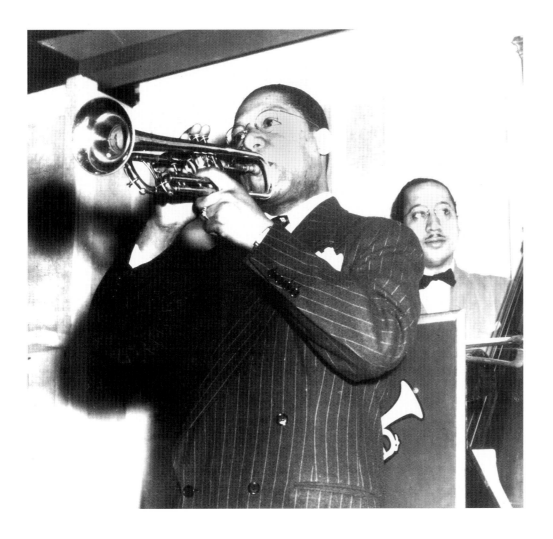

beat Max Baer, and Fats Waller used to come in with big parties. When Claude closed at the Cotton Club, I put my own band together.

H: Then you were at Roseland for over ten years. What happened after that?
O: About that time I went back to Harlem with a small group in the late 1940s and early 1950s and played regularly at the Baby Grand on 125th Street. I lived out on Long Island in those days, but I'd go back and play at the club when I wasn't working on Long Island. Sometimes my daughter would even sing with my band, but then I began to cut back and by 1960 I wasn't playing very much at all. I'd taken an examination with the Department of Public Works, and I became a drawbridge operator. I worked at night and opened a bridge for about

fifteen years. I was always good with mechanical things, so I didn't have any trouble passing the test. I also studied electronics and am pretty good at that. I left that job in 1971—I was sixty-five—and moved back to Washington, D.C.

H: I lived in Washington until 1967. Did you work at music in the city when you moved back?
O: No, but people started calling me when the word got around that I was in town. They said I could get work over on Wisconsin Avenue in Georgetown, but I didn't have any interest in that. Too much smoke and whiskey. I didn't even go over there to listen to them play. I haven't touched my trumpet in years; my lip is soft.

30 July 1987

Ovie Alston at the Roseland Ballroom, 1940

Eddie Durham
(b. 1906)

Hank: *When did you first come to New York?*

Eddie: I was here in the mid-1920s. I came with the Miller Brothers 101 Wild West Circus, and they played in a large baseball stadium. When we left, they tore it down. They had two minstrel bands with the circus and I played with one of them. It was a lot of fun for a kid, and I got to meet all the cowboys and Indians—Chief White Horse, Chief White Cloud—I remember all those guys. The band was scheduled to go to Europe, but I was young and didn't want to go and stayed behind. Edgar Battle was also in the show and he didn't want to go either, so I hooked up with him; he had a band called the Dixie Ramblers. I mostly toured around the Midwest, spent some years with Bennie Moten. I didn't come back to New York regularly until about 1934 or early 1935.

H: *Why did you come back?*

E: Willie Bryant asked me to come to New York and join his band. I was in Kansas City then but he wanted me to write arrangements and play in the band. He sent me seventy-five dollars to make the trip and told me he was playing at Connie's Inn. I think he'd heard about me because Battle was already in the band. I didn't get to play much with the band because an 802 [union] delegate stopped me and said I couldn't play because I didn't have a card. So I wrote arrangements and hung out with the band. Sometimes I played a little guitar or, if Teddy Wilson was late, I sat in on piano—and Teddy was always late.

H: *Did you ever play regularly with the band?*

E: Not too much. I was on a couple of records, that's about all. Most of my playing was just sitting in with the band or gigging at joints and rent parties, you know, pay fifty cents at the door places. I stayed with Bryant about six months and then moved on.

H: *When did you join Jimmy Lunceford and how did it come about?*

E: I joined Lunceford in 1935; I knew some guys in the band—two trumpet players, Eddie Tompkins and Paul Webster. We'd all been in Bennie Moten's band together; we were sort of a clique. They wanted me to come out and join the band in Buffalo, but I told them I'd wait until they got back to New York City so I could check them out. I wanted to see what kind of a band it was before I joined up.

Opposite:

Eddie Durham, 1987

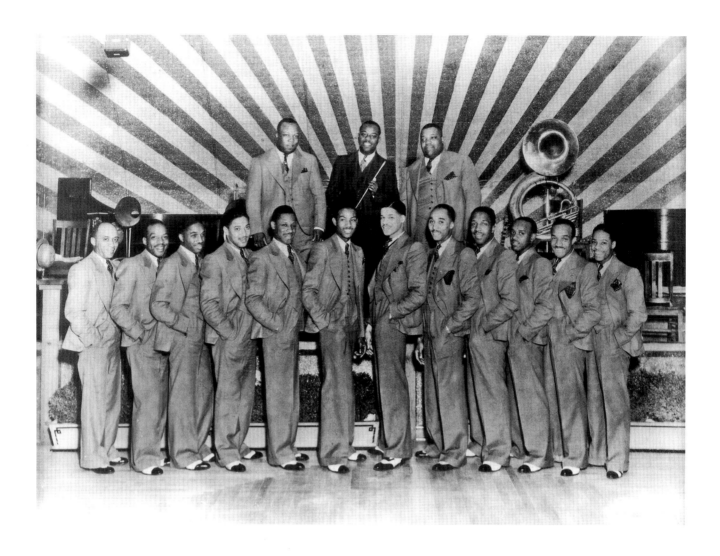

Eddie Durham with Bennie
Moten and His Orchestra,
Fairyland Park, Kansas
City, 1931

*H: You must have liked what you heard,
because you stayed with the band a few
years.*

E: I waited until I could check them out.
They didn't even know I was there—I
hid in the back behind a curtain at the
Apollo. I liked what I heard, and three
days later I was with the band. I liked
that show business angle. I think a band
should be able to entertain, and the
Lunceford band did a lot of different
things. He had a trio that sang real nice,
and different guys in the band sang—Dan
Grissom and Sy Oliver both sang with
the band. Then he had the Shim-Sham-
Shimmy Boys; they were named after
the dance, but they were just guys in the
band. First they'd play and then about six
guys would come out, dance around, then
jump offstage and run all around and

tear up the house. As soon as that's over,
there was a glee club. The whole band
was in that. Then Willie Smith would
sing "Rhythm Is Our Business," and we
all did things behind him while he was
singing. The band also did imitations
of people who were hot; sometimes we
did it with the curtain closed in front of
us—we might play like Guy Lombardo
or Louis Armstrong. Lombardo played
with that big vibrato and we could imitate
it. I taught a lot of tricks to the other
trombones in the band, Russell [Bowles]
and Elmer [Crumbley]. Sometimes when
the band was playing, Russell and I would
jump out of our chairs and get in a sword
fight with our trombones. I'd pretend to
cut him and then jump off the stage while
the band was playing. We were a regular
clown outfit, but then the band could go

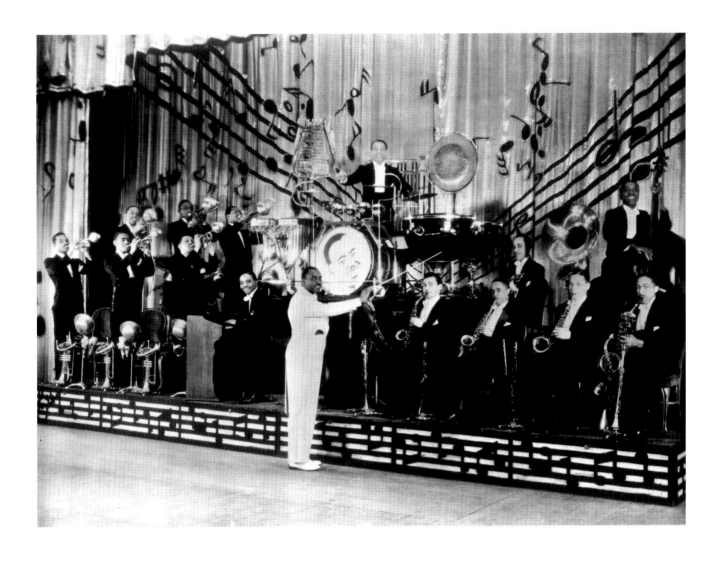

back and blow you away. I made a lot of arrangements for that band.

H: You said you heard Lunceford at the Apollo. Did you also work at the Savoy Ballroom?
E: No, Lunceford liked to play at the Renaissance. You know why? Lunceford didn't like to play those places where they only paid him salary; he wanted percentage all the time. That was the way the man operated. I've seen times when they had six or seven bands at the Savoy, big names. You couldn't get two bands in the Renaissance, and when Lunceford would play there, he'd just pack 'em in. You couldn't get in the place and he probably cleaned up since he was getting a percentage, but he never passed any of that along to the people in his band. The

most I ever made was seventy dollars a week, and I only made ten dollars on the arrangements. I'd call him on this, but he'd always say we were crazy, that he was paying us enough—and that was his biggest mistake. Lunceford thought musicians didn't need money. He thought they were still just little school kids and he was the professor. I've always said he was the black Glenn Miller or that Miller was a white Jimmy Lunceford. They both had the same ideas. Glenn Miller always considered the men in his band his soldiers. He'd thought like a major all his life; he craved that authority. Nobody ever got close to him but me, and the only reason I got close to him was because I acted so simple. He thought he was running a school all the time, and so did Lunceford. I began to get tired of

Eddie Durham with Jimmy Lunceford and His Orchestra, Shea's Theater, Buffalo, 1935

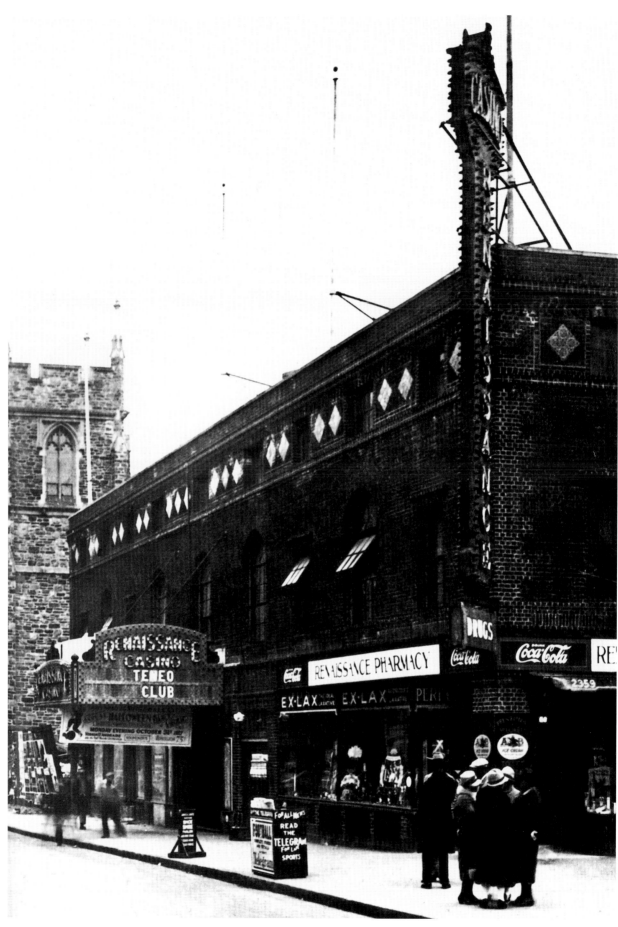

Renaissance Ballroom, mid-1920s

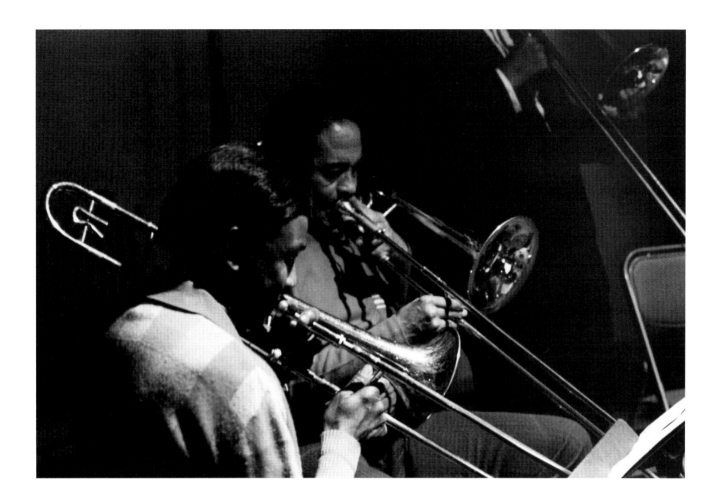

the band and decided to leave. I'd been playing and arranging a lot, plus I was teaching Sy [Oliver] and Eddie [Wilcox]. You see, Sy was a fine writer; he had good ideas. But at that time he didn't know how to voice any further than maybe five-part harmony, so I helped him with lessons. I was still only making seventy dollars a week, and Lunceford was bringing in enough to do better than that even if he did have to pay people off. I was a little more hip than some of the guys in the band; I guess they'd been hungry enough times to want to keep their jobs, but I'd been hungry too.

I knew Lunceford had just booked a three-thousand-dollar job, and we were still only getting our regular salary, and I told the guys in the band that I couldn't take it, that I was going to leave. About this time John Hammond came by where we're playing, up in Larchmont, New

York, and asked Lunceford if he could borrow me for a week to write some arrangements for Count Basie. You see, Basie only had about six arrangements then, and he'd told John I'd written some of them. Now here is Hammond talking to Jimmy and I'm standing right there— nobody asked me what I thought—but he told Hammond he couldn't get along without me. Then I said to Lunceford that he should let me go for a while; I'd go help Basie and if I wasn't successful I'd come back and stay for a year. I went down and checked out the Basie band—they were at Roseland—and they had some problems and I thought I could help them with some arrangements. Not too much later, John Hammond came around and offered me $125 a week to go with the band. I've got to give John credit. He always felt

Eddie Durham, *left,* and Dicky Wells, recording session at WARP studio, 1973

Eddie Durham, recording session at WARP studio, 1973

the band could be something, and it was at a time when nobody else was paying them any attention. About the same time, Lunceford sees what's happening and begins to give a few raises—[Eddie] Wilcox to ninety dollars, Willie [Smith] up to seventy dollars—and he tells Sy that he'll pay more for arrangements. He'd only been paying Sy five dollars for each arrangement, but I knew he wasn't thinking about giving them any money.

So I told the guys in the band I was going over to Basie, and then I gave Jimmy my notice that I was going over to Basie. When I gave him the notice, some promoters set up a battle of music in Hartford, Connecticut, with Lunceford and Basie, side by side. Then about three days after I'd given my notice, Lunceford came over to where I was staying and

started complaining to me that I'd started a mutiny in his band. I asked, "Who's leaving?" and he said, "Almost all of them." He said, "They're going to come to see you, and they're going to ask you why you are leaving the band. Please don't tell them you're leaving because of the money; tell them you just want to play with Basie." Then he started to try and use psychology on me and said, "You don't want to break up the band. Don't you love this band?" I looked at him and said, "Yeah, I love this band. I just don't enjoy being with it anymore." Lunceford didn't really seem to care what I thought; he could have offered me more money right then, but he didn't do it. So I left the band up in Hartford. I played the first set with Lunceford and when it was over the guys in the band helped me pick up

Opposite: Snub Mosley, *left,* and Eddie Durham, Meriden, Connecticut, 1969

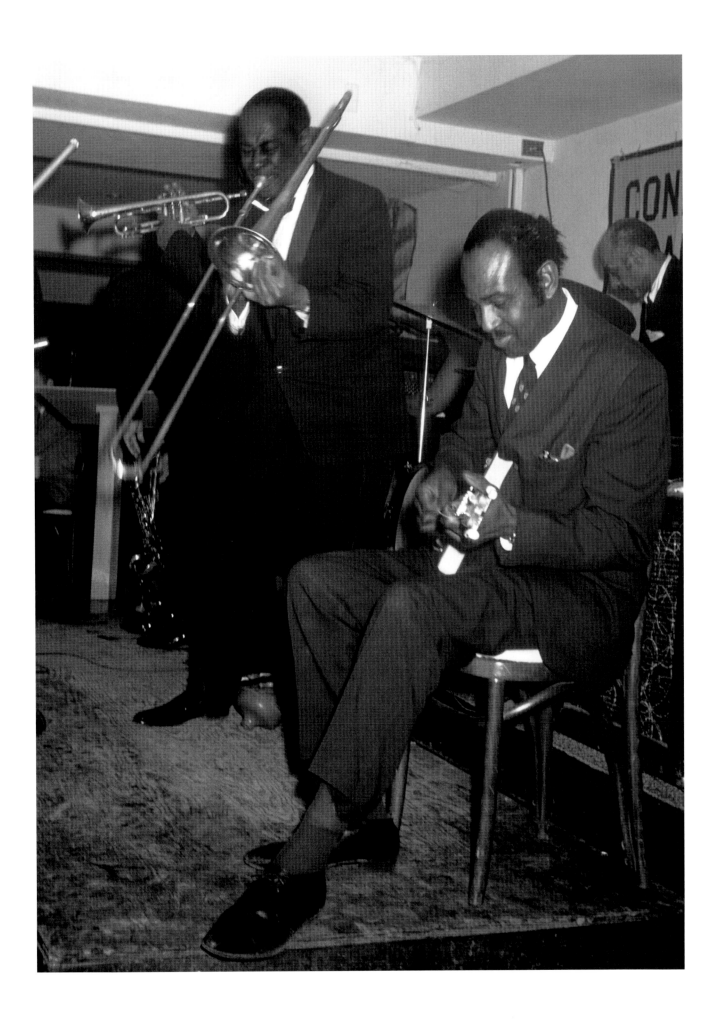

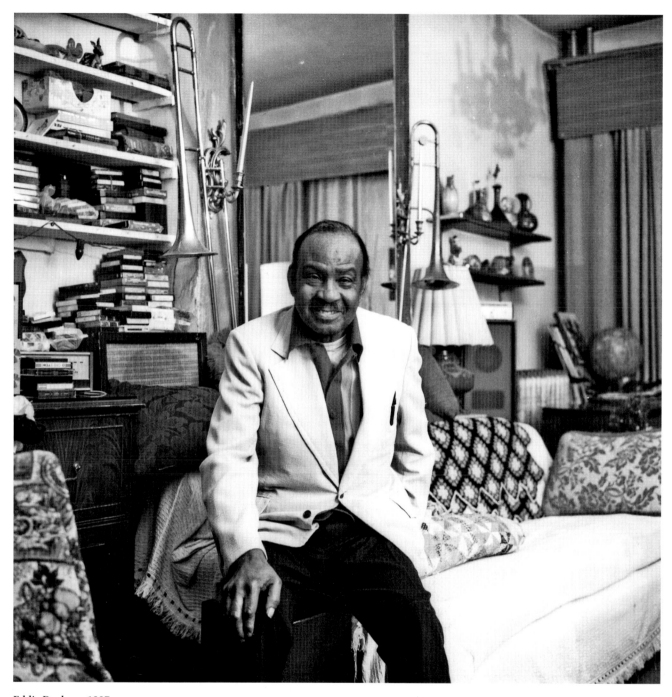

Eddie Durham, 1987

all my stuff and move it over to the Basie band, right in front of the audience.

H: Did you enjoy your time with Count Basie?
E: When Basie first came to New York, he was pretty ragged. I wrote some things for them that helped them; "Good Morning Blues," "Time Out," "Topsy"— those were the first ones I did for the band. I only stayed about a year and put maybe twenty-five numbers in the book. The reason I left was because it got so wild, and sometimes Basie just didn't pay attention. He'd be sitting over at the bar drinking chocolate or something, listening to what we were doing. He'd come by and give you a handful of notes and leave. He was a great talent but sometimes you couldn't get anything out of him. We'd be sitting on a bus somewhere in Virginia wondering where he was, and I finally put in my notice and he told me I was crazy, and I said, "Man, this ain't all there is!" Tommy Dorsey came to me after I'd left—this was before he'd hired Sy. He said, "I see where you left Basie, and I didn't think anybody ever left that band," and I said, "Well, you don't know what a fool I am!" I told him I didn't want to join up with anybody else right then and he said, "Do you think I can get Sy?" and I said, "You better ask him yourself." That's just what he did, and Sy left Lunceford and joined Tommy Dorsey. I went over and talked to Sy before Tommy did, and he asked me what he should say. I told him to just tell him what kind of money you want for the job. Then Sy said, "Wait a minute, I'll be right back," and he came back with his horn and his bag.

9 February 1987

[Note: The interview with Eddie Durham ended very abruptly when an old friend of his, the pianist Kelly Martin, dropped by unexpectedly. The three of us talked for a short while and Eddie and I made plans to get together in March, when he returned from an upcoming out-of-town engagement. He became ill during this engagement and died on 6 March, shortly after he returned to New York.]

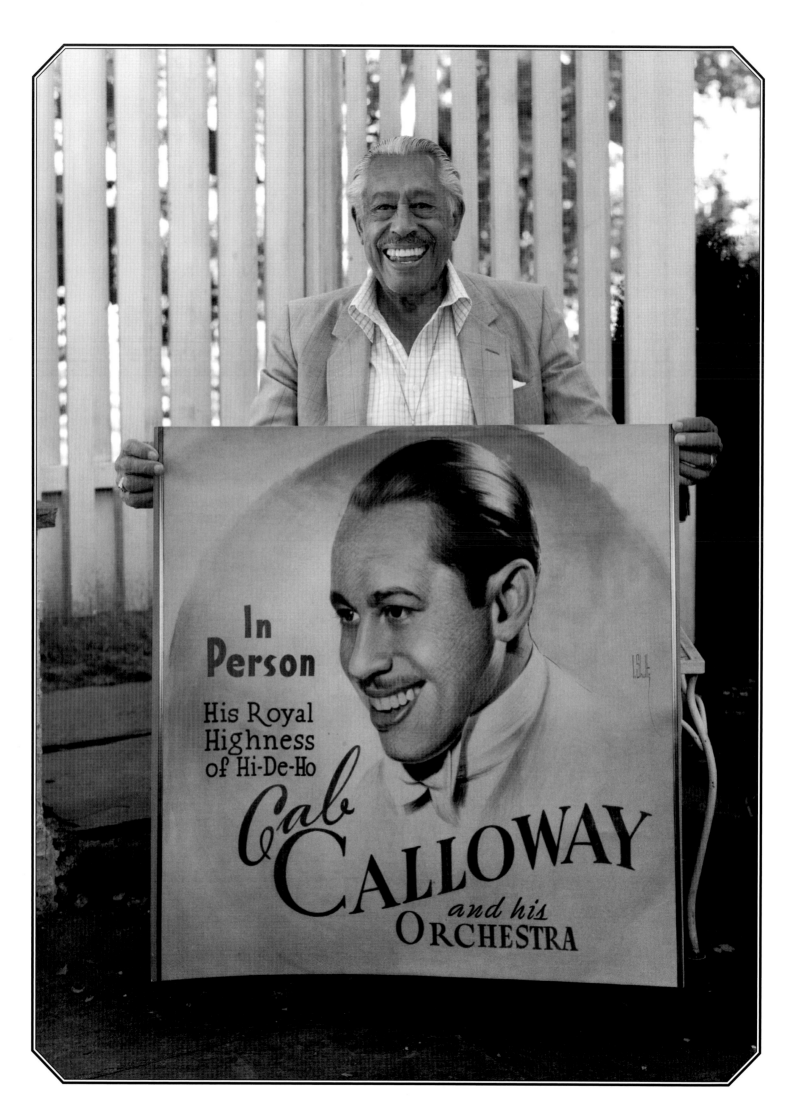

Cab Calloway
(b. 1907)

Hank: *You came to New York from Chicago in the late 1920s?*
Cab: Yes, in 1929. November 1929, just after the crash.

H: *The first band you came in with was a Midwest band?*
C: Yes. The band was called the Alabamians. Some of them had played in New York before, but the first place we played in Harlem was the Savoy Ballroom.

H: *The Savoy was the first one? What was it like at your first engagement?*
C: Well, it was rather thrilling because the Savoy was big time, the top spot. As a matter of fact, it was the only spot of its kind in New York, but I had a lot of trouble with the band. I was trying to make the band play New York charts, and they couldn't see it. The Alabamians was more an entertainment band, a musical band, and we did a lot of novelty things and I was worried this kind of music could drive the people out. I said, "They're not going to take these novelty numbers." One thing we used to do was a song, "You're Coming Out Tonight"—a funny little song, you know, odd, novelty things. I had a rough time with them, trying to get some of the beat, and they

didn't do it. They wouldn't do it. An alto player named Marion Hardy had once led the band, but now it was a cooperative band. I was just a leader. It wasn't my band. It was everybody's band and we'd play some funny little tune and clear the floor.

H: *How large was it?*
C: Fourteen pieces. We bombed at the Savoy because we weren't playing the right music. You couldn't play square music for the Harlem audience.

H: *Were you alternating with another band?*
C: With Cecil Scott's band, the Bright Boys. He played tenor clarinet. Boy, he was a character. That Cecil Scott, he'd get off that bandstand with the tenor and start parading around the Savoy while everybody's marching behind him, dancing behind him. Oh, man, what a sight!

H: *So you not only had to compete with Cecil Scott and in this case the band wasn't up to it, but the Alabamians were used to playing different kinds of functions. They weren't ready for the best dance hall in the world, and Cecil Scott probably had a pretty big following.*

Opposite:
Cab Calloway, 1986

THE · BIGGEST · PARTY · OF · THE · YEAR
Savoy's Anniversary
FEATURING THE ONE AND ONLY
DUKE ELLINGTON
And His Cotton Club Orchestra
Also! the return of CECIL SCOTT And His "BRIGHT BOYS"
Including Chicago's Sensational Band
SAMMY STEWART and His Orchestra
4 ORCHESTRAS 4

The Date
WEDNESDAY
MARCH
12
The Place
SAVOY
World's Finest Ballroom
Lenox Avenue—140-141st St.

Duke Ellington flyer, 1930

C: That's right. He was tops then. He'd cut everybody that come in there. He'd be playing battle of bands there, and every band that would come in, he'd start toodle a loo, marching all around, and that was it.

H: *How big a band?*
C: About ten or eleven pieces, and he had some good men—Bill Coleman, Don Frye, Dicky Wells, I think.

H: *Did any of the fellows in the Alabamians band stick around New York with you, or did it disperse and they went back to their hometowns?*
C: Well, at least two fellows stuck around, maybe more—Eddie Mallory, a trumpet player, and Charlie "Fats" Turner, a bass player. That's it. He opened a place up in Harlem years later, a couple of years later. Had a bar up there on 155th Street, on 155th Street and Lexington Avenue. He called it Fatman's Cafe.

H: *When the Alabamians completed the two weeks and most of the players left town, did you go with the Missourians*

immediately or was there a break in there?
C: No. There was a break and, like everybody else, I was out of a job. Louis Armstrong was at Connie's Inn on Seventh Avenue between 131st and 132nd.

H: *Yes, the building's still there. It's an A&P store now.*
C: Once it was even a church. I contacted Louis to see if I could gig with his band. He said no, man, he didn't need another vocalist but he was also in *Connie's Hot Chocolates* and said they needed a singer. He said, "You can sing at *Connie's Hot Chocolates*; I'll get you an audition." I went with *Connie's Hot Chocolates* for about five or six months. The show closed on Broadway and we went on the road, but the people from the Savoy contacted me every place I went with the show on the road, begging me to come back and take over the Missourians. The audience at the Savoy hated my band but in that short time I'd become personally very popular and even won a popularity contest just before our two weeks were up with the Alabamians. They worked on me for quite a while. I decided to come back.

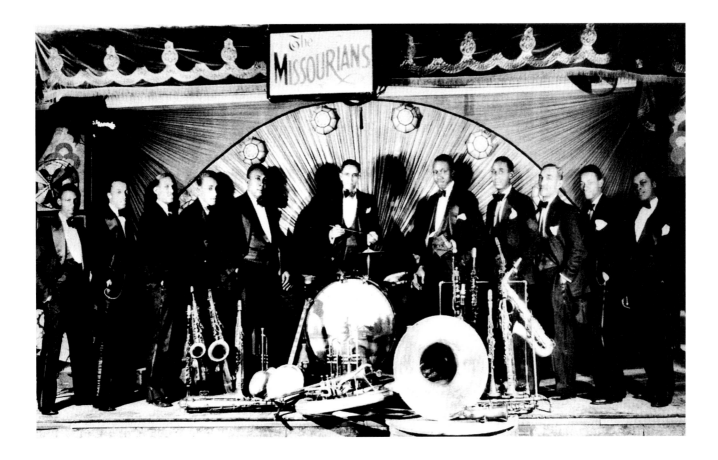

There were some wonderful players in the Missourians. It was a fine band.

H: *They were a wonderful band and have never gotten the credit they probably deserved.*
C: I don't think they did.

H: *Everybody always talks Duke Ellington, but in 1929 Charlie Johnson's was an exciting band.*
C: Charlie Johnson had a very good band. Another guy who had a good band was Luis Russell. Don Redman, Red Allen—they were in that band.

H: *So you went into the Savoy with the Missourians?*
C: No, the Cotton Club.

H: *Did you ever play with the Missourians in the Savoy?*
C: No, I was to take over the band and open at a new place, the Plantation Club,

but I never did. The club was ready, the band was rehearsed, and we were ready for opening night, but the gangsters who owned the Cotton Club had the place wrecked on the day the Plantation was to open. The bandstand was even all set up with our music, but we never played a note. The surprise was everything was destroyed except our music. I remember arriving for work and seeing fire trucks in the street.

H: *What did you do? Did you go back to the Savoy?*
C: No, maybe once or twice, but Charlie Buchanan and Moe Gale got us some little jobs here and there, uptown, downtown—once in Philadelphia, I think. Then Moe got us into the Crazy Cat.

H: *Was the Crazy Cat in Harlem?*
C: No, the Crazy Cat was on the southwest corner of Forty-eighth and

The Missourians, late 1920s

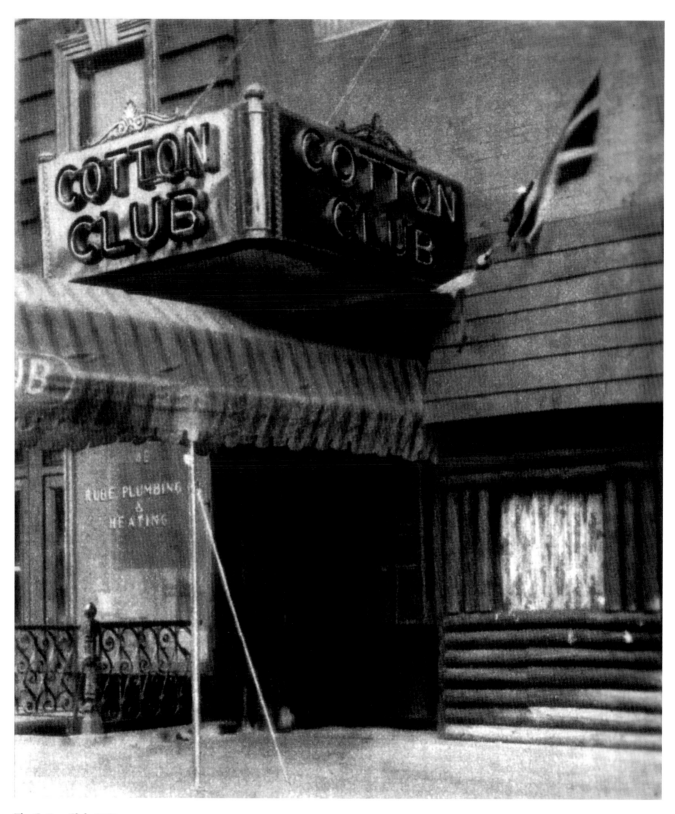

The Cotton Club, 1931

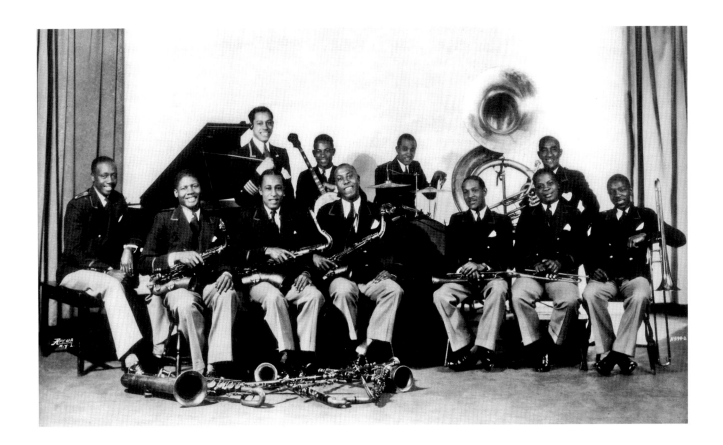

Broadway, in the basement of a big restaurant. We began to get a reputation at the Crazy Cat. People came to see us; sometimes we were on the radio. We were just there a few weeks when somebody from the Cotton Club came by and offered me a job. I thought he was kidding, but he wasn't.

H: Once you started at the Cotton Club, I assume, you never performed anyplace else in Harlem?
C: We did a few things at the Alhambra before we went to the Cotton Club, and while we were at the Cotton Club we sometimes played the Savoy for a battle of the bands, but that was all. That was the only place we played in Harlem except for the theaters; the Lafayette is where we played in Harlem. It was brutal when we were doing the Cotton Club and the Lafayette at the same time. Seven shows at the Lafayette and we started at about ten o'clock in the morning. Then two big shows at the Cotton Club. It was rough.

H: Tell me just a little bit about what it was like in 1930 at the Cotton Club as opposed to that nonsense we saw in the movie. Your band, I presume, accompanied everybody.
C: That's right, and the shows were the most elaborate anyone ever staged in Harlem. Everything was tightly structured. Much of the music developed for these shows was written by one of world's greatest composers, Harold Arlen. This man's still going strong, and we did all of his wonderful songs. Later he wrote all those standards like "Blues in the Night," "Stormy Weather." He even wrote a thing called "Calloway for President with a Hi De Hi De Ho." It was for a special Cotton Club show in the early 1930s. It was hard work there, but not as hard as in a theater, part of a stage show. We played two shows a night at the Cotton Club. Sometimes we'd finish early enough for some of the men to go out to local clubs and jam, if they didn't have sessions somewhere else, but remember,

Cab Calloway and His Orchestra, 1930

Cab Calloway, Floating Jazz
Festival, 1985

most of the time the band had to make a show at the Lafayette or some other theater, maybe downtown, at ten o'clock in the morning. When they weren't working or if they thought they could make it, some of the men used to have sessions at a place called the Rhythm Club; that's where everybody went to jam. They all wanted to play, especially the new musicians from downtown who used to come up to dig the riffs.

H: Did you every go to these clubs or after-hours places?
C: Not very often. I wasn't much of a playboy. If the job wasn't over too late, before three o'clock in the morning, maybe I'd go across the street to Mike's, just to have a drink and relax. There was no music, no jazz, just a place to relax. Sometimes we'd have parties at somebody's apartment; then there was

music, people would hang out, listen to music, eat and drink. That's all.

H: Did anyone ask you to sing at those informal parties?
C: Maybe, but I never did that.

H: When you'd take the band out of New York City and go on the road—and say you play in Philadelphia or Boston or wherever; what was the main difference in playing in a city like that as opposed to playing at the Cotton Club? Was there any difference?
C: No, there wasn't any difference because we didn't take our shows on the road. When I was on the road with the band, I put in acts to fill out the time but we never used the Cotton Club shows. The Cotton Club shows never played anywhere but in the Cotton Club; and when we were in New York, we

only played the Cotton Club or movie theaters, except occasionally we used to do benefit shows in New Jersey or somewhere for politicians—a place that was an easy drive—and all these benefits were outside of Harlem. We never did a benefit in Harlem, but the Cotton Club meant a lot to Harlem, benefit-wise or otherwise. We used to feed thousands of people. Nobody has ever mentioned that.

H: Well, mention it. That's important.
C: Nobody has ever mentioned it, but every year at Thanksgiving, Christmas, performers, musicians, everybody would be at that Cotton Club and we would pack thousands of baskets of food. Full dinners. Bags this high full of food, and on the day before a holiday, on Thanksgiving eve, people marched up to the Cotton Club, came up the steps and got bags of food—thousands of people. We never missed a holiday the whole time I was there, and nobody has ever said a thing about it. We were well paid and highly respected in Harlem. The girls in the chorus came to work in fur coats when so many people on the street were in rags. We did what we could, but it seemed like we were working all the time.

H: What were some of the other residual benefits of the Cotton Club? You did what you could in bad times; the club employed people, gave them work. I know one club can't make a difference, and eventually, Harlem died.
C: I attribute that to economics. Everybody was broke. You know, we went through that Depression. And

another thing, Harlem is responsible for all of the lotto, which is a big business. No place in New York, no section in New York but Harlem, was running the numbers. Billions have changed hands and now it's a commercial thing for the state.

H: They say it's for education. Most of it doesn't wind up there, which is a pity.
C: Now you go in a grocery store and buy a lottery ticket instead of a loaf of bread. You don't realize it until you sit down and say, "Man, that actually happened."

H: When the Cotton Club closed and moved downtown, did you move with it?
C: I think it was 1937 or 1938, and once it moved, the band never played uptown, except a theater. The Apollo was the only place that I ever played in Harlem after that. At the Apollo, I was just part of a stage show.

H: How long did the Cotton Club last downtown?
C: Two or three years.

H: Was it the same kind of show?
C: It was more elaborate, that's all, but I'll never know why they took it out of Harlem. It didn't make any sense to me.

H: Was it a relief to get out of town and take the band on the road?
C: Sometimes it was easier. When we were working the Cotton Club and playing theaters at the same time, we even had beds in the dressing room so we could grab some sleep between shows.

Cab Calloway, Floating Jazz Festival, 1985

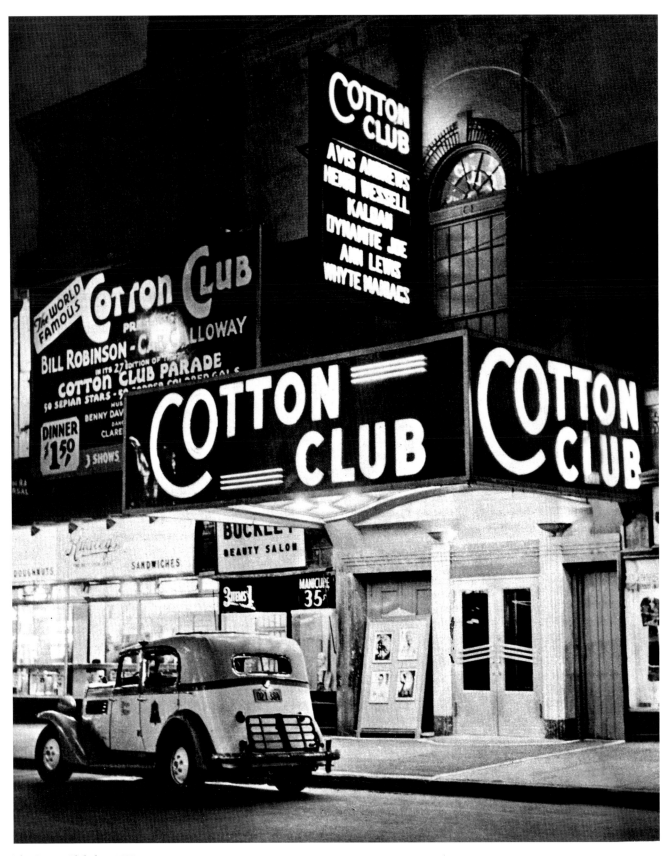

The Cotton Club, late 1930s

H: *Doc Cheatham told me there were cots in the basement of the Apollo.*
C: Maybe. I remember them in the dressing rooms. But it was easier on the road, especially after we had our own train. You see, if we were on a bus, we'd go from New York to Miami but there wouldn't be any hotels for us, sometimes no place to eat. We had a hard time on our earliest tours. On a bus, two or three hundred miles between jobs, day after day, and it got worse the further south we went. Run out of towns, police bothering us all the time. In Florida, Virginia, North Carolina. There were some bad things. Riots, people shooting at us. In Harlem we were celebrities, but we weren't down south, and finally I solved that problem with my own train. We'd travel in luxury and sleep on the train. It was something to have your own dining car and a sleeping car. I used to

Cab Calloway, Floating Jazz Festival, 1985

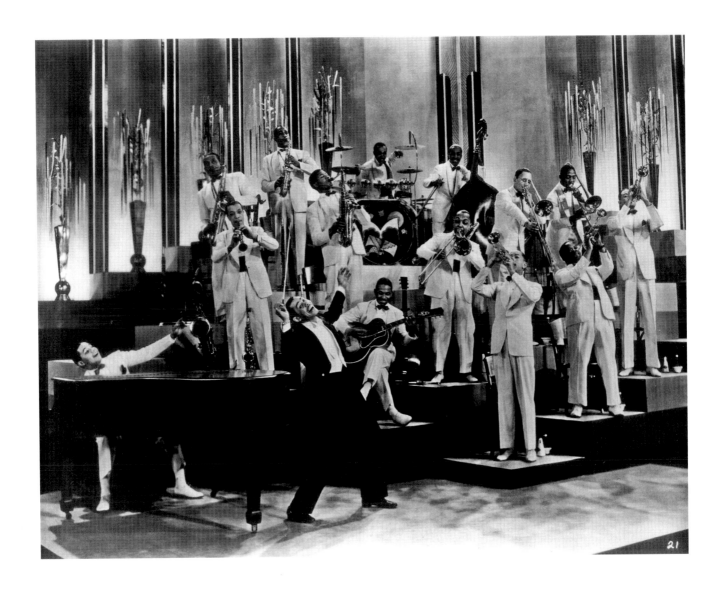

Cab Calloway and His
Orchestra, 1937

carry my Pierce Arrow on the train. I'd
let them pull the train into town, then
unload my car and drive into town. It was
cool, but nothing like being in Harlem. I
remember when we came back from our
first tour down south, we were met like
returning heroes.

*H: When did everything come together
for you?*
C: Well, I'd say the Cotton Club peaked
for me in 1932, 1933. I had hit records.
I'd written lots of songs. I started in the
movies.

*H: When you started making the movies
did your band ever open for a movie*

*that featured you, such as International
House or The Big Broadcast?*
C: No, I don't think so.

*H: To change the subject, other than
economics, if you had to think of one
thing that killed the music scene uptown,
what was it? Other than most people just
couldn't afford it.*
C: That's the reason; they couldn't afford
it, and it was the same thing everywhere.
The same thing went on all over New
York, not just in Harlem. You know,
they had the fine clubs downtown. The
Paradise. Copacabana. Mike Todd had a
club, the Latin Quarter. We had all that,
but they all went out, all disappeared, and

it's a funny thing. You see, it's happened everywhere. Chicago used to have tons of clubs. I mean you could go out and have a ball in Chicago. Nothing. No place to go in Chicago.

H: Maybe everything goes in cycles. Do you think clubs like these will ever come back?
C: How long is a cycle? When you stop to think about it and you look everywhere, I mean, look, Kansas City used to be wonderful. My god, I don't believe it. Entertainment, music that you get from Kansas City. You go there now and there's nothing. Positively nothing.

H: When was the last time you were in New Orleans and tried to hear somebody playing really well? There's nobody there.
C: That's right, and what's happened to it? I just don't know. I sing with symphony orchestras now. Things change in Harlem; they change right here in White Plains. You see what they've done right here where I've been living for thirty-five years? I moved up here thirty-five years ago, if a car went up the road, I'd think, "Gee, a car just went up the road," and now you can't get near the road.

H: At least they haven't put a super highway in front of your house.
C: That's not a super highway?

H: No, I mean a four-lane super highway.
C: Heck, that's a super highway without four lanes. That's a two-lane super highway. To get in and out my driveway, you've got to take out an insurance policy. [Calloway's wife, Nuffie, brings in a large poster of Cab.]

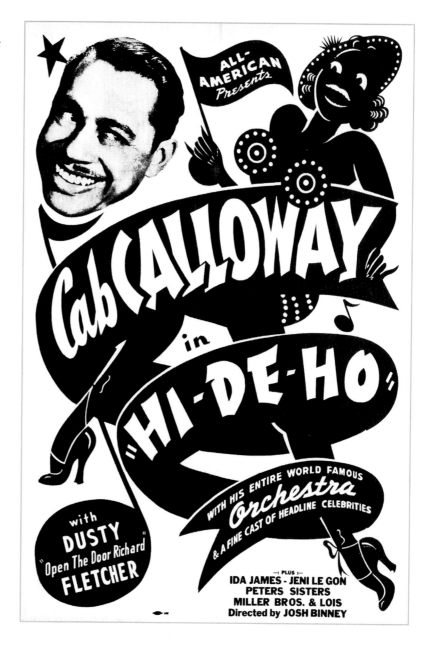

Hi-De-Ho poster, 1945

H: Look at that! Isn't that wonderful!
C: Oh, that handsome young guy. He was something else.
Nuffie: He's still something else!

H: It says "His Royal Highness of the Hi-De-Ho." We have to find a place where there's good light so we can take some pictures. Let's go outside.

9 September 1986

Benny Carter
(b. 1907)

Hank: *Do you recall the first place you worked or played in Harlem?*
Benny: Yes, it was in the early 1920s. I wasn't playing yet, but that's when I first heard Coleman Hawkins, before he went with Fletcher Henderson. The place was called the Garden of Joy—some people called it the Garden on the Hill—on Seventh Avenue. Charlie Gaines, a trumpet player, may have been there about the same time, and Ginger Young, a pianist. Frankly, I don't remember if this was the first place I heard music in Harlem, but it certainly was one of the first, if not the first.

H: *You began playing professionally shortly thereafter. Do you remember the first place you worked?*
B: I worked both in Harlem and downtown, about the same time. I ran into a man just two weeks ago who told me I'd worked opposite him in a trio in those dime dance palaces down on Fourteenth Street and in the Times Square area. His name was Bernie Brightman, and he's well into his eighties. He reminded me I had a saxophone, piano, and drums, and he had the same lineup. This trio wasn't my group; I was just a member. Freddie Johnson was

on piano and Walter Johnson was the drummer. He told me we were together at a place called the Tango Palace. He's probably right. This was probably about 1924.

H: *Where was the first place you worked uptown?*
B: I can't remember the first one because we used to take our horns and go around to wherever they'd allow us play. I remember one guy who encouraged me greatly was Bill Basie, who was not yet known as Count Basie. He was just Bill Basie playing at a club called Leroy's [Restaurant], over on Fifth Avenue. He hadn't yet gone to Kansas City; he was just working with his piano, sometimes a drummer, and playing lots of wonderful notes. A lot of people don't realize that he has a very strong left hand. He was an incredible pianist. I recall he let me sit in with him a few times.

H: *Leroy's seems to have been a place where a number of fine pianists worked. Do you remember the year you first sat in with Basie at Leroy's, and did you hear other pianists there?*
B: It would probably have been about 1923. I also remember Willie "The Lion"

Opposite:

Benny Carter, 1987

Willie "The Lion" Smith
at the Village Gate, 1967

Smith. He was a few years older than Basie, but Basie was only a few years older than me. Willie was still in his twenties; Basie was maybe twenty; and if it was 1923, I was sixteen. Later I worked with Willie; he was also helpful. He encouraged me to drop the C melody saxophone and concentrate on the alto.

H: Did you ever spend much time at the Rhythm Club looking for work or trying to meet other musicians?
B: Oh, yes, it was a wonderful place. There were cutting contests and wonderful pianists. People like Paul

Seminole—and did you ever hear of a man named Sam Weber? He was Jewish and blind. He didn't live in Harlem but he'd come uptown to play, and he was dynamite. This wasn't at the Rhythm Club but at a place called Reuben's, which I remember more as just a house than a club—maybe it was someone's home. But he'd come up there and play with the Beetle, Willie the Lion, James P. [Johnson], and Willie Gant. Nobody's ever heard of Willie Gant. I don't think he ever made any records. There were a lot of people like that. I don't think Paul Seminole ever recorded.

H: Do you remember any other individuals who were helpful to you in those years or with whom you played regularly?

B: I worked in dance halls with June Clark, not playing what someone might call hot jazz but just dance music. We played uptown and downtown; perhaps we also played at that Tango Palace the man mentioned to me, but I distinctly remember we played at Small's—not the one I played at later with Charlie Johnson but another one, over on Fifth Avenue.

H: Could it have been Small's Sugar Cane Club?

B: That sounds familiar. If that was the only other Small's, it was probably the place.

H: Were you still playing C melody, or had you switched to alto?

B: The jobs with June Clark may have been the last times I played C melody. I'd been playing with Willie the Lion just before that and he told me if I wanted to play with bands I'd better have an E-flat alto. I remember this very well because it was an important decision. One of my first jobs with an organized group was with Billy Paige's band. He was from Pittsburgh and not very well known in New York. His band was called the Broadway Syncopators, and we had an engagement at the Capitol Palace in 1924 or 1925. I spent some time in Pittsburgh in those years. Did I tell you I met Horace Henderson, Fletcher's younger brother, in Pittsburgh?

H: No, tell me about that.

B: He was in school in Pittsburgh at Wilberforce and had a band called the Wilberforce Collegians. I joined the band for a while; this would have been about 1925. Some people say I went to school there, but this is a misconception. I just worked with them a short while in and around Pittsburgh. I left the band but rejoined it two years later when they had an engagement in New York. I worked at the Savoy Ballroom with them in 1928. Horace [Henderson] was the leader, and for some reason he had to leave the band. The band was a sort of a co-op situation, and I was elected leader. This was my first experience as the leader of a larger band.

H: You had worked with other big bands prior to this; can you tell me about some of them?

B: I also worked with other big bands after I broke up this band. I worked with Charlie Johnson at Small's Paradise; my friend Ben Whittet was also in the band at the time. It was a good band. I made some records with it, some of my first. Charlie was a darling man, he was a fun guy, and while the band was often very good, Charlie might have had more success if he'd not had so many good times. He enjoyed his band more than anybody. I'm sure it was worth all the work just to have his own band—he enjoyed it so much. About the same time, I worked with a sweet band led by a man named Billy Fowler. It was a society band; I guess you'd call it a sweet band—not like Guy Lombardo, sweet but not sugary. It was light music. I'll bet you've never heard of Leon Abbey. He played violin with a band called the Savoy Bearcats. This was one of the first bands to play at the Savoy when it opened. He played light jazz and society music, as did Luckey Roberts, who was—How shall I put it?—a poor man's Meyer Davis, in that he had a smaller operation. He took orchestras from New York and played society parties in Palm Beach. A lot of people don't know this. I never played with Luckey's band.

Benny Carter, *left,* and Clark Terry, Floating Jazz Festival, 1989

H: You were also associated with Chick Webb for a while.

B: Yes. Both Chick Webb and Fletcher Henderson. Chick's was more exciting than Fletcher's, because of his drumming, even though he wasn't in front of the band. He was almost an attraction, like Buddy Rich. He kicked his band like no one else, and the people who knew him liked him very much because he was quite a character. I enjoyed playing with both of them, and even though Chick was more exciting, I think Fletcher's band was more prestigious. This may have been because it primarily played downtown, for white audiences.

H: You must have spent a good deal of time at the Savoy when you were with Chick Webb. I've heard the Savoy was a great place but it was tough on the musicians.

B: It was long work, the audiences were demanding because they were used to the very best bands, and the pay was not very good. No one was paid very well in those

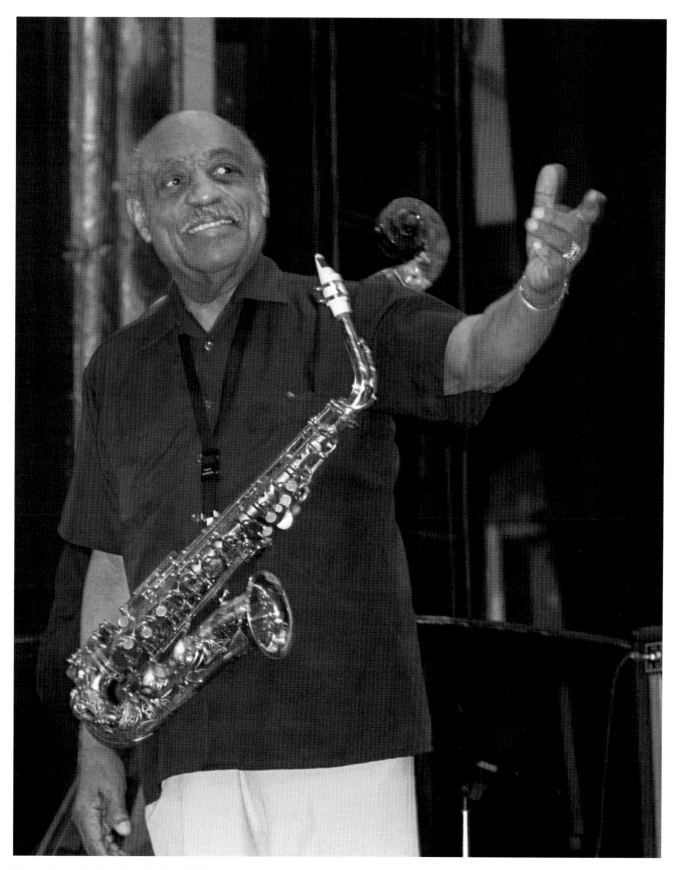

Benny Carter, Floating Jazz Festival, 1989

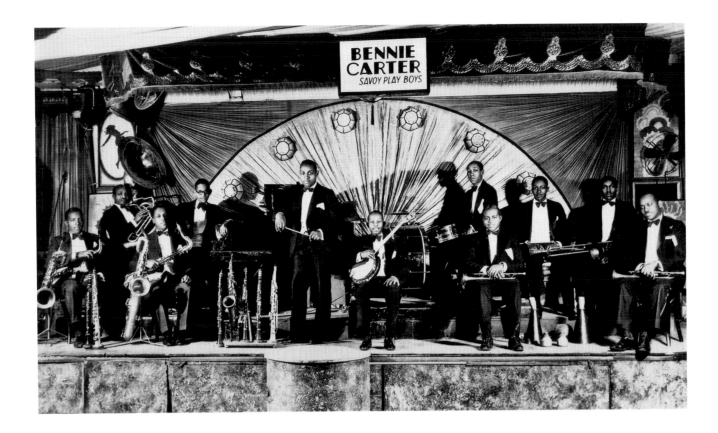

"Bennie" Carter and His Orchestra, Savoy Ballroom, 1928

days and, as I recall, we were particularly underpaid at the Savoy. There were also the long rehearsals.

H: Tell me about the Harlem Club.
B: This was in 1934, before I went to Europe. I had a very dear friend named George Rich who wanted to make me a club owner. It was his money that went into the venture, but he wanted me to have a home for my band but he didn't want the responsibility of being a club owner. He enjoyed coming in, seeing a show, and chatting with the girls in the chorus line. It was on the site of Connie's Inn.

H: Was the club a success?
B: Not particularly. I wasn't a businessman, and George was interested in it just for fun. There wasn't much to the place. I think it lasted four or five months, but it was a fine showcase for my band while it lasted.

H: Wasn't this about the same time your big band opened at the Apollo?
B: Yes, about the same time, but we didn't exactly open the Apollo. They had changed their policy and we played some featured numbers. We were there for a couple of weeks at the beginning and then we came back later.

H: I seem to recall John Hammond told me that Billie Holiday sang with your band about that time. Did this happen frequently?
B: Infrequently. I was one of the people who heard her early on, but I certainly can't say I discovered her. As I remember, she was at a place called the Bright Spot. It was just a bar and a back room with a piano at about 139th and Seventh Avenue. But I'm not sure of the location—there was another little club near the Savoy, it might have been there. These things fade in my memory as the years go by, but the time would have been

about 1933. Sometime after that I asked her to sing with my band, which she did on a few occasions.

H: Was she exceptional from the beginning?
B: Absolutely. She was always herself. Whatever you heard then, that was what you always heard.

H: You went to Europe in the mid-1930s. When you returned, did it seem Harlem changed a great deal while you were away?
B: Things always change, but I don't recall that much difference. I think it is important to remember that Harlem was never the heaven that some people claim it to have been nor was it the den of iniquity that others have suggested. I'm sure it was somewhere in between. There seems to be many problems today, but there were problems in the 1920s and 1930s.

H: One major difference today— discounting the problems with drugs and general urban blight—is, however, that there is very little if any live music. Al Cobbs used to have a big band in the basement of Small's on Monday nights, and that's about all. I've heard this may not even exist any longer.
B: Changing musical tastes probably hurt the big-band business as much as anything. It didn't affect me as much as it affected others, because I moved to California before things began to get so rough in Harlem and, of course, I was lucky enough to have a wonderful big band in California. I've always enjoyed writing and arranging for my own big band; I didn't write so much for other bands. Did I ever tell you how a lot of my arrangements got around town? I had a copyist, and when he'd copy the arrangements, he made one for me

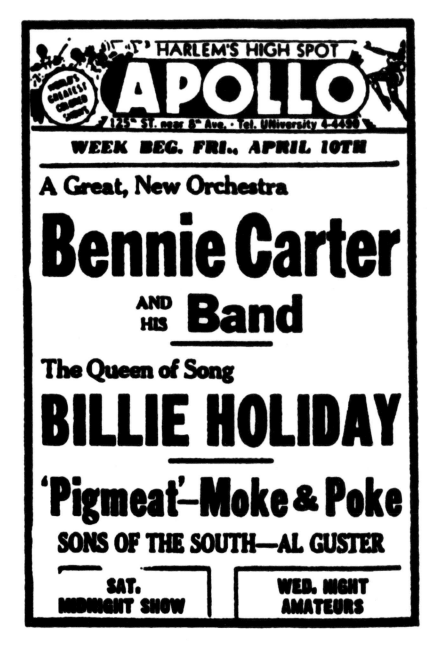

Apollo poster, 1942

and one for himself. He sold them, and that's how some people got hold of my arrangements. It didn't bother me too much. I looked at it like added exposure that didn't cost me anything.

H: When was the last time you worked uptown?
B: It was in the 1940s, shortly before I moved to California. I was a house band at the Savoy for a couple of years. I'd started there in 1939, shortly after I'd returned from Europe when I became closely associated with Moe Gale, one of the owners. I toured and then returned to

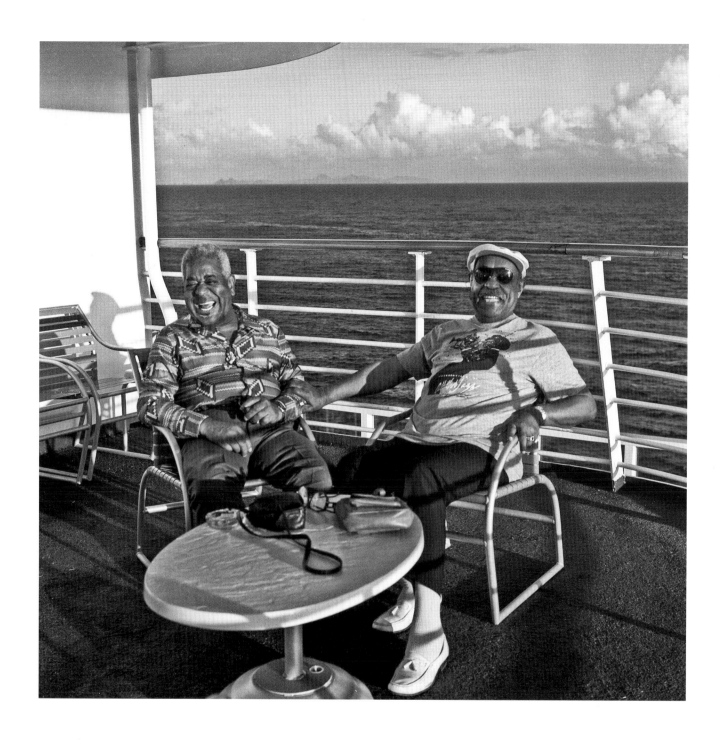

Dizzy Gillespie, *left,* and Benny Carter, Floating Jazz Festival, 1988

New York. This was one of my extended engagements in Harlem.

H: When you left town, Harlem was in pretty good shape.
B: It wasn't too bad when I left, but it's pitiful now. I don't really know what killed Harlem and the music other than changing tastes, and the music the kids started dancing to after the war had a beat. The beat was there, whereas be bop lost it, absolutely lost it. Some of the music was a little too cerebral.

H: Dizzy [Gillespie] once told me the reason nobody danced at Minton's was because there wasn't any room to dance.
B: Maybe, but I was never in that place.

18 May 1987

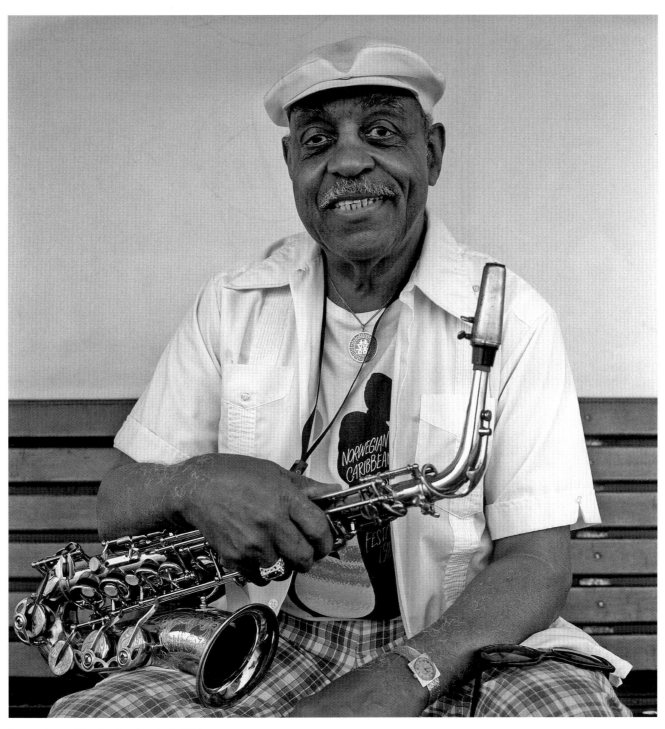

Benny Carter, Floating Jazz Festival, 1989

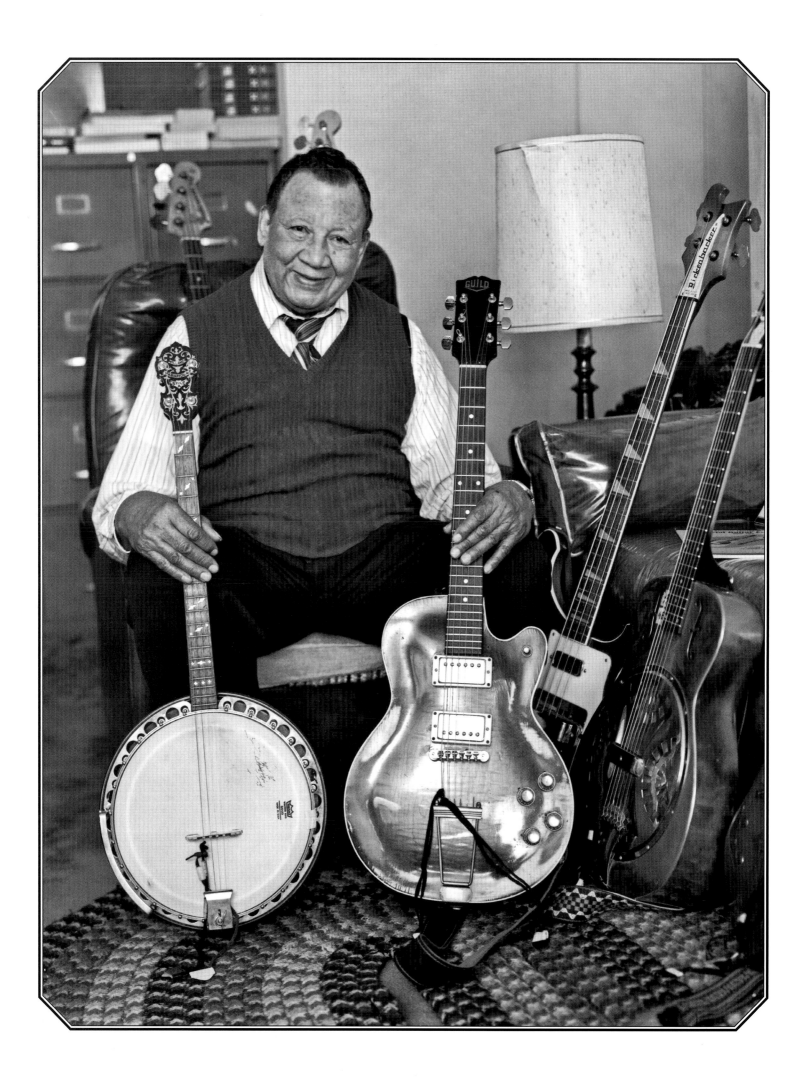

Lawrence Lucie

(b. 1907)

Hank: *Tell me about your musical life before you came to New York.*

Lawrence: I'm from Virginia, and the first instrument I learned to play was the mandolin. My father was a barber by trade but he was also a fiddle player. He played music that some might call hillbilly music. We had a family band, and on Saturday nights, after my father would finish barbering, we'd go to dances and perform. We called them eight-hand sets. That was my start in the music business, in the early 1920s. I also went to a lot of minstrel shows, listened to what they did, and learned their songs, and there were a lot of blues guitar players strolling through, sometimes with medicine shows. We called them strollers, and I'd listen to them, learn what they played.

H: *When did you come to New York City?*

L: It must have been about 1927, and naturally I was a barber. My father taught me the trade and I had a job before I came here. A friend of the family was already in New York and said he knew a fellow who needed a barber, so I had a job before I arrived. I also had a friend of the family, Dr. T. H. Amos, to look after me. I arrived in New York and took the train to Harlem, to 135th Street, and walked up 137th to the barbershop. I stayed there awhile and then worked at one down on 135th. I worked as a barber, studied the guitar, and worked my way through school. I wanted to go to college right away, but I was missing some classes and I took them at DeWitt Clinton High School. I had to work in the day and go to school in night. It was hard, but I kept studying. I finally stopped barbering because I thought I could make more money doing other things to support my studies. I was a soda jerk, an elevator operator, a porter. I did a lot of different jobs. I also studied at the Brooklyn Conservatory; I learned how to read music and also took up banjo and violin, and by 1930 I was able to play all those instruments.

H: *When did you begin to play music as a full-time professional?*

L: In 1930, when I joined the musicians union. You couldn't work if you weren't in the union, and it took me a long time to get the money together to pay the initiation fee. I had a friend, a pianist named Jimmy Reynolds, and we were both trying to get the money together; the fee was sixty dollars. I don't know how I managed it, the Lord must have

Opposite:

Lawrence Lucie, 1996

169

been with me, because I hit the numbers and made the sixty dollars, and then a few weeks later, Jimmy hit the numbers. We both paid the money and got in the union, and I've been working ever since.

H: What happened to your friend Jimmy Reynolds?
L: He didn't have much luck because he never worked steadily with a real famous band. He played with Chick Webb for a short time, and I got him on a Red Allen recording session in the mid-1930s because I helped Red put those sessions together. I wasn't actually a contractor but I helped with all the arrangements for the date. Jimmy worked around but never got a break.

H: Tell me about your first steady work in New York.
L: My first job was with June Clark. I was just lucky, because the first day I joined the union I went to the Rhythm Club. I'd been hanging out there a lot and knew many of the people there, and I ran into a fellow named Benny James—he was a big-time banjo player who played with the Mills Blue Rhythm Band. He said, "Hey, kid, do you want a job?" I said I did and he told me to go down and see June Clark, who had a band at a dance hall on Fourteenth Street. He was working the job but had just gotten a better one somewhere. So I went down to see Clark at Hogan's Fourteenth Street Dancing School. Hogan—I don't remember his first name—had the band and June Clark led it. He was so good he kept a big job all the time and just hired musicians to work on Fourteenth Street. Musicians worked there when they were between jobs or laying off. You worked down there until a better job came along. The pay was union scale, about twenty-eight dollars a week, so a lot of people took the work until they

could move on. I know Benny Carter worked there in the 1920s. If you got a job paying more money, you would leave and June wouldn't care. He'd just call another guy to take your place.

H: Tell me about June Clark—he just fronted the band for Hogan?
L: He was a trumpet player who played like Louis Armstrong. He idolized Louis Armstrong, even sang like Louis Armstrong with a gravely voice, and everything he played was like Louis Armstrong. He even had the same warm smile. I loved the guy; he was so personable, ran the band, and had the most popular dance hall on Fourteenth Street. I don't know what became of him after I moved on to a better job.

H: Did you go back to the Rhythm Club to look for other work while you were working on Fourteenth Street?
L: Sure, I was there all the time. I learned a lot there. You didn't just go there to get a job, you went there to meet people, to pick up pointers. As soon as you'd have your breakfast in the morning, you'd head down to the Rhythm Club. I can think of a lot of guys that really got on the big time from being there, and I learned a lot. When I first went there, I could play a little but I couldn't play all that well, and working in those dancing schools you had to know a lot of songs; you had to memorize them. I'd talk to older musicians and ask them to give me pointers on remembering all these songs and playing the correct chords, and I'll never forget what a trombone player told me; he said, "Listen, if you want to memorize chords to all the songs, listen to them; just play your scales every day, and sing your scales every day." So I started playing and singing the scales every day and

training my ear so when a melody went somewhere I'd know exactly where it was going. The place was also used to relax and socialize. They had a piano there, and that's where I first met Jelly Roll Morton. It's probably why I got the call to play on his records a few years later.

H: Do you remember the first time you had a regular job in Harlem?

L: I certainly do, because once I did that job I never was out of work for years and years. It must have been about 1932. I'd been taking little jobs here and there, just gigging with one group and another, when I got a call to come and sub for Freddy Guy in Duke Ellington's band at the Cotton Club. Now, most everybody was still playing banjo in those days, but Ellington was more progressive and he told me to bring my guitar. I played rhythm guitar with Duke Ellington for eight days, and I never laid off after that; everybody wanted to know about that kid playing guitar with Duke Ellington. I was just lucky—that stop with Ellington was all I needed. Everybody just figured I was good if I could play with him. Rhythm guitar was very popular then, and you'd be surprised how many calls I got in the next few years for record dates. Right after my experience with Duke, I joined Benny Carter and stayed with him for a couple of years. I was with him when the band opened the Apollo Theater, but we were playing at the Harlem Opera House just before we played at the Apollo. I think they were in competition with each other, but we'd played for about two weeks at the Harlem Opera House and were going over real big because the band was so outstanding. Benny had the best players; he had to have good players because his music was so hard to play. When Frank Schiffman saw how much business we

Cotton Club poster, 1932

were doing down the street, he changed the policy at the Apollo and brought in Benny's band and we were just as big a hit at his theater. It was a great all-star band, wonderful players—Chu Berry, Sidney Catlett, men like that. We played in the pit and were onstage as a featured part of the show, with the chorus and different kinds of stage acts. I stayed with the band until I went with Fletcher Henderson in 1934.

H: Why did you leave Benny Carter for Fletcher Henderson?

L: I think John Hammond had something to do with it. You see, Liblab [Clarence Holiday] had played guitar with that band for a long time, but for some reason he had to leave; I think he got sick. When he left, Bernard Addison took his place. Addison was one of the best players around—a great banjo player—and he played guitar just as well, but he was a soloist, not just a rhythm player. He didn't like to just play rhythm all the time, he wanted to play solos, so he was dissatisfied with the job and wanted to leave. That's when I think John Hammond recommended me; he told Fletcher Henderson I was a good rhythm guitar player who was happy to play rhythm all night long.

H: This was the beginning of your long association with Fletcher Henderson.

L: I was with Henderson about a year, left, and then came back for two more years in 1936 or maybe 1937. It was a pleasure to play with that band, primarily because of Walter Johnson, the drummer. He wasn't always the drummer when I was with the band, but when he was there, the band was my favorite.

H: Why was Walter Johnson so special?

L: Walter Johnson was just like Jo Jones. He played so softly, he didn't drown out the guitar, and the rest of the rhythm section could be heard all the time, just like in Count Basie's band. When he had to be loud, he'd be loud, but then he'd come right back down and the band would swing like mad. People don't realize that when a drummer plays soft, the other part of the rhythm section can help him out, assist him, because a band swings more with the entire rhythm section than if it's just the drummer all

by himself. When you can hear all the instruments—the bass, the guitar, and the piano—it's a better sound, and Walter was that type of a drummer. Walter influenced a lot of drummers, and I remember those nights when we were playing in St. Louis, it must be 1936 or so, and Jo Jones would come in all the time to catch the band but mainly to listen to Walter. He wasn't with Basie then, he was with Jetar-Pillars. He'd sneak out whenever he could to listen to Walter, the way he could play so softly. When Jo Jones went back with Basie, that was just the way he was playing. You could hear the bass and guitar all the time. When Jo needed to kick it, he'd kick it, but then he'd bring it right back down so you could hear everyone, and that was the secret to keeping Basie's band swinging.

H: Why isn't Walter Johnson better known?

L: Walter didn't take care of himself; he didn't treat himself too well. He drank, stayed up, and seemed to have a party every night. When we were at a hotel, if we wanted to go to a party, it was always in Walter's room. We'd get through pretty late and then he'd stay up later, but he was a wonderful player. I enjoyed playing with him more than any other drummer.

H: I'm sure you heard Chick Webb many times at the Savoy; how would you compare Walter Johnson and Chick Webb?

L: Chick Webb was the master. He was the king of the Savoy and a great salesman. With his drumming he could fall down soft but he would come back strong and do his soloing and selling the band. He was a terrific rhythm drummer. You could feel his playing; he didn't have to play loud for you to feel it. He was another guy that would play hard and then come back down

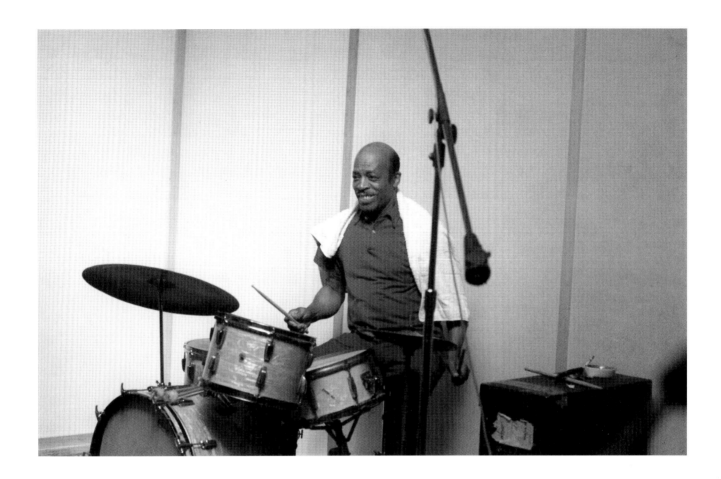

soft so you hear the rhythm section. Sometimes you would only hear [John] Trueheart playing guitar, and the guitar and bass were responsible for the rhythm section. Count Basie's a very smart rhythm man, and he listened to all these different bands and wound up doing the same thing; he realized when the drummer plays soft and you hear the bass and guitar, the band can swing, but if you can't hear them, the band doesn't swing that much. A younger fellow who understands that is Panama [Francis]— he's a natural. Panama can swing all by himself. He's just a natural when it comes to swinging, so when I had a job with him, I didn't have to worry about the band swinging. With a guy like Panama, I just play with him the same way I played with Fletcher Henderson—I'm more or less leading the beat, carrying the beat, with the bass. I'm listening to the bass all the time because I can hear what he's

doing because the drummer's soft and swinging; and that's what Chick did— he'd make different things with his feet and do all these different kinds of things like that and then fall back down and let the rhythm section play. Those were great days.

H: Tell me about your experiences with Lucky Millinder.
L: I'd been with Fletcher Henderson about a year, and after a lot of one-nighters we got to Cleveland, Ohio. Lucky Millinder had just taken over the [Mills] Blue Rhythm Band, and he had some problems and wanted to change some people. He couldn't get along with Benny James, for one, so he called and said he wanted Buster Bailey, Red Allen, and me from Fletcher's. He said he was trying to build up a different kind of band and he made us a good offer, so the three of us left the band in Cleveland and joined

Jo Jones, recording at WARP studio, 1973

Lucky in late 1934. At that time, when you left a band, nobody felt bad about it because everybody knew it was just because you were getting more money, and the band you left just replaced you. That band became a great band and I stayed there until, a couple of years later, Fletcher offered me more money than I was making with Lucky. Fletcher liked my playing enough to make me a good offer, so I left Lucky and joined Fletcher in Chicago. Chu Berry was in the band, Walter Johnson had come back, and the band was swinging like mad. It had some records that were selling pretty well, like "Christopher Columbus," and it was getting a lot of work. We were based in Chicago and mainly toured in the West, all the way to California; and then we'd come back to the Grand Terrace, and Earl Hines would take his big band out on the road. We did that for almost three years. We went everywhere in the West. We went to LA, all over the country—you know, one-nighters—and then back to the Grand Terrace for nearly three years. I finally quit the band at the end of 1939 and came back to New York.

H: You've told me about your favorite drummers; who were your favorite guitarists, your first influences?
L: I don't count those strolling blues players I'd heard in Virginia, but I did listen to Eddie Lang when I came to New York. He was an incredible player, easily the best at the time. I studied everything about him I possibly could; he was absolutely the master, and I would consider myself an Eddie Lang disciple. There was no better guitar picker than Eddie Lang. My all-time favorite rhythm guitar player is John Trueheart; he was my idol. He was the best rhythm guitar player I ever heard; he could swing the whole band, along with Chick—he kept

the [rhythm] section swinging, and it was the section that kept the people on the floor dancing. When bebop came in, there was no rhythm guitar; there was no rhythm section to make anybody want to dance. The piano would be playing stop-time, the drummer's dropping bombs, the bass might be going one, two, three, four, but there was no rhythm guitar in those bands, only guitar soloists.

H: Did you ever listen to any of the early electric guitarists?
L: I listened to Eddie Durham and Charlie Christian. When I heard these two guys, I thought about maybe playing solo guitar sometimes; up to then I was strictly a rhythm player. I first heard Charlie Christian in Oklahoma City when I was on tour with Lucky Millinder, in 1935 or 1936. We got to know one another pretty well because the band was there for a couple of weeks and we used to hang out together. What I noticed was that Charlie did a lot of downpicking, like Eddie Durham, and he wasn't playing any modern chords. In fact his rhythm playing was weak, and I suggested he should follow some of the ideas I had about chords. I have a system of 120 chords, and I think he listened to what I had to say. If he had come to town playing rhythm as weak as he was when I first heard him, he wouldn't have made such an impact. I don't know exactly what influence Eddie Durham had on Charlie—people have said a lot of different things—but I always liked the way Eddie played. He was a trombone player and he applied the way he played trombone to the guitar. I don't know if he studies with anyone or if he was just a natural player, but he was very melodic and had his own downpicking style. Those were the men who influenced me—Eddie Lang first, then John Trueheart for rhythm guitar, and Eddie

Durham and Charlie Christian for solo electric guitar.

H: You've left out Freddie Green.
L: He wasn't my favorite. He was a wonderful player, but I like someone who plays lighter chords. Basie was looking for someone a little heavier that John Trueheart. I think Freddie listened a lot to Allen Ruess, the guitar player who was with Benny Goodman. At one time it was suggested that I leave Fletcher and go with Benny Goodman, but for some reason I didn't want to leave Fletcher when they were talking about it.

H: One thing you've mentioned twice is the concept of the "strolling" guitar player. I've never heard the word used in that context. Could you tell me about this?

L: We called them strollers because these guitar players—sometimes old blues men or just regular guitar players—would wander from club to club, and we used to call it strolling. Years ago, you would just go strolling, wander in to a bar, and play. I've done it many times, but not very recently. I remember when the Brooklyn Dodgers won their World Series, everybody in Brooklyn was so happy, they were just beside themselves with joy. When it happened, Elmer Snowden and I were in a bar on Fiftieth Street; I was off cause my wife's mother was sick, and Elmer didn't have a job right then. I said, "Elmer, let's go strolling in Brooklyn. You get your banjo and I'll take my guitar." We got on the train and went to Brooklyn and went into bars, and I guess we came back with about two hundred dollars apiece that night, because when we walked in a bar, the customers were

The top of Lawrence Lucie's piano, 1996

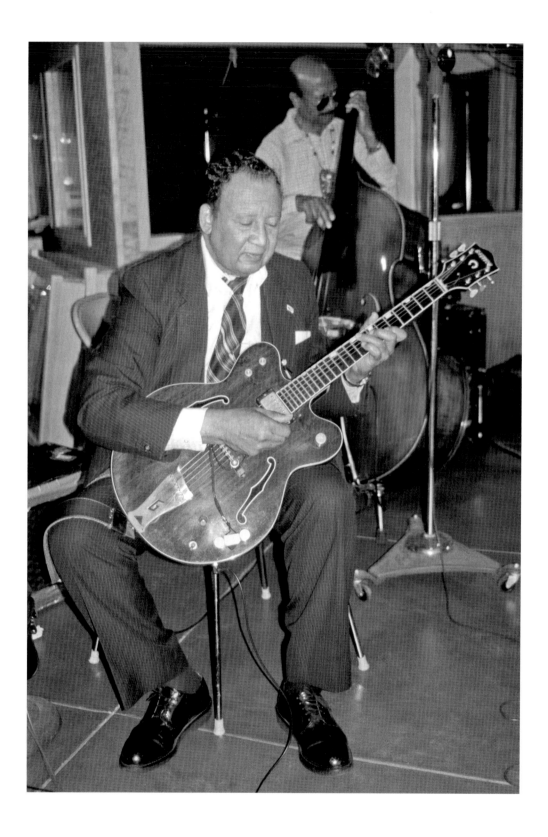

Lawrence Lucie, *foreground,* and Johnny Williams, Van Gelder recording studio, 1990

so glad to see us they gave us nice tips. We just went from one bar to another and played all night. Imagine a famous guy like Elmer Snowden doing that kind of thing; and I had been in all those big bands, but that night we weren't doing anything so we went out to Brooklyn

where everybody was happy because they won the World Series. I used to do the same thing when I'd have some time off with Lucky Millinder. There was a singer with the band named Chuck Richards; he was a wonderful singer. People called him the black Bing Crosby. He was inspired

by Bing and sang just like him. If we had some time off we'd go strolling over in New Jersey. We'd get on the boat and go to New Jersey and go from bar to bar—he'd sing and I'd play guitar. They didn't have much entertainment over there, and they were glad to see us. Sometimes we'd come back with a few hundred dollars.

H: Did you ever go strolling in Harlem?
L: Oh, no. Harlem was too hot at the time. There was something going on everywhere. Everybody had a first-rate professional band and even little places had jam sessions going on, with good musicians playing all the time. Harlem was busy—people with money from downtown coming uptown to spend it and have a good time. It was a very different atmosphere in Harlem than in Brooklyn or New Jersey. They didn't have anything in those places. If you went to Brooklyn or New Jersey, they were glad to see you coming, happy when you came through the door.

H: You mentioned little bars that had jam sessions. Did you ever go jam in the smaller clubs and bars?
L: No, I sometimes went and listened but I didn't jam much in those days. After I had those eight days with Duke Ellington, I was never without a job, usually with a good big band. We worked hard when we were in New York, and then we were on the road. When I was in New York, I was also busy with recording; I was asked to appear as a rhythm guitar player on a lot of different dates.

H: Could you give me an example of some memorable dates?
L: There were so many. I made Chu Berry's first date as a leader, many records with working bands like Fletcher Henderson, the Mills Blue Rhythm Band, and Benny Carter. I was also on

dates with Jelly Roll Morton—one of his last—and bands they put together just for recording like Red Allen's group, the Chocolate Dandies, and Billie Holiday with Teddy Wilson.

H: Had you ever worked with Billie Holiday before those recordings?
L: Maybe she sang a tune or two with Benny Carter, I don't remember, but I'd seen her around for a few years. I first met her at the Ubangi Club, the old Connie's Inn. That was the first club Benny Carter played after I joined the band. We played a show for a singer named Gladys Bentley, a girl who dressed up like a man. I seem to recall Billie came in one night and sang with the band. Sid Catlett was in the band when we started, but Cozy Cole was the drummer when the job was over.

H: Tell me about what it was like making a record with Teddy Wilson and Billie Holiday in 1935.
L: I think Teddy was coaching Billie a lot before those records. We didn't have any arrangements, we just made head arrangements in the recording studio. There was a format, an introduction, maybe a solo by somebody, so many choruses by Billie, maybe another solo, and then an ending. The song publishers provided the music—the tunes to be recorded—and we usually just had piano copies to work with. Teddy would play the song—he'd already worked things out with Billie—we'd get a feeling for the tune and that was it. Teddy, or maybe John Hammond, would pick out the musicians. It would depend on who was available. They were acting as contractors, just like I did when I produced rock 'n' roll records in the 1950s. These recording bands never played together. On those first Teddy Wilson/Billie Holiday

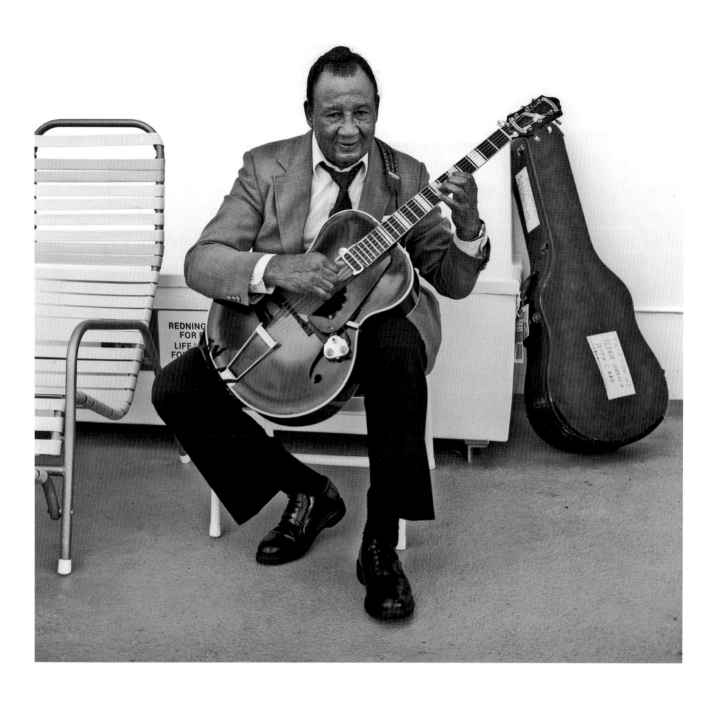

Lawrence Lucie, Floating
Jazz Festival, 1991

recordings, I was on some and John Trueheart was on the others. It was fun to play with those guys; Ben [Webster] and Roy [Eldridge] were on one date, and some Ellington guys—Johnny Hodges and Harry Carney—were on another.

H: You said earlier you quit Fletcher Henderson and came back to New York in 1939; was it because, once again, you had a better offer?

L: I had the opportunity to go with Coleman Hawkins. He'd just made "Body and Soul" and was very popular. He had a fine band and we spent most of the time playing at the Golden Gate Ballroom. It turned out the Golden Gate was the only steady job the Hawkins band had. I don't know why, because Coleman was a very good bandleader. He knew what tempos meant, the right tempos, and people seemed to like the band. Maybe he just didn't have any luck; there was

trouble at the Golden Gate—they were in competition with the Savoy. The band worked around a little, played some theaters in Baltimore and Philadelphia. I think the last place I worked with the band was a show at the Apollo—I can't be sure—but I was pretty sure the band wasn't going to last. That's when I joined Louis Armstrong. Louis thought I was a good guitar player and would fit in with his rhythm section, so they offered me the job. I took it because I thought it would be a lot more reliable than playing with Coleman Hawkins. I was right; I was with Louis Armstrong for almost four years, until the draft board caught up with me in Mobile, Alabama.

H: You went from Louis Armstrong to the army?

L: Yes. You see, I was older than a lot of the kids who were being drafted. I was thirty-seven and, because of my age, they told me I had to take what they called an essential job. Playing guitar with Louis Armstrong wasn't essential to them, so I packed my guitar and was sent to bus-driving school for one month. I spent the rest of the war driving a bus in Brooklyn. I couldn't wait for the war to end so I could get off that bus, because I knew I had a job with Lucky Millinder waiting for me when it was over. I quit the minute I could and joined Lucky, but it wasn't the same. He was having some problems—things were different after the war—so I quit and came back to New York. A few weeks later I ran into Joe Glaser downtown and he asked me to join Louis—he was organizing a small band—but I said I wanted to stick around New York for a while. It was a good choice; this was when I met my wife, Nora Lee [King], a wonderful singer. We were together for forty-seven years and never had to wonder where we'd get our next job.

H: Did you ever play with big bands again?

L: Once or twice. I met Don Redman one day in the 1950s, and he asked if I wanted to be in a big band with Louis Bellson. I took the job and we went to California to play at the Coconut Grove, but the band broke up before it played a note, and everyone was given money to come back to New York, but I stayed in California. My wife sent for her accordion, I got us cleared with the union, I picked up a drummer, and we worked on the West Coast for a while.

Lawrence Lucie's list songs for daily practice, 1996

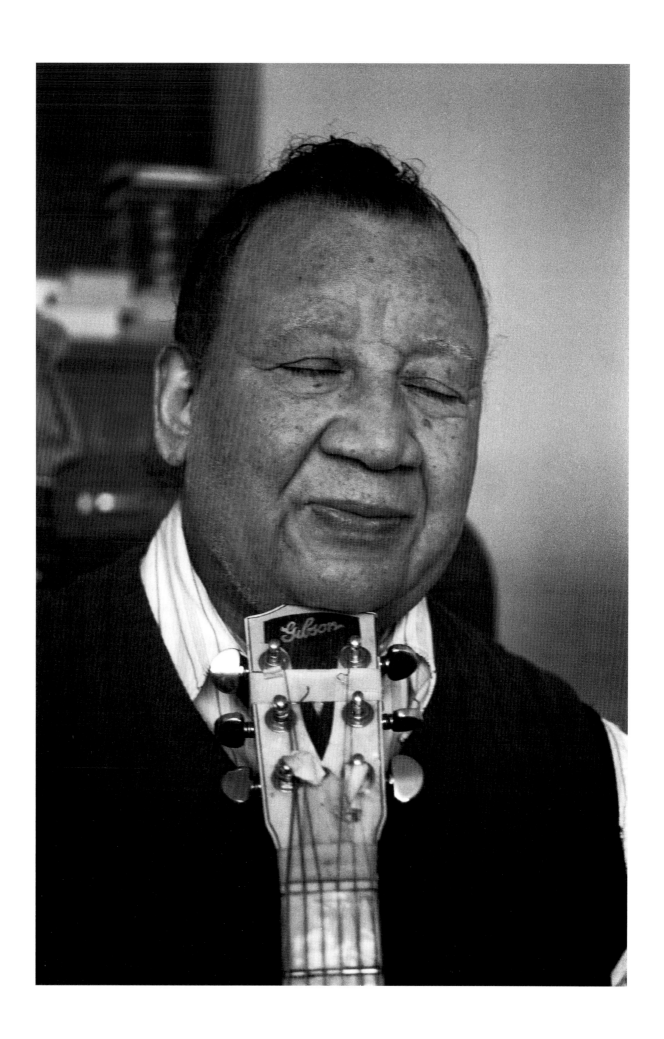

H: *Did you ever work in Harlem with your wife?*

L: I seem to recall I worked in a place on 125th Street once, but only for a short time. There wasn't any place for us to play up there. I had occasional club dates uptown but nothing regular.

H: *Did you ever visit any of the remaining uptown clubs after you began performing with your wife?*

L: Sometimes I'd go to Count Basie's because Wes Montgomery played there and I enjoyed his playing. I was from the big-band era and that's what I enjoyed. There weren't any of them playing anymore uptown or hardly anyplace else. I went from the big bands to a trio with my wife and into the recording studio. I got lucky with a few records in the 1950s. I had a hit, "Till Then," with four white Italian boys who called themselves the Classics. The problem was, they were crazy and broke up the act.

H: *You've had a very complete career in music. You've played with the best, always were employed, and you've taught young musicians. Things have changed a lot during the sixty-five years you've been in the business. What do you miss the most from the 1930s and 1940s?*

L: The big bands. As I said, I was a big-band player and that's the kind of music I enjoyed. I loved working with big bands, listening to big bands, and dancing to big bands. I used to go to the Savoy or the Golden Gate just to listen to the bands, and when I was playing in a band at a ballroom I'd enjoy listening to the other band when we were off. If I had some time off, I'd go to the Savoy. It was a great place to work, even if the pay was ridiculous, and it was a great place to visit. If you went there you couldn't help but dance—that's what the place was for—but while I was dancing I'd make sure I'd dance close to the bandstand, where I could hear better and check out what everybody was doing. If I was dancing to Chick Webb, I'd be checking out everything I could—the rhythm section, checking the tempos, listening to what Wayman Carver or Elmer Williams might be playing. Chick always had good players and it was a joy to listen to them. One reason his band was so good was that the guys weren't worried about the jobs; they were satisfied with what they were doing. They were playing at the Savoy and that was it.

26 March 1996

Opposite: Lawrence Lucie
listening to an old record,
1996

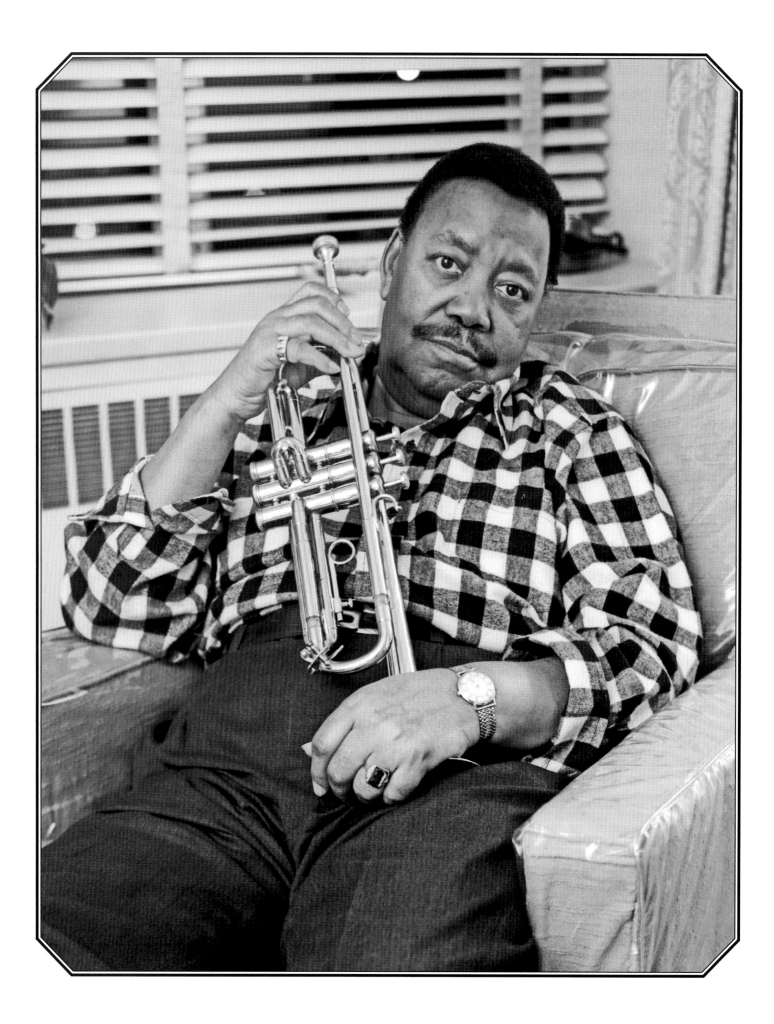

Jonah Jones

(b. 1908)

Hank: *Do you remember the first time you ever set foot in Harlem and who it was with and where?*

Jonah: Sure. The first time I played in Harlem at the Savoy Ballroom was 1932. I played there with a band led by Jimmy Smith at the Savoy. It's a long story. Jimmy was the bass player with the Missourians. This was the band Cab Calloway took over. The Missourians had come into the Cotton Club when Duke Ellington left. They flopped, and the management needed something to pep up the band. The guy who later became my manager, Sam Berk, worked with Irving Mills and booked the Cotton Club. Sam was the outside man. If they needed another girl in the chorus, Sam would find her. Irving Mills stayed inside but Sam was on the street. He'd heard Cab singing somewhere and thought he might be what the band needed, so he invited Cab to take over the band. And he did—he broke it up. I've read so many different stories about how Cab got in the Cotton Club, but this is how Sam said it happened.

H: *How does that all relate to you playing at the Savoy Ballroom?*

J: In a little while Cab was in charge; there was no more Missourians, it was Cab Calloway's Cotton Club Orchestra. Cab was great to work for—I worked for him a lot of years—but he told all the men in the band they could stay if they wanted to but they were also free to leave. Four or five of them left and got a band together, and the leader of the band was Jimmy Smith, the bass player. I'm living in Buffalo at the time and they asked if I'd like to come to New York to play in a band he was taking into the Savoy Ballroom.

H: *What were you doing in Buffalo in those days?*

J: I was just playing around town, mostly in a trio in a hotel. The piano player's name was Benny Johnson, and Jack Something was on drums. He also played saxophone but I don't remember his name. I was with Horace Henderson's band for a little while before that and with Jimmy Lunceford and a lot of little bands you never heard of. I played all around the Midwest.

H: *When you were with Horace Henderson, did you ever come to New York or were you always out on the road?*

J: No, we were being booked out of Cleveland and played all around, mainly

Opposite:

Jonah Jones, 1987

in Pennsylvania and Ohio. The guy who booked us sent us to Buffalo for two weeks in a club called Garden City, but when we got to Buffalo, there was no Garden City. We were in Buffalo with no job, so we tried to find something. Roy Eldridge was in the band—he was about was seventeen; I was a little older, maybe a year or two. I couldn't get over it; I couldn't understand a guy playing that much. None of us had ever heard anything like it. This guy could blow, man. I went to rehearsal one day and somebody said, "Take one, Jonah." We were doing "Nobody's Sweetheart," so I took one, but then somebody says, "You take one, Roy," and Roy started off and he must've taken about ten. Oh, man. Everything I did after that was just playing first, because I knew how to read good. I mean *good*, because when I was coming up as a kid ten, eleven years old, I was playing in a band in Louisville, Louis G. Washington's Community Center Band; we had thirty-five pieces, and I had to play an overture every Sunday, and I had to read it. "Poet and Peasant," "William Tell," that kind of thing. I got a lot of work because I could read so well. When we got stuck, Roy went with Speed Webb and so did I. Speed just happened to be around and he took us back to Cleveland. I had family in Cleveland— my wife's aunt and her brother, Russell Bowles, the trombonist. I stayed with them and I was neat, but it was hard because I'd been brought up never to take advantage of anyone.

So I finally left and went back home to Louisville. A little later I joined a ten-piece band in Cincinnati called the Troubadours—the brass section was Jeff Cass and myself on trumpet and Milt Robinson, who later played with Andy Kirk, on trombone. The saxophones were a guy named Johnny Henderson and another, George Levin. Both these guys played alto. It was a good band, but we were just kids. We used to go to Louisville to play battles with other bands—I remember a good one was with King Purdie and His Pirates. Then I got a telegram from the guitar player that was with Horace [Henderson], Luke Stewart. He could really play and used to tie up on Fifty-second Street at Kelly's Stable with Charlie Christian. I still talk to him. He went on back to Buffalo and is still there with bad arthritis. He can't even open his fingers, but he was a great guitar player. Roy [Eldridge] can tell you about him. He also had a brother could play like hell—Louisville had more guitars than anyplace, I think.

H: Now, tell me about going to New York City, playing in Harlem.
J: Those were great times, but now it's 1932 and I went to New York to play with Jimmy Smith. The first week the money wasn't too bad. I think it was about $22.50. We were also doubling around the corner in a theater called the Harlem Opera House and so it wasn't too bad. That paid about $28, so I'm taking in about $50 a week. That was nice taste but then they cut it to $22, and I said, Well, I have got to go back to putting up furniture in stores. They wouldn't put me back so I quit and went back to Buffalo, and I started playing around with Stuff's [Smith] band.

H: You'd worked with Stuff before, hadn't you?
J: Yes, around the time I was working with Lunceford. I liked Lunceford but Stuff kept after me to go with him, and one time when we came back to Buffalo from a trip we found our job had been taken over by some lady bandleader. So we come on back and there's no job and my wife's arguing at me about Stuff, who keeps offering me this and that. I

wasn't making much with Lunceford, so I finally quit. I told him it hurt because I liked his music, but I had a family to support. I went on to work with Stuff in a small band at a club called Little Harlem. About that time Lunceford got a break, and Stuff figured he could get a big break like that. So he organized a bigger band and I was back in Harlem; we came down and worked the Lafayette Theater around on Seventh Avenue and 132nd Street. This was about 1932, maybe 1933. Stuff wanted the Lafayette because he was trying to do what Lunceford did, but what he got was a job we called "around the world." That means you play New York Lafayette, then you go from there to the Lincoln Theater in Philadelphia, then into the Royal Theater in Baltimore. After a week in Baltimore we'd be at the Howard Theater in Washington, D.C. When you got four of them in a row, you call that going around the world.

H: Then you'd come back and start all over again?
J: No, you'd come back and start scuffling, doing one-nighters, until finally the band broke up. We all went back to Buffalo. So this time when I got back, here comes Lil, Louis Armstrong's wife, and she wanted to get a band together. So we had a band and were stuck, so we all went with her. She called me King Louis the Second. We went on the road, but the money wasn't enough. When we got to Detroit, we were only doing one-nighters, but the Cotton Pickers were breaking up so we picked up three weeks' work. We got the job because of George Clark, the saxophone player; he was a friend, so he recommended us. We took the three weeks, got our money, and went back to Buffalo. I was lucky; there was always work because I think Peanuts Holland and I were about the only trumpet players in town. There were

others but we were the ones who got the work. There were two or three places there that carried bands, so you couldn't be out of work. Al Sears had a band about that time.

H: Didn't you hook up with Stuff when you got back?
J: Yes, I was in town and he called me up. He said, "What you doing?" and I said, "Oh, just looking around." He said, "Well, come on over here to the Silver Grill." So I hooked up with Stuff at the Silver Grill. Six pieces—Stuff and I with four rhythm. It was going pretty good. We could do anything we wanted to do. The money was twenty-five dollars a week, but we could go in and out the refrigerator anytime we wanted to. Take a chicken out of there and take it home with you if you wanted to. The owner didn't care, the place was always packed because he only charged fifteen cents to get in, and everybody loved us, brought us drinks up on the bandstand. We were real popular, and one day Ben Bernie with Dick Stabile came into the Buffalo Theater. One night after work they were making the rounds and they heard us. About the same time Riley and Farley had a big hit with "The Music Goes Round and Round," and I guess they needed somebody to replace them. They came in, heard what we were doing, and said, "How would you guys like to go to New York and play the Onyx Club?" They said the club needed a group just like us. Stuff and I had a good relationship; we were always clowning around, you know. They had treated us nice at the Silver Grill and we didn't want to just walk out, so we told Stuff to go to New York, check it out, and get some guys to replace us. The manager of the Silver Grill had said to me, "I'll give you fifty dollars a week if you get in front of that band." He said the rest of the band would get forty dollars. It was a raise

from twenty-five, and I was right there at home. I only lived a block and a half from the place—but he wanted me to sign a contract.

Stuff called from New York—he was staying at the Woodside Hotel—and asked if I would be ready to come to New York and open the next week, Tuesday, February 4, 1936. Now I had two jobs. The guys in New York wanted us, and so did the man in Buffalo. The people in New York wanted the same band they'd seen in Buffalo—no substitutes. Stuff had told them he could get even better musicians, but they just wanted us. I went to the union man; he was a tough guy and knew all the rules. He said, "Well, I've been teaching you guys the rules in the book, but this is out of the book and you got yourselves all mixed up." Then he told me, "You want my advice, you go on down there and you'll be all right." So we went down there and we stayed for about sixteen months without a night off, and we liked it. We were young, and we liked it. We found Cozy [Cole] after about six months—we liked him, so we put him in the band, and then a little later on we went on to California to do a picture. We didn't like California; we had a six-month contract but quit after two. It was too quiet, nothing happening, so we came back to New York. New York was open all night. People were walking the street all night. Sometimes we'd find a place and jam all night and then find another place if the first place closed. Sometimes there was nobody there, nothing but a piano. Stuff would sit on one side; I'd sit on the other. We'd play and play, but sometimes it was mostly to drink whiskey, because we were both whiskey lovers.

H: These places you'd play with Stuff, were they uptown or downtown?
J: Uptown, that's what I'm talking about. After we would finish playing Fifty-second Street, we'd go uptown. And not only Stuff, but everybody.

H: Which were the places you liked the best?
J: The good places, the ones you could go to just jam. There were some places where you could go into and drink and play all night. After-hours joints. This guy I knew had a bar. He knew what he had to do to get wired. He got a good drummer, a good bass player, a good piano player, and he didn't have to worry about it. The word would get around, and pretty soon we'd all be up there. So he did that and sure enough, bands started coming. Some nights we'd have thirty pieces in the band.

H: And the guy who owned the bar didn't pay for any of it.
J: No, and we didn't even care. All we wanted to do was blow, you know. Then someone talked, and the union got into it. But it was great. We just roamed the streets all night and then go over and blow at the Paradise.

H: Tell me about the Paradise.
J: It was just a joint at 110th and Seventh Avenue, and it was a ball. The place was always loaded. Breakfast dances, you couldn't even get in. Some of the others were joints on side streets. You'd go in there and wouldn't have anything but a piano in there, but you could blow, you know. Over on Seventh Avenue they had a club called the Hot-Cha. Nothing but a bar. It had a bandstand hanging down from the wall. I think it's torn down now.

H: No, the building's still there but it's not open.

J: There was a place called the 101 Ranch Club on 139th. I used to play there. There were so many places where people could go and blow when you'd get off from work, because that's what everyone liked to do. Cozy and I used to walk around in the daytime because we usually didn't start playing till ten o'clock. We'd be walking around and he'd say, "Sure'll be glad when ten o'clock comes around." I'd say, "Yeah." We played when we were getting paid for it, and we played when we didn't. I would have liked to play just for myself all the time, but you learn things as you go along, and later I settled down and did very well. I got tired of blowing all the time. A lot of times now I can't really blow the way I used to. When I first came to Harlem in 1932 with Smitty it was different. The guys showed me around. I had a room at 66 St. Nicholas Place. There were rent parties and I ran around all the time. When I came back in 1936, it was more like steady work. I still ran around, went to places I could blow, but we had our favorite spots. Even when the work was steady, I ran around too much. I used to hang out all the time, and I probably haven't gotten over it yet. I started feeling bad and went to the doctor and he told me my blood pressure was high; he said I should lose a little weight, get some of the flab off my diaphragm. I lived hard in those days and it got me in trouble.

H: Tell me about your days at the Onyx Club with Stuff and the band.

J: There were so many clubs, so much happening. There was Leon and Eddie's—that's where Buddy [Rich] was playing with Eddie Condon—and across the street you had the Yacht Club.

Fats Waller used to play in there. Then you had the Famous Door. That was later, because the Onyx was the first one you ran into when you turned off Sixth Avenue, coming down the street. When you turned off Sixth, the first one was the Onyx Club. Then you had Famous Door, but then after about a year, the Onyx moved from number 62 to 72. They moved up, got a larger place, because it would be jumping in there. Everything was jumping in all the clubs. At the Chicken Shack there was fried chicken and stuff like that. It was jumping. It was better in the 1930s than in the 1940s. By the 1940s it was into a girlie phase. The music was still there but it was different.

H: Were you the only band at the Onyx Club at the time?

J: No, sometimes we'd alternate with the Five Spirits of Rhythm and sometimes there'd be a white piano player. Billie Holiday was in there a lot. I made records with her then, back in the days of "I Cried For You" and "These Foolish Things." Teddy [Wilson] was in charge of the band and he picked out all the men he wanted. I was scared to death the first time I walked in the recording session. I'd made records with Stuff about six months earlier, but this was different. Johnny Hodges was there, and so was Harry Carney. At least Cozy was on drums, so I felt a little better. Benny Goodman and Ben Webster were on a date a little later, the first time I recorded with them. And Billie was so wonderful. These were good times. It was great on the street in those days. You never knew what was going to happen, who would catch on, who wouldn't. Remember John Kirby? He had a long run on Fifty-second Street and some big hits, but he just got lucky. He had Charlie Shavers, Buster

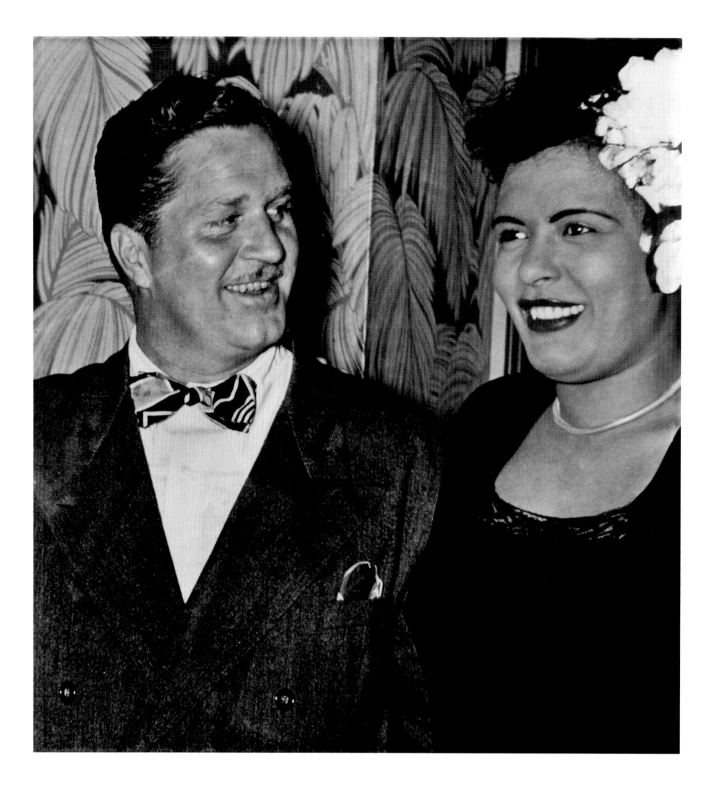

Billie Holiday with Jimmy
McPartland in the 1940s

Bailey, Russell Procope, Billy Kyle, and
O'Neil Spencer, but the band didn't really
ride until a girl from Pittsburgh came in
as an intermission singer. Her name was
Maxine Williams then, but pretty soon it
was changed to Maxine Sullivan. Helbock
[Joe Helbock, the owner of the Onyx
Club] said, "I think if we take this girl
and put her in front of the Kirby band,

it'll move." So he put her in there, and
away they went. She'd come in singing,
"You take the high road and I'll take the
low road," and people liked it. It caught
on and they had some hits. It was a great
little band, but they'd have never made it
without Maxine Sullivan, and it was just
lucky they came together. I never knew
why they broke up because it was such

a nice band; they all had white tails and looked so nice. I used to run into them in Chicago at the Ambassador Hotel. They were playing out there when we were playing the LaSalle Hotel.

Yeah, the street was great. Ralph Watkins ran Kelly's Stables. That place jumped all the time. Art Tatum used to play in there, and across the street was the Hickory House. Joe Bushkin played there with Joe Marsala and sometimes the Three Ts—Trumbauer, Jack and Charlie Teagarden. All these different bands were playing in different clubs, and then we'd get off and have our breaks at the same time. We'd be walking around or hanging out on the corner, you know, talking and goofing around. Of course, everybody was smoking pot. Pot was nothing then. That was the musician's thing—but the other stuff, the hard stuff, well, I don't know when it came, but when it did, it messed everything up. We had so much fun playing in those days, playing anything you wanted to play, and Stuff had an ear like I never heard before. He could hear something once and— boom! that was it—he had it forever. He'd have a tune and would say, "Just follow me," and we did. That's the way he was. He was a crazy rough-and-tumbling guy, but he played that violin. I never heard anybody play like Stuff; to me he was the greatest violinist—jazz violinist—that I've ever heard.

H: Tell me more about Stuff Smith.
J: I'd known him for years; we first worked together in Buffalo. I remember a time in about 1934 we had a job there, working in a tough place. The manager had a lot of rules—like no drinking, no bringing any red whiskey bottles in the place, don't be sitting at the customer's table, and don't be at the bar. When you're finished, go out back, and after a break get back on stage. We broke all

the rules the first night. We were always sitting around. We partied, and the manager, Mr. Smith—I always called him "Mr. Smith"—says, "Gentleman, I told y'all not to sit at the table and things." I said, "Well, talk to Stuff, he's the boss." He said, "I don't want to talk to him." He said, "I had no business for months, and you guys come in and you pack the place." I didn't have anything to do with the business part. I just got up there and played what I was supposed to play. That's the type of guy I am. I'll cooperate with the people, but Stuff would only do what he wanted to. The manager wanted us to play mellow stuff during dinner, so the first thing Stuff would call is "Stompin' at the Savoy." I said, "Stuff, the man told you don't play that. Play something nice and pretty, pretty mellow." He said, "Oh, the hell with that man, I want to play what I want to play." Stuff would do all kinds of crazy things. He stacked up whiskey bottles in his locker, and then some way he got hold of a tear-gas gun. We were back in the kitchen one day, and he shoots it off. Shoots the tear gas and starts laughing his head off. The waiters came in for the food and they can't go back out because they're crying, tears running out of their eyes. Now the people are waiting for their food, and the hostess—a little Dutch girl dressed in a blue and white bonnet—comes in to see what's going on. Then she tells the manager about the tear-gas gun, that all the waiters and the cook is crying. He called me and said, "Jonah can't you talk to him?" I said, "No, I've been knowing him for years; I've even visited him in a crazy house." I remember a time in Buffalo when I'd just hooked up with him, I was walking down Michigan Avenue and I saw a lot of people standing at the corner and just looking up. There was a barbershop in a building there,

Jonah Jones, *left,* with Pinky Tomlin and Maureen O'Sullivan in *Thanks for Listening,* 1937

and Stuff had gone in to get a haircut but had to wait, and he just couldn't stay still. He always liked to keep moving. So he went upstairs, opened a window, and got out on a ledge. When I showed up, he was walking out there, tiny little steps, one foot in front of the other foot, and everybody was looking up at him. I yelled up at him, "Hey, Stuff, come on down, man, what's going on, are you crazy?" He looked down at me and said, "Hey, Jonah, how you doing?" We finally got him down and they put him away. About three days later, I went to see him and he had a straitjacket on and everything. He said, "Jonah, get me out of here. You know I ain't crazy." I said, "I ain't too sure about that."

H: What was it like to play with Stuff in New York?
J: We started at the Onyx in 1936 but it took a few months for us to catch on. "I'se a-Muggin' " and "You'se a Viper"

were hits, and the people kept coming in. We went to California in 1937 and that's when Maxine Sullivan and John Kirby were so big at the club. When we came back in, we weren't so popular and Stuff broke up the band for a while, but I played with him off and on until about 1940. He could always get the band together to make records. Sometimes it was tough to play with Stuff because he *was* crazy. You had to be high with Stuff because he'd fine you if you weren't high. I'm not kidding. He'd get an advance and then drink all day. He'd still be drinking when he got to the club and kept drinking and smoking all night. He was always high before he'd start playing. One night Cozy and I grabbed him and said, "Look, man, come down one night, because you've been high six months straight." We'd been high almost all the time too, so we came down with him. One night he started playing and it didn't sound right. I don't know what it

Stuff Smith outside the
Onyx Club, 1937

was, but something didn't sound right. We finished the song and Stuff said, "Let's take another one right about here." So he started it off and we finished it. He said, "Something's wrong." And then he said, "Jonah, you high?" I said, "No, I'm taking it easy." Then he said, "Cozy, Clyde, you high?" But both of these guys were straight. That was it, Stuff said. "Everybody get high on the next set or there's a ten-dollar fine." That's the way it was with Stuff.

H: It sounds like it was a lot of fun hanging out with Stuff and playing in his band, but it must have taken a toll on you. When did it start to catch up with you?
J: Well, like I said, Stuff was high all the time, and like I said, that's the way it was on the bandstand. Then one day in 1940—I was in Chicago—something

happened. One morning I woke up. I'd been asleep about three hours and I woke up. My heart was fluttering. I ran downstairs to the desk and told the clerk something was wrong, and he told me to not even bother with clothes, just grab a robe and he'd get a car for me. I did what he said, just grabbed a robe, and he took me to the doctor. The doctor examined me and said, "I'll tell you just what you've been doing, and you better stop it. You've been drinking that 100-proof whiskey and that speeds your heart up and then you're smoking pot on top of that—that slows you down. The two of them have been working against each other for a long time. There's nothing wrong with your heart—you don't have a murmur— but it's tired. It's just making it, and if you want to make it now you've got to stop all of that fooling around with that stuff and eat right and behave yourself. You've only

· TURN OVER ·

Onyx Club flyer, 1936

half, we were feeling so good. Stuff would holler, "One more, Jonah," or he'd holler at Cozy to do something, and then we'd start up all over again. I remember one night we were on the radio and Stuff called for "Stompin' at the Savoy." It was only a half-hour broadcast but at the end of the half hour we were still playing "Stompin' at the Savoy," so the announcer comes on and says, "You've been listening to Stuff Smith and he's still playing 'Stompin' at the Savoy.' " And you know what we did? We played it for another half hour. So I was playing all this stuff and surrounded by guys smoking pot and drinking all the time, and they were on me, and one of those gangsters gave me a beer. Well, that was all right, but the next night I had a beer and a drink of whiskey, but no more; I told them what the doctors had said, that I couldn't drink and smoke on top of it. Everybody said to forget it, that those doctors didn't know anything, so we'd all go outside and smoke. Well, everything was still all right but the next night I had three drinks, and after three hours I was asleep and the heart started again.

I ran downstairs and got me a taxi. I didn't bother the manager this time; I just went right to the doctor. He took one look at me and told me to get out of his office, that he never wanted to see me again. He said, "I know I wasted my breath, and I don't need your money. There's about twenty people out there— see those people? They're trying to get well." I went and sat in that place until he waited on all those people, and he looked out and said, "You're still here?" I told him to please believe me, I really wanted some help. He said, "Look, I'm going to try this again. Now you never take a drop of whiskey and never pick up none of that pot." That was it. What he said stayed in my mind. That was in 1940 and I haven't had red whiskey since.

been eating barbecue, drinking whiskey, smoking, and then going to bed." He said I had to cut it out and he gave me some pills. I did what he said; I cut it all out and took the pills and pretty soon I'm feeling good, and I went back to see him, told him I was feeling good. He examined me and said I was all right but I had to take it easy. But you see, I'm still playing with Stuff, and that isn't so easy.

Lots of things can mess you up, just stuff. There were some gangsters who were always hanging out at the Three Deuces in Chicago. One night, a Saturday night, we were really in a groove and everybody felt good; we were playing and nobody wanted to stop. We'd play an hour straight, maybe an hour and a

H: Wasn't it about that time you joined up with Cab Calloway?
J: A little later. I finally quit Stuff in 1940. I saw too many things and I wanted to stay straight. I hooked up with Benny Carter's big band. We were doing a night here and a night there. A lot of work on the road. I didn't like it much but I sure liked Benny's music. I was only with Benny a few months and when it looked like the band might not last much longer, I joined Fletcher Henderson. In fact, almost everybody from Benny's band joined Fletcher. He was putting a band together to play at Roseland, and I liked to stay in New York City. That was when Cab asked me again to join his band.

H: Had he tried to hire you in the past?
J: Oh, sure. He called me at least three times. He called me the first time in 1938 and I just couldn't make it. A year or so later he called again, so I went over to see what he had to say. He had a good band—the guys were really clean—but I knew I wasn't going to get to play twenty choruses. I told him I'd think about it. But I didn't do anything about it, but now it was 1940 and I was at Roseland with Fletcher, making about fifty dollars a week, and they took out a few bucks in taxes. Cozy was talking with Cab about this time, and he came back and told me he would get a hundred dollars a week over there. That sounded good to me, and even though I didn't like some of the music, it was getting better, especially after they got Buster Harding. Buster Harding made that band sound five times as great as it was. I remember Joe Thomas and I were in a bus one night, and we heard a band and didn't know who it was. You know how it was—you could tell all the bands because you're a musician and you've been in them, but nobody could figure it out who it was, and those cats were blowing. Finally the announcer said,

"Cab Calloway's coming to you from Chicago's Sherman Hotel, and the next number will be so-and-so."

The band was a lot better than I remembered, and the bread was even better, so I decided it was about time to make a change. I told Fletcher I was going and he said, "You're not going to blow with him like you do with me. Here, you've got all the singers, all the playing, and all the solos." I said, "I don't know, that's my man over there, and he said it's pretty good." But Fletcher was persistent; he said, "No, it's not right for you. I've been in the business a long time, and you ain't going to like it over there." So he talked me out of it. Then I had to call Cab and tell him I'm sorry but I just can't make it. He said, "What's wrong this time? This is the third time you've done this to me." I was in a fix, so I made up a story that I borrowed two hundred dollars from Fletcher and I had to stay there and work it out. He said, "Don't worry. I'll have you some money there in the morning, and then you can pay him off." Soon as the next morning strikes, Western Union brought in a check for three hundred dollars, and I told Fletcher I had to go, that I wanted to try out the band and see if I liked it. He said, "Anytime you want to come back to my band, you've got a job here."

H: That was the start of an eleven-year run with Cab. What was it like working with Cab in those years?
J: I never did understand why Cab wanted me so badly. I don't play that much horn; I guess it's because I carried myself, and then I think sometimes different people like different things, you know. Some like melody and some people

like swing. Some people like Dixieland, and some people like rock 'n' roll, some people like bebop. So you can't say—I don't what it was, why he wanted me so bad, but he sent me three hundred dollars and told me to meet up with the band at the Stanley Theater in Pittsburgh.

H: You didn't just show up, did you? I thought all the guys in the Calloway band had perfect uniforms and everything.

J: Sure, man. When you join Cab's band, the first thing you do is to go to the trunk company he does business with, and they supply you with a H&M trunk, the best trunk at that time; I know it was good because I threw it around a lot for eleven years. I didn't have to pay for it—just signed my name and then they printed my name on it in large letters. The man told me that when the train pulled out, my trunk would always be in the baggage car waiting for me. I'm jumping ahead a little, but Cab told me I was going to be in berth five, to put all my clothes and stuff in the trunk, that anytime I needed something it would be in the trunk and just to go look in the baggage car. All the trunks were in the baggage car, each one of us had our own trunk; and sometimes we didn't stay in a hotel, we'd just stay on the train, get dressed in the Pullman car, go to the job, and when we were finished playing, we'd come back and get in the car, put on our pajamas, and go to bed. You asked about uniforms. When I went with Cab I left measurements with his tailor. Anytime he wanted a new uniform, he didn't ask you anything about it. He'd just tell the tailor what to send in. You'd go back to the baggage car; you'd look around and see a whole rack of new uniforms in it. He didn't say anything about it. He didn't tell you when to put them on or not. He'll tell you when he gets ready, you know, but he

liked to dress. Cab was sharp. He'd come out in all white. Then the next thing, an act would come out and he'd be back in powder blue. Powder blue shoes to match the suit. Powder blue shirt. Powder blue necktie. Everything is powder blue. Next time he comes out—the third time he comes out—he'll have all tan. Tan shoes. Tan shirt. Tan bow tie. Everything matched, you know, and he always looked good. And another thing about Cab—when it came time to pay, they were looking for you. You didn't have to look for them for your money. You could be down the street somewhere and the manager, Hugh Wright, would find you. He'd be hanging low with your bread in his hand.

H: You joined up at the right time with Calloway. It was one of the best bands he ever had. There were eight or nine certified star instrumentalists in the 1940 edition of that band.

J: Yeah, I walked onto a bandstand with Dizzy and Lammar Wright. Tyree [Glenn], Quentin [Jackson], and Keg [Johnson] were on bones; Chu [Berry] and Hilton [Jefferson] were in the sax section; and the best rhythm section in the world with Cozy, Milt [Hinton], and Danny [Barker]. It was a great band and we had a good time. We had the Cotton Club Girls and the Cotton Club Boys, tap-dance acts—three guys, and sometimes Bill Bailey, Pearl's brother. He'd always break up the house. Sometimes Cab would have a comedian and other times another singer, like Alice Andrews, a beautiful singer who added even more class to the whole show. Her voice was so beautiful. The only problem was that when we played these shows, there wasn't any place for the band. We opened up, played an overture, and that was it. Sometimes Chu Berry got a spot, either by himself or with the Cab Jivers.

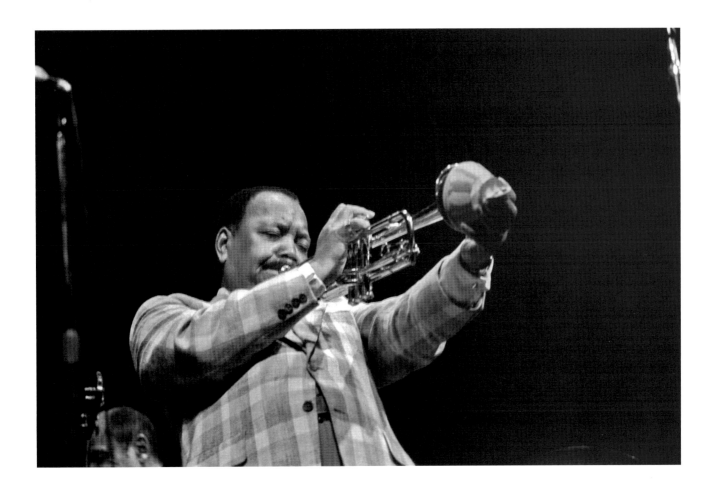

Sometimes Dizzy would get a feature but not very often. When he did get to play, he just stood there and played it, nothing very special. Sometimes I'd get to play if Cab made a mistake—he'd have me down front and maybe forget some words and would sing, "Here come Jonah on his trumpet," and I'd do six or seven choruses of swinging blues.

When we weren't doing much, we used to talk and cause a little trouble—act up, you know. We used to shoot paper wads during the show; we'd be rolling these paper wads. So when the Cab Jivers would come down for a feature—that would be Chu Berry, Tyree, Danny Barker on the guitar, Bennie Payne on piano, and the drums would be Cozy— we'd be shooting paper wads and spitballs at them. Nobody would be saying anything because it was mostly fun. Dizzy was a real character back in those days.

He really liked to clown around. Cab saw those paper wads on the stage for a long time and he never said nothing, but one night up in Hartford, Connecticut, we were playing the State Theater and he came out and said, "Listen, I'm getting tired of all this. Are you never gonna grow up and be a man?" I don't know why he spoke up, but Diz said, "What you talking about?" Then Cab got mad and yelled, "I'll tell you what I'm talking about. I'm talking about the paper wads." Before we knew it, they started getting into it. We grabbed for Diz, but he got away and they started fighting and Diz cut Cab. We got them apart but Diz got fired. I felt terrible because we'd all been doing it. I don't think Dizzy even threw a wad of paper that night, but I knew I threw one. I went over to Dizzy and told him that Charlie Barnet had been trying to hire me for six months, that I'd talk

Jonah Jones, Floating Jazz Festival, 1983

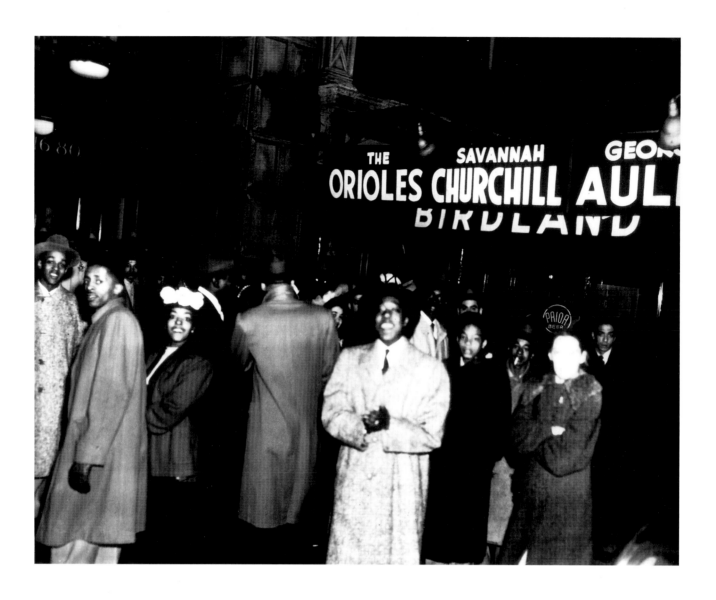

Outside Birdland, 1949

to Barnet, and the next day I called him. Now, the fight was on a Sunday night, and I called on a Monday. I told Charlie I couldn't make it but Dizzy could, and Charlie said, "He's the guy who cut Cab; I don't want that guy in my band." I told him that it wasn't Diz who threw the spitball, that Cab had fired the wrong guy, but all Charlie could do was go on cussing Diz, and he wouldn't listen to me. Nothing I could say made a difference, so I gave up.

H: Well, I think things worked out just fine for Dizzy.
J: Oh, sure. It was better for jazz that he left the band. He'd heard Charlie Parker with Jay McShann a few months earlier

and thought it was the greatest thing he had ever heard in his life. He saw them playing somewhere and Diz told me, "That's it! That's it! That's what I've been looking for. That's it!" You see, before Diz heard Parker, he played something like Roy [Eldridge]—not exactly, but something like Roy. It was then he started to practice real hard. Every day he'd go downstairs between shows and take Milt with him. They'd work on tunes, and sometimes Milt wouldn't know what note to hit so he'd run a chord against it. They'd finally get it down without it sounding too bad, but sometimes it sounded a little harsh. One day he was down there practicing and made a great run into "Some of These Days." Cab

heard him and said, "What is that? Look, I don't want that in my band. Don't blow that in my band!" So Diz stopped, but next show he got up and did it. So then Cab said, "Give that part to Jonah." Diz and I were pretty tight, so there wasn't a problem when they gave it to me, but I wouldn't fool around with it. I was going to play it my way, but on the sly Dizzy started showing me things. I tried it his way one night and Cab said, "If you play it like that, Jonah, I'm gonna fire both of you!"

H: Did you spend much time with Dizzy after he left the band, when he started to associate with Charlie Parker?
J: Not so much. Dizzy started hanging out more with Charlie and other guys, and they started playing until they got it down. They got it down and knew what they wanted to do and then they had to sell it. I don't think Charlie could sell it as well as Dizzy because Dizzy could clown around, but he was slowed down by the trumpet. It was harder to do what he wanted to do on a trumpet than on a saxophone. He really worked at it, and I was so happy for him because I knew all the changes he went through to get where he was, to be able to play his music. He could never have done it with Cab.

H: You enjoyed the years you spent with Cab, despite some of the limitations?
J: Sure. It was hard to speak up in Cab's band; Chu [Berry] would speak up more than anyone else, but nobody spoke up much in Cab's band. Cab would always say he didn't worry about any clique because he'd fire the clique. I think he was a great guy. You see, I was the guy who was coming off of getting high all the time, and Cab's was the place to do it. You better not do it in there. No, you better not do it. One time I asked Cab why he was so hard on a guy that smokes

pot. He said, "I sing all of those songs about going down to Chinatown, get fifty bongs around, and smoke your joe. People think I use that stuff because I sing all of those dopey songs. The first time they catch one of you, then there goes my name." Cab said he was not going to have it, and he'd be all the way across the stage if he thought anything was funny, and he'd be looking to see if he could smell anything coming out of someone's room. He didn't care who you were—if he caught you, you had to go, and he wouldn't even give you no two weeks' notice. He'd give you two weeks' money and you take it back to New York.

Cab was always right with the money; he would give us a raise, and as time went by he gave you another raise. Every August you got off for four weeks and he gave you a four-week salary. Every Christmas and birthday, no matter where you are, you get two weeks off with pay. I never heard any other band doing that. So I said, "Yeah, this is nice. I'll probably die here because I ain't going nowhere." Then in 1952 we were playing Birdland. He said he was breaking up the band, that anytime he couldn't get his guarantee, it's over with. It was getting too rough out there for big bands. Cab formed a small group, a quartet with Panama Francis, Dave Rivera on piano, and Milt Hinton. We did that for a while, but it was never the same.

H: The last time you played with Cab's big band was at Birdland?
J: Birdland—and we played there for a week.

H: When you got to be a big star in the 1950s with all those hits and everything, did you ever go back uptown and play, even at the Apollo?
J: After I got lucky with the quartet, I never went back uptown again because I

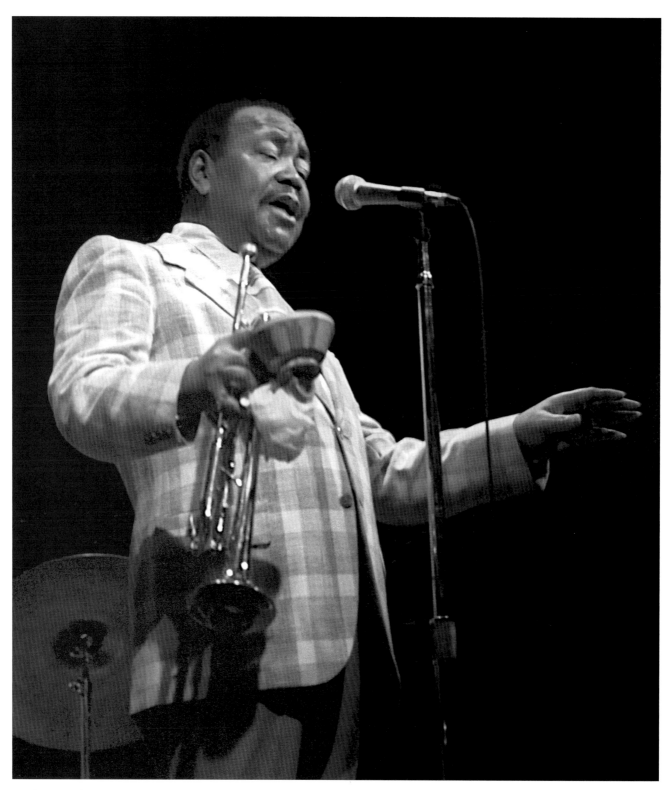

Jonah Jones, Floating Jazz Festival, 1983

didn't think I should be playing uptown. I was trying to keep straight and I knew all those guys and played with them when I was coming up. I didn't want to just blow, blow, blow. I wanted to play what I felt, and I was trying to keep my family together. I played what I liked and I know a lot of people didn't like that, but if they didn't, that was all right with me. If you don't like what I'm playing, forget about it. After I made all those albums, people wanted to hear those songs; they'd come in and want me to play those tunes just like I did on the album, and if I played them differently, they'd ask why I did this or that. I'd just tell them I might play it a little slower or faster, a little longer or a little shorter. Whatever I felt like. One night at the Carlyle Hotel a lady came up to me and said she had all my albums and she knew I was taking a breath in the wrong place on "Rose Room." I just fell out, and so did my drummer. But we had a lot of fun. I had a lot of fun before I had so much luck with the quartet. After I left Cab, I had some success in Europe; Cab even wanted me to work with him in Europe in *Porgy and Bess,* but I came back and stuck with Sam Berk, my manager, and the quartet. It took off after a year or so, and for ten years or so I rarely had a day off. Made all those records for Capitol and Decca. I was so busy, I couldn't have gone uptown if I wanted to.

15 January 1987

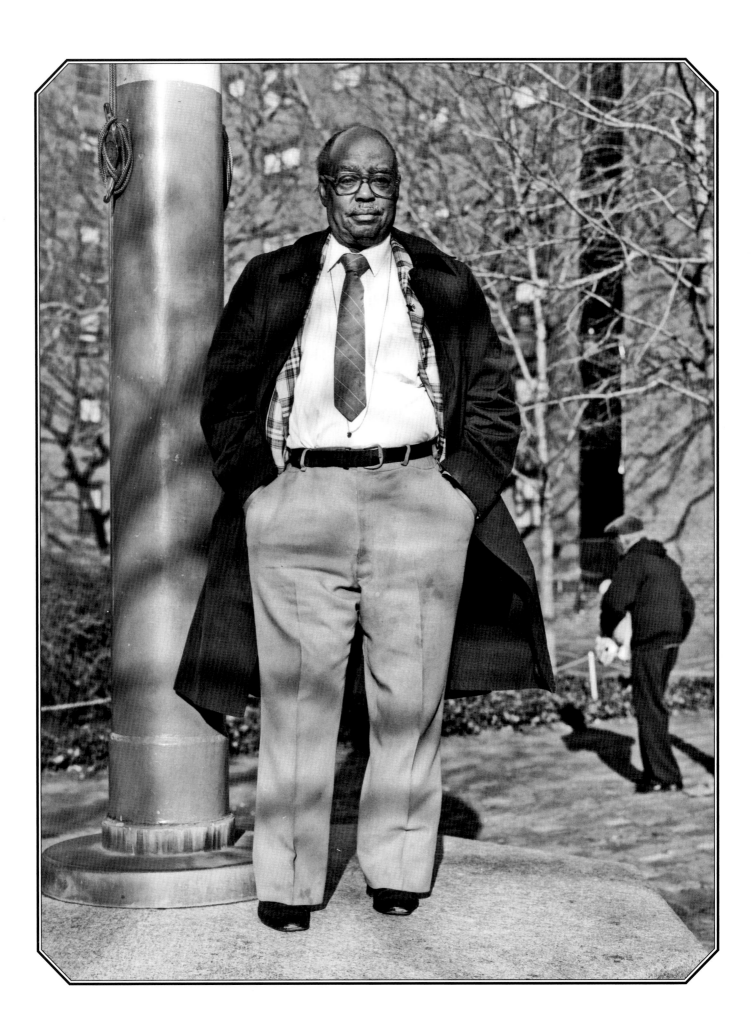

Sammy Price

(b. 1908)

Hank: *When did you first come to New York City?*

Sammy: I came in 1937; I was almost thirty years old but I'd traveled all over the country. I was born in Texas—Honey Grove, Texas—but lived in Waco as a child and finally in Dallas. I have total recall; I can remember everything from those years. I can remember hearing Blind Lemon Jefferson singing on the courthouse steps in Waco. This was in 1914; I was five or six years old. I also remember him in Dallas. There were many blues singers in Dallas in the 1920s, but Blind Lemon was more than just a singer—he was a blues artist.

H: *Tell me about your early musical training.*

S: There was a neighbor in Dallas in the early 1920s who let me play her piano in exchange for odd jobs, but the first person to encourage me was Mrs. Portia Pittman; she was my first and only piano teacher. She was the daughter of Booker T. Washington. She had a son, Booker, who was about my age. He played around Dallas and in the Midwest.

H: *How long did you study with Mrs. Pittman?*

S: Just long enough to learn some fundamental things. I don't think Mrs. Pittman thought I was her best student. She thought I was more of a natural player than someone who would become a great pianist.

H: *You seem to have known or at least listened to many blues singers in and around Dallas. Did you ever encounter Blind Willie Johnson?*

S: I don't think, so but I did run into Blind Lemon Jefferson a number of times. He lived in south Dallas on the tracks. There was a railroad that used to run right through the black section, and Blind Lemon lived out in that section. He used to leave home about ten in the morning and he would walk all the way—maybe forty blocks—into town and then at night, maybe nine or ten, he'd walk back home. On Friday and Saturday nights he'd stay out later; he might go down to Live Oak or to wherever he could attract a crowd. People used to congregate there or along the tracks; people were selling food and there was gambling. It was a good place to play.

Opposite:

Sammy Price, 1987

H: Do you recall any examples of Blind Lemon ever performing with anyone else, or was he strictly a solo performer?
S: I don't remember any of those blues players working with others. I think they were too selfish. There was no such thing as a guitar group. I think they all thought they were better than each other. At picnics and social gatherings there might be a number of musicians, but they didn't perform together. I thought Blind Lemon was the best of the ones I heard; he was a good performer who could attract and hold a crowd, and he was very independent—he got around by himself. He was also the first person I heard who used the term "booga rooga," which later became "boogie-woogie" when Pinetop Smith made that record. Some blues singers, somebody like Texas Alexander, were very primitive compared to Blind Lemon. Later, when I went to other cities, playing in shows, I met many other singers, good and bad. Singers were much more important in those days than somebody playing a horn or the piano, especially in theaters.

H: How did you make a living in those days?
S: I went into theaters. I was on the TOBA circuit—they called it Tough on Black Asses, and it sure was. I didn't get paid much, but I was just a kid and it was a good training ground. Sometimes they used to have some extracurricular things on the shows, something extra for the people. They weren't paying anything anyway, so they let you do something extra for nothing. You didn't get any money. You just played. The guy running things would promise you something, and then when the show broke up he would just fade away. I imagine they made some money, because the guy would have the responsibility of twenty people on a show going into fifteen or twenty towns, so he had to have something. There wasn't much money around but we were always fed and had a place to sleep, and I was just a kid. I remember one tour started in St. Louis, to Kansas City, to Tulsa, Oklahoma City, Dallas, Houston, Galveston, Shreveport, Mobile, Birmingham, Jacksonville, Atlanta, and Savannah. I think we broke up in Washington after we'd played in North and South Carolina. I met Art Tatum in Louisville in 1928 during one of those tours, but most of the time during these years I was in Dallas or on tours in the Southwest from Dallas—in Houston, Waco, Wichita Falls, Tulsa, Oklahoma City, places like that.

H: What did you do in the shows?
S: I played a little piano; remember, I couldn't read so well, but if there was a piano spot, I might play something I called the "Dallas Boogie" or the "Dallas Blues." Sometimes we had a piano contest on the stage, and all the pianists would play, and the audience would judge the winner by their applause. I didn't win many, but I kept meeting people who were in the shows, and I worked with them in later years. People like Coot Grant and Sox Wilson. I first met them in a show and ten years later I recorded them for Decca.

H: You play a lot of boogie-woogie piano these days; did you do the same in Dallas in the late 1920s?
S: Mrs. Pittman had shown me the fundamentals, except we didn't call it boogie-woogie; the first time I heard it called that was by Mayo Williams for the record of "Pinetop's Boogie Woogie." It was really a new thing. I'd heard Blind Lemon playing that kind of thing on a guitar.

H: Did you play with any jazz bands in Dallas?

S: Sure. I played with local guys and made my first record in Dallas. It was called Sammy Price and His Four Quarters. Local players, you've probably never heard of them—a guy we called Kid Lips on trumpet, Bert Johnson on trombone, and Percy Darensbourg on banjo. I went to Kansas City shortly after I made that record and stayed there for a few years and then headed to Chicago.

[Note: Kid Lips is identified as Douglas Finnell in the fifth revised and enlarged edition of Brian Rust's Jazz Records, 1897–1942.]

H: This must have been where you met up with Mayo Williams, who was later to be instrumental in your work at Decca.

S: No, I met Mayo Williams in Dallas; that record I made was for him, but by the time I got to New York City in 1937, I knew him pretty well. You see, I never took music seriously. I was more like a playboy; I loved to gamble, to move around, and I knew my way around. I met up with Art Tatum again in Chicago in 1933, and the same year I met Teddy Wilson, working in a little place under the El with Jimmy Noone. I used to go around—I supported those guys morally; if they played someplace, I was there. I became very close with Art in Cleveland, Detroit, and finally in New York. I had a lot of success in New York. I hadn't been here too long, a few months, and one day I went up to the Woodside Hotel—that's where a lot of the musicians used to hang out—and Count Basie's band was rehearsing downstairs. Count Basie's valet told me that Mayo Williams was in town and in big trouble. I said, "What kind of trouble?" And he said, "Well, he's got Cow Cow Davenport with him, and his

arthritis is acting up and he can't play." A little later Mayo Williams comes in and spots me standing in the lobby. He came over and said, "Sam Price, man, I got a problem. Charles Davenport is upstairs and he's getting drunk. He's discouraged because he can't play." I said, "What does he want to play?" And Mayo says, "The Cow Cow Blues." So Mayo and I went upstairs and went in his room, and I went and opened the door and said, "Hey, Charles," and he looked at me and said to Mayo, "Hey, man, this kid knows the song. He knows it!" I said, "Know what?" He said, "The Cow Cow Blues. Remember I taught you how to play it in Norfolk? And we had a piano contest on the stage and you beat everybody, you won the contest."

I became affiliated with Decca with those recordings in 1938. I played the piano—Charles only sang on those records. This is how it worked. Mayo would decide who he wanted to record. Sometimes the people were in New York, but the blues singers were mostly in Chicago. He'd give me his car and I'd go to Chicago and pick up somebody—say, Johnnie Temple. I'd bring him back to New York and check him into the Woodside Hotel and get him a bottle of booze if that's what he wanted, or food, whatever he needed. I'd have him sign a contract. Naturally, in those days the union played an important part in recording, so any musicians I had signing a contract had to have a union card, and I'd take care of all of these details. I'd help Mayo make sure all of their material was in correct order. Sometimes we'd come to town a few days early and work on the songs with them. I did the same thing with most of the Decca blues artists that recorded in New York. I was untrained, but I knew the basics of the blues and could work with them. I worked

with Sister Rosetta [Tharpe], Peetie Wheatstraw, Johnnie Temple, Georgia White, Trixie Smith, Blue Lu Barker, Joe Turner, Cow Cow Davenport, Jimmie Gordon, and Coot Grant [Leola Wilson] and Sox [Kid Wesley] Wilson. I also recorded my own group. I called it Sammy Price and His Texas Blusicians. I played piano and sang on these records.

H: Did any of these blues artists work uptown, or did they just come in, record, and leave?
S: They came in and left. That would be it. Normally, there were blues acts on the TOBA shows, but there was never an all-blues show. They had other acts—variety acts. In Chicago there were places where blues artists could work, but it seemed that the people who controlled things in New York didn't want to feature blues singers. Blues singing was not a musical style that was generally popular in Harlem. It was a more amalgamated community than Chicago. In Harlem there were West Indians, Puerto Ricans, southern blacks, and people from the Midwest. These people followed what they liked—dance bands, chorus girls, people who sang ballads, like Pha Terrell. They liked comedians like Pigmeat [Markham] and personalities who could do a show. This is the reason there weren't a lot of blues singers uptown.

H: I presume your Texas Blusicians were just a recording band that never worked as a group uptown.
S: You're right. I had a lot of bands that just recorded which had imaginary names. I never played uptown with any of them, and I never went around and

jammed uptown. Sometimes I went to places to listen or to hang out, but I never played uptown.

H: Why is it you never went around and jammed?
S: I'm peculiar. For example, if I go to a job, I don't touch the piano before I play. That's a superstition. I don't believe a musician should own a piano, and I don't just play for the fun of it. I am one musician that plays for one thing—money. Money is the main factor with me. I learned about money at an early age, and I knew I had to have it. I knew that in Texas sixty years ago, and I still know it. You learn how to cultivate people and how to gain their acceptance. You learn to overlook certain things and how to never let an opportunity pass, how to turn things around if you have to do it. I don't mean physically or all that business with guns—although I was a pretty good shot; I could shoot a rabbit in his eye with an air rifle in Texas. I learned what to do and my motto is, "Be nice to everybody, be sweet to everybody, be courteous, and be as honest as you possibly can be, even if you have to sometimes tell a little white lie." That's how I've been able to make it.

H: When you put your own bands together, how did you choose your musicians?
S: I just picked who was available. I didn't analyze the guy, though I knew Chu Berry wasn't a bad tenor saxophone player, and Lester was pretty good. If they were available, I used them.

H: I know you once used Fess Williams on clarinet.
S: It was the worst record that I ever made! He's the only man I know who could make a clarinet sound like it

had hay fever. Fess was one of my dear friends; he admired me and lulled me into letting him play on those records. I've never listened to it from the time I recorded it to this day—that's what I thought of it. Fess Williams opened the Regal Theater in Chicago. He made a pretty big name for himself at that opening and played all the other big theaters—the Apollo, the Lincoln, the Lafayette, a big theater in Cleveland, and one in Memphis, all those prominent theaters—but poor old Fess didn't get to the end of the line, really; he walked through the last part of the mile. Don't remind me of that awful record.

H: I know you were close to Ida Cox. When she came to New York in 1939 and made those records, did she also work here?
S: She worked for a while at Cafe Society. I remember the last records she made before she went back to Chattanooga in 1961. I was sitting in this room and my niece came in and said, "Uncle Sam, Cousin Ida said if you don't come here and play for her, she's going home." This was a complicated thing because another piano player had already been hired for the date. I played the date, but they gave the money to the other piano player and gave me some too. I made those records with Ida, and she went back to Chattanooga. I'd first heard her back in 1925.

H: Who did you think was best of all those singers you heard?
S: Ida Cox. Bessie was really the best singer for texture and all that, but I loved Ida Cox. The song that impressed me the most was Trixie Smith's "Freight Train Blues"—I rate that as one of the great blues recordings. Nobody ever picks it as their favorite.

H: Are you sure you never worked uptown?
S: I played a week at the Apollo Theater with some blues singer. I can't think of his name. I think I also worked once at a little joint at 116th and Lenox—I don't remember the name—but other than these two examples, I never worked uptown.

H: You almost never worked uptown but you still live in Harlem? Why do you live here?
S: Always. I've always lived in Harlem since I came to New York. When I came in 1937, I went to a boat ride that was sponsored by the NAACP, and as I was about to get on with a group of eight people who were with me, I spotted an uncle I hadn't seen in twenty years. He was collecting tickets. I went up to him and said, "Yeah, give me eight tickets. I've been looking for you since 1913." He didn't know what to think and said, "What did I do now?" I said, "You didn't do anything; you're just my uncle." He was black but he turned white for five minutes; then I saw the color come back. He hadn't contacted his mother or any of his relatives; we all thought he was dead. He was a very political person, close to Adam Clayton Powell, a man behind the scenes, and we became friends. It was then I decided, since I'd been involved in political things in Dallas, I might as well get involved with them in New York, in Harlem. My uncle really knew the political arena; he knew the pulse of the people, and I learned from him. I've also stayed uptown because I like people to recognize me as a personality in the community and as a friend. I've always stayed here. My daughter also lives here; she's my secretary. I have another apartment on 138th Street close to the Catholic

School, because I raised her a Catholic, and when I'd go away, my wife could walk her to the door.

H: What do you think killed music in Harlem?

S: There are many reasons. You see many minority groups that have fads in dressing—well, there are also fads in music. Remember when I said there was a big cross-section of people in Harlem? Well, there still is, and we've become even more diversified. All these groups bring their own culture—they make advances, they're on television, they make records, they have their own clubs. Some of us—many of us, I'm sorry to say—are ashamed to embrace the blues as our own. Unless, of course, you mention Charlie Parker to them. But he played the blues. You take Fats Waller—a lot of musicians won't play "Honeysuckle Rose"; they think it's old-fashioned. But they'll play "Scrapple from the Apple," and that's nothing but changes on "Honeysuckle Rose"! This is a real problem, and so is all the different kinds of entertainment—television, cassettes, stereos, video, audio, radio— the marketplace is so crowded with everything but live musicians, you can't tell the flies from the horses. That's what I think it is. There is just no live music. And I'll tell you another thing. When the blacks moved from San Juan Hill here, they replaced another ethnic group; they brought their culture with them. When we began to shake hands

Opposite: Sammy Price, 1987

with each other, the blacks became real progressive and made money. Many of them who owned these houses and property here in Harlem sold it and left. I think that's one thing. Another thing is we have failed to teach our youngsters their heritage and to be proud of their heritage. With integration has come a transformation of the old path.

I'll tell you a story. I know a fellow who went into Jack Dempsey's—a well-known musician—with Billy Rose and some other people, Tallulah Bankhead and others. When the check came, the black musician, who was also a numbers guy, asked for the check; the check was $108 and he gave the waiter a thousand-dollar bill. This wasn't well received in those days, but now you can go to Waldorf, you can go to Trump Towers, you can go anywhere. If you go to Pennsylvania Station or Grand Central at 5:00 and see who's catching the 5:15, the black guys with the *New York Times* and four buttons on their sleeves. They're on their way home to Westchester or Long Island. If you ask them, they'll tell you they live in New York, but Westchester and Long Island isn't New York City and it sure ain't Harlem. This is the problem; there are many problems. We don't have any black landmarks in Harlem. Just look at the Tree of Hope. We should try and rejuvenate some things, fix up Strivers Row, put up some statues around the State Office Building, things like that. I know David Dinkins, and I'm going to talk to him about it.

26 March 1987

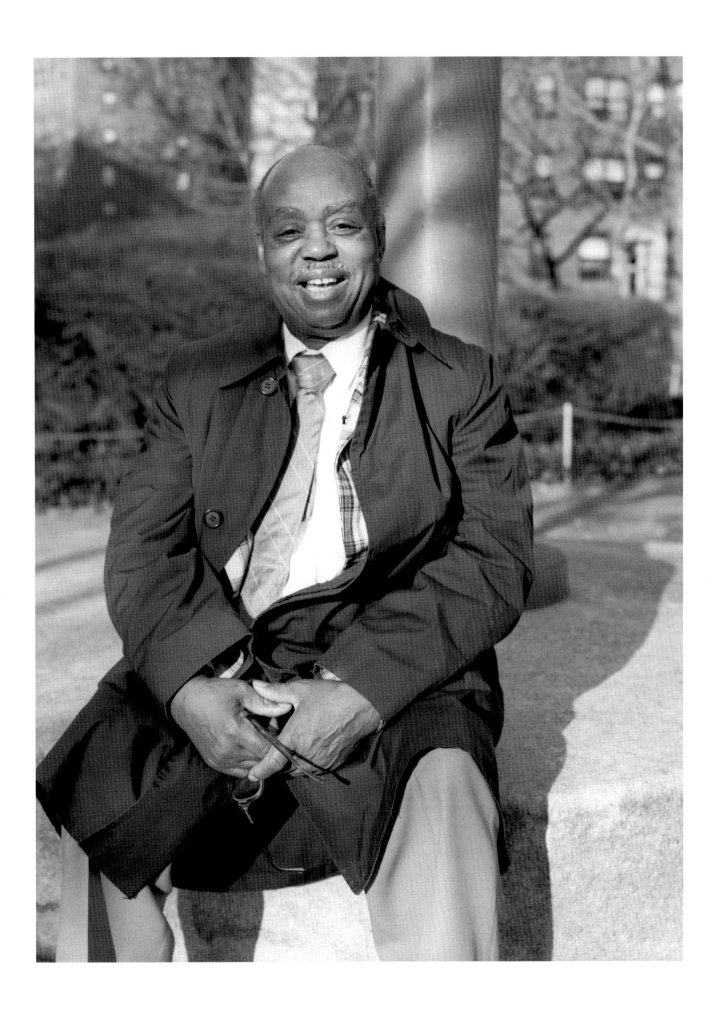

Johnny Williams
(b. 1908)

Hank: I believe you're from Memphis.
Johnny: Yes, I was born in Memphis on March 13, 1908.

H: You're going to have your eightieth birthday very soon.
J: I'll be very happy if I can have it. I've had a fine career in music. It started with lessons on violin in Memphis. I studied at the Popolardors music school. I later switched to bass, plus I played the tuba.

H: When did you decide to become a professional musician?
J: It was about 1930. I'd been playing different things in Memphis but wasn't sure I was going to a full-time musician. I even went away to college but joined Graham Jackson's band in Atlanta instead. He was a pianist who was very popular in Atlanta. He became famous because President Roosevelt was very fond of him. He's the one who played the accordion in the railroad terminal when the funeral train came up from Georgia. He had a twelve-piece orchestra and worked for a man named William Shaw. We were called Graham Jackson's Society Syncopators. He got jobs for us all around the state—roof gardens in Atlanta, at the University of Georgia—and the people from Coca-Cola were crazy about Graham. You see, Graham was a teacher.

I think he gave lessons to the daughter of the man from Coca-Cola. I was in Atlanta a few months ago working at the Peachtree Hotel, and I found out Graham was also there. I slipped up behind him and said, "Hello, Mr. Jackson." It had been thirty-six years. He's still doing things for Coca-Cola; they're still sponsoring him after all these years.

H: When was the first time you worked in New York?
J: The first time I was just passing through; I was with Jean Calloway. It was the same band I was part of in Atlanta but Graham wouldn't leave town except in the summer, so the band went out with a different leader. She was Cab's cousin, and there were posters that read "Cousin to Cab Calloway." We didn't play in New York; we just passed through on the way to the Midwest, Minnesota, Colorado, the Dakotas. I'll *never* forget North Dakota in January. We were snowed in and the state troopers had to get us out.

H: What brought you to New York?
J: I think the first band I played with in New York was the Belton Society Syncopators. I had worked around for a few years and found myself in Akron, Ohio, working with Billy Shaw, the same man who I'd worked for in Atlanta.

Opposite:
Johnny Williams, 1987

Somehow, Belton heard I was in Akron and asked if I wanted to join his band in New York. This was about 1935 or 1936. I think we were supposed to play the Savoy Ballroom. We wound up playing in a place called the Empire Ballroom, and because of a dispute we were reported to the union as being an out-of-town band with a regular engagement. This closed us down, and somehow we were teamed up with Jack Johnson, the boxer.

H: You did a show with Jack Johnson?

J: We even went on tour with him, playing theaters in Baltimore, Pittsburgh, Philadelphia, and as far west as Chicago. It was a wild show; Johnson closed it. He'd come out stripped to the waist and talk about his days as a fighter and then he'd shadowbox and dance around the stage. Then he'd invite people to come and do a round with him and try to hit him. It was quite a show and we made good money—maybe more than I would have made if I'd stayed in New York and worked with someone at the Savoy. The band broke up when we came back to New York. It was about this time—maybe 1936—that I hooked up with Lucky Millinder and the Mills Blue Rhythm Band. This was the first band I worked with regularly in New York. It was a good band and the pay was good. We made at least forty dollars a week, and I'll never forget the first night. It was New Year's Eve. There were a lot of good players in that band, and that first night I noticed something funny going on. At intermission I saw some of the guys were given envelopes, and I thought, "My God, I gave up a job in Philadelphia to come here and now the band is breaking up." So I asked Danny [Barker], "What's going on?" He told me

there was a dispute in the band about who was going to be the leader, and some of the guys were leaving because they didn't want to work for Lucky—that some new men were going to join the band. That's exactly what happened. Charlie Shavers and Harry Edison came in. [Carl] Bama Warwick was the first trumpet; Billy Kyle was on piano. Later that year I even made some records with Billy. But wouldn't you know it, with all those new players, we had to rehearse. They called a rehearsal on New Year's Day.

H: I've heard that some people treated the Mills Blue Rhythm Band as a second-tier orchestra.

J: The Mills office wanted to keep everybody working. Naturally, Duke Ellington and Cab Calloway were the big headliners, but there were some cities where Lucky was very popular, where we got good crowds. But we got a lot of work; they kept us busy. We'd do the circuit—Baltimore, Philadelphia, Boston, sometimes little theaters in New England. When we were on the road we'd get seventy-five dollars a week. If we were in New York at the Savoy, we'd only get forty dollars. Everybody got less at the Savoy. When we were there, we usually were opposite Chick Webb, and he was the most popular band.

H: Who was your favorite?

J: Duke Ellington was the best to me. He came after me twice to join his band; I worked with him for about six weeks in 1942 at the Capitol Theater, and that was a thrill. I also loved Chick Webb and Fletcher Henderson—you have to love those two bands—and I'm told that Charlie Johnson had a pretty good band, but I never heard it.

H: What was your favorite place uptown?

J: I'd have to say Small's or the Ubangi. They didn't want you to mingle with the

guests at the Cotton Club and some other places, but you could at these clubs.

H: In terms of playing, which groups were the most enjoyable?

J: I don't count the time with Duke Ellington—it was wonderful—but I enjoyed Teddy Wilson's small band in the 1940s and Frankie Newton's band in the late 1930s. Both were terrific groups—nice players, nice arrangements. With Teddy it was just a pleasure to come to work. I worked with him for almost four years, mostly in one place, but we also worked at the Golden Gate Ballroom.

H: Tell me about the Golden Gate.

J: It was a big place, bigger than the Savoy, and just up the street. They had room for two bands, and I think they were hurting the Savoy. Teddy Wilson was a house band there; we were there with Coleman Hawkins, Tommy Dorsey, and some others. The bands alternated, playing half-hour sets. It wasn't laid out as well as the Savoy; it was just a massive dance hall. They didn't have a liquor license, but they were still putting pressure on the Savoy, and I think that had to do with it being closed down. One day it was just padlocked. I heard it was because they found liquor in the place and there was no liquor license. I don't know if it's true, but that's what I heard, and it was locked up. The owners of the Savoy bought it and kept it locked up for a long time. Later they started renting it out for private parties and special functions.

H: How did you get to know Teddy Wilson?

J: I first met Teddy at the Victoria, a little bar next to the Woodside Hotel. It was a popular place and I remember the night I met Teddy; Roy Eldridge came in and played all night. Did you

know the Victoria was one of the first places uptown to have a jukebox? These jukeboxes started showing up in the mid-1930s, and they probably hurt live music. There were a lot of little bars where guys probably played that were replaced by a jukebox. Anyway, Teddy probably heard about me from other people—I'd made a lot of dates with Billie Holiday; maybe he'd heard about them—and I certainly knew about him. As I said, it was a pleasure to work with him.

H: You also spent time with Coleman Hawkins and Louis Armstrong. Tell me about these experiences.

J: I enjoyed both but probably enjoyed Hawkins more. It was a fun job. He must have had about three hundred numbers in the book. A lot from Fletcher [Henderson], and Benny Carter gave him some.

H: Did Hawkins write arrangements himself?

J: Not that I know about—maybe he did. I remember Van Alexander wrote for him. It was a very enjoyable band; there was so much variety in what we played—soft things while people were eating supper, then the mutes would come out and we'd blow our heads off. I'm pretty sure I played the Golden Gate with Hawkins. This was one of my last big-band experiences.

H: Did you take part in many late-night uptown jam sessions?

J: Not really. You have to remember that I worked downtown a lot, with Frankie [Newton], Teddy [Wilson], and others. We might play at some spot on Fifty-second Street or Cafe Society until 3:00 in the morning or even later on weekends. By the time I'd get uptown, it might be

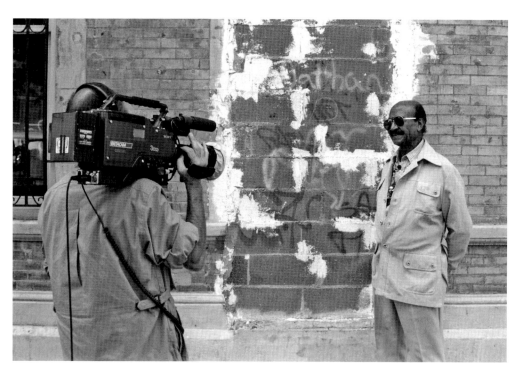

5:00. There was a place I used to go on
St. Nicholas at about 126th Street, but I
didn't go too often.

*H: So you weren't part of the Monroe's
and Minton's scene?*
J: No, but I remember Monroe's got in
trouble and the union started closing
down on those jam session places.

*H: What are some of the things that
were most harmful to the uptown music
scene?*
J: There were a lot of little things that
probably hurt. Maybe even those
jukeboxes. I do remember seeing small
signs downtown during the war years
that said things like, "You go to Harlem at
your own risk," things like that. The other

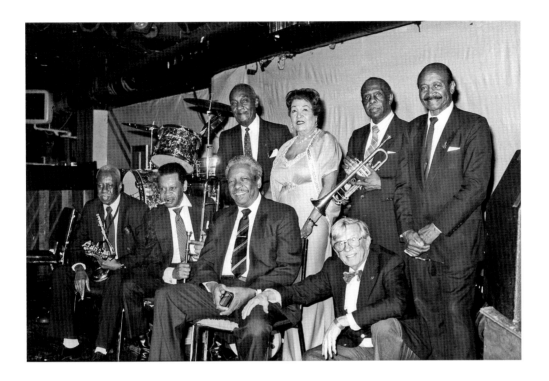

Johnny Williams and the
Harlem Blues and Jazz
Band, the Cat Club, 1989

thing was by then Fifty-second Street was in full bloom, and there was good music in Greenwich Village. There was a lot of talent downtown, and people who might have once gone uptown stayed downtown to hear them.

H: What sort of work did you do after the war?
J: I stayed at Cafe Society until about 1948 and then went with Tab Smith. We played the Savoy for almost four years. He was a house band from 1948 until 1952. It was still crowded and pretty much the same. The union had the pay up to $87.50 a week by 1948.

H: Tell me about Tab's band.
J: It was a good eight-piece band. Red Richards on piano, Frank Humphries on trumpet. Walter Johnson was the drummer, a fellow named Johnny Hicks on tenor, and, of course, Tab on alto, clarinet, and soprano. We were the small band that played opposite the big band. It was usually Erskine Hawkins or whoever they might bring in. The Savoy was about the only place I played in Harlem in

those years. Most places were starting to close up. I think Small's was about the last place running any kind of shows.

H: In the mid 1980s Al Cobbs had a big band that played at Small's on Monday night. Did you ever sit in with that band?
J: No, I've been with the Harlem Blues and Jazz Band for quite awhile.

H: Has that band ever played in Harlem?
J: No, I don't think we ever have. No, come to think of it, we never have.

H: I find it astounding that when they recently reopened the Apollo they didn't ask someone like Benny Carter to put together a band for a special show.
J: They'd never do that. They're too backward to even think about that. It's just like that Cotton Club movie. I think the girl they had doing research on it was about twenty years old. What could she know?

21 April 1987

Eddie Barefield
(b. 1909)

Hank: *When did you first come to New York?*

Eddie: In 1932. I'm originally from Iowa and had played in the Midwest. In 1932 I was with Bennie Moten and we were in New York City for a short while, but I actually came to town to stay in 1933. I was with McKinney's Cotton Pickers in Baltimore. Cab Calloway came through there, heard me play one night, and put me in his band. The first place I played in Harlem was the Cotton Club, but the band played a dozen different places while we were at the Cotton Club—the Harlem Opera House, the Savoy Ballroom, the Flushing Theater, downtown at the Capitol Theater. I stayed with Cab about four years the first time I was with him; then I went to California and had my own band.

H: *When you were with Cab, did you play any places uptown after hours, or were you happy to just have the time off to rest?*

E: Cab didn't like the guys to go out and play, but I used to go out on the town and run into different people and we'd hang out together. I remember I used to run into Jimmy Dorsey. Sometimes we go around and play a little. The Rhythm Club on 133rd Street was one place I liked to hang out in and play, and Pod's and Jerry's, which was right across the street. Later, I spent some time at the Hollywood Cafe and, of course, Minton's. I used to go in there with the drummer Harold West and Nick Fenton, who played bass. I worked at the club off and on in the late 1930s. Later, when all the bebop stuff started happening there, Kenny Clarke had a trio at the club. I was away from New York for a few years after I left Cab in 1935 but came back in 1938. For a year or so I actually worked at places uptown, leading my own small band. I remember a group I had at Mimo's [Professional Club]. It wasn't much of a place. Bill Robinson had started it a year or so before I got there, and it was never much of a success. Clyde Hart [piano], Ernst Hill [bass], and Otis Johnson were part of the band, but I don't remember the others. It was just a little downstairs joint. It wasn't much of a jam session spot.

H: *Where did you enjoy playing the most?*

E: The music was best in the late 1920s and early 1930s, and it was great to play in many different places. Anyplace could be great, depending on which guys you found playing there. Sometimes I'd be

Opposite:

Eddie Barefield, 1986

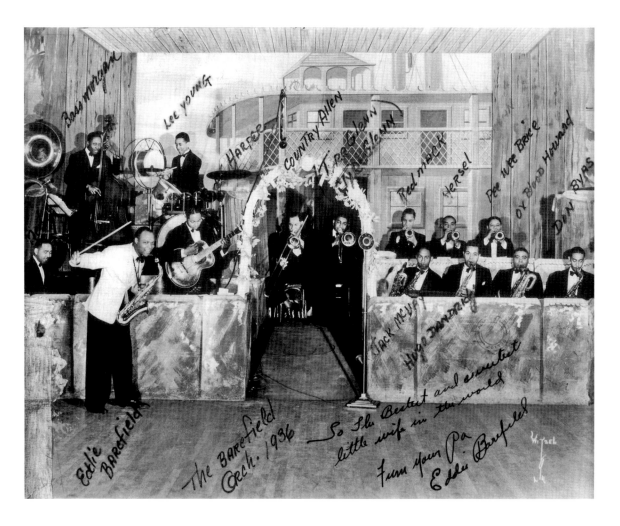

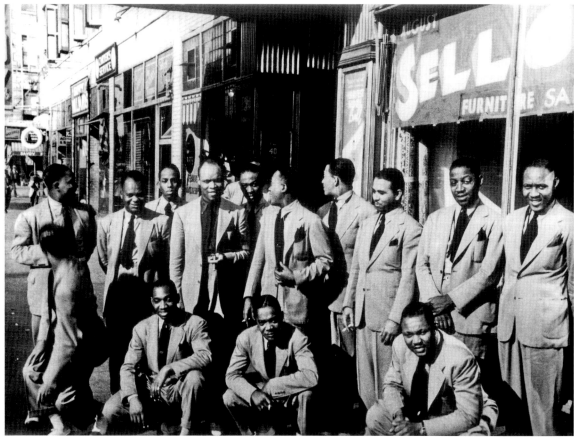

in a place without my horn and people would come in and start playing, and I'd go home and get my saxophone and come back quick. The Savoy Ballroom was the best for dancing—the best dance hall anywhere in the United States. It was well run and safe. All nationalities went there. They had eight or nine big bouncers and at least a dozen hostesses, maybe more. And they had the best bands—at least two, sometimes more. Different bands on Friday, Saturday, and Sunday. You could go in there on a Friday for fifty cents and stay until Monday morning, if you could hold out. When I came back to New York City, I was with Fletcher [Henderson] off and on, but I took my own ten-piece band into the Savoy in 1939. We even recorded, but nobody's been able to find the records. I played the Savoy with Fletcher's band and later with Ella Fitzgerald's band. Both these bands were very popular with the dancers.

H: *You went back with Cab about that time, didn't you?*
E: Yes, in 1939. I've been associated with Cab in one way or another since 1933. I was his music director for years [in the 1950s], and I still write arrangements for him.

H: *Yes, I know—I've looked at Cab's book, and your name is on a lot of his music.*
E: I stay busy. Always have, even after I stopped playing with big bands in the early 1940s.

H: *Why did you stop?*
E: That's when the big bands started to break up. In 1941 I was the music director and conductor for Ella Fitzgerald's big band. It was about then when it started. The first thing they started to do was to take the singers away

from the bands—Ella from her own band, Sinatra away from Tommy Dorsey. They took all the singers away from the bands because they could get the same money for just the singers and wouldn't have to be bothered with transportation and hotels for an entire band. It was just the money; musical tastes didn't change that fast. There were a couple of other things. In 1942 or 1943 politics got involved, and the government put a tax on dance halls and this helped close up all the pavilions. At one time there was a dance hall or dance pavilion in every town in the United States. And they had a theater where musicians played. Big bands would come in and play in those theaters. In the beginning of the 1940s, they put a tax on all these dance halls, and they began to close. People stopped dancing for ten to fifteen years. They didn't start dancing again until rock came out. And it wasn't because people couldn't dance to bebop. Dizzy played for dances, and so did Monk.

H: *What did you do when you were no longer in a big band?*
E: When I left Ella, I was on staff at ABC for four or five years; John Hammond worked that out for me.

H: *John seems to have helped a number of black artists get radio work. I know he helped Bill Dillard get a radio job.*
E: John was a jazz fan and he helped people out. Basie wouldn't have had a band if it wasn't for John. He didn't really have a real band out there in Kansas City. Yeah, he had a band, but it was pretty rough. At the same time Basie had his band in Kansas City, I had one in California. Buck Clayton was in Los Angeles when I was there; John called him and asked him to join Basie. Earle Warren was in Cleveland, and John

Opposite, above: Eddie Barefield and His Orchestra, Club Alabam, Los Angeles, 1936

Below: Eddie Barefield with Ella Fitzgerald's Orchestra outside the Savoy Ballroom, 1939

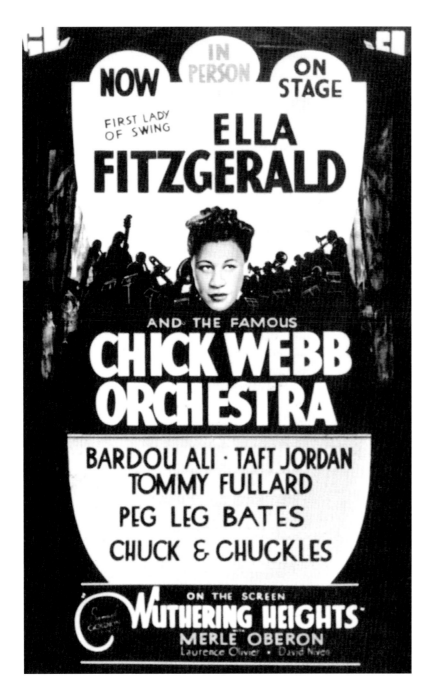

Ella Fitzgerald poster, 1939

called the Elk's Rendezvous. It wasn't much of a place. Most of the guys were working downtown after the war, and I was stuck there for the rest of my career. Some of the younger guys would come uptown to jam, but most of the music was downtown by then. I'd work with the same guys; we had a little sextet at Cafe Society downtown. I think it was one of Fletcher's last jobs; Lucky Thompson and Jimmy Crawford were in the band. The music being downtown is what hurt Harlem—all the little spots started closing up. When I came to New York, white people came to Harlem in busloads. They made the rounds—the Cotton Club, Small's, the Savoy—and Harlem was twenty-four hours a day. White folks went everywhere there was music, and most of the downtown musicians came uptown. When I came back to stay in 1938, the music was already moving downtown to Fifty-second Street and Greenwich Village. Fifty-second Street was the greatest jazz street—you could hear so much there— and this really hurt Harlem because the blacks started going downtown and the whites stayed downtown.

H: I know this is off the subject of Harlem, but give me your take on the difference in the way jazz is presented today and in, say, 1938.

E: In 1938, the ordinary dance people on the floor could tell when a band missed a beat, played a wrong note, or anything. If anything was bad, they knew right away. Today, it doesn't make any difference; the public is very aloof to what music is all about. Today, it's really as much about atmosphere as about music. And there are few black listeners. Black people are not interested in jazz any more. They only want to hear gospel music, and gospel's not jazz, it's folk music. I went to

encouraged him to hook up with Basie. The Kansas City band needed to be filled out and praised at every opportunity. John did this, and I'm sure Basie was very grateful.

H: When did you start to see the music scene in Harlem begin to change?
E: I moved downtown in 1942, so I played less and less uptown. If you discount the Apollo, the last place I played in Harlem was a little social club

France in 1957—played the best places in Paris with Sammy Price and J. C. Heard. The people there were very jazz conscious because they had to learn it the hard way. One of the big problems today is not just the people, but—like it's always been— the promoters and politics. The city made it hard to keep a jazz club open and for jazz musicians to keep working, but somehow the promoters all got rich, sent their kids to law school, and abandoned the musicians altogether.

H: What are your main musical interests in 1986?
E: I'm seventy-seven years old. Music has been my entire life and still learning. I'm working more and more on the piano these days. When I got my radio job in 1942, I thought I needed more formal training, so I went to Julliard. I started on piano but took up the saxophone a year or two later. I studied piano for a short while again at Julliard and then dropped it until about five years ago. Every time

Earle Warren, recording at WARP studio, 1974

Earl Hines, Syracuse, New York, 1972

no one to teach him the fundamentals of jazz. You listen to Louis Armstrong and get a beat in your head, then it'll come out. Otherwise it's not going to come out. Marsalis is at the point where he doesn't have to listen to Louis Armstrong, and that's the worst thing that can happen. His father's a terrific piano player—I heard him out in Chicago when I was there a while ago—and he has a brother who plays good saxophone, but he's still fishing around for the truth, sometimes making apologies for things he shouldn't have said.

H: When you were coming up, which saxophonists impressed you the most?
E: First there was Coleman Hawkins, then Benny Carter and Frank Trumbauer. When I started playing more tenor, Don Byas turned out to be my favorite. Then when I listened real hard, I added Ben Webster. I've recently been writing a lot of arrangements for Illinois Jacquet, and he's right up there. That man can really play.

H: In your travels did you ever meet up with Buster Smith? He was a fine arranger.
E: Buster was not much of a player, but he was a fine arranger. He was with the Blue Devils, Lester Young, and Snake White.

H: I don't know Snake White.
E: Snake [Leroy] White grew up with me in Iowa, and we left Des Moines together in the late 1920s. In 1930 I had a group in Minneapolis at a little place called the Nest Club. Snake was the trumpet player in the band; I was playing mostly alto and some clarinet; Lester [Young] was playing tenor. The band was together for about a year, until I left and went to Chicago. Snake and Lester continued to work in

I start out strong, but I just don't have the technique to sustain it. I always felt if a person wanted to be a complete musician, he had to master the piano. I'm still trying.

H: Who were your favorite pianists?
E: Earl Hines started jazz piano and then Art Tatum came along, copied Earl, and improved upon it. Teddy Wilson hung out with Art, and right behind them a whole bunch of guys came along, and you have a lot of great piano players. The problem with many young musicians today is they have so few people to look up to. Like that young man Wynton Marsalis. He's one of the outstanding young players in this country, but he has

bands together in the Midwest, and he was the one who convinced Lester to go with the Blue Devils. Snake's still active in Iowa; I saw him recently. He'd just done a religious album with some schoolkids.

H: You seem to have very good recall of the past.
E: I remember my whole life from the age of three, because I reflect a lot. I used to tell my mother things, and she'd ask me how I could remember such things. I started writing my autobiography twenty years ago because I don't want somebody writing something I didn't really say, but in fifty years from now there won't be anybody who'll want to know it. I've stopped writing it down, except for just some notes now and then. It's hard to find the time to do everything you want to do. I have to play all my horns every day to stay in shape, but I don't have as much stamina as I once did. I have to slow down, take a nap in the afternoon. I try to stay away from things that trouble me, like certain parts of the music business. The record business, for example. I remember in the 1940s I took some of my things to a company and nobody paid any attention because they weren't different enough. The white boys would come in and record anything they wanted to, but when black artists came in, the record boys were always looking for something different, which is all right because the black guys were always coming up with ideas, but how far could you go? That's why Dizzy and the others played bop; they were trying to find something different. This kind of thing is still going on, and I don't want it to trouble me. I keep up with my own music and old friends.

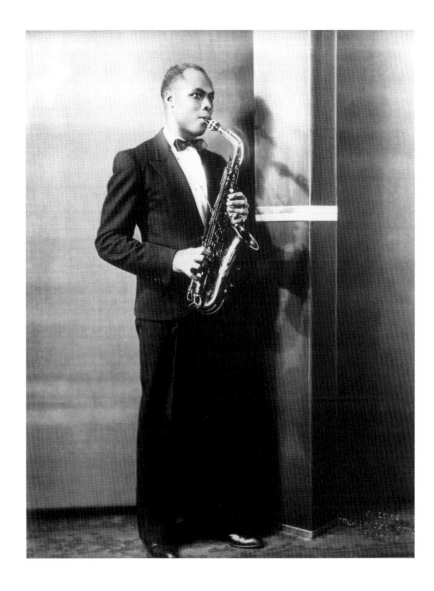

Eddie Barefield, 1932

H: Who did you see most recently?
E: I just talked to Doc Cheatham yesterday. He's a real gentleman. Doc was in Cab's band when I first joined it and he was there when I left, both times! Doc didn't get much of a chance to play in those days, but when he'd play a solo, he'd break up the place and he still does. He's had a hernia operation but is starting to practice again. Maybe if he's not playing, we can get together for a visit. He was up here for chicken and dumplings a few months ago and we should do it again.

14 April 1987

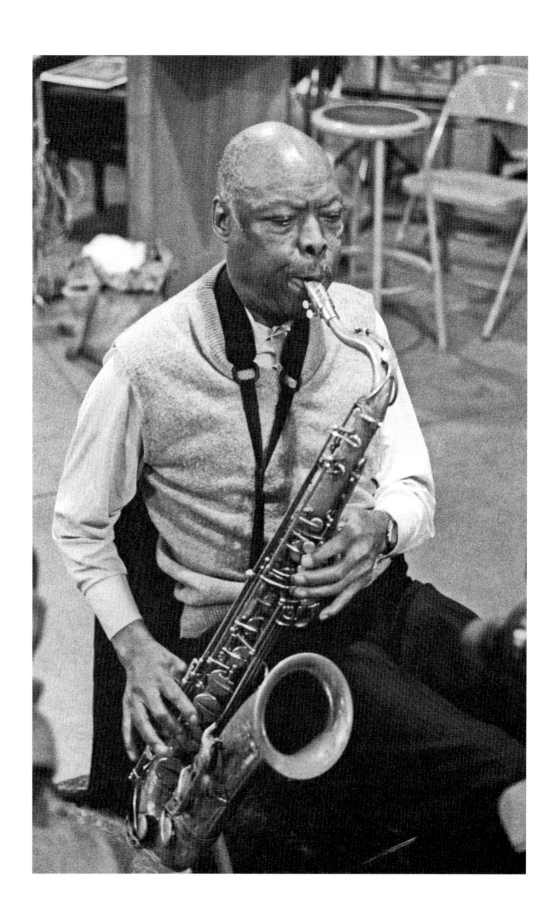

Eddie Barefield outside his home, 1987

Opposite: Eddie Barefield, recording session at Van Gelder studio, Englewood Cliffs, New Jersey, 1986

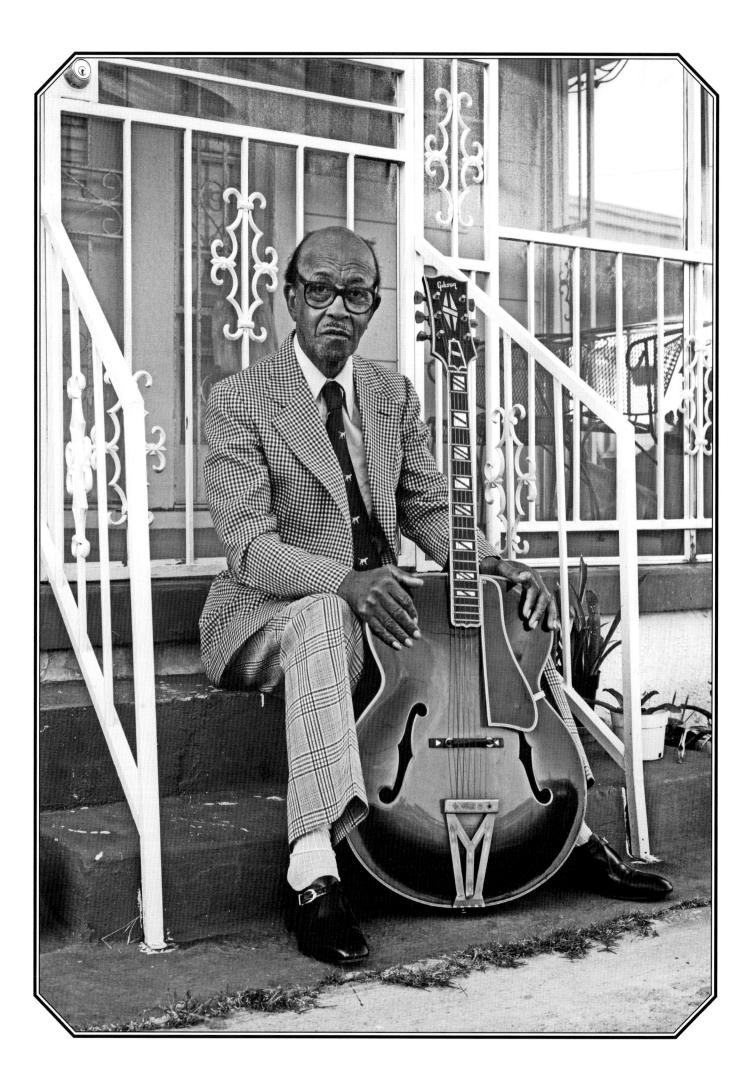

Danny Barker

(b. 1909)

Hank: *You were active in New Orleans before you came to New York City. What prompted you to leave New Orleans and go to New York?*

Danny: I married Lu in early 1930 and went to New York later that year. There were a number of New Orleans musicians in New York by then, and I thought I might find more work than I was finding at the time in New Orleans. The Great Depression had hit most of the country; it had hit the South, had hit the West—it hit all portions of the country, but it hadn't hit New York City yet. New York is not an industrial city; it's a business city. There were still offices there. People were still swinging in New York. The Ziegfeld Follies were still going, Earl Carroll's Vanities, the Cotton Club, the Loew's circuit; people were still booking acts—entertainment hadn't fizzled yet. New York still had vaudeville in its theaters, and they hadn't put on two movies in the theater to eliminate vaudeville. So I wound up smack dab in the middle of New York City where everybody was moving so fast. My intuition told me I had to move fast too—this ain't the South, there's no foolishness here. So I just started moving with them, and I found out right away to keep neat, with a collar and tie; I kept up my appearance.

I learned that people will hire you when you've got the right appearance. So I kept my appearance up and stayed on the scene. And when the banjo or guitar player was missing in a band, I tried to make myself available. I rehearsed with almost everybody—about thirty bands, I'd say. I tried out for jobs with them.

H: *Did you hook up with New Orleans musicians?*

D: No, the first band I worked with regularly was led by a trombonist and arranger named Harry White. He was a contemporary of Duke Ellington and had played with Ellington in Washington, D.C. He was a respected man who had once led the White Brothers Band; it had three of his brothers and two cousins in the group. When I hooked up with him, he was leading a band at the Nest Club on 133rd Street. I was introduced to White by my cousin, Paul Barbarin. When I got to New York, a couple of bands were playing his arrangements. The Nest Club had been very popular for a while, but now it was just hanging on, mainly because the owners also controlled the Rhythm Club on 132nd Street. Later, they moved the Rhythm Club to the building where the Nest Club was located. The club folded a short time after I arrived in

Opposite:
Danny Barker, 1987

225

The Nest Club, 1927

New York, and the Rhythm Club moved there about 1932.

H: *Tell me more about this first job.*
D: Well, Harry White said, "Come on, you want to come with us to the Nest—it would be a good start for you in New York." I jumped at it; he was paying five dollars a night, which was as much as some people were getting at Roseland or the Savoy Ballroom. So I went with White in the Nest Club, and there's a lot of rehearsal while I'm working there. After we rehearsed one day, I left the banjo on the bandstand. I didn't want to carry it around with me for the rest of the day—I didn't think anyone would steal it, but they had weirdos around there,

guys coming and going, hoping to get a job as a waiter or something. Anyway, when I came back to work that night, the banjo was gone. It was a disaster, and I was in trouble. Harry White was calm about it; he said, "I'll tell you what. Get a guitar—guitar is becoming more popular, and I play a little guitar. I can show you." I said, "But I never played a guitar, and all the guitars I've ever seen were played by blind men." I'm from New Orleans, and I'd never heard of any great classical guitar players like Segovia. I had to borrow a guitar, and we asked Bill Johnson, who played guitar for Luis Russell. I got the guitar but I asked White, "When I come to work, what you gonna tell the boss?" He said not to worry, and

later at the Nest he told the boss, "He left his banjo here and it was stolen, and I told him to get a guitar, and I can show him how to play this guitar in a week's time. I can show him the basics, and he can get started." The boss said, "Well, all right with me. You just keep smiling up there and make believe you're playing." I said, "Are you sure?" The boss said, "This is New York—its a show. Put on a show. Put on a pretty smile. People don't know what you're doing—just make believe you're playing." So that's what I did. I sat on the bandstand fooling around. The ukulele's like the guitar, so I started playing the first four strings, I learned a few chords, I got a book to study, and that's how I learned the guitar.

H: What was it like on an ordinary night at the Nest?
D: Sometimes it was just playing for whoever was there, and sometimes it was slow. It wasn't what the people who came from downtown saw; it was cold and calculated. If nothing was happening, we wouldn't be playing, we'd be sleeping, but there was a doorman outside to let us know if anything was about to happen. If he spotted a party coming, the doorman would ring the buzzer—zoom, zoom, zoom, zoom, a ring for the number of people—and soon five or six people, finger-popping people having a good time, would come in the club. We'd be playing long before they came in the door, the waiters would be clapping, and the people who came in would think, It's swinging in here! Five minutes before, everybody was sleeping. Clapping them hands, man, get out there and do the dance, come on in, sit down, big hoopla, I'm so glad to see you. The headwaiter sits them down, and I just keep on playing. Some nights, slow nights, I'd have a lot of time on my hands. You see, we'd get there at ten o'clock and sometimes not play a

note until one o'clock. There was a guy in the band named Trent, a saxophone player. He taught me how to read a newspaper—you know, the editorial page, the sports page. He'd buy three or four papers every day and bring them to the club.

H: Tell me about the Rhythm Club.
D: It was a fantastic place. Everybody hung out there. The first time I went there with Paul [Barbarin], I couldn't believe my eyes. Jelly Roll Morton was there that day, and so was Fletcher Henderson, just shooting pool. It was crowded that day, but it was always crowded with musicians, gamblers, hustlers—people trying to make a deal or just get hired for something. It was in a basement on 133rd Street, close to the Lafayette Theater. There were lots of jam sessions there; if you could make it there, you could get hired on the spot. It was more of a social hall than a nightclub, but it was a wonderful place and very exciting for me. Paul Seminole played piano there, and I even heard him play the banjo. It's too bad he left New York. What a player!

H: It sounds as if at one time or another almost all the great musicians who lived and worked in Harlem came to the Rhythm Club. Did most of the musicians who'd come from New Orleans congregate there as well?
D: Oh, sure, but you have to remember, New York and New Orleans were very different, and the musicians from each city were also very different. The laid-back jazz we played in New Orleans was different. In New York it was a high-speed thing, fast drums and cymbals. Chick Webb had those big cymbals, and he was chopping down everybody. Jazz had become more modern; the dances were different—you had to play for the Lindy Hoppers. I learned that sometimes

you have to just cool it, because if you went in there too strong, well, everything you did, there was somebody who could do it better than you. So everybody was cool. Most New Orleans musicians could play with respect, and some of them were the equal or better than anyone in New York. There was no bass player better than Pops Foster. He was the boss, and some people got mad because no one was playing bass in New York then, they were still playing tubas. I went into there with a banjo, and there must of been fifteen banjo players that could play more than me. All those great players from Baltimore—guys like Elmer Snowden—all those people coming out of Baltimore chewing up banjo. I went there like a lamb, and acting like a quiet little lamb, trying to survive. I went from band to band, step by step, until I could find myself.

H: If you had to point out two or three things that were different between the way the music scene was in New Orleans when you left and the way it was in Harlem in the early thirties, what were the main differences?

D: The music in New Orleans was more casual; a lot of guys could just pick up the instrument and play without reading, and never be a reading musician. Maybe someone couldn't afford to take lessons, but he could play from his soul and his feelings. You see, in New Orleans all you had to do was play it and give the people what they wanted. Nobody was in a hurry. You just played it and became a good player of music, because people didn't pay you to read, they paid you to play. They pay to see you to play, to listen to what you play. But in New York there's big ballrooms and fancy cabarets and nightclubs. They put the checkerboard table away and put the white tablecloths—then it became a

nightclub. It was a whole different thing. New Orleans didn't have any ballrooms. Sure, they had a couple of dance halls, but in New York there are big organized ballrooms like Roseland, the Savoy, and the Renaissance, and that big barn uptown. Harlem had six or seven big ballrooms where they might have a thousand people dancing—even more on weekends. You're not playing for a couple of hundred people like in these halls in New Orleans. In New Orleans we had a nice little baseball team, the Pelicans, but in New York you had the Yankees, Giants, and Dodgers. That was the difference, and you had to fall in with the thing or you'd get passed by. Everything is tremendous and faster in New York.

And you come here and you're always looking around, watching what's going on, to see people, who's going down. People would say to me, "He was great at twenty-five, but he's gone now. He's finished." You see these people still trying, trying to make a comeback. All these bandleaders trying to make it and trying to make a comeback. Who's got the ambition and still wants to do something. There were so many people like that: "Come on, Danny, please make rehearsal with me." Trying all the time, but getting ground up and passed by. In other words, I was from a tank town. New Orleans is a tank town compared to New York. It's wise and it's weird, but the momentum is different. New Orleans is a place where people beg you to eat and if you don't eat with them, they get mad with you. In New York City, ain't nobody gonna beg you to eat. Maybe they'll offer you a drink, but you better not look at nobody's kitchen or go to nobody's house expecting them to set a plate out for you. In New Orleans that's the main thing people want; they want you to enjoy a good meal. That's what I was up

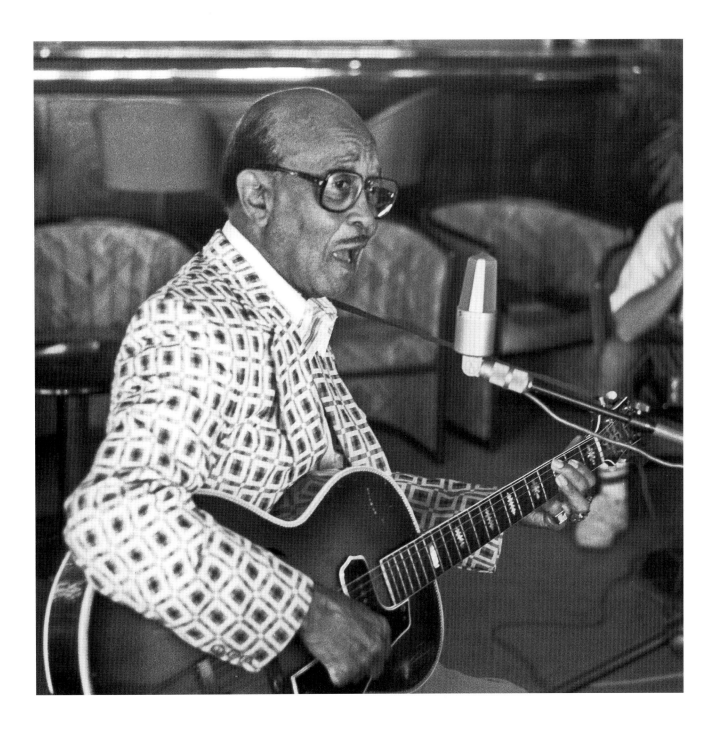

Danny Barker, Floating Jazz
Festival, 1989

against in New York; that's what anyone's up against in New York. You have to get all of New Orleans out of your head; you've got to become cold and calculating to survive. That's the difference.

H: Some of the first people you worked with in New York were people you'd known in New Orleans or people from New Orleans—Jelly Roll Morton, Red Allen, and Paul Barbarin. Tell me about them.

D: Uncle Paul made a splash early on with Luis Russell and King Oliver. One time he even washed out Chick Webb at the Savoy on "Tiger Rag." I'm told Chick played waltzes the rest of the day. It was a battle of the bands between Luis and Chick, and the Russell band just washed them out. I never worked with Luis Russell, but I did work with Jelly Roll, Red [Allen], and Dave Nelson. Jelly Roll used to call me "Hometown," and he was always at the Rhythm Club

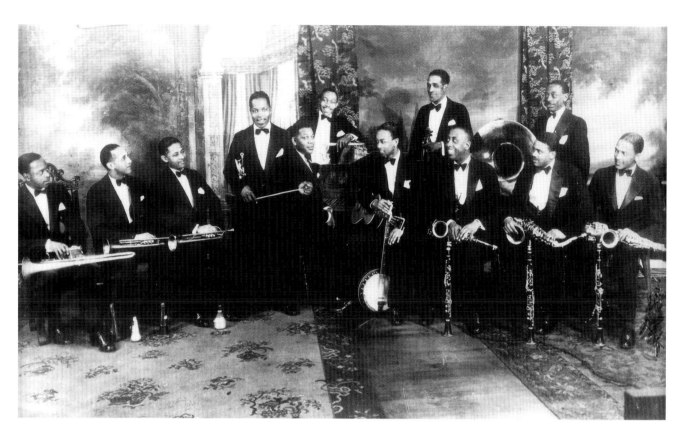

Dave Nelson and His
Orchestra, Harlem, 1931

organizing a band or working out jobs.
He took me out with him a few times,
but it was never regular. Most of the big-
name players around New York didn't
pay much attention to him because he
was always talking so loud about New
Orleans musicians, but I did learn there
was usually at least a grain of truth to
all the things he said—sometimes they
were all true. Jelly was a novelty in New
York; there was nobody like him. When
I got to town, he'd been there four or five
years, but he wasn't the master in New
York he'd been in New Orleans. I worked
with Red Allen lots of times in the 1930s;
I was on his Vocalion records. I did some
cabaret-type work with Dave Nelson.
Some people say I even recorded with
him, but I didn't. Those were the main
people from New Orleans.

*H: You once mentioned a singer to me
named Mattie Hite. I'm not familiar
with the name; could you tell me about
her?*

D: The queen! The top cabaret singer and
entertainer. A very spicy lady. She's the
one who originated a dance where she'd
pick up rolled-up dollar bills between her
legs with her dress held high. She taught
the other girls how to do it. Some guy
would come in and maybe he'd have a
hundred-dollar bill. He'd get it changed
into singles and he'd put 'em up on the
table and those girls would do their
thing.

*H: There's a song called "The Dollar
Dance." Is it about that dance?*
D: "The Dollar Dance" was in our
repertoire. Mattie worked at the Nest
Club when I played with Harry White.
She also worked across the street at Pod's
and Jerry's. There were a lot of vocalists
who worked with us at the Nest—
performers like Mamie Smith, Clara
Smith, Lizzie Miles, and a girl named
Freckles. I remember Mattie. She was an
elderly woman—at least she seemed old
to me. She was slim and dark and wore
a wig. I know this because I happened to

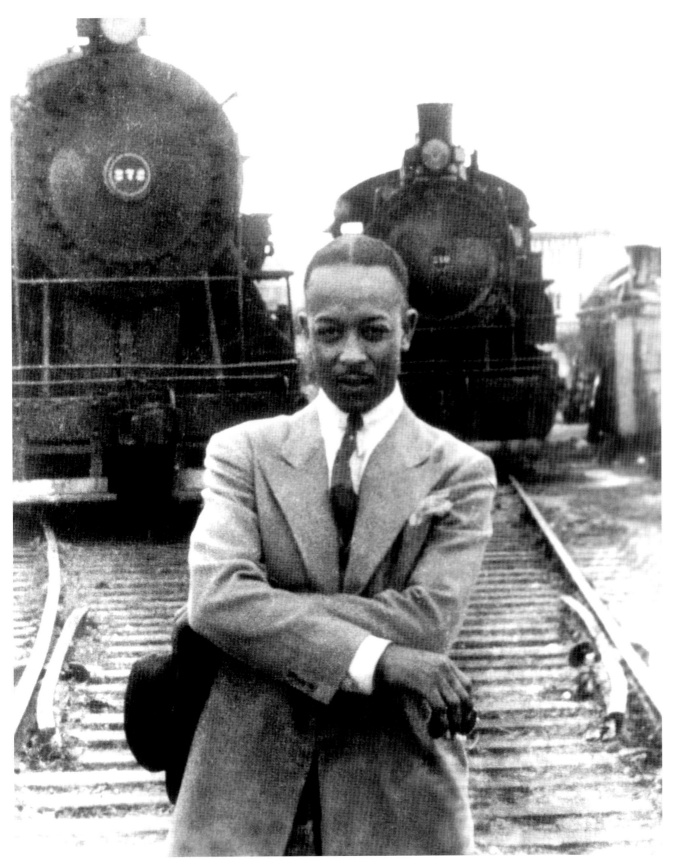

Danny Barker, 1939, photographed by Milt Hinton,
© The Milton J. Hinton Photographic Collection

Cotton Club poster, 1939

pass her dressing room once and saw she was bald headed. She had a little patch of hair on her head, but then she'd put on that big wig and she'd look like a different person. Everybody respected Mattie. You had to get permission before you went to her dressing room. The great Mattie Hite; she worked there as long as I worked there, until the place folded. When I left, I never heard any more about Mattie Hite or any of the other girls who worked there, girls like Mary Stafford. They all made records, but I didn't keep up with them.

H: Do you remember a girl named Anna Robinson?
D: Yes, Anna Robinson was the first woman scat singer that scatted bebop.

H: John Hammond told me that in 1932 or 1933 she was one of the best singers he ever heard, but she made only one record, an awful record with James P. Johnson, and nobody ever knew how good she was. Was Mattie Hite like that?
D: No, she was just a cabaret entertainer.

H: You had a very productive career in New York, uptown and downtown, throughout the 1930s. Were there any turning points for you?
D: I worked with great guys, wonderful bands, big bands, small bands. Made all kinds of records. I worked with Benny Carter, went around the world with his band—all the theaters [in New York, Newark, Philadelphia, Baltimore, and Washington, D.C.]—and before that I was with Lucky Millinder; this is 1937. About the same time, my wife, Lu, had this tune, "Don't You Feel My Leg." It was a spicy tune, and I told her she should sing it at an audition at the Cotton Club, that it might work as a novelty number. Cab Calloway and Bill Robinson were

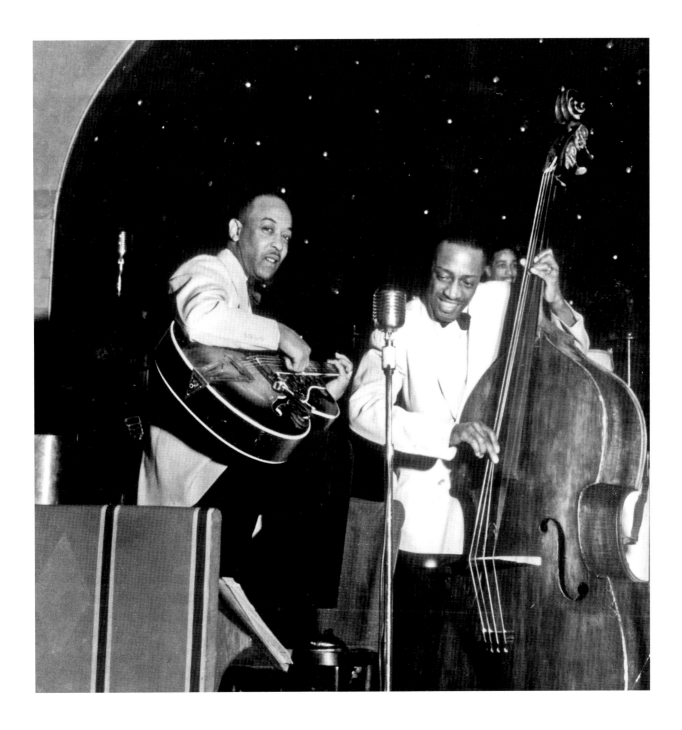

there the day Lu sang the song. The song made Robinson mad as hell—I thought he wanted to hit me—but Cab stuck up for the song, and he asked me if I wanted a job in his band. I was with Cab until after the war, almost ten years. Ten good years.

H: When you went with Cab, your activity uptown probably slowed down because you were so busy all the time.

D: I was very busy, but I still found time for other things, mainly recording. I had my Fly-Cats and I made that great date with Chu [Berry] and Roy [Eldridge]. And a lot of others. But I was happy to be with Cab; it was security.

H: You were with him when the uptown scene started to change. What do you feel caused these changes?

From left: Danny Barker, Milt Hinton, and J. C. Heard, Meadowbrook Lounge, Cedargrove, New Jersey, 1945

Danny and Blue Lu Barker,
New Orleans, 1987

D: Harlem was a fantasy. It was a place where people who were tight-fisted and stingy downtown could come to and relax, a place where whites could live in make-believe, booze and entertainment. The truth is that lots of it was just an act, and most everybody who lived uptown was having a hard time, just like blacks were having a hard time everywhere else. But people acted differently uptown; they were stiff downtown, loose uptown, and there were a lot of ways to get you to part with your money. Harlem was jumping when I got to town; people were coming up to Harlem—you'd see four or five guys, and they'd all be together, and they'd be having fun, go to some fella's chicken shack for chicken, sweet potato, and biscuits. Everybody was having a good time, but all of a sudden it started changing. People said, "Don't go uptown; it's dangerous to go uptown." The word

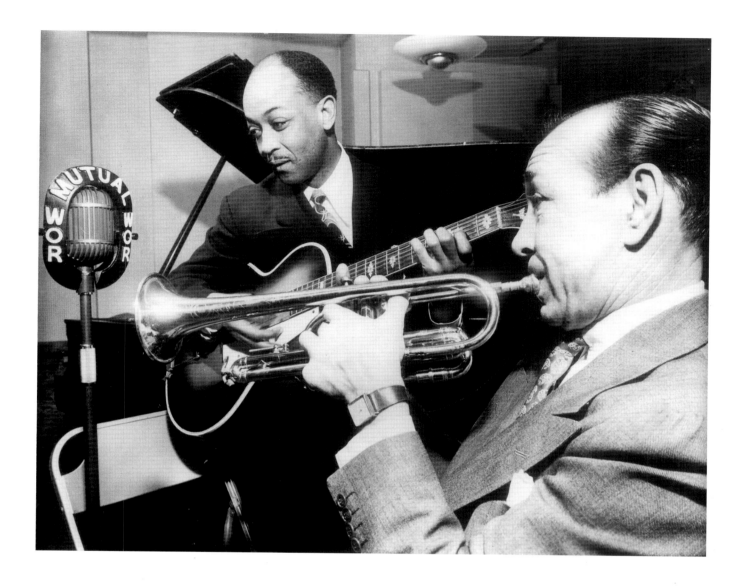

Danny Barker and Muggsy Spanier, 1947

that killed it all was "mugging." Don't go up to Harlem, you'll get mugged, or there was story about somebody being mugged in Harlem. I didn't know much about that kind of thing and a friend explained to me: "Man, a mugging's when one guy asks you for a cigarette or a dime, you give him a dime, and some other guy grabs his hand around your neck, or maybe with the pit of his elbow bent around your neck, and chokes you—chokes you till you can't catch your breath. While this is going on, the other guy is riffling in your pockets. They have you by the neck and you're suffocating. You think you're going to die. They still hold you and then when they turn you loose, you're so weak your knees buckle, and they let you down light or let you fall hard. That's what they call a muggin'. Now, when they've got your money, they can walk off cause you can't holler or yell or scream because you're all out of breath. That's a muggin'." There was even a song, "I'se a-Muggin'," and it caught on. It gave hoodlums the idea to mug people. It helped keep that muggin' business in front of everybody.

H: Was this one of the things that helped kill the music scene uptown?
D: It was just a little thing. The music moved downtown. There were powerful white people who wanted to keep the

Danny Barker and Milt Hinton,
Floating Jazz Festival, 1989

money downtown. The jobs on Fifty-second Street and in Greenwich Village paid better. A lot of the people who loved the music fizzled out and died. The guys who promoted piano players or little bands were dying off, and they're all gone now. You now have a generation of young people walking around with those ghetto blasters. They don't want to dance to anything their grandfather danced to.

H: What was the last place you played in Harlem?
D: I didn't go back to Harlem when I came out of Cab's Calloway's band. I moved around, worked with a lot of different bands. Lu and I were out as a single for a while. I even took a few theater gigs, and I learned how to talk to the people—all the people making the money had the mikes. I played bars, I was an MC, I learned how to talk to people. I'd be home running my mouth and Lu would ask me why I was talking so much, and I told her I was just practicing.

H: What do you think about Harlem today?
D: I don't think about it, but a person without any education has no business going there. Somebody right off the boat, coming up from down south. If you don't make it big and make a lot of money, you won't make it. In 1930 we managed because we were smart. Today it's different.

14 April 1987

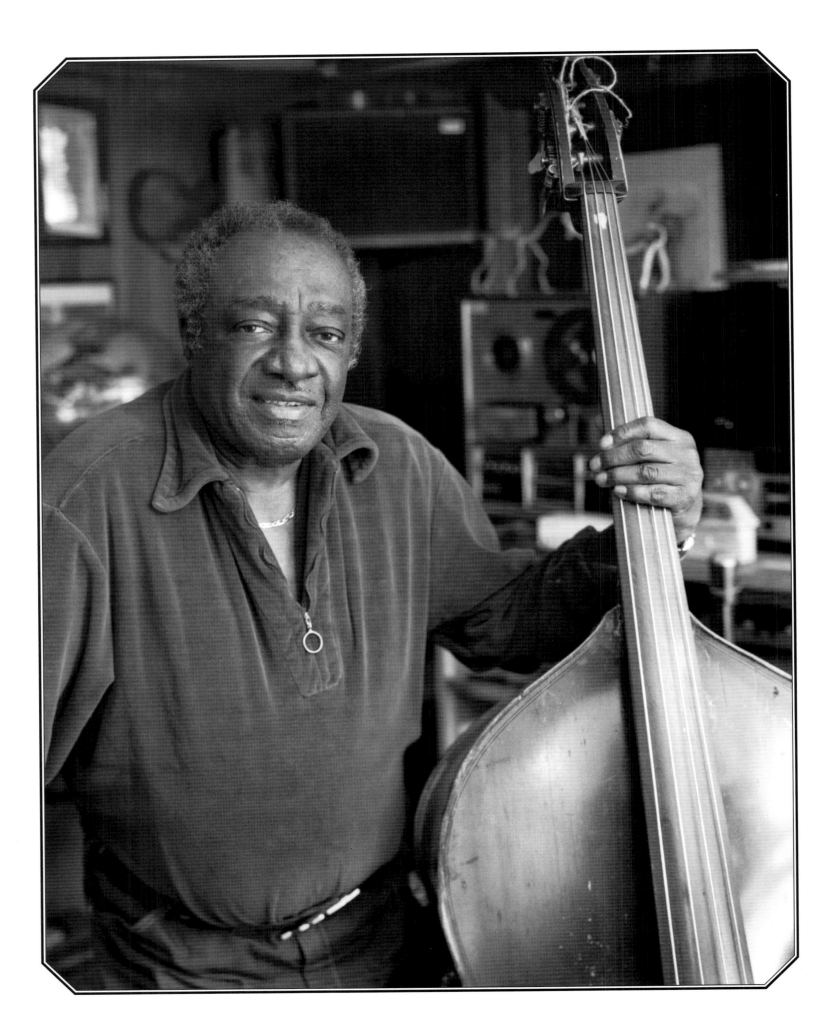

Milt Hinton
(b. 1910)

Hank: *You've had a long journey from Vicksburg, Mississippi, to St. Albans, New York. Tell me a little about it.*

Milt: Everybody was coming to Chicago. There was a migration scene during that time. The black folks, my folks, were coming from Mississippi because the conditions there were so terrible. They'd have to sneak out one by one, because in Mississippi in 1910 you couldn't go to railroad stations and buy you a ticket. My uncle was working at a barber shop—a white barber shop in Vicksburg—and in those days there were even a lot of white folks who didn't have bathrooms in their homes, so everyone came down to the barber shop to get a bath, but no self respecting white barber would on Sunday, so he'd put one of the black barbers in charge of the bathhouses, to keep the tubs clean, keep that water hot, the towels ready, the razors sharp. When the folks came in, my uncle would charge them twenty-five cents for a hot tub. When Monday came the boss would come in and ask how many he'd sold, and if he'd sold fifty, he'd tell him he'd sold thirty-five, and he kept those fifteen quarters for himself, and when he got enough he used them to go to Chicago.

Of course, he couldn't just go to Chicago, because he wasn't allowed to buy a ticket, so he had a friend to write him a letter saying that he had an aunt in Memphis, Tennessee, that was very sick and she wanted to see him before she died, and he took it to the boss. The boss read the letter and asked my uncle if he had any money and then took him down to the station, and my uncle bought a round-trip ticket to Memphis. His boss expected him to come right back, but as soon as he got to Memphis, he sold the return half and headed to Chicago. That was in 1910, the year I was born. He got a job and it was fabulous, because everything was happening in Chicago. There's just so much I could tell you, but to cut it down a little, he got a job as a porter in a big hotel and because he was smart he's finally clearing enough money so he could send for his brother and my mother. My mother was the secretary and organist of the church, the Mt. Haven Baptist Church in Vicksburg. She was the only one in the family with any education, so my mother was really running the family, and all of a sudden the minister, Reverend Eric Perry Jones, began preaching, telling the folks down there that things weren't good for them, that they had to give the young people a chance, for the young people to have a future. Well, the white folks heard about

Opposite:

Milt Hinton, 1987

239

that, and they told him to get out. So he had to leave, and he took my mother with him. They left me in Mississippi with my grandmother. I came along later with Reverend Jones's three sons. After he died, those three kids put together the Harlem and Bronx Policy Company and made millions, but the government got after them and they wound up in Mexico.

H: Tell me about your early musical life in Chicago.

M: If you were from Mississippi, Chicago was heaven on earth; the living conditions were so much better. I was at Wendell Phillips High School; it was the only high school for the black community, and so many wonderful musicians went to that school. John Levy, the bass player turned manager, was there; I gave him my book from the ROTC when I graduated, because I was leaving. Lionel Hampton was there. Lionel tried to kick me out of the band because he was a year or so older than I was. Now he says he's younger, but I know he had on long pants before I did and was playing drums in the high school band and he tried to put me out. I wanted to get in the band and he didn't want me in because I was in short pants, but I knew I could read as much as he could because I was a violin student. I'd been playing violin since I was thirteen years old, and I fought my way into the band. Then I tried to keep other people out; I tried to keep Nat Cole out—he wanted to play lyre in the band. My mother was his piano teacher, and she used to make me so angry. I hated Nat, you know, because he was always perfect. He was just the nicest little kid, and I was always getting into trouble or something and my mother would say to me, "Why can't you be nice like Nathaniel?" Then, of course, I couldn't stand him. Later, we used to do the same

thing to Joe Williams—we wouldn't let him sing with us; we didn't want any singers. At that time Chicago had Harlem beat by far in terms of music. The guys were coming up the river, stopping in St. Louis, and then coming to Chicago; it had all those white guys playing at the big white hotels—the Edgewater, the College Inn—with Ben Pollack, Jack Teagarden, Benny Goodman, people like that. All those young white musicians would come to the South Side to hear Jimmy Noone, Punch Miller, or Guy Kelly. They'd been coming for years, long before I started playing, and all the Chicago gangsters ran the clubs where they played because they were good places to sell their bootleg whiskey. Al Capone and all those gangsters like him had clubs, and many of my friends worked in the places they owned. When they were working for the gangsters, I was still playing violin and delivering newspapers. I remember one day someone yelled at me from a car, "Hey, Sporty, why don't you get a horn?" I knew I could play—I was just playing the wrong instrument—and that's when I decided to switch over to bass from violin and give up my newspaper route and go into music full-time.

One of my first jobs was with the "dark angel of the violin," Eddie South—his mother had been on my paper route. The first time I played in New York was with Eddie South, probably about 1931, at the Palace Theater. We were on the RKO circuit, playing theaters. I lived at the YMCA up on 135th Street; it cost about six dollars a week and we made good money with Eddie, but then we were off for thirteen weeks and I ran out of money. I didn't dare call my mother and tell her I wasn't doing cool, that I was in trouble. She would have sent me money, but then she'd want me to go back to school. You see, I hadn't kept up on my studies because I was trying

to work in Chicago and go to Evanston to school in the daytime, and I would sleep during the history classes. One of my teachers asked me how much I was making. I had two jobs in Chicago, sixty dollars a week in the Regal Theater and forty dollars a week in a nightclub, and my teacher looked at me and said, "I don't make a hundred dollars a week." He said, "I suggest that you go get a fine teacher and improve yourself on your instrument and not try to get a degree here, because you're killing yourself, and if you can make that kind of money now, you should do all right for yourself." I'm very grateful for the advice he gave me, and I still consider myself an alumni of the school even though I never got a degree from there. So I was in trouble, but then I met a lady named Ann Robinson, a pretty jazz singer. She looked like Martha Raye, only she was black. She had a wonderful shape like Martha Raye, a terrible face like Martha Raye, and a big mouth like Martha Raye. I swear to God, she was a black Martha Raye, who stole everything she had from Ann Robinson, copied her exactly. Now picture this: I'm standing at a hot-plate bar at 126th Street and Seventh Avenue and I'm broke. I'm looking at the steam table on the other side of the bar, when all of a sudden this chick comes in and she's got this helluva shape. When she'd stepped out of the cab, she must have seen me. Well, I must have been a pretty sharp-looking dude in those days, because she comes up to me and says, "What's your name?" and I told her. She said, "My name's Ann Robinson. Do you want a drink?" Now, I wasn't drinking but since I had to have something, I said I'd have a beer, and she wanted to know all about me. I told her I was with Eddie South but we were off right now and I was living at the YMCA. She said, "Look, I've got to do another show at the Cotton Club. Do you want to

wait here until I get off? I want to hang out with you." I thought that was just fine and as she was walking away, she yells to the bartender, "Foster, this is my guy, give him anything he wants." And she walks out the door, took a cab back to the Cotton Club. As soon as she got out the door, I asked the bartender, "Does that mean anything in the house?" He said I could have anything I wanted, so I went over to the steam table to get something to eat because I was very hungry, but then I had to wait until she came back to pay for it.

We became friends; she took me around to some clubs and I think she was a les, but she'd taken a liking to me. We went into one place and she handed me her wallet and said I should buy drinks for everyone—a lot of people I didn't even know. So I bought a drink for everybody, and the guys were all looking at me because I was sure they were thinking, Why in the hell does this kid get this chick? And I am just a kid—I wasn't even smoking or drinking. I didn't know anything about that, and then she takes me back to her pad and we walk in and she takes out a joint and I said, "Well, I don't do that." Then she takes every strip of her clothes off, and she's walking around, and she's got this gorgeous body, and she's walking around with no clothes on, and I can't even look at her. I'd never seen a girl nude before. I couldn't believe it. And then the doorbell rang; she went to the door and it's a guy. She let the guy in, and then I really fainted because here I am in there and this girl doesn't have one thread on, and she hands this guy the joint, and they begin to get high while I'm just sitting there. She just told him I was a groovy guy. Well, it turned out that this lady was a real benefactor to me, because she took me in with her and fed me until I finally got a job to go back to Chicago. When I left, I thanked her and told her

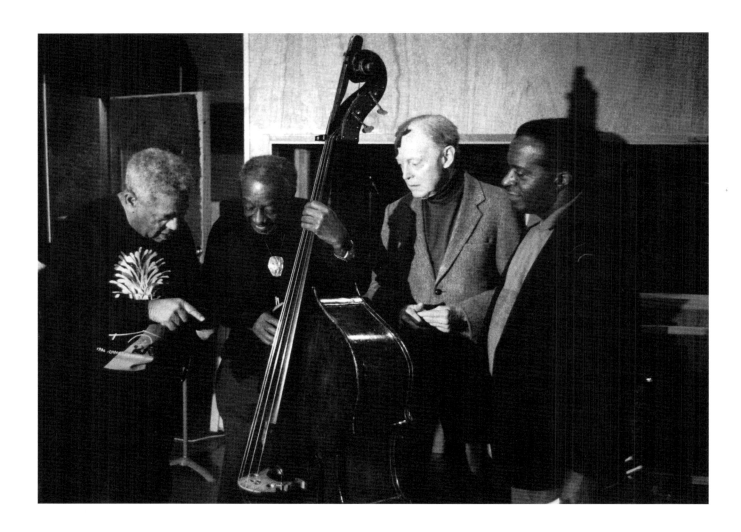

Dizzy Gillespie, *left*, Milt
Hinton, John Bunch,
and Jackie Williams, Van
Gelder recording studio,
Englewood Cliffs, New
Jersey, 1989

that I really appreciated all she had done.
Now, it's a few years later, and by then
I've met Mona and we're married. I come
back to New York with Mona and we're
walking around downtown, and there is
Ann Robinson standing on the corner in
front of the Brill Building. I said to Mona,
"Look, there's a girl over here that I've
got to introduce you to her. I've got to
go say hello to her because she really did
me a favor. She was really a friend when
I needed one. She'd give me some money
and she fed me." So I walked over to her
and I said, "Hey, Ann, I want you to meet
my wife, Mona Hinton," and she looked
at Mona and she said, "That's just what
you need, a schoolteaching bitch like
that." Poor Mona was with my mother's
choir—that's where I met her. Later on
we became very good friends, but things

didn't work out for Ann. I was in Florida
with Cab when I heard they'd found her
dead in an alley up in Harlem. She was
a very hip girl but had some problems;
she wrote some of those songs for Nat
Cole, things like "Hit That Jive, Jack" and
"Straighten Up and Fly Right." In my
mind, I can still see her uptown, with
Martha Raye in there watching her every
night.

*H: Then you returned to Chicago and
worked there for the next few years
before you joined Cab Calloway.*
M: That's about right. I stayed with Eddie
and we toured—as far as California in
1933. When I was there I ran into Lionel
Hampton; he was working for Les Hite,
and Lionel's wife, Gladys, was sewing
clothes for Gloria Swanson. When we got

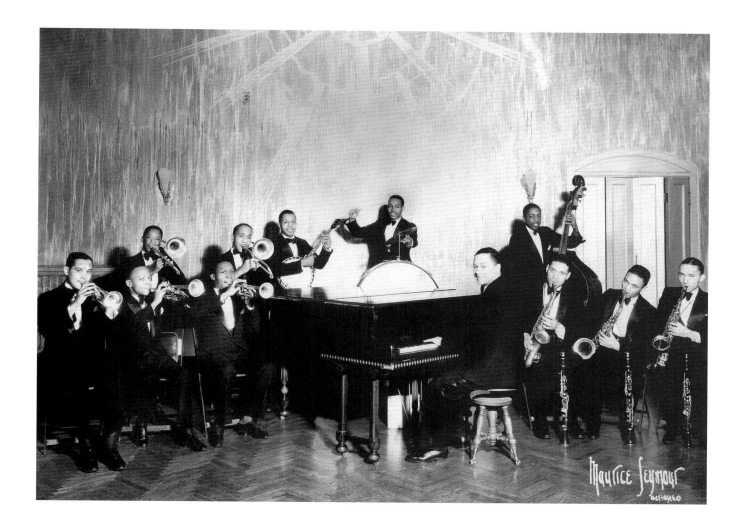

there, Lionel had a band at the station to greet us, and then he took us by to meet his wife. She told us she had to keep an eye on him and we should too; if she let him out on his own, he'd go crazy. We stayed at the Dunbar Hotel, where Jack Johnson, the prizefighter, had a club on the first floor. He tried to play bass, you know, and he always was after me to jam with him. It was hard to say no to him.

When I left Eddie South I spent time with Zutty Singleton. I was with Zutty when I joined Cab. I was hired as a substitute bass player and stayed fifteen years. This would have been in 1936. I worked for him for all those years, but he was also my friend, and he taught me so much. I learned so much when I was in that band. Let me give you an example—a story about Will Vodrey,

who wrote for the Ziegfeld shows. A black man, he wrote in every Ziegfeld show for twenty-three years. He worked with Bert Williams, and when you'd hear the big arrangements, with the English horns and bassoons, it was Will Vodrey. He did the Cotton Club shows, he did many things like that, and in the early days, George Gershwin was his copyist. How do you think George Gershwin could come up with all of that music so suddenly? How could this young Jewish boy write all these songs about black people if he didn't hang out with some black people and some black women too? Vodrey scored in ink, and I remember one incident at the Cotton Club. Cab was scheduled to play the opening night of the new Cotton Club—the one downtown at Forty-eighth

Milt Hinton with the Cassino Simpson Orchestra, 1931

Zutty Singleton, Manassas, Virginia, 1967

and Broadway—and Mr. Vodrey was the arranger. We did the first show and afterwards, Chu Berry came up to him and said, "Mr. Vodrey, I've got a note here that I don't understand in the second bar." And Mr. Vodrey, a brown-skinned man who talked deep and way back in his throat, like he had a stuffy nose, said, "That's a D." Chu said, "Well, I have an F here." Then Mr. Vodrey says, "Well, if you've got an F, it's the copyist's mistake because I score in ink," and he turned his score around for us to see. It was the copyist's mistake—that's how perfect he was. He was fabulous. I'll never forget the

first time I met him. It was my first real time in New York.

I almost didn't make that first engagement at the Cotton Club. We'd been rehearsing for about six weeks, taking small jobs out in the Bronx or Long Island and then coming back into town for rehearsals. It was a few nights before we were to open, and the local 802 delegate came down to check everyone's card. I hadn't even thought about this and neither had anybody else in the band. The guy took one look at my card and threw it on the floor. He told Cab he couldn't use a guy with a Chicago union

card. Well, Cab was very busy and under a lot of pressure and he said, "The kid's got to go. Replace him, give him some money, and send him back to Chicago." I was heartbroken. I picked up my card and started to leave, but a lot of the guys in the band were pulling for me. Later that day my dear friend, Keg Johnson, went to Cab and told him a big star like Cab Calloway shouldn't let some little union guy mess with him. The guys in the band wanted me, he said, and besides there was a union rule that said an out-of-town player could work two nights a week. Keg said he thought I should play the two nights the band broadcasted, that the band didn't want some new bass player who didn't know the music. Cab agreed he wasn't going to let the union push him around. I stayed on to play the broadcasts, and Elmer James from Chick Webb played the other nights. We were in competition, but I won out and stayed until Cab broke up the band.

H: Since you spent so many years with Cab, playing the best places, you had less time than some to hang out at the Savoy or places like that.
M: Maybe, but they were great years. Cab was a great person, a tremendous businessman, and a strict disciplinarian. He insisted that you be on time, and anybody that ever worked for Cab Calloway—well, don't ever be late for the job. I was never late. Let me give you a couple of examples. A few years ago I was working out in Rick's Cafe in Chicago with some group—I can't remember which group, but I was working with them—and Cab was close by, doing that picture *The Blues Brothers*. He was passing by one day and saw my name on the marquee, and we hit at nine o'clock. Cab Calloway came in about eight o'clock, walked to the bar, had a drink, and asked the bartender if we started at

nine o'clock. The bartender said that was the schedule, and Cab said, "I'll tell you who's going to be the first person here—it'll be Milt Hinton." And at 8:30 I walked into the place, the first guy to show up. We always have that tradition with him. Fess [that is, Cab] just didn't allow you to be late. One time we were doing one of those reunion concerts at Carnegie Hall. Tyree [Glenn] was there, Illinois [Jacquet], a lot of different guys. Jacquet came in five minutes late and everybody said, "Fess, there he is, fire him again!" We all loved Cab; he bought all of the uniforms—four, five sets of them. Even the shoes and the shirts and the ties that matched. He said, "You keep your uniforms clean and come on time—I've got to be here, you better be here." Another thing he said was, "Lay dead till Thursday." I worked for him sixteen years, and I never, never remember anybody ever missing a payroll. It didn't matter whether there was anybody in the audience or not. When it got very slim, the money was always there.

It got very bad. It was very sad to see what show business did to him, because with his class and showmanship he wanted to present the best to his audiences, but it got so that it wasn't chic to have black performers dressed up very sharp and dignified, especially going down south. We still made those tours through the South, but the powers that be down there didn't want to see black entertainment coming in dressed up talking about a "Copper Colored Girl of Mine" and all these beautiful things. They wanted to hear the blues or "I'll cut your nappy head," or see people play the fool. They did not want to see this, and I can honestly tell you that the powers down there would tell the black people in the community that these guys were coming down from up north, they think they're better than you are, and then they'd tell

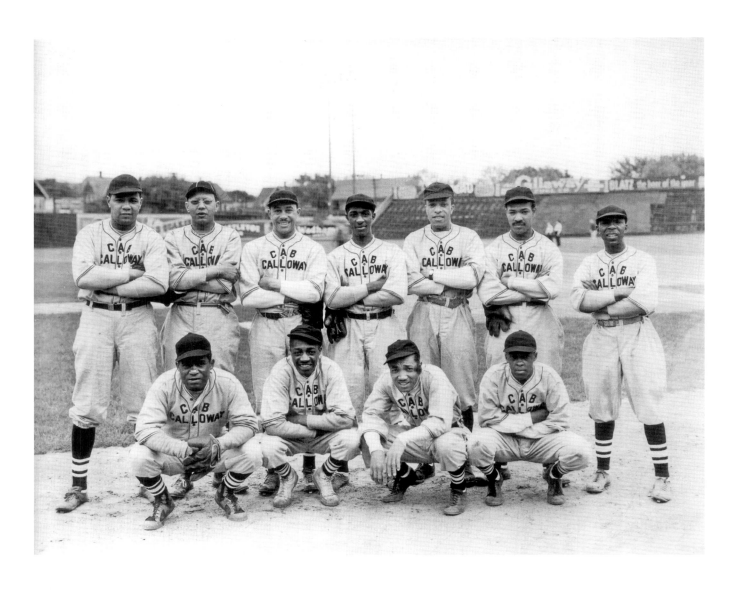

Milt Hinton with Cab Calloway's baseball team, 1936

the men we were going to come in and bother their women, that we were going to take all their chicks away. Then they'd tell them if they wanted to cut one of us, they wouldn't do any time for it—we heard all about it. We went down by Pullman. Cab would take a train down and park it on the side, and then we'd get cabs and go into the dance hall. He'd warn us that when the dance was over to get back in the cabs and go back to the train. If we wanted to hang out with one of those chicks, put her in the cab and bring her back to the train with you. Don't go to the local hotels with them because they'd been warned, they'd been notified. If some local guy hurts you, he wouldn't do a day.

That was the kind of thing we had to go through, but sometimes there were funny things. I remember one time we went in Atlanta and we were going to stay a couple of days, so Cab said if we didn't want to stay on the train we could get a room somewhere, but not a hotel. So we looked around for a place to stay and a place to eat, because you just couldn't eat anyplace. There were marvelous restaurants–black restaurants—and every town had a good, big restaurant where you could eat. In Atlanta, it was Mom Sutton. She had a big, open kitchen, and this lady could cook like you wouldn't believe. The food was delicious, very reasonable, and she also had a row of houses that she could rent to us. Lammar

Wright, lead trumpet player, and I rented a little house, a two-bedroom affair. It was cold as hell in Atlanta, so we got some kid and paid him a buck to stay in the place while we were playing the dance. He was supposed to keep the fire burning so the house would be warm when we got home. We'd bought a bottle of booze and left it at the house so we could have a taste when we come back. Now, Lammar met some chick at the dance and he was walking her home from the dance when some local guys got behind him and started chasing him home. He's yelling at me to have the door open so he can run right in, but a guy was so close on him that he had to run right by the house. When he got back, he'd lost the girl, the kid had finished the whiskey, and the fire had gone out. We laughed about that for many years. Those are the kind of situations we went through with Cab. I never worked for anybody I liked better or treated me as well. He was born on Christmas Day, December 25, and he never worked for anybody on December 25. We got a month off in the summer and two weeks at Christmas.

H: You left Cab in the early 1950s.
M: I was lucky; when I left Cab when he broke up the band, I went into the studios, into freelance work. I was out of work and didn't seem to know anybody in town. I'd been on the road all those years and had lost contact. One day I ran into Jackie Gleason on the street. I'd known him for years, when he wasn't so famous. We were always friendly; I used to see him at little clubs and laugh at his jokes when he couldn't get arrested. Anyway, he was making a record the next day with strings, one of those records with Bobby Hackett, and he told his manager he wanted me to be on it. His manager told him he already had a bass player, but Jackie wanted me and told

me to be there. I arrived at the session and brought my good 1740 bass, and the string players couldn't believe it. Now, I'd been studying; I'd studied with all the best bass teachers in Chicago and New York, and I could play anything. There were several contractors at that session, and they noticed I had a good bass, could play, and they started calling me. Then Jack Lesberg passed a job at CBS on to me—it was on radio so I wouldn't come jumping out into anyone's living room—and pretty soon I found myself making three records a day, radio things, and commercials. The business was lucrative, but I always tried to stay in touch with my friends who didn't have such good luck. I'd usually meet them on Mondays at Beefsteak Charlies, that place on Fiftieth Street between Broadway and Eighth Avenue. It was just a cheap joint, but we'd all meet there, have a few drinks, talk about old times, and stay in touch. What isn't so well known is the guy who ran the place was a nice guy and let us stash our instruments upstairs—Cozy [Cole], Osie [Johnson], all the guys who were making all those recording dates. It was great for me; I could go out and make a gig and then come back and leave my bass and not have to take it home.

Then dope—narcotics—began to rear its ugly head. I've never been involved in anything like that—nobody ever even asked me, and for that I'm grateful—but people started coming in and would stand down at the other end of the bar and buy stuff, but we would sit there and drink and then I'd look up and see some guys at the end of the bar. Most guys didn't pay much attention because we're all having so much fun—Oscar Pettiford, Quincy Jones, Bill Pemberton, Osie Johnson, Hilton Jefferson, and Danny Barker, all standing there just having a

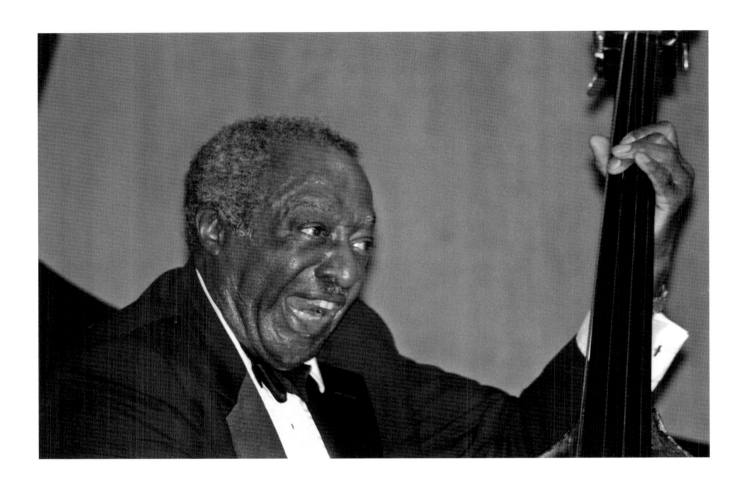

Milt Hinton in action
at The New School, 1993

beer. Then all of a sudden, the connection guy with the narcotics would come in and he would go to the men's room and these guys at the end of the bar would follow him right back to the men's room, and in a few minutes they would come out and they'd be in terrible shape. The bartender never knew about this, what was going on. He said, "Milt, get that guy out of here! Look at him; he's all down in the corner. How did he get drunk so fast?" That guy hadn't gotten drunk, but the narcotics guys knew that police never looked for a junkie or peddler in a bar like Beefsteak Charlies because only alcoholics, or guys just hanging out, drink in a bar like that so they never looked for narcotic guys there. They had a free run of the place peddling narcotics, because, even though we didn't know it, we were their cover, up at the front of the bar having this great time. We didn't

really pay much attention and the police never really found about it. I mean, it was never busted or anything like that.

H: Since you left Cab Calloway, you've freelanced, undoubtedly been on more recordings than any bass player in the history of jazz, taught, and have been everyone's first call for many years. Is there anything you've missed?
M: Not much—I've been very lucky. I just wish I could pass more along to students and to young black kids who should know more about their heritage—there's just so many things people ought to know. I was just thinking about one the other day, the Gaiety Building. It was one of those buildings up at Forty-sixth and Broadway they were tearing down to make way for that new hotel. They was all kinds of talk about tearing down those buildings, but they mainly just talked

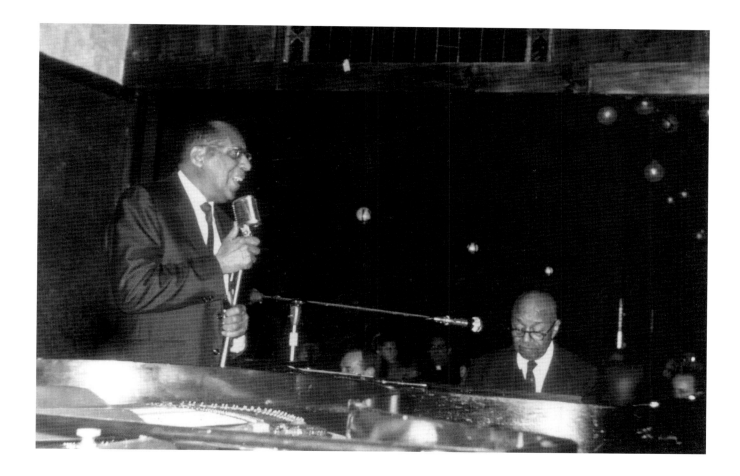

about the theater. Everybody raising hell about the theaters, but not one person says anything about the Gaiety, where all the great black entertainers had their offices, all the black stars like Bill Robinson and Sissle and Blake. Not a word. There were so many black entertainers in that building that George M. Cohan used to call the building Uncle Tom's Cabin. I guess all the young black folks don't know anything about it, but this was the place where a lot of black music was first organized.

Why does a white guy like you have to write this book about Harlem? Aren't there any young black writers who care? In my classes I try to talk about things like this. It's a very sad thing with us. I can go down to a little college with young kids and I can say to the young black kids, "Look, if you'll come out to my house, man, I think I can help you," and

I get so very few of them to come by. I don't just offer it to black kids; I offer it to anyone in my class. Music is an auditory art; you have to hear someone play it. I've told them if they don't understand something, if they want to come out to my house on a Saturday afternoon or after church Sunday, come on out; we can have some chat downstairs, and Mona will always fix a big pot of chili or chicken wings or something, and we can listen to some records. We can talk and ask questions and enlighten ourselves. But I get very few black kids to come out here. The same thing goes for the white kids, although they come more often and they help put my records back in place. I've got one young man that's coming out here this afternoon. He won a scholarship on bass, and now he's playing, he's got his degree. He's substitute teaching and playing with [Illinois] Jacquet. Evidently,

Noble Sissle, *left*, and Eubie Blake at the Village Gate, 1967

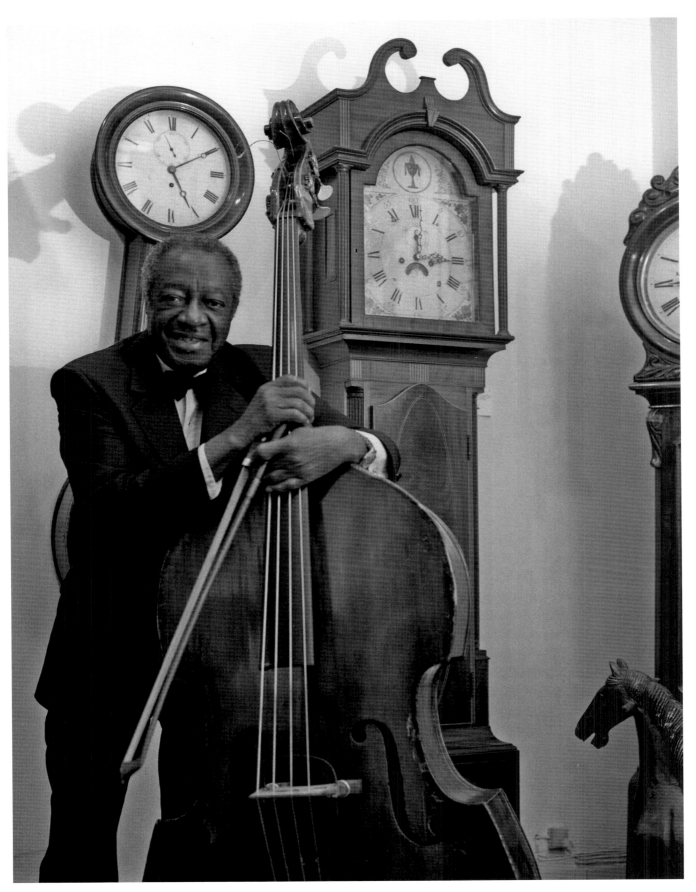

Milt Hinton at Fanelli's Antique Timepieces, 1991

Jacquet's not quite satisfied with his playing, so he's got him meeting with me. Jacquet told him, "You go see Milt Hinton and find out how he played in a big band." So this kid called and said he'll be out this afternoon, this evening. Sure, I can just tell him about my experience with Cab Calloway, playing before there was amplification and how to try to get a decent sound. It's not much of a secret—just don't rely so much on amplification. These kids are in such a hurry.

H: There's probably another problem—a lot of young folks don't think it's cool to spend too much time with old folks.
M: You're probably right.

H: Do you remember the last time you played in Harlem?
M: I do, and it's very sad. I was playing for a woman up at City College who was very interested in black creative dancing.

She was working with a lot of kids, but many of them were misbehaving—but she kept on trying. She finally got all these kids together to put on a concert. She knew I'd worked at the Cotton Club, so she asked me to get the music together. I put a good band together—Eddie Barefield, Eddie Bert, Jimmy Nottingham, good people like that. Just seven pieces. We rehearsed all afternoon and it was going to be a good show. After rehearsal Mona and I went out to dinner and we found out Martin Luther King had been shot. We stayed at the bar trying to get some details, but then went back to the school and everybody there was going crazy. Everything was in a turmoil, so there was no concert. We just packed up our instruments and left. That's the last time I played in Harlem, and you know how long ago that was.

27 January 1987

Sy Oliver
(b. 1910)

Hank: *Tell me about the first time you played in Harlem.*

Sy: When I got here first it was with Zack White's band in 1929. We played the Savoy. As a matter of fact, we played twice, in 1929 and 1930. The last time we were there was when Cab Calloway opened up the Savoy with the Alabamians. I was there the night they opened; we were there for our second engagement and we played the first half of the night. The Alabamians came on the stand and I stayed to watch them. Cab broke it up. The women just fell in love with him. When he ran off the stage, I thought they would tear the place to pieces. I was impressed with Cab and knew he was going to be a star. Even back in those days, dance bands, particularly black bands—even white bands, for that matter—were best with personalities out front, and Cab was a hell of an entertainer. The band itself wasn't a swing band. They played sweet music but the music was highly rhythmic. They played songs like "Roses of Picardy." It was what you would call a sweet band, and it didn't last very long.

H: *How long did you stay in Harlem?*

S: We didn't stay very long; the Savoy was just part of the tour. We played our way to New York and we played our way back to Cincinnati. We were based in that city, and there was good music in that town.

H: *Do you remember anything in particular?*

S: Roy Eldridge came in from Pittsburgh when he was just a kid. I was about eighteen, and he was a year younger. He played just like he did later when he was with Gene Krupa. Roy had more drive than anybody I ever heard. He was an exciting player.

H: *You were also with Alfonso Trent after Zack White. Did this band ever come to New York?*

S: Not while I was with it; I was with the Trent band towards the end of its career. Stuff Smith fronted the band when it was the house band at a club in Cleveland. They were burnt out and Stuff left; I joined the band to write them a new book. I wasn't with them very long.

H: *When was the first time you had an extended run in New York?*

S: I came to New York in 1933 with Jimmy Lunceford. We opened up the Lafayette Theater.

Opposite:

Sy Oliver, 1987

Sy Oliver with Zach Whyte
and His Chocolate Beau
Brummels, 1929

*H: Did you join the band in Buffalo or
hook up with it in New York?*
S: Well, the band had been operating
out of Buffalo for several years, but when
I joined I knew they were planning on
leaving Buffalo for New York. I remember
we opened the Lafayette in October of
1933 and the band was an overnight
sensation. We eventually wound up
playing at the Cotton Club after January
1934, and then we took over for Cab
Calloway at the Cotton Club. During
this same engagement the club came up
with a new show, which opened in July
of 1934. We weren't part of the show. The
show was like a Broadway production.

*H: Eddie Durham told me the Lunceford
band also played at the Renaissance.*
S: Eddie wasn't even with the band then.

*H: I know, but he said later the primary
place Lunceford used to play was the
Renaissance. That's where he enjoyed
playing most.*

S: The only time I remember playing
the Renaissance was when we played
what they used to call breakfast dances.
Every Easter morning. That's the only
time we ever played the Renaissance
Club. You see, I don't put much stock
in people who can tell you exactly what
they were doing on June 13, 1910. I don't
believe that. I've read stories about myself
based on interviews, and it's something
completely different from what I said.
Then it's reprinted and reprinted until
suddenly somebody has made up a part
of my life that's been specially designed
for me, something I'm not even aware
of. Some guy did an article on me in
my hometown paper and sent it to me,
very proud of it. He thought this was
factual, and he wasn't trying to do this
to put me down. He was trying to build
me up. He had me in a cartoon in recess
sitting back against the tree practicing
the trumpet, and this is supposed to be
in grade school. I didn't start practicing
trumpet until I was in high school. This is

one of the reasons I don't give interviews. I don't think there is any single element in our society which has more nonsense going on than in the music business. Incidentally, when I say this, not only do I question other people's memories, I question my own. I don't remember all this stuff—"You remember the breakfast dance we used to play at the Renaissance Ball once a year." Everybody will eventually have their own version of what happened and almost invariably be the hero.

H: You stayed with Lunceford for six or more years.

S: I left in 1939. I'd been with the band for six years, and that was long enough. It's all right when you're a youngster, but it's no fun being an old man and running up and down the road on a bus. Also, remember, except for the last three or four months I was in Lunceford's band, he only paid me five dollars an arrangement and I was copying them myself. That's the way the business went down in those days. I put up with it because of two reasons. First of all, I considered that my school. That's where I learned—it was my graduate school—but I never let anybody do anything if I didn't want them to. I remember Lunceford put his name on all of the arrangements that I wrote, the ones with his band. He also took a lot of the royalties, and when I joined Tommy Dorsey, he was preparing to sue Lunceford and his manager. They got all my copyrights back, and do you know what happened? They both died before they could make anything on them. So you see, it didn't do them a hell of a lot of good. In later years, I was more fortunate. I remember when I did some work for MGM or with some other bands. I was with Dorsey at the time, and some of the bands, some I liked very much, made the point of asking me to do

From left: Sy Oliver, Eddie Tompkins, and Willie Smith in California with the Jimmy Lunceford Orchestra, 1936

some of the underscoring. They asked if I could write screen scores, and I said, "Oh, sure." I got in my car and ran around and read—dug out what I could find about scoring for movies, read it, and did what they required. I was able to do this because of the few years I was Lunceford. I'm not very worried about people taking advantage of me.

H: Eddie Durham told me when he was going to quit the band and go with Basie that Lunceford didn't want him to leave and said to him, "Don't you love this band?" and Eddie said, "Yes, I love this band. I just don't love being in it!"

S: Eddie Durham is probably one of the nicest guys I've ever known. I've never heard him say anything bad about anything or anybody. I never even heard him raise his voice. Do you have Eddie's phone number? They had an affair for him—a salute some time not too long ago—and I couldn't get there. I've been trying to get in touch with him ever since to apologize, but I'll get in touch with him. Most of the fellows in the band are all dead. Moses Allen, Jimmy Crawford, and Ed Wilcox in the rhythm section. All the saxophone players are dead. The only

one left alive from that band, other than me, in the original band that I wrote with would be Russell Bowles, one of the trombone players, and he hasn't been in the business for years. I don't think I've seen Russell since I left the band. Jonah Jones married Russell's sister. Come to think of it, there's not many people I know in the business older than me.

H: In the decade of the 1930s, which was your favorite band?
S: Duke Ellington. During that period he had a really great band. Ellington was unique. With most bands, there was another band that sounded like them or somebody who attempted to sound like them. There was a lot of imitation, but there was only one Ellington. There will never be another one like him. When I was in high school I heard one of the early records, "East St. Louis Toodle-Oo," and on the other side was "Birmingham Breakdown," and my life was never the same after that. I used to tell Duke all the time I didn't know whether to hug him or hit him. The band I remember as his best was from the early 1930s to the early 1940s. I remember seeing him in the theaters downtown, the Paramount or one of the others, and this was one of the most exciting things that I ever saw. Duke had designed the bandstand for his equipment trunks, and all the members seated at different levels. He had overhead spots and scrims especially designed for the show. The man was an artist too. He painted. This lighting was all designed for handsome numbers, of course. The electrician onstage was apparently actually doing it, and there was a presentation that was so wonderful you could almost forget about the music. He would be standing there, one of the most handsome men ever. Back in that time he was a young

man. He was beautiful. He was masculine and beautiful—you know what I mean—and he was articulate. All I could think of was, There's one of God's children. Well, I never had that feeling about anyone since. It was an amazing thing. Duke was funny. He'd run into you and he'd greet you like he'd just been waiting all day long just to see you.

Believe me, Ellington's was an exciting band. I never heard anything like it in any other band. The Lunceford band created a lot of excitement on the stage but in no way compared to the Ellington. In the first place, everything Ellington did was original. The next thing, everybody in Ellington's band was an instrumental star. They were all stars. He framed the music for his stars. I always said he was the greatest framer in the world; even in later years [when] he would take what some might consider lesser players. They weren't mediocre musicians, but they came into his band and it was way over their heads. I always liked to say that he was the sort of guy who'd take a zircon and put it in a diamond setting around it. Like in the case of Johnny Hodges and Lawrence Brown, as fine as they were, they would have been great anyplace but he made them greater than they actually were. They would have been wasted anyplace but Ellington's band. Many of those stars left the band, but when they left they died and always came back, except perhaps for Ben Webster. Ben was a great talent. He was a great talent with no control.

H: Tell me about the time you spent with Tommy Dorsey.
S: When I left Lunceford, I intended to go to college to study law. I just never got to school. As a matter of fact, people think I left the band to go with Dorsey. I left Lunceford's band to go to college. A few days after I'd made up my mind

to quit, I was out at Brighton Beach and got a ride back into town with Tommy Dorsey's road manager. I told him I put in my notice that night. Dorsey had been trying to get me to write for his band, but as I told him that night, I didn't quit Lunceford to join Dorsey's band, I quit to get out of the music business. Tommy approached me several more times, so I decided to give it another whirl.

H: Do you have any regrets that you did that instead of going to law school?
S: No, I've had a very satisfactory life. I've been lucky in many respects.

H: Weren't there times when you were doing business at Decca and things like that when you wished you were a music lawyer?
S: No. I'm not one of these people who tries to do three or four different things at the same time. I am also not one of these who compares success and who agonizes because he hasn't written the great American novel. When I went into the music business and decided to stick with it, that was it.

H: When was the last time you played or arranged for anybody who played uptown?
S: The last band I played with uptown was Lunceford, if you don't count a couple of Apollo jobs in the 1940s. I don't remember the last time he even played in Harlem. A matter of fact, the last time I played with Lunceford wasn't even in Harlem. The last time I played in New York with the band was in Brighton Beach in Brooklyn. That's the night I put in my notice. Lunceford didn't play in Harlem very much. As a matter of fact, in later years, aside from him playing the theaters, we didn't play much uptown— the breakfast dances at the Renaissance on Easter, but very little else.

H: Did you ever live uptown?
S: Yes, I lived two or three different places—405 Edgecombe, 930 St. Nicholas. But I didn't really live there. I was on the road with Lunceford. After two or three years I got a place up in Westchester.

H: When you joined Dorsey as an arranger and occasional vocalist, did you ever go uptown with members of the band?
S: I really didn't go anyplace. I didn't hang out. I was never a hanger outer. I've been in the music business all my life, and I've never been noticed hanging out, if you know what I mean. I never went uptown with Dorsey, and I don't know of any time he went uptown, for that matter. I supposed he did but I didn't know about it.

H: I'm told Lunceford led his band in a very professional manner. Which one did you enjoy working for musically the most in terms of writing what you did, Dorsey or Lunceford?
S: I learned a lot from Lunceford, but I enjoyed the association with Dorsey.

H: You felt Dorsey had a better band?
S: It had better musicians.

H: The general level of musicians in the band? Was Davey Tough in the band when you joined the band?
S: No, he had left. He was on his last leg. Dorsey was sort of taking care of him— but who the hell was the drummer when I joined the band? Buddy Rich came in shortly after I joined. I stayed until about 1943, when I went in the service.

H: I think Buddy is the best drummer I ever heard in person. Who was the best you ever heard?

S: I'd say Buddy. He's the best drummer, and most drummers who do a Buddy Rich are not good band drummers. He does it all.

H: What was Chick Webb like in the 1930s?
S: He was great, but it was a different time. I never heard him take an extended solo.

H: If you don't count Ellington, who did you listen to the most carefully in the 1930s?
S: When I was with Lunceford, I was interested in learning to write. I wasn't interested in listening to anybody else or copying anybody else, and I didn't much think about anybody else. I didn't listen to bands. I never listened to bands. When I was a kid, when I first came along, when I first got interested in music, I listened to everything—Fletcher Henderson and Duke Ellington. Of course, they were, as I said, in the mid-1920s, and they were just starting. Back in that time Fletcher Henderson did things like "Clarinet Marmalade" and "Stampede," that sort of thing. That was my listening period after I left home, began playing, trying to learn to write. I just couldn't listen to anybody else at all. I didn't have time to. I didn't get off work, go home, and put on the record player. No, I don't remember listening to any bands particularly. It wasn't Fletcher Henderson's writing I liked as much as I did Jimmy Mundy's. I remember the first time I heard the Goodman band. I was driving up Seventh Avenue the first time I heard them, and I was impressed. Very few records ever caught my attention, but this one did; it was "And the Angels Sing." I pulled over and double-parked. This is good, I thought. Another time, a few years later I was on the way to the work. I was

working for MGM and MGM is on one side of Los Angeles and I lived on the other side, out near Pasadena. I heard a great Louis Jordan thing. I pulled over and listened to that too, but I rarely listened to music on the radio or the record player. If it weren't for my wife, there wouldn't be any records in the house. I can kick myself. All of those years I was working for Decca, I don't have half of the things. I have all the Lunceford and Dorsey bands. Most of them have been reissued, and people send them to me.

H: Your external influences have been minimal?
S: Let me clarify what I said. When you asked me about that, about the bands I listened to in the 1920s and early 1930s. I used to listen to them when I was a youngster, when I was first started out in my early twenties; I was completely wrapped up in music, and I was trying to learn. I was trying to learn to write. Back in those days, I didn't have any formal training so I sort of invented this whole thing all myself. It took me years to learn things that I could've learned reading a book in two minutes, but back in those days, the books written about orchestration, if you could understand one, were so complicated it was difficult to make use of them. Unfortunately, as I learned and developed and really got into the business in a commercial fashion, well, that's what it became— commercial. I treated what I did very professionally, like a profession. I did the best I could, but I wasn't necessarily salivating to get to work in the morning. It was work. But even now I get great joy if I write something and it's well played, if it turns out to be exactly what I wanted. I really enjoy that. But remember, this was not a reason for

doing it; I never really planned to be a musician.

H: When you got back from military service, you went into the Zanzibar. Tell me about that experience—1946 touring and residency at the Zanzibar.
S: The Zanzibar was a black club. They were very successful during the war years and they had used all the black bands—Ellington, Louis Armstrong, Cab Calloway. They used them all time and time again, so they decided on the policy of a house band. They hired me to put a house band in, play the shows, and to write the shows. That was my reason for going in there. This was shortly after the war, and I finally got my name up in lights on Broadway, but they had brownouts, and the lights were out when we opened. I was never interested in having a band. I went in there as a house band—the conductor/arranger. I put the band together, of course, but not with any intentions of organizing the Sy Oliver Orchestra. The manager, a man named Joe Howard, must've been part owner, because after we had been in there a short while, he had a stroke and the place eventually closed because of his illness. I went out on the road with the band; the William Morris Agency did this booking. The only reason I went out on the road with the band was to recoup my investment. I had invested in uniforms and was buying arrangements. I didn't have time to make all the arrangements for the band because I was working for Decca and had many clients. As a matter of fact I had an office in the building where the Zanzibar was located. I went out on the road to recoup my investment, and my first engagement was at the Apollo Theater. I remember we were in Indianapolis or maybe Akron, and the road manager came in with the schedule for the continuation of the trip. I saw the jumps and I just got on the phone and told William Morris to cancel the tour. I came on back to New York, and that's the end of that. That was the extent of my touring with the band.

H: Tell me about your years at Decca.
S: I was there for nearly twenty years. I was musical director for Decca Records.

H: That album I see over on your shelf—the Louis Armstrong autobiography, I assume, over there— I assume you probably wrote all the charts.
S: Most of it.

H: Was this a rewarding musical project? Is there any kind of thing that you prefer to do?
S: When you're doing commercial arranging, the only thing that is rewarding is when you deliver what a client wants. I was working for a record company that had fifty artists, all of whom were different, none of whom sounded like I did or liked the kind of music I liked. I admired some of them and enjoyed others very much. Some of them were real turkeys, but the rewarding thing about it is another thing. I don't have same attitude towards this business that most people do. During my active life, after my childhood, I considered this a profession, and I treated it and worked at it like a professional. There was no question of having fun or getting kicks or going out jamming all night. That was not my idea of what it was all about. The people who weren't professional didn't last very long. I have never heard a mistake on an Earl Hines record.

H: To me, Benny Carter is in the same class.

Earl Hines at the home of
Sherman Fairchild, 1970

S: Benny—to me, Benny Carter is in the class of Duke. He's unique.

H: In his way Earl Hines is like that. Nobody played the piano like Earl.
S: That's right. The funny thing about it, Earl, to me, the things that he did with Louis Armstrong back in the late 1920s, "West End Blues" and those things, I remember those were the best piano solos. I just loved the way he played with him. They are as unique today as they were then.

H: Do you do your arranging at the piano or do you need a piano? Do you just write it out?
S: I use a piano quite a bit in arranging, and that's one thing I've learned about arranging. It doesn't frighten me to be alone at a piano.

H: What sort of music do you enjoy personally?
S: Usually, when I listen to something, I listen to the structure. I guess overall, though, I am pretty much the man on the street. I have my preferences. Some things I like; some things I don't like. All I'm saying is, just because I don't like something it doesn't mean I think it's bad; it's just not my taste. It's also been my experience as a commercial arranger/conductor that anytime you hear a musician putting down any type of music, you bet your bottom dollar he can't play it.

H: I get the impression you are very satisfied with your contributions to American music, that you don't have any regrets about not going to law school.

S: I've had a very satisfactory life. I've been very lucky in many respects. I was fortunate in that I have always done something that is not onerous. I have always enjoyed making good music. I'll give you an example. I had a band in the Rainbow Room for ten years, and the band was in the room for thirty-five or forty weeks a year. I probably worked harder than anybody else in the band, because I had to add so many new arrangements to the book. There were a lot of repeat customers at the Rainbow Room; the audience knew the book very well—you know, they'd say, play number 73, that kind of thing. Sometimes I'd be writing new arrangements on breaks. I never worked that hard when I was with Dorsey or Lunceford. But I felt the hard work was very worthwhile. Earlier you asked me if I preferred writing for Dorsey or Lunceford. I spent much of my life not writing what I wanted to write but writing to accommodate the needs of other musicians. This isn't necessarily wrong—I learned early on that there was little point in writing music if no one was going to play it.

H: Would you elaborate on your feelings about writing for others?
S: Once I did an arrangement of "Swanee River." When I wrote that arrangement, I was looking for subtlety, not power or crazy technique. Lunceford and Dorsey both played the tune, but the Dorsey record is so superior. The Lunceford band couldn't have played it as well. It's one of my favorite records.

H: When you wrote for Dorsey, did you produce all types of arrangements, instrumentals, things for Sinatra?
S: As a matter of fact I got very few assignments when I was with Dorsey. I mainly wrote originals or just things

I liked. I also wrote a lot of the round-robin vocal numbers with Sinatra and the Pied Pipers, songs like "Let's Get Away from It All" and "Oh, Look at Me Now."

H: I've heard records—or perhaps they were from radio broadcasts—which featured you singing with the band. Did you do that often? Did you travel on the road with the band?
S: I was an arranger with the band; I never played with the band. That's one of the main reasons I left Lunceford. I was never interested in playing, and I disliked the constant traveling. Lunceford wouldn't hire me as an arranger, so I left the band. You see, almost every good arranger spent some time playing with a band, usually arranging for the band he was playing in. But to me, riding up and down the road in a bus is not the best way to live. To answer your other question, I did sing occasionally, but this was primarily on records or, more infrequently, on a broadcast.

H: I have the feeling that travel is not your favorite thing to do.
S: If 865 West End Avenue had been two blocks further from the Rainbow Room, I probably wouldn't have been there for ten years. I don't hate to travel; I just don't enjoy traveling in bad circumstances. One thing I remember really enjoying was going to California on the train. I'd have my own stateroom. After leaving Chicago I wouldn't put my clothes on until I got to California! But things change. The last time I was on a train, I was certain it had square wheels. I took it just to be nostalgic and it was a terrible trip. A baby crying all night long, that kind of thing. It was a real disappointment.

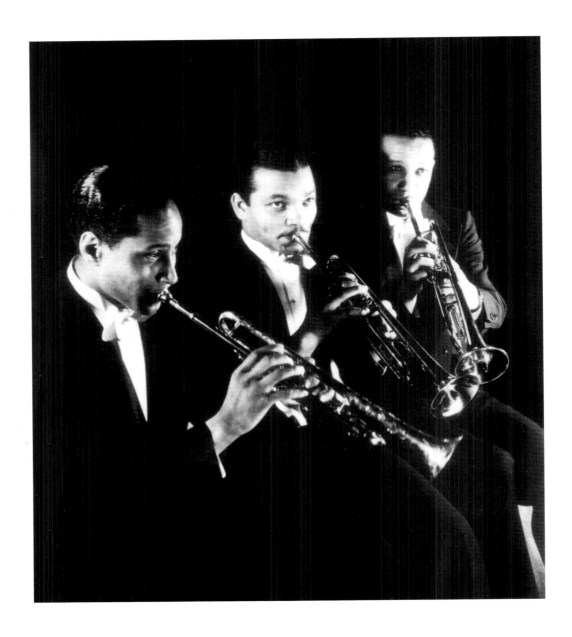

From left: Tommy
Stevenson, Sy Oliver, and
Eddie Tompkins with
the Jimmy Lunceford
Orchestra, 1934

H: *A year or so ago I came upon your name in a catalog issued by the New School for Social Research. They have a new jazz studies program. What do you think of jazz education? Were you planning to be part of the faculty?*

S: Nobody talked to me before they listed my name in the catalog. They just did it, and for a moment I thought I'd sue them but then I decided not to. What difference would listing my name possibly make? In this society a person can spend a third of his life in school and spend a lot of money to get degrees and then just wind up teaching school somewhere, and the next-door neighbor is a garbage man who earns three times as much money. There is something wrong here. Our illiteracy quotient is increasing. The whole thing doesn't make any sense.

H: *But what about jazz education?*

S: You have to learn how to play—how to play the kind of music that can get you a job. You have to learn it from others; you have to actually play. A workshop course is about the only thing that can really make a difference, where someone with experience can show you something.

And, of course, these kids have to have a place to play. It's harder and harder to find a place to play. The band business stinks. In fact, there is no band business. Why does Buddy Rich have to run up and down the road fifty-two weeks a year playing one night at a time? The people who run the music business, unlike the people who run the schools, are not in the education business. They aren't obligated to educate the public about what is good or bad; they are in the business of catering to popular tastes. They sell music, they don't make music, and the young people who want to be in the music business will have to play what is saleable or find another profession.

H: A number of music critics voice their opinions about the birth or death of one sort of music or another, who is good, who is not. Have you ever paid any attention to this sort of commentary?
S: I read a lot but I never paid much attention to critical commentary then or now. It seemed to me it was always about the same. I remember when magazines like *Downbeat* got started. The college kids followed the big bands around. Then jazz critics began writing in those magazines and, like most critics, their critiques were based on their private, personal tastes, which of course invalidates their critiques. I could understand the public believing these critics, because the American public believes almost everything it reads or watches on television, but pretty soon musicians who should have known better began believing the critics. I found this very amusing. I was also very puzzled by one thing regarding reading. As far back as I can remember, and it is probably true today, people wasted their time. We would be on a bus, day after day. I could never understand how the guys could just sit there and gaze into space for hour

after hour. If I finished my book and the bus driver wouldn't stop and let me get another one, I'd kill him. The other guys would be sitting there playing pinochle or staring into space. I was going to take the subway downtown the other day, and on the way to the train I noticed I'd forgotten my reading glasses. I went right back and got them. I didn't want to waste the time on the train not being able to read.

H: Do you go out to clubs much these days, uptown or downtown?
S: Not so often. I've gone to hear a few guys in so-called jazz clubs. Some saxophone player will play ten thousand choruses with a rhythm section and then sit down and look worried. I wonder why he did it. He may wonder why he did it. There's no way you can sustain a viable solo for that length of time. It's just impossible. So much of it is redundant. It doesn't interest me.

H: What about uptown?
S: There aren't any clubs uptown anymore. A short time ago I had to go to the airport to pick up someone on a Sunday night. I drove uptown and went across 125th Street and when I came to the Apollo, I pulled over and looked around. It was *Sunday night in Harlem* and it was absolutely deserted. Not a person on the street. Storefronts closed and locked up. I just couldn't believe it. I thought back to when Harlem was Harlem. The music was everywhere. Everybody dressed up sharp as could be all the time. Sunday was a highpoint of the week, going to the last show at the Apollo. Excitement was in the air. Now there was nothing but potholes in the street and boarded-up buildings. It was a disaster and it made me very sad.

18 February 1987

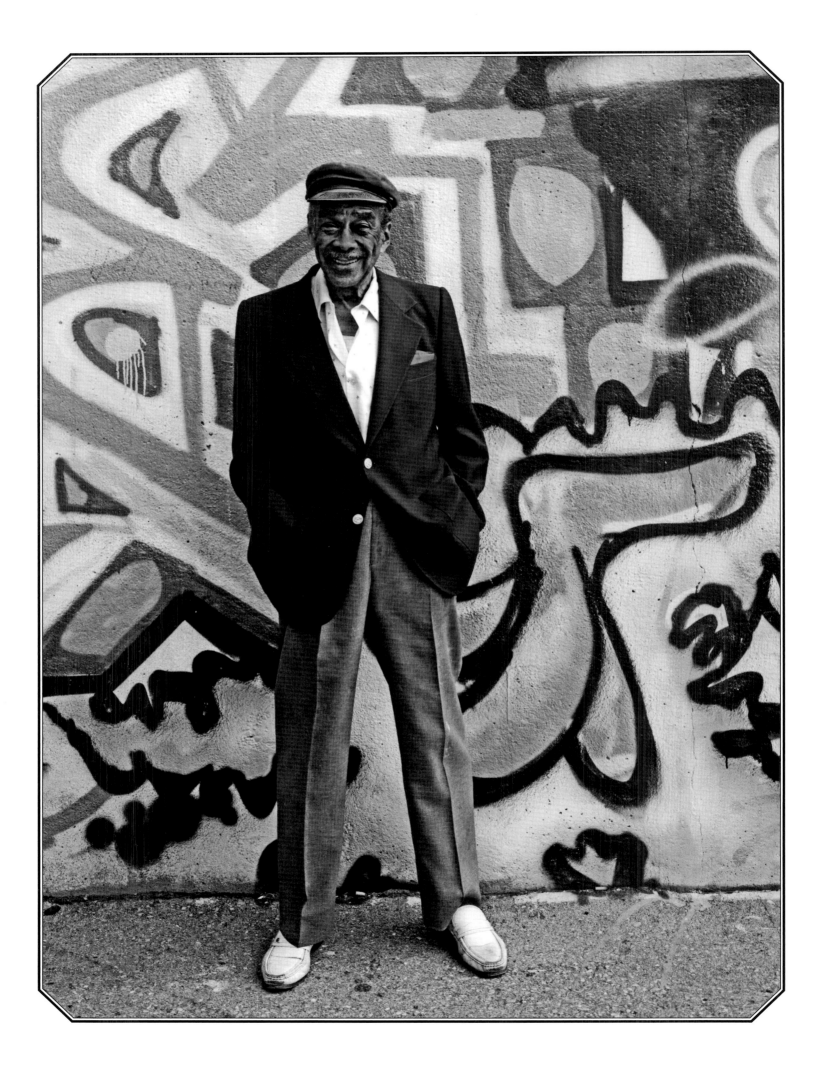

Buck Clayton
(b. 1911)

Buck: *The Ghosts of Harlem* is a good idea and a good title for a book. I think about Harlem all the time. I always wondered what the old Cotton Club looked like. I know it is gone, but is there anything there to remind you of it? I don't get uptown anymore.

Hank: *The building that housed the Cotton Club at 644 Lenox has been demolished, and an apartment house development is now on the site. I've driven around Harlem a lot in the past few months. You can still see where the Celebrity Club used to be. The sign is hanging on the building but nothing's there. The Baby Grand is still on 125th Street but not much is going on. Small's Paradise is closed and will probably never reopen. The Alhambra's still there and so is the Renaissance, but they're bricked up. The Renaissance sign is still hanging on at 138th Street on the side of the building. It must be about twenty feet tall but it's all rusting and peeling. The building where the Hot-Cha Club was located is still there, but recently they tore the sign off and painted the entire building a funny pink color. I wonder why you board up a building and then paint it pink. It's a strange*

thing to do. There are other places where buildings are still standing, but there is no indication a nightclub was ever there. The feeling you get when you drive or walk around uptown is desolation, and almost all the musicians who could afford to leave did so long ago. There's almost nobody who lives uptown anymore. Sammy Price lives in an apartment just off 135th. Andy Kirk is still at 555 Edgecombe. Doc Cheatham lives just outside Harlem down at Lexington and Ninety-second Street, but there are not many people left.

B: I didn't get to Harlem until the midthirties with Count Basie, even though I led a band called the Fourteen Gentlemen from Harlem before I joined the Count. I was from Kansas but instead of heading east, I headed west and wound up in Los Angeles in 1932. I eventually hooked up with a man from back east named Earl Dancer, who was a big man in show business for a while in those days. He was Ethel Waters's old man and her booking agent, but she had kicked him out because he was always hustling money, gambling and losing. He had come out to California but he wasn't a musician, he was a go-getter, a hustler with connections. He knew a

lot of people and he hustled up jobs for people in the movies; he even wanted me to play for some movies he planned to make. Sometime in 1934, I think, he managed to get someone to sponsor a nightclub, the Ebony, for him, so he had to have a band. He organized a group of fourteen guys. I was one of them and, as it turns out, I was the only one who could write music, so in addition to playing I had to write arrangements. I remember at the end of the first week at the club, he didn't pay us. He had gone off to Hollywood, got in a poker game, and he lost. He did this for about four weeks in a row and finally everyone in the band was broke. We couldn't pay our rent, we couldn't buy dinner, so we just kicked him out. We tried to stick with him but he just continuously lost our money. We all thought the band was too good to break up, and I was elected to be the leader because I was the only who could write and arrange. We kept the name Fourteen Gentlemen from Harlem, but there wasn't one guy in the band who had ever been there. I was born in Parsons, Kansas, and everyone else was from California, but we all knew where Harlem was and it had a magic name. In 1934 when I took over the Fourteen Gentlemen from Harlem, I became the leader of a band that had very little work, but one night when we did have a job Teddy [Weatherford] stopped in and heard us. Teddy had some work in China, and he hired us to play in Shanghai. I didn't know exactly what I was getting into, but it turned out that I stayed in China with the band for almost two years. Over there, the word "Harlem" meant Duke Ellington, and maybe that helped us get the job in the first place. I had an interesting time, but I didn't learn

to speak in Chinese. All I learned was how to call a rickshaw. I came back with the band in 1936 but there wasn't much work for us in Los Angeles, so I started thinking about breaking up the band and leaving.

One of the things that happened just after I got back was I heard Herschel Evans and stole him away from Lionel Hampton for my band, but as I said, we didn't have very much work. We did get to play once or twice at Frank Sebastian's Cotton Club but not much else. About the same time, I was in touch with some friends in New York and I started writing arrangements for Willie Bryant, who was leading a good big band in Harlem at the time. Willie liked the music I was sending him and told me that if I ever wanted to come to New York, I could always have a job with his band. Willie always had a terrific band—at one time Teddy Wilson was on piano; Benny Carter and Ben Webster had been in his band. I talked to my guys and asked them if they would want to go to New York if they had a chance, and everyone said no. They thought it was too tough in New York and there were too many gangsters. Maybe they were right, but a little while later, when there was just no work at all, I disbanded, turned all of my arrangements and everything in the band over to my piano player, and I headed east to join Willie Bryant. On the way to New York I stopped off for a moment in Kansas City and then I went down to Parsons to visit my mother, but before I continued to New York, I went back to Kansas City one more time to hear the Count Basie band and to see Herschel Evans, who was with him by then. I liked what I heard when I listened to the band, and Basie told me the band was going to New York City in a couple of months and he asked me if I would like to hook up with him. I told him that sounded pretty

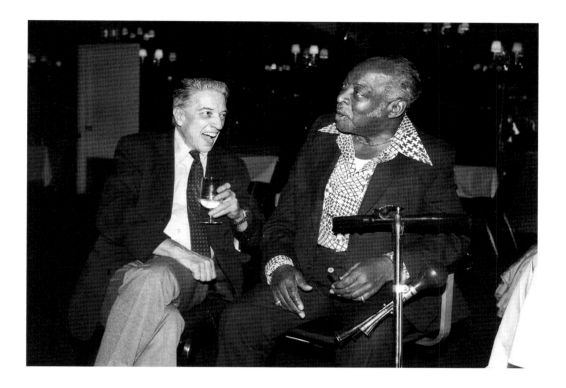

good, and I wrote Willie Bryant and told him I wouldn't be joining him because I was going to be joining up with Count Basie.

I had never been east of Kansas but the Basie band worked its way across the country to New York. We arrived in New York City early one morning and I remember driving down Lenox Avenue. It looked just wonderful to me. We drove around Harlem for a little while just looking at the sites. Chick Webb was playing that day at the Savoy Ballroom and his name was on a poster outside. It also mentioned Ella Fitzgerald. The band finally checked into the Woodside Hotel, a nice place that offered us rehearsal space in the basement. I was the only man in the band who didn't stay at the hotel; I had my own apartment over on Seventh Avenue. We rehearsed at the Woodside for our first job in New York City, downtown at the Roseland Ballroom. We were scheduled to play opposite Woody Herman. I remember the night we opened; Woody and all of

his guys stood around and listened to us and then they played. They really messed us up and washed us away that night. It really wasn't even close. We were a bit underrehearsed and some of our guys had to be replaced. We got a lot better very quickly, but it was a bad start. I thought John Hammond could die that first night when we played so badly.

H: You were a featured soloist with a band that quickly became one of the best big jazz bands in the United States. I know you were on the road a good deal of the time, but you were in New York City a lot of the time because the band was based there. What are your recollections of the band playing uptown, and where did you go to just hang out uptown?
B: The Count Basie band only played in two places in Harlem, the Apollo Theater and the Savoy Ballroom. Some of the guys in the band may have jammed at other places, but our main club to hang out was Clark Monroe's Uptown House.

John Hammond, *left*, and Count Basie, Sardi's, 1981

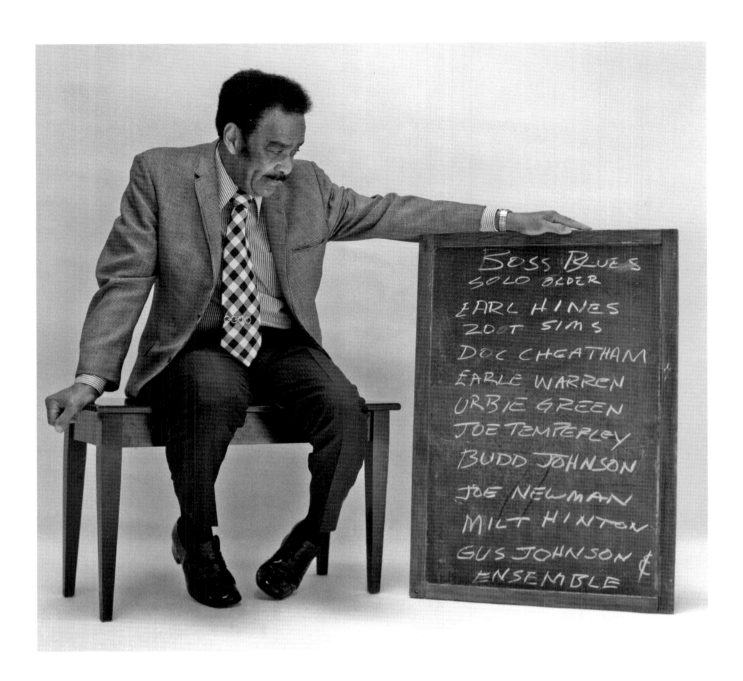

On the chalkboard:

BOSS BLUES
SOLO ORDER
EARL HINES
ZOOT SIMS
DOC CHEATHAM
EARLE WARREN
URBIE GREEN
JOE TEMPERLEY
BUDD JOHNSON
JOE NEWMAN
MILT HINTON
GUS JOHNSON &
ENSEMBLE

Buck Clayton, recording session at WARP studio, 1974

The first place we played was the Apollo Theater and we not only played as a band but we played for the shows. Sometimes the singers would have their own pianists so Basie would sit out those numbers, but we were almost always onstage playing for singers and dancers and even at amateur nights. It was a tough schedule. We started late in the morning and played all afternoon and all evening in between movies, and when you finished the day at the Apollo, you sometimes didn't have a lot of energy to go out and play in a jam session somewhere. It was a lot of fun in those days; we were young, could take the long hours, heard a lot of great performers. Sometimes we would just play the acts on and sit there and listen to them or look at the comediennes and things like that. I loved to watch Puerto Rico, especially on amateur nights when he would chase contestants off the stage if they did badly.

It was easier playing the Savoy Ballroom because you didn't have to start so early and there was another band to

play as well. Early on, we were the new band in town when we played there and when we went up against Chick Webb, he would usually be more popular. Of all the bands we played against at the Savoy, our only problem was with Chick Webb because he had such a following. He had been playing at the Savoy since the 1920s and had a lot of fans. The first time we played against him in 1937, I thought we won, but there were so many of his fans there, I think he got the nod that night. We would get burned occasionally but not very often. I remember one time when Lucky Millinder blew us out of Baltimore, but we rarely had a problem at the Savoy. It was a great place. The dancers were the best in the world. It was so crowded that you couldn't get a table unless you arrived in the afternoon, and almost everyone was well behaved. The dancers were wild Lindy Hoppers but there was never any trouble because the bouncers at the Savoy were the toughest guys in New York, and everyone knew it. If you caused trouble, first they would throw you down the stairs and then they would pick you up and throw you out on the street, so there wasn't much trouble at the Savoy. There was always a wonderful house band there, a small band, and the best of them was the Savoy Sultans. A terrific nine-piece band—Al Cooper's Savoy Sultans. One time Cootie Williams had a small band in there, and once Jimmy Rushing even put together a small band of guys from the Basie band for an engagement at the Savoy, but that was after the war. The main bands we played against in addition to Chick Webb were Benny Goodman and Duke Ellington, and these were my two favorite bands.

H: What was it like at Clark Monroe's Uptown House?
B: Monroe's was a great after-hours place. On any night at three in the morning

Menu autographed by members of Count Basie's Orchestra, 1940

there would be a collection of some of the greatest players in the world at Monroe's. They didn't have much of a menu. I think all they served was chili, but it was a great place. I remember one night I went up with John Hammond to hear Billie [Holiday] sing. She had married Clark's brother Jimmy, but I don't remember if they were married then, but we were sitting there and Benny Goodman and Harry James came in. John convinced Harry to get his trumpet out, and then I had to get mine out and we spent the rest of the night playing at one another with just a rhythm section. We were a mean little band. Ben Webster was there that

Buck Clayton relaxing at home, 1986

Opposite, above: Buck Clayton conducting a recording session with Buddy Tate, Doc Cheatham and Eddie Barefield, Van Gelder studio, Englewood Cliffs, New Jersey, 1980

Below: Vic Dickenson, *left,* and Buck Clayton at Sardi's, 1981

night, but he just listened. Benny, John, and Billie stayed all night just listening. No one came up and joined us. Monroe encouraged 3:00 AM sessions like that and there were a lot of other places in Harlem that did the same thing, where the music didn't start until the other places had closed down. You could find Marlowe Morris and Ben Webster at the Shalamar, but Monroe's was where I usually went. There was a night when Coleman Hawkins had come back from Europe and all the tenor players wanted to do battle with him. He'd just made "Body and Soul." Don Byas, Ben Webster, and a lot of other guys were there that night. There was some great music at those after-hours places but finally that

scene began to die down because the union got after the clubs. Nobody was being paid and many of those after-hours places were taking advantage of a lot of musicians, so the union started to crack down on them. This caused some of these after-hours places to fold.

H: Could you tell much difference between what Harlem was like when you first arrived in 1937 and in 1943 when you went away to war and then when you came back in 1945? How had it changed?
B: I stayed with Count Basie right up until I went into the army, so I played uptown in the Savoy and at the Apollo up until 1943. Then I had to go and serve

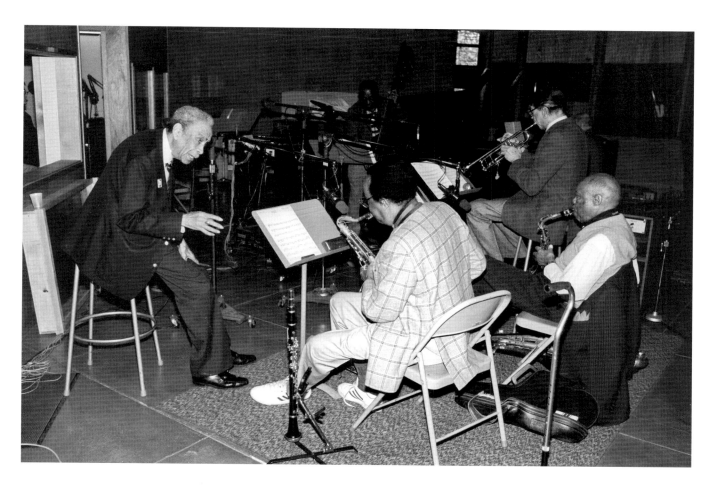

in the army. Things had started moving downtown even before I joined the army. Our success at the Savoy Ballroom led to an engagement at the Paramount down on Times Square and, of course, Fifty-second Street was getting hotter all the time, plus there was the beginnings of a good deal of music in Greenwich Village. During and after the war, there was a significant shift downtown. In a lot of the clubs uptown during the war and some of those downtown, you had to leave by one o'clock. I think there was some kind of a rule issued by Mayor LaGuardia. He didn't want to have soldiers out on the street very late where they might get in trouble or get mugged, so things were a little quieter during the war.

When I got out of the army, I never played in clubs uptown any longer. I had my own band for a while and we played the Apollo, but that was the only place I ever played in Harlem after I left Basie. By that time, everything was really changing and Charlie Parker, Coleman Hawkins, Billy Eckstine, and people like that only played downtown. Sometimes they might play a dance in a ballroom uptown but not very often. The unions had shut down all the after-hours jamming, and this put a lot of places out of business. The music changed too. When Birdland came along, there was nothing in that kind of music that had a steady rhythm, something that you could dance to. Rock 'n' roll has a big beat but bebop didn't, so people stopped

dancing in the clubs uptown. The music changed and so did the clubs.

H: Do you think there will ever be a viable music scene in Harlem again?
B: I really doubt it. What they had for a while was wonderful, but things change and you can never go back. I hope something new comes up, but I don't think it will. The music is just different today and it is so hard to have a big band or even a small band that works regularly. Frank Foster is trying to carry on with the Basie band and I have been up to Small's and heard Al Cobbs's band. They play up there every so often and I heard them a few times. I went up and danced to the band but I could tell no one was happy. The band wasn't happy. They couldn't buy uniforms. They could barely buy a necktie. I think the guys were getting seven or eight dollars a night, and the guys who were running Small's were terrible. They were just pocketing all the money. Al Cobbs told me that he knew he wasn't seeing any of it. The kind of music we used to play in Harlem doesn't seem to have any kind of a future. I taught at Hunter College for a long time and in my jazz classes, the kids had no idea of what the music was like or what it was supposed to be. They knew nothing about Louis Armstrong. Nothing about Coleman Hawkins or Lester Young. They'd heard of Charlie Parker but didn't know much about him. They knew Miles and Coltrane and maybe Mick Jagger, but that's all they knew.

24 September 1986

Buck Clayton at WARP studio, 1974

Bill Dillard
(b. 1911)

Hank: *You came to New York in 1929. Tell me about the circumstances.*

Bill: I'd been playing in Philadelphia for several years in some of the speakeasies and ballrooms there with local bands. A friend who played banjo, Howard Hill, left Philadelphia to go to New York and got a job at one of the dancing schools on Third Avenue and Fourteenth Street, the Diana Dime a Dance School. He'd been there a short time when the trumpet player said he was going to leave, so Howard asked me to come up and replace him for three weeks or until the band could find somebody else. Well, I came up and I never went back to Philadelphia. I worked at many different dancing schools and they were wonderful training grounds for musicians because you played continuously. The management didn't care whether you were good or just learning, because they had a room full of girls, and all they wanted to do was keep music going so the fellows would buy the tickets from the girls and dance with them. Some very prominent jazz musicians got their basic training in the dancing schools in New York City on Fourteenth Street or in Times Square.

H: *Did they have any dancing schools uptown, in Harlem?*

B: There was only one I can remember; it was on 125th street. It was white owned, just like the stores and the theaters. I played at that dancing school with a bass player, a very short fellow. I remember when I played at the Savoy with him, he used to stand on a box. I can't think of his name.

H: *At about the same time you worked with Jelly Roll Morton.*

B: Yes, I was very fond of Jelly. It all came about because of a banjo player I'd known in Philadelphia, Barney Alexander. Barney had played with Jelly but had settled in Philadelphia. Jelly came through town a few weeks after I'd gone to New York and Barney had already told him about me. He thought I was still in Philadelphia and planned to ask me to join his band, but I'd already left. I didn't really meet Jelly until several weeks later. Eventually, I did work with Jelly, made at least two record dates with him. As I said, I was very fond of him, liked him a lot, he was a wonderful guy. It was in 1930 or 1931 when we recorded in the old Victor Studios in Camden. At the time Jelly Roll Morton was a musical director for what they called Race Records. I think he was their first black musical director. I toured with the band as well.

Opposite:
Bill Dillard, 1987

H: The band is always listed on the records as the Red Hot Peppers. Did he use this name when you toured, and did you ever play any of the theaters or clubs uptown?

B: No, I don't think he used that name or toured with the band that recorded. When I met him he had a big band—at least ten men, it was quite a big band—but when we recorded in Camden for Victor we had seven or eight men, and maybe that band wasn't even called the Red Hot Peppers.

H: Did he ever play with the big band in the theaters?

B: Oh, yes. I think we even possibly played at the Savoy. I know we did a lot of touring on the road. Dances in the parks, pavilions, those kind of things

H: When you played in pavilions and ballrooms, Morton could play for straight dancing, the songs of the day, and do it successfully?

B: Certainly—he was an entertainer, a very professional entertainer. He didn't want you to drink on the job; he wanted you to be on time. I used to see him when he was running a club in Washington called Jungle Inn. Whenever I played Washington, I always went by his club. It was a fairly large room and he played piano and occasionally he'd sing a song. People could dance, but it was just Jelly and his piano and when he sang, there was no amp or microphone, he just sang; but he had a pretty large voice. No band, just him. If a fight started, he was the bouncer; he had to run the whole place himself. It was his club. I don't know if he owned it but he seemed to be in charge. His wife would usually stay in the back dressing room most of the time.

I remember he used to smoke a pipe and he never talked much, but when he did he was very bright, a philosophical, learned guy. When we recorded he used to write out the parts for many of the things we played. Most of the bands played by ear, but he wrote out a lot of what we played, special little trio sections and things like that.

H: As a man of the theater, what do you think of the new show which is loosely based on Morton's life?

B: I don't think Gregory [Hines] is the man to play Jelly Roll Morton. Vernel [Bagneris] would be much better. He has the right kind of dignity, the kind of philosophical approach to things that Jelly Roll Morton had.

H: Do you remember the first club or theater you played in Harlem?

B: The first regular job was at the Lafayette Theater and I was with Luis Russell's band. It was in 1931. I'd just replaced somebody in the band. I'm sure I'd played here and there in little places, but this was the first regular job. At about the same time we also worked in the Saratoga Club, a basement club across the street from the Savoy. Those were wonderful days; I was young and could stand the pace. A year or so later I joined Benny Carter and we opened the Apollo Theater. This was about the time I first heard Billie Holiday. I knew her when she was young, when she was singing in the little back room of the Hot-Cha Bar and Grill at Seventh Avenue and 134th Street. My church is right across the street. So many Sundays, but now it has changed. The Hot-Cha is now just a burned-out back room, and every time I pass it I remembered that I used to go in there to hear Billie in those days. There were

dozens of places that had a little back room and a piano.

H: Do you remember her accompanist, Bobby Henderson?
B: Yes, but I didn't really know him. Billie was very special. I see so much written about her and I listen to her records, but I didn't see the movie. I am afraid it might disturb my actual remembrance of the real thing. They usually just talk about the sad part of her life, but I knew her when she was happy. I remember her first theater job. John Hammond encouraged Benny [Carter] to use her in a theater in Long Island City for three days, and it was her first theater job. She wasn't too well groomed but very excited about getting out of that little back room club and singing in a real theater. She had the style and a particular vocal quality that was very distinctive. Those were very busy, interesting days. Benny doubled up sometimes, working in a theater and a club. When we were at the Apollo we were also working in the Harlem Club—Connie's Inn had closed and had reopened as the Harlem Club and later it was called the Ubangi Club. All those different clubs were at the same location. We went downstairs—I guess the little doors are still there. I worked with Lucky Millinder and Luis Russell at the same place. It was right next to it was the Hoofers Club. Many of the same men who just worked with me in Paris in *Black and Blue* were there is those days. I remember some of them tap dancing there, on the floor in Hoofers Club. This was a club that wasn't particularly successful but they kept it open anyhow. All the dancers usually went there to work out dance routines. They had a fellow who made sandwiches and coffee and you could go down there and get something to eat. You could spend the

whole day and half of the night as well at the Hoofers Club.

H: When you worked at the Apollo with Benny Carter, were you onstage or in the pit?
B: We worked both places, but you asking that made me remember a funny act we once accompanied at the Apollo, and I don't remember which band I was in but I remember the act—Norma the Fan Dancer. This was about the time Sally Rand did her famous fan dance and they wanted to have something similar at the Apollo, a black Sally Rand. They built sets—a half-moon on wires, that kind of thing—and they lowered Norma

Bobby Henderson, circa 1940

down; she stepped off the moon and did her dance. I'm pretty sure we were in the pit for that act. We played the first half of the show in the pit and then we went on the stage and did the rest of the show, because I remember looking from the pit up at this fan dancer. If the band was in back of the fan dancer, she would have had to have twice as many fans, and maybe that's why we were in the pit. I'm pretty sure this was with Benny Carter's band. In those days we had to learn to do everything—play behind singers and then for all the dance routines. We had to memorize a lot of the things that the dancers would use because quite often they didn't have any music. They'd just tell you what they wanted and how they wanted it. And sure enough, you had to play it with harmonies and everything else. We had to learn to harmonize because someone would come into the rehearsal with a tune or an idea and he'd play it, and sure enough, we would harmonize the first sixteen bars and something for the release and then finish out the next sixteen, and then they would go into a solo and behind the solo the sax, the brass, would think of some kind of a rhythm, harmonize. This is what we did before all the books were arranged.

H: *You spent a good deal of time with Teddy Hill.*

B: About four years and it was a wonderful band, but you had to be there. We made many records, but I tell you a lot of people have said that when they listen to the recordings that Teddy Hill made, well, sometimes it seems that the band wasn't up to par. I hear the same thing, but I know what happened at the time. Quite often we'd have a record session just to record a publisher's tunes. When we got to the studio they'd pass the

music around, songs we'd never seen, and we have to put the recording together. I even sang a lot on these recordings. I never sing them anymore; it was just a matter of me recording the publisher's tune. Many of these recordings didn't have the same feeling we would have had, had we created something ourselves. Just look at who we had in that band! Dicky Wells, Chu Berry, Bill Coleman, Frankie Newton, people like that. Dicky Wells was a big inspiration when it came to second riffs. Especially behind the reed players. Dicky Wells was a remarkable player. Later on, Dizzy Gillespie joined the band. He was just a kid; it was probably his first big band. Dizzy is such a wonderful guy. I met him in 1937 when he joined Teddy Hill and we all went to Paris. He was maybe eighteen, and even then he had a great sense of humor, always a lot of fun in the band. Of course, this was reflected in his style of playing as well. Because his style was completely new, not only to the trumpet players, but to all the other musicians in the band as well. When we were in England, Hugues Panassié had come to London to hear the band—it was like an audition—and decided he wanted to record us when we got to Paris. After hearing Dizzy play in London, he decided to replace him with Bill Coleman for the recording. If he hadn't done that, these would have been Dizzy's first records. Panassie probably made a mistake but in those days, quite often, Dizzy would be playing high and fast and make a mistake. When this happened, he would just break down, stop playing and laugh. That was his humor and his personality that he always protected. The records we made are still very popular; they've been reissued as an LP called *Dicky Wells in Paris, 1937.* Everywhere I go I find people, especially musicians, who have heard those records. An interesting thing happened a few

years ago when I was in Australia the first time, touring with *One Mo' Time.* One night after the performance, some of us went to a little club—they call them pubs, but it's like a little nightclub. The band was on a break and one of the fellows in *One Mo' Time* introduced me to the trumpet player, a man named Peter Gordian. He looked at me like I was a ghost, and said, "Bill Dillard! I learned to play your trumpet solo on 'The Devil and the Deep Blue Sea' from the record you made with Dicky Wells in Paris." Later on we had a jam session together at the Musicians Club and had a wonderful time.

H: What was your favorite place in Harlem?

B: The Savoy, except possibly the Cotton Club, but probably the Savoy. The atmosphere was better at the Savoy than any other place up in Harlem. The bandstands were large enough for two bands. Quite often we had these battles of music and one band would set up while the other band was playing. We were very close to the dancers—you weren't miles away. You could relate to them. The saxophones usually sat in front and the floor started within three feet. You could relate to the dancers and they could relate to you. When you left the stage, you walked through the room; you were an integral part of the whole operation of the Savoy. They had hostesses, everything was friendly, and, of course, at that time they had two or three busloads of tourists coming in every night. The tourists would sit at ringside; they had a fence around the floor, a banister, and they sat at the tables and watched the Lindy Hoppers. It was a wonderful place. I enjoyed it.

H: Of all the bands you heard there, who was your favorite?

B: Well, I remember when I was playing with Coleman Hawkins we battled with Count Basie's band. That was in 1939 or early 1940, and it was really a battle between Basie's saxes and Coleman Hawkins. I loved both those bands, but I'd have to say my favorite was Duke Ellington. I liked the individual soloists he had; they were all so distinctive. That's another thing about the instrumentalists in the bands of that era. You didn't have to see them—you could distinguish who they were by their style of playing. Today it is pretty difficult to know who is playing. You just can't tell, because so many younger players have learned the same clichés, the same figures and phrases, and play them over and over. They play the same thing, time and time again. There was a time when you could tell right away it was Johnny Hodges. You could tell from the first note.

H: I know you were on the NBC staff and began your legitimate theater career in the early 1940s. Was your last big-band experience with Coleman Hawkins?

B: No, Louis Armstrong's was my last big band. I was with him twice and was with him when the war broke up his big band. The war hurt many of the big bands—there were fewer ballrooms as the years went by, fewer places to play. The war hurt music a lot of different ways. I was too old to be drafted but I was told I had to take an essential job, so I was out of music and worked as a machinist for a while.

H: You feel the demise of ballrooms and the war were major factors in the decline of big bands and music in Harlem?

B: These were very important reasons. So was the way music changed and the lack of entertainment. If you dedicate your life

to being a musician, whether a classical performer or a jazz singer or any kind of an entertainer, you have to be prepared to accept the difficulties and the problems that you are confronted with before you reach the pinnacle of success. You have to realize that your whole objective is to make people happy. You want to make them feel good. You want to make them laugh. You want to make them sigh. You are giving them something the world really needs. If you don't believe it, just imagine the world without music, singing, or the things that we musicians, entertainers, and singers do. So with a positive approach to this, even though sometimes it is difficult, it shouldn't deter you in any respect or harm you mentally or physically. That is my opinion and I know some people don't agree with these ideas. With some musicians, it's very difficult to accept the idea of being an entertainer, and I guess in many cases their objective is to satisfy and please themselves, instead of pleasing the audience and listeners. I recall quite a few years ago when bop or progressive music became in and that was the new music that was being projected by individuals and groups. Quite often a soloist would leave the bandstand and not return except to go out to the microphone and take a solo. At the end of the solo, he wouldn't smile. He wouldn't bow. He wouldn't acknowledge the audience at all. He would finish and just walk back to his seat with practically no expression. He might even walk off the stage, depending on where he came from. This sort of thing left me cold. I'd come up in an earlier time when the performers and the music they made was supposed to please the audience. When the music and the musicians stopped doing this, part of the audience was lost. All these things hurt the clubs and places in Harlem.

H: When was the last time you played in Harlem?
B: Before the war. When I went into NBC and then onto the stage, I didn't play in Harlem any longer. John Hammond helped me get on the NBC staff and then later, when he was helping Billy Rose cast *Carmen Jones,* he suggested me for one of the parts. They changed part of the story and instead of a bullfight they had a prizefight. Somebody had to be the bull—one of the fighters. In those days I was two hundred pounds and used to compete in physique contests, posing, just like Schwarzenegger and all of these young guys do today. John set up an audition for me to meet Oscar Hammerstein. I walked into the audition and he took one look and said, "OK, fine." I never did anything that day but sign a contract, and I went right into the show. I did all right and over the years was in nine different Broadway shows, not playing in the pit but onstage in performing roles. *Green Pastures, Porgy and Bess, Lost in the Stars,* shows like that. I was even in Bill Robinson's last show, *Memphis Bound,* and I did my share of off-Broadway and television. I studied acting and replaced Sidney Poitier in a play when he couldn't do it.

H: You never stopped playing trumpet.
B: No, I never stopped. I've always played. Sometimes I even played onstage on Broadway, but other than that I rarely played in New York City. Since I was a trumpet player and a singer who could act, there were many jobs I could do that weren't available to every jazz trumpet player. I could easily play weddings and bar mitzvahs and did so frequently. I could be an entertainer. In recent years I've toured with *One Mo' Time* and most recently was in Paris with *Black and Blue.* It's coming to Broadway, but I'm sure I

won't be in it. They have a new music director and I'm sure he'll want to bring in as many of his friends as he can. We had a wonderful cast in Paris—Linda Hopkins, Ruth Brown, Savion Glover. We stayed in France two months longer than we expected in Paris but got back in April. *Black and Blue* is a musical about the 1940s and 1950s, almost a typical Apollo Theater–type review. No book or anything, just dancing and singing and music of that era. We had a twelve-piece band and quite often we'd leave the theater—we'd be on the street going home—and the young French kids and the teens would be waiting just to give us a hand as we passed. This told me they had heard or seen something that possibly they had not heard before or seen before. It was just like the way music affected us in the 1920s and 1930s and the other people that were fortunate enough to be around at that time. You could just feel the response and the wonderful reaction that you got from music of that era.

4 February 1987

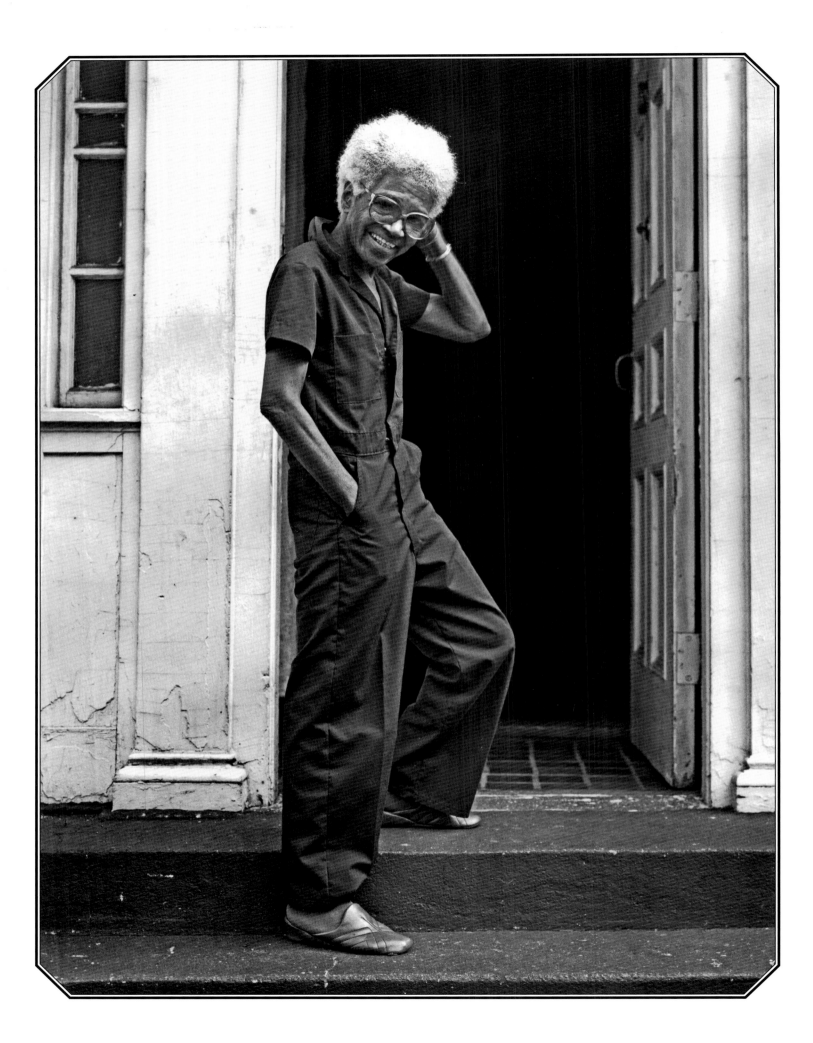

Maxine Sullivan

(b. 1911)

Hank: *When did you come to New York from Pittsburgh?*

Maxine: I came to New York in 1937 and was still known as Maxine Williams. The Cotton Club had already moved downtown. I started working at the Onyx Club and made my first records right away. I was lucky because my first records were very successful, first with Claude's [Thornhill] band and then under my own name. When I got my own contract, Claude still led the band and many of the same people were in the band. I never worked uptown very much except at the Apollo Theater and then later, in the mid-1940s, at Jock's Music Room [formerly known as the Yeah Man]. I went into Jock's in the mid-1940s.

H: *Tell me about what it was like at the Onyx Club when you first came to town.*

M: You know, when I first went in there I didn't work with the band. I didn't have any arrangements, so I just worked with the piano player. Sometimes it was Don Frye, sometimes Clyde Hart. I started singing with the band after Claude wrote the arrangements for me. The band was led by Frankie Newton—that's why he's on my first recordings. I don't know how things worked out but pretty soon it became John Kirby's group; he was

the bass player with Frankie when I was first there. I was stupid about what was going on. O'Neil Spencer was also in that first band and when Kirby took over, he kept him on drums. It was all very confusing to me. Leo Watson and the Spirits of Rhythm was the alternating band. I married John Kirby in 1938 and we were married for a couple of years.

H: *You became a star right away with your hit record "Loch Lomond." You never played in little joints and worked your way up.*

M: No, I just visited them after we got off of work. And of course I went to the Savoy Ballroom to dance. I hit a lot of after-hours clubs; there were so many of them in those days. That's where I got a chance to meet so many great musicians. All the musicians, even the ones who worked downtown, came up to Harlem to play after hours. There were great places to eat. I'd go uptown just to eat the chicken and waffles. Joe Wells—I loved to go to Joe Wells's [Joe Wells Upstairs Room]—and Monroe's Uptown House. Those places stayed open late

Opposite:

Maxine Sullivan, 1986

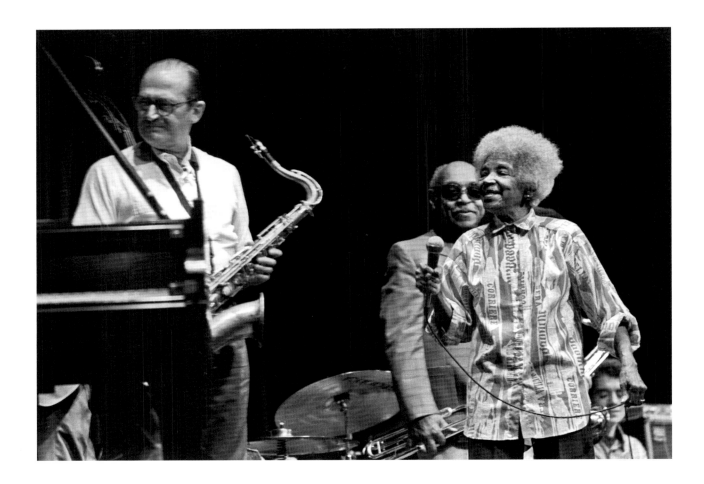

Al Cohn, Benny Carter, and Maxine Sullivan, Floating Jazz Festival, 1985

Opposite, above: Maxine Sullivan with Matty Malneck's Orchestra, 1939

Below: Louis Armstrong and Maxine Sullivan onstage at the Cotton Club, 1938

and there were always good guys playing there. A little band or maybe an organ trio. Marlowe [Morris], Wild Bill [Davis], people like that.

H: I know there were many organ rooms in the 1950s but were there that many in the 1940s? I thought the organ rooms came in when Harlem was starting to slow down a few years later.

M: There were lots of places with organs in those days, and Harlem was slowing down a long time before it closed down completely. There were a lot of things that messed things up. The Cotton Club moved downtown and there was something a lot of people don't talk about—something that really hurt the community. During the war everything above 110th Street was declared off-limits for white soldiers. North of 110th Street was out of bounds. And that's

when Harlem really went down the drain; it almost became out of bounds for whites, period. That was the end of our community.

H: Tell me about places you might have gone to dance or to just socialize, after the wartime restrictions had changed things.

M: Well, except for the dance halls like the Savoy and the Golden Gate, most of the music I went to hear was in places where they served food. The Savoy hung on into the mid-1950s but the Golden Gate didn't last as long. There was also the Renaissance Ballroom. Social groups hired that hall, especially women's groups like the National Council of Negro Women, but you had to be invited to events sponsored by organizations like these. There were also breakfast dances at the Renaissance.

Maxine Sullivan, 1939

H: *Tell about the first time you worked uptown.*

M: My first appearance was at the Apollo Theater, a midnight show. It was either at Christmas or New Year's Eve—I forget which. Noble Sissle led the band; Kirby's band wasn't organized at that time. I don't remember much about it or even the exact year. I had a lot of work downtown and I made a couple of movies—*Going Places* in 1938 and *St. Louis Blues* in 1939. I was back in New York in time to appear in *Swingin' the Dream* on Broadway and play the Cotton Club in 1940. Louis

Armstrong and I closed the place, the last people to work at the Cotton Club. When I first came to New York I didn't have the experience to go into a big place like the Cotton Club, and then when I had the experience it closed down. It's too bad *Swingin' the Dream* didn't last. It had an incredible cast and I was Titania, Queen of the Fairies. And little Sonny Payne—he was about nine years old—was my little drummer boy. Bill Bailey, Juan Hernandez, and Louis Armstrong were in the cast. Benny Goodman's small band had some numbers, and so did Eddie

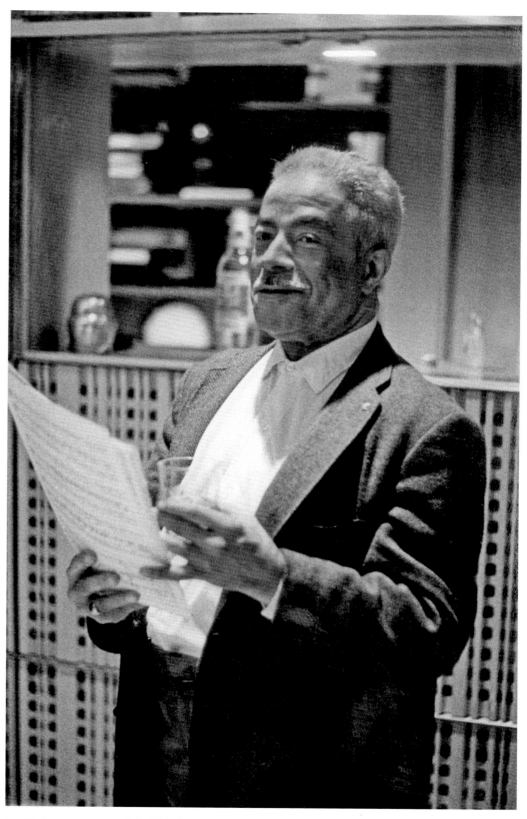

Cliff Jackson at Sherman Fairchild's home, 1968

Maxine Sullivan, 1986

Condon's group. But it was the Lindy Hoppers who stole the show. They'd built a bridge on the set and they danced up on that bridge, then they danced on the stage, then back to the bridge, and finally they all jumped off the bridge into a split on the stage. How could anything top that? We lasted a couple of weeks.

H: Tell me more about Jock's Music Room.
M: It was there for a long time. A very popular Harlem spot, particularly with show people. The manager was a man named Johnny Velasco. It was a downstairs place—you walked down about three steps to get in. I remember I followed Billy Daniels and I think it was about 1948. Eartha Kitt followed me. Donald Lambert was the intermission pianist. Len Ware had a trio there off and on. It was really the only club I ever worked in Harlem. As I said, I used to visit a lot of them for listening or having a meal, but not to work. I used to enjoy Fatman's Cafe on 155th Street. I mostly worked downtown and I never worked in Harlem after Jock's.

H: When did you move to the Bronx?
M: I lived in Harlem until I moved here in 1945. The first place I lived was with a girlfriend on Edgecombe Avenue and then, when Claude put me in front of the band, I moved to my own place at 2040 Seventh Avenue; the matron in the bathroom at the Onyx lived there and found me a room. When Kirby and I got

married, we lived at the Roger Morris at 160th Street. Joe Louis and Paul Robeson lived there for a while. I was living in the Bronx when I was at Jock's. A lot of people had moved out of Harlem by then, to the Bronx, Long Island, and Queens. Red Allen lived just down the street—you can see the building from here. Money Johnson lived in that house over there until he was killed in an automobile crash coming home from work. There was a lot of activity in the Bronx on Boston Road. Pearl Bailey got her start up here in a place called the Blue Moon Cafe; there was a good place called the Fair Deal. A lot of groups played at the Eight Forty Five Club on Prospect Avenue because there wasn't anyplace left in Harlem to play.

Cliff [Jackson] had played in Harlem in the early days but he mostly worked downtown. He gave up his band early on because he got tired of babysitting musicians. I think there's still a few of those guys alive, and I just heard that Bob Howard has a steady gig up in Mount Kisco. And that's the key. Steady work. There wasn't any steady work in Harlem for me or anybody else, and there hasn't been any for many years.

H: Let's go outside. I'll set up my camera and take some pictures.
M: That's fine with me but remember, what you see is what you get!

2 July 1986

Franz Jackson
(b. 1912)

Hank: *You were based in Chicago for most of your career, but you did have some experiences in New York in the 1930s and 1940s.*

Franz: I was in New York a few times, gigged around a little, but it didn't amount to anything. I was with Roy [Eldridge] in New York in 1939 and maybe 1940. I came into town with Earl Hines's big band a few times and even recorded here with them. A few years later I was here with Cootie Williams.

H: *What do you remember of the uptown music scene?*

F: The main thing I remember were the peekaboos, those union delegates, and how I had to dodge them. There was a fellow we called Peekaboo Jimmy, I don't know what his real name was but he was a delegate, always sneaking around trying to find out who was working and who wasn't, if you had a union card, that kind of thing. Those peekaboos would come by your house at night, just to see if you were home or if you might be out working. I was able to get a few club dates, things with West Indian musicians. Somebody would rent a hall and put together a little band. I scuffled in New York for about six months and then managed to hook up with Roy. He was already here, working for Joe Glaser. He got me because I'd been with him in Chicago. I worked with Roy many times over the years—I was even in that big band he had in the mid-1940s.

H: *I remember you made a record in New York about the same time you were here with Eldridge.*

F: I even used some of the guys who were in Roy's band—Ted [Sturgis], Panama [Francis], his brother Joe [Eldridge]. We made it for Decca with that no-good, conniving Mayo Williams. He got a lot of guys on records, but he exploited people, and I mean *exploited*. He could always find a way to take your money; he knew all the ins and outs— how to get himself a higher royalty, that kind of thing.

H: *Did you work regularly with this band?*

F: No, it was just a recording group. I had a number of little bands that played around at that time. I worked at Small's Paradise. They had bands in there for seven or eight weeks and then would give them a week off, but since they had a show in there, the replacement band had to be able to play the show. I did that a couple of times. I even had Thelonious

Opposite:

Franz Jackson, 1986

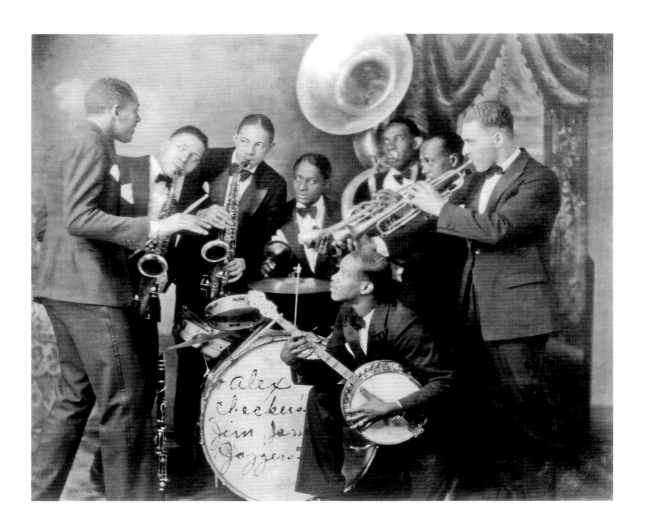

Franz Jackson with the
Francois Mosely Band,
Chicago, 1929

Monk in my band one of those times,
and he used to drive me crazy. He didn't
want to do the show and every time the
lights would come on for the show, he'd
go to sleep. Right on the bandstand. He
drove me crazy. I replaced Monk with
Sonny White. He didn't go to sleep. Clyde
Bernhardt was also in the band. The band
was only together a few weeks.

*H: The early 1940s were a busy time
for you; it seems this was one of the few
times you weren't permanently based in
Chicago.*
F: It was very confusing. I was with Earl
Hines, on the road most of the time; then
I was with Fats Waller. I spent some time
with Benny Carter. I'm glad I worked
with Earl—that's when I started writing,

when I wrote "Yellow Fire" for the band.
It was a hard, confusing time, sleeping
on a bus all the time, show up in a city
and play a ballroom or a theater and then
move on to another. I don't miss it at all.
Sometimes I'd get fed up and quit—that's
why I wasn't with anybody too long.
I'd just quit and freelance. Pick up gigs
playing or writing wherever I could. I
was never deeply involved with the New
York or Harlem music scene after the
mid-1940s. I was just in and out. The last
time I played in Harlem may have been
with Benny Carter, in a theater. I settled
permanently in Chicago in 1950 and have
never been in Harlem since then.

24 June 1986

Thomas P. Benford
(Drums)

THE CONNECTICUT TRADITIONAL JAZZ CLUB, Inc.
AND THE NEW YORK HOT JAZZ SOCIETY

Present

Franz Jackson

Franz Jackson's Chicagoan's

Direct From Chicago Only New York Appearance

FRANZ JACKSON Clarinet
BOB SHOFFNER Cornet
PRESTON JACKSON Trombone *Preston Jackson*
LIL ARMSTRONG Piano
BILL OLDHAM Tuba
IKE ROBINSON Banjo
TOMMY BENFORD Drums

"Banjo" Ike Robinson"

Lil Armstrong

Sunday, December 8th -- 4-8 p.m.

Bill Oldham — Tuba at the *Leon Scott Trumpet*

VILLAGE GATE

Thompson and Bleeker Streets

New York City Tel. 212 GR 5-5120

ADMISSION
Members C. T. J. C. and N. Y. H. J. S, $2.00
Guests and Non-Members $3.00

TICKETS: HANK O'NEAL 242-3305
 JACK BRADLEY WA 8-4896
 AL VOLLMER 914 TE 4-0053

Franz Jackson's Chicagoan's flyer, 1969

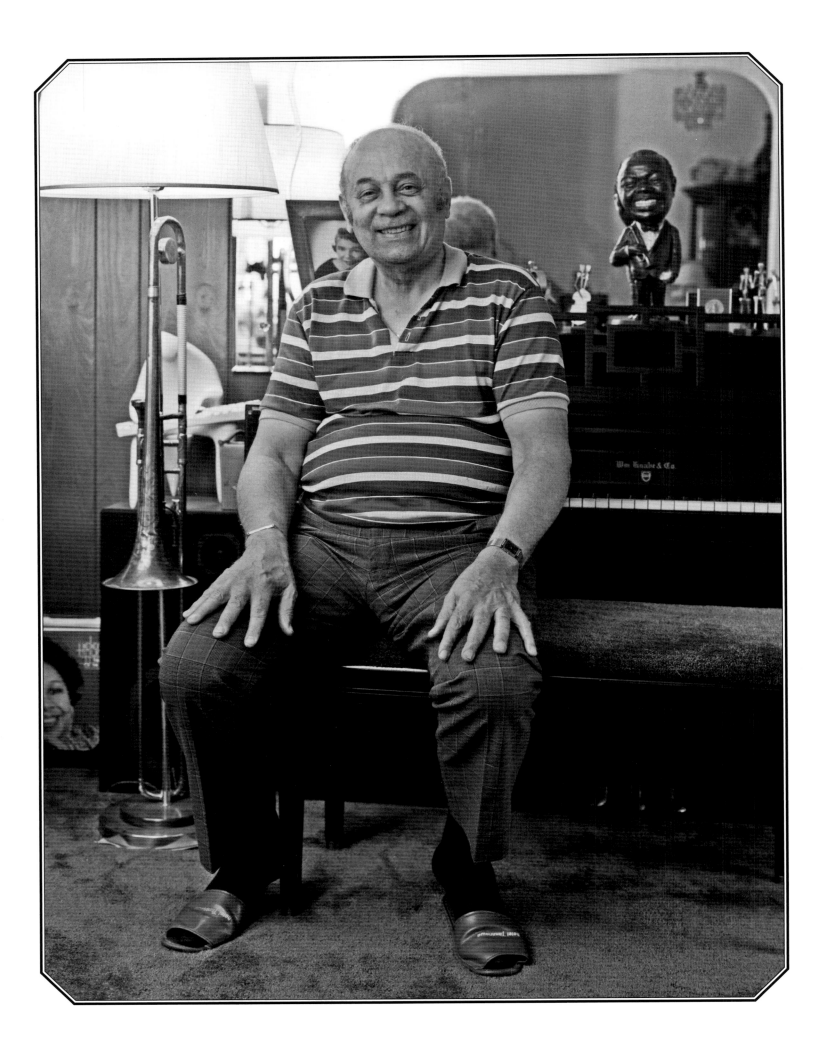

Red Richards
(b. 1912)

Hank: *When did you first begin to play the piano?*

Red: I started taking piano when I was about ten years old and studied the classics for about six years. I was born in Brooklyn but by the time I was taking lessons, I lived on 127th Street in Harlem. An older friend of mine who lived in the same block—he was maybe four or five years older—said to me one day, "I'm going to take you someplace." He took me to a house party and I heard Fats Waller, James P [Johnson], and Willie the Lion [Smith], and that turned me around. That's how I starting learning jazz, playing in those house parties in the early 1930s.

H: *Did you ever run into Bobby Henderson?*

R: No, I knew of him but I didn't know him personally at the time. In those years I liked Fats and James P—they were my two favorite piano players. James P was right up there with Fats to me, but Fats had more charisma and personality. The first professional playing I did was at rent parties. I'd make about six dollars for the night, a lot of money in those days for someone my age. You wanted to play as many of those parties as you could because someone who might be big would hear you. The main thing at a rent party was to get people to get up and dance, and if you could get them to dance somebody else who was going to give a party the following Saturday or in two weeks might hire you. That's the way it went, just piano, no other instruments. The people that came, they'd pay maybe a quarter or fifty cents to get in. A pitcher of corn whiskey was fifty cents and they might serve something like pigs' feet and potato salad. Some people had large apartments and were only paying, maybe, thirty dollars a month rent, so they'd throw these parties to make their rent. They were a lot of fun. If you passed by and saw an apartment building with three or four red lights, you knew each one of them had a party, and in those days everybody had an upright. People would go from one floor to another and sometimes it would go on for a couple of days—maybe start on Friday night and wind up Sunday afternoon. I first met Ella [Fitzgerald] at one of these parties. She was sixteen years old and we used to go to house parties together. She came from Yonkers and used to stay with a fellow and his sister on 128th between Convent and Eighth Avenue. That's when I first met her.

Opposite:
Red Richards, 1987

H: What was the longest one you remember playing?
R: I can't remember exactly, but I'll never forget there were times I'd leave on Saturday morning and wouldn't come home until Monday morning and then I'd sleep for twenty hours. Those are the kinds of things you don't forget.

H: If you were having such a good time playing the piano at parties, what prompted you to join the band?
R: I grew up and started meeting other musicians, and I wanted to get in with what they were doing. I started learning some harmony and theory from a teacher in the WPA project on Seventh Avenue. I was able to go there for free because a friend of my younger brother ran the place. This was the first place I played with horns and learned about music theory.

H: When did you go out with bands?
R: The first group that I ever played with was in 1936, a job in the Catskill Mountains, near Fallsburg, New York. We had to play a show with a comedian and a singer. The job lasted for the summer, and it was my first experience playing in a band. The first times I played in New York was just gigging with little groups here and there. The first real band I played with in New York was in 1940 with Skeets Tolbert; he had a lot of good contracts at the time. We played a lot of places like the Queens Terrace in Long Island, where Jackie Gleason got his start, and all around New Jersey. It was just six pieces, a nice little band with three horns and three rhythm. I made my first records with Skeets and even sang on one of them. After I left this band I gigged in Harlem in those little places—the Hot-Cha or Monroe's, different places like that. All of those places had weekend work, a trio that would play Friday,

Saturday, and Sunday. Sometimes I wouldn't even go to work until 12:30 at Monroe's. The first time I actually played a steady gig in Harlem was working with Tab Smith's band in 1945. We were the house band at the Savoy Ballroom for four years. I started gigging in the early forties, around the corner from Dicky Wells at Monroe's; that was one of my first jobs. Sometimes it was a small group led by a guy they called Horse Collar [possibly Floyd Williams]. Kermit Scott, a saxophone player from Texas who played with Coleman Hawkins, was in the band. We had two saxophones and a rhythm section. Julian Dash was also in the band for a while, until he left to go with Erskine Hawkins. When he left, Scottie [Kermit Scott] became the leader. Monroe's was a place where different performers would come by sometimes and sit in. We'd go to maybe six in the morning, seven in the morning.

H: Is it fair to say Monroe's was a place that would hire a rhythm section and hope a lot of musicians would come by?
R: No, this was a place that had us as a steady group. Like Dickie Wells—the dancer, not the trombonist—had a steady band at his place on 133rd Street. It was after-hours at that time. You go by there at two o'clock in the morning and you see all kinds of expensive cars parked outside. He had a tremendous following.

H: There was a place called Joe Wells Upstairs Room. This isn't the same place?
R: No, Joe Wells was a chicken joint on Seventh Avenue. This is Dicky Wells around the corner. I never played at this club; I'd just go there to listen. I did most of my playing at Monroe's. I remember the night I met Maxine Sullivan at Monroe's—she was still married to John Kirby and was real famous. This is before all the bop guys who were at Minton's

started coming up to Monroe's. I worked there about a year.

H: What was the most enjoyable place for you to go and listen?
R: There was another place on Seventh Avenue near the Woodside Hotel called the Victoria [Cafe]. It was right on the corner, and Freddie Moore was there all the time. This is the first place I met him, and I think he was the house drummer. There were lots of sessions there, and I liked to just go there to relax. There was another place on Seventh Avenue and 142nd where a lot of us used to go quite often called Mike's. It was quite a well-known spot at the time.

H: Was the Rhythm Club still a good place to get hired when you were coming up?
R: It sure was. It was a big clearinghouse and you could make new connections every week. Different guys you didn't even know might offer you a job. A guy would say they're looking for a piano player over there, and some guy would introduce you to another guy. It was a terrific place.

H: Where else did you work in Harlem?
R: I went in the service and was away from 1942 until 1944. I came out on Thanksgiving Day in 1944, and first week in January 1945 I joined Tab Smith's band—he was on his way to Chicago. We worked in a club for ten weeks on the South Side of Chicago and then we came back and got in the Savoy Ballroom. We were a house band and stayed for four years, from 1945 until 1949. We were just an eight-piece group for dancing—three saxophones, two trumpets, and three rhythm. We made a lot of records, were very popular, and would alternate with other bands, usually larger bands that came in.

H: Who were your favorites?
R: Without any question, George Hudson. Clark Terry and Ernie Wilkins were in that band. Every time I see Clark we talk about that band. They were sooooo good. I remember they all stayed together at the Braddock Hotel on Eighth Avenue. The people at the Savoy just loved them. It was the best band that played opposite us. It was so good that during my intermission I'd stand right near the trumpets listening to them play. The intonation was perfect; they were terrific—what a band! When they were there, the Savoy was a busy place.

H: How often did you go out on tour?
R: We'd go out once a year on a long tour of one-nighters. Usually down south, and when we were on tour we'd take a vocalist, someone like Savannah Churchill. But it was always better to be back at the Savoy. We'd taken the Sultans' [Savoy Sultans] place, and they'd been very popular so we had to come up to their standards. We stayed four years, so I guess we did. It was a nice experience seeing the people out there Lindy Hopping and dancing. I didn't make alot of money at the Savoy, but I had alot of fun. My old buddy Johnny Williams was in that band with me for a while. I saw Charlie Buchanan [the manager of the Savoy] not long before he passed. I was playing a private affair at the World Trade Center for a black businessmen's association. He was there and we talked about the old days. He died a short time later. He was way up in age and he'd lived a good life.

H: When you left Tab Smith, did you ever have any engagements at the Savoy or other places uptown?
R: No, I didn't have any other engagements at the Savoy. Erskine Hawkins was there all the time (it was

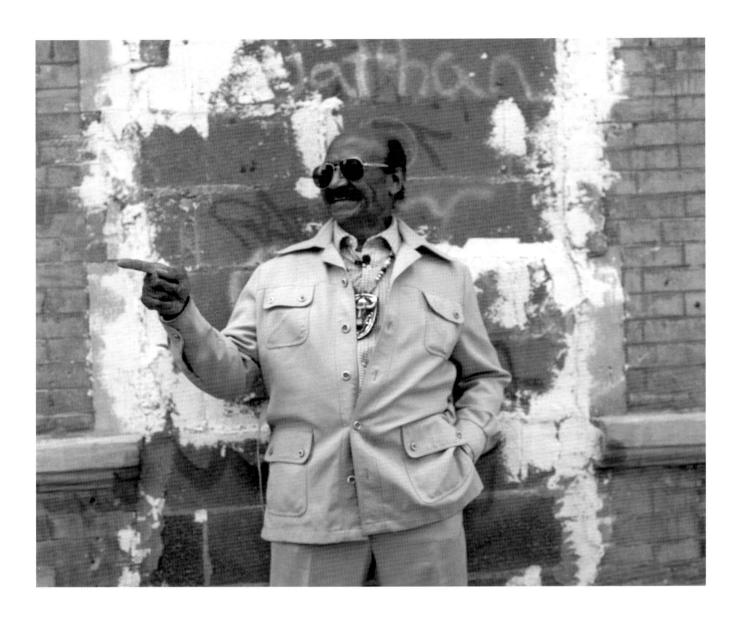

Johnny Williams outside
Minton's Playhouse, 1990

his home), and Jimmy Rushing had a
band for a short time with a lot of guys
who'd played with Basie—Smiley [Earle
Warren], Buck [Clayton], Buddy [Tate],
and some others. They stayed for a
while but not as long as we did. Buddy
Johnson had a band in there; so did
Cootie Williams; and remember, Dizzy's
[Gillespie] first big band played at the
Savoy. That was a few years earlier. I'll
never forget, he had John Lewis on piano.

*H: If you had to pick out one or two
things that were important to you, that
you gained from working in Harlem in
the 1930s and 1940s, what might they
be?*

R: Just the experience of doing it, playing
with all those great musicians. All the
kids going to schools these days, that's no
experience because all they're doing is
learning how to read music. That's what
made Harlem so great. You could go in
the smallest joint and see guys like Chu
Berry. I'll never forget, I was working in a
little place called the Alhambra Grill and
he came in. He was playing downtown
with Cab [Calloway] at the Zanzibar, but
he would come uptown and sit in with
us every night. That's what those guys

used to do. The same thing with Roy [Eldridge] and other guys. Whenever they finished downtown, they'd head for Harlem. It was a training ground for a young guy like me, and today's young musicians don't have that—there's no place to play—and I feel sorry for them. A kid learns a horn, all he does is get in a band like Buddy Rich's or something and it's not the same. All he's doing is reading a part. This don't mean nothing. When they come out of those schools, these guys haven't been to the minor league yet, so to speak, there's no place for these guys to get a chance. Some of these younger players have great technique but they're not really jazz guys. Years ago they couldn't even attempt to pull their horns out at one of those sessions.

There was a place on 130th and St. Nicholas, a private house, where all the horn players like Lester Young and Coleman Hawkins liked to hang out. I'll never forget when Coleman Hawkins came back around 1938. Different guys at that time, when people were listening hard to Lester, were saying things like, "Oh, Hawk ain't playing; he left everything in Europe." Then Hawk turned around and made *Body and Soul*, and everybody shut up. Because Hawk would go and just listen to everyone and see what these guys were up to, because he was an observing guy. You had types of places where guys could just hang out and play. There was a guy named Max Maddox, a good trumpet player who used to play with Fletcher [Henderson]. He drank a little too much—maybe that's why he's not well known—but he kept an apartment on 137th Street, and he had an upright piano. When Roy [Eldridge] was in town, he was right there. You could go to Max's apartment and play the piano, and there would be guys playing until 1:00 *in the daytime!* And nobody would

complain about the music because the music was so good. The people who lived in the building thought they were lucky. It was such a constructive era for a lot of musicians coming up. Many guys in that era joined bands on the road. A band would come through their town, and a guy would put his nose in and somehow get hired. Then he'd arrive in New York and find out there was a lot to learn.

H: The hours sound a little rough—and there was just so much to do, so many places to go, and so much to hear. Is this why some great musicians from out of town burned out?

R: Sure. That's what happened to people like Jimmy Blanton and Charlie Christian. It killed them. Sonny Greer was in a place in St. Louis and heard Blanton and told Duke [Ellington] that he had to come hear this kid playing bass. Duke went, listened for a couple of hours, and hired him on the spot. There were some bad influences on Blanton in the band, older guys who liked to drink and hang out. They took him around, and he was just a young, impressionable kid who couldn't resist—after-hours spots everywhere, the thrill of playing with so many great musicians. The same thing with Charlie Christian. A kid from a little town in a big city. Work all night with Benny Goodman and then go to Harlem and play until daybreak at Minton's, jamming with all those great guys. Play a theater all day, drink and jam all night, died of tuberculosis. If you're young you can do it for a while, but you can't do it forever, and if you kept hanging out it was inevitable what would happen to you, and I saw a lot of great players fall by the wayside. The opportunity to learn and play in Harlem was there, but there was also the opportunity to kill yourself. So many people did, died or burnt out in

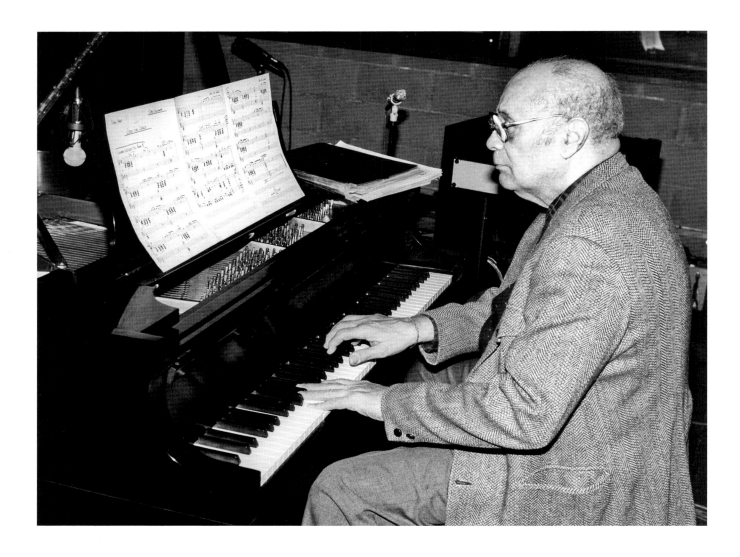

Red Richards, recording session at Van Gelder studio, Englewood Cliffs, New Jersey, 1990

their twenties. Fats Waller was dead in his thirties; so was Charlie Parker. The guys who survived were the guys who learned how to cool it. When you're working that hard blowing a horn, you have to pace yourself. Sure, go to parties and jam sessions, but not *every night.* There were too many opportunities and there was so much work.

H: Is it true things were not so competitive in those days?
R: There was lots of competition, but not for the jobs. You could always get weekend work, go to the Rhythm Club and get hired, and remember, you didn't need that much to survive. You were paying cheap rent, things didn't cost as

much, and we were all pretty close-knit. We helped one another, but sometimes it was hard to help someone who thought it was New Year's Eve every night, who didn't know that you had to get some rest or that corn whiskey could kill you.

H: Where was the last place you played uptown?
R: I couldn't even begin to remember. It might have been in the early 1950s. The fellow I mentioned who ran the WPA project, Buddy Walker, had a band and used to put on dances. I think the last place I played in Harlem was with him, at dances and functions at the Hotel Theresa, 125th Street and Seventh Avenue. They used to rent the upstairs,

up on the roof, for private affairs when a club would hire it. We played there the night Eisenhower came up when he was running for president in 1952. The Secret Service was running all over the place. W. C. Handy was there that night. I'm not sure if that was the last night I played in Harlem, but that was the last place. It's an office building now.

H: I know you rarely work in New York City.
R: I'm on the road about 80 percent of the time. All over the world. I think the last time I played in New York City was a one-nighter a year or so ago. I'm better known in Tokyo than New York.

H: In your opinion, what are some of the factors that made the music disappear in Harlem?
R: I always tell people, when they ask me that question, I think the war brought an influx of the wrong people to cities like New York, Chicago, and Philadelphia. People that came to make maybe two or three hundred dollars a month, which to them was a fortune, and these people couldn't cope. I used to see them in the Savoy; the bouncers had to throw these people out. Sometimes they'd throw them out bodily, down the stairs. These people would come up to the Savoy looking for fights; the ordinary people, the regulars, only wanted to drink and dance, but these low-class people wanted something else. The bouncers would be polite and ask them, "Why don't you go home?" But they didn't go home;

they would look for a fight or pester women coming out of the ladies room. They figured that since they'd paid their admission, they had the right to bother anyone. The wrong element was creeping in, and as years went by there were more and more people who just couldn't cope. Instead of having fun, these people wanted to cause trouble.

H: Did you see the same thing when you left the Savoy and went out on the road with Tab's band?
R: There was always someone looking for a fight, but it wasn't such a regular thing. It was in the big cities where people started causing so much tension. This didn't affect a neighborhood bar so much, but it did cause problems at larger places where there were crowds. This helped shut the music down as much as anything.

H: Where did you hear the best music in Harlem?
R: I don't have a name for it—maybe I never knew its name or maybe it never had a name. It was that private house over on St. Nicholas Avenue where people used to just hang out and jam. All I remember is, it was a private house. I don't know if I'd recognize it if I saw it today. If you ride through there these days, it's sad to see, because there used to be so many wonderful apartments, buildings, and places to play—and now it's all gone.

22 April 1987

Erskine Hawkins
(b. 1914)

Hank: *When did you first work in Harlem?*

Erskine: In 1934—I was only twenty or twenty-one years old. I was born in Birmingham, Alabama, in 1914. I went to school there, my family is there, and one of my sisters is still there. I go back at least once every year, especially when I have time off. My wife and myself will head south and drive through the country, and we may stop here and there. Sometimes we even go by way of Florida and once or twice we went by the way of New Orleans, but Birmingham is always the last stop. I like to spend my time there; Birmingham is where I started my music. If I remember right, I was about six years old, but I didn't start on trumpet. The trumpet was the last instrument I picked up. I started off on triangle, cymbal, and drums. Then I went to alto horn, baritone saxophone, trombone. I picked up on trumpet when I was about sixteen.

H: *Is this when you began playing professionally?*

E: No. In those days I played every summer, when school was out, at Tuxedo Park, in a suburb of Birmingham. I would take a streetcar from where I lived and get off at Tuxedo Junction and walk a few blocks to Tuxedo Park. I played there every summer; it was a place for all kinds of recreation—swimming pools, dancing, and things like that.

H: *Now I know where you got the title for your biggest hit.*

E: Yes, but I didn't come up with the name. When I put that tune together in 1939, we were fishing around for a title and one of my valets said, "Hawk, why don't you call it 'Tuxedo Junction'—that's where you're from"; and I said, "No more suggestions—that's the name of the tune." When we first recorded it, the song didn't have a name. Later, after the tune was moving good and I told what Tuxedo Junction was, they put the lyrics to it and that was it.

H: *What kind of a band did you play in at Tuxedo Park?*

E: It was just a small combo. The leader was a drummer named George Earl. I was too young to go to the park by myself, so he would come by my house and pick me up. When we were finished, he'd bring me home.

H: *Were there other musicians in your family?*

Opposite:
Erskine Hawkins, 1987

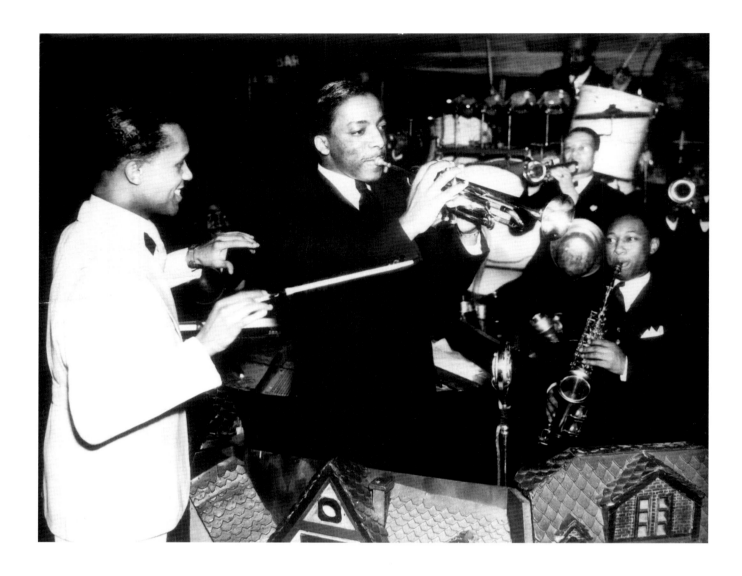

Erskine Hawkins and 'Bama State Collegians, Ubangi Club, 1935

E: They wouldn't even consider it. My brother next to me played the trumpet a little—he played in the service—and I had a younger brother who played the drums, but not professionally.

H: This must have been in the late 1920s, early 1930s.
E: It was late 1920s, because I went to Montgomery in 1931 to attend Alabama State Teachers College. That's where the 'Bama State Collegians originated. After my first year at school, the president made me the leader of the band. It was already formed when I arrived—I just joined the band. When I went there, along with some of the others who were later *original* members, we just went there

to be in the second band, which was called the 'Bama State Revelers. Later we moved up to be the Collegians.

H: You took some of the guys that had played with you in Tuxedo Park?
E: No, they were Birmingham boys who went to other schools there. We all entered Alabama State Teachers College together that first year.

H: You went out on the road with that band out of college and toured, first as a college band and then as a professional band?
E: The tour up north was in July or August of 1934. We got as far as Asbury Park, New Jersey, then from there to

Newark, and when we were in Elizabeth, Frank Schiffman of the Apollo Theater came over to listen at us. He liked the band and booked us into the Harlem Opera House and then later the Apollo Theater.

H: Playing a show or playing for the shows?

E: We did the whole thing. We played for the show and did our act and everything. We didn't have a featured vocalist then, but we had singers within the band. There were other acts on the bill, and we weren't too good at playing show music because we hadn't had the experience. They had real tough music and a line of girls we had to follow. After we got in there and worked real hard, everybody really cooperated with us and soon we played the show like we had been playing for years. We were only there for a week and then we went on tour, what they called "around the world"—a theater in Philadelphia, the Royal Theater in Baltimore, the Howard in Washington. Then we came back and went right into the Harlem Opera House because we drew very big. Those shows were crowded, crowded, crowded. Sometimes six shows—usually do four, but when there was demand we had to do six. It would be near midnight and we'd been playing all day and were usually too tired to play anyplace else.

H: How long did the 'Bama State Collegians stay together and play in NY?

E: Well, we stayed together but we had to drop the name the 'Bama State Collegians because that was the school's name. The band had to go under my name. I had just turned twenty-one when I came to NY, and I was a bandleader, the youngest bandleader they had. Of all the bands— the Dorseys, Lunceford, Duke, Cab—I was the youngest one.

H: You started leading your own band in 1934 and had a big band up until the 1950s?

E: That's right. The whole band stayed with me right out of the school band. Fourteen of us along with the vocalists. There was Merle Turner and a cute girl from Philadelphia, Ida James. I got Dolores Brown from Duke Ellington. I went down to catch Duke at Loew's State and heard Dolores Brown and Ivie Anderson singing—he had two girls. So when I went backstage, I said, "Duke, you don't need two girl vocalists, and I need a vocalist now. I know I'm not going to get Ivie, but what about Dolores?" Duke said, "Go ahead and talk to her," and that's just what I did. She stayed with me seven or eight years, maybe more. She became very close to Kelley Martin, who was playing drums with me for a time. I've stayed in touch with her over the years, and she comes up to see me at times. She's working out at Kennedy Airport and sometimes sings on the side.

H: When was the first time your band went into the Savoy?

E: I went up there in 1935. At one time I was alternating with Chick Webb. I still remember the first night the band played the Savoy. We were opposite Chick Webb and it was very crowded. Sometimes it got so crowded you couldn't even get in, like the night Chick Webb and Benny Goodman were there. I tried to get in but I finally just gave up. If I could have reached the door, they'd have let me in, but I couldn't even get to the door. It was really something, Benny Goodman and Chick Webb! That's where I got my personal manager, Moe Gale, who was one of the owners of the Savoy, and the only personal manager I ever had. He's the one that had me in all the theaters. He did everything.

Vocalion

Fox Trot

Not Licensed for Radio Broadcast
(152740)
STOMPIN' AT THE SAVOY
-Goodman-Webb-Sampson-
CHICK WEBB and his ORCHESTRA
3246

U.S. PAT. 1677544 BRUNSWICK RECORD CORPORATION

H: I suspect that of all the bands that played in the Savoy, if you started in 1935 and continued until it closed in the 1950s, you had a longer run there than anybody.

E: That's right. I could've had the longest run. The last time I played was about a year before it closed; I still had the big band. Sometime in the mid-1950s. At the time the Savoy was coming to an end, I was also in the Blue Room of the Lincoln Hotel. We were usually on NBC when we broadcast from the Savoy, but in the 1950s it was different at the Lincoln. Some nights I was doing ABC, NBC, and CBS. They would follow each other, like I would start off on ABC for one-half hour, then they'd switch me right over to NBC at midnight for another half-hour, and then right onto CBS for an hour and one-half.

H: Which band did you enjoy the most?

E: Jimmy Lunceford and my band. I like Jimmy's style but I really enjoyed them all. I was the youngest one. All of them were in front of me. I really enjoyed them. I was a fan of all of them. I played in the Savoy beside Duke Ellington, and I cracked an ear for every band, every name band. You see, I became a house band not too much after 1935, maybe 1936, so I had the opportunity of alternating with all the bands, first on Sunday afternoons and then during the week. Before Chick [Webb] passed I was alternating with him as a house band. I would go out on the road and then Chick would go out. I would go out and stay for three or four months, then come back, and Chick would go on tour. Moe Gale booked us all around the country—theaters, dances, ballrooms, and even offices. Sometimes we'd even have novelty acts like Stepin Fetchit or the Ink Spots with us. I did a lot of traveling in those days.

H: Did you keep a band through World War II?

E: Oh, yes, the band was together all the time.

H: How did the uptown scene change during the war?

E: As the years went along, we got less and less of the white trade. There was a time when there were tourists with buses and everything. Movie stars—I have pictures with me with lots of stars—and every night you'd have these tourists. Then after so many years—I don't remember the years—they start to thinning out. They had the troubles up there; that might have had to have something to do with it. After that, I don't know just how to explain it, but we used to have after-hours spots. Musicians used to go and jam. There were a lot of fine places—Small's, Clark Monroe's. Count Basie even had a little place at 132nd Street in the 1950s. The musicians from downtown would come up. Then they finally stopped it, putting a tag on them, can't stay out that late. Then they had to find other places and the musicians uptown started going downtown. Fifty-second Street got really big.

H: Did you ever work in any of these places?

E: No, I worked at the Harlem Opera House, the Apollo, and the Savoy. But I was at the Ubangi Club before I went to the Savoy. After we played the Harlem Opera House and I'd decided to stay, we went into the Ubangi for a while. Don Redman was there at the time and some agent put me in the Ubangi until we got going. The place was like the Cotton Club except it was smaller. We didn't have the big chorus line or the fancy shows. The audience was mixed but mainly white. I first met John Hammond at the Ubangi,

Erskine Hawkins and Ella Fitzgerald at Roseland, 1941

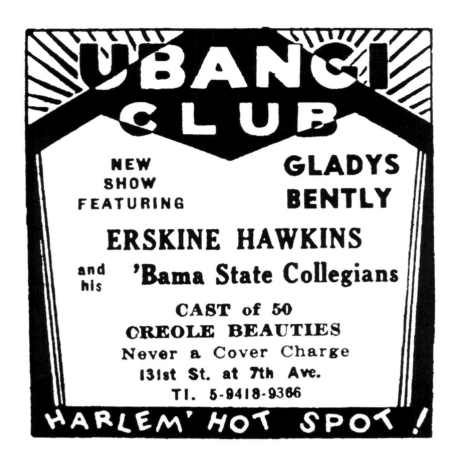

NEW
SHOW
FEATURING

GLADYS
BENTLY

ERSKINE HAWKINS

and
his
'Bama State Collegians

CAST of 50
CREOLE BEAUTIES
Never a Cover Charge
131st St. at 7th Ave.
TI. 5-9418-9366

HARLEM' HOT SPOT!

Advertisement for Erskine
Hawkins at the Ubangi
Club, 1935

and he helped me get recorded on
Vocalion.

*H: Tell me about your band. Was it
always a fourteen- or fifteen-piece
orchestra?*
E: Yes, but sometimes larger. I had it up
to twenty-one after the war. During the
war days, some of the folks were in the
service and came back, and I had it up
to about twenty-one. I didn't want to put
anybody out of the band, and I wanted to
have a place for the fellows coming back
from service, so I just kept adding them
on.

*H: That must have been a marvelous
band!*
E: It was—we had five trumpets, five
trombones, six saxophones, rhythm.
And there I was trying to stay in front
of everybody. We were having a ball,
and I remember one time when we had
two drummers, Eddie McConney and

Kelley Martin. I did quite a bit with that
band before I brought it back down to
a smaller size. I had them onstage, in
Harlem, around the world.

*H: In addition to being in residence at
the Savoy all those years, you also kept
going out on tour?*
E: I did a lot of touring. We were one of
the best drawing cards on the road. We
played somewhere—Dayton, Ohio, I
think—and Duke was also there playing
a one-night stand, and Ivie [Anderson]
came by to see us and told me we'd
outdrawn Duke. She used to always tell
me, "You young boys are going to blow us
out of there," because we were younger
than Duke's men. Yes, we did quite a bit
of touring. We made all the forty-eight
states; we didn't make the last two.

*H: They weren't states when you played.
Did the band ever go overseas?*
E: No, they tried their best to get me to
go over there, but I wouldn't fly. Some
of the boys remember the statement I
made when we were very popular, during
the war. I said, "Well, when they build a
bridge where I can drive, then I'll go." In
those days I just wouldn't fly, but now I'll
go anytime. I remember my first flight;
I'd gotten sick and had to stay behind on
a string of one-nighters and had to catch
up with the band. They gave me some
kind of pill to make me feel better and
told me not to worry about flying. I fly all
the time now.

*H: When things started to slow down for
big bands and you didn't work so much
at the Savoy, what did you do?*
E: When the theaters started going
and after the Savoy, I started getting
into a lot of clubs and hotels. Before I
came here [the Concord], I was in the
Copacabana for a few years. I went in
there in 1954 and I did things like the

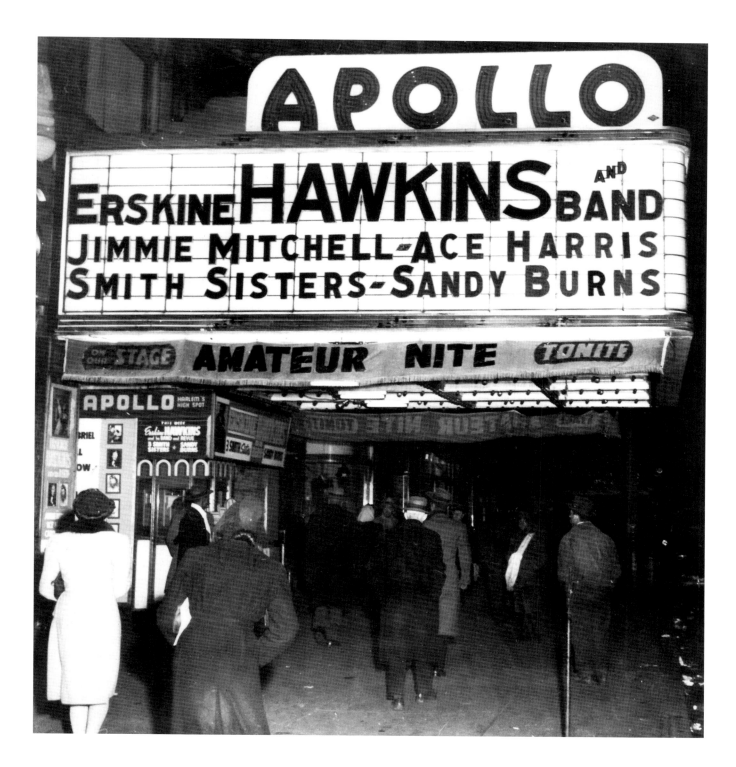

World's Fair; I played the 7-Up Pavilion. It was rough work, seven hours a day, forty-five minutes on and fifteen off, from noon until seven o'clock, then into the Copacabana from ten o'clock until four. It was with a small band, and this kind of work just wore me out. I did the World's Fair for two weeks and the Copacabana for a year. I had to do seven nights a week. It was wearing me out. My manager said I could take off as long as I wanted, but I was out front and had to take care of the boys, so I kept it up for a year, maybe a little more, but then I had to rest. When I started touring again, it turned out I had a week off and my agent asked if I wanted to play a week at the Concord because it was on

Apollo Marquee, circa 1944

Erskine Hawkins, recording session at Van Gelder studio, Englewood Cliffs, New Jersey, 1990

the way to where he had booked me. I wasn't eager to, but I did it as a favor to him. I made the date and the people here talked to me on the second night. I've been here ever since, a real long run. I have an apartment and everyone's very nice. The only time I'd go out was once or twice a year for a concert or maybe to make a reunion recording. I always loved recording—that's when we put together some of our best songs.

H: Give me an example.
E: I once did a recording session that featured the tune "Fine and Mellow," the song Billie Holiday did so well. Dolores Brown did our version, and the arrangement called for piano solos in front, an introduction, before the vocals come in. Avery used to play all those choruses before Doroles come in

to sing. But when I got ready to record, it was too long. I had him scratch all those choruses out except for one. A few months later at another recording session we had finished five numbers and someone asked, "Hawk, what you going to do for a sixth number?" I said, "Give me about half an hour." Avery and I went to another room and I said, "Avery, you know all those choruses I took out of 'Fine and Mellow'?" He played all those choruses and then we lined them up. After we lined them up, I called the band back; then we faked an out chorus for the end. We played just with rhythm. I played drums on that record—I didn't have anything else to do! I had my drummer stand up in front of the bandstand and I told him, "When they put that red light on, you put your hand down." I played drums on the

original recording of "After Hours." Most people don't know that.

That's also the way I finished "Tuxedo Junction." I had five recordings. They wanted to know what I was going to do for my sixth recording. I said give me half an hour. I took the rhythm section into another room. We sat down, and I made up an introduction and everything else was an add on, because we had been playing the first sixteen bars all the time at the Savoy as a sign-off and for the other band to come on. Bill Johnson put in the bridge and then we put it all together. No music, just talking it out. He might have put music to the bridge. Then, when it was finished somebody said, "What you going to name it?" One of my valets said, "Why don't you call it 'Tuxedo Junction'?" and that's how the name came about. The same thing with

"After Hours." Both of them turned out to be big hits for me.

H: How about "Tippin' In"? Did you compose that the same way?
E: "Tippin' In" was composed by my first alto player, Bobby Smith. We were in California at the time he wrote the tune. I think he named it after one of his dogs he called Tippy. We were traveling by train and every time we played it on a job I liked it more and more. I started figuring my solos and stuff I wanted to play. I was changing my solos around each time we played. We were on a bunch of one-night stands coming back to NY, going from city to city, and before we got to Chicago, I called my agent and told him to set me up a recording date in Chicago. I got off the train in Chicago and went to RCA Victor and recorded "Tippin' In." The

Erskine Hawkins, Floating Jazz Festival, 1990

other side was "Remember." This was my first recording for RCA; I'd been on Bluebird up to then.

H: One question about that. Glenn Miller was also on Bluebird and you both made "Tuxedo Junction." How did that come about?

E: I'd met Glenn in Boston a year or so before he recorded "Tuxedo Junction," and we kept running into one another here and there. One night he was a guest band at the Savoy and during a break he came over to me and said, "I like your tune 'Tuxedo Junction,' and I want to play it, but they tell me I have to ask you because two bands on the same label aren't supposed to feature the same song." I had already sold a lot of records with the tune, but it was starting to slow down. Glenn told me I should start to use it as my theme song, especially on broadcasts, but that he'd record it too and use it on his broadcasts as well. I agreed and he recorded it and started playing it at the Pennsylvania Hotel and places like that. The tune went right up and sold millions. I still get statements from all over the world for that tune.

H: One other song I wanted to ask you about is called "Gabriel Meets the Duke." I suspect this was somehow inspired by Duke Ellington. How did it come about?

E: The tune was an original, and everybody was inspired by Duke, and I got named Gabriel from a NBC announcer. I was broadcasting out of the Savoy Ballroom on a Saturday afternoon, like we often did, and the announcer had been saying different things for each broadcast; he used to make a dry announcement before I hit. That day he

said, "Coming to you live from the Savoy Ballroom, the twentieth-century Gabriel, Erskine Hawkins." Moe Gale heard it and liked it and said, "Keep that in," and they've used that tag on me since then. My theme song at that time was still "Swing Out," not "Tuxedo Junction." On "Swing Out" I used to make a kind of ad-lib introduction. The band would come in swinging right behind me, after I make my ad-lib. "Gabriel Meets the Duke" was also a hit. We had a lot of nice original tunes; they'd let me record almost anything I brought in because they did pretty well. We even followed up "Tuxedo Junction" with "Junction Blues."

H: You never played anyplace other than the Savoy Ballroom during those last years in Harlem?

E: I haven't even been in Harlem in twenty or thirty years.

22 May 1987

[Note: In July 1991, Erskine Hawkins returned to Harlem for a one-day visit to take part in a documentary film being prepared for German television. He visited many locations, with the film crew in hot pursuit. Of the places he once knew in Harlem, only the Apollo Theater was still in business; there he was greeted by an unpleasant employee who said it was forbidden to film anyone in front of the theater. When this young employee was told the man being filmed was Erskine Hawkins, who had once been a star performer when stars performed regularly at the Apollo, he was unimpressed. He'd never heard of Erskine Hawkins and gave the distinct impression he didn't want to know about an old man standing on the sidewalk. I suggested we go inside and I'd point out

Erskine's photograph on the wall, and when we did he was still unimpressed. This was in marked contrast to the reception we'd had at Sylvia's an hour or two earlier, when everyone was thrilled to have the Hawk in the restaurant. One of the many photographs they took that day is probably still on the wall.

We spent the rest of that day and the next visiting the locations of former glories—the sites of the Savoy and Connie's Inn [the Ubangi, for Erskine] and the bricked-up shells of Small's Paradise, the Renaissance, Minton's, and, at the edge of Harlem, the Audubon Ballroom. Everyone we met near these places was gracious, both interested in what we were doing and interesting as individuals.]

Erskine Hawkins at Sylvia's Restaurant, Harlem, 1990

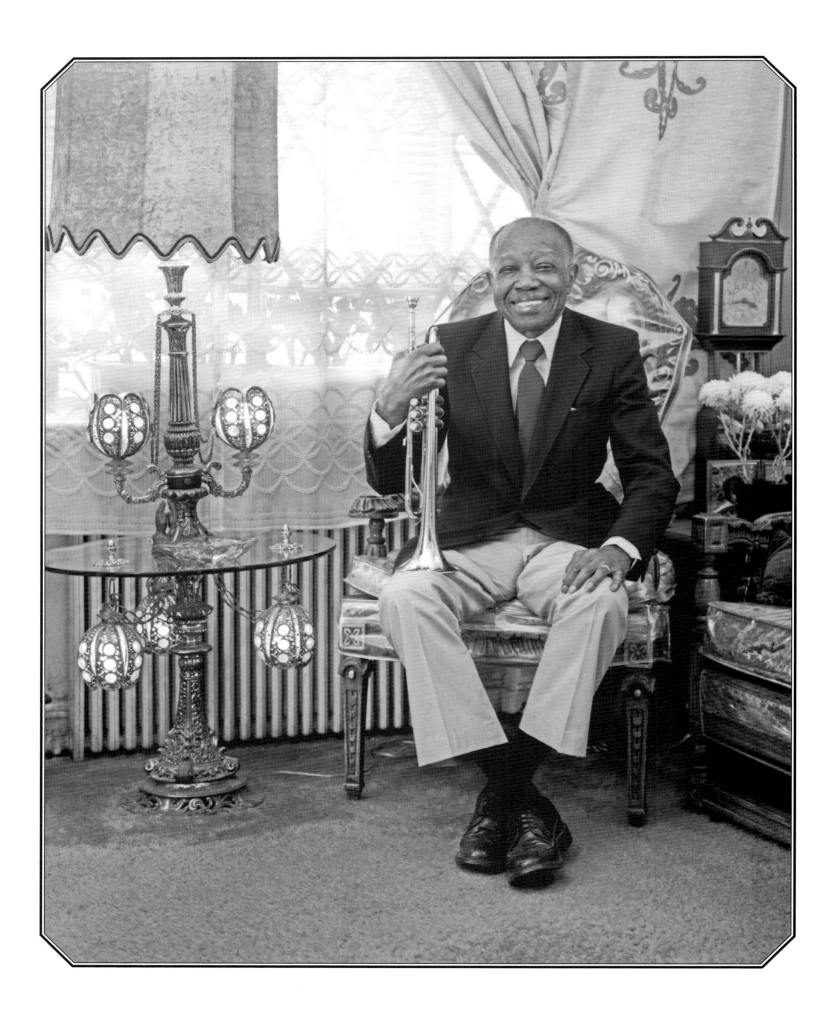

Bobby Williams

(b. 1914)

Hank: *I've heard you're originally from Alabama.*
Bobby: Yes, Capps, Alabama, a little town way down at the bottom of the state. My mother used to tell me it was so small you could put it in four boxcars and haul it away. I was three when we moved away to New Jersey and that's what I now call home.

H: *When was the first time you performed in Harlem?*
B: That was in 1937, but I'd been in a show called *Harlem on Parade* long before that. It was a show based in New Jersey, but we played all over the country. We toured as far as Texas—Dallas, Ft. Worth, Houston, places like that. We even toured up in Canada with the show. We had some rough times up there, touring around on rickety buses, but it was a pretty good show. Buck and Bubbles were in the show; so was Ada Ward. There were quite a few dancers, and we had a pretty good band.

H: *Tell me about your first experiences uptown.*
B: As I said, it was in 1937. Ovie Alston had a band that went into a place called the Plantation Club. It was in the building where the Cotton Club

was located but before it had moved downtown. It was a big band, twelve or thirteen pieces. Sylvester Lewis was the other trumpet player; we had a good trumpet section. We played for shows and for dancing. There were at least ten girls in the chorus—Lucille Wilson, who married Louis Armstrong was one of the dancers in the show. The audiences must have been mixed, because I remember Joe Louis coming in one night. The place didn't stay open very long and I moved along to Willie Bryant's band, and I stayed with him for a couple of years. The first time I played the Savoy Ballroom was with Willie, but we also went out on the road and played theaters; we went around the world—Philadelphia, Baltimore, and Washington—but when we were in New York, the main place we played was the Savoy.

H: *When you were working at the Savoy, who did you enjoy playing opposite?*
B: My two favorites were Chick Webb and Fletcher Henderson. Henderson didn't play at the Savoy all that often because he was down at Roseland most of the time, but I remember one night when there were three bands at the Savoy— Chick Webb, Fletcher Henderson, and ours. He came up late after he was off

Opposite:

Bobby Williams, 1987

One Week Only!

Commencing

SATURDAY JULY 14th

★

The Incomparable

FLETCHER HENDERSON

and his FAMOUS ORCHESTRA

playing against

Chick Webb...

... and his Sensational Band

SAVOY World's Finest Ballroom
Lenox Ave., 140-141 Sts.

Savoy Ballroom poster,
1934

at Roseland. When Fletcher would play, all the musicians would just stand around and listen. He was something. I remember he used to come over and play in New Jersey when I lived there. If I wasn't working, I'd just go hang out and listen to his band. I also heard Chick Webb in Newark before I heard him at the Savoy. That man was beautiful.

H: What do you consider the best band in which you worked?
B: When I left Willie Bryant, I joined Benny Carter's band in about 1940. I think it was the first big band he'd had since he came back from Europe. I was only with the band a few months,

but I got to record with it and it was a wonderful band with fine arrangements, the best big band I ever worked with. I worked with Benny at the Savoy; in fact, that may have been the first place I played with his band.

H: What was your favorite place to work or listen?
B: The Savoy—without a doubt, the Savoy. I used to go up quite often because musicians would usually get in free even if you weren't playing. I go up there just to listen and somebody on the door would say, "Come on, come on, come on in." Jimmy Lunceford, maybe my favorites, Chick and Fletcher. It was just a lot of fun to go up there and listen. I enjoyed Andy Kirk, and some nights when I wasn't working I go up and catch Earl Hines, when he was in from Chicago, to catch some of that western sound. When Count Basie started playing the Savoy, I caught him—the Savoy was definitely the place. It was nice at that time. They didn't have too much fighting—those big bouncers took care of that. All those guys knew me—not that I wanted to cause any trouble. I just wanted to dance a little, but really all I wanted to do was listen to the bands.

H: Tell me about your tour with Fats Waller.
B: I joined Fats Waller's band just before the war years. I forget who called me, but someone did; they told me Fats wanted me to come to a rehearsal. I made the rehearsal, played the music, and was told the band was going out on tour, to California. This is Fats's big band—I joined that band, not the small group. We worked our way out to California; it was my first time there and I met some movie stars, like Eddie Anderson [Rochester]. The band didn't make any movies but we made some records and then toured up

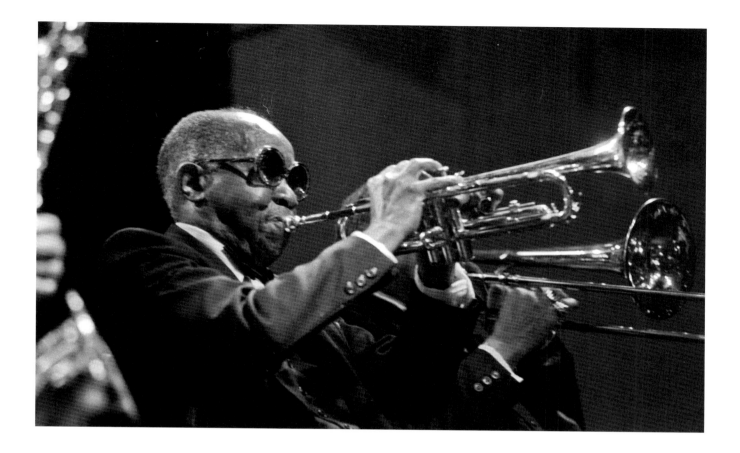

the coast as far as Seattle. That was quite a trip. I really enjoyed myself working with Fats Waller. He was a funny man. I made my first tour with his big band in 1940 and then I was asked to go back with him again in 1941. I never played uptown with that band—it was strictly a road band. Don Donaldson, the relief pianist, wrote most of the arrangements and Fats would play them. It wasn't the best band I ever worked with, but I enjoyed that band more than anything. Fats would keep you laughing all the time; just hanging out with him was so much fun. He'd come in and say, "Come on, you're all going to go drinking with me," but I didn't drink very much. I just went along and watched what went on.

H: How did World War II affect you?
B: I went into the service in 1943. I was sent to Fort Dix and at my first interview, I told the sergeant I was a musician. He

said he had once worked for Bunny Berigan and asked me to name the people I worked with. He made a list of all the names and then told me I was going to have it good in the army. I stayed at Ft. Dix for a while and then they sent me to Camp Shanks up in Orangeburg, New York, and I stayed there quite a while.

H: Did you play in an army band?
B: Yes, and it was a good one. Sy Oliver and Buck Clayton were there and a lot of other good players. The band was supposed to go to Europe but that never worked out, so they got a bunch of us out of the band and sent us over to Camp Kilmer, where Mercer Ellington and all those guys were stationed. I spent two and one-half years in the army; Buck Clayton and I were some of the last guys to get out. Just before we got out of the army, Buck Clayton had

Bobby Williams at the Cat Club, 1987

made arrangements to have a big band. I was going to be the first trumpet player but it didn't work out, and Buck went on tour without his own band.

H: *When you came back in 1946, what changes did you see in the uptown music scene?*

B: Well, for one thing the Savoy Sultans or another small band were always at the Savoy; there were not so many big bands there. They'd have a big band and Al Cooper's or another smaller group. The big band would play against the Sultans. Willie Bryant didn't have a band anymore; he was more of just a master of ceremonies, a commentator. I hooked up with Don Redman for a short while and then joined Cab Calloway in February 1947. My old buddy Jonah Jones was my roommate when we were on the road. Jonah and I used to make all the after-hours places together before the war—Minton's, the Rhythm Club, places like that. I wrote a few arrangements for the band and I stayed with it until about the end of 1948, but by that time things were slowing down. I remember Cab telling everybody that "TV is going to knock us out." Maybe he was right; we did get knocked out, and at that time there wasn't much TV.

H: *What else did you notice that hurt the music scene uptown?*

B: Not just uptown, all over. There was a ballroom tax. It seemed like they put a tax on just about every kind of entertainment, and about that time things started to change.

H: *Can you recall anything that hurt the uptown scene in particular?*

B: I heard about the signs they were sticking up downtown that said it was risky to go to Harlem, and the press also had a lot to do with it. They used to write

about the music uptown, and then after the war they didn't do it anymore. People started to move away. I lived on Eighth Avenue, just off 133rd Street a block away from the Rhythm Club, but I moved away when the neighborhood started to go down.

H: *When was the last time you played in Harlem on a regular basis?*

B: Probably in the late 1950s at the Baby Grand, after the Savoy had closed. When the Savoy closed, it was really the end. A few places hung on for a while, but it was over by then. Al Cobbs had this little band at the Baby Grand. Nipsey Russell was there then. Before the Savoy closed, I was in a band that Edgar Sampson had organized to play there, but Charlie Buchanan didn't like it when we auditioned for him and the band never got off the ground.

H: *What do you miss most about the lack of music uptown?*

B: Just the regular work, a place to play where I enjoyed playing. I have to tell you, though, I hated weekends at the Savoy because it was such tough work. On Saturday you'd start at six o'clock and play all night until two or three. Then you had to go back early on Sunday. There wasn't even time for lunch. You'd have half an hour to run across the street and grab a sandwich, gobble it down, and be ready to play. Don't even mention the Apollo. It was even tougher there. No time to eat, no time to do anything. The last time I worked there was with Hot Lips Page. My goodness it was hard—five or six shows, each show at least and hour and a half, half-hour off, grab a sandwich. I was younger then and could make that kind of a schedule. I don't think I could make it today.

27 April 1987

Opposite: **Bobby Williams at Downtown Sound, 1978**

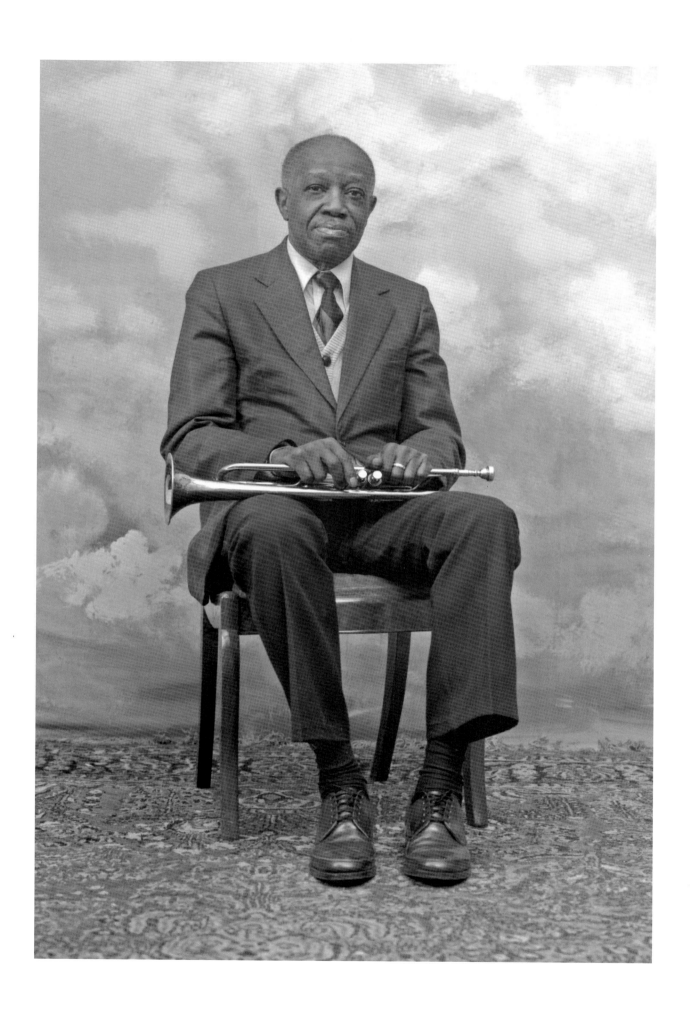

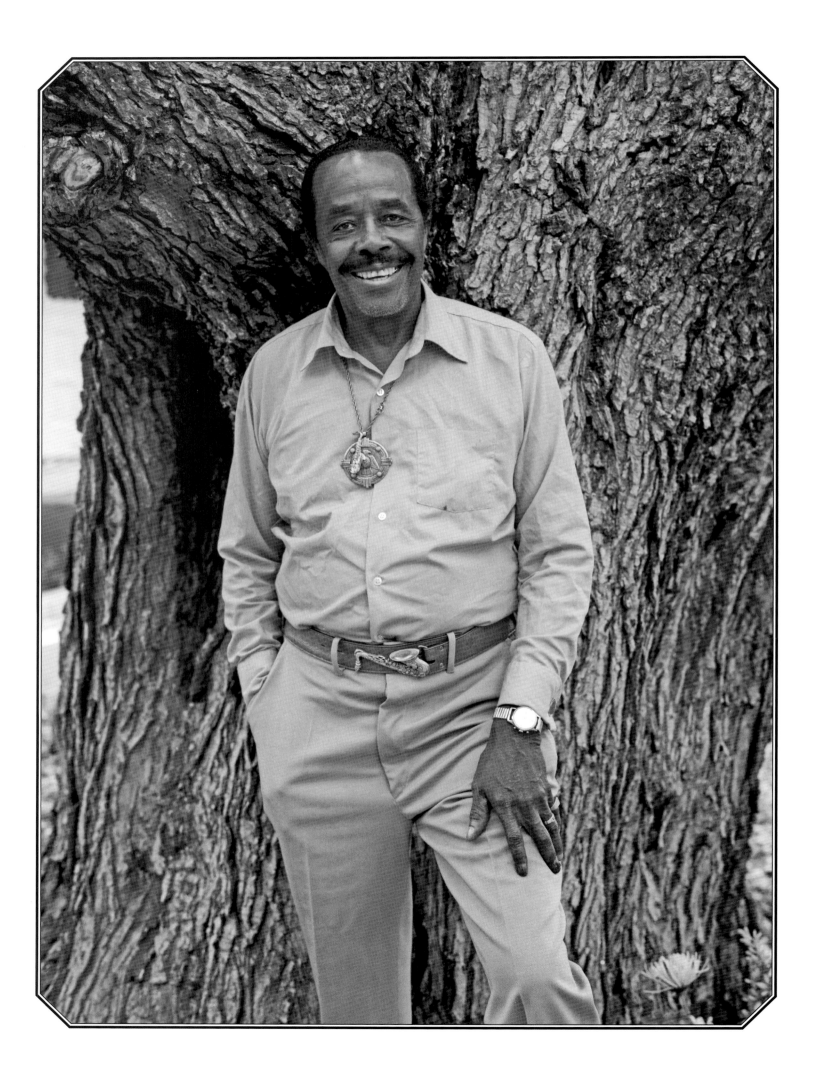

Buddy Tate
(b. 1915)

Hank: What was your first musical experience in Harlem?

Buddy: The first time I played in Harlem, I was with Andy Kirk. We were based in Buffalo at the time but Mamie Smith, the blues singer, took over the band for a while and brought us to New York for a one-nighter at the Savoy Ballroom. This was in 1934, a long time before I joined Count Basie. We played the one-nighter and then went back to Buffalo. We didn't stay in New York very long, but it was long enough to see that everything was jumping. There was so many places to play then in 1934. There were famous places like the Cotton Club, but it also seemed like every little club had three-, four-, or five-piece bands. I tried to see everything that was happening, all in one night. I didn't come back until 1939, with Count Basie, but Harlem was still swinging when I came back. Everybody was still coming uptown, dragging those minks, and all of Harlem had mixed audiences. It lasted until the middle 1940s, until after the war. Maybe not as much as they had been in the earlier years, but they were still swinging, coming uptown—there were still quite a few clubs left. Bowman's was going, and Jimmy's Chicken Shack. Now that's a place that used to always be crowded,

Jimmy's Chicken Shack on St. Nicholas and 148th Street. I remember Jimmy's still having big things going on in there—Hawk [Coleman Hawkins] played in there and Luckey Roberts. Jimmy's was like Luckey's place, and they had very good food in there.

H: You spent a long time on the road before you came to New York with Count Basie.

B: I'd been all over the Midwest, mainly with Nat Towles. Now, that was some band. When the Basie band came east they didn't have five arrangements, and Nat Towles would have torn them up. The band was rehearsed and had good players—Sir Charles [Thompson], Fred Beckett, Henry Coker. The band didn't record, but we almost did. Andy Kirk had contacted us and said a talent scout was coming to Kansas City, but we were playing at a little place in Trenton [Missouri] and the boss wouldn't let us off. I went down to Kansas City by myself. At the time, Basie had a little band, six or seven pieces—Buster [Smith], Lips [Hot Lips Page], and some others. Herschel [Evans] and Buck [Clayton] were still in California. Joe Glaser got there first and signed up Lips for fifty dollars. I think Glaser wanted

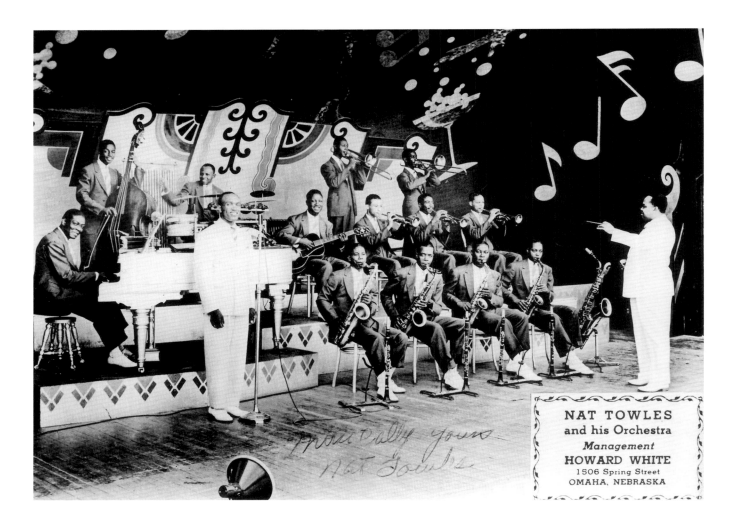

NAT TOWLES
and his Orchestra
Management
HOWARD WHITE
1506 Spring Street
OMAHA, NEBRASKA

Buddy Tate with the Nat Towles Orchestra, Peony Park, Omaha, Nebraska, 1936

Basie to go to New York with Lips, but Lips was to front the band and Basie didn't want anything to do with that kind of deal. Later, the band got a little more together, John [Hammond] got some things arranged, and they were off to New York City. I'd known Basie for a few years—even worked for him a couple of years earlier—but I wasn't ready to leave Nat. I was having a lot of fun, eating three meals a day. There were a lot of things I did in those days that were probably wrong. I missed out on some things because I was in the wrong town or I didn't join one band or another. Andy Kirk had asked me to join him about the same time all this was happening with Count Basie.

H: Were you still with Towles when Basie called you to replace Herschel Evans?

B: The Towles band was breaking up. He didn't want to go to New York, and some of the guys had already left. I got the call to join Basie in March 1939; Herschel had died in February. The telegram from Basie said to meet him in Kansas City on March 2.

Vi Tate: He didn't want to go. He just didn't want to go.

B: Well, it was a very heavy band by then and to join Basie at that time was something, particularly since I would be replacing Herschel. One Texan replacing another Texan. I remembered when I worked with Basie in 1934, with Lips, Rush [Jimmy Rushing], and Buster. It was seven days a week, fifteen dollars apiece

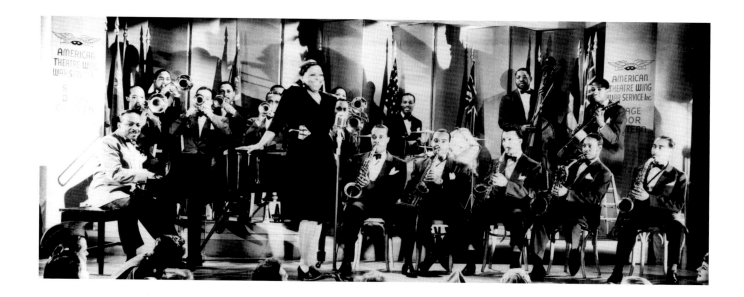

for everybody in the band. But I decided to make the move, and I never regretted it. I stayed with the band for ten years and then made guest appearances and performed with Basie alumni groups. In fact, one of the groups I played with when I left was one organized by Jimmy Rushing. Buck Clayton, Emmett Berry, Walter Page. We worked at the Savoy. I was in and out of the Savoy a good deal.

H: That wasn't the primary place you worked uptown; you're unique in that you led a band that appeared regularly uptown for many, many years as the uptown music scene was fading.
B: Twenty-one years at the Celebrity Club, starting in 1950. They were beautiful years because we weren't playing any rock 'n' roll, we were playing swing, and people could dance. The way I started at the Celebrity Club in Harlem was they also had a club out in Freeport [Long Island]. I frequently worked there, and the same man, Irving Cohen, ran them both. He used to give me a ride home when I was working in New York. One night he told me, "The band I have in the 125th Street Celebrity Club is good, full of good musicians, but they're all alcoholics—half the time they're late,

and sometimes they don't even show up." He told me he liked my conduct and said, "I've never seen you get high or drunk or anything like that. How would you like to work for my club in New York? We'll talk about it." In the meantime, I'm still playing at the Celebrity Club in Freeport, but one night he came to me and said, "Are you ready? Get your band and get whoever you want, and you've got a job as long as you want."

That's the way I started at the Celebrity Club on 125th Street. I got it together with Skip Hall, who wrote some arrangements, and later, Eli Robinson wrote more. God bless both of them—they're gone. We got that band so tight, playing dance music, and the band was fine. We were very popular; sometimes the clubs would come in and the crowds would be too big so we'd have to move to Rockland Palace or we'd go to the place Malcolm X was assassinated, the Audubon Ballroom. We were playing good swing dance music, the band was really tight, and, like I said, we didn't just play at the Celebrity; there were a lot of clubs that hired us—dances, social functions, even breakfast dances. If we were hired out to play for a social

Buddy Tate and Ethel Waters with Count Basie and His Orchestra, 1943

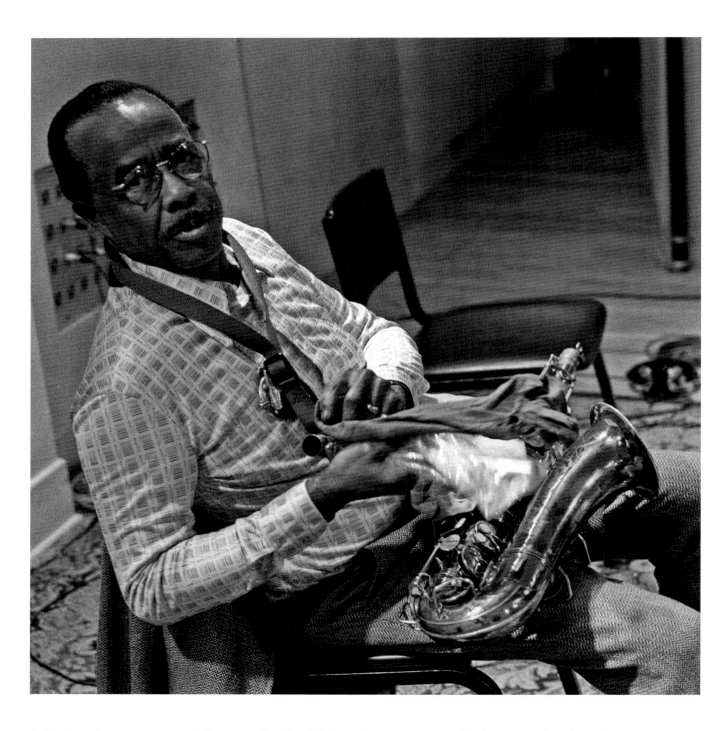

Buddy Tate relaxing between takes, recording session, Clinton studio, 1988

club at, say, Rockland Palace, there was always a minimum number of men you had to have. Rockland Palace required twelve musicians. I had a good swing book and a lot of ex-Basie musicians to choose from, and over the years I'm sure I played for every club. One club had us every Easter—these were the girls who danced at the Cotton Club. When we had time off at the Celebrity, I had the band in almost every club in New York and

the downtown hotels, and at one time or another in those twenty years almost every good musician in New York was in the band for a while.

In the 1950s we also played at the Savoy Ballroom—I was a Celebrity Club band and a Savoy band. Mr. Buchanan and Irving Cohen, who employed me at the Celebrity Club, got together. I had them fighting, you know, they both wanted me; my band was popular. Mr.

Buchanan asked me, "Why can't you come up here and play some in my place too? Would you want to be my band?" I told him I was employed at the Celebrity Club, and then I told Irving about it. He said, "Look, I don't go up there and ask for any of Moe Gale's attractions! No, you're my band—I don't ask him to let Erskine Hawkins to come down here and play, I don't ask him to let me have Lucky Millinder." I told Buchanan I'd love to work something out, and he suggested I try to get Irving to come up and talk to him. Buchanan was going to suggest I work six months at the Celebrity and six months at the Savoy, but Irving didn't want to hear anything about it. He said, "I don't like the idea, so I'm not going up there to talk to him." It was like a feud, and I thought that while they were fighting, I was losing work—I could be doing much more if they'd just get together. Finally, Buchanan said, "Since he won't come up to see me, I'll go down and see him." They got together, and that's why for the last seven years I was also a Savoy band, from 1950 until 1957. But my mainstay was in my having a band at the Celebrity Club.

H: You left the Celebrity in 1971, but when did the club close? I know there is still a sign hanging outside on the building.
B: It closed for good about two years ago [1983]. It became a disco, with topless girls and things like that. In the later years, just before we quit, more youngsters started coming in, and they were more interested in the James Brown type of music, and that wasn't my type of band. The guys started losing interest in the band. As bad as I hated to disband the group, it became impossible to book in a seven-piece band in or out of town. I'd have to make do with trios or quartets, and that was the beginning of the end.

One day I just went to Mr. Cohen and said, "I thank you for giving us all these wonderful years," and then we left.

H: Did you ever play anywhere in Harlem after that?
B: Only for private clubs. They would hire a band to play different halls and things like that. There were no jazz clubs. They had just about all closed. They might have a bar with a piano player. That was just about the last of everything, because the Savoy had long been closed. That's when everybody saw the handwriting on the wall; that's when they saw the light.

H: Tell me about your experiences at the Savoy.
B: I was happy to be there because people came from all over the world to the Savoy. Mr. Buchanan told me one time—and this is the truth—out of his forty-one or -two years of running the Savoy Ballroom, every band that had a name played in the Savoy Ballroom, including Guy Lombardo. Honest to God. Guy Lombardo played there. Tommy Dorsey was up there all the time. And the famous battle between Chick Webb and Benny Goodman, that went on up there. Just name a band—all the name bands played the Savoy Ballroom. Mr. Buchanan told me, "Buddy, I don't know my music. But I know whether or not anybody is on that floor. I go downstairs and I listen, and I know when the floor is crowded, and if they're not on that floor I know something is wrong, and no matter who's there, they've got to go. I just listen to the feet!"

I'll never forget the time he booked three bands—mine, Arnett's [Cobb], and Willis Jackson. At the time, no seven-piece band was as good as mine—that's just the way it was. Skip Hall was playing piano, and when it was right he would

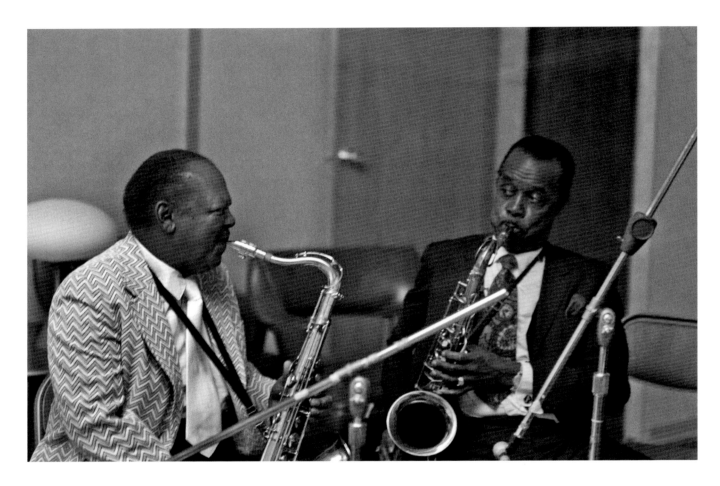

Budd Johnson and Buddy
Tate, recording session,
WARP studio, 1973

Opposite: From MPS album
cover, 1970

slide right over to the organ. We were
the first band that had over four pieces
that also used an organ. Skip Hall,
a great arranger, one of the greatest
arrangers that ever lived. Now they also
had a show band onstage. They weren't
very good, and after they did one or
two numbers, they wouldn't have five
people on the floor. They would be
sitting, waiting for our band. The floor
was packed before we got through our
introductions! We had the right tempos
and the right thing for the Savoy. We
had arrangements by five different men;
we had variety. The other two bands
had arrangements by the same guy.
Mr. Buchanan came in one night—he
never looked up—he came in walking
with his head down, he's all dressed up,
wearing his hat. Something is on his
mind, and what's on his mind is that
nobody's on the floor. Those other bands
had the same instrumentation, the same

arrangers, so they're really playing the
same thing. It had been on his mind for a
few days, and one of his boys came up to
me and said, "Tate, Mr. Buchanan wants
to see you in his office. Will you bring the
other leaders in?" I brought the guys up
to the office and Mr. Buchanan just says,
"Hello, fellows. The reason I got you in
here is because I want to know how long
you're supposed to be here." Somebody
said, "Well, Moe Gale booked us in here
for the month." Then Mr. Buchanan said,
"What I want to know is what in the hell
is happening out there; you guys can't
get them on the floor. What's happening?
Tate's got those people on the floor.
Buddy, why don't you tell them what to
play?" Now, this is embarrassing—he
put it all in my lap—but before I can say
anything, he tore into these two guys. I
won't repeat what he said, but it was if
they didn't play the right kind of tunes
and the right tempos they'd not only be

unbroken

THE
BUDDY TATE
CELEBRITY
CLUB
ORCHESTRA

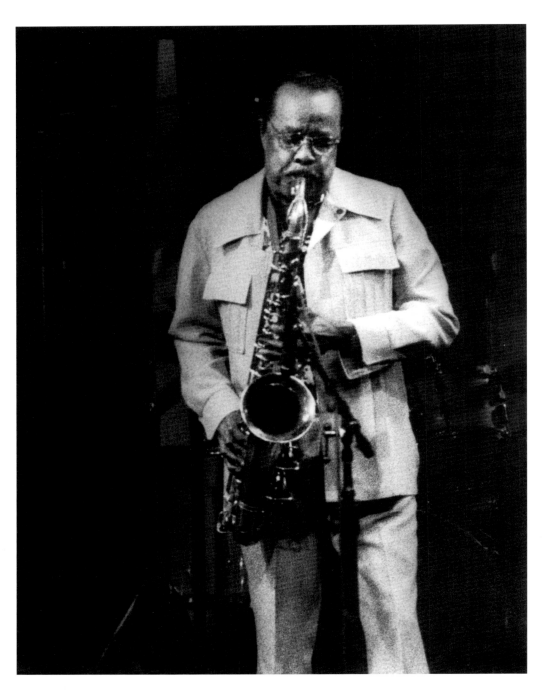

out of there but they'd get something else they'd never forget as a bonus.

It was so sad when the Savoy closed. Let me tell you what Mr. Buchanan said to me after it closed—we just lost him, you know. He said, "Buddy, when we had to close the Savoy, many people talked about getting another ballroom. But to get the kind of ballroom to compare to the Savoy would cost way over a million dollars and I'm sixty-five years old. Everybody will talk big, but when they sit

down to find a place to convert it over to a ballroom, a place like Rockland Palace, or someplace like that, nobody will be around. I don't think it's too wise for me to invest what I've got, what I've made." That's just what he said; we had a nice talk. He went into the insurance business and things like that. Nobody was there to go in with him. But I do think if we could have had another Savoy, things would have been different. The Savoy was one of the most protected places in the world.

If a lady wanted to, she could come up alone—I don't care who she was or what she was. When she was up in the Savoy Ballroom, she never was molested. They had the worst bouncers in the world. They broke so many jaws up there, they once called Mr. Buchanan downtown. He was tight with all the officials down there. They said, "Now look, Charlie, we know you have everything under control but you're breaking too many jaws up there. You all got to slow down on those jaws. We love what you're doing up there, but you've got to lighten up on those jaws, you're hitting them too hard." They didn't allow anyone to bother any woman in there. The taxis sat downstairs, and if a single woman was there they'd take her downstairs to a cab. So many young girls that were working, white and black, would come to the Savoy alone because they were protected. If anybody got out of line, they hit the floor.

Vi: Thursday night was girls' night to come to the Savoy—the girls that worked in the home, the domestics.

B: We called them kitchen mechanics.

Vi: Thursday nights they were off, and Sundays. Mr. Buchanan knew he would have a big crowd of girls that would come in on Thursday night, by themselves, and he protected those girls. He really did. This was like hundreds of girls, not no two or three.

B: These were girls who spent their days cooking and staying home, except on Thursdays.

Vi: It was their night off. They came to dance; they didn't come to pick up guys, they just wanted to dance.

B: That's right, they came to dance and they were protected.

Vi: Don't forget the Rinky Dinks. Sometimes they'd rent the Savoy for their club. Catherine [Basie] would rent the place from one to six—if Basie was off, he might play the function, then the house band would come on at six.

B: Yes, it was a beautiful place. I hated to see it go. It was really nice inside. There really was a lot of class in there. I really hated to see it go. It was a terrible loss for Harlem.

H: What else hurt the music scene uptown?

B: Integration was one of the things—an important thing—and so was the migration of people to New York during the war. These are some of the things that killed it. It is as simple as that. It killed a lot of things. We don't have a black hotel uptown. The [Hotel] Theresa used to be one of the finest and swingingest places in the world; then people got afraid to come. It wasn't like this Monday-night affair that's going on at Small's, because the people who go there now get put in cabs and are taken right back downtown. They're actually afraid to come to Harlem. I remember there was a girl who came to New York—now this is a lady, a very inner-city lady—who wanted to see what was happening. Naturally, we told her there are places you just don't visit. We told her the Celebrity was a safe place, and I asked her where else she wanted to go, and she said she wanted to go down to 110th Street to hear some music. I was shaking in my boots. I told her not to go down there.

Vi: Let me tell you something. During the war, we had a lot of people move to New York from Virginia, South Carolina, North Carolina, places like that. I think they came for work in factories and plants. Well, after the war they didn't go back home; they stayed. When we first moved into our apartment in 1939, it was so nice and quiet—then all of a sudden you saw so many strangers on the street. I thought, Who in the world are all these people? You couldn't walk

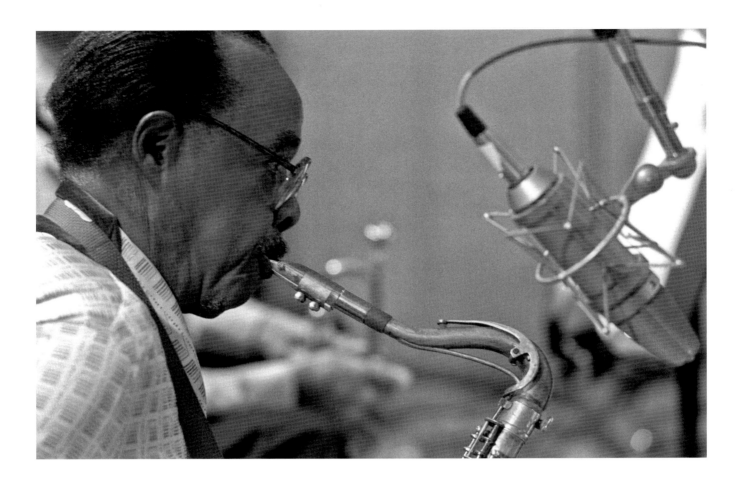

Buddy Tate, recording session, Clinton studio, 1991

the street; there were strangers in town. After the war it was just worse; I'd come downstairs and there were people all over, strangers I didn't want to know and many of them were a bad element. That's why we moved away. This was all over Harlem.

B: I want to say something—if it doesn't fit, you can always take it out. They made Harlem the dumping ground for dropping off dope—I mean dropping off drugs. I remember Adam Clayton Powell made a speech, and I thought he was going to get killed because he named some people. He said, "Don't tell me you can't stop it because you keep armies from coming in, but you're killing our youth. When it gets downtown, you're going to know this thing is getting serious." And didn't it happen? It got all over. But Harlem was the first place they started doing this—they dropped it off

and made a dumping ground, so nicely. They started becoming addicts and began robbing people and doing things like that. I saw the beginning. I saw the beginning of it.

Vi: We saw it with our eyes; we watched it grow. Harlem was so fine when we came in 1939.

B: In those days I didn't have to go downtown for anything. It wasn't second class uptown; it was the same thing. No second-class anything. Of course, integration helped some things. I could be down south with a thousand dollars in my pocket and not have anyplace to eat. It helped in that respect, but when everybody who lived uptown started going downtown, well, a lot of them stayed. Or moved away like we did. Then the people from downtown stopped coming uptown; they were afraid—it was almost like we wanted to run those

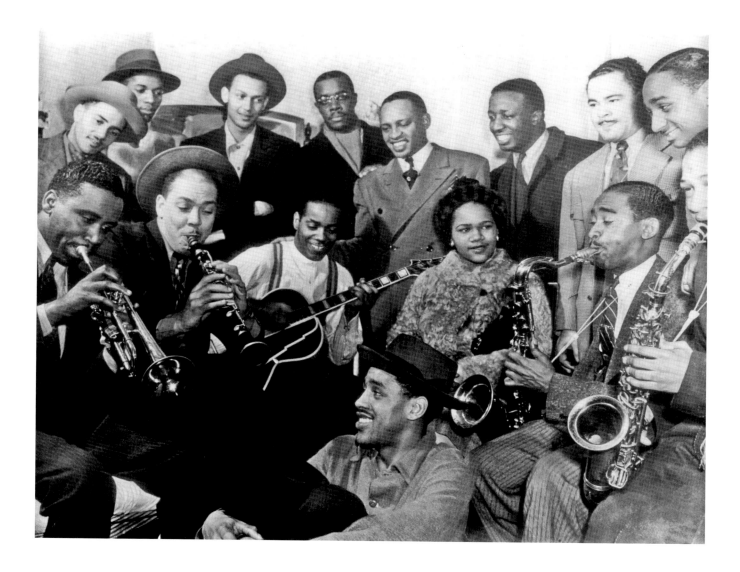

people out of town. Integration, the people who came in during the war, and the dope they started to drop off—all these things hurt a lot.

H: What about the music? Did musical changes have any impact?
B: Of course they did. People started playing for themselves and forgot about their audience. They didn't care if they were communicating or not, they wouldn't talk to the audience, they didn't care what the people wanted. The personality of the newer musicians was different. They played to please themselves and said, "If you don't dig this, you ain't hip." They lost the beat and the young kids wanted to dance—and

remember, that rock music had a big heavy beat and they could dance to it. We kind of hurt ourselves in a lot of ways.

H: After the war, can you think of many instances where there was any interaction with the mainstream players and the bebop musicians?
B: Mainly at Minton's, but, you know, Monroe's was more popular, particularly in later years. Monroe's was Barron's Exclusive Club when I first came to New York, but it was just a little small downstairs place under an apartment. In those years Bird [Charlie Parker] was sleeping in the basement. He was strung out, he was so thin, and I used

Buddy Tate and Lionel Hampton (*back row, fourth and fifth from left*) at an after-hours jam session, 1941

to try and get Basie to hire him, but Basie would say, "I can't do that," and of course, he never did.

H: *Did you know Charlie Parker well?*
B: I'd known him from Kansas City, for many years. You see, Bird came up in the big bands. He loved big bands. Did I ever tell you what he said to me four days before he died? I'd made a record one morning, with a big band at a studio at Fortieth Street and Sixth Avenue. I don't remember its name, but there used to be a studio there. It was an early morning call, and all I was scheduled to do was play clarinet. It was a big integrated band. When the date was over, I was going along Forty-second Street towards Grand Central Station and I see somebody, a guy walking like he's trucking. I remember it was still a bit foggy, but the man looked like somebody I knew, and the closer I got, I knew it was somebody I knew. I get up to him and it was Bird, and we'd been good friends for years. I used to have him up to the house for dinner all the time, and, as I said, when I first joined the Basie band, I tried to get him in the band. His face was all puffed up and his eyes were swollen; he looked like he had been in the ring with Joe Louis. He said, "Buddy Tate, my God, so happy to see you. I just got out of the hospital." They'd just let him out of Bellevue. I asked him where he was going and he said, "I'm going to the office and tell them off. I'm going to tell them off. I've got a bill for $2,500—I've got to pay the string section. How can I pay $2,500?" I said, "Easy, if you take care of business." He said, "Well, buy me a drink," and I said, "I'd love to." He was

messed up and I carried him on over to a little old two-for-one bar. He couldn't get in the door—I had to guide him. That one drink cooled him down. He wasn't really a drinker. I said, "I'm going to have one too. We'll talk."

We started talking about the old days and the Savoy. He said he read about me playing up there. He said, "You know, that's the first place I came with McShann." I said, "Well, have another drink," but he said, "No, man, I'm straight, you know that ain't my thing." So then he said, "Where have you been?" I said, "I did a recording date." "With a big band?" he asked. I said, "Yeah, with a big band, just clarinet." He looked at me sadly and said, "Boy, to tell you the truth, I'd give anything in the world to record with a big band. You know, I don't ever get any dates unless it's mine. I wish somebody would call me." I said, "Don't you know why they don't call you?" And he said, "No, why?" I told him, "Everybody figures you want more money than the date's going to pay the whole band." He looked at me and said, "You think so? I'd love to do it for scale, just to play in a big band." I said, "Do you mean that? I'll tell everybody!" Four days later he was dead. That's true. He said, "Man, well, tell everybody, that's my thing. I came up with the big bands, I want to play with some saxophones, I want to hear that harmony, but I don't get a date unless it's my own record date." That's what he told me, so help me God, and four days later he died at the Baroness's house.

10 October 1985

Opposite: **Buddy Tate**
at home, 1986

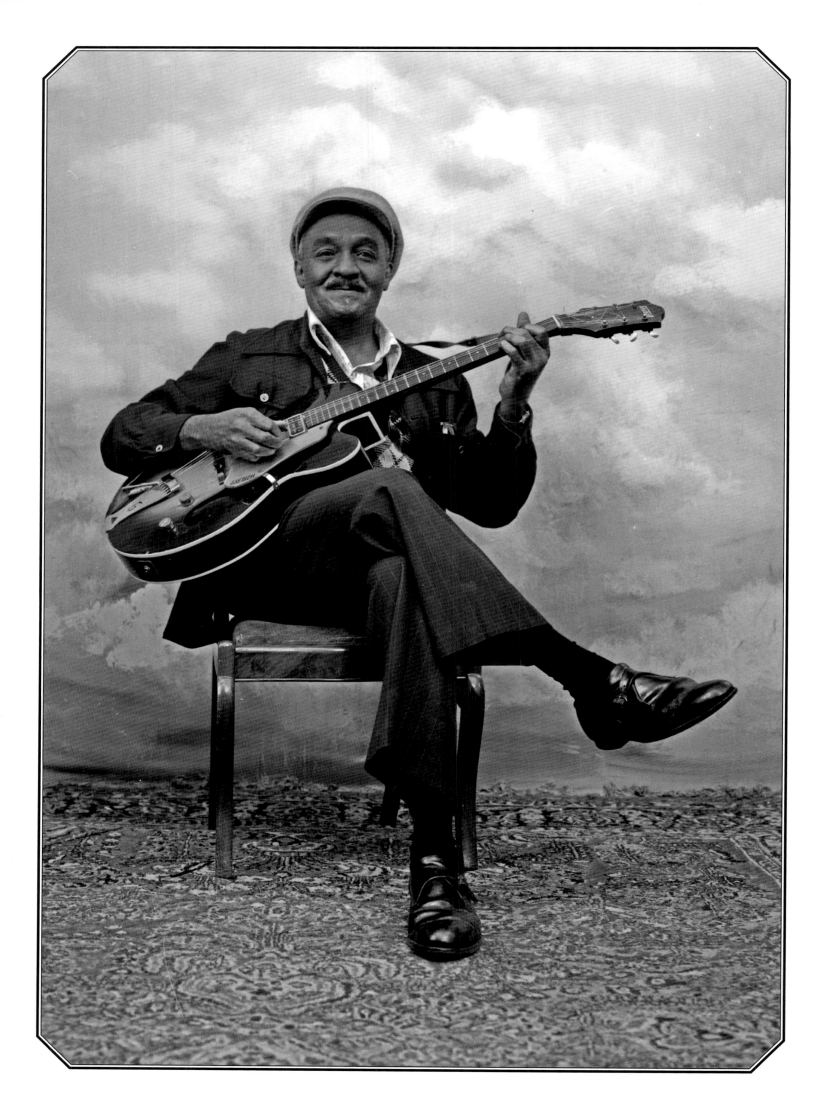

Al Casey
(b. 1915)

Hank: *You always seem to be linked with Fats Waller. Tell me about how you first were introduced to him.*

Al: Yes, I've been very lucky that way. I was associated with Fats when I was very young and stayed with him many years. I'm from Louisville [Kentucky] and was raised by an adoptive grandmother—I was adopted, you know. When I was a teenager, I learned to play a little ukulele and later some guitar, mainly just to impress the little girls. My grandmother had some relatives who lived in a small town not too far from Louisville who formed a vocal group called the Southern Singers. They were pretty good and went to Cincinnati for a radio audition at WLW. This was about 1932 and Fats Waller was performing regularly on that station. Somehow, the Southern Singers wound up being on the Fats Waller radio broadcasts. It turned out to be a permanent thing for them and when Fats went back to New York City, the singers decided they'd also go to New York. They kept on working with him in New York.

H: *What did that do for you? You were in Louisville?*

A: About that time my grandmother asked me if I wanted to move to New York, and what did I know? We came to New York. I went to DeWitt Clinton High School and began to study guitar at the Martin Smith Music School, a school up in Harlem which was run by a lady and her son. He was a guitar player who played a little jazz, and she was a classical musician. I learned to read music at this school and also developed a love for classical music. I was progressing pretty good, and one day some of my relatives took me along when they went to visit Fats Waller. He lived in a basement apartment up in Harlem on some small street off St. Nicholas—I think it was Bradhurst Street. They introduced me to Fats and then I just sat there while they discussed things they had in common, things about working together. Someone mentioned that I played a little guitar, and when we left Fats said, "Bring him back one day, and make sure he has his guitar." So I did. They brought me back and I just played a little, played the best I could. I wasn't trying to impress anybody—I was just a kid. When I was finished, he said, "Okay, I'd like you to come down on my next recording session." Now, I'm still in school, I don't have a union card or anything, but I went down and made those records. I was very excited by all this and the bug bit me—I wanted to play in his band, I really

Opposite:
Al Casey, 1978

Al Casey's hands framing a 1935 photograph of Fats Waller's big band

wanted to play in his big band, to go on tour with him down south. I wanted to leave school, but Fats said to me, "You can record with me every now and then, but you're not going on tour with me until you show me a diploma." One year I did get to go down south on a short tour, but not as a musician, but as a helper, a band boy sort of thing. I was just carrying bags, but I enjoyed it. I graduated in June 1935, showed him my diploma, and joined the band full-time.

H: When you were in school, did you work anywhere as a musician?
A: Just from time to time. Some guys in Harlem would get together and we'd pick up a little job. Just Saturday-night gigs where we could make a couple of dollars. I wanted to get some experience playing, and I thought that was a good way to do it.

H: Did you listen to recordings by guitarists?
A: Yes, I just love guitar records. I listened to Lonnie Johnson, later Dick

McDonough and Carl Kress. Every chance I get, I listen to guitar players—I listen to them all. When I hear what they're doing, well, I know I can't play what they play but I'll take from them and play it my way. This worked for me, I think.

H: Tell me about the difference when you played with Fats's big band and his small band.
A: Fats Waller and His Rhythm only had seven pieces; the big band had seventeen pieces, and he only took the big band out in the summer, to play theaters and shows. I loved the small band because I had a chance to play a solo now and then, but I loved the big band too, just working with the rhythm section. I never got a solo but I just enjoyed playing, trying to make the thing swing. I loved them both as long as he was there, and believe me, *he was there.* When we went out with the big band there was an extra pianist, Don Donaldson, a guy who could play just like Fats. Some nights he'd take one of

the pianos, Fats would just sing, and the band would sound just the same.

H: When you weren't appearing or recording with Fats, what was your schedule like? Did you visit other clubs, hang out at the Rhythm Club?

A: I loved the Rhythm Club. To me it was the greatest place in the world, even before I got started full-time. The first one was on 132nd Street, just off Seventh Avenue. It moved a little later around the corner to 133rd, but in the summertime the big bands would come back in and the guys would go home and say hello to their wives and then head right over to the Rhythm Club to see old friends. I started doing it, and I met some big musicians in there. They had a piano and they'd have little battles—not serious but, you know, you play something, I'll play something, guys stealing from each other. I just loved it. Another thing was, if you didn't have a gig for the weekend, you could pick one up on a Friday afternoon. When it moved around the corner, the atmosphere changed a little, there was more gambling, that kind of thing; but you never knew who you might meet in there, who would walk in off the street. I was young and just loved it. All you had to have to belong to that club was a union card. As time went by, I spent less time there because I had two jobs—the little band and the big band—but if you'd been out on the road for three months, it was great to stop by and catch up with old friends.

H: When you weren't touring, did you visit other clubs uptown?

A: Sure, I used to go out all the time; sometimes I'd sit in and jam at one place or another. But the union put a stop to all that, and I was sorry they did because those sessions were a good place for youngsters to learn. I don't mean kids, I mean young musicians who had a union card but needed to play with better people or gain experience. I remember going into Minton's and hearing Charlie Christian, and it kind of made me sick to my stomach because I knew I couldn't do anything like that. That wasn't the first time I'd heard him; the first time was in Oklahoma. I was out touring with Fats and after we got through with a job, he liked to hang out. He'd heard about a little joint and we went there and Charlie Christian was playing. That was the first and last time I heard him until he came to New York, but I knew when I heard him he was going to do things. He played his guitar like a horn, and the next thing I knew, he was with Benny Goodman. That was another thing I liked about being on the road, traveling with a band from town to town. You'd always run into a great tenor player or a great trumpet player and everybody wanted to hire them but they wouldn't leave town. I met so many tenor players, and Fats was nice, he'd always let them come up and play with the band. Of course, he knew this would help those guys after he left town, to be able to say they'd played with Fats Waller. Once in a while some of these guys would take the bite and come to New York and try and make it, but most of them stayed home.

H: You took a break from Fats Waller for a year with Teddy Wilson. Tell me about that. What made you want to leave Fats's band?

A: I just wanted to try a different kind of music. I went to Fats and told him what I wanted to do; I told him Teddy had asked me to join his band. This would have been about 1939. Fats told me, Go ahead and try it. If it works, I'll be glad

Al Casey, relaxing at home, 1996

for you, but if something happens, come right back, come on home." The band only lasted a year or so—there was so much pressure on it—but I learned a lot. I only played rhythm guitar the whole time, no solos. When I was with Teddy, I loved it so much because I was learning. He had good men and he had good arrangements; there were some guys from out of town that made the band a little different, men like J. C. Heard from Detroit. The band sounded good—and another thing, it was one of the few black bands that played in tune. It played in tune and it could swing like hell. Teddy was very meticulous; he knew exactly what he wanted, from the band and each individual in it. I don't know what happened to him businesswise, but frankly, if the band had made it, I would have stayed and not gone back to Fats.

LADY OF MYSTERY
Fox Trot
-Wilson-Harding-
TEDDY WILSON
and his ORCHESTRA
35207 B

H: Did the band tour or were you pretty much based in New York City?
A: We toured, but not nearly as much as with Fats. I remember a tour we made in Vermont. Thelma [Carpenter] was on that tour. The band sounded good—maybe it sounded too good, too much like Benny Goodman. We had a lot of arrangements that were like Benny's; maybe some of them were Benny's. I heard things about that but I don't really know. That stuff all got mixed up—I heard there were problems with bookers. You just hear so many stories, you don't know what to believe.

H: I've heard that Teddy's band was one of the groups that opened the Golden Gate Ballroom. Do you remember anything about opening night?
A: I never knew very much about the inside-outside thing, all that stuff between the Savoy and the Golden Gate, but I remember opening night. There were about seven bands, white bands and black bands. When we were on the bandstand, we were next to Andy Kirk. They had two bandstands at each end, and we were at one end next to Andy. The reason I remember is because Floyd Smith played with Andy, and he was a wonderful player. He played all kinds of guitar—he played early electric and was a big hit. I enjoyed that night very much and I remember saying to myself that the Golden Gate was going to be quite a thing against the Savoy. Of course, I didn't know the Savoy had taken it over, and the crowds started falling off, there were fewer bands, and then all of a sudden the place was empty. It was a shame because it was a beautiful place and we had a damn good band.

H: When Teddy's band folded, you went back with Fats?
A: I went back with Fats and stayed with him until the end. We toured, made more records. It was wonderful and I was very lucky—I was blessed, you might say. When he died, I thought it was over for me in a way, but I got a little trio together and we played down in Greenwich Village and I worked

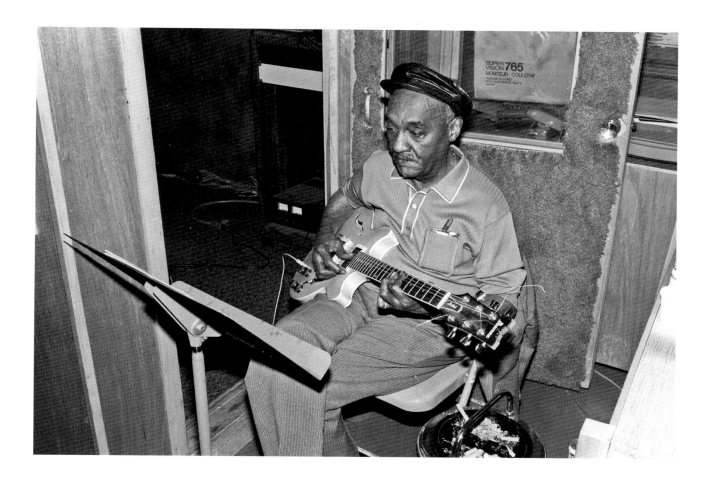

with Clarence Profit for a while. Clarence was kind of sickly and had to quit so I put my own trio together and signed with Joe Glaser. He put us in the Village Vanguard—how I don't know—but we did fairly well and then went up to the Onyx on Fifty-second Street. We played at other places on Fifty-second Street and always did fairly well.

H: Did you ever work uptown in those years?
A: Yes, but not very regularly—Joe Glaser was sending us all around the country. I worked at a place on Seventh Avenue between 137th and 138th but I don't remember its name. My wife would remember. It was on the corner, just a beer joint with a nice clientele. When things started to slow down, I began working with some outside groups—a group from Philadelphia called the Sharptones—and I spent a lot of years

with King Curtis. That was probably the last time I worked uptown, while I was with King Curtis in the late 1950s. I was playing electric then and learned to play a little rock 'n' roll. Of course, I'm still working. I work regularly with the Harlem Blues and Jazz Band—I've been with them since the 1970s—and I do little gigs now and again.

H: What was the most fun you ever had uptown when you weren't working with Fats or Teddy?
A: When I could go listen to a band with a good guitar player in it. I'd go listen to them all. I enjoyed Teddy Bunn—he was one of the guys I loved to hear play. He's the one who started me playing with my thumb. You know, Teddy never used a pick, that's why he had his own sound, and he was so great it wasn't even funny. Sometimes I'd even sit in a little, I forget the names of the places. I used to

Al Casey, recording session, Van Gelder studio, Englewood Cliffs, New Jersey, 1990

A: You could almost do that all over the country. You'd go into some town and there would be one or two hometown boys who were really great. They were fine players. You'd go into a town, finish your job, and go somewhere just to listen and you'd hear fine players—sometimes they were so good you'd just go back to the hotel shaking your head. There was an army of musicians out there. Some of them didn't even have steady jobs, but they were waiting for you out there, waiting for you to come to town so they could cut you. Fats once told me, "Don't ever let your head get too big because there is always that little boy around the corner that can outplay you and outdo everything you do." I never forgot that because a lot of guys get that attitude, I'm the greatest. Don't ever get that way. There is always somebody somewhere who can do what you do better than you do it, and then what do you do? You try to make the best you can on your own. To me, the music business is the greatest thing that ever happened to me, the music and the people that make the music. You learn so much from being in the business, meeting people, playing wonderful music. If you have the right idea in your own head—I don't mean trying to be the biggest thing that ever happened, but just trying to be yourself—it's a great life. You have to remember, you never finish learning music, there's always something to learn, something you don't know—and I don't care how great you are. At least that's what I found out. When you get that thing in your head that I'm the best that ever did it, well, I'm sorry, you better forget it.

11 April 1996

Les Paul in his studio, Mahwah, New Jersey, 2000

jam with Les Paul at a place up on 141st Street. Just in the back room. There was a piano and we'd just jam.

H: Someone once told me that if you were a jazz musician, all you had to do was go uptown to find out how little you knew.

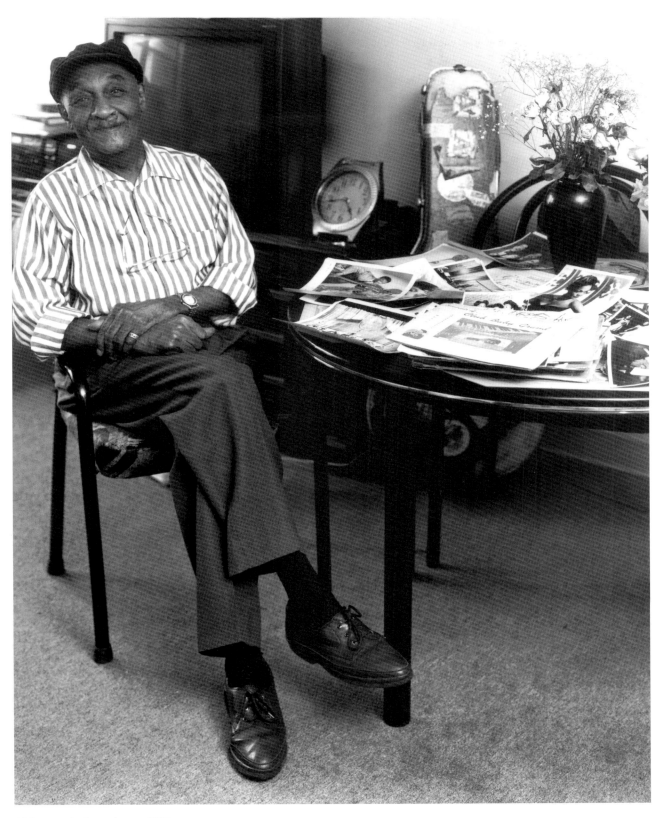

Al Casey, relaxing at home, 1996

Harry Edison
(b. 1915)

Hank: *Tell me about your life in Columbus, Ohio, when you first began to play the trumpet.*

Harry: I was still in high school, no more than fourteen or fifteen years old. I played with a guy named Earl Hood. I remember I had to have a tuxedo and my mother paid two dollars for it. We played little jobs around Columbus and every time I got home my mother used to ask me, "How much did you make?" I'd tell her that Mr. Hood told me I was playing for the experience, and she said, "To hell with experience, you might as well stay home if you're not going to get paid." He finally cut me in, $0.75, sometimes $1.00 a night. I don't think I ever earned more than $1.60.

Hank: *I've heard Columbus was a decent jazz town.*

Harry: In those days all the good bands used to come to Columbus—Earl Hines, Fletcher Henderson, McKinney's Cotton Pickers, Bennie Moten—and they used to get all the girls. There was one beautiful girl who lived next door to me and I really did have eyes for her, but every time the Moten band would come to town, Hot Lips Page would have her. I made up my mind I'd have to learn how to play the trumpet because these guys were getting all the girls. I remember when Louis Armstrong first played in town and I was teaching myself how to play. I never had any lessons. Some world-renowned trumpet virtuosos had said the things Armstrong was playing were impossible, he was playing high Cs, Fs, Gs, As up above that. Somebody said he had a trick horn, that the horn wasn't real. They claimed he was putting chewing gum in the little hole in the mouthpiece, in the cup, which made the hole smaller and made him play higher. He was scheduled to play the Palace Theater, but at the time Columbus was a very prejudice city and we couldn't go to the Palace Theater. My mother was a maid at a big hotel downtown and was very well liked by the owners, who were good friends of the people who owned the theater. She asked if I could go and hear Louis Armstrong, that I wanted to be a trumpet player. They worked it out and I'll never forget, they examined his horn, disassembled the horn, they looked at it and everything, but it was just another trumpet. At the concert Armstrong made an announcement that on "Tiger Rag" he would play two hundred high Cs and would end on a high F. And, gee whiz, he was just going from one end of the stage to the other

Opposite:

Harry Edison, 1987

From left: Eddie Durham, Dicky Wells, and Benny Morton, recording session, WARP studio, 1973

and counting them. Just hitting high Cs, and it was such a thrill, if I had been older I would have had a heart attack, it was so thrilling. He played this high F so loud it seemed like the lights shattered. This was one of the greatest thrills of my life—it was about 1932, maybe 1933. At that time I had my doubts on whether I wanted to be a trumpet player or a piano player. After hearing Armstrong all the doubts, all the other instruments, went out of my mind. That was my real beginning. Louis Armstrong became my idol and after that my mother bought me a good trumpet. She paid nine dollars for it. When I went back to Columbus last year for the anniversary and did a concert, she told the people she put twenty-five cents down on the horn, and there were times when she was certain she was never going to get it paid off. She paid for it for many years, fifty cents a month when she could afford it.

Hank: *How did you make your way to New York?*

Harry: I left town about 1933 with Jeter Pillar's band, went to Cleveland and from there to St. Louis. I traveled around and played with different bands. It's funny how I got to go to New York. It was 1937 and Lucky Millinder was changing his band. He sent to St. Louis for Hal Baker and the tenor player Harold Arnold. Millinder didn't know Baker had already joined Don Redman. Arnold and I were very good friends and he said, "Hey, Harry, why don't you take the ticket and go to New York. Millinder will never know the difference—we all look alike." I said, "Well, he knows Hal Baker cause he sent the telegram and the ticket, the train ticket, for Hal Baker." Arnold, who was half loaded all the time said, "Well, come on anyway, you know Birdie's in New York." Birdie was the girl I was in love with at the time, and we were going

to get married. That's what really got me on the train. When I arrived, Millinder said, "You aren't Hal Baker," but I joined the band anyway. The other trumpets were Charlie Shavers and Carl Warwick. The first place I played was the Apollo Theater. We played in the pit first; then the band would get on the stage and we'd do our thing. We had to play for all the girls, the dancers and the chorus girls. Bill Bailey was there and he was the greatest. He used to go out and at the end of his act he'd do what they call the moonwalk today. Now that's supposed to be a new dance, but don't talk to Pearl [Bailey] about that or she'll go berserk. I was with her at Carnegie Hall a little while ago and somebody mentioned that and she said, "Sweets, come here. You hear these little suckers talking about the moonwalk and Michael Jackson, you tell them who did it first."

Hank: *How long did you stay with Millinder before you went with Basie?*
Harry: Not very long—a year or so. He acted like he wasn't satisfied with my playing. After a while, Millinder fired me so he could hire Dizzy Gillespie, but he didn't know that Dizzy had joined Teddy Hill. Then Lucky asked me if I wanted to rejoin the band. I didn't, because little Bobby Moore had taken ill with the Basie band and Jo Jones, Walter Page, and Herschel Evans all told Basie he should hire me, that I was a good trumpet player, and that's what happened. Lucky wanted me back, but I wanted to go with Basie and I told him so. It was 1938.

Hank: *What was the Basie band like in 1938?*
Harry: Well, Buddy Tate still hadn't joined, but Eddie Durham had just left. The trombones were Dan Minor, Dicky Wells, and Benny Morton. Everything was head arrangements; there was almost

no music. I even put in my notice because there was so little music. I wanted to learn how to read better and couldn't if there was nothing to read. When Basie found out I'd put in my notice, he said, "What the hell is wrong?" I said, "You know, I'm really trying to be a good musician, but I have no music to read, and somebody's always playing the same notes I want to play. I can only read a little, and I want to learn how to read well." He said, "Well, if you find something tonight that sounds good, play the same damn thing every night." So that's what I did for all the years until we got more music.

Hank: *I've always heard the Basie band at that time was a big band that improvised like a small band.*
Harry: Exactly. Everybody wanted to join Basie's band because it was free. He'd let you play as many solos as you wanted. Bands like Ellington and Jimmy Lunceford and all the rest of the bands had written music, and you would stand up and play eight bars and you would have to sit back down. Consequently, they never got to expand their ideas like we could in Basie's band. That's how Lester Young became so popular. He had a different sound, a sound of his own, and when he would get up to play, he'd play five or six choruses because his mind was active all the time. He wouldn't sit down wanting to still play after eight bars, he'd be ready to sit down after five or six choruses and he still hadn't run out of ideas. I usually played before him because nobody could follow him. I'd be too embarrassed to play after him because he would play so much.

Hank: *I've heard there was a friendly rivalry between Young and Herschel*

*Evans. What evidence did you see of this
supposed rivalry?*

Harry: Lester Young liked Herschel as a
person but he didn't like his style, because
Herschel was a Coleman Hawkins
disciple. Pres loved Coleman Hawkins
but he didn't like his playing. What Pres
really loved was his own playing, and it's
an old cliché, If you don't love yourself,
nobody else will either, and that's why
Pres was so successful. He would listen
to his own records and would play along
with them. He just loved to play, and he
could play all night long. I'm just grateful
I got a chance to play with him in those
days when he was the world's greatest
soloist. Lester and Jo Jones were the
epitome of the profession at the time.
There was just nobody like Jo Jones,
Lester Young, or Count Basie. Basie's
theory was it's not how many notes you

put in a solo that makes it effective but
how many notes you leave out, and he
put the right notes in the right place at
the right time. But he was a mean piano
player at one time; he played just like Fats
Waller. He could really do it but finally
felt there was no need to be playing all
this piano when he had Pres, Herschel,
and Buck. He told me that once, and
I said, "What the hell are you talking
about? You're supposed to be playing like
everybody else!" But he said, "That's what
I'm paying you for."

Hank: *I've heard it was a very closely
knit band.*

Harry: We were a band of brotherly love.
Everyone just loved each other. There was
never any confusion. Sometimes I think
we were too tired to have any confusion.
It was such a unique band—there was no

music, Basie would just play something on the piano at the Woodside Hotel and tell Buck to take the trumpets to a room up there, the reed section would go up to Pres's room, and the rhythm section rehearsed in the basement, right in the Woodside Hotel. We would rehearse two or three hours and later, after everyone had a little drink, we'd come back downstairs and we had an arrangement. That's the way the band was based on just arrangements. It was enjoyable like that. I enjoyed it after that because I was in on the rehearsals and I knew which notes to play. Before that I really was miserable.

Hank: How long did the band work like this?

Harry: It lasted from when I joined until the war broke it up. This was the greatest band of the era, but the war ruined it. It took Buck Clayton, Jack Washington, Jo Jones, Lester Young—and that was the beginning of the end for Lester. The army really wasn't any place for a musician, but it was especially tough on Lester. They put him in a padded cell at one time and took his horn away from him.

Hank: Tell me about the band playing in New York. What was the most important thing for you in those days?

Harry: We all wanted to be known by our sound. Everybody, every band, had its own sound. Everyone wanted to be an individualist, known by their own unique way of playing or singing. Everyone had a distinctive style. As they used to say, I'd rather be the world's worst originator than the world's greatest imitator, because if you imitate someone you'll always be an imitator, but even if what you played sounded sad, but you originated it, you'd be recognized one day as having something that nobody else had. And the people listened to what you were playing. Dancers at the Savoy were the most

discriminating listeners there were. They would know exactly if somebody messed up, and if the band didn't keep the dancers on the floor then the band wasn't there. Charlie Buchanan was the owner of the Savoy at the time and he'd fired you if you couldn't make the people dance. The dancers were the critics, and the Apollo Theater was the most critical theater on earth. On Fridays, every critic from New York and Harlem would stay up all night to catch a band on opening night at the Apollo, because if the band didn't click with the people in the audience they'd throw an egg at you, sometimes a tomato. You know, I felt sorry for a couple of bands. They just didn't make it that first day. Schiffman [Frank Schiffman, the owner of the Apollo] would come back and say, "I'm sorry, but come back when you're

CONNIE'S
presents Leonard Harper's
NEW SUMMER REVUE
"HOT FEET"
2 Gala Revues Nightly 2
featuring
PRINCESS VIKANA
30 Beautiful Brownskins 30
LOUIS ARMSTRONG
AND ORCHESTRA
"You'll Want to Dance"
7th AVE. at 131st ST.
Reservations Suggested
Phone Harlem 6630

Connie's Inn poster, 1929

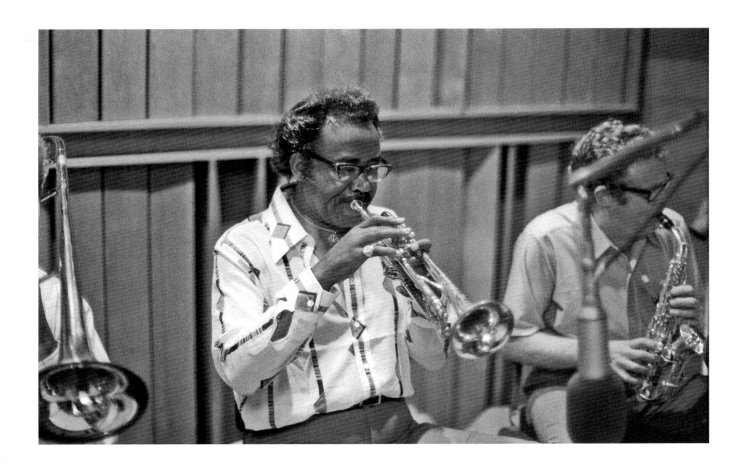

Harry Edison and Bob
Wilber, recording session,
Downtown Sound, 1976

ready." Then he'd send for a substitute
band that people would know. It was the
same way in the clubs and after-hours
places. If somebody would come in
Monroe's with their horn and didn't make
the right waves to the audience, Monroe
would ask them off of the bandstand.
He'd say, "Take your horn and get off the
bandstand and come back when you're
ready." I've seen them take guys bodily,
take their horn and put him outside the
door. He wasn't diplomatic at all. He'd
say something like, "You know you're
dragging everybody," and they'd be gone.
He wasn't diplomatic at all.

If you could play an instrument,
all you had to do was come to Harlem
and you could find out how little you
could play, how little you knew about
your horn. When I came to New York,
it was where the music was. Art Tatum
was playing on 133rd Street at a place
called the Bird Cage. Across the street

was Connie's Inn, the Ubangi Club. Billie
Holiday was singing at a place called
the Yeah Man at 138th and Small's at
134th Street. Why would anybody want
to go downtown? There was nothing
downtown except the Cotton Club, and
you couldn't go in there because they
wouldn't allow us in there. I used to go
down there to pick up my wife and had
to wait outside. Later, Fifty-second Street
opened up and there was Roseland, but
Harlem was the place to hear music.

Hank: *Did you ever hear of a pianist
named Willie Gant? I think he used to
play at some of the clubs uptown.*
Harry: I knew him very well. He used
to instigate all of the cutting contests
with the piano players. In fact, I heard
Art Tatum and Donald Lambert have
a cutting contest one night at Reuben's.
This is how he did it. Willie Gant tells

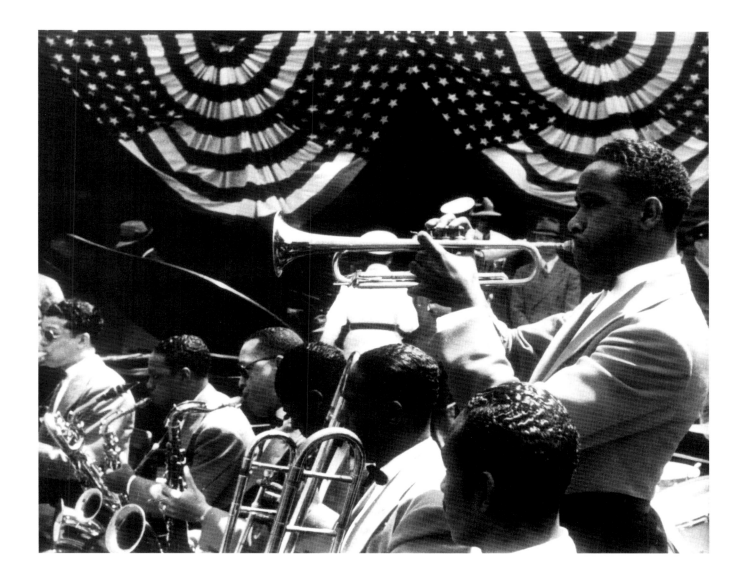

Tatum about a piano player coming in from New Jersey tonight, and he tells Art, "The guy says you can't play, your left hand is terrible, you can't even raise your left hand." Then he goes to Jersey and he tells Donald Lambert, "Art Tatum is looking for you at Reuben's on such and such a night, and Art says he's going to run you back to Jersey." That night I happen to be in New York with the Basie band. You couldn't get in the joint— Reuben's was only about as big as this room. Gant came in, full of beer as usual, and then Lambert walked in and told Art to get up, saying something like, "Get up off the chair. You can't play, you've got no left hand, you're the world's worst

piano player." So Art got up and Donald Lambert sat down. He played—there was no doubt about it, he played—and then he was finished. Everybody was wondering if Tatum was going to play after all of that. Billy Kyle was there. Teddy Wilson was there. A piano player from Kelly's Stable named Nat Jaffe was there. Marlowe Morris, everybody, even Willie the Lion [Smith] was there. When Donald Lambert got through playing, Art came out. He'd been fooling around in the kitchen drinking beer. Finally he came out, and Willie Gant set a beer on the piano. Art started playing with his left hand and drinking beer with his right hand. Then he'd start drinking with

Harry Edison with Count Basie and His Orchestra, Randall's Island, New York, 1938

his left hand and playing with his right hand. When he put the beer on top of the piano, he'd start playing with both hands. I never heard so much piano playing. If you could have recorded it, it would have been worth a fortune. After that, Donald Lambert went back to New Jersey and never came back to New York. Art Tatum was responsible for him being in Jersey and staying there. He ran him back under the tunnel. This was a night that was absolutely unforgettable.

Hank: *It sounds to me like there were some wonderful things to be heard in some of those little joints uptown.*
Harry: There sure were. I used to hang out at Minton's a lot. Jaws [Eddie "Lockjaw" Davis] was there a lot. You'd hear wonderful things. Charlie Parker would be playing. Ben Webster would be playing—he was another great innovator, but on the tenor saxophone, nobody will ever sound like Ben. Maybe even Benny Carter. All those people were just absolutely the best, musicians to be admired, because they were doing something that hadn't been done before. It was just like inventing the electric light. Inventing something that will go on forever and ever. I don't care if it's fifty years from today, a hundred years from today, if you hear a Ben Webster record, nobody will ever duplicate that sound. Nobody will ever sound like Zoot. Zoot had a sound, had a beautiful tone, he's one of my favorite tenor players. He had a sound of his own; he was a Lester Young disciple. Zoot loved Pres, and out of loving Pres he developed something of his own. I really think Lester Young is the most influential tenor player that ever lived. Because his sound is so simple and what he plays is so simple. The first guy to start running changes on the saxophone was Coleman Hawkins. He was the first one. Everybody was playing nothing but

the melody and then Coleman Hawkins started taking the melody and running the changes. If it was an F-seventh, he'd run the F-seventh, he wouldn't just play the melody. He was a well-schooled musician; he played piano and cello. I admire Wynton Marsalis because he's gone and learned the trumpet well. He has learned what he had to do, but at the time when we were coming up, the way he's playing now he would never get a job, because you had to play solos and you had to play a different style. You had to play with fire, like Roy Eldridge. Roy Eldridge was one of the most exciting trumpet players I ever heard. He was absolutely just fantastic on that horn. What an exciting trumpet player he was! Now it's the cool jazz, you know. Who am I to say who is right and who is wrong? I just believe that you are supposed to play with a lot of fire if you're going to play jazz.

Hank: *You stayed with Basie until 1950. The band continued to play uptown after the war, but did things begin to change?*
Harry: One reason the places closed were there were so many places opening up downtown. Musicians started going, and listeners stayed downtown. After the war there were so many little bands, and the big bands started to phase out. Ballrooms closed. People went to these little places to sit down and listen to music instead of dancing. Jazz became more of a concert instead of a dance. I can't think it was economics because we used to play dances—you could get in the dance halls for two dollars, and it would cost more or less the same to sit and drink in a club. Then the music became so involved, and it wasn't swinging like it used to be. There was no tapping the foot. No fire at all, no bass drum. The music became very technical. They called the new music be-bop, but it's just music to

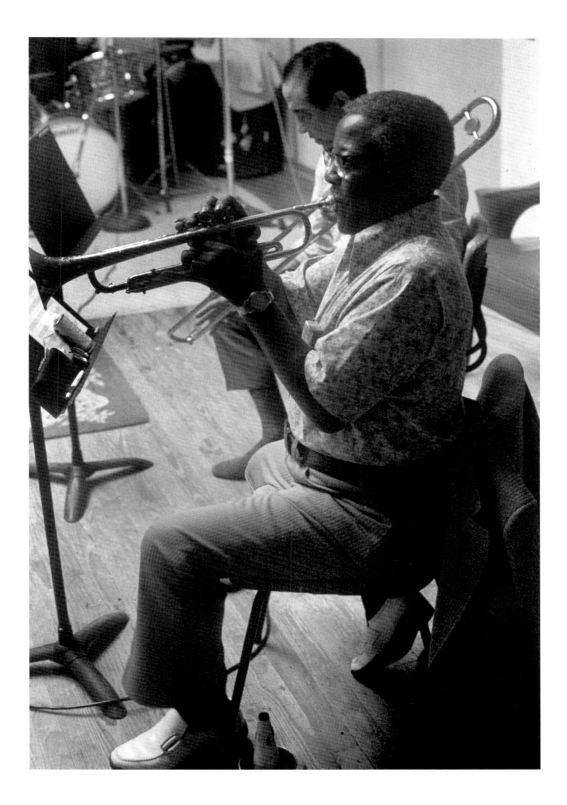

me. I'm like Duke, who said, whatever name you call it, it's just music, whether be-bop or whatever. But you couldn't dance to whatever you called it. I think that's why the big bands, the nightclubs, dance halls closed—you just couldn't dance to that kind of music. I don't call a lot of the music today jazz, really, because jazz is music you can dance to. It is music that moves me, something that makes me pop my finger, makes me feel good. Music now, they say, is cool; it is cool. If you go to dance, you can't be cool. If you're going to play jazz, you can't

Roy Eldridge, *foreground*, and Dickie Wells, recording session, WARP studio, 1973

Harry Edison, Floating Jazz Festival, 1995

be cool. You've got to put effort into it and really light a fire behind the people that would make them want to dance. I haven't heard any band since the old bands that would really make you want to dance. Really give you that spark, make you want to move. And rock 'n' roll, forget it, that's not my idea of music. It's the same beat that goes from loud to louder; there are no dynamics in it.

Hank: *When you left Count Basie, you didn't stay in New York for very long, so you didn't see the uptown music scene close down.*

Harry: No, I was in Los Angeles. I was with Jazz at the Philharmonic. But I was in New York in the late 1950s, and that's about when Harlem began to close down, but I was playing downtown. Then I moved back to Los Angeles. You've got to love the business to stay in it because it's really a hard profession. If you make it in jazz, you make it the hard way because it's not promoted. They don't promote jazz in America like they do in Europe. If you make a hit jazzwise, it has to make it on its own. There is no promotion; they do not promote it like rock 'n' roll or anything else, even country western. Very few cities have a jazz radio station. On television you can see rock shows all day and all night, whanging and twanging on the guitar, but you never get to see a Duke Ellington film or a Count Basie film, you never get to see a documentary unless it's on PBS. But who am I to say who's right and wrong? When I talk to my daughter about this, she says, "Well, Dad, you're just getting old." Maybe that is it. I was on the Motown staff for about twelve years in Los Angeles, but it was just a check to me. I really didn't like the music. I made a lot of records with Smokey Robinson, the Jackson Five, Marvin Gaye, Gladys Knight and the Pips. I was in the background for years and when people would hear one of these groups play, they'd think they were the ones who made the record. The difference between us and the rock 'n' roll musicians is they can't play jazz. If they tried to swing, it would kill 'em. But a jazz musician can play rock 'n' roll because we used to make our own rock 'n' roll records.

14 May 1987

George Kelly
(b. 1915)

George: I was born in Miami, July 31, 1915. The house I was born in, well, the city wanted to make a highway through there, so they tore the house down. A few years after they'd torn it down—I hadn't been home in many years—I was visiting and was driving around with one of my cousins. He stopped the car and asked me where I was. I didn't know and he said, "Your house used to be right where we're parked."

Hank: *What were your first experiences in music?*

G: I started on piano when I was about nine, in 1924. I studied for about six years; then I went into saxophone. I really didn't want to play piano; it was my grandmother's idea. My father wanted me to be a tap dancer. My grandmother said, "No, this boy is going to play music." We had a piano—it was for my mother, but she had passed on—and my grandmother said, "Your mother has passed on, so somebody is going to play her piano, and it's going to be you!" I didn't want to play the piano, and once I started the guys would pass by my house coming from football or baseball practice, and I would be sitting there playing my lessons on the piano. They'd yell things like, "You gonna wind up being a sissy!" but I kept on

practicing. Then I told my grandmother, "I want to play saxophone." My uncle had bought an alto saxophone but he couldn't learn to play it, so my grandmother told him he should just let me use it, that if I showed any talent, she'd buy it from him. Sure enough, I showed some talent and learned how to play it and got my first job playing a birthday party for my cousin. They gave me a little handout, a dollar or two, and I decided I wanted to learn more about the saxophone. I told my grandmother, "You said if I learned to play the piano, you would buy me a horn." She said, "You and that damned horn again," and I had to fight for it. I was making a lot of progress. I was studying saxophone and piano with two different teachers, and both teachers told my grandmother I was doing very well, so she finally got me the saxophone. I've still got it. I can still play it.

H: *You're still playing the same horn?*
G: Not exactly. I got my first alto and had that horn until I came to New York. When I got to New York, that horn was so old—it was built in 1925—that horn was so old, it gave out my first night at the Savoy Ballroom. I jumped up to the mike to do a solo and one of the keys dropped off. Luckily for me Erskine

Opposite:
George Kelly, 1996

355

Hawkins's band was playing opposite us and Paul Bascomb had a tenor he let me use for the rest of the night. In those days they had two bandstands; when one band got finished, the other band would go on. The next day Al Cooper told me he'd take me downtown to Conn to get another horn, but I didn't want to get rid of the horn my grandmother got me because, well, it was just a sentimental thing. Al said, "Look, George, you've got to have a horn for tonight. You have to forget about being sentimental. We'll get you a horn." He bought me a student horn. I played with that for a while and then I traded it in. I've had about three or four horns. I just got a new one—I bought one about three or four months ago.

H: Were the Savoy Sultans the first band you played with in New York, or had you been here before?
G: No, I'd never been here before. In fact I came from Miami to New York to join the Savoy Sultans. Al Cooper, the leader of the band, was from Miami and he'd heard about me. His brother was a bass player and we'd worked together in Miami. Al was having trouble with the tenor player in the band, Skinny Brown—his real name was Irving—and he sent for me to replace him. It's a funny thing, but when I went to play I was nervous. I had never seen that many people in one ballroom in my life. Then the keys fell off my horn and made me even more nervous. I got through the first set and then Paul lent me his horn and by then I'd had a little wine so I was less nervous. Al told me I sounded a lot better with Paul's horn, but I had to find something to replace the wine because I didn't like it. It all worked

out. I didn't go back to Miami for about four years. I stayed with the Savoy Sultans from 1941 to 1944, when I went into the service.

H: I've heard the Sultans were the band that could get people out on the floor faster than anybody.
G: That's true. We had a thing the band would do as a group. When Rudy Williams, the star of the band, would start soloing, it was so exciting that we used to do a thing with our feet, and then the dancers noticed it and they started doing it. Another thing we'd do when Rudy was soloing was Al Cooper had some hammers, and he'd start beating on the floor with these hammers. We did all sorts of funny, entertaining things, fun things.

H: Which band did you enjoy listening to yourself?
G: There were several bands I liked. It was always fun when we were in there with Erskine Hawkins. It was a swinging band. I remember one story I heard about Count Basie. He was about ready to play the Savoy and he asked who'd he be playing opposite. Mr. Buchanan told him it would be the Sultans. Basie said, "Those pesky Sultans," because we used to give the Basie band fits. We used to give all the bands fits. The only band that Cooper let up on was Guy Lombardo. Did you know Guy Lombardo drew more people on the night he played at the Savoy than any other band?

H: I've heard that. Were you there that night?
G: I was there, and it was the first time I'd seen him, the night we played against him.

H: When you weren't performing yourself, who did you enjoy?

G: The main band that I liked to listen to was Jay McShann. The reason for that was Charlie Parker—nobody could play like that.

H: Did the McShann band play at the Savoy very often?
G: I don't know how often he played there. He wasn't a house band—he was a touring band. Hootie and I got to be good friends later; we were in the army together. A funny thing happened to me with the McShann band. One time when they were in New York, they got a commercial on the radio and they couldn't find Charlie Parker so they asked me to play in Charlie's place. When I got there with my horn, I had my tenor, and Hootie said, "You've got your tenor. We need an alto." I told Hootie, "Don't worry about it." In those days I could transpose really fast, but Hootie didn't know this

and asked me what I was going to do. I said, "I'll transpose it," and he said, "How are you going to do that?" I told him not to worry and sure enough we played and I transposed his music. Hootie was surprised and said, "Man, you're a genius!"

H: You said you were in the service with Hootie. How did the war affect the Savoy Sultans?
G: It hurt them a good deal. One night in 1944 I was playing with the Sultans, and at intermission a couple of guys came up to me and said, "You play nice horn." Al Cooper said something about me coming up to New York and making a name for myself. After the next set these guys came up to me and said they wanted to talk to me. They took me right off the bandstand. I wound up in the army with Hootie, and neither of us were in as

Jay McShann, recording session, Van Gelder studio, Englewood Cliffs, New Jersey, 1990

musicians. They told us they had enough musicians, they wanted fighting men. But we had some funny times together. One time we were down in Georgia wearing army issue clothes that didn't fit. Hootie had on a pair of army pants that were way up his legs, and I had a pair of army pants that hung down over my shoes. We were walking down the company road together and an officer saw us. He stopped us and said, "You are the worst-looking soldiers I have ever seen in my life. Where did you get those clothes?" Hootie said, "This is what they gave me," and I told him the same thing. He said, "Well, I'm going to take you over to the supply room and get you some more clothes, because you are misrepresenting the soldiers of the United States Army." We both got new uniforms, but we didn't keep them very long.

H: When you came back from the army, did you go back to the Sultans?
G: Uncle Sam shut down the Sultans. The war took guys out of the band and Al replaced some of them, but they weren't playing the way Al wanted them to play. When I came back, I think I worked with Al a couple of times but then he just quit. He broke up the band and went into the booking business. He became a very successful booker, sold his horn, and moved to Florida.

H: In the years before the war did you jam in Harlem clubs when you weren't playing with the Sultans?
G: I used to go down to Minton's to relax, especially when we played in the Apollo Theater. After the last show we'd go down to Minton's and just sit around and jam. Let me tell you a funny thing about that, when I'd first joined the band. We'd just played the Apollo and a guy come by and said to me, "When new musicians come in, they usually go to Minton's and jam."

That sounded all right to me, and when I arrived, there were three other saxophone players. I didn't know any of them, and I was a little nervous. Whoever was running the session would set you up. They'd let this guy over here play first, the next guy would play a little, then I would play. I'm watching these guys, listening to them play, and I play a little. All the guys play a little, then they start to get a little stronger, and we all went around again. And then finally one guy tore out, and I got nervous. Finally, they introduced everyone and the man said, "We have a new fellow from the Savoy Sultans named George Kelly. He was nice; let's give him a hand." The man who was so terrific was Don Byas, and I got to know him pretty well. One night a few days later I was back at the Savoy and some guys were razzing me. They were friends of Skinny Brown, the guy I'd replaced. Don Byas was there with Ben Webster and they stuck up for me. Don said, "Leave the kid alone. He's all right." And then Ben came by and said, "Yeah, the kid can play. The kid can play." This made me feel real good.

H: When the Sultans broke up, did you form your own group?
G: Yes, I had small groups—a quartet, a quintet. Once I had a trio that worked at Sugar Ray's [Robinson], an organ trio, about the time I recorded all those things with Cozy Cole. I had small groups that worked at many different places—Small's, parties at the Renaissance, those kinds of things—until finally there weren't any places left to play. It's hard to remember when I even worked in Harlem, it was so long ago.

H: You've told me how the war hurt the Savoy Sultans. What would you point to as other things that hurt the music scene in Harlem?

Opposite: George Kelly, recording with the Harlem Blues and Jazz Band, Van Gelder studio, Englewood Cliffs, New Jersey, 1990

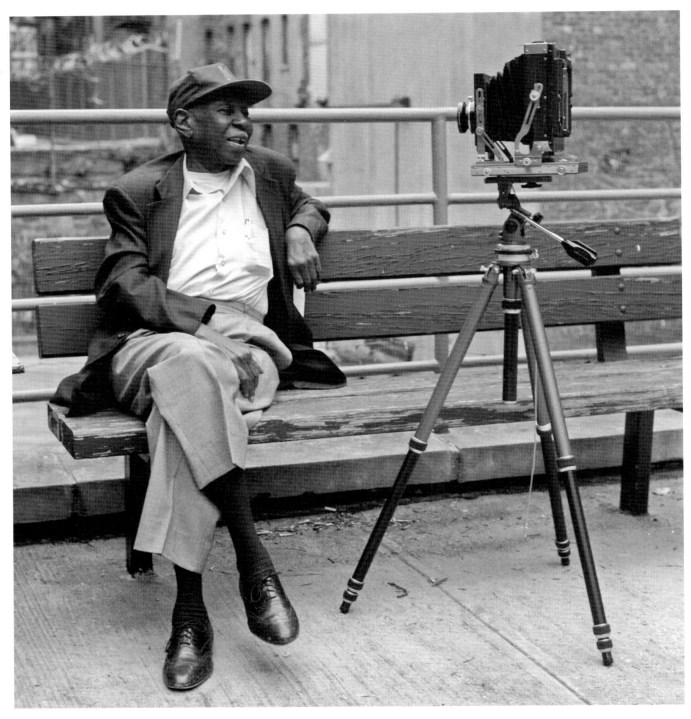

George Kelly and a camera, 1996

G: Prostitution, for one thing, this was one of them. Pimps would come around, start doing their business at the Savoy. When this began, it started going down, the Savoy started going down, and after the Savoy failed there wasn't any place to work. When Al Cooper broke up the Sultans, the Savoy started going down. People didn't support it the same way they had before the war. I remember it got so the bouncers would have to go home in groups of three and four because people would be hiding on the roof, and when they'd see them come out they'd throw garbage cans down on them. It all started to change in the late 1940s.

H: If you could think of one thing that would help the music come back uptown, what would it be? Perhaps just a place to play?
G: That would help, but these days there are so many different kinds of music going on, music a lot of people just don't understand, and people don't dance like they used to. People just don't dance anymore. They don't seem to be happy listening to the music. If there was a place to play where people could be happy with the music, well, that's the main thing. If we could just get that going.

20 April 1996

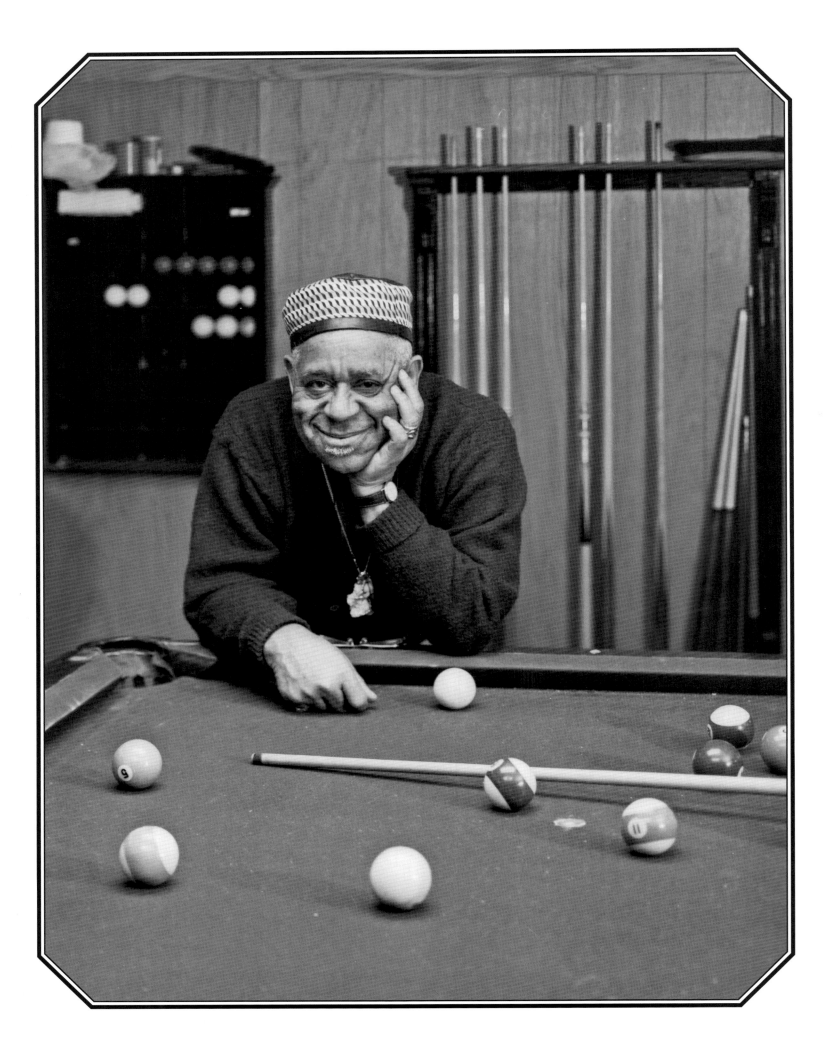

Dizzy Gillespie
(b. 1917)

Hank: *What was the first club you ever played in Harlem?*

Dizzy: Working or just playing around?

H: *Working or just sitting in.*

D: I played in more places than I can remember, but the first place I worked, where I got paid, was the Savoy Ballroom, with Teddy Hill. I'd been hanging out there for a while, had even sat in with the band a few times, but then things happened and I hooked up with the band. I'd been in Philadelphia and came to New York to join Lucky Millinder. Charlie Shavers and Bama [Carl Warwick] had worked that out. I was supposed to take Sweets's [Harry Edison] place. When I got to town, there was also a spot with Count Basie because Bobby Moore had gone crazy. I wouldn't take the job with Basie and Sweets took it. But before that I was to have had Harry's job with Lucky, but he didn't hire me. I was without a job, so I hung out at the Savoy and a lot of other places. I'd sit in everywhere. I even sat in with Chick Webb—that was something, because Chick didn't let many people sit in with his band. But I never worked with that band until after Chick died.

H: *Tell me about the Savoy Ballroom and joining up with Teddy Hill.*

D: I went there a lot because I could get in for free. Charlie Buchanan was good to some of the musicians who were kind of regulars. I was a regular and I used to get in without paying. I heard most of the good bands there—Willie Bryant, the Sultans, Claude Hopkins, even Fess Williams once or twice, and Teddy Hill, who hired me after a while. I'd been sitting in with the band off and on; he had a European tour coming up, someone quit, and I got the job. He hired me because I sounded like Roy [Eldridge]. I was just a kid, not even twenty.

H: *What sort of places had you been jamming at in those days?*

D: Places you've never heard of. The Victoria was one. It was at 141st Street and Seventh Avenue. I got to know Edgar Hayes there; he had the house trio. Later I had some trouble with him. It was just a little place, nothing much. I used to jam at the Brittwood on Lenox Avenue and across the way at the Club Baron. And the Yeah Man, a nice place. I used

Opposite:
Dizzy Gillespie, 1990

Apollo poster, 1949

I remember I met June Clark there, an old trumpet player who'd been around for a long time. He talked just like Louis Armstrong.

H: *Later, after you'd become established, did you work in any of these places?*
D: I played almost everywhere there was to play uptown, but I didn't work anywhere except at the Savoy Ballroom and the Apollo Theater. There was a difference. In the early days I'd sit in at Fatman's, the Hollywood, Minton's, Monroe's, and later at places like Count Basie's, but I never worked there. I was never paid for playing at these places. Most of the time in those years I was in bands that played theaters and dance halls. These were after-hours places. Maybe they'd have a trio and these guys were paid, but nobody else got anything, except maybe a drink. Some of the places didn't even have a trio—people just showed up.

H: *Give me your impressions of the Savoy Ballroom when you were first sitting in and then working with Teddy Hill.*
D: I loved that place. I had a ball at the Savoy. I learned all the dance routines. The Lindy Hop, everything. Tuesday nights were special, it was show time and all the white people would come up to see the jitterbugs and Lindy Hoppers. I'd be playing in Teddy's band, or even if I was sitting in with someone else, I'd dance when the other band was on and we were off. You see, there were always two bands at the Savoy. When I wasn't playing I was dancing, and the girls used to show me all the steps. Shit, man, I was good! I used to throw a girl way, way up and this way and that way, down through here and pick her up and throw her sideways. You had to know the

to go there a lot—it was just up the street from where I lived. There was a real pretty white girl who sang there, Ann Hathaway. It was kind of unusual for a white girl to have a regular job uptown, but I guess she did because she was there all the time. Boy, she loved Lady Day [Billie Holiday]. She was crazy for Lady Day. I'd go someplace to see her and Ann would be there, and she'd be foaming at the mouth, I mean foaming at the mouth, listening to Lady Day. Clarence Profit was there with a little band sometimes.

dancing to play the music. If you don't know how to move to music you don't know how to play the music—you've gotta know dancing to play our music. There are some guys today who move like a lumbering ox onstage. They can't put one foot in front of another. A lot of musicians are like that. They're disjointed and they get off time, they're down there when they should be up here. You can't have your body going one way, your instrument another way, and the music still another way. You have to know how to move.

H: You played with some great big bands—Teddy Hill and then a little later Cab Calloway.
D: Cab and Duke Ellington were the prize bands. They paid the most and worked under the best conditions.

Everybody knows about the spitball and my fight with Cab, but most people don't know Cab never really hired me. You see, I'd met Mario Bauzá when he was playing with Chick [Webb], but by 1939 he was with Cab. I ran into him one night, and he said I should go in his place to play with the band at the Cotton Club downtown and play all the solos. Mario knew Cab was looking for someone to solo. I went down and played that night, and then the next week I was back uptown at the Apollo with Teddy Hill. We weren't married yet and Lorraine was still dancing every night at the Apollo and was good friends with Cab's valet, Rudolph [Rivers], and she told him he should get me a job with Cab. She said, "Get that nigger a job, Rudolph!" and that's just what he did. Rudolph called the Apollo later that week and said I should

Charlie Parker sign, Dizzy Gillespie's recreation room, Englewood, New Jersey, 1990

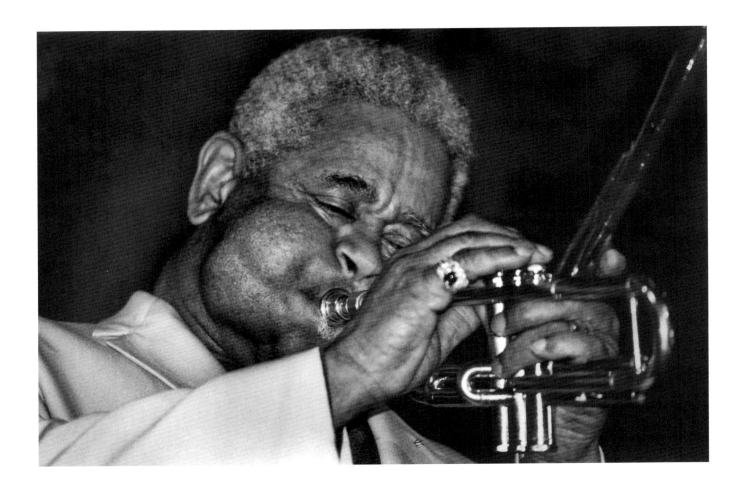

Dizzy Gillespie in concert, The New School Beacons in Jazz Awards, 1993

come downtown and join the band. I never spoke with Cab. I knew the money would be better than I was making with Teddy, so I went downtown, put on the uniform, and played. I was with Cab for over two years.

H: Tell me about Minton's Playhouse. You were with Cab when all the exciting new music began evolving at Minton's.
D: I didn't dance there! And I didn't get paid either. If I was in town, I'd go there after hours or maybe on a Monday night—we were usually off that night. There was a trio—[Thelonious] Monk, Kenny Clarke, a bass player. By that time Teddy [Hill] had given up his band and was running the place. Nobody from the union bothered anyone there because it was started a few years earlier by a union leader. But this place, like Clark Monroe's,

was just a place I played. I didn't work there. As I said, the only places I worked were the Apollo and the Savoy Ballroom, first with bands like Cab and then, in the late forties, when I had my own big band I played in both places.

H: Which did you enjoy the most?
D: The Savoy was always crowded. And the people danced. They didn't just listen to my band. But my big band also played downtown in theaters. There weren't too many theaters left after the war, only the Apollo uptown. There were only two places for me to work uptown and as time passed fewer and fewer places to just play, but I didn't have as much time or energy to go hang out and jam.

H: When was the last time you worked or played anywhere uptown?

D: Probably sometime in the 1950s. I sat in at Count Basie's once or twice. The last time anyone asked me to play at the Apollo, it didn't work out. A disc jockey was trying to work out some kind of show there. We came to an agreement about the money for my group but then at the last moment he called it off. No one has ever offered me anything in Harlem since then.

H: *A lot of people have their own ideas about what killed the music scene in Harlem. What do you think?*
D: There was a time when Harlem was very safe. You could walk anywhere in Harlem and not get mugged. Nobody would bother you. And white people came uptown to hear the music. Some places were just for whites, like the old Cotton Club, and that wasn't right but there were other places where there were mixed audiences. Like Minton's. There were a lot of white guys who came up there to sit in. I remember there was

some little joint I was playing in where Jimmy Dorsey used to come in all the time. Not to play, just to listen. I even wrote some arrangements for the Dorsey band and for Woody Herman. The Dorsey band had trouble with them, but Woody was different. His guys didn't have any trouble.

H: *So you feel the lack of safety was one of the main things that killed music uptown?*
D: It was one of them. There were lots of reasons, but when white people stopped coming uptown, uptown was in trouble. I know I'd be in the poorhouse without white people. White people make it possible for me to make a decent living. Black people want to go out and hear a comedian. Who's that girl with the dirty mouth?

H: *I don't know, there are a lot of them.*

19 March 1991

Dizzy Gillespie in conversation at home, 1990

Jimmy Hamilton
(b. 1917)

Jimmy: I went to New York in 1939 in hopes of playing with Jimmy Mundy's big band. He was trying to put together a band with a lot of young musicians. The band had potential but in those days it was very hard to get a band off the ground. If you didn't have money and the right connections, it was hard to finance a band and find a place to work. We had a rough time trying to get organized. One of the first jobs we played with the big band was downtown on Fifty-second Street—I think it was the Onyx Club. It may have been another place; they were always switching the names of those places. We had been rehearsing for months, hoping we were going to get a job. I had nothing else then. The only way I could make it in New York was that Jimmy Mundy had promised to look out for me. A couple of us in the band were from Philadelphia and he'd told us, "Come on to New York and I'll look out for you." He got us a room uptown and a place where we could eat every day. We were lucky we didn't have to worry about room and board; it was all taken care of. There was an old fellow named Mr. Collins. He used to feed us and give us little loans. I think he was a shylock, but he never asked us for the money back. I think he was using church money or something like that. We lived in this old apartment house owned by a German fellow, but we didn't have to worry about that, it was all taken care of. Sometimes when the rent was due, he'd come and bang on the door and ask for the rent, but we never paid it. Jimmy Mundy would pay it. His valet, a guy named Jimmy, took care of that, but if he was a little late paying the bill, we'd have that German guy at the door. He was on us all the time if he didn't get paid. We stayed there for some time and then we got that job downtown, but it only lasted a week—and now here we are, a seventeen-piece band out in the street.

What do you do now? Jimmy's out scuffling, trying to find a place where he can put his band. He negotiated a deal to get us in Kelly's Stables, another place downtown. We were working opposite Nat King Cole, who had his trio. We only worked there for a week and then didn't have anyplace to go. The next job was four months away, a theater date in Washington, D.C. All that time, from October to February, and no job. In the meantime, I had made good friends around New York, because I used to go around and jam at all the joints. I wasn't actually allowed to do this; nobody was allowed to go in the places and jam. If

Opposite:

Jimmy Hamilton, 1986

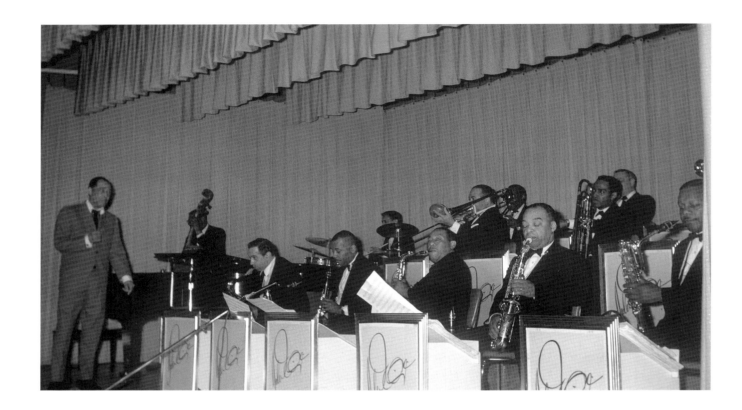

a union delegate would catch you, he'd put a fine on you. So I used to sneak around into the out-of-the-way places, and I made a lot of friends. I played all over uptown, in little joints where there was just a back room, a piano player, a guy with a saxophone, and maybe a drummer. I used to come in places that just had a piano player and a drummer and then we had a trio. I got to be known a little in the neighborhood. There were some people who were putting me up when I had no work, and another guy let me use his room. Then I had to go to Washington for the theater date and I decided that when I got back to New York I was going to get myself straight and file for a union card. This fellow who'd been helping me out, he was a church man, told me to come back, that he'd help me. You see, I had to sacrifice three months of work to get my card before I could get any regular work. This man said he'd stake me.

Hank: *This is about the time you joined Teddy Wilson.*

J: Almost. You see, I was originally supposed to join Count Basie, but evidently Basie didn't get the green light from somebody who had authority in his band and it didn't work out. So I got tired of waiting for Basie, so I put my union card in. It stayed in about three months and Basie never called. I was just sweating it out. I only had a little money but that man was still staking me. Basie was working up at the Golden Gate and Teddy Wilson also had his big band up there. I didn't even know Teddy Wilson, but I'd made a lot of friends in those places where I jammed and somebody got in touch with me and asked if I'd like to join his new group. He was putting a small band together because his big band wasn't making it. My union card had been in almost three months and I was told Teddy planned to open up at the Cafe Society with a six-piece group. Then Count Basie sends a guy around to where

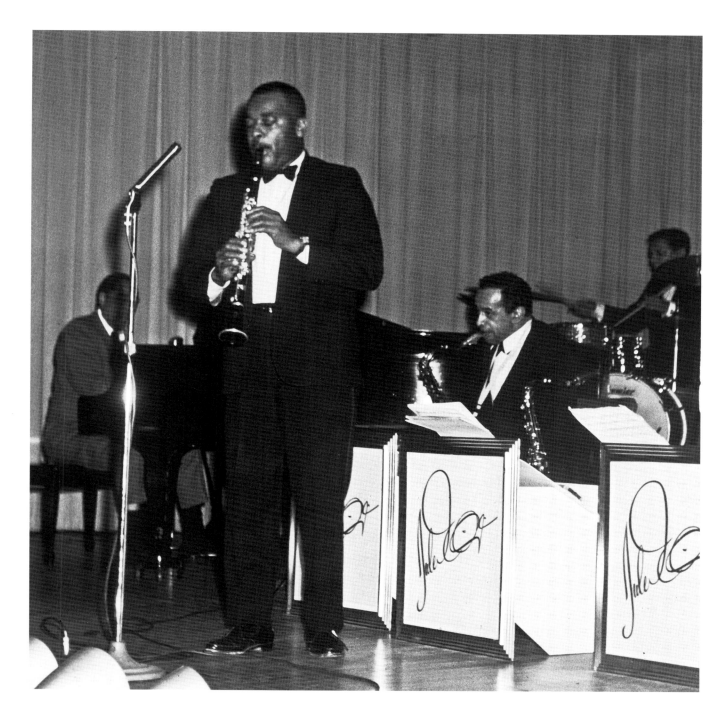

I'm living and he said Basie wanted to see me, that he wanted me to come with the band. I told him I didn't want to join, that I'd sweated out the three months and I wanted to stay in New York. Now that I was able to stay in New York, I wanted to take advantage of it. I joined Teddy and we started rehearsing.

Then John Hammond came by to listen to the group and didn't like some of the people who were in the band.

Luckily, I escaped because I was a lot like Benny [Goodman]. I liked Benny's music—I used to listen to him all the time—and I guess John liked that, so he didn't fire me. The band got together. We rehearsed some tunes and went down to Cafe Society and stayed there a long time. We had a steady gig, working good hours, making about forty bucks a week, which was a good salary in those days. We were there when the war

Above and opposite:
Jimmy Hamilton with Duke Ellington and His Orchestra, Fort Meade, Maryland, 1964

broke out, but business was so good they opened the Cafe Society uptown, on Fifty-eighth Street, and the band went up there. We had to put on white tails to work uptown; we were sharp, and they doubled the salary! Then we went back downtown and the salary dropped back down to forty dollars. After a few weeks I asked Teddy for a raise. I said, "Teddy, I think you ought to put a little yeast in the money." I shouldn't have said that because I think he already had eyes to hire someone else. You see, different guys used to come in all the time. Benny Goodman used to come in and play my clarinet on the bandstand, and Edmund Hall also came in very often. When I asked him for a raise that's when he told me he was going to let me go. This was just a good excuse for him, because I think John [Hammond] had convinced him to replace me with Edmund Hall.

H: Well, based on how your career progressed, maybe that was a good thing,
J: Probably. I said to myself, Well, you're not so hot, that guy just kicked me out. This is when I became very serious about the clarinet and began to study it very hard. I took a job with Eddie Heywood and I put a lot of time in just practicing and studying, and it paid off. I felt really good about it when I was doing it, and I'm glad it happened. All that work and practice got me to where I am right now. I never thought I'd be here. You never know where fate is going to take you. I joined Duke [Ellington] in 1943, after all those years of getting banged around, and I stayed twenty-six years. And do you know what's funny? I really didn't want to join the Ellington band.

H: Why not?
J: I'd worked with a number of bands after Teddy and Eddie Heywood, and

at the time I was with Benny Carter and he was very nice to me. I was still insecure. I thought I didn't play that well, and I appreciated Benny tolerating me. Anyway, I'd been studying very hard and I didn't want to leave NY for anybody. Then Duke started calling me from Boston and I was avoiding his calls, but one time he caught me at home and I had to talk to him. I told him I didn't want to go on the road, that I didn't want to travel. He told me I'd be in New York at least six months a year. He asked me to come by and see him when he got back to New York. I was working out in Brooklyn at the St. George's hotel with a band that played nothing but corn. It was a society band—they'd play two bars of something modern and then it goes back to real corny stuff. I told the leader of the band I'd gotten a call from Duke, and the leader, being an older man who knew about business, told me I should take the offer, that I shouldn't stay with him in Brooklyn. A little while later Duke opened in New York at the Hurricane. I went down and sat in and he hired me. That's how I wound up with Duke. I really didn't want to go with him. As I said, I spent twenty-six years.

H: Did you ever play in Harlem with the Ellington band?
J: We played the Savoy a few times, maybe twice. We played other places uptown, shows at the Apollo. We even played the Audubon. We played a couple places uptown, I just can't remember the names of the places. In later years we never were uptown, there was no place to play. I left the band in 1968 and moved to St. Croix and have been here ever since.

10 June 1986

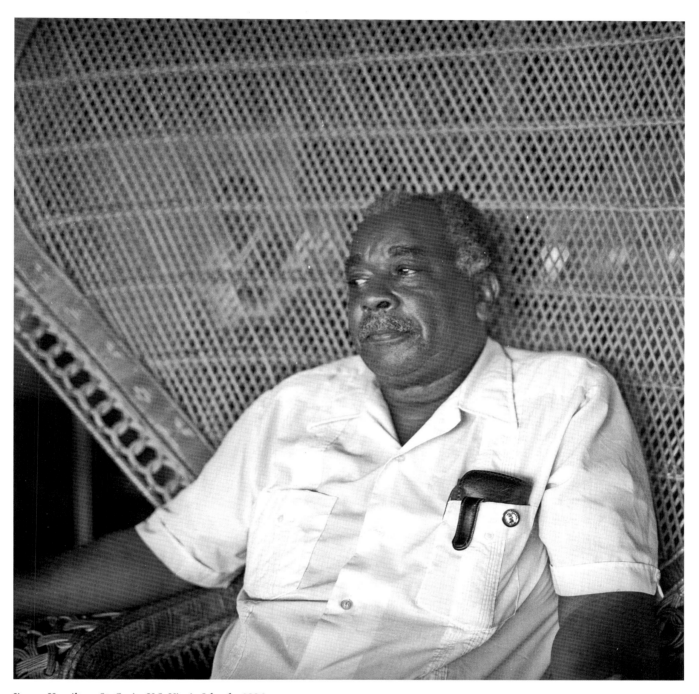

Jimmy Hamilton, St. Croix, U.S. Virgin Islands, 1986

J. C. Heard
(b. 1917)

Hank: *Tell me about your first experiences uptown.*

J.C.: The first club I played was Monroe's Uptown House in 1938. Benny Harris was on trumpet, Clarence Profit on piano, but I don't remember any of the other guys because so many different people used to sit in. It was one of those kind of joints. A lot of sittin' in. Man, those were good times, when people could come by and sit in. The Red Rooster was across the street and Small's Paradise was on the next corner.

H: *Tell me about The Red Rooster.*

J.C.: The Red Rooster was a hangout for a lot of singers. Hazel Scott used to work in there. She was fantastic. I worked with her sometimes and even recorded with her a couple of years later. Billie Holiday stopped in to sing at Monroe's and I also saw her at the Red Rooster. And there was Dicky Wells's place. He was a smooth guy. All the movie stars used to go up to his place. It was a helluva place, jumping all the time. After that I started working with Teddy Wilson's band. Teddy had left Benny [Goodman] and people were pushing him to start a band. It was a good, clean band that played with wonderful intonation but it only lasted a short while, maybe about

a year. Some people wanted Teddy to have a rocking big band, like Lionel Hampton, but that wasn't Teddy. He was dainty, smooth and nice, with looks like a college guy. We played at the Golden Gate Ballroom towards the end of the year, and I think the band folded up a short time later. I joined up with Coleman Hawkins when I left Teddy and played in different places, some uptown. In 1941 I was with Benny Carter's big band at the Savoy Ballroom. I jumped around a lot in those years, in and out of bands, large and small. I went back and forth with Teddy; I played Cafe Society with him downtown. As I say, I did a lot of freelancing at places like Small's Paradise, the Brittwood Bar, Monroe's, and the Braddock Bar. The Braddock was a place that was really always jumping, helluva place, right around the corner from the Apollo Theater. This is where all the musicians would go between shows—they'd be drinking, chewing the fat, gambling in the back room, or maybe even playing dice in the street. It was a good place to spend half an hour between shows.

H: *It sounds as if you got around to almost every club in Harlem.*

Opposite:

J. C. Heard, 1985

J.C.: I did a lot of gigging. I played in the Elks Rendezvous and the Fatman's up on the hill. The Fatman was a guy named [Charlie] Turner, a bass player who'd worked with Fats [Waller], and just like Fats he was wider than a big table and he ran a fabulous little lounge up on Sugar Hill. Duke [Ellington] lived down the street.

H: When you were gigging around did you ever accompany dancers at places like the Hoofers Club?
J.C.: I sure did. I worked the Hoofers Club. I've always been part of the entertainment side of the business, as well as a jazz drummer. A few years ago I took a show to Europe, a band and tap dancers. Bunny Briggs, Sandman Sims, and Chuck Green were part of the show. They tore it up in Europe, just like they'd torn it up at the Hoofers Club in 1941. I think Bill Robinson had something to do with starting the club. All the places had their own thing—dancers at the Hoofers, pianists at Reuben's. There were piano battles at Reuben's. Fats Waller, Clarence Profit, Willie the Lion [Smith], Meade Lux [Lewis], all those guys used to hang out there.

H: You jumped around from band to band a good deal. Where did you stay the longest?
J.C.: I was with Cab for about three years in the mid-1940s. I was with Cab out in California when I first hooked up with Norman Granz. We were playing the Palomar Ballroom and heard there was going to be a jam session. I think we all got paid about ten dollars apiece—Illinois Jacquet, Buck Clayton, Nat Cole, and some other guys. I did it just for kicks but after I left Cab, I did a lot of work for

Norman on records and at his Jazz at the Philharmonic concerts. This would have been about 1946.

H: Did you ever play a Jazz at the Philharmonic concert uptown?
J.C.: I don't know if there ever were any, but I know I didn't play any. I didn't work uptown much after I began making the Jazz at the Philharmonic concerts. I jammed a little at Minton's during this last go-round. Minton's may have been the last club I played in Harlem, or maybe it was Small's. The time was the late 1940s. I used to hang out at Sugar Ray's [Robinson] Tavern in the 1950s but I never worked there, except to teach some drum routines to Sugar Ray. I never worked at any of those places like that—small organ rooms, Count Basie's, none of them. I'd hang out in those clubs but I never worked in them.

H: What made everything change?
J.C.: There was so much music downtown. This made a difference. I was working at Cafe Society, not at Braddock's Bar. And there was a new generation of musicians who were pushing new things, new ideas. There was also the politics—political bosses who moved things around to suit their own purposes. This hurt the music. And the music changed. There were no more big bands because there weren't any places for them to play, and a lot of the most popular players in the 1950s just didn't play for dancing, and they didn't want to play in little joints in Harlem. A lot of it had to do with entertainment. Louie Jordan was an entertainer that a lot of people could relate to. It was harder to relate to Miles Davis.

17 October 1985

J. C. Heard, Floating Jazz Festival, 1986

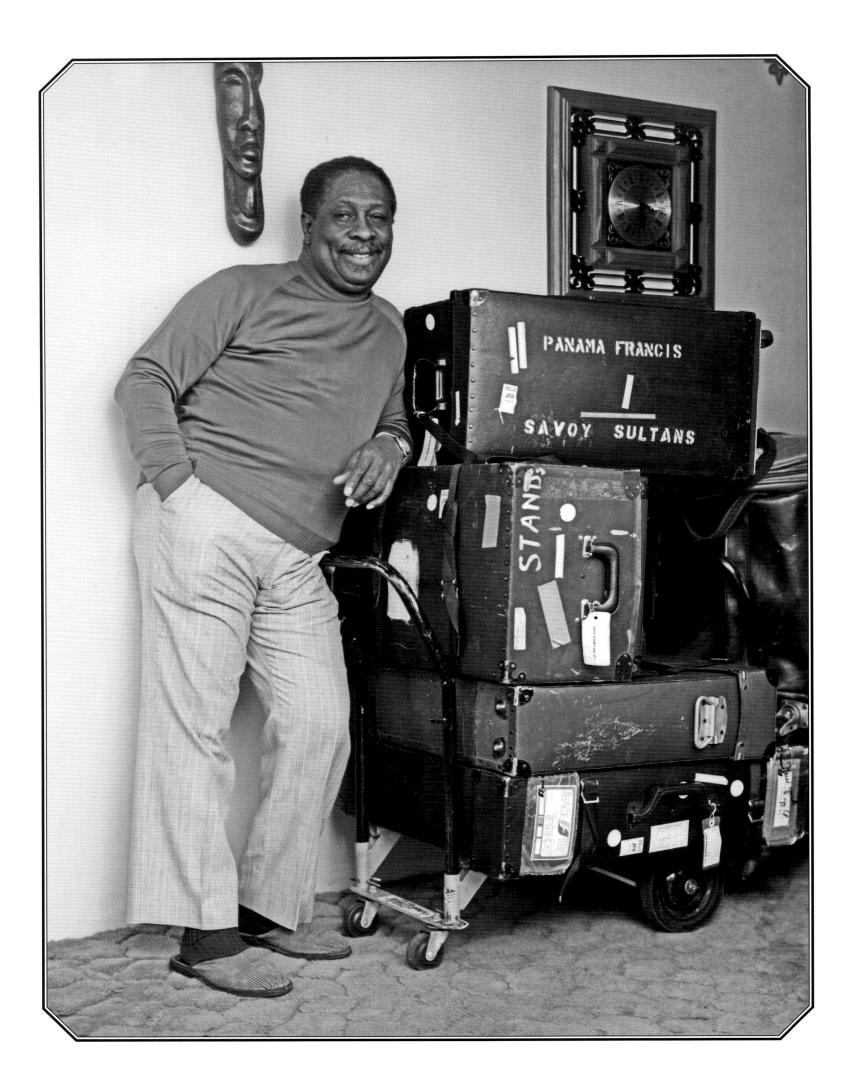

Panama Francis

(b. 1918)

Hank: *Tell me about your early life in Florida.*

Panama: I started playing when I was about four. My mother told me I just started picking things up. I'd be sitting at the table eating and I'd start beating on a table, and people tell me that's all I ever did, beat on the table, beat on the side of the house. People will tell you they saw me beating on the steps, hitting garbage cans, anything I could. I guess one of the neighbors said, "Why don't you get that boy a drum?" and my parents finally did. I never had any formal training anywhere. My ability was a just a gift from God—that's where it came from. I was probably listening to jazz in my mother's womb. My father was a jazz collector; he had almost three thousand 78s, but they were all lost in a fire. The first records I remember were by Ferde Grofe, somebody named Virginia singing "Runnin' Wild," and Gene Austin singing "My Blue Heaven." That's how far back I go. There was a lot of jazz in Miami and I heard a lot of it. I had a cousin who used to play all the house parties. He was a trumpet player and I remember that by the time some of those parties were two hours old, the whole band was drunk. They were sure a bunch of drunks, but they played some good music. Some people say that jazz was born in New Orleans. Well, maybe that's where somebody discovered it, but it was born and being played all over. Music was the thing among black people, and wherever there was a group of black people, there was music. Born in New Orleans—so jazz was born in New Orleans? How could they get a six- or seven-piece band in one of those whorehouses? All the whorehouses had were piano players, and jazz is a music that was created for dancing, it was not created for people just to sit and listen to. If you wanted to sit or stand around and listen, that was okay, but you had to be able to dance to it.

H: *When did you come to New York?*
P: I'd already left Miami and had been playing with a band in Florida. I was playing in Tampa and decided to come to New York. It was just me and my drums. My first job was at a place called the Rosebud in Brooklyn in 1938. I did something very few musicians have ever done: I got to New York on a Tuesday, went to work Sunday, and I never looked back. Tab Smith was the leader of the band. I stayed with him about three months. We only played in Brooklyn. If you got a steady job like that you stayed put until it was over. Towards the end

Opposite:
Panama Francis, 1987

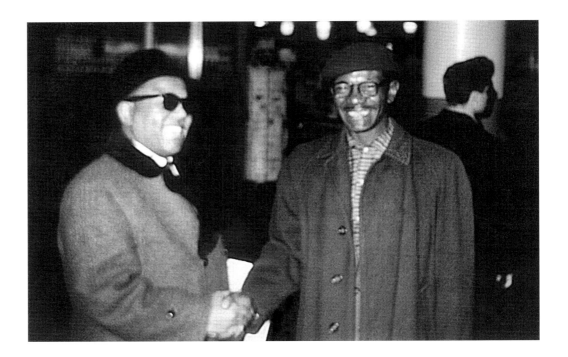

Roy Eldridge and Jabbo Smith meeting at the Washington National Airport, 1965

of 1938, I joined Billy Hicks, a trumpet player—not a very good trumpet player but a good entertainer. This was a six-piece band, and it's hard to believe but we played at the St. Regis Hotel. We must have caught someone's attention because the band was booked into the Apollo and we were part of the show. This was the first time I worked in Harlem. I had sat in at little clubs on my own, but I wasn't hired. The very first place I played was the 721 Club on St. Nicholas Avenue at 146th Street. Jabbo Smith had a band in there and I asked him to let me sit in. That was my first night in Harlem. I remember Jabbo was drinking Coca-Cola. He'd put an aspirin in it, trying to get high. He was playing good, a talented man, but he was a loser.

H: I seem to remember you were with Roy Eldridge about this time.
P: I was with Roy in 1939. We played at the Arcadia Ballroom and made some records—my first records, in fact. The Arcadia was a lot like Roseland. It was run by a guy named Kerrigan. We always knew when he was coming because

he used to jingle his keys. There were hostesses to dance with guys who didn't have dates, and we played all kinds of music, not just jazz and swing. We played waltzes and tangos.

H: Roy Eldridge's band playing waltzes and tangos? I've heard broadcasts of that band and it sounded pretty hot to me.
P: We just played jazz on the broadcasts. The people wouldn't be dancing; they'd be standing around the bandstand like they were part of the broadcast, just listening. Very few were dancing, but as soon as the broadcast was over we went right back to playing all the other things.

H: Tell me about your first regular job uptown.
P: That would have been with Lucky Millinder. I joined Lucky in 1940. I remember we did an audition at the Savoy and Mr. Buchanan liked us so we were in. We became a house band and were booked in other places by Moe Gale. When Erskine Hawkins was at the Savoy, we were out on the road. The other regular band, a smaller band, was the

Savoy Sultans. When they'd go out, the Sunset Royales would come in. In 1940, Lucky's band was pretty good, and it was the first time I worked regularly with a big band.

H: Did Lucky Millinder play an instrument?

P: Not when I was there; he was just a front man. You would think that you were watching Toscanini. He'd be up there waving a stick, but Lucky knew what he was doing. He was another one of those people who could hear an arrangement one time and remember everything in it. That's the way I was; I just listened and learned. Like an idiot I played for over twenty years, and I couldn't read a note. I missed a lot of things, but I don't think Lucky did. He could direct that band. We had an arrangement on the Rachmaninoff Prelude in C-sharp, and when we finished it the whole theater stood up and cheered. "Holiday for Strings" was another one that used to break them up. The band had two books, just like I've got now. We could go from flag-wavers to swing tunes to swinging the classics. We used to break 'em up when we'd swing the classics. I still do the same thing today. I learned from Lucky; I never forget you can always learn. One time we had a battle of music at the Savoy with Tommy Dorsey's Orchestra. Sy Oliver was writing most of Dorsey's arrangements then, so they had some great music.

You have to remember that it was always very competitive with black bands when I was coming up; music was almost like sports. You'd start out with a little band in high school, and some other school would have a band and you'd want to be better. Music was always an outlet for blacks in those days in all the cities. Music was one of the prime things a black person could do—singing, taking

up an instrument, or playing in a band. Many of the black schools—before they were funded by states—were funded by their music departments. They used to send their quartets, their orchestras, all over the world. It wasn't like the way white musicians got involved with jazz. We'd be competitive, but you'd never tell someone he couldn't play. You'd just let him play until he could hear it for himself, he'd get it. When a couple of bands were competing, having a battle, it was like two boxers or two baseball teams. Here we were getting set to have

Gig and Saddle **movie poster, 1933**

a battle with Tommy Dorsey. Some of us might have been the best of friends, but when we got on the bandstand, man, we were out to cut each other.

What usually happened at the Savoy when visiting bands came up there, especially the white bands, well, we just washed them away, and I had a lot of features with Lucky's band, but I wasn't prepared for Buddy Rich. When he came up there with Tommy Dorsey, I didn't know what to expect, and Sy, being competitive, had just written a drum specialty for Buddy, a piece just written for the drums, with the band all around it. I never had an arrangement built for just me, a piece that was built around the band and the drums. It was just like instead of the trumpet player taking the solo, they gave the solo to me. When Buddy Rich came up there and played Sy's new arrangement—I think it was called "Quiet Please"—well, he kicked my ass. I had never heard that much drums in my entire life. If I had known what he was going to do, I would have been prepared for it, but I was so embarrassed that night, I couldn't hold my sticks. My hands were wet, like somebody had taken a pitcher of water and poured water in them. I'd go to hit a cymbal and the sticks would slip out of my hands. This happened in 1942 and I learned my lesson. Sometime later Gene Krupa came up and I kicked his ass. Nobody said much about it but the people uptown knew about it. But I tell you, Buddy Rich really put a hurting on me. He was a natural. He had a God-given gift, you know.

H: When you were with Lucky Millinder at the Savoy, was that the only place the band played uptown?

P: Oh, no. We played the Apollo and sometimes we'd go downtown and play white hotels. Today they have the club date bands that have eliminated the uptown music, and we used to do what would be considered a club date, maybe opposite a terrible Mickey Mouse band at the Waldorf. We might even play down there for a couple of nights. We just played where Moe Gale booked us.

H: When did you have your own band uptown?
P: I stayed with Lucky until 1946 and then organized my own band to play at the Savoy. Al Cooper was breaking up the Savoy Sultans; he'd decided to go into the booking business. He'd book name artists—people like Illinois Jacquet and other people who were hot—all over the country. He made a fortune doing it, but when he broke up the Sultans they needed a new house band, and I had the job for about two months and then I got dumped. Tab Smith started a band and he had a bigger name, so they brought him in and I was out. When my band broke up, I went with Willie Bryant for a short time and then joined Cab Calloway in 1947. I stuck with Cab until he broke up his big band in 1952. I had a lot of fun with that band. Cab was a great leader. I even got to announce the selections on some of those soundies we made out in Astoria.

H: There was a lot of new musical activity in Harlem in the 1940s—the birth of bebop at Minton's and Monroe's. Were you ever a part of this music scene?
P: Don't get me started on that. In the first place nobody ever gets it right—the critics and those people who write about music. They used to hang out at bars frequented by musicians, and they'd ask you a lot of questions. The guys knew

what they were up to and gave them any kind of answers. When the critic would leave, they'd say, "I told the son of a bitch what he wanted to hear." I'll give you an example. I read all the time that Teddy Hill had a band at Minton's. He didn't have a band. He was just the hired manager. The guy who had the band was a tenor saxophone player named Kermit Scott. A lot of people have written inaccurate things; intellectuals came into the business and ruined it.

I'll tell you another thing, and people will hate me for saying it, but I'll say it anyway. If you sit down and pay strict attention to the music they made at Minton's, the music that became bebop, you'll see it's rebellious music. The reason why it was rebellious music is because the guys who created that music were rejects from big bands. Dizzy [Gillespie] had just had a run-in with Cab, so the other leaders didn't want him. Charlie Parker, who the white musicians idolized—since they're mainly technicians, they could relate to what he was doing—had such a bad sound that black players at the time didn't relate to him. So he was a reject. [Thelonious] Monk was a reject. He came into Lucky's band and lasted exactly one set. They were all rejects. One of the bass players that hung out with that group, somebody they never even talk about, was a guy named Nick Fenton. He'd stay high all the time—he used to get high off of nutmeg and anything else he could get his hands on.

It's true, there were a lot of jam sessions going on. I used to go to Minton's and sit in. The guys who were there most of the time learned certain little riffs of tunes like "Liza," "I Got Rhythm," and "[Oh] Lady Be Good." Dizzy and his friends knew what they were doing. They wanted to keep certain guys off the stand, so they

started experimenting with the chords, substituting things, and making different chord changes. The guys who didn't know their instruments or didn't know the new chord changes had to stay off the stand. While these guys were experimenting on the stand, they forgot about the public out there. Plus the drummer, somebody like Kenny Clarke, he changed things for himself. You see, it's hard to sit there and play a bass drum to drive a band along, but it's an important part of a big-band sound. The average drummer can't play a bass drum well. It takes years and years of practice, and it's hard to do it night after night. Now, Kenny Clarke, who was rebellious, was dropping bombs all over the place. He didn't play a steady bass drum beat, so the big-band leaders didn't want him. He fit right in with those other guys at Minton's.

Then what happened was the white guys started coming from downtown to uptown and, being good technicians and knowing their instruments, started listening to this new music and they jumped on it. They jumped on Charlie Parker and all those other things, and you know what? The music they made has become stagnant. Bebop is stagnant. It hasn't really changed in all these years, and a lot of those guys still can't play a pretty ballad.

H: When Cab broke up the band, you changed directions.

P: I went into the studios and played a lot of rhythm and blues dates. I started with Jesse Stone at Atlantic in 1952. I'd known the two Ertegun brothers when they still lived in Washington, long before they came to New York. They were great jazz fans, rhythm and blues fans. They later did some things that surprised me, but

we made some wonderful records in the 1950s. Ruth Brown, LaVern Baker, Joe Turner. I eventually got frozen out of that studio work because I wouldn't put on a show in the studio. I just came in and did my job, but there were some people who put up signs with their telephone number and danced around the room. Somebody once said to me that I didn't liven up a date like so and so, and I said, "Well, that's just not my personality. I came to do a job. I don't see the other musicians dancing around and carrying on. If that's what's expected of me then I don't think I should be here." I was only there because I could do the job, not because of my personality. I've always considered myself a professional; I don't act like someone expects me to act. Some people want black musicians to act a certain way, play the fool. I will not do that under any circumstances.

They just did a profile of me in *Modern Drummer* and I spoke out against what a lot of drummers are doing today. You see, jazz was a marriage of European melody and African rhythm. Not real African rhythm, but the rhythm that came here with the slaves and was played on the owner's instruments. The bass drum is not an African instrument, but it was what the slaves had when their African drums were taken away. When I was a kid, you could go by one of those Pentecostal churches or a Church of God and you'd find some sisters who could swing you into bad health with those bass drums, and that's been left out of jazz. The people running the business these days don't want to know about that kind of thing. They don't want this kind of music to be heard anymore, and little black kids coming up don't know anything about this, and since most of them don't read anything anyway, all they know is what they're told, and all they're

told is Charlie Parker and John Coltrane. I get so fed up with that. I was at a party the other day with my daughter and she had invited some of the professors from her school. They were supposed to know about jazz and I started calling some names and they didn't know what I was talking about—and these are the professors! They said they hadn't seen these names in their books. Some jazz musicians seem to have forgotten all about where the music came from. I can understand it with some white players, but there are black players out there who are so damn white, well, they're whiter than you. I just don't understand why it's tolerated.

H: Maybe it's tolerated for the same reason the music scene collapsed uptown.
P: The music scene died uptown because of drugs. Drugs ruined Harlem. Dope shut down the music. There were so many other things that messed things up. I remember an incident—it was in the 1940s sometime—when there was a story going around that some black guy got hold of Walter Winchell's daughter and kept her out for a couple of days. I don't mean he abducted her; they just stayed out for a couple of days. From that day on a day didn't pass when there wasn't something in his column derogatory about Harlem, and this went on for a long time.

H: Do you remember the last time you played uptown?
P: I certainly never played in Harlem with my Savoy Sultans. When I first got the band together, we worked in the Bronx, but that's not Harlem. The last band I worked with that played uptown was Cab's band, and I don't think we played anywhere except at the Apollo.

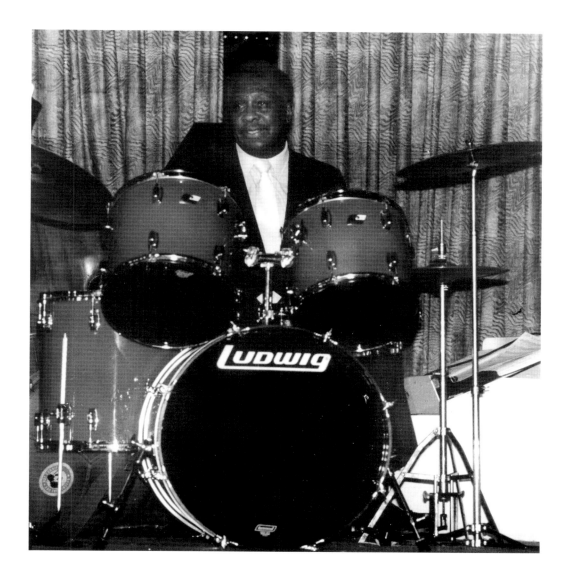

That would be the last place. The music scene really began to fall off in the 1950s, about the time I began playing more rhythm and blues dates. I might have done some Apollo shows, but I don't remember. There were no clubs left to play. By that time, I think the only things left were the Baby Grand and the Celebrity on 125th Street. Maybe there were some others, but I never worked in any of them. It was very sad, because I can remember when it was a twenty-four-hour-a-day place. There were clubs all in a row, one right next to another. It was a place where you could get pig, spareribs, it was full of barbecue joints. There was a guy named Eddie who had three different places, and there was Sherman's Barbecue. There were places where you could hear good music and then go buy the best biscuits and sausage and ham and eggs. A woman named Jenny Lou was right across the street from Small's, and down the street Wells had chicken and waffles. I saw where the guy who owned Wells died the other day. His place used to be packed all the time. I get depressed when I drive up there now. It just depresses me.

Panama Francis, Floating Jazz Festival, 1989

5 May 1987

Sammy Lowe
(b. 1918)

Hank: *You're one of those rare people in the big-band era who spent the major part of their big-band career with a single orchestra, in your case, with Erskine Hawkins.*

Sammy: That's right. I arrived in New York City on February 1, 1936, to join Erskine's 'Bama State Collegians and I stuck with him until he shut down the band in about 1957.

H: *Tell me about the early part of your career, before you came to New York.*

S: I was born in Birmingham, like Erskine, just a few years later. When I was a kid, I knew about Erskine, but I didn't know him. That came later. I was pretty good in school and skipped two grades. That's why I graduated when I was only sixteen. I'd studied trumpet and arranging while I was in high school, so when I went away to college I already had a lot of training. I'd played in a band from Birmingham called the Black and Tan Syncopators, named after the Duke Ellington song. I had a scholarship and went to Tennessee State College for a couple of years and had a band there, the Tennessee State Collegians. It was a pretty good band; Jimmy Blanton was our bass player. I remember when I got the call to go to New York to join Erskine's band,
Jimmy went with me to the bus station to see me off.

H: *Why did you get the call?*

S: I'd stayed in touch with some of the guys from Birmingham who were in the band and had been in school with Dud Bascomb. I'd never met Erskine until his band came through Nashville. I told all the fellows in my band, "We've got to go see a lot of my friends, so don't embarrass me." I think I met him that night—maybe not, but I knew some of the guys in the band and one of them said to me, "Hey, man, some things are going to have to change in this band so don't be surprised if you're with us next year." As it turned out, it was sooner than that. They were having trouble with one of the trumpet players who was trying to live a pretty rough life, who couldn't handle New York. He was trying to do everything he was supposed to do, but he was doing it all wrong and it was disruptive. So I got the call, Jimmy [Blanton] rode with me to the station, and I headed to New York.

H: *Tell me a little about Jimmy Blanton in those early days. He must have been very young.*

Opposite:

Sammy Lowe, 1987

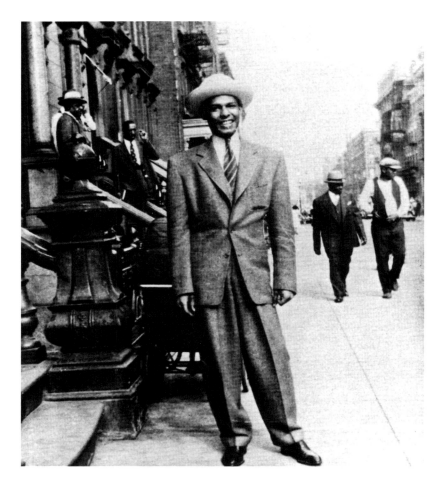

Jimmy Blanton, circa 1940

playing up a storm, and at that very moment, Juan Tizol had a towel, wiping Jimmy's head. It was hot as hell, no air conditioning. The band was really playing that night. This was about 1939.

H: This was before Blanton became seriously ill?
S: Jimmy's sister told me that tuberculosis was a family thing; it had run in their family for years, and Jimmy had it.

H: So there's no reason to think that running around too much was the cause of his early death?
S: Probably not in the long run. I don't think he got into any drinking trouble or was always out late chasing women. He could get all the women he wanted, he was so handsome, and one of the nicest guys you ever want to meet. You know, he was a composite of three or four races—there was some white in him, some Indian and black, and he had the best features of all of them. When he'd start playing that big bass fiddle, he'd get going and his hair would fall down in his face. That would knock the girls out! But he had tuberculosis, and it was before there were any of those wonder drugs.

H: Tell me about your first experiences with the Hawkins band.
S: Well, I was the youngest man in the band—the youngest guy in a band led by the youngest leader in New York. Sometimes it was tough and maybe I was green. They used the call me Sam from Alabam—that's when I changed my name to Sammy. We were a pretty modest band but we worked all the time. It all changed after "Tuxedo Junction."

H: In what way did things change?
S: We played bigger ballrooms and got more money. When we played as a solo act we got pretty good crowds, but after

S: He was my age and real handsome. No trouble with women. We used to play duets together, just jamming. He didn't play a full-size bass or a cello; it was something in between. I never did find out what he called it, but he could really play it, and whenever the band played I always let him stand out front. He'd always break up the house with his playing. Nobody had heard stuff like that before. A few years later, when I was with Erskine, we went through St. Louis and [Duke] Ellington was in town. I saw Johnny Hodges outside the Booker T. Washington Hotel and he said, "Hey, when you guys check in, I've got a bass player for you to hear." I said, "Johnny, is it Jimmy Blanton?" and he said, "Yeah, you know him?" I told him we'd gone to school together and then I told the guys in the band they had to go hear him. When we walked in, Duke was on piano,

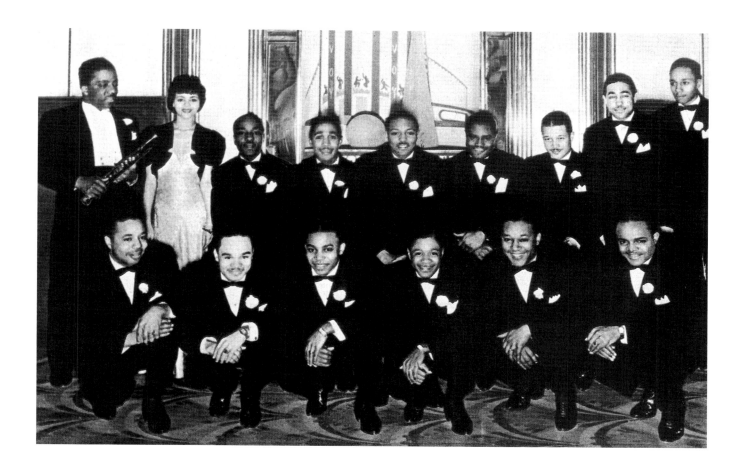

"Tuxedo Junction" we started packing the place and it stayed that way until the big bands became less popular. You know, we never got the best write-ups from the critics. There were always guys who wrote articles that put down Erskine, who said it was sad that men like Haywood Henry, Julian Dash, or the Bascomb brothers had to play with Erskine.

They said he played too many high notes, and one of the critics even called him "Irksome" Hawkins. This was unfair, because the only reason the band made it in New York was because of Erskine and the way that band was put together. You see, I eventually wrote a lot of the arrangements for the band, but when I first came into the band as the fifth trumpet player and looked at the book, with all those high notes, I thought I'd better get right back on that bus and get back to Tennessee. But then I started working on the book, bringing some of

those charts down a little, and we worked out a little style where Dud [Bascomb] would take a solo, then Paul [Bascomb], Julian [Dash], and Haywood [Henry]. On the last chorus we'd have the brass and then the entire band with Erskine riding on top of it all. It used to drive the crowds wild. It was very exciting.

H: You said "Tuxedo Junction" was an important turning point for the band. Tell me how that song came about.
S: "Tuxedo Junction" started down in Baltimore. You see, sometimes the band didn't go out as a single, we accompanied star acts, like the Ink Spots, and in Baltimore we were accompanying Pigmeat Markham. It just so happened he needed some music for his act. Julian played the first seven notes and we started adding to it, because Pigs needed to be out there for seven or eight minutes. The guys started adding different things.

Sammy Lowe with Erskine Hawkins and His Orchestra, 1940

The solo Dud played on the record was the one he started playing that first day. Of course, when we were behind Pigmeat he played two or three choruses. It remained that way and we used to play it up at the Savoy and all around the country as a throwaway number whenever we had three or four minutes to go and didn't want to bother getting on a big arrangement. When we got in the studio, we sometimes needed an extra tune, and one day this was the extra one. It still didn't have a name and there was no introduction, but somebody suggested that Erskine play a few notes in the intro, and what he came up with off the top of his head is what you hear on the record. Off the top of his head. The alto player, Billy Johnson, came up with the release. Everybody in the band put something into this number, but the actual melody of the song belongs to Julian Dash, Erskine Hawkins, and Bill Johnson. I know a lot of bands who would have said the whole band wrote it and all would have shared in it—I guess maybe we should have done it that way, but that's not the way it went down. It wound up being a big hit and was on the street for at least a year before Glenn Miller recorded it and made it an even bigger hit.

H: *You were part of a Savoy house band. Tell me how that system worked.*
S: It worked well. We were in New York and on the road. Moe Gale booked us on the road. When we were out, we made about nine dollars a night. I remember once when we were on tour and we had to come right back because there was some trouble with the Golden Gate Ballroom. They canceled the tour so we could come back and save the place. This would have been about 1940. Things were pretty slow on Monday nights up there,

and we were supposed to play until two or three in the morning but sometimes it would just turn into jam sessions. Sometimes this even happened at the Savoy. Late sets on slow nights, things would happen. Anyway, there were some wonderful sessions with Charlie Christian and Les Paul—they came up on Mondays for at least three weeks. Both these guys were in town and looking to jam, and that's when most of us first heard that kind of guitar playing. The two of them would sit there, and you'd think they were in love with each other—they were playing and enjoying each other. And all the people crowded around, and, of course, Les and Charlie were making out that it was a battle, but they were just having fun. They recognized the ability of each other. Charlie would play something and you could see Les thinking, Now what will I do? And then he'd play a great chorus. They were having fun. It was about the time the guitar was starting to get more popular. Later, we even had a guy in the band who'd played guitar with Andy Kirk—Floyd Smith. He played electric guitar with us sometimes.

[Note: Les Paul also recalls these evenings at the Golden Gate and remembers them with great affection. He'd first met Charlie Christian in Tulsa, Oklahoma, a few years earlier and the two young guitarists remained close until Charlie's death in 1942. The sessions at the Golden Gate were not unique—the two men played in other places in Harlem—but one thing that made the sessions at the Golden Gate different was that Erskine Hawkins arranged to have amplifier on hand as well as an extra guitar, just in case Les or Charlie arrived without his instrument.]

H: *Erskine told me the band got larger after the war.*

S: We had some monsters in the band. Just look at the brass section. We had Cat Anderson, Renauld Jones, and Dud Bascomb, all playing those high notes. I'd been playing first trumpet for a while, but now they put everything higher and I went back to fifth. People loved to come see us just to listen to the brass. Sugar Ray Robinson would come just to hear the trumpets. We were pretty good at the battle of the bands. We didn't win all the time, but since we were on our home ground at the Savoy, we defied anybody to challenge us because we knew how to get the dancers into a mood. I remember one night when we came up against Lionel Hampton and he ran us out of there! Most people don't know it, but it was Lionel who started that backbeat thing that's so popular with rock 'n' roll and rhythm and blues. He also played things a lot longer than most people. When we heard we were going to play opposite Hampton, Bill Johnson, Avery Parrish,

and I worked out some new things to use against him. I went up to the Apollo and heard him play "Flying Home" for about fifteen minutes. I made an arrangement of "Flying Home" and said, "Hey, we're going to play it for thirty minutes." I figured he'd play it as his last tune and we would hit just as he finished. Well, Hamp came on and ended with something that sounded like "Flying Home," and the guys said, "That's it, we're going to do 'Flying Home.'" We started our set with my arrangement of "Flying Home" and got a good hand. As soon as we came off, Hamp started playing the real "Flying Home" and the people started screaming and yelling about one more time, and he played that ending over and over and then he jumped up on the tom-toms and the people went berserk! Dud and I were running out the back door when Ernie Royal started playing those high notes. Ernie and I later became very close—he'd keep me laughing for hours, telling stories about being the only black guy

Les Paul, Mahwah, New Jersey, 1982

in Woody's band—but that night I was running out the back door.

H: *When did the music start to change for you?*
S: I think jazz was in two phases. First there was basic jazz, and then Dizzy [Gillespie] and Charlie [Parker] came along. From that point on most of the youngsters gravitated to that kind of music, which is all right just as long as they don't look down on the guys who originated the stuff. People stopped dancing; they just stood around and watched. I think one of the reasons Lionel Hampton hung around so long is because he kept a beat going. He was one of the last bands and, in fact, he's still got a band out there. The reason is because you don't see his drummers throwing too many bombs. I think Hampton sits on the drummer and he keeps pounding and it's so repetitive it gets to you and you start to tap your foot. The attitude of some of those guys hurt things. They forgot that they were playing to please the people, and when they'd see some angry guy onstage they'd say, "Hey, what's happening here?" I think all kinds of these little things hurt, and also, the singers really took over.

There was another thing. When we were on the bandstand playing a tune we'd recorded, the people dancing could hum the song, knew the solos. They would crowd around the bandstand and know the song. When people went to hear Parker, they couldn't hum it. Damn, *I* couldn't hum it! I had to slow the records down to find out what the hell they were doing. I remember Reuben Phillips and I went to hear Duke Ellington one night when he put on a concert at Lewison Stadium. Johnny [Hodges] had left the band and Willie Smith was in his place. I'll never forget that night because Ellington put on such

a great performance. Reuben and I left the show wondering where we'd go from there. Ellington was on one side, and Dizzy and Charlie were on the other. There was room for a lot of things in jazz, but these were the extremes, at least for me. Reuben and I decided the best thing to do was to come up with some sounds in the Ellington vein, because all that other stuff, well, you could forget it.

H: *Is this when you went to work with Reuben Phillips at the Apollo?*
S: Not exactly. A little later. I stayed with Erskine for twenty-one years, if you count the two or three years when he had the small band—Erskine and myself, Bobby Smith, and Julian Dash, plus three rhythm. This was about the time I'd gotten married. I hadn't been married long, my wife was pregnant, and I was getting tired of the road. Before I was married, it was different when I was out there on the road, and I sent money home to my mother; and I didn't have to do it every week, I might just let it accumulate. So, at some point, around 1956, when I came off the road one last time, I left Erskine and started playing with Reuben Phillips's band at the Apollo. He had the big band there, fourteen pieces, and accompanied all the acts that came in. They had many rock 'n' roll acts that could only play for themselves, but every now and then they got a band where they had four or five guys who could read music. They'd put them with the pit band, which meant some New York musicians had to take off, but some of the acts wouldn't have any music and some of them would develop an attitude, even though we were trying to help them. If they screamed at Reuben, he'd be real cool and call an intermission and say, "Now, you go up and talk to Mr. Schiffman and you'll find out your contract reads

that you got to have music for fourteen pieces." They'd go up there and come back down and someone would say, "Where can I get somebody to write the music?" Reuben would point to me and say, "There's the man. Give him your records," and I'd write the music overnight. I got so busy, I was writing more than I was playing.

One day the Platters came around. Buck Ram was managing them and Earl Waters was working with them, but most of the records they made were by ear. They needed some music for the show and for a recording. The first one I did for them was "My Prayer," and my telephone started jumping off the hook. People wanted to know if I made the arrangement. I said I did, and then they wanted something like it. That's how I got into the record business. I was working around the clock. I told Erskine and he said, "Take it all while you're hot!" He'd told me I could go back with him anytime I wanted to, and I knew I could go back with Reuben. That's when I stopped playing. I often say I'm going back to playing, that I want to play some basic jazz, but then I realize it will take me three or four months to get my chops back. The reason I didn't play more with the band is because Dud Bascomb was sitting next to me and Erskine was out front. If Dud could play all the pretty solos and Erskine could make the high notes, there wasn't much left, even though Erskine had nothing against me playing when I wanted to. He'd let anybody play; he'd let all the cats play. I had two or three numbers, but they were never recorded. When I played them I'd break it up, especially on a tune called "Sweet Little Rain." I made my credenza and then made a low G on the trumpet and that was different. While I was doing it, Erskine was off the stand so I was

conducting, and I would hit that note and throw my arms. I had fun that way, but it was never recorded. I remember Sy Oliver once said to me that when he played solos, he knew he had a band behind him and knew how to put himself in there in the right places.

H: What was it like the last time you played at the Savoy with Erskine's band?
S: The band went over good. It wasn't packed like it had been, but the people liked it. A funny thing I noticed that Charlie Buchanan did up there. He knew what he was doing, how to save money. He brought in instrumental bands. He brought in the attractions like little bands and saved money with these little bands. I noticed he didn't bring in the guys with those groups that were singing. He brought in guys that had instrumentals bands. Towards the end there were small instrumental bands; Buddy Tate had a small band up there. Why pay fourteen guys when you can pay seven? Of course, it was just a sign of the times. Things were slowing down. When I first got to New York, people were jamming all over the place. You could walk in practically any bar up and down Seventh Avenue or Lenox, they always had some guys, two or three pieces in there, and other guys would come in and jam. The first place I ever saw Artie Shaw was at a little bar next to the Woodside Hotel. It was in places like that where I heard a lot of musicians, and when I first got here there were many times I was just so frightened I wanted to go back to Alabama. But I kept walking the streets seeing and hearing different things, and I heard guys that weren't so cool, and I said, Hey, I guess I could make it up here. I made it and I had a good time.

25 May 1987

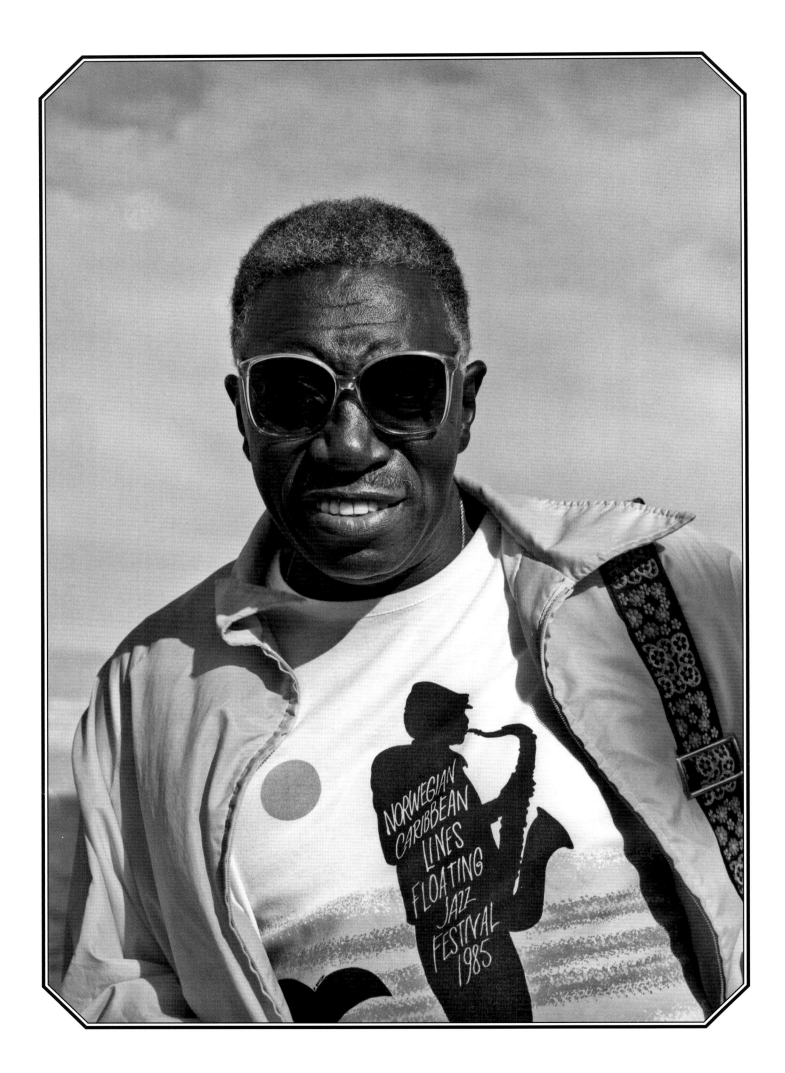

Joe Williams

(b. 1918)

Hank: *You had a very interesting career in Chicago long before you came to New York City.*

Joe: It was a wonderful city. Very exciting. As a boy I even saw Louis Armstrong with Erskine Tate at the old Vendome Theater. I was very impressed by that. There were so many great players. It was common to have the Fletcher Henderson Orchestra and the Earl Hines Orchestra in town for months at a time, and each band was full of fine musicians. We heard these bands in person and on the radio. In 1937 I was working with Jimmy Noone, one of my first professional jobs, and we were broadcasting on CBS every night. When someone like Coleman Hawkins would come to Chicago, it was a real occasion and later I worked with him for a while. He was the first New York–based leader I worked with and at the time he was an internationally famous musician, and it was a thrill to just be with him. He had such a big tone, such a warm smile, such a reputation. Working with him was an inspiration every single night. He always blew better than anybody I'd ever heard before, and he insisted that you listen to him. Hawkins played with such a spirit, such drive and verve, it was something you couldn't quite understand. But this brilliance, this tone, and this drive, the innovation, running those changes—he ran changes to everything—he just swung, and he swung hard. Sometimes he had an almost brittle sound going with that deep hard sound. Then he could take a ballad and sound like a cello. He was a thrill to listen to every night. And sometimes when we got through working all night, it might be about five o'clock in the morning but Art Tatum would sit down somewhere and he would play for an hour while a lot of musicians sat around listening. That was Chicago. That was the best, believe me.

H: *Did you make it to New York with Hawkins?*

J: No, the first time I worked in New York was with Lionel Hampton in 1943. He'd heard me in Chicago and when his regular vocalist, Rubel Blakey, left the band on short notice, I got the call to join the band in Boston. It was a great band—Arnett Cobb and Earl Bostic, Rudy Rutherford was playing baritone sax, Joe Newman on trumpet, Fred Beckett on trombone. Dinah Washington was the other vocalist. We did forty-two shows at the Apollo Theater in July, six shows a day for seven straight days. We played for the other acts—the dancers

Opposite:
Joe Williams, 1985

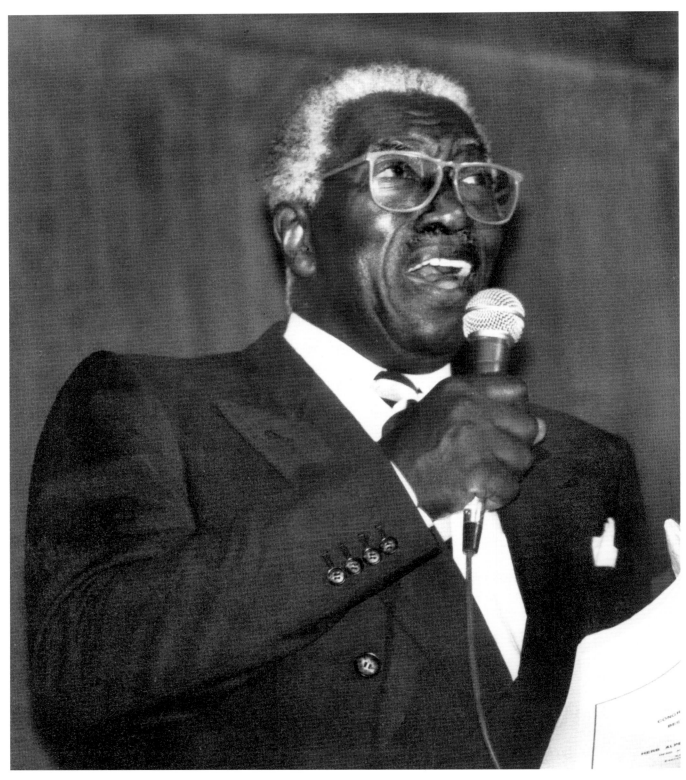

Joe Williams, The New School Beacons in Jazz Awards, 1995

and whatever—but the orchestra was the attraction. "Flying Home" was still a big hit. I was singing ballads with the band, songs like "Brazil," "You'll Never Know," and "Let's Get Lost," stuff like that.

H: I remember the first record I ever had that featured you, A Night at Count Basie's. They listed all the instrumentalists and the instruments they played, but you were the headliner, listed as "blues and ballad singer."
J: That's right. I sang the ballads with the band, and Dinah sang the blues. One night we did a blues together and broke it up too, just broke it up, but Hampton didn't let that happen very often because I was about to wipe out Dinah, and Dinah was his girl. But I tell you it was a good band, a very, very good band! I used to watch a bunch of priests standing in the wings, swinging with the band, swinging and clapping their hands and tapping their feet. That was a sight to see in 1943, white priests standing in the some theater in Boston, getting so excited by the band. We toured a lot, played dances too. We played the Savoy Ballroom in Chicago, but we didn't play the Savoy in New York while I was with the band. We played the Loew's State Theater downtown during that period of time. Frank [Sinatra] was at the Paramount, which was almost across the street from the Loew's. Duke Ellington was at Hurricane or Zanzibar—I forgot which name they called it then. Cab Calloway was at the Strand. That street was really jumping. Oh man! And we still hadn't hit Harlem yet!

H: When you did that week at the Apollo, did you have a chance to check out the music scene in Harlem?
J: Not very much. I didn't hang out much in those days. I was living with Jesse Stone and his wife up on 138th Street.

Vanguard album cover, 1956

I may have visited the Baby Grand or gone up to Small's Paradise. I don't really remember. I wasn't with Hampton very long and only part of the time was in New York. When I left the band, I went back to Chicago. I didn't come back to New York regularly until I joined [Count] Basie in 1954.

H: Did you work uptown with the Basie band?
J: Only at the Apollo. I don't remember ever appearing at the Savoy. One night I appeared with Basie at his bar on Seventh Avenue.

H: That was when you made A Night at Count Basie's. I recall that in John Hammond's liner notes he said it was probably the first and possibly the last record ever made at a neighborhood bar.
J: Count Basie's was just a neighborhood bar. I think Basie opened it about 1955. We made the record there in 1956 and

I remember we'd just returned from a long European tour. I think we recorded for a couple of nights. I wasn't supposed to be on the date; it was supposed to be Jimmy Rushing, but Jimmy got sick and they called me. We had a ball. Emmett Berry was in the band—the first time I'd worked with him in some years. Vic Dickenson, Marlowe Morris, and Bobby Henderson. I think this was the first time I was ever in the place and I don't think they normally had bands like this; it may have been an organ trio room. I don't think they brought the organ in for the recording. There was only a small spinet piano. There was still music on Seventh Avenue in 1956. Wells was just next door and they probably had a trio. Small's was across the street and they had something going on. I remember how wonderful that street was in 1943 when I was living up on 138th. I'd leave the Apollo after the last show and walk back home—every night, every day, every night, and it was so elegant. There were never any problems. If there were problems, I never thought about them, never saw any of them.

[Note: *Count Basie's was still in business and records were being made there as late as 1961.* The Joe Newman Quintet at Count Basie's, *produced by Quincy Jones, featuring Joe on trumpet, Oliver Nelson (woodwinds), Lloyd Mayers (piano), Art Davis (bass), and Ed Shaughnessy (drums), was released as Mercury SR 60696.*]

H: I remember a record I bought when I was a teenager called Breakfast Dance and Barbecue *recorded at a hotel in Florida. Did the Basie band ever play a breakfast dance in Harlem while you were part of it?*
J: No, but you're right, that album was recorded in Miami at the Americana

Hotel. We were at Birdland in New York, and they flew the entire band to Miami for a reception and the recording. There was a dinner before and we never went on until maybe three o'clock AM. When I sang "It's Five O'clock in the Morning," it *was* five o'clock in the morning.

H: Did you every work uptown after you left Basie?
J: Many times. In the early 1960s I worked in a place uptown—what was its name—at about 133rd and Lenox. I don't recall the name, but they offered me some serious money to come in with a band. I asked Thad [Jones] to put together a band and it turned out to be all brass and rhythm. Thad, Snooky Young, Benny Powell, Jimmy Knepper, Britt Woodman, Hal Galper, Freddie Waits. [David] Fathead Newman was also on the bill. I wish I could remember the place. I remember I would come off and could walk over to Wells for chicken and waffles. I remember also my old boss, Andy Kirk, came in one night and looked at my all-brass band. He took one look and said, "How did you manage to come up with that combination?" and I said, "Don't worry, Andy, one of these days I'll have an all-woodwinds band!" Everybody came up to see us because it was such an unusual group. We had a ball with that band. About the same time, I played the Apollo with Carmen McRae and Harry Sweets Edison, who was leading the band I'd hired to work with me. I also played the Apollo with Tito Puente, and it was fun. Here was a Latin band playing the blues. I can see them now, they'd say, "Hey Joe . . . 'Come Back Baby' . . . ya . . . six, eight, ya know, one, clap, two, clap, three, clap, one, two, three." They loved it. They loved it, man, and they played a universal language.

In 1971 I was at the Apollo again, maybe for the last time. My manager

John Levy put on a thing up there called *Black Music '71*. And we did it again the next year, *Black Music '72*. At that time John was managing Cannonball [Adderley], Walter Booker, Nancy Wilson, Roberta Flack, Johnny Hathaway, Les McCann, and me. What we devised was we were going to start with reading letters, African things, and to show the progress of the music, begin with the work song, which is the chain gang thing, and move the music forward—the development of black music. It was a monster, a monster show, and the word got out quick. I looked up and Adam Clayton Powell was there. The champ came by—Mohammed Ali came. Jesse Jackson showed up. Jackie Robinson

Joe Williams and Dizzy Gillespie, Floating Jazz Festival, 1985

Abyssinian Baptist Church, 2007

was there all the time because he was right there on the street. Oh man, it was sensational! Absolutely sensational, but nobody taped it. There's no videotape of it, but it was an absolute sensation. I remember some of the segues were tough; the letters we read didn't always make it, so sometimes we opened with maybe six work songs. There were three drummers, conga, and two straight drum sets, and they'd be very quiet or loud, like thunder. Man, it was something. I did a work song with a group, and then I'd make a little introduction for Mother Superior, Roberta Flack, to recite about her heritage. It was something like: "My mother, the greatest and the prettiest; my father, just handsome but the wittiest; my granddaddy, natural-born proud; grandma, so gentle, so fine. The men before them worked hard, sang loud about the beautiful women in this family of mine. Our homestead, the warmest hospitality. In me you see the least of the family tree personality. I was raised in the palm of the hand, the very best people

in the land, from sun to sun, their hearts beat as one, my mother, my father, and I." Then I sang it. After I sang, I introduced the next artist, who was Les McCann. I'd say something like: "To celebrate some of the high spiritual points of the legacy of black music is our next performing artist, Les McCann." And then he'd hit, bam! Celebrated the heritage of black music. No more time than that, then the next artist would follow, everything flowed. Everything flowed. It was absolutely gorgeous. John Levy could put things together but then he got tired of it, trifling with the artists, and got rid of everybody but Nancy Wilson and me. But he really put one together.

H: When was the last time you sang uptown?
J: Last spring, at Count Basie's funeral. I sang "Come Sunday" at the First Abyssinian Baptist Church. It was tough.

24 October 1985

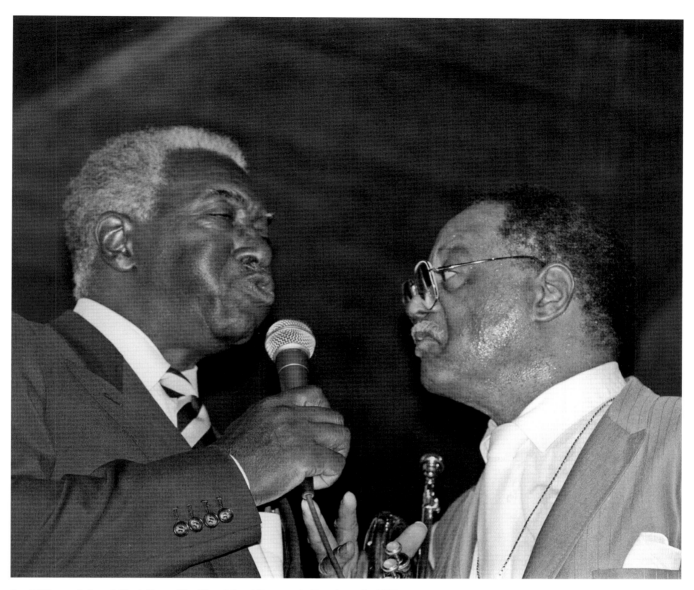

Joe Williams, *left*, and Clark Terry, The New School Beacons in Jazz Awards, 1993

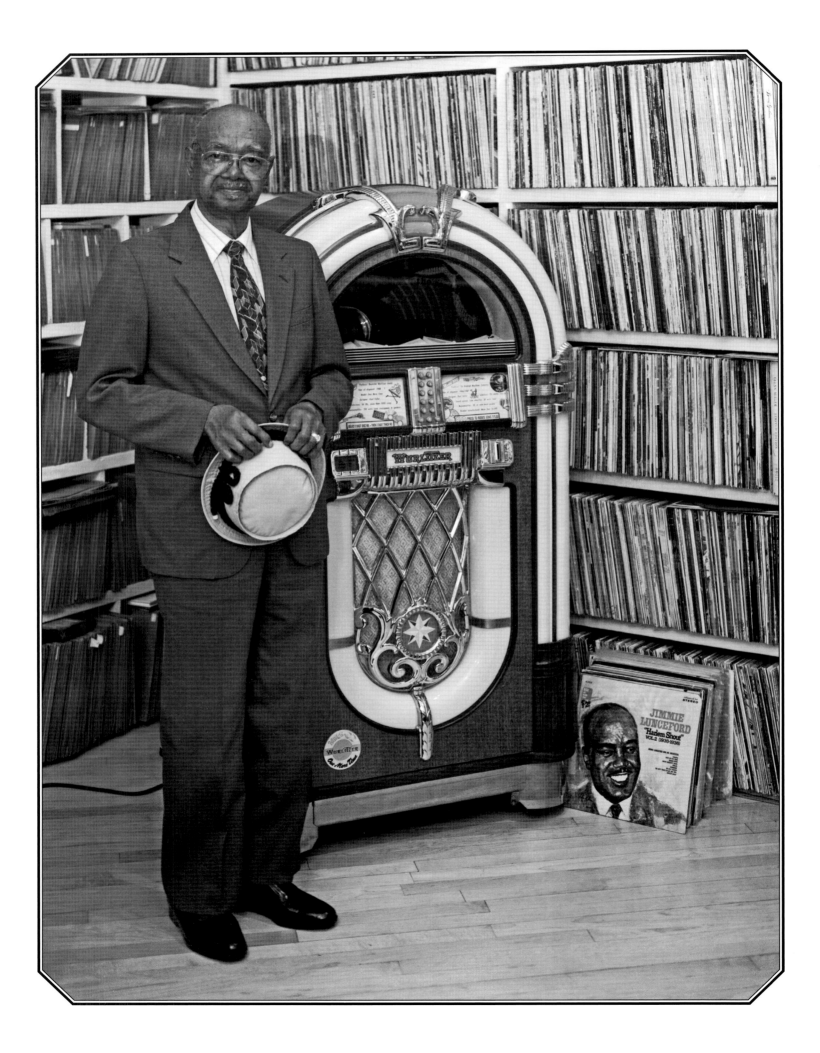

Al Cobbs
(b. 1920)

Hank: *Tell me about your earliest experiences in New York City.*

Al: It was about 1935. I'd been on the road playing with various bands here and there and I came into New York and somehow Fletcher Henderson heard about me and asked me to come down to Roseland to audition, to sit in with the band. I went down to Roseland—it was on Fiftieth Street—and there's the band sitting up there with tuxedos, and I've got on this raggedy old brown suit and I'm carrying my old horn. Mr. Henderson said, "Come on, sit in with the band," and he sat me between two trombone players, Ed Cuffee and Fernando Arbello, two guys I'll never forget. The first number he called was "Hotter Than 'ell." I got down in the middle of the chart—it was in B-natural, all those sharps—and I got down in the middle. It's going real fast and I'm catching every other note, and then Cuffee said, "You got the next solo." And I said, "No man, you're crazy, you've got the next solo." I had to count to find out what key I was in, and I found out I was in F-sharp, and I hadn't ever played in F-sharp before. I put my horn on F-sharp, and everywhere that horn slid, I blew. I knew it didn't make any difference, because I knew I wasn't going to get the job. I'm just sliding and playing

and sliding and playing. I think I'm about finished and ready to sit down when someone yells at me, "Take another one!" Now, by this time my knees are shaking so much I just keep playing. Afterwards, Mr. Henderson told me I'd played a heck of a solo and then he said, "Now come back next Tuesday and I'm going to see how well you can read. If you read well, I want you to join the band." All that I could say was, "Can I leave now?" And he said I could go. I was so nervous when I left, I walked all the way home from Fiftieth Street—and I was living on 141st Street. I went right to bed and the next morning I'm up at five o'clock, and I got right on the train back to Philadelphia. I wasn't going to go through that anymore.

I didn't see his brother [Horace Henderson] for a few years and when I did, I told him what happened and it tickled him to death. I told Horace I'd never seen so many sharps in my life, the most I'd ever played in up to then was, maybe, two, and to see six or seven was just too much. So, to answer your question, my first experience in New York was one song in 1935 with Fletcher Henderson. It was a wonderful experience—the first time I'd ever done anything like that. I met some fine players, if only for a minute. I remember

Opposite:

Al Cobbs, 1996

that tune was so fast and the drummer was Walter Johnson. I got to know him better a few years later; we used to call him the Metronome. No matter what the tempo, the way he started was the way he ended. No slower, no faster.

H: When did you come back to New York from Philadelphia?
A: It was a year or so later, in 1937. I came back with Charlie Shavers—we hitched a ride on Count Basie's bus. Charlie was like family; we had even gone to school together in Bordentown, New Jersey, where we formed a band. His parents were my children's godparents. We came to New York and Charlie joined Lucky Millinder and the Mills Blue Rhythm Band, and then I joined it a month or two later, replacing Sandy Watson. I stayed with Lucky for quite awhile. At the time we were a racehorse kind of band, with so many up-tempo tunes. You know, Dizzy [Gillespie] didn't even make it all the time, we played so fast. The trumpets were Charlie, Harry Edison, and Bama [Carl Warwick]. The first time I worked in Harlem was with Millinder at the Savoy Ballroom, and it was a thrill. We also worked at Small's Paradise and the Alhambra Ballroom.

H: You worked with a number of different big bands after Millinder. Who was your favorite?
A: I liked the Jimmy Lunceford band, but I was with Les Hite before I joined Jimmy. Les Hite had a heck of a good band. It was from California—all good players, very good men. The woman who owned the band was a millionaire; we had at least six changes of uniforms. When we came east, Hite got Don Redman and Van Alexander to rehearse the band, to break it down and make an even better band out of it. I remember

one time we were up in Boston and the lady who owned the band said, "Oh, my goodness, we're going into the Apollo Theater next week and we don't have any new music for it." I was very young then, probably didn't know any better, but I said, "Ma'am, don't worry about it, I'll write a hit arrangement." She looked at me and said, "You're going to do what?" I said, "I'll write a hit performance." After I said that, some of us went out. We had some chicks and something to drink. When I got back to the hotel that night, my mind was racing and I remembered I had to write some new music, so I wrote out a number for the band to rehearse the next day. I was afraid to rehearse it because I didn't know really what I wrote. We played it and it sounded pretty good. A week or so later we played it at the Apollo Theater. I called the number "Three Bones," and you know, we had to play that number twice a day, every day, for seven days. After that the lady came to me and said, "Cobbs, I know you like fine clothes. You write me more like that one, and I'll open an account for you downtown." I liked that very much, but pretty soon there was dissension in the band and it started to break down. One day they told us they were going to take the band back to California, and I decided not to go with them. That was about when I joined Jimmy Lunceford.

H: Why did you like the Lunceford band?
A: I just liked the style. It was a technical band, but I liked the style. I liked the music Sy Oliver had written for the band. It was a very smooth band, but one that could be very entertaining. The day I first joined the band, they were rehearsing how to throw their horns in the air, and they spent two days on that. It was a band that would take four or five days just to rehearse one passage. I was with the band

in 1946 and 1947 and was still with the band when Jimmy died. We had gone on a West Coast tour and were in Seaside, Oregon. Joe Wilder and I had gone next door to the place we were playing, a record store. We wanted to listen to some of the new things, and Jimmy came in and told us not to take too long in the store, to go back in a couple of minutes and tell the fellows to start setting up. We only played one record and then went back next door to tell the fellows to get ready. In about a minute somebody came in and told us Jimmy was dead. It was that fast. We had to play that night without a leader, and it was something to see, a whole band playing and crying at the same time. We had to go all the way back to New York; they gave us our own car on the train. I really loved that band. I'd just written a new arrangement on "Alexander's Ragtime Band." It was a novelty number. It started with me at the microphone playing my violin. I made a mistake right off and Jimmy was to grab me by the collar and put me in my seat, but we never got to play it. It was rumored he was poisoned. There was nothing wrong with that man. He was strong and healthy, only forty-five years old. I don't know who would want to poison him, but that's the rumor.

H: Tell me about how you learned to arrange.
A: I learned from Don Redman, Sy Oliver, and Andy Gibson. I asked them so many questions. I know I used to worry Don Redman to death. I'd go up to his house and just worry him and that's how I learned. He'd be sitting in a big chair writing. He didn't use a piano, he just sat there and wrote like he was writing a story. He didn't work like anybody else. Sy was more conventional, and I worked with Sy for many years. He was very fast—he'd get up at two in

the morning and have two wonderful arrangements ready for a date later that day. I joined his little group, made studio sessions, and worked as his copyist. I enjoyed this work because it paid very well. If you were a successful copyist, you could earn royalties, and I liked this. At that time I was also working with Eddie Wilcox, who'd been the pianist with Lunceford all those years. He was also a very good arranger. The only problem with copying was that it got to the point where they'd give you something at nine in the morning and want it back by noon, and I finally said I wasn't going to do that anymore.

H: You say Jimmy Lunceford was your favorite band to work in, but which band did you enjoy just for listening?
A: I used to like Tommy Dorsey. I liked the way he played his horn—his breathing and attack were beautiful. He did so many things on his horn. One time I went backstage to visit with Charlie [Shavers] when he was playing with Dorsey. I had my horn with me and I sat it down in the dressing room and went to look for Charlie. I looked all over and couldn't find him so I went back to get my horn, only to find that Tommy Dorsey had taken it out of its case and was playing it, trying it out. I remember he said, "It plays pretty good."

H: You've continued to perform in Harlem to this very day. Tell me about your big band at Small's. How did it come about?
A: The band I brought into Small's was first organized in about 1980 by a man named Bobby Booker. I was in the band, and when he passed away, the other members asked me to take it over. I tried to modernize the band and give it some new arrangements, and we had a book of about 250 songs. I wanted to have a

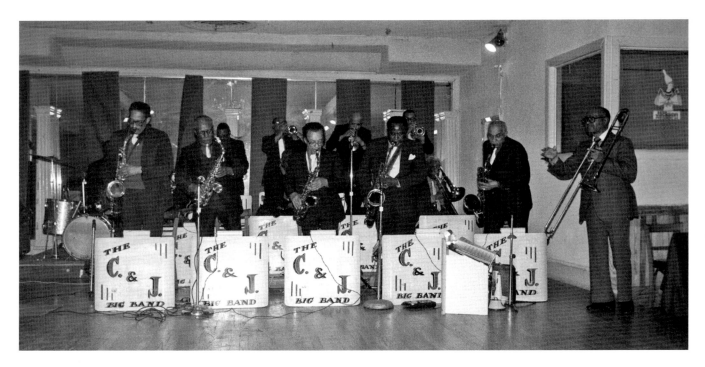

Al Cobbs and the C & J Big Band, Small's Paradise, 1985

permanent place to play, and in 1984 I approached the man who was running Small's. I told him if he'd let me bring in my band, we could both make some money. I told him we should charge a small admission, and it would be possible to fill up the room in the basement. He let me do it on Monday nights. We charged five dollars and the people started to come, and pretty soon it caught on very well—the room was crowded. Usually, there were more white than colored patrons, but pretty soon some of the colored patrons got mad because the white people came early and took all the seats. They complained to me, but

I said there was nothing I could do—it was first come, first served. We became more and more popular. The crowds were good, but then greed set in. The manager told me I was out, that he wanted to try another band with someone who had a bigger name. He fired me without any notice. I told him I'd go but if he wanted me back, it would cost him. He had two different bands in there. Frank Foster led the first one—this is before he took over the Count Basie Orchestra—and somebody else I don't remember led the other one, but they both failed. Then the manager wanted me to come back but he'd never ask me; he couldn't bring

himself to ask me face to face. He sent other people to ask me to come back, but I decided to make them wait a little while, and then the place just shut down. It's all boarded up today. I've heard the owner was so mad about everything that happened, he went in there with an ax and chopped up the place. It's too bad, because it was management that killed it. I think it could be going today—it should be going today. In the late 1980s or early 1990s some Japanese investors got involved with Small's and began to fix it up. They wanted to make a good room in the basement for music and have dining on the first floor. They did a lot of work in the basement—I even saw the blueprints of what they were doing—but the Japanese wanted to get some people from Harlem, from the local community, involved but no one was willing to work with them, so it's still closed up.

H: What do you feel are some of the other reasons the music scene faded uptown?

A: The music just changed, and some of the musicians changed. There was a time when a good musician was as well respected as a doctor or a lawyer, but when the music changed, so did some of the musicians. I worked with Louis Armstrong for a short time, and I remember we were once playing downtown. Someone asked Louis about his success, how he always could draw a big crowd of people. He told the man, "Let me tell you something. The kind of music I'm playing makes people feel good—the folks come in and they buy steaks. But some of the things people are playing make people sad, and these folks will just sit there, drink a Coca-Cola, and stay all night." He was giving people what they wanted to hear and making them feel good. After the war some of the

music didn't make people feel so good. Another thing is some people make their music too complicated. I've always tried to keep my arrangements simple. Some arrangers write too much, too many notes. I learned that from Sy Oliver. Keep things simple, don't throw too many things in, and that's still the way I write for a big band or a small group.

H: Do you think there is any future for a music scene uptown?

A: Well, I'm still playing twice a week in Harlem at senior citizen centers, one on 135th Street between Fifth Avenue and Lenox Avenue [Malcolm X Boulevard] and another on 140th Street between Lenox and Seventh Avenue [Adam Clayton Powell Boulevard]. We begin at noon, have a bite to eat, and then play for the people, and we have nice crowds. I'm told there are plans to build a permanent building where we could perform regularly. I don't know if that will happen. I've also heard there was some money put aside to fix up some of the old places where people played, like the Renaissance Ballroom, that there was money set aside two or three times, but instead of it going to fix up a place for music, it went to the preachers. When the preachers get the money, it just vanishes, and it's the preachers who get the money most of the time. Maybe some of those preachers have a hard time, but as far as I see, it's the entertainers who are always struggling, and they've been struggling for a long time. But maybe tomorrow can be their day. Tomorrow is in front of them, and that's what keeps the entertainers going—tomorrow and tomorrow.

<div align="right">31 May 1987
19 April 1996</div>

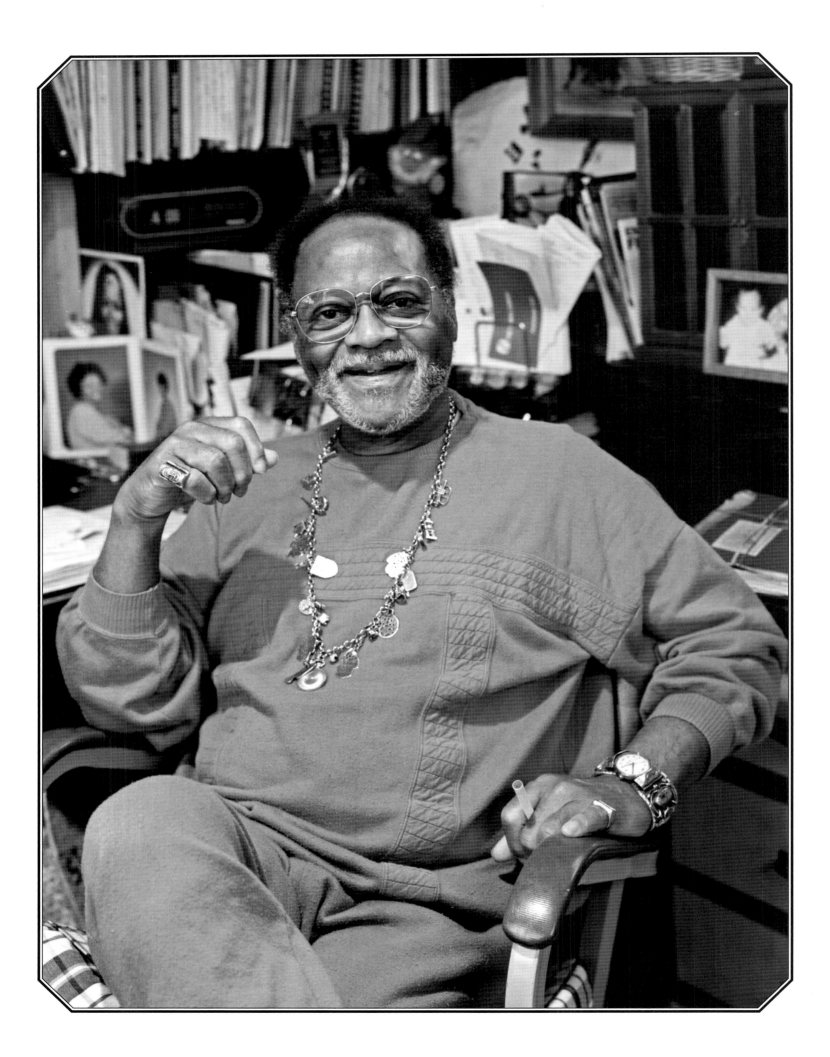

Clark Terry

(b. 1920)

Hank: *Tell me about your first experiences in New York City.*
Clark: I was in the navy and on my return to camp after boot leave, I went to New York to visit my cousin William Scott, who lived up on Morningside at the time. He invited me to New York, and when I arrived, I went right down to Fifty-second Street to check it out because that was the thing everybody did in those days. I went downtown, and there was Ben Webster and Tony Scott in one club; Stuff Smith was across the street with Jimmy Jones and the bass player who is managing now, John Levy. Tony saw me, a sailor at the bar with a trumpet, and said, "Hey, there's a sailor over there with a trumpet. Come on up here, sailor! You want to play something?" I'm scared to death, you know, but I went up and played something. Tony and I have been good friends ever since then, and while I was in town on that leave, Tony got me a gig at the 845 Club in the Bronx. I had a chance to go back up there when I came back through with the George Hudson band.

H: *Tell me about the Hudson band. I've heard it was very popular at the Savoy.*
C: This was the first band I really worked with in Harlem. The George Hudson band was out of St. Louis, and the first place we played was the Apollo Theater. The band had a good reputation; it played in the Club Plantation in St. Louis, accompanying all the major acts that came through town. The acts that heard the band in St. Louis would come back to New York and say, "Man, you've got to go to St. Louis and play the Club Plantation so you can get your music played right." We had an opportunity to come to New York on a little tour—it must have been about 1946. I came out of the navy in 1945, and it was just a short time later when we played in New York the first time, and I'll never forget it. Illinois Jacquet was very hot at this time, and we were on his show at the Apollo. Now, we had a fantastic tenor player by the name of Weasel. Willie Parker was his real name, but we called him Weasel. He's in Cleveland now; he was a great player. We had marvelous arrangements that had been written for the shows at the Club Plantation in St. Louis. Many of them featured Weasel, and one of the best was on "Body and Soul," which we often used to close a show. Since Jacquet was the star attraction, we went on first. The audience was with us, and when we closed with "Body and Soul," Weasel was fantastic. The arrangement featured an up-tempo,

Opposite:

Clark Terry, 1987

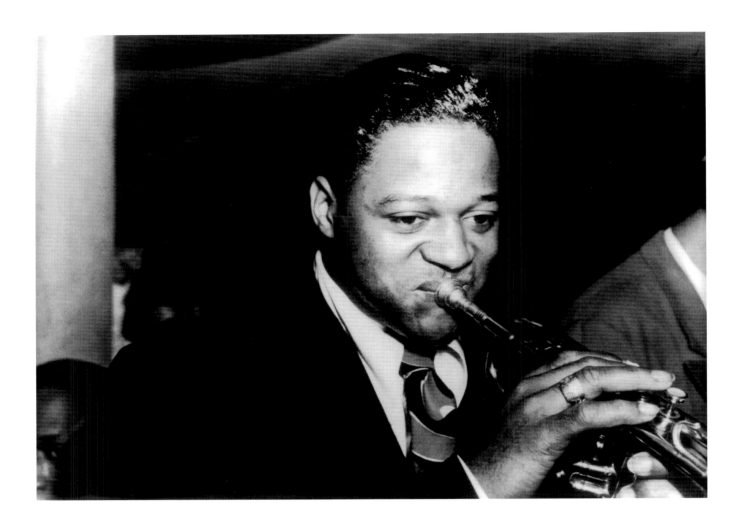

Clark Terry, 1945

prolonged ending and we had the house roaring, everybody standing up and cheering the band. Jacquet was running around yelling, "Take that number out! Take it out!" There was so much excitement, he couldn't get on. They took the number out for the rest of the shows.

H: Tell me more about the Hudson band. Did you play any other places in Harlem besides the Apollo?
C: We played the Savoy Ballroom a few times, opposite Tab Smith, Erskine Hawkins, Lucky Millinder, and the [Savoy] Sultans from time to time. There were many excellent bands there, mostly long forgotten. There were a lot of fine players in the band. Oscar Pettiford's brother Ira was in the band, and Stanley's brother Tommy Turrentine was in the

trumpet section, along with another fine player, Paul Campbell. Ernie Wilkins was on tenor. They made a record called "Applejack Boogie" that was almost a hit, but I'd left the band by then.

H: I remember you were with Charlie Barnet in the late 1940s.
C: I went to California to join Barnet in 1947, and I stayed with him about a year. That's about as long as that version of Charlie's band lasted. We came back to New York and played uptown a few times at the Apollo and the Savoy. We played a concert in Town Hall downtown, which was recorded. It was a great band— Jimmy Nottingham and Doc Severinsen were on trumpet, and Bud Shank came in and played tenor. One time when the lead alto couldn't make it, Bud asked

Charlie if he could take the alto part, and Charlie didn't care—he said something like, "All right, give it a whirl and let's see what you've got." That was Bud's turning point on alto. We didn't play uptown very much, but when we did there's one thing I enjoyed—it's probably something everyone who played uptown in the late 1940s remembers. Frank's was this fabulous restaurant around the corner from the Baby Grand. People would come from everywhere to eat at Frank's. What a place! We'd treat ourselves when we had the occasion to eat at Frank's, instead of the other greasy spoons in the neighborhood.

H: After Barnet you joined Count Basie?
C: I joined the big band, but then Basie had to break it up to work himself out of debt. He planned to cut it down to a small group and when he broke up the band I headed to St. Louis, and he told me when I got to St. Louis I should look around and see if you could find anybody to put in the new group. We had already played Louisville, Kentucky, on the last trip with the big band, and he'd found a fine bass player, Jimmy Lewis. He decided to go with Jimmy Lewis, Gus Johnson, and—since Buddy DeFranco was working out of the same booking office— he decided to put Buddy in the group. Basie asked me who was in St. Louis that played good tenor. I told him there were two outstanding players in town, Jimmy Forrest and a young Caucasian kid named Bobby Graf. He said to see if I could get the kid, so I talked to Bob and he was so eager to join the group he went crazy, so I brought him to Chicago and we started the group. Bob and I were roommates, and I took him all around the places on the South Side. We went all around town—the Colored Club and all the spots we used to go to jazz after we finished. After a few weeks Bobby

Album cover for Town Hall Concert, 1947

wanted to go out and jam, and I said, "Man, you know your way around now; you know everybody. I introduced you to everybody, so you can go out on your own." He left the group a little later and Wardell [Gray] came in; I know Wardell was in the band when he married Dorothy, because I went with him to City Hall to get his license. That little band didn't play in New York very much; we were on the road all the time.

H: Then it was on to Duke Ellington?
C: That's a long story, but Ellington hired me away from Basie. He'd heard me play in Chicago and wanted me in his band. Basie had just given me a raise from $125 a week to $140. Now I'm a big shot with $140 a week, and Duke Ellington wants to hire me. I don't know what to do, and Duke says, "I can't just hire you out of my friend's band. You have to leave, get sick, disappear—then all of a sudden you join me." I agreed and told Basie I was sick and went home to St. Louis. Duke

had told me he was coming through St. Louis to do a big Armistice Day show on November 11. It was scheduled to be a big show with Sarah Vaughn, Peg Leg Bates, Nat King Cole, and many others. Ellington came through, needed another trumpet player, and I just happened to be available. Of course the guys in the band had most of the show memorized, and I had a little flashlight on the music, and I'm down there trying to see the cues and read the parts in the dark. I had to ask the guys to tell me the tune because Duke would never called a tune. The band could tell what was coming just from introductions, and the guys would only get their music out if they needed it. The trumpet players wouldn't tell me anything, but Quentin Jackson, in the trombone section, always used his music, so I looked over his shoulder. He was a buddy and knew I needed help. Harry Carney also got his music out, but that was too far away to see. I stayed with Duke for about ten years.

H: When you played with Ellington's did you ever work at the Apollo, the Savoy, or any other place else uptown?
C: Not very often, but I did work uptown with my own band, maybe ten or fifteen years ago. I think it was at a place called the Club Baron. I've gotta tell you a story about that. It was a big band, maybe seventeen pieces, and it just so happens it's about half and half, blacks and whites. One night three black Mafia guys, Black Muslims, come into the club and they corner me, saying, "What are you doing playing with all these whiteys in Harlem?" I knew they meant business and I'm a little bit frightened, but I know I've gotta be stern, so I say, "Well, to tell you the truth, I happened to be aware of the fact, and I think you're aware of the fact that Harlem is responsible and has always been responsible for great jazz,

big-band jazz, all kinds of jazz, individual jazz, and it's been missing from the scene for a number of years. There's been no big band up here for years, right?" They looked at me and said, "Yeah, we have no big bands around." Then I said, "Well, I feel it's my duty to bring big bands back to Harlem. Somebody has to do it. And in doing so I just choose the best musicians I can find, and I don't listen with my eyes." I can see I'm getting to them now. I think they're getting the message, and then one of them says, "Well, we got a kid here, a little black kid, and he wants to play, and we want to hear him play." I said, "That's OK, I've spent half my life making it possible for young musicians to be heard, so we'll bring him up at the beginning of the set and turn him loose."

So we start the set and I asked Lou Soloff, who had the jazz chair, "Lou, would you mind staying off and let this kid sit in?" He didn't have a problem and Lou got off and the kid came up. I kicked off with a medium tempo tune, one of Chris Woods's tunes, a very simple tune, very easy to play on, nice changes. The kid started when I kicked it off, "One, two, three, four," and I said, "Hey, man, you play the music and when you get down to letter D, that's when you come in." We started again, "One, two, three, four," and he started in again. I stopped the band again and said, "Hey, baby, no, you misunderstood me. When we start, you play the music. When you get down to letter D, then your solo comes, and we're gonna even open it up so you can play long." He said, "I just want to express! I want to express!" I said, "Well, you're going to get plenty of chances to express because we're going to open it up so you can really express." So we kicked it off again, "One, two, three, four," and he comes wrong again. I was fed up and said, "Express your ass off

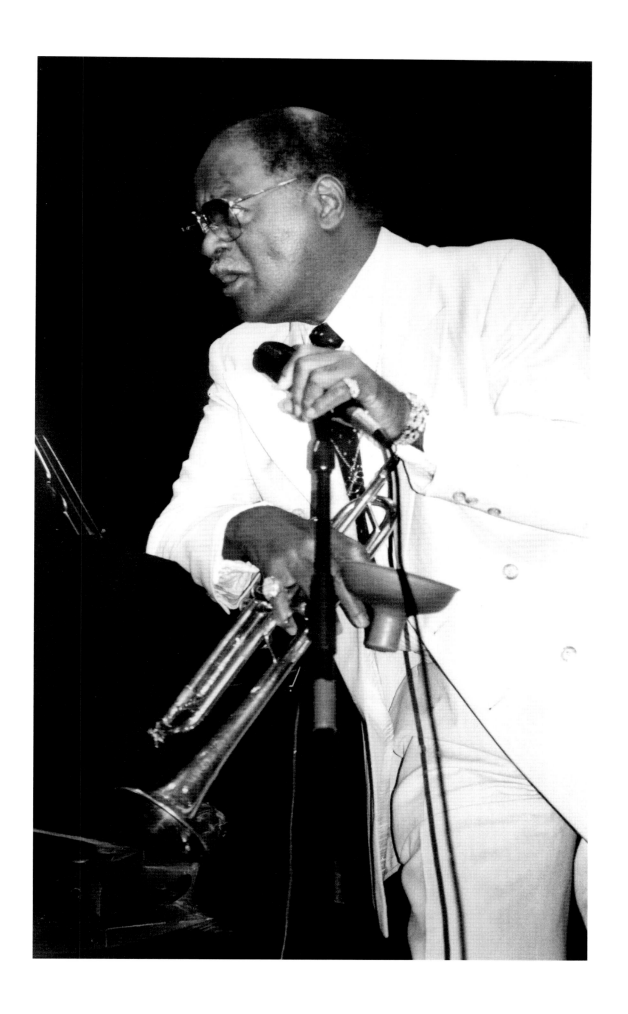

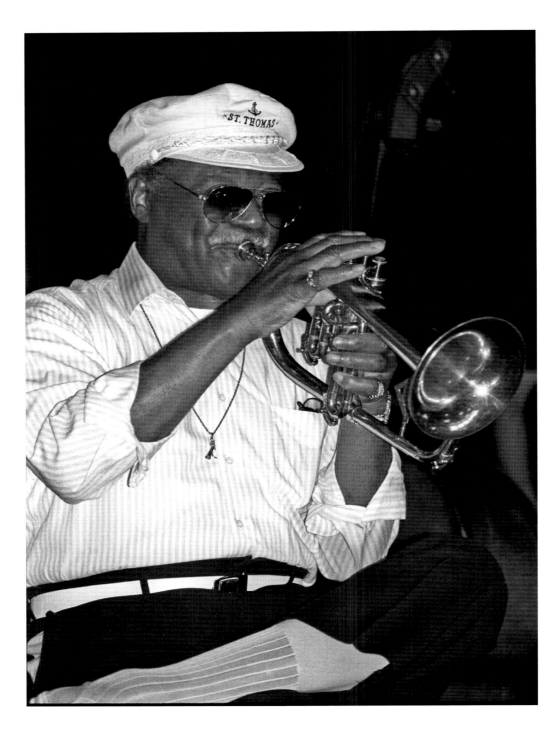

Clark Terry, Floating Jazz
Festival, 1994

my stage!" I didn't care what the cats with the three guns said. When we came off, I went straight up to them and said, "Now you see what you've done? You brought a dude up here and you stuck your necks out to represent this dude to do something that he's not qualified to do. He's not prepared, he didn't do his homework, he can't read music!" In a low grumbly voice, one of them said, "Well, the son of bitch didn't tell us that."

H: How long did you play there?
C: We were there for ages, every Monday. It was the only night they had a big band; they had other things the rest of the week. This was the last regular thing I had uptown. By the time I left Ellington

and got back on the scene, things were closing down. The places that were left had house bands, and there weren't many of them. I remember I played Small's once or twice—there's a record I made with Babs [Gonzales] and Johnny Griffin. I even played at the old Celebrity Club on 125th Street with Buddy Tate. I was just talking with Buddy about that the other day.

H: What do you think killed the music scene uptown?
C: Many things, but television was one of them. Everybody was staying home watching television. Another thing was attitude. That's something I should tell you about, something I have to mention. Before the Jazzmobile started, the forerunner to the Jazzmobile was my pocket. I gathered a lot of little kids out of Harlem and took them to a rehearsal studio on 125th Street, over near Fifth Avenue. The Walker Rehearsal Studios. It was hot up there; even in the wintertime it was hot, and in the summer it was ridiculous. I used to get all these kids to walk up there, and I had a cat named Fred Stare that wrote a book for those kids to play; we had sixty tunes in the last year. I bought some of these kids instruments, and we rehearsed all the time.

H: What years did you do this?
C: I really couldn't tell you. I don't remember exactly when the hell it was, but in the 1960s sometime. But I'll tell you what happened. Some of the kids that came out of there turned out to be good musicians, and some of them got their first experience in that hot old rehearsal hall. I bought a lot of those kids horns—I'd go to the pawn shop, I'd get them anywhere I could. I gave a lot of horns to kids who I knew really deserved

them. I couldn't be there all the time, and sometimes other people worked with these kids. Another guy who helped a lot was Don Stratton. He was an old friend, a good trumpet player, and at the time was affiliated with the Manhattan School of Music. He wanted to help out and made arrangements for me to use the facilities at Manhattan College. Now these kids have access to a real university atmosphere, we have blackboards, textbooks, film, pianos, real instruments, which some of them didn't have. When I couldn't be there, I'd sometimes have Ernie [Wilkins] take my place. When Ernie and I were away together, sometimes I'd call Kenny Dorham. We'd hire whoever was competent enough to teach the kids, and it was a lot of work because we had to teach a lot of them how to read music.

One time when I'd been away for a while I came back and Don told me attendance was down to almost nothing. It seemed there was a lot of anti-Caucasian sentiment and one of the students had persuaded all the others not to respond to help from Caucasians. I confronted the kids about it and finally one of them said, "We don't want whitey trying to teach us about our music." I said, "Oh, you'd rather walk up five flights of stairs and swelter in the hot room up there rather than be exposed to the real atmosphere of the university, which some of you will probably never experience again in life. You've got all the facilities of a college student here and all the possibilities of learning anything you could learn in college, and you'd let bigotry come before that. OK, if that's what you cats are about, you got it, see you later." And that was the end of it. I don't even know where the library is or if it even still exists. I just walked away from all of it. I put a whole lot of time

Clark Terry at home, Whitestone, New York, 1987

and money into that program. Shortly after this, Jazzmobile comes up with the same concept and they are fully subsidized with big salaries to the people who run it. That's what I mean about attitude.

H: When did you have the most fun playing uptown?
C: Probably when I played at the Savoy with George Hudson, because of the involvement of the people who were there. They came to enjoy the band and to dance. I think there's something about dancing that just goes along with the big band. Years ago people would come to dances and would dance. That's one ingredient I feel is missing from the scene today, dancing. Harlem was always known for places with creative dance, and it was just fun to watch all that and see all that happening—lots of people who really enjoyed being there. They'd work out from the time the place opened till the end. They'd be all hot and sweaty. A lot of fun.

H: Do you think that the Harlem music scene could ever come back?
C: Well, there's a remote possibility. I'm always a cock-eyed optimist about things that I feel are necessary and things that are good, especially when it relates to music, to my craft, but I don't think it's likely to happen any time soon. There are so many things that are against it. First of all, most of the support these days— almost lopsided support—of the jazz scene comes from the Caucasian side, at least financially. There's still a lot of race hatred up there, and that makes for a very unpleasant atmosphere. Whenever this kind of thing happens and there is no true support for something, it's very difficult for it to take roots and grow.

16 February 1987

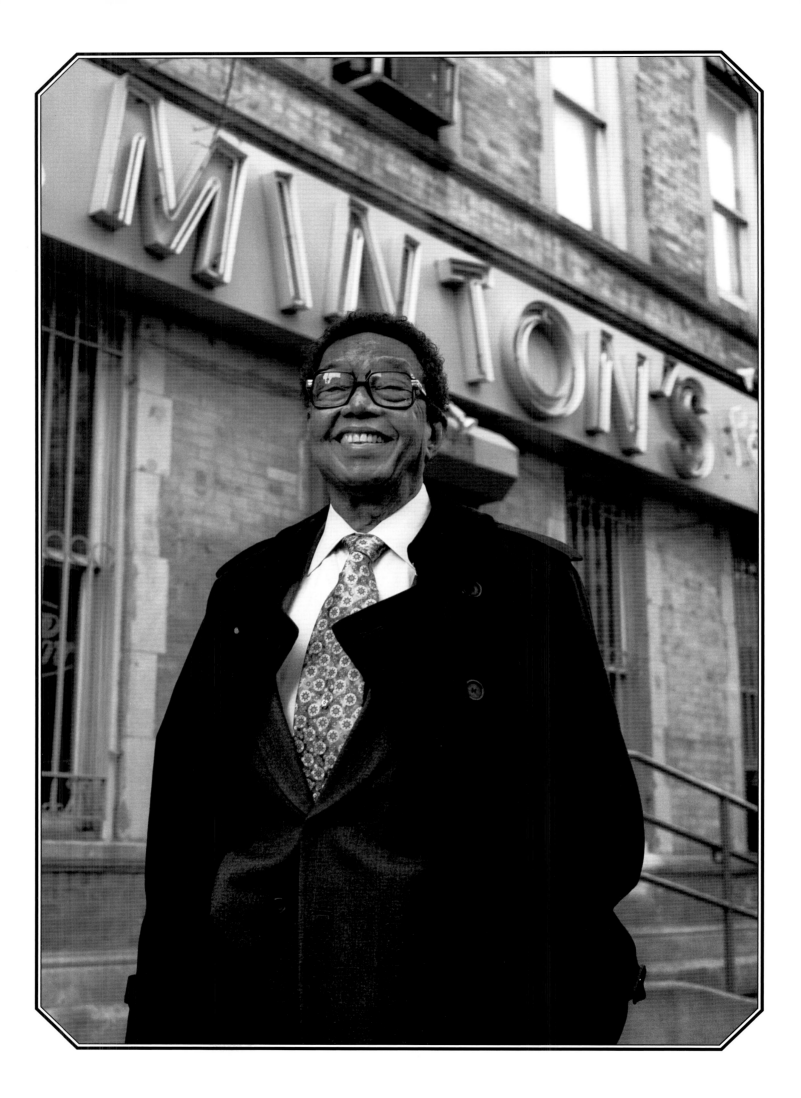

Billy Taylor
(b. 1921)

Hank: *When was the first time you heard music in Harlem?*

Billy: I heard music from Harlem when I was living in Washington, D.C., because I used to get it on the radio, broadcasts from the Apollo Theater and other places in Harlem. It sounded so exciting—there were live broadcasts from the Savoy Ballroom. So I was aware of Harlem before I ever saw it.

H: *Did this inspire you to become a musician, or to become a better musician?*

B: It certainly did, because the music I heard on the radio was very exciting, and I'd think how much I'd like to be there and see the guys playing and hear them. Several of the theaters in Washington carried newsreels—it wasn't March of Time, but they were for the black community and they were very interesting, because you got to see Cab Calloway, Duke Ellington, and other people that we only saw in the movies. I heard Chick Webb on the radio. I heard Lucky Millinder. A few years later I heard Sabby Lewis. I didn't know the broadcast was from Boston and later, when I met him, I said, "Oh yeah. I've heard you. I've heard you on the radio."

H: *When did you come to New York?*

B: I came in 1944, but I'd come on visits a few years before. I had an uncle who lived in New York, my mother's brother. We came up to visit him and he took us around through Harlem. He lived in Harlem and took us sightseeing and everything. I knew I wanted to come back, but I didn't until much later. I came back to New York when I was in school, about 1940. I was already playing the piano in the local bands down in Virginia, and I wanted to hear Teddy Wilson. Teddy Wilson had a ten-piece or twelve-piece band. He had Ben Webster. It was just one of those dream bands.

I called my father and said, "Look, send me some money. I want to go hear Teddy Wilson because I'm not gonna get a chance to hear him in a big band." And he sent me some money. Then he said, "If want you to go to Harlem, look up this friend of mine. He runs a nightclub in Harlem. I want you to check in with him. I know your uncle will be with you, but I want somebody that I know that knows what he's doing to check on you and make sure that you're all right." I said OK.

So I went to this club near 138th Street and Seventh Avenue. I don't

Opposite:

Billy Taylor, 2008

remember the name, but I went to the club and introduced myself to my father's friend. He said, "Well, your dad told me you play the piano. Come on in the back room and play something for me." I said OK and went back where there was a trio playing—a guitar, piano, and bass. I said hello to the gentlemen. I didn't know them. And he said, "Hey, this kid's gonna play something for you." I said, "I'm gonna play my favorite song," which was "Lullaby in Rhythm." I noticed the piano player looked at me kind of funny when I started playing, but I keep playing and when I got through there was applause, applause, applause. When I got through, I said, "Now I'm gonna run to hear Teddy Wilson." But before I can go, the piano player says, "Look, son, that was very nice, but don't rush off. I've got some friends that would like to hear you play." I don't know anybody in New York, so this is a big deal for me. He plays the last show, the last set for that night. Then we went around the corner onto 138th Street and he knocked on a door of one of those big brownstones. A guy comes to the door, and he says, "Hey, fellas, I got a piano player here."

Now, that should have told me something. I should have gone home. Right there. But I didn't. I went in, and I sat down to play. I played about sixteen bars of a tune, and an elderly gentleman from over on the other side said, "Son, let me try a little of that." I didn't know it, but it was Willie "The Lion" Smith. Willie the Lion sat down, and I had never in my life heard a left hand like that. I'd heard Fats Waller in person. I heard him when he played at the Howard Theater and the Lincoln Theater, but when I heard Willie the Lion, there was like two hands down there. I said, "Wow!" It turned out almost everybody in the place was a pianist, just hanging out. This was James

P. Johnson's house. He wasn't there, so I didn't get to see him at that particular time. One of the guys was about my age. He sat down and played, and he's a good piano player. But he was trying to play like Art Tatum, and I said, "Oh, I got him. I mean, I can do better than that as far as Art is concerned." But the same thing happened to him that happened to me. He played about sixteen bars, and Willie the Lion said, "Come on, Monk. Don't you know we already got an Art Tatum? Play your own stuff." Monk was playing harmonically. Much more sophisticatedly than he ever did, than I ever heard later, when he began to really do his stuff. But in those days he was trying to play Art, and what he had heard in Art's playing was harmony. And so he was playing some very harmonic things in those days. He was really getting it, but you know he was always a stride piano player. So he was doing that. So it was Art kind of playing through Fats Waller or something.

H: So the first club that you played in Harlem wasn't a club at all. It was James P. Johnson's house.
B: That's right. And then I went back to school, but not before I got up to hear Teddy Wilson at the Golden Gate. Like I said, it was just a dream band for me, but a band that I'd only heard on record. He had Ben Webster in the band. Shorty Baker was on trumpet. I think Doc [Cheatham] and Al Casey, and Teddy was playing his tail off in those days. He was walkin' everything. The Golden Gate was an interesting place, and I didn't go anywhere but there. I never got to the other dance clubs. I found out about these places later, when I moved to Harlem. There were a couple of places down 125th Street. There were several on Seventh Avenue that were small—there

were all these guys playing gigs. It was very lively then.

H: When did you move to 125th Street?
B: I came to New York in 1944. I had graduated from college and saved some money and came to New York with my own money, ready to earn a living as a musician. I was very lucky. I've told this story many times, because it sounds like a fairy tale to me. I was supposed to stay with him—with my mother's brother—but I knew I was just going to drop my bags at his house and go somewhere else, but it was cool because at least I didn't have to pay rent for a minute or two. So I dropped my bag and said, "Look, I have to meet some guys at a nightclub. Maybe I can get to see some of the people I've already met and establish some kind of a presence." So I got on the bus and went down to Minton's. My uncle lived at 145th Street and Minton's was at 118th. I knew where it was.

In those days, you could introduce yourself to somebody and say, "I'm a piano player. I'd like to sit in." And then, all things equal, the guys would let you do it. Well, this was such a popular jam place that even by the time I got there, there were three or four other guys that were waiting to sit in, and finally everybody got to sit in and everybody played good. Now I've been a bandleader, and I'm very, very cocky. I'm ready. I mean, I don't care who you are, who you guys are, but I sat around all night. I got there about nine o'clock, when they started, and I sat around until three o'clock in the morning before I got to play because the guy who was in charge knew the other guys—they were friends and people he knew. He'd say, "Hey, man. How you doin'? Come on, play." He didn't know whether I could play or not but finally about three

o'clock I got to play. All night long, it's been just a rhythm section and maybe two horns, or something like that. Now there are about fifteen horns. I mean, they've got horns. Everybody's off work. Guys are strolling in as I sit down, and as they play, somebody else comes in and takes it, adds another chorus to whatever they're doing. So I don't really get to play. I'm just comping for all these horns. I really would like to play something, but then I look up, and Ben Webster is standing at the edge of the stage. He is one of my all-time favorites. He comes up and stands over by where I am, looking over my shoulder when I'm playing. So now I'm really trying to do everything I know harmonically, and I hate to think of who was trying to play a chorus or something because I was showing off all everything I knew harmonically.

After we played a little he decided he really wanted to play and he played a couple of things. After that he said to me, "Look, I like what you did. Give me a call on Fifty-second Street. I'm at a club down there and I'm looking for a piano player. I'd like to hear more of you. I can't hear you in this context. So come on down." I said, "Sure. I'll be down tomorrow." "No," he said, "not tomorrow. Tomorrow's Saturday. Come in on Sunday, it's quieter, and you know, we'll see how you sound." "Sure," I said, "it's Sunday." I don't know what I did on Saturday. I never remember what I did, I was so anxious and wondering, Is it Sunday yet?

On Sunday I get off the subway at Fiftieth Street and I come up the street to Fifty-second Street. I turn and look and see all these clubs, the ones that you see in the pictures. One thing troubled me, and I don't know why. I thought the first name that I should have seen was Art Tatum, but I don't remember seeing

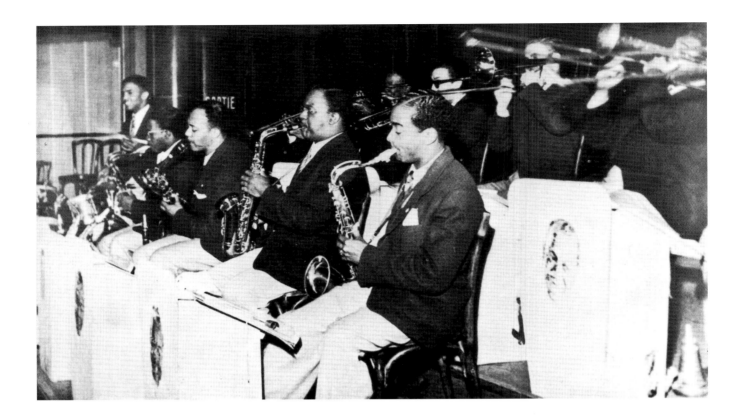

Don Redman Orchestra,
Europe, 1946

his name. I mean, I was so anxious to get to the scene that for all I knew it was the first club, and I'm looking, not even looking up. I walked in the club, and somebody comes up and grabs me and she says, "Billy, what're you doing in New York?" It's a friend of mine, a pianist named Norma Shepard, and she was wonderful, one of the women I really looked up to, someone who caused me to feel about women the way I do. She was Washington's Mary Lou Williams, a wonderful player. She never got an opportunity to do what she did because they made her sing and become a cocktail player. But, at that time, she and Tatum were very friendly. Now I'm rushing up to the bandstand, and she said, "Now, you've got a minute. I want you to meet a couple of friends of mine."

She didn't know what I was going to do. She thought I was going to sit down, so I said, "Look, I'm going right over here." She said, "No. This is Miss So-and-so, Mr. So-and-so; Mr. Taylor,

this is Mr. Tatum," and so on, and so on. I went up to the bandstand and looked for Ben and he said, "Come on." So I sat down, we played a set, and I got the job. The third day I was in New York, I had a job. I wasn't in the union, but they had Sammy Cahn, who ran the Three Deuces and had connections. So on the third day, I had a gig. It was one of the great things that happened to me in terms of meeting people. I met all kinds of musicians by virtue of the fact that I was playing with Ben.

Jo Jones, who I had met when I was in college at Virginia State, took me on almost immediately and became my guardian, if you will. When I met him, he was with Basie, and I took my whole band to hear them. One of the guys in my band said, "You know, we got a piano player—the guy that plays with us—and he's pretty good." It turned out Basie wanted to hear me play. I was ready to play almost anything because in those days, you could buy all the arrangements

of their recordings for a dollar. I mean, the whole orchestration with the solos and everything written out. Everything was there, so I was ready to play anything from his repertory that had been recorded or had been published. I got to sit in and met Jo. Later, he took me around to the White Rose. I had been over there before, but he introduced me to all of these guys and it was just wonderful. I began to get a reputation on Fifty-second Street. The jobs were better there, and I got jobs from the union at other kinds of places. So I never had any occasion to work in Harlem, except on occasion when Duke Ellington or other leaders were off and I'd sit in for them. But I worked with Hawk [Coleman Hawkins], Billie Holiday, Dizzy Gillespie, and a lot of other folks. In 1946 I was with Don Redman and we went to Europe and then I stayed in Paris on my own for a while, so I didn't get to really play Harlem until I came back from Europe in 1947. Redman's was the first big band that played bebop in Europe. We had Don Byas, Tyree Glenn, and Butter [Quentin Jackson]—an interesting band that he had put together to take to Europe to show them Europeans what we were doing back home. Don [Byas] was a member of the first band that played bebop on Fifty-second Street, and I used to sit in with him. That's when I really learned to play bebop—and of course from Dizzy. So when we got to Europe, everybody said, "Can you play bebop?" And we said, "Yeah, sure. Here are a couple lines, folks." Don was one of the first guys to get there and show them what Dizzy and Bird were doing. He didn't play bebop himself, but he knew all of those changes and had played them with the guys who did it—Monk, everybody.

H: You came back from Europe. What was it like when you returned? Did you head uptown?

B: I had been away for nearly a year and people forgot about me. And besides, the war was over and all of the old piano players that were in the army when I got the job with Ben, all these guys are back and everybody's going to school and doing other stuff, learning to play better and read. I could read music, so there were a lot of things I could do others couldn't, but when I got back it was rough, hard to find work. This was the first time I lived and worked in Harlem. I worked at Joe Wells's place, and that was fun. We really did a lot of things. I played solo piano, and this was around the time when organs were coming in and they were popular in Harlem—an organ trio, or something like that. Wild Bill Davis started everybody doing things like that. Joe Wells said, "Why don't we have a show with an organ and a piano and when I have a singer, the singer will sing with the two of you?" Bob Wyatt was on organ—he was classically trained—and we established a good reputation. A lot of people from downtown came up to see us. Bob used to play at theaters like the Roxy and other places that used live music, so a lot of people came to hear him play because he was very, very good. He was also a good writer and was writing for Ethel Smith, who was very popular in those days as an organist.

I also wrote several things for her, and this is when I began to write. I wrote the first book on bebop. A publisher came to me, and he had already asked Dizzy and Bird to do that, and for whatever reason, they turned him down. The publisher asked if I could write something and I said, "Sure." So I went back to school and wrote a very simple book. Actually, I did four or five small

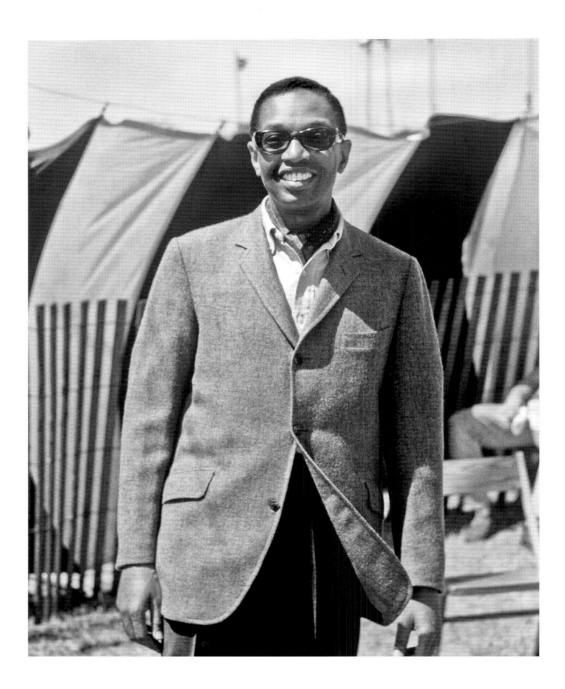

Billy Taylor at the Newport Jazz Festival, 1965, photographed by George Wein, © George Wein

books, and now they're all back in print. It was called *Basic Be-Bop Instruction*, and I was very proud of it. I had learned from the horse's mouth. Dizzy was one of the great teachers. He showed me many of the things that harmonically and melodically I had to do if I was going to play bebop.

But back to Wells. It was fun, a very popular place. This is one of the places that after the Savoy dance was over, people would come for chicken and waffles. That was a big deal, chicken and waffles, man. Fried chicken and waffles.

H: Dick Hyman told me that one of his very first jobs out of college was at Wells, and he's very proud of that.
B: That's right, and he should be. Because there were not a lot of guys who were white who could hold a gig in Harlem like that. I mean, he came up and he played. He was a young guy, and he played beautifully, and he knew the

styles, and you know, he just fit in. He was a nice guy and people liked him.

H: Where did you go from Wells?
B: I played several places during that period. I even played a few weeks at the Royal Roost with Bob Wyatt and our organ duo. We were very successful. I remember Miles [Davis] was there at that time.

H: Did you ever play next door at Count Basie's?
B: No, and I loved Basie's. That was when Lockjaw was there, managing or doing something. Marlowe Morris was playing there for a while. I met Marlowe when I first came to New York and was working at the Deuces. He's never been given the credit or received the attention he should have. He was one of Tatum's favorite younger players at that time. He could do things with his right hand and with his left hand—he was very Tatumesque. He was one of the few guys who could actually do that, but ultimately, he couldn't get arrested doing that, so he went to the organ. But he could play many of Tatum's things—the style, not the songs themselves. I used to go with Tatum right up the street from Wells to a place in the next block, because he liked to hang out there and he was there all the time. Every time I'd look up, he'd be there if he was in town. It was just a bar with a piano. I think the guy put it in because he knew Tatum was coming. He'd hold court there. He'd be working somewhere downtown, and Ram Ramirez and all of us would be uptown on Monday night, waiting for him to show up. We'd be sitting around, somebody would be playing, and when he showed up Ram, Dave Rivera, and the rest of us would all try to talk him into playing. It was Tom Tilghman's place.

H: Did you ever play shows at the Apollo?
B: I played shows at the Apollo when I was working with Slam Stewart in the 1950s. We did a tour—the RKO Boston, where I finally met Sabby Lewis; Philadelphia; Baltimore; Washington, D.C.; and the Apollo. We worked our way down to Washington. It was a good show. Slam did a lot of singing and playing, but he played great jazz. John Collins, a great jazz guitarist, was in the group. The first quartet I ever had was with John. I was so fascinated with the way he played guitar; he was one of the greatest guitarists I ever met.

H: Do you remember when the end came, when there were fewer and fewer jobs and finally the Savoy closed?
B: Yeah. A lot of the things happened in the late '40s and early '50s. Harlem suffered because things were changing, and people were not prepared. I don't know whether somebody died or just what happened, but when the Savoy closed, that closed down a whole era, and there never has been anything like it. It seemed to me that when it closed, everything else closed and people were just going downtown. It wasn't as segregated as it used to be. People were going to the Deuces, or the Hickory House, or a lot of places. I was working in all of the places that I had started off working, and now I'm seeing all the people from uptown, my neighbors, and people that I know. They're all coming downtown. It was a social thing and it just changed. I always had more luck working downtown. I was better known there. I didn't have as big a reputation in Harlem. When I started on Fifty-second Street, black and white guys got in fights because of the mixing, fooling around with one of the other's girlfriends, or

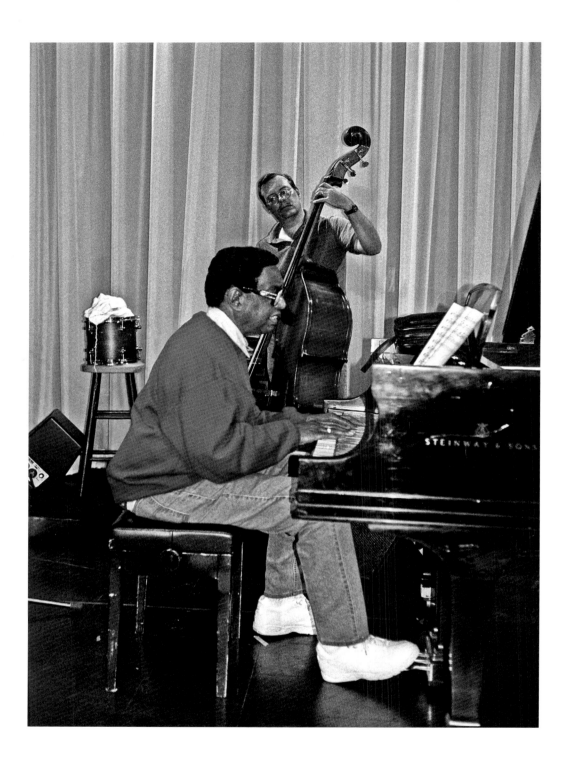

Billy Taylor rehearsing with Chip Jackson, Floating Jazz Festival, 1997

something. I remember Oscar Pettiford and Dizzy got into a big fight with a guy. Some guy made a move coming back from a rehearsal for a bebop group. I had left, but a couple of Marines or somebody started a fight. They punched a couple guys in the mouth and then ran to the subway and got away because they knew how to do that. They just punched

him out and then went on about their business.

H: When was the last time you played an engagement at a club or theater in Harlem?
B: I played at the Prelude, a club on West 125th Street. I even recorded there. I'd been working on Fifty-eighth Street at

a club, and the guy who owned it also owned the Prelude and said, "Can I get you to come up to Harlem?" Well, Harlem never paid any money, and by that time I'm earning a living, so I don't want to go backward on the pay scale. This guy didn't argue. He said, "No, man, come on up, and I'll pay you what you're getting here." I said OK. This was about 1960. Ray Mosca was my drummer. I think Doug Watkins was on bass. I was already teaching by then.

H: How did the Jazzmobile project come about? How did it get started?
B: I was on the radio doing a radio show at WLIB. I was a disc jockey and had a lot of visibility in the community and was asked to become a member of the Harlem Cultural Council. I'd been on the radio talking about the fact that they'd cut out jazz—not just jazz, but all music in the schools. I was very upset about that. I said, "This is stupid, because you're not saving any money and you're hurting kids

Billy Taylor at home,
Riverdale, New York, 2007

who you're supposed to be educating."
I was on a soapbox about this and I was
really incensed by it. I made so much
noise that the civil people said, "Well,
we have this group called the Harlem
Cultural Council. We'd like to have you
as a member." I said, "Well, fine. You
know this is where I want to be. I want
to speak up. I'm already shouting at the
top of my lungs on the radio, so, you
know, maybe that can be of assistance."

It was an integrated group, and
one of our members came back from
the World's Fair and said, "I was out
at the World's Fair and I saw all these
buildings that people have spent
millions of dollars to catch the eye
of the public. Then I saw this group
riding around in what looks like a little
car, several cars pushed together. The
drivers are taking these cars from place
to place." The thing that fascinated her
was that there were some guys playing
music on one of the vehicles that had
room for musicians. She said, "Isn't
that fascinating?" They happened to
be playing jazz, and a lot of people
stopped and checked them out. She
said, "That's a good idea. Why can't we
do something like that?" I said, "What
do you suggest?" She said, "Well, why
don't we find out who puts out those
trucks?" And then someone else said,
"Well, we can do better than that. Why
don't we go to a beer company? I've
got a connection with one, and maybe
we can get one of their floats and do
something." I piped in and I said, "Well,
if we're gonna do something like that,
then we can update the New Orleans
tradition, but the parade will be motor
driven, and this way you can cover more
ground. You can go to more places."
We agreed this was a good idea, and
we went to Ballantine Beer and asked
them to give us one of their parade
floats, which they had already had built

for other reasons. And they gave us one.
I did the first concert with about six or
seven guys that I was working with, my
trio and several other guys. We were
playing bebop.

We drew a big crowd. You wouldn't
believe it. We started at 125th Street and
we had a police escort. We drove around
in a circle and came back to 125th Street.
I mean, it was heavy. It was wow, with
people coming out of buildings and
everything, shouting, "Hey, what's going
on? A parade? What's happening, you
know?" It really was very exciting. The
cops came up after the fact, after we had
settled somewhere, and we didn't have
a permit but they were cool. They said,
"Well, okay, just get a permit and you'll
be all right."

I did the first one. Then I put the
arm on Dizzy Gillespie to do the second,
because I was working. I could get off for
one day. I was on the air so I can't get off
around the time that we're supposed to
be there to play. I got Lionel Hampton
for the third concert. I went through
my list of good guys, but the key was
the fact that I started with Dizzy and
Hamp, because those two guys gave it so
much visibility. We made all the papers.
It was a smash hit from the beginning.
We decided we wanted to go out to the
neighborhoods and play. That meant
we had to get a parade permit from
the city, but by that time we had good
connections, so we got what we needed
and played. We did about ten concerts
and then the next year we wanted to do
it again because we knew how popular
it was and we could have police escort.
We knew we could do a lot of things, and
it just took off. One of the people that
played for me was Buddy Rich. He was
working at the Riverboat in the Empire
State Building, and he brought his whole
band and played on the Jazzmobile. He
brought the entire band up near Park

Drive near Columbus Circle and Fifty-ninth Street. They wouldn't let us use the park itself, so the band set up outside the park and he started playing, and once it got started there was no way to stop it. Everybody was trying to get to the musicians because they were so close, and we didn't know what to do; we just wanted to protect the musicians. The whole block was happening, but once you start something like that you can't say, "Stop"—it'll take you a while to get it stopped. The cops said, "If you stop him

playing, you know, it's gonna cause more of a problem than letting him to just play. We'll let you go. We'll work something out."

H: When was the last time you played uptown?
B: I played at the Prelude in about 1960 or '61. It didn't last long, but it was very popular when it was going. It was diagonally across from what they call the Cotton Club today—that new Cotton Club on West 125th Street. There

Billy Taylor at home,
Riverdale, New York, 2007

were several restaurants on 125th Street right beneath the elevated. They tore the buildings down. But the last place I played uptown probably had to do with the Jazzmobile. I played a lot of places, just nothing recently.

H: It seems to me that there is a bit of a musical comeback in Harlem.
B: Yes, very much so. As a matter of fact, a couple of musicians have bought brownstones. One of them, a saxophone player, bought the place where I used to go to jam, one of the after-hours spots that Tatum really loved on 133rd Street.

H: There's a new place called Bill's at 148. It used to be Covan's Club Morocco.
B: Right. That's it. The guy is Bill Saxton. I think he bought it and I know something's going on there because they're advertising.

H: The Lenox Lounge is back in business. They have name acts, and Danny Mixon is in charge of the music policy.
B: That was a nothing club for years and now they've finally made something out of it, you know what I'm saying?

H: Do you see it coming back?
B: Sure. I think what's happening is that a lot of guys are realizing that they can do something on their own—they don't have to wait for a club owner. Several guys are doing things that seem to be in that line, and that's very healthy. A lot of things that the guys are doing, like using the Internet, they don't have to wait for managers and other people to say, "Well, come to do this." They now say, "Well, no, this is what I want to do." And they do it, because they have facilities that they can work with, you know, the electronics and all kinds of things. You let people know where you are on Web sites

and it's a big change for the better. It's very positive right now. I'm glad, because one of the things I've been fighting is that it's hip to say jazz is dead. It's very hip to say that, and I said, "Well, it may be hip, but it's dumb, because it's not true." Recently a guy wrote this article on me for the *Washington Post,* and the headline was "Is This the Last Thing That Billy Did?" And I'm like, "Come on, man." I was so upset. I spent a lot of time with this guy, trying to show him that jazz is not big in this country because of people who write things like he did. I said, "If you guys would do your homework and realize that all of the festivals and clubs and cruises and universities are happening, you'd understand jazz is not dead. This kind of talk is not only unnecessary, it is untrue." This kind of talk turns off a lot of kids who don't know what to do or what to listen to.

Jazzmobile is trying to do something about that. Robin Bell Stevens is our executive director. She's Aaron Bell's daughter. He was my bass player and left me to go with Duke Ellington. She remembers him bringing her to the Jazzmobile—she grew up with that stuff. There's a lot to be proud of because, I mean, so many people—you named a few—but I mean people that were coming to Harlem and who are saying, "Now let's do something that really shows off what we're doing in Harlem, just like they are doing where Basie used to live over in Long Island or in Brooklyn, and they're doing some other things." Harlem is now just taking its place, back to where it was before everybody said, "Well, let's get out of Harlem because we're gonna go be somewhere else." There are a lot of things that helped. When Clinton moved his office to Harlem, it helped a lot.

2 November 2007

Opposite: Billy Taylor at IAJE Convention, New York, 2004

Illinois Jacquet
(b. 1922)

Hank: *Tell me a little about your musical experiences before you joined Lionel Hampton.*

Illinois: I was playing alto in those days, in Houston and then in California. I was just a kid. One of the best bands I ever played with was in Houston at the time, Milton Larkin's band.

H: *I don't know much about that band. Tell me about it.*

I: Milton Larkin was a trumpet player. He had a band down in Texas that was one of the greatest bands I ever heard or ever played with. Arnett Cobb, Cleanhead [Vinson], all sorts of good players came out of that band. I was with that band when I met Charlie Parker in 1939. There were many great bands in Texas. I remember my brother and father talking about Alphonso Trent. That band played all over Texas—they were so good they even were allowed to play in white hotels in Dallas. Another was T. [Terrence] Holder—my brother talked about him. These guys were sharp. They worked the biggest white hotels in the south. Milton Larkin came later and was just as good. One time we battled the Jimmy Lunceford band in Houston. We'd heard all their records. We played all their charts and we played all our charts,

and when we got finished, they didn't have anything left to play. Our band was something else. When bands came into town, they'd come in and catch us when we played after hours. I remember Basie came to town and after they got through, they came up to hear us, to see what these kids are doing. Boy, we shouted down on them. Herschel [Evans] got up to go but he came back, sat down, and stayed till it was the last note cause he was from Texas. He knew what was happening. It was an unbelievable band.

H: *I never heard about any recordings by this band.*

I: It never recorded; they were supposed to make some, but it didn't work out. I asked him about it and he didn't know anything about it. So I can see why he broke up his band. He wasn't too into what he had. He didn't know the band was as good as it was.

H: *You said you met Charlie Parker in 1939.*

I: Yes, I was playing alto, and he took me to a club in Kansas City, and we jammed. We started off with a rhythm section, but it wound up it was just the two of us playing. If you could play, he'd play with you all night long, and he was really

Opposite:

Illinois Jacquet, 1996

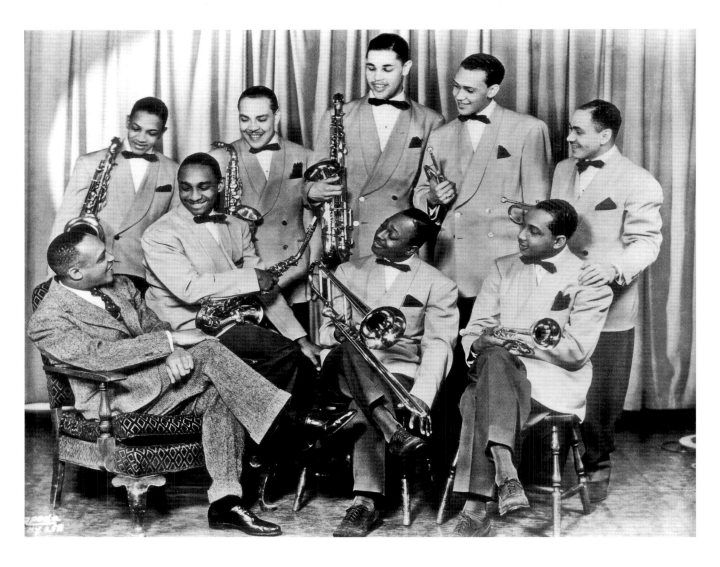

Illinois Jacquet with Lionel Hampton and members of his orchestra, 1941

playing that night—he was unbelievable, and he told me I was "something else." I can tell you he was playing just like he was playing before he died. I don't know about his personal problems—I didn't follow him when he went in those dark alleys. They say it was his father who first turned him on. But playing with him and people like him were an inspiration. I learned you had to play with professionals.

H: You first came to prominence when you were with Lionel Hampton. What were the circumstances of you joining his band?
I: I'd gone to California with Floyd Ray in 1941, and people started talking about "that little alto player from Texas." The

musicians union organized a picnic every Labor Day, and after a parade, all the musicians would wind up at the union. There would be a big jam session, and that's when I first met Nat King Cole. He told me he liked the way I played and wanted to organize a session with a quintet. He'd be on piano, I'd play my horn, and Jimmy Blanton, Sid Catlett, and Charlie Christian would make up the rhythm section. That sounded great to me, since I'd fallen in love with the [Benny] Goodman band after I'd heard Charlie Christian play "Solo Flight." He played like the horns. He ran chords, and the way he played, we understood his language. He played like Lester [Young] and other saxophone players. When I heard him, I said to myself I had to play

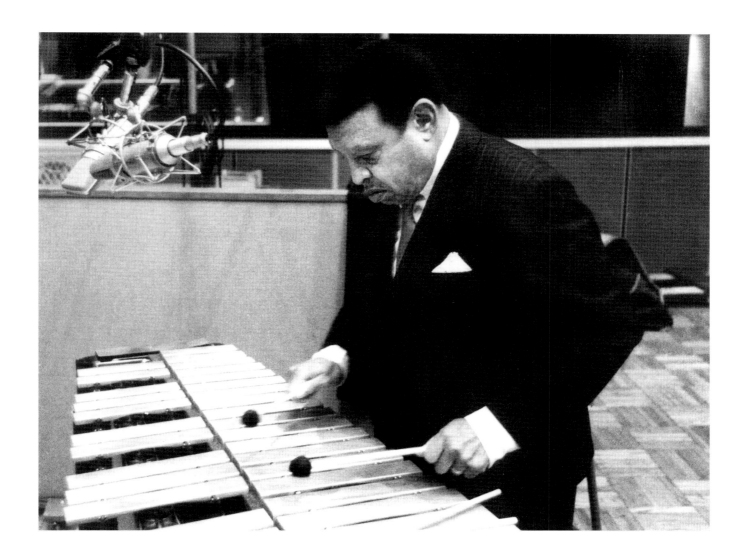

with him, and that's when I began to realize you had to surround yourself with the best players because they'd help mold you—they'd inspire you to be a better player. I'm sorry Nat never arranged to make those recordings.

H: Then you joined Lionel Hampton?
I: Yes, it was 1941, and we left Los Angeles by bus. I figured I was in the big time. We jumped from Los Angeles to Ft. Worth, Texas, and when we got there I figured we'd walk right in the front door. Not that night. It was bang! right up the service elevator. We had to stay at a terrible hotel. My cousin was a principal of a high school in Ft. Worth and he heard I was there, and he came and got me out of the fleabag where we

were living. The screen door on the place was broken, but the mosquitoes were so bad they'd come right through the screen on their own even if it wasn't broken, and they were eating me up. This was Texas, man. Then we jumped to another place and finally made it to Houston. We were going to New York City but stopping all along the way. When we got to Houston, I took Dexter [Gordon] and some of the other guys to my house. My mother threw a party for us, but I remember we all had to take off our shoes because it had been raining. It was about this time I "quit" the band for a short while. They were going to St. Louis, and they left without me. I planned to take an airplane and catch up with them. At that time people weren't flying in airplanes very

Lionel Hampton, RCA recording studios, 1990

much, and it was an awful feeling to get on a plane and not to know what to do when it's taking off. You don't know how to sit down. You don't know what you're doing. You don't know what's holding you. I got to St. Louis and went to the Crystal Ballroom. Hamp came up to me and said, "Hey, man, who do you want to fire? How did you get in here?" I guess he thought I was mad at somebody, but I was just mad at what we were going through with that bus. Hamp told me, "You're back in the band, but you're committed now. You're going to be out there where you're going to play towns you never heard of, places like Bogalusa, Louisiana."

So I stuck with the band, and we finally began getting closer to New York. We're in Norfolk, Virginia, and run into Jimmy Lunceford's band in this colored hotel, and they all were there, all the same guys I'd seen in Texas. They'd all heard me playing alto, and they all wanted me in their band. Willie Smith and I started talking, but then he finally told me the band was going deep down south and we were just coming out of it. I said, "Bye." Hampton's raggedy bus headed north and we finally made it to the George Washington Bridge, but when we got there, we were told to get out of the bus and take all our things with us. The bus was so bad they didn't think it would make it over the bridge into New York. We had to get all of our bags, carry them across the bridge, and then another bus met us and took us to Harlem, to the YMCA on 135th Street. I thought we were going to stay at the Hotel Theresa! I woke up the next morning and went to the men's room and I said, "What is this?" You talk about a cat going to the desk and checking out to go anywhere. Oh, man, that place was something else.

Quite naturally, all of us wanted to go to the Apollo Theater to see what it looked like, and when I got down to 125th Street I thought I was on Broadway. I saw all those lights—at that time everything was glittery. If you'd never been to New York and you saw that, you never forgot it. That night we went to the Savoy. You saw places you'd always heard about. You're nervous, you're young, you just got to town, and you're at the Savoy. Erskine Hawkins and the Savoy Sultans have all the people dancing. This was the place where there was action.

H: Where did the band play when you arrived in Harlem?
I: We didn't play anywhere. We rested up to go to Chicago. They must have fixed that old raggedy bus and then they put us on it and we were off to Chicago. At least it had a heater in it, because when we got to Chicago, it was buried in snow. I went to sleep and figured there'd be nothing going on that night. A foot of snow and we were lucky to get to the hotel to get some rest. We were supposed to open that night at the Grand Terrace, and they like to broke my door down. I didn't think anyone would go out in that snow, but the place was packed. People in Chicago were used to going out in a blizzard. You couldn't even get in when you got there. We had a good run in Chicago and then headed back to New York.

H: Then you got to play in Harlem?
I: When we came back to New York, we went into the Apollo Theater, and it was unbelievable.

H: Had you recorded "Flying Home" yet?
I: Not yet, but I was warming up to it because that audience was giving me the signal to go ahead. They were saying keep on doing what you're doing. I'd

been playing it in Chicago and you could tell—the audience always lets you know. When we opened there, the Apollo still had its magnitude; old man Schiffman was still running the theater. He's the only one that could run that theater. Old man Schiffman made it work because he lived that theater; it was his life, you know. He got all the bands to play there. He gave the public the best music, the greatest big bands in the world. No matter how famous they were or what

Harlem YMCA, 2007

Illinois Jacquet at the
Apollo Theater, 1947

color they were. Benny Goodman played it, Buddy Rich—all the bands played the Apollo Theater. That was the thing—the best shows, all the greatest comedians, especially Redd Foxx, who I adored. It was just fantastic, Harlem was fantastic, there were places to go, things to do all the time. On the day we opened, Billie Holliday was also on the bill. We played first, and I played "Flying Home," and the applause must have gone on for an hour. I don't know why, but she was backstage and had to wait to come on. The audience went wild, and I took a pencil and piece of paper and tried to write down what I'd played, to give me an idea of what to put on the record, if we recorded. Many people had already recorded that tune

before. Benny Goodman had done it, and others had done it in different way. It was Charlie Christian's tune—they took it from him, all the people who put their names on it. He didn't know anything about what he was playing, and everything he played was a masterpiece. Somebody else would hear it, write it down, and they were gone. But then we started playing "Flying Home" every night, all the time. It was a crowd pleaser.

H: When you were with Hampton, did you just work at the Apollo or did the band appear at other places?
I: We worked at the Savoy, and I remember one night we battled Count Basie. Basie was blowing us out up until

we got to the solo on "Flying Home," and then Basie packed up. I loved the Savoy—they had battling bands in there, and if you weren't ready, the Savoy Sultans would throw you out of there. It didn't matter what you'd bring in there, if the Sultans were on that other stage, you better be ready, because they had that dance crowd under complete control.

They'd have them weaving together, bobbing up and down and racing around. They were something, and they were also at that show. I remember it was a Sunday; they had matinees in those days, and Basie started the matinee. That was the format—one band would start early, and when the early show was over, the other band would come on about eight

The Apollo Theater, 1996

o'clock. Basie had Jo Jones right in front of the band. He was playing like he was directing the band. He had some kind of a way of playing. Boy, what a show that was when they put him out front! Basie was smart; he took Jo from the back and put him out front, and he was fantastic. What a drummer! They put him in the front. They really made it tough for us because the Basie band was really hitting, and then Hamp's band hit and was trying its best to get off the ground. Buchanan knew about "Flying Home," so about time we went into it, he turned all the lights off, and you could hear those padlocks on those back doors. The back doors looked like they were going to bust open, you know, and then we went into "Flying Home" and they turned the lights on and all you could see were faces and heads, and when we started playing the whole audience jumped on the floor. I thought the place was going to explode. The excitement the Basie band had going sort of ceased after that, but if you didn't have that kind of finale, you were dead.

H: Tell me why the Savoy was so important in Harlem.
I: Harlem was jumping in those days, but the Savoy Ballroom was the most jumping place. It was probably one of the most popular places in all of New York, not just in Harlem. You'd go to the Savoy for dancing or listening, but the truth was, the dancing you'd see at the Savoy you'd see nowhere else in the world. Not in the movies, not anywhere. It was a dream to see those people dance to the big bands in the Savoy. That in itself was worth seeing.

H: Did any of the hostesses teach you how to be a Lindy Hopper?
I: I was a dancer before I got to New York. I could tap dance, but what those dancers were doing was nice and special

because what they were doing, they were doing with perfect steps in time with the music. They knew what they were doing. They knew the bands and they knew the soloists. They knew what was going on. They threw those chicks over their heads. Threw them under their legs, and they would catch them, and the band would hit a chord, and all was in perfect time.

H: You stayed with Hampton a year or so longer and then joined Cab Calloway. What prompted you to leave?
I: It was after "Flying Home" came out. We were in Jacksonville, Florida, playing at a place called the Two Spot. I was at a hotel up on the third floor, and a sound truck came by playing my solo. I thought I'd jump out the window. You couldn't get near the Two Spot that night, and something told me if I stuck with the band, I'd be playing that song every night, all night long, and it would be too much. I looked at myself in the mirror, saw I'd gotten very thin, and I said to myself, When we get to California, I'm going to leave the band. I was loyal to Hamp, though, I didn't just leave. I arranged to have Arnett [Cobb] take my place. They wrote out my solo and he had to play it every night. Hamp made him play it so much, I'm sure he thought he made it.

H: You then joined Cab and after a couple of more years worked with Count Basie before you went out on your own for good.
I: I learned a lot from working in those bands—how to be a professional, how to take care of business, to deal with managers and the other people in the music business.

H: When was the last time you played uptown regularly?

Opposite: Illinois Jacquet soloing with his big band, Floating Jazz Festival, 1995

I: It was sometime in the 1950s, the late 1950s, at Count Basie's. I don't remember all the details except it was something Basie wanted me to do, a trio with Milt Buckner and Jo Jones. You couldn't get in the place; people crowded in that little bar and stayed all night. It just proved that even with Harlem on its last leg, if you gave people something they wanted to hear, something they couldn't hear downtown, people would come uptown to hear you. There was still some activity up and down Seventh Avenue in those days, and you know what? I wish they'd leave those street names alone. There's Martin Luther King and Malcolm X.

H: Don't forget Frederick Douglass.
I: Now, you really don't know where you are with that one.

H: There's a new one next to the Apollo Theater, Nat King Cole Walk, but it seems to just be a street sign without a street.
I: No street? They should do better than that for Nat. He was one of my good friends. No street? Give him something, at least a barbershop or a movie theater. Why should he just get a sign?

H: Why do you think jazz, and almost all live music, just vanished uptown? What ran it out of town?
I: Things within Harlem itself. Many of the people who came to nightclubs seemed to stop coming to them. Clubs started closing when drugs started taking over Harlem, and people stopped coming up there. The drug scene became so overwhelming and the place looked so bad, like it was running down. Nobody wanted to go to Harlem because its reputation was so bad. I still think that Harlem could come back. I think this project to build those movie theaters and the stores that's scheduled to take place on 125th Street will rejuvenate Harlem. It may bring people back because Harlem is, after all, one of the most beautiful sections of New York City. There are some beautiful buildings up there, and some of those big apartment buildings will last forever. It's just that Harlem has to clean up. They have to clean up the mess that's there, and I think that this new building will be a good start. I'm told they're going to have a jazz club in it. One of the things they spoke about in the paper was the concert hall and the theaters, and that's the way to go, the way they do things in Europe. I was just in Germany—the band did concerts in four cities. We played in new concert halls, and the tickets were sold by jazz organizations. You could even buy the tickets in department stores. You've got to modernize things today, give people good places to go and bring the best attractions you can give them. They want something for their money and they want to go to a first-rate place where they'll feel safe. If they do it right in Harlem with this new building and bring in the right kind of entertainers, it might be a success. It might start things going for all of Harlem. Things have got to change up there, and this might be the start. I hope so.

H: They had a big tribute concert for Lionel Hampton at the Apollo in March. It was good to see jazz musicians at the Apollo again.
I: I couldn't be there. I was in Germany.

18 April 1996

Illinois Jacquet at home, St. Albans, New York, 1996

Frank Wess
(b. 1922)

Hank: *Tell me about your early days in music.*

Frank: I was born in Kansas City but was raised in Sapulpa, Oklahoma, and came to Washington, D.C., when I was thirteen. I started playing alto when I was about ten years old. I went to college when I was fifteen, and I've been working since I was sixteen. My teacher in Washington, D.C., was Henry L. Grant, the same man who taught Duke Ellington and Billy Taylor. I worked in kid bands in Washington and some dance bands. A little later I got a job in the pit band of the Howard Theater. I remember jamming with Al Casey in the basement of the Howard when he came through with Fats Waller. Fats was so drunk that night they had to take him to the hospital and pump him out. When they got through with him, he was as light as you are. Musicians drank a lot in those days.

H: *When did you leave Washington?*

F: Well, I was in and out for a while and then I went into the service. Blanche Calloway took over the pit band at the Howard for a New England tour. It was a good band and we went all over New England, but we never made it into New York City. We played at one place, the Highway Casino, for about six months, accompanying old stars like Ann Pennington and FiFi D'Orsay. George Jenkins was on drums, Ray Perry on alto—both those guys wound up going with Lionel Hampton. I was supposed to go with Hampton but it got messed up. That's probably how [Illinois] Jacquet got the job—he was an alto player then, just like I was.

H: *What happened?*

F: We had our run in New England and then in Atlantic City. I had signed a contract to play in a band for Bill Robinson at the Southland in Boston, but I'd been jamming with a lot of guys in Hampton's band that summer. We used to work from ten until four, and afterwards the guys from Hamp's band would come in and jam, so I got to know some of them. Hampton seemed to be interested in some of us, and after we played a dance in Philadelphia I was getting ready to go to New York and join the band. We were down at the bus station getting ready to go to New York when some of the bookers came looking for us. George [Jenkins] and Ray [Perry] spotted them and ducked out, but they caught up with Rufus [Wagner] and me. They told us we'd signed the contract to play in Boston with Bill Robinson, and if

**Josephine Baker poster
featuring Frank Wess, 1943**

we didn't honor it, they'd report us to the union and we'd never work again. I made the job, went to Boston, and made my seventy dollars a week, which was good money in those days. I was just a kid, but I was already married and had a son. He was born in 1940, when I was eighteen. I remember I messed up one night in Boston. I was having some trouble with Bill Robinson, and one night I got so drunk I passed out onstage and they had to drop the curtain.

H: After you'd missed out on the Hampton band, what was your next musical stop?
F: Uncle Sam. Rufus and I both went back to Washington and joined the army. You see, I'd been in the ROTC band at Howard University, and the man who

ran that band was already in the army, assembling professional musicians for large orchestras. He was offering a good deal: You got a musician's rating the day you enlisted, and you didn't have to do any basic training—all you did was play music. I signed up, and it wasn't too long before I found myself in charge of a seventeen-piece band. We were assigned to a field engineering battalion and shipped out to Liberia, and it took us thirty days to go from Charleston, South Carolina, to Liberia, and then when we got there wasn't any place to dock. We had to climb out of that ship on a rope ladder and go onto shore in a rubber boat. We were in Liberia for a while and then we were told we were going to North Africa, so it was back on another boat for the trip to Dakar, then Casablanca,

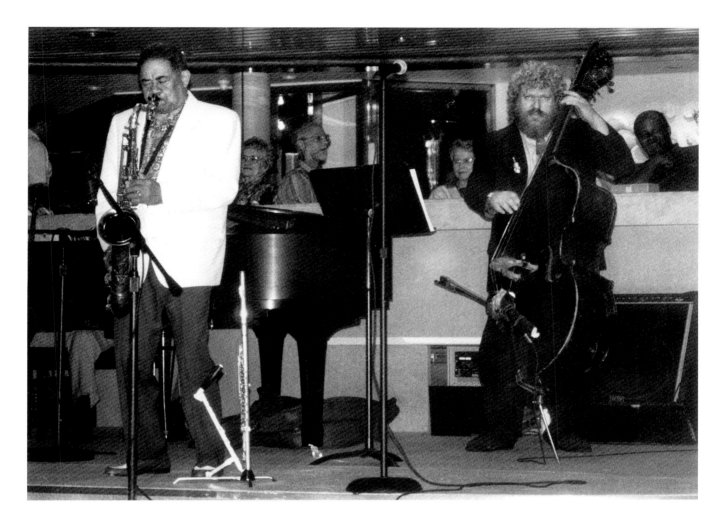

and finally into North Africa. This was in 1943. We were sleeping on the ground, and even though we were right on the equator, it was cold as hell. Bombs were going off all the time, and we'd have to jump in a hole somewhere. Then I heard that Josephine Baker was going to be entertaining in North Africa and was looking for a band, so I went down to Special Services and put our name in. We got an audition and when she came out I played six of my best arrangements and the band was romping. It was a helluva band. And then she showed us one of her arrangements and said, "Let's see how you do with this." The tune was "Lull in My Life," and I had to conduct it. When we finished, she said, "You got it," and from that point on we played for French, American, and English soldiers with Josephine Baker. She got us attached to

the French Army for rations; everybody loved her anyway, but they loved her even more when she did that.

H: It sounds like you enjoyed that part of your duty.
F: Are you kidding? I couldn't wait to get out of there. I got to Africa six months before the invasion. I watched all those planes take off from Liberia—that's why our engineering battalion was there, we built the field those airplanes took off from. When we got there, we played all over North Africa, Oran, Algiers, places like that. Sometimes we had to stop shows because bombs were going off. One time one of my trumpet players never did come back after a bombing raid. We all came back to finish the show, but that one guy never came back. You can have your French rations and getting

Frank Wess, *left,* and Lynn Seaton, Floating Jazz Festival, 1994

lost in the Casbah. Hell, sometimes I couldn't find half my band. If I'd see one of the guys, I'll tell them to tell anyone else they saw to come on in. I did almost three years over there. But Josephine Baker was a beautiful person. I have an old newspaper clipping of the two of us together.

H: Did you finally make it to New York City after the war?
F: It was 1946 and I joined Billy Eckstine's band for about a year. I was in there with Jug [Gene Ammons], Fats [Navarro], Art Blakey, Hank Jones, and some other good musicians—people like King Kolax, Bill McMahon, Jerry Valentine, Howard Scott. You know, it just came to me. Howard Scott. I've been trying to think of his name for years. He's the little trombone player in all the pictures that is identified as "Unknown." It just came to me, he's Howard Scott—we used to call him Bags. It was some band. I have a picture somewhere of some of us standing around together at the Club Sudan on Lenox Avenue.

H: The Club Sudan was on the site of the old Cotton Club. I don't think it lasted very long. Tell me what you know about it.
F: It was a large club and they had a big chorus line, maybe sixteen girls. Blanche Shavers, Charlie Shavers's wife, danced there, and so did Esmerelda, who was married to Charlie Rouse. She used to dance right in front of me. They all danced in there, and I remember Gloria Vanderbilt used to come up there all the time. When I was there it was the band, Billy, the chorus girls, and a comedian. I remember I had a big feature with the band. Jay Jay Johnson made me an arrangement on "Yesterdays," and he wrote me a hell of an arrangement. We used to play it slow; then I would double

it up; then I would triple up. Yeah, it was a big hit with everybody. Tadd Dameron was also writing for us. His music was a little different, but you could still dance to it. This was about the time people started playing more concert music, but what we were playing wasn't so different from anybody else. We stayed at the Sudan for a couple of months, maybe a little longer but not much. I don't remember what happened to the place; they probably tore it down. We went out on the road and played one-nighters. We never played the Savoy. People just didn't dance much with this band—there was just too much happening.

H: Were you close to Fats Navarro?
F: I loved that man—he was something else. I remember I was working with Eddie Heywood at the Apollo and I came out after a show and was walking up by the Braddock Hotel. I heard a voice say, "Hey, Fletch," and I turned around and it was Fats. He looked so bad I nearly cried. I hadn't seen him for a while, and during those weeks we were together at the Sudan, we used to get to work early every day, just the two of us. We used to sit down in the dark facing each other and blow, just the two of us. He'd say, "What you wanna play, Fletch?" and we'd start playing, every night, just the two of us.

H: You played with a lot of people after Billy Eckstine broke up his band. Were any of the jobs memorable?
F: I went with Eddie [Heywood] after Billy broke up his band, and then when his band failed, I went with Lucky Millinder. I left that band before it broke up—my brother drowned, and I was very upset. It also bothered me the way Lucky used to ride some of the men in the band. He never bothered me—we always got along fine—but he used to

heckle almost everybody else, so I finally had enough of that and split. I joined up with Bullmoose Jackson for a while and then went back home to Washington. I was still very young; I was twenty-six or twenty-seven. Ray Perry used to always say to me, "You're the youngest one now, but just you wait, because one of these days you'll be the oldest one." He died about a year later, and he was something else. He's the one someone should have recorded. He played violin and alto and he was a bitch on both. He was with Hampton but never really got a chance to play. Then he played with Lunceford until Jimmy died. I remember I caught Ray down on Fifty-second Street in about 1946—it was when I was still with Billy Eckstine. He was playing alto just like Bird [Charlie Parker] and a customized fiddle that he could make sound like a tenor.

H: You joined Count Basie in 1953, and many people remember you from the years you spent with that band.
F: Hell, I haven't been with that band in thirty years, but that's the band that made Basie rich.

H: Did you ever play uptown with the Basie band?
F: Maybe once or twice at the Savoy, possibly at the Apollo, but there weren't many places to work uptown when I was with Basie. This was a different band—it wasn't like those bands he had before and just after the war. Basie had some terrific soloists with his old bands, but he starved to death with them. In fact, it was still a sad-assed band when I joined them in 1953. It just sounded bad, and they didn't have enough music. But we tightened it up, got some new music and some new players. Men like Sonny Cohn, Eric Dixon, Thad Jones, Joe Newman, Bill Hughes, people like that. You see, Basie

didn't know anybody, and the people who were in the band were brought in by people who were already in the band. I got a lot of people in the band—I brought in Thad Jones. Then we started getting those good arrangements, Joe Williams started having some hits, we made "April in Paris," and the band made Basie rich. Now John [Hammond] didn't like the band—he liked the old band. He'd come down to see us at Birdland and read his paper and the place would be packed. You couldn't get in the place and there was John, reading his paper. He didn't care about us, and we didn't care about him.

H: You almost single-handedly established the flute as a jazz instrument when you were with Basie. Did you have to write your own arrangements that featured flute?
F: It wasn't easy. I remember one time we were doing the *Tonight Show*, when Steve Allen was there. We were supposed to play "One O'clock Jump" and Basie said to me, "Why don't you play the last four notes on flute?" Now I don't know why I thought I could hit a high D-flat after playing my tenor, but I tried, and it came out do-do-do-phhht. At the end of the show a comic who was on, Lenny Kent, who had a routine where he reprised the entire show in double talk, ended his bit with "do-do-do-phhht."

H: Did you or any of the other guys in the band ever play at Basie's little club on Seventh Avenue?
F: No, but I used to go up there all the time to hear Lockjaw. He loved to play up there, and Basie just loved Lockjaw. He was always in the band. He could come back anytime he wanted to, even if there wasn't a place for him. He could just come back home.

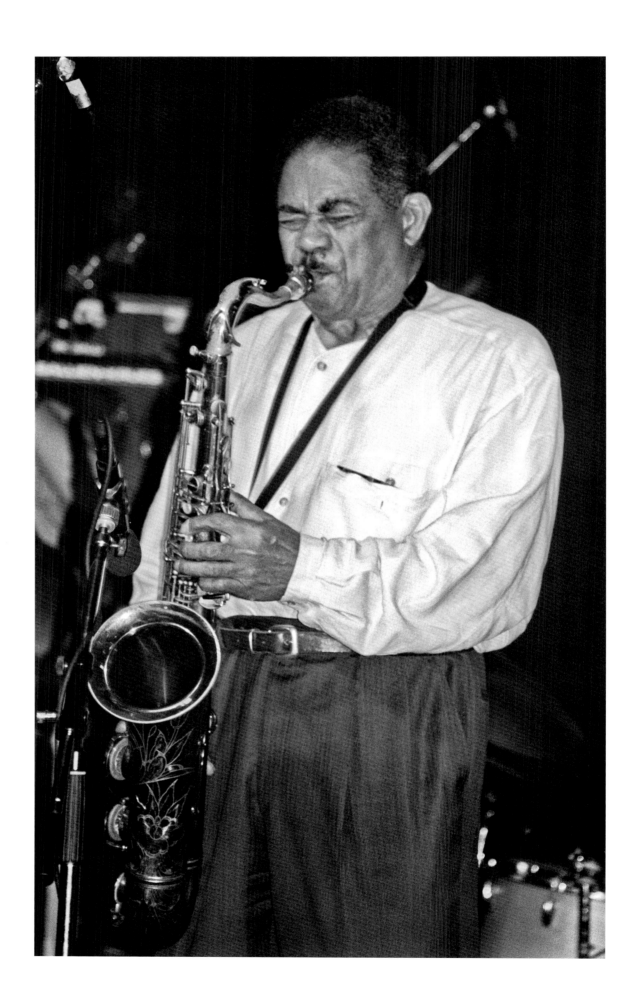

H: Do you remember any places where you used to go and jam?

F: Not many, but I do remember going to a place down on 110th, I think, called the Paradise. Big Nick [Nicholas] used to play there. Hot Lips Page used to turn up there before he died.

H: Do you remember the last time you played uptown?

F: No, but it must have been a long time ago. I just can't remember. It's changed so much up there, man. I used to live up there. I had a room up there for two or three years in the last of the 1940s and beginning of the 1950s. You know, then I walked the streets all night, I'd be hanging out in the after-hours clubs, and I'd never get home before eight in the morning. Everybody knew everybody and there were no problems. Now you can't do that, and I don't get uptown too much. I go up sometimes. When I want some soul food, I'll drop by Sylvia's and pick up something, especially if we're having a party here.

H: What do you miss the most about Harlem the way it was?

F: The people, I guess. Did I tell you I spoke with Andy Kirk just before he died? I knew he had Alzheimer's but I wanted to talk to him. His nephew or somebody answered the telephone. I told him who I was, and he said I should wait a minute, he'd see if Andy recognized my name. Now I'd first met Andy when I was a kid in Oklahoma, and I hung out with Dick Wilson, one of the guys in his band, a great saxophonist. He got on the telephone and said, "Hey, Frank." He remembered me, and we talked for a little while. I just wanted to thank him for being so nice to me when I was a kid.

18 March 1996

Opposite: Frank Wess, Oslo, Norway, 1994

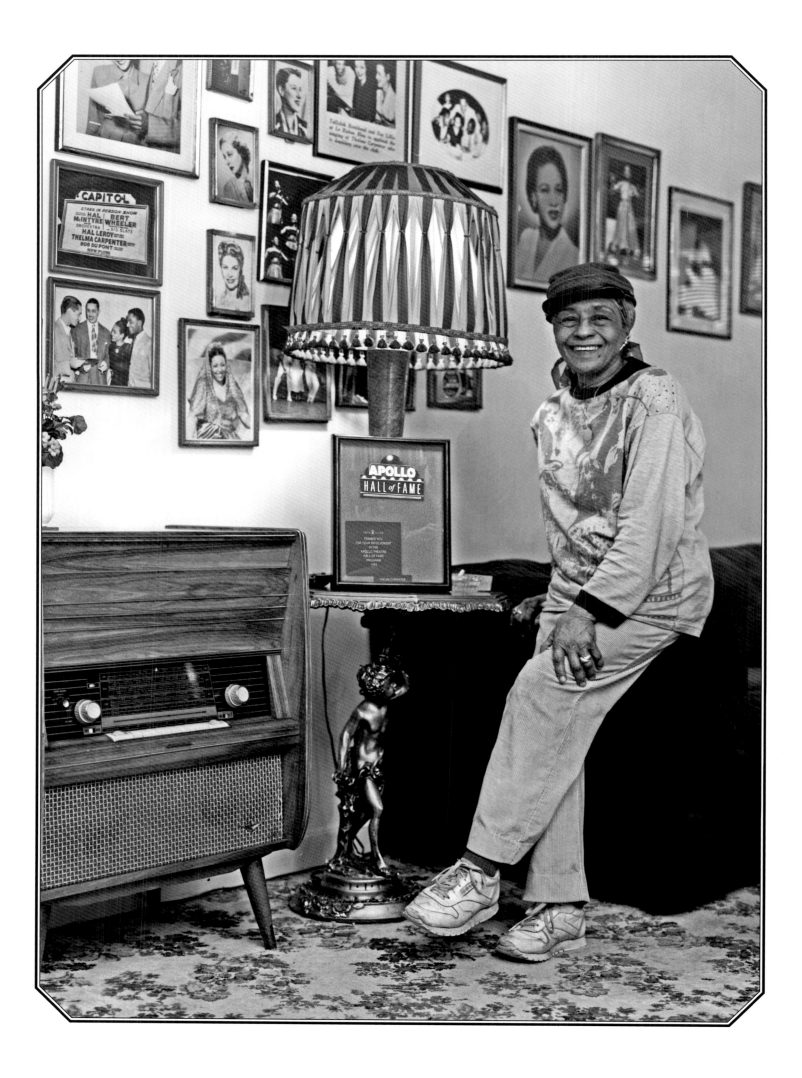

Thelma Carpenter
(b. 1922)

Hank: Tell me about winning the amateur contest at the Apollo.

Thelma: Well, you know, I'm from Brooklyn. They used to say you needed a passport to go from Brooklyn to Harlem, and you just had to go to Harlem in those days. We'd usually go after Sunday mass—we would be a group of girls, and we'd be allowed to go to the Apollo for a show. Sometimes I'd be the only colored girl in the group; most of my little girlfriends were white. It was a wonderful experience just to be able to walk around up in Harlem—it was just glorious! I was just a little kid, eleven or twelve years old, but it was just fantastic to see everybody all dressed up on Sunday. I loved Lenox Avenue. It was like a fashion show. In those years Lenox Avenue was one of the most famous streets in the world, like the Champs-Elysées in Paris or Piccadilly in London. Everybody who came from Europe wanted to see Lenox Avenue, and it was so glorious. We were only allowed to see one show on Sunday, and then we had to go back home. After I'd seen some of these shows at the Apollo, I found out about the amateur night and decided to try out for it.

H: *When did you start singing? And who were your first influences?*

T: I was raised on Ethel Waters's records. Ethel Waters was the only thing my mother and father agreed on—they fought about almost everything else. I started to sing when I was about four years old. And I could always read; I don't remember when I wasn't able to read. I don't know how I started, but I know in our family, the first thing they did, as soon as you started walking, was to shove a book in your hand. I had all the nursery rhyme books and I could read them. I must have been about six years old when I first sang on the "Kiddie Hour" on WNYC. They wouldn't announce me as a little colored girl; they would say something like, "Now for our little coon child, Thelma Carpenter." It wasn't so much a matter of me being white or colored, it was the way I sang the song. They wouldn't necessarily say that about Baby Rose Marie or Mary Small, but if they'd sung words like "Lazy bones, sitting in the sun, how you gonna get your day's work done," it might be considered coon shouting—but not necessarily about being a coon. A white girl could sing the same thing, but when they called me a "little coon child," it was their way of saying I was brown-skinned. I had a funny childhood—some freedom to do things like go to the Apollo on

Opposite:

Thelma Carpenter, 1996

Sundays, but it was important to always be home on time. I skipped some grades in school and had a little celebrity from being on the radio.

H: Tell me about the night you won the amateur contest. You were almost a professional when you sang there, since you'd been on the radio for a few years.

T: I was twelve years old but looked like I was about eight and sang "Stormy Weather," word for word from Ethel Waters. My mother had kept me in curls like a little Shirley Temple. I sang with Willie Bryant's Orchestra and I had a pretty good voice, but what did I know about stormy weather? I'd sing words like "There's something inside my heart that cries, it cries but wants to live," or "I must have a heart to sing to, or my song won't be sincere," that kind of thing. What did I know about that? People would look at me and say, "How old is that kid?" But you see, I had all the records. I just played them all the time and learned the words. After I won the contest, I remember telling my teacher I wouldn't be in school for a week because I had to do a show, and somebody sent a truant officer to the theater. They hid me for a while, but then I did my lessons and I got to do the shows. I just had the right kind of thing to win the contest. I'd been singing so long so by the time I was twelve, I was like a veteran. People used to say I was a midget.

H: Did you have arrangements for your songs, or did the band just accompany you with head arrangements?

T: In those days you just went and sang your song, and those men in the band would just follow you. Forget it with

arrangements—I didn't know anything about written arrangements until the 1940s. There were no arrangements. Everybody knew the popular songs, and I would just say, "I want to sing so and so and so," and the piano player would go into it. All you had to do was talk it and the musicians would pick it up and accompany you. A good accompanist is very important. I had some good ones and some that weren't so good. I was very lucky to have Garland Wilson for a few years, and he was just fantastic. Crazy and evil sometimes, but fantastic. I never forget, Garland refused to have a piano in his house. I remember I went to the movies one day and heard Bing Crosby sing "You Keep Coming Back Like a Song." I called Garland up and said, "Garland, I've got a song," and I'd sing, "You keep coming back like a song, a song that keeps saying remember the sweet used to be, that was once you and me," and then it was always the same routine. He'd go get a glass and a fork and say, "Start it again," and I'd hear him hit the glass with the fork. Later that night when it was time for the show, he'd have it down, a complete arrangement. The left hand would be doing one thing and the right hand another.

Nobody ever gave Garland the credit he deserved, because he could outplay anybody—anybody—and he couldn't read a note of music. He told me when he was a kid in school they kept keeping him back because they needed him to play in the assembly. He was some musician. All I had to do was call him up. He'd say, "Wait a minute," get the glass and fork, and tell me, "No, you're going to do that in D-flat." He was a genius. Here's an example. Once I was booked with Eugene Ormandy and the Philadelphia Orchestra to sing at Robin Hood Dell. I had to sing some songs, and there were complicated

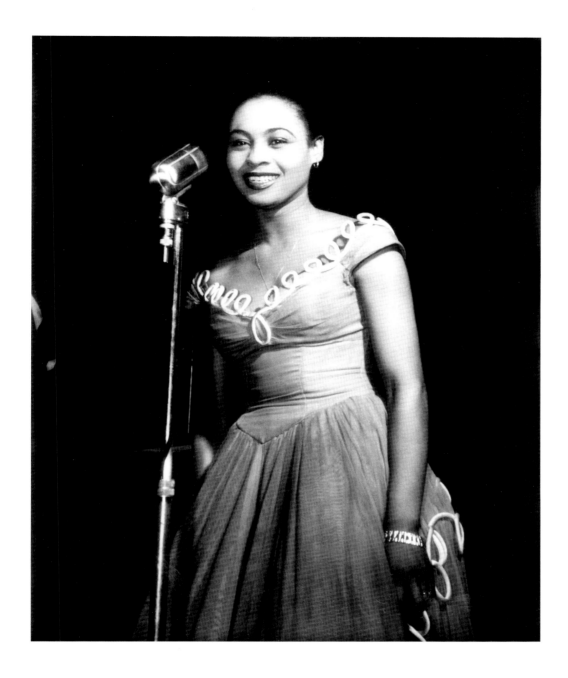

arrangements. Garland couldn't read a note of them. I was singing, and all of a sudden I get the feeling that something's going on and I look around and there's Garland conducting. He just got up and started with that left hand of his. That left hand was a weapon, and he couldn't read a note of music. The few records he made don't do him justice.

H: You were very young when you made your uptown debut, but since you were *so young, were you able to learn from older performers?*

T: You bet. I'd stand around backstage and talk to people, the other entertainers who were there. Not just the jazz players or the guys in the band, the entertainers, the singers, the dancers. I got in on a lot of great acts, people like Butterbeans and Susie. These days nobody wants to know what older entertainers have to say, but I'd go and sit in their dressing rooms and ask questions and they'd tell me about

Thelma Carpenter, Lincoln Hotel, 1944

Thelma Carpenter
at home, 1996

vaudeville and the chitlin' circuit. They'd tell me about show business and, believe me, many of them could do it all. The juggler could play the piano if he had to. Even in later years, when I worked at theaters downtown, some of the acts were fantastic and you could learn from them and they helped me very much. Those real vaudevillians were very clever, and I tried to pick their brains. When they used me to break the color line in some theaters, what I'd learned from them over the years was very useful. They used me because I was little and cute and wasn't a threat to anybody, and I was the first colored entertainer in a lot of places. The other thing that I learned in those early days was how to sing with a band. It's the best training in the world. Frank Sinatra lasted as long as he did because he started with big bands; he learned that way, and so did I. He got the discipline of working with a band. He might kid around onstage but when he was ready to sing, he wasn't playing.

H: You worked with a number of big bands. Which one was the first?
T: It was Teddy Wilson, just after he'd left Benny Goodman. It's a weird story, but honest to God, this is the way it happened. I'd just graduated from high school. I had a diploma and everything, even my first high-heel shoes. I was sitting in a drugstore near Times Square when a blond man sitting at the counter, someone I didn't know, looked at me and said, "Thelma, Teddy Wilson is going to form a band and he's looking for a vocalist." I was surprised, but to be polite I said, "I'm sure he's going to go with Billie Holiday." The man said, "I don't think they're going that way. They want to go young." Now, Billie is young, but not as young as me, and, so help me God, this blond man takes me by the arm, walks me across the street to the Taft

Hotel and upstairs to a recording studio where John Hammond is recording Mildred Bailey. The man went in and said something to Mildred Bailey, and then when I went in, Mildred said, "John, come out here, I have something cute for you." She interrupted her recording session and let me sing a song. I did "Embraceable You," and everyone seemed to like the way I did it. When I was finished, I looked around and the blond guy was gone. After I talked to the people there, I went back downstairs and over to the drugstore. I asked the man at the counter, "Did the guy who took me out of here come back?" He looked at me and said, "You didn't go out of here with anyone. All I know is, you got up and left." I said, "Come on, you're pulling my leg, this guy walked me across the street to the hotel for an audition." I never saw the man again, but I got the job and was with Teddy for over a year. It was my first steady job with a band, and it was great experience, even if Teddy was a little weird. I'm not putting him down, but he was a little strange. We toured some, played uptown at the Golden Gate—a big old ballroom that was in competition with the Savoy—and I even recorded a few songs with the band. Teddy's band wasn't successful. It was a good band, but a lot of people said it sounded too white. They even said I sounded too white.

H: Tell me about Coleman Hawkins and "Body and Soul."
T: I joined Coleman Hawkins after I left Teddy Wilson, in the fall of 1939. You know, he did that off the top of his head one night at Kelly's Stables, before I went with his band. He was always in the back there, always sitting and writing. He'd take a piece of paper and would just sketch something and go on the bandstand and he gave the pieces of paper to the men. The night he played

"Body and Soul," it blew everybody away. When I joined the band, he kept playing it, and one night at Roseland, I decided I'd ask him about the song. Now remember, I'm only sixteen or seventeen and because of the way I was brought up I wasn't thinking about too many sexual things, but somehow I knew there was a sexual connotation somewhere in that song. So I turned to Coleman and said, "Coleman, guess what?" And he probably said, as he did so often because I was always asking him outrageous questions, "Oh, God, here she comes again." Because I used to ask these outrageous questions. I said, "Tell me about 'Body and Soul.'" And of course he starts looking around and not knowing what to say. Now, Coleman is an old yard dog but he always looked out for me, and said, "You don't know about it, but it's like making love, you know," and then he said, "Now, excuse me, but you don't just hop on somebody and hop off, you lead her up to it." I'm sitting there thinking to myself, Lead up to what?

Later on, when I realized what he was talking about, I said to myself, "Wait a minute, you've been listening to music all of your life and now it's making sense." I went home and said to my mother, "Come on over to Roseland tomorrow night and listen to Coleman Hawkins play 'Body and Soul.'" She said, "Why should I?" And I said, "Mother, because there's something going on there you should hear." She showed up, and because she was so pretty Coleman came over and joined us at a table. He was a real gentleman and felt more secure talking with her about the song. He talked about how the song was just like making love to a woman, and I thought this was fantastic, but I never figured it out on my own. I remember when he played that tune at the Savoy, the people just stood around listening.

There was no dancing when he played "Body and Soul." We were a big hit at the Savoy, opposite Erskine Hawkins the first time we played there. One of their tenor players—I think his name was [Paul] Bascomb—tried to cut Coleman on "Body and Soul," but after the first night Erskine's band didn't play that song anymore. He thought it was rude that they tried to cut him on that song, and when he played it that night, he just ran them out of there. It was no competition. I enjoyed singing with Coleman. He was a real gentleman; he used to telephone his mother every night. I'd hear him backstage, "Yes, Mama. No, Mama. That's not true, Mama." I thought it was fabulous. Here was this big star giving his mother respect.

H: Your next stop was Count Basie.
T: Yes, I was with Basie for most of 1943 and 1944. Coleman Hawkins recommended me to Basie, and this was the last time I worked regularly with a band like that. I sang with the band in the Blue Room of the Lincoln Hotel, toured a lot—I remember we went to California—but in early 1945 I started working as a single in a wonderful little East Side place, Le Ruban Bleu, and you couldn't get any fancier than that. That's where I first met Garland Wilson—he was playing there. I don't remember why I went there the first time, but Julius Monk took one look at me and said, "That's it." I put in my notice with Basie and went to work downtown. I learned a lot of new songs—show songs. The only show business I really knew up to then was with the big bands, and this was a totally different thing. It was very elegant, very sophisticated, and not totally integrated, but I remember people saying, "Oh, put Thelma in there! She doesn't

Marquee announcing
Count Basie and His
Orchestra with Thelma
Carpenter, 1951

even know she's colored!" I worked in
places like this, in the United States
and Europe, for many years, along with
special shows in theaters and Broadway
shows. When Garland moved to France
in the early 1950s, I had a hard time
finding the right accompanist. I've always
had a hard time finding the right person,
someone who'll play "Dixie" if you ask
them to play "Dixie" and not question
you about it. I finally found a wonderful
Englishman named Gil Stevens. Garland
understood what I wanted to hear and
even though I was young, I was able to
mold him into playing the way I wanted
him to play because I had heard all those
wonderful records by Ethel Waters and
others. I knew what the songs should
sound like. When I was singing in places

like that, I tried to remember what
Coleman Hawkins had said about "Body
and Soul"—when I'd sing, it was like I
was singing to someone in bed. A woman
in the audience came up to me after one
of my shows and said, "You put yourself
in bed with everybody in this room!"
I probably wasn't conscious of it when
I first started singing that way, but that
lady was right!

*H: Did you ever sing uptown after
you began appearing in supper clubs
downtown?*
T: Not too many times. I recall one time
when I worked at the Apollo with Gil
Stevens and there was some trouble with
the musicians. Now, Gil was white, but
he was the closest thing I ever heard to

Garland Wilson. He wasn't any better but he was just as good. In the 1950s I played at the theater as a headliner, accompanied by a big band. I once did a show with Gene Krupa's Orchestra and, I think, Count Basie. But there was one time when there was some trouble because the musicians at the theater didn't want to accompany me because I wanted to use Gil. The band didn't want to work with him because he was white—not only white, but an Englishman. Maybe they didn't even want to work with me; some of them used to say I thought I was white. Well, they were wrong. I didn't think I was white, I *thought* white, and there's a big difference. This came from my childhood. I lived in a mixed neighborhood, and I'll never forget something that happened when I was about twelve years old. There were lots of different people in my neighborhood—

communists, preachers—all out on the street with something to say. There was this old colored preacher on the street corner, and one day I heard him say, "Why don't you pray white?" He didn't mean you're supposed to *be* white; he just said you should pray white, think white. It has nothing to do with you being a Caucasian. And that stayed with me for years.

Anyway, that time at the Apollo there was a problem. When it came time for Gil to pass out the arrangements, the men in the band were rude to him and it was clear they had no intention of playing his music. And who knows, maybe they couldn't play his music, I don't know. You see, from my standpoint, I was just singing. I'd sing uptown at the Apollo or downtown at the Waldorf, in the United States or England or France. I was just singing, but I wasn't just singing

Thelma Carpenter's
wall of photographs, 1996

Thelma Carpenter with photograph of Billie Holiday, 1996

to a colored audience. All that mattered was the singing and what I could sing. The guy who played piano in the band wouldn't even get up and let Gil sit down at the piano. While this was going on, Gil came up to me and said, "Now I know what it means to be discriminated against." There was no way the band was going to play with Gil at the piano, and I saw Mr. Schiffman watching what's going on. Gil goes up to him and said, "They can't dim my enthusiasm. I've always wanted to perform at the Apollo, and I'm delighted to be here." This is how Mr. Schiffman handled it. He rented a baby grand, and when it came time for my spot

in the show, they dropped the curtain in front of the band and wheeled the piano out in front of the curtain. Well, Gil sat at that piano and played his ass off and, believe me, I sang my ass off. We sang and played up a storm and when it was over I went back to the microphone and said, "Ladies and gentlemen, this is Mr. Gil Stevens at the piano. Isn't he marvelous? And you know something funny? He isn't prejudiced—he plays the black keys just as well as he plays the white ones." Well, with that the audience fell down. They just fell down, and I loved it. There's *nothing* like a good colored audience.

H: The last time you performed uptown was probably in 1993, when you were inducted into the Apollo Hall of Fame. What was the main difference between 1934 and 1993?

T: I wasn't as frightened in 1993! Oh sure, there was a big difference, because in 1993 I was a part of history. I had to introduce a little girl, just like someone probably introduced me all those years ago. I sang "Do Nothin' Till You Hear from Me." I just sang a chorus, and I didn't think the musicians played very well. It was like they didn't know the song. It brought back a lot of memories and I'm sorry it wasn't a happier musical evening, but I've always had trouble with the right kind of accompaniment. It's the hardest thing, to find someone who'll just play the songs, play the arrangements for you. Wonderful people wrote for me—men like Jimmy Mundy, Luther Henderson. They would fit the chords to give me room; the chord was merely to send me off to where I wanted to go. I recently played an affair at a big hotel downtown and all the accompanist had to do was play an arpeggio on "100 Years from Today," and he didn't make it: "Life is such a great adventure, / Learn to live it as you go, / Because no one in the world / Can censor what we do here below."

15 March 1996

Major Holley
(b. 1924)

Hank: When did you leave Detroit and come to New York City?

Major: I arrived in New York in the winter of 1947–48. I was working regularly with Rose "Chi Chi" Murphy. We played at places like the Blue Angel. I think Max Gordon, the man who owned the Village Vanguard, also owned the place, maybe with a partner. It was my first real job in New York. It's been torn down. In those days there was a lot going on in New York. I went to all the places, just to listen.

H: Did you ever work uptown at the time?

M: The first job I ever had uptown was at Small's, in the back. I worked for Gus Aiken, a nice guy. I remember he was very, very humble. It wasn't much of a band, two or three horns and rhythm. We played for dancing at Small's. I was only there for a short time because I left for Europe in 1950 and didn't return until 1956.

H: Tell me how things seemed to you in 1956, after an absence of six years.

M: The scene in Harlem had slowed down a lot, but I still worked around a lot. Somebody always needed a bass player. I worked at Minton's in 1957. Teddy Hill was still the manager and he

liked me. He even had a sign printed up that said "World's Greatest Bass Player," and it hung in back of me on a mirror. I never led a group in Minton's, but I worked there off and on until about 1963. I was with people like Kenny Burrell and Leo Wright. In the late 1950s, not too long after I'd come back, I worked with Eddie Bonnemere at the Savoy Ballroom. I think it was just before the place closed up; we only played on Sunday afternoons and there wasn't much attendance. I was worried about whether or not I'd even get paid. I know for sure we were one of the last bands that played there. We worked at the Prelude at 129th Street and Broadway about the same time, and a place called something like the Copyright Bar. I don't remember its exact name, but we did all right in places like that. I just kept taking work where I could get it. I went with Woody Herman in 1958 and I'd played with Illinois Jacquet's big band, but I never worked uptown very much with them. I played the Apollo with Woody Herman once or twice, but not very often. Most of the work I did uptown was strictly freelance. Somebody always needed a bass player.

H: If you had a night off and just wanted to hear somebody, where did you go if you were uptown?

M: There were a few places. Count Basie's on Seventh Avenue, now Adam Clayton Powell Boulevard. There was also a place where Pres [Lester Young] used to play on the same street, between 124th and 125th. I think it was called the Red Rooster or something like that. There's a church there now.

H: Tell me about this freelance work.
M: It was just work in small clubs or private functions at places like the Audubon [Ballroom] or the Renaissance [Ballroom]. Someone was always having a function, and I was scrounging around trying to find whatever work was available. It seemed for a while I had something every week at one or the other of these places. At one time or another I

picked up work with Coleman Hawkins, Teddy Wilson, and people like that. You worked anywhere you could—little jobs at Bowman's Grill up on Sugar Hill to shows at the Alhambra Theater with Rose Murphy and Valaida Snow, maybe one of Valaida's last appearances. I remember meeting a young comedian named Richard Pryor at the Alhambra. Willie Bryant was the master of ceremonies some of the time when I was working there, but most of my memories of Harlem are ones of looking for work and there not being enough of it. There are still a lot of people out there to talk to about this, people who are authentic Harlem, who were there for many years. The other day I played with Chris Columbus. I hadn't seen him since Count

Basie's funeral, and I hadn't heard him play since when I played at Club Harlem in the early 1960s. He's in his eighties and can still play. I remember he used a motorcycle seat for a drum stool in the old days. He's an interesting guy and there's a lot of people who have great stories to tell, but I think lots of them are at senior citizens centers and places like that—the ladies who danced in the line at the Cotton Clubs, singers in the chorus, tap dancers, people like that. There are a lot of people like this around, but they're fading fast.

18 October 1985

Major Holley, recording session at Downtown Sound, 1976

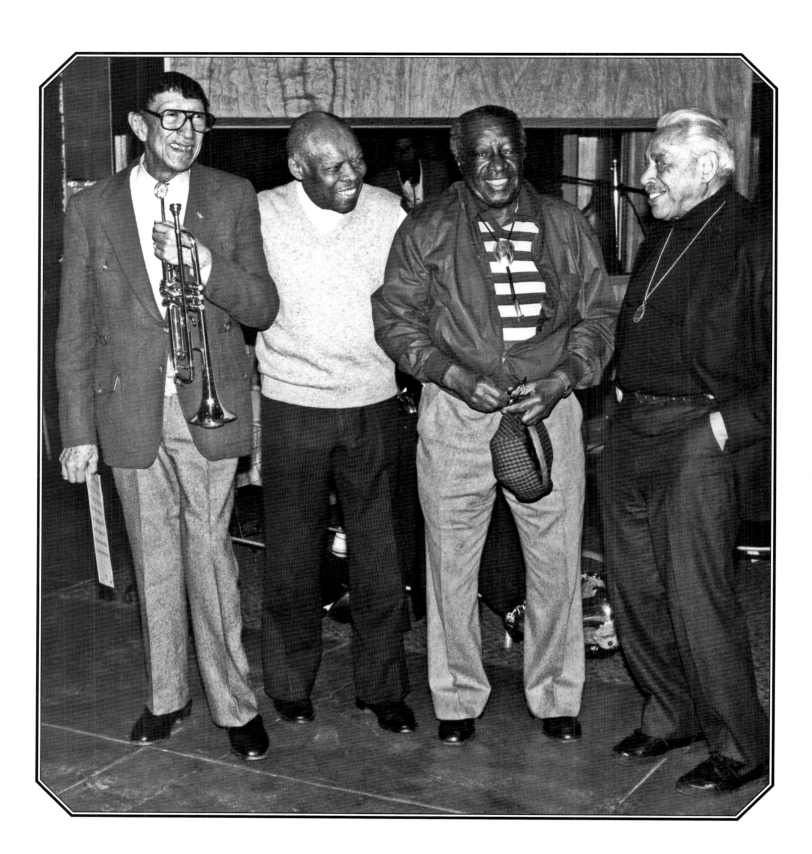

The Survivors

(Eddie Barefield, Cab Calloway, Doc Cheatham, and Milt Hinton)

Milt Hinton: Let's talk about this wonderful cat that we worked for all those years. This is 1990. When did you join the band, Eddie?

Eddie Barefield: Nineteen thirty-three.

Milt: When did you join Doc?

Doc Cheatham: Nineteen thirty-one, wasn't it?

Cab Calloway: Yeah, 1931.

Milt: I joined in the last of '35, first of '36.

Cab: Got you from McKinney's Cotton Pickers.

Eddie: I'm from the Cotton Pickers too.

Milt: There's never been a bandleader like this cat, you know.

Eddie: No, ain't been no band like that.

Milt: That's right. The class of that band, the dignity. I can't think of all the things I really learned about being on time, about being courteous to people. I didn't know any of those things when I joined Cab's band. I'd never been on a train except the one I came from Mississippi on, and I didn't come in a Pullman. He hired me from Zutty Singleton. I was working with Zutty Singleton and Art Tatum, and he called me and said, "The train leaves from the South Street Station at nine o'clock. Be there." Remember that, Doc? I went to the train in the morning. I had one little suit. My mother fixed me a bag with clean underwear and a clean shirt. I got on the train but Cab and Ben Webster missed the train that morning, and they got on at Sixty-third Street Station. When I got on, I told Keg Johnson, my dear friend Keg, "You know I was making thirty-five dollars a week with Zutty and that was great. I'm tickled to death to be here, but I didn't say anything to Cab about money." He said everybody in this band made a hundred dollars a week. I like to fainted. I figured I would be rich in three months, man, and then Cab came on there with Ben Webster. They'd been out somewhere all night.

Cab: Balling somewhere.

Milt: Balling. And Ben looked at me and said, "What is that?" And Cab said, "That's the new bass player." And he said, "The new what?" I swore I would never like him the rest of my life. He turned out to be one of my dearest friends.

Eddie: Ben was a beautiful guy.

Milt: Doc, what happened with you? We were in the band together in 1936. You worked with Cotton Pickers.

Doc: Oh sure, certainly. You know what? I'm going to tell you something I never told Cab. It hasn't been a week

Opposite, from left: Doc Cheatham, Eddie Barefield, Milt Hinton, and Cab Calloway, Van Gelder studio, Englewood Cliffs, New Jersey, 1990

467

since I left his band that I haven't dreamt about Cab and the band.

Eddie: I do too. I dream about him. I dream about him all the time.

Doc: It hasn't been a week. This week I dreamt I'm always late getting on the bandstand!

Eddie: That's me. I dreamt that too!

Milt: Well, that was a no-no. You know that.

Doc: Every time I'm trying to get on the bandstand. Cab comes out with the stick. I never could get on that bandstand.

Eddie: I do that too. I have that same dream. See, when I joined the band, Roy Eldridge and I used to hang out together and go jamming all around the joints, you know. So we're jamming in Bailey's near the Capitol Ballroom on North Clinton. We were with [McKinney's] Cotton Pickers and Cab and his band came to the Hippodrome.

Cab: No, we were at the Century.

Eddie: Well, I thought it was the Hippodrome.

Cab: No, it was the Century.

Eddie: Anyway, Cab comes in this joint this night and I'm drunk, standing up in the chair playing "Memories of You." Cab said, "Who is he?" you know, that kind of thing. Finally he says, "Do you want a job?" And I said, "Sure." He said, "Well, come down to the theater tomorrow." I thought he was kidding because he had been drinking a little too, you know. So I didn't go down there. That evening Foots Thomas and Doc Cheatham came down to see me and said, "Man, where were you? Cab was telling us all about you and everything. You were supposed to come down." I said, "Well, I thought he was kidding." So the next day I went down there and I go to the backstage door. The band

was getting ready to go on the stage and the doorman stopped me at the door and said, "What do you want?" because, you know, it was segregated down there. I said, "I want to see Mr. Calloway." He said, "Well, he's going on the stage now, you have to wait or come back." But then Cab saw me and he came out and got me and took me in. I stood in the wings and watched the show. After the show he calls all the guys out and has a jam session with all the cats in the band. I had an old horn that was all raggedy. We had a jam session and then Cab goes and called up [Irving] Mills, who's the manager, and told him to come down, that he had Benny Carter and Johnny Hodges all in one person. So now I go back to the Cotton Pickers and tell them that I'm going to go with Cab.

Milt: This is wonderful.

Eddie: I go back to them and so they said I could quit but I had to give them two weeks' notice. We only made thirty dollars a week, so I said I'm not going to give you no notice, I'm just cutting on out. They didn't want to pay me and we had a big fight about it. I get to the theater with a black eye, and Cab asked me what happened. I told him they wouldn't pay me. He said, "What do you need?" And he gave me a hundred-dollar bill. To make it short, I went and paid my dues and got myself together to come on back.

Cab: But the real story, you see, is he just took a job.

Doc: Sure did. He certainly did. I'll never forget that.

Milt: That's Eddie. That's him all over.

Cab: Because we didn't have but three saxes, and I said, "Well, you got to write your own book." He wrote his own book.

Eddie Barefield, recording session, WARP studio, 1973

Milt: He's been writing it ever since. Teacher. That's it. He hired me and said, "Well, kid, I'm on the road. I'll hire you until we get to New York and get a good bass player." And sixteen years later I was still there. Man, I'll tell you. Every payday. I've still got some savings bonds from those days. Nobody ever did that thing again. I can go and talk about Cab forever. Remember when I had my daughter?

Cab: Sure, that's my child.

Milt: I told him, I said, "My wife is pregnant." He said, "Mona pregnant?" I said she was, and he said, "My wife's pregnant too," and then said, "Have this one on me," and he paid for it. Once, Charlotte was three months old and we were out in California. We were trying to make that two o'clock feeding, trying to feed the baby and work at the ballroom with Cab, and I'm getting kind of sick and Mona wasn't feeling too well. I'm running short of money and Cab comes to me and said, "I told you to have this one on me. How much did it cost you?" And he paid every dime of it. It was like manna from heaven. And years later we had a cotillion together, his daughters and mine.

Eddie: See, we used to do fourteen weeks of theater right here in New York and double at the Cotton Club at night. Then we went on the road down south. We traveled in a Pullman and Cab carried his Studebaker on the back.

Cab: That was not a Studebaker.

Eddie: You had a Studebaker.

Milt: A Lincoln—a green Lincoln.

Cab: I had a Studebaker, but that was a Lincoln.

Eddie: Well, you got a Lincoln afterwards.

Cab: Well, I've had eleven Lincolns.

Eddie: You should have ninety, as old as you are!

Doc: You remember, Thump, I don't think you were in the band then. We were in the South playing. I don't remember the city but we were doing intermission, so we were all out in the back of a warehouse, and there was somebody there that looked suspicious, and we thought he was going to hold us up or something. We got behind the guy and hit him on the head with the bottle. Were you in the band then?

Milt: No, I don't think that I was in the band then.

Doc: Well, that night—I never told Cab about this; I have to confess this—that night on the Pullman car was pay night and they called me first to get paid, so I went up and got paid. Then the guys, one by one, went up and they got paid. When everybody had been paid, Cab said to me, "Don't you want your damn money?" I said, "OK, I'll come up there. I'll get it." I went up there and got paid twice. I never told him about that. I'm sorry.

Cab: Do you realize how much interest you owe me for that money?

Eddie: Do you remember Memphis?

Cab: Memphis—sure I remember Memphis.

Doc: Oh man, Memphis, Tennessee.

Eddie: Yeah, when we played out at this fair.

Cab: There was a fairground.

Eddie: We played two times, a black dance and the white dance.

Cab: We played the colored dance first out at the fairgrounds, and the second dance for the white folks was in the pavilion. Now, the ofays there didn't like the idea that we played for colored people first. Never will forget that one boy. What really caused the whole thing was the boy—I forget his name—the white boy who used to sell programs. He had those programs—for twenty-five cents you could get a program. Whole life story of Cab Calloway. There's the whole band, pictures of the band and everything, and a guy walked up to the stand and says, "What are you doing? You're a white boy out here selling programs for a nigger. You ought to be ashamed of yourself. Give me them programs."

Eddie: I think his name was Alex.

Cab: That's his name. And the man tore them up and Alex went into him, and then the big electrician from Milwaukee—What was the name?—came in to help Alex cause Alex was tied up with this cat. Ten minutes later it was a riot.

Eddie: Yeah, but see, you haven't got the story right. You were back there checking with the man about the money.

Cab: Right, that's how I found out about it.

Eddie: When you came out, we were fighting, and what happened was these two guys were standing down in front of the bandstand drunk calling us all kinds of names when we were playing, and I was getting mad and you said, "Cool it, cool it, cool it!" So finally when you went back there and we started packing up, these cats came up on the stage and were taking the music stands, and I hit this guy. He fell past Benny Payne, and Benny Payne hit at him with his knife and he fell on the floor. The people who knew what was going on started to come back

in there, and that's when the band and the people—everybody started fighting. You came out and you yelled, "What the hell is happening?"

Cab: Now, what happened?

Eddie: You called up the police station to get a police escort, and they wouldn't send one.

Cab: That's right. And the police said, "You've got to get back the best you can." So I said we had to get back the best we could, and I told those cops, "We'll get back."

Eddie: So you sent for Sam, the guy that ran the hotel down on Beale Street.

Cab: And I came back. I told everybody, called everybody. I said, "Get your ammunition."

Eddie: And he came up there with his truck.

Cab: And I said, "Don't use it until I tell you." And we got the truck. Remember when we got the truck?

Doc: I remember that.

Eddie: They were throwing bottles at us.

Doc: Bricks.

Cab: And we started out from the fairgrounds to the station and, as we went down the main street, lights were coming on from each side of the street. Guys were in the cars. They followed us, chased us all the way down till we got to Beale Street. When we got to Beale Street, I said, "Stop the bus! Stop the bus! Stop the truck!" Cats got out. They were gone.

Milt: It's like Bill Bailey used to say Cab said: "Fire at will." I didn't know any of their names. Hey, this has been beautiful. Thank you. This has been a joy. And thank you for being with us, Cab. We are the nucleus of one of the greatest musical organizations I've ever wanted to be with, and it's been timeless. We've looked out for each other and kept being concerned with each other, and it's all because of you, man. Thank you.

Doc: Absolutely.

Cab: I'll take the check.

6 March 1990

[Note: This is an approximate transcription of a conversation contained on the 1991 Chiaroscuro release, Milt Hinton—Old Man Time. *I use the word "approximate" because there is much overlapping conversation and a good deal of laughter. One of the bands I assembled for Milt on this record included Cab, Eddie, and Doc. It was the only time Cab officially worked for Milt, but I can report that when Cab was in the studio, everybody, including all non-playing participants, knew who was in charge.]*

Vi Tate, *background*, Hank O'Neal, and Buddy Tate, Massapequa,
New York, 1986, photographed by Shelley M. Shier

Photography

The majority of the formal portraits presented in *The Ghosts of Harlem* were taken with a 5x7 Deardorff utilizing a 4x5 reducing back. In most instances a Schneider Kreuznach Symmar-S 180/f5.6 lens was my lens of choice, but in a few circumstances, in cramped quarters, I used a Schneider Kreuznach Symmar-S 135/f5.6 lens. I used Kodak Tri-X or TMY sheet film, and the reproductions made from these negatives were normally about 90 to 95 percent full frame.

I also photographed many of the men and women in color. I used a 2.8 Rolleiflex with a Carl Zeiss 80mm/f2.8 lens for the photographs made before 1990 and a Rollei 80mm/f2.8 for those made after that date. The film stock was Kodak Vericolor II or III, VPL or VPS, depending if it was an indoor or outdoor situation. In some instances—Jimmy Hamilton, for example—I chose to make a black-and-white print from a color negative because I thought the color portrait was superior to the black and white. In some instances the supplemental photographs were originally printed from color negatives, using Kodak Panalure paper.

For this new edition of *The Ghosts of Harlem*, all negatives and reflective art has been scanned with either a Nikon CoolScan 8000ED (35mm and medium-format negatives) or a Microtek TMA 1600 (large-format negatives and reflective art). These illustrations have been adjusted and this edition of the book has been printed using these electronic files.

The many small, illustrative photographs date from as long ago as 1969 to the present. I took them at recording sessions at my own studio, Downtown Sound, or at other facilities, at performances I attended, at events I produced, in musician's homes, at informal gatherings, or on the streets of Harlem. I took most of these images with a 35mm Leica or Nikon, usually using black-and-white film and whatever lens seemed appropriate for the circumstances.

I took the majority of the formal portraits at the homes of the subjects, usually inside, but on some occasions in the backyard or at a nearby location. I photographed Major Holley, J. C. Heard, and Joe Williams aboard the *SS Norway* in 1985; Jimmy Hamilton in Chistiansted, St. Croix in 1986; Benny Waters on the balcony of his room at the Grand Hotel in Oslo, Norway, during the 1986 Oslo Jazz Festival; Erskine Hawkins in the lobby of the Concord Hotel; Eddie Durham and George Kelly at the home of friends in Harlem; and Jabbo Smith at Lorraine Gordon's apartment. Al Cobbs wanted me to take his portrait at my New York City office.

The vast majority of the pre-1964 historical photographs and paper ephemera are part of the remarkable Frank Driggs Collection and are used with his permission. The record labels are from original 78s or LPs in my collection. In a few instances, others provided historical photographs. The photographs by Berenice Abbott of Buddy Gilmore and Leadbelly are courtesy of Commerce Graphics. The photograph by George Wein of Billy Taylor is courtesy of the photographer. The photograph by Berenice Abbott of Chick Webb is courtesy of Cheryl Finley and Commerce Graphics. The photograph of Milt Hinton with Cassino Simpson is courtesy of the Milt Hinton Family Collection, and the photograph of Danny Barker by Milt Hinton is courtesy of the Milton J. Hinton Photographic Collection. The photograph of me with John Hammond was taken by Allen Ginsberg; the photograph of me with Buddy Tate was taken by Shelley M. Shier. "Bennie" Carter and his band at the Savoy Ballroom is courtesy of Ed Berger and is part of the Benny Carter Collection. A dozen or so older photographs, such as those of Louis Armstrong with the Luis Russell Orchestra, Billie Holiday, Bobby Henderson, and Louis Armstrong with Maxine Sullivan are from my own collection. Unhappily, the names of the photographers of these older photographs are largely unknown. I took all other photographs in *The Ghosts of Harlem*.

The dates and locations of the formal portraits are as follows:

1. Andy Kirk: New York, New York, 1986 (Harlem)
2. Benny Waters: Oslo, Norway, 1986
3. Greely Walton: New York, New York, 1987 (Harlem)
4. Tommy Benford: Mt. Vernon, New York, 1986
5. Doc Cheatham: New York, New York, 1986
6. Gene Prince: Elmhurst, New York, 1987
7. Ovie Alston: Washington, D.C., 1987
8. Eddie Durham: New York, New York, 1987 (Harlem)
9. Cab Calloway: White Plains, New York, 1986
10. Benny Carter: Los Angeles, California, 1987
11. Lawrence Lucie: New York, New York, 1996
12. Jonah Jones: New York, New York, 1987
13. Sammy Price: New York, New York, 1987 (Harlem)
14. Jabbo Smith: New York, New York, 1986
15. Johnny Williams: New York, New York, 1987
16. Eddie Barefield: Bronx, New York, 1986
17. Danny Barker: New Orleans, Louisiana, 1987
18. Milt Hinton: St. Albans, New York, 1987
19. Sy Oliver: New York, New York, 1987
20. Al Sears: Jamaica, New York, 1987
21. Buck Clayton: Jamaica, New York, 1986
22. Bill Dillard: Elmhurst, New York, 1987
23. Maxine Sullivan: Bronx, New York, 1986
24. Franz Jackson: New York, New York, 1986
25. Red Richards: Bronx, New York, 1987
26. Erskine Hawkins: Monticello, New York, 1987
27. Bobby Williams: Brooklyn, New York, 1987
28. Buddy Tate: Massapequa, New York, 1986
29. Al Casey: New York, New York, 1996
30. Harry Edison: Los Angeles, California, 1987
31. George Kelly: New York, New York, 1996 (Harlem)
32. Dizzy Gillespie: Englewood, New Jersey, 1990
33. Jimmy Hamilton: Christiansted, St. Croix, USVI, 1986
34. J. C. Heard: *SS Norway*, Caribbean Sea, 1985
35. Panama Francis: New York, New York, 1987
36. Sammy Lowe: Teaneck, New Jersey, 1987
37. Joe Williams: *SS Norway*, Caribbean Sea, 1985
38. Al Cobbs: New York, New York, 1996
39. Clark Terry: Whitestone, New York, 1987
40. Billy Taylor: New York, New York, 2008 (Harlem)
41. Illinois Jacquet: St. Albans, New York, 1996
42. Frank Wess: New York, New York, 1996
43. Thelma Carpenter: New York, New York, 1996
44. Major Holley: *SS Norway*, Caribbean Sea, 1985
45. Eddie Barefield/Cab Calloway/Doc Cheatham/Milt Hinton, Englewood Cliffs, New Jersey, 1990

Selected Discography

The artists who are featured in *The Ghosts of Harlem* have performed on many thousands of recordings from the mid-1920s until today. Indeed, two, Frank Wess and Clark Terry, released new recordings in 2008. Many of the artists documented in this book continued to play well in their seventies, eighties, and beyond. I personally recorded many of them in their later years, including Milt Hinton, Harry Edison, Joe Williams, Clark Terry, and Frank Wess.

A complete discography of the recordings of just these five men would run to hundreds of pages; over one thousand pages would be required to list all the recordings on which all the ghosts have appeared. Since this is not practical, I have decided to present a list of representative recordings, old and new, which are currently available on compact disc. These recordings can be obtained at any number of record stores, Internet sources, or via mail order, but in order to have the most informed selection, a buyer should visit larger stores that have extensive jazz departments or, better still, jazz specialty shops. I realize this is increasingly difficult as CD sales fall, but fortunately the decline in the pop market has not adversely affected small jazz labels.

There is no lack of recordings from which to choose. So many recordings on which the various ghosts appear, from both the distant and the recent past, have been issued and reissued on vinyl and compact disc that, with sufficient industry, a diligent collector might come to possess virtually everything commercially recorded by these men and women. There are sources for these recordings that are accessible on the Internet that can be used to track down all these recordings.

This selected discography focuses on a few representative recordings by the forty-two artists who were interviewed and photographed for *The Ghosts of Harlem,* as well as recordings by Al Sears and Jabbo Smith, who were photographed but not interviewed. An asterisk indicates that the ghost appeared as a sideman; otherwise he or she is the featured artist on the CD. At the conclusion of this selected discography I have noted a handful of other CD releases that will be of general interest to anyone interested in the music made in Harlem during the years 1925–55.

Ovie Alston: The eight sides Ovie Alston recorded as a leader for Vocalion in 1938 are not generally available on CD. He can be heard with Claude Hopkins. Unfortunately, he was not active in the LP era.
Claude Hopkins and His Orchestra 1932–34: Classics 699
Claude Hopkins and His Orchestra 1934–35: Classics 716
Claude Hopkins and His Orchestra 1936–40: Classics 733

Eddie Barefield: The earliest Eddie Barefield recordings are those he made with Cab Calloway, but he can also be found on collections of recordings by Ella Fitzgerald, Billie Holiday, Don Redman, and Benny Carter. He recorded extensively in the LP era, but most of these LPs have not been reissued as CDs.
Cab Calloway and His Orchestra 1932: Classics 537
Milt Hinton—Old Man Time 1989:
 Chiaroscuro CR(D) 310

Danny Barker: The many LPs Danny Barker recorded in the 1950s through the 1970s are not generally available on CD. His early recordings can be found with Cab Calloway, Benny Carter, and Lucky Millinder.
Cab Calloway and His Orchestra 1940–41: Classics 629
Milt Hinton—Old Man Time 1989: Chiaroscuro CR(D) 310
Save the Bones: Orleans 1018

Tommy Benford: The first recordings on which Tommy Benford appeared were with Jelly Roll Morton. He also recorded with Freddy Johnson, Willie Lewis, and Coleman Hawkins. He made many recordings in the LP era, the majority of which are not available as CDs.

Jelly Roll Morton: Complete Victor Recordings:
 Bluebird 2361-2-RB
Coleman Hawkins 1937–39: Classics 613
Willie Lewis 1941: Classics 880

Cab Calloway: The majority of Cab Calloway's recordings, from the earliest to his last, are available as CDs. His most interesting recordings date from the 1930s and 1940s, when his band was one of the finest ever assembled.
Are You Hep to the Jive?: Columbia CK 57645
Cab & Company (1930s): RCA 2-66496
Cab Calloway and His Orchestra 1930–47: Classics 516, 526,
 537, 544, 554, 568, 576, 595, 614, 628, 629
Broadcast Recordings 1943–44: Musidisc MUS 550232
The Radio Years 1940–45: Jazz Unlimited 2027

Thelma Carpenter: The few recordings Thelma Carpenter made in the late 1930s and early 1940s were with Teddy Wilson and Coleman Hawkins. Her later work as a cabaret performer and in Broadway shows is not available as CDs.
Coleman Hawkins Indispensable: RCA 66495-2
Teddy Wilson 1939–41: Classics 620
It Seems Like Old Times: Sepia 1080
A Souvenir: Audiophile 111

Benny Carter: Benny Carter has made superb recordings in eight decades. He maintained very high standards, and almost all of his many recordings are available on CD. A representative sample is noted here.
All of Me (1930s and 1940s): Bluebird 3000-2RB
Benny Carter and His Orchestra 1929–33: Classics 522
Benny Carter and His Orchestra 1933–36: Classics 530
Benny Carter and His Orchestra 1936: Classics 541
Benny Carter and His Orchestra 1937-39: Classics 552
Benny Carter and His Orchestra 1939-40: Classics 579
Best of Benny Carter (1980s and 1990s):
 MusicMaster 01612-65133
Cosmopolite: Verve 314-521673-2
Jazz Giant: Contemporary 7555

Al Casey: The many recordings Al Casey made with Fats Waller are readily available, as are his recordings with Teddy Wilson. Most of his recordings during the LP era have not been reissued as CDs.
Fats Waller and His Rhythm 1934–35: Bluebird 66618-2
Fats Waller and His Rhythm 1935–36: RCA 66640-2
Buck Jumping: Fantasy/OJCCD 675-2
Jumpin' with Al (1973): Black and Blue 233056

Doc Cheatham: In the last eight decades Doc Cheatham has appeared on thousands of recordings, first as a sideman and more recently as a leader. Many are available as CDs.
Cab Calloway and His Orchestra: RCA 66496-2

The Eighty-Seven Years of Doc Cheatham (1993):
 Columbia CK 53215
The Fabulous Doc Cheatham (1983): Parkwood PWCD 104
Live at Sweet Basil's: Jazzology JCD-283
The Music of Lil Armstrong (1988): Chiaroscuro CR(D) 302
Meets Nicholas Payton (1993): Verve 537062

Buck Clayton: The long career of Buck Clayton, as both a sideman with Count Basie and as a leader, is well documented by many fine recordings currently available as CDs. Some of his more exceptional as a leader are noted here.
The Complete CBS Jam Sessions (1950s): Mosaic MD6-144
The Essential Buck Clayton (1950s): Vanguard 103/104-2
A Buck Clayton Jam Session (1977): Chiaroscuro 132
A Buck Clayton Jam Session Vol. 2 (1975): Chiaroscuro 142
Going to Kansas City: Fantasy OJCCD 1757-2
Buddy and Buck Blow the Blues (1961): Fantasy OJC CD850

Al Cobbs: There are few contemporary recordings by Al Cobbs; he can be heard on the final recordings of Jimmy Lunceford's Orchestra in the late 1940s.
Jimmy Lunceford and His Orchestra: JazzUp 325
Jimmy Lunceford and His Orchestra: Savoy ZDS 1209
Louis Armstrong from Big band to All Stars:
 Jazz Archives 197 (EPM 160212)

Bill Dillard: The first Bill Dillard recordings can be found with Luis Russell, and later recordings with Teddy Hill, Lucky Millinder, and Louis Armstrong. The LPs on which he performed have not been widely reissued.
Luis Russell and His Orchestra 1930–34: Classics 606
Teddy Hill and His Orchestra: Classics 646
With Michael Bovings Rhythmakers (1991):
 Storyville 793163

Eddie Durham: Known as an arranger-composer, trombonist and guitarist Eddie Durham recorded with Count Basie and Jimmy Lunceford in the 1930s. His recordings in the LP era have been reissued on CD infrequently.
Jimmy Lunceford and His Orchestra 1934–35: Classics 505
Jimmy Lunceford and His Orchestra 1935–37: Classics 510
Count Basie and His Orchestra: Decca GRD3-611
K.C. Sessions: Commodore 402
Blue Bone (1981): JSP 793416

Harry Edison: Early in his career, Harry "Sweets" Edison recorded with Lucky Millinder and Count Basie. Since that time he recorded extensively, and his sixty-year recording career is well represented on CDs.
Count Basie and His Orchestra: Decca GRD3-611
Sweets (1956): Verve 393602

Teddy Wilson and His All Stars (1974):
 Chiaroscuro CR(D) 150
Swing Summit (1992): Candid CCD 79050
For My Pals (1970s): Pablo PACD-2310-934-2
Harry "Sweets" Edison & Buddy Tate (1985):
 Progressive 7028
With Red Holloway (1995): Chiaroscuro CR(D) 348

Panama Francis: In the 1950s and early 1960s Panama Francis was on more studio recordings than perhaps any other New York City–based drummer. His earliest recorded work is with Roy Eldridge and Lucky Millinder. In the 1970s he reformed the Savoy Sultans and recorded extensively, but most of these recordings are not available on CD.
Roy Eldridge and His Orchestra (1939): Classics 725
Lucky Millinder and His Orchestra (1941): Classics 712
Get Up and Dance (1983): Stash ST-CD 5
Everything Swings (1984): Viper's Nest 1005

Dizzy Gillespie: This legendary musician recorded extensively throughout his long career. His early work can be heard with Teddy Hill, Lionel Hampton, and Cab Calloway. His first ventures into bebop and his own big-band recordings from the 1940s are also available, along with over one hundred other CDs.
Teddy Hill and His Orchestra 1935–37: Classics 645
Lionel Hampton and His Orchestra 1937–39:
 Bluebird 6458-2RB
After Hours (1942): OJC 1932
The Complete RCA Recordings: RCA 66528-2
Groovin' High: Savoy 152
Roy and Diz: Verve 314-521647-2

Jimmy Hamilton: Duke Ellington featured Jimmy Hamilton from 1943 until 1968, and any of the more than one hundred Ellington CDs from the period will have at least one Hamilton showcase. He can also be found on Teddy Wilson big-band recordings and with his own groups.
Teddy Wilson and His Orchestra 1939–41: Classics 620
Oscar Pettiford 1954–55: Classics 1454
Jimmy Hamilton and the New York Jazz Quintet:
 Fresh Sound FSRCD-2002
Rediscovered at the Buccaneer: Who's Who WWJ-21029-2

Erskine Hawkins: The career of Erskine Hawkins is well documented on CDs, from his earliest big band in 1935 to remotes in later years. None of his LP-era performances have been transferred to CD.
Erskine Hawkins and His Orchestra 1936–38: Classics 653
Erskine Hawkins and His Orchestra 1938–39: Classics 667
The Original Tuxedo Junction: Bluebird 9682-2-RB
Original Broadcast (1945): Musidisc MUS-550262
Complete Erskine Hawkins 1938–39: Collectors 2814

J. C. Heard: There are many CDs on which J. C. Heard is a featured artist. His first recordings were with Teddy Wilson and Cab Calloway. Much of his LP-era work with Jazz at the Philharmonic groups has been reissued on CDs.
Teddy Wilson and His Orchestra 1939–41: Classics 620
Cab Calloway and His Orchestra 1943–44:
 Musidisc MUS-550232
Charlie Parker Jam Session Verve 833-564-2
Complete Jazz at the Philharmonic 1944–49: Verve 523893

Milt Hinton: The earliest Milt Hinton recordings are with Eddie South and then with Cab Calloway. He was on thousands of recordings in the LP era, many of which have been reissued as CDs. He has appeared as a leader during the CD era.
Eddie South and His Orchestra 1923–37: Classics 707
Cab Calloway and His Orchestra: Columbia CK-57645
Old Man Time (1989): Chiaroscuro CR(D) 310
The Basement Tapes (1989–90): Chiaroscuro CR(D) 222
The Trio (1994): Chiaroscuro CR(D) 310
Laughing at Life (1995): Columbia CK-66454

Major Holley: Though not active as a recording artist in the late 1940s, Major Holley is well represented with recordings from the LP and CD eras as a leader and a sideman.
The Dave McKenna Quartet (1974):
 Chiaroscuro CR(D) 136
Teddy Wilson and His All Stars (1976):
 Chiaroscuro CR(D) 150
Slam Stewart and Major Holley (1991): Delos 13491-1024-2
Major Step: Timeless CD-SJP-364
Mule: Black and Blue 8622
Excuse Me Ludwig: Black and Blue 8892

Franz Jackson: The long career of this Chicago-based artist has been well documented with recordings. His earliest were with Earl Hines, and more recent releases under his own name are also available. His first session for Decca as a leader, in 1940, is not available on CD.
Earl Hines and His Orchestra 1939–40: Classics 567
Original Jazz All Stars (1961): Fantasy/OJCCD 1824-2
Snag It (1990): Delmark DD-223
Yellow Fire (1990s): Delmark 237

Illinois Jacquet: In May 1942 Illinois Jacquet recorded "Flying Home" with Lionel Hampton, and overnight it became one of the most famous jazz solos. Since that time there have been countless exceptional recordings by Illinois Jacquet, many of which are available as CDs.
Lionel Hampton and His Orchestra: Decca GRD-2-652
The Complete Illinois Jacquet Sessions 1945–50:
 Mosaic MD4-165
Jumpin' at Apollo: Delmark 538

The Illinois Jacquet Story: Proper 49
Illinois Jacquet Flies Again (1959): Roulette CDP 7972722
Illinois Jacquet and His Big Band (1988): Atlantic 81816-2

Jonah Jones: Recordings in the 1950s and 1960s by Jonah Jones, one of the first crossover jazz artists, sold millions of LPs. It is peculiar, but none of these LPs have been reissued as CDs. Jones's early work, however, is available on CD, as is a classic 1972 recording.
Stuff Smith and His Orchestra 1936–39: Classics 706
Cab Calloway and His Orchestra 1940–41: Classics 629
Butterflies in the Rain (1944): Circle CCD 18
Back on the Street (1972): Chiaroscuro CR(D) 118
Confessin' (1978): Black and Blue 9202

George Kelly: Al Cooper's recordings in 1941 were George Kelly's first and are available on CD. Most of his LP-era recordings have not been reissued, but four of his more recent releases are available as CDs.
Al Cooper and His Savoy Sultans 1938–41: Classics 728
Confessin' the Blues (with Carrie Smith, 1977):
 Evidence 26021
The Music of Don Redman (1984): Natasha NI 4027CD
Echoes of Harlem with Doc Cheatham (1985):
 Natasha NI 4023CD
I'm Shooting High (with Red Richards, 1987):
 Sackville SKCDR-2017

Andy Kirk: This noted bandleader recorded extensively from the late 1920s until the mid-1940s. Many of these recordings have been reissued on CD.
Andy Kirk and His Twelve Clouds of Joy 1929–31:
 Classics 655
Andy Kirk and His Twelve Clouds of Joy 1936–37:
 Classics 573
Andy Kirk and His Twelve Clouds of Joy 1937–38:
 Classics 581
Andy Kirk and His Twelve Clouds of Joy 1939–40:
 Classics 640
Andy Kirk and His Twelve Clouds of Joy: AVS 5108
Andy Kirk—Lotta Sax Appeal: Frog DGF 54

Sammy Lowe: The Erskine Hawkins Orchestra featured many arrangements by Sammy Lowe, and although he didn't solo a great deal, he was an important part of the band from 1936 to 1955. After he left Hawkins, he was primarily active in pop music; there are few jazz recordings of Sammy Lowe from the LP era.
Erskine Hawkins and His Orchestra 1936–38: Classics 653
Erskine Hawkins and His Orchestra 1938–39: Classics 667
Erskine Hawkins and His Orchestra 1939–40: Classics 678

Lawrence Lucie: In the majority of Lawrence Lucie's recordings, he plays as a rhythm guitarist with some of the finest small ensembles and big bands. Few of his recordings as a sideman in the LP era have been reissued.
Fletcher Henderson and His Orchestra 1937–38:
 Classics 519
Fletcher Henderson—Tidal Wave: GRP 643
Mills Blue Rhythm Band 1936–37: Classics 731
Louis Armstrong and His Orchestra 1940–42:
 King Jazz KJCD 6169
Coleman Hawkins—Body and Soul: RCA 68515

Sy Oliver: The many recordings by Sy Oliver that were released by Decca in the 1940s and 1950s are not available on CD, nor are the majority of his recordings from the LP era. His early work, both on trumpet and as an arranger, with Jimmy Lunceford and Tommy Dorsey, is well represented on CD.
Jimmy Lunceford and His Orchestra 1935–37: Classics 510
Jimmy Lunceford and His Orchestra 1939: Classics 532
Tommy Dorsey and His Orchestra: Bluebird 9987-2-RB
Tommy Dorsey and His Orchestra: RCA 51643—2
Oliver's Twist/Easy Walker: Mobile Fidelity MFUDCD 638
The Best of Ella: Hip-O 069886
Louis and the Good Book: Verve 548593

Sammy Price: Except for a handful of blues accompaniments, the earliest recordings of Sammy Price are unavailable on CD. The blues recordings he made for Decca in the 1930s and 1940s are occasionally available on blues anthologies. His later work as a soloist is well documented.
Paris Blues (with Lucky Thompson, 1957):
 Sunny Side 013038
Barrelhouse & Blues (1960s): Black Lion 760159
Doc Cheatham and Sammy Price (1970s):
 Sackville SK2CD-5002
Rockin' Boogie (1975): Black and Blue 9212

Gene Prince: There are few recordings by Gene Prince available on CD; his premature retirement from the music business after World War II makes it difficult to find even LP reissues of his early work. He can be found on selected recordings by Andy Kirk and Louis Armstrong.
Andy Kirk and His Twelve Clouds of Joy 1929–31:
 Classics 655
Louis Armstrong and His Orchestra 1940–42:
 King Jazz KJCD 6169

Red Richards: The many recordings Red Richards made during the LP era remain largely unissued on CD. In recent decades, however, he has released a number of new recordings that showcase his talents as a solo pianist and leader.

It's a Wonderful World (1980): Black and Blue 761
Dreamy (1980s): Sackville SKCD2 -3053
My Romance (1990s): Jazz Point 1042
Groove Move (1980s): Jazz Point 1045

Al Sears: A long career in big bands led Al Sears to Duke Ellington in 1943, and his work can be heard with that band for the next few years. In the LP era he became a noted pop and rock 'n' roll producer and bandleader, but he still occasionally assembled a jazz group, such as that on the 1960 recording noted here.
Andy Kirk and His Clouds of Joy: Classics 681-2
Duke Ellington Carnegie Hall Concerts 1944:
 Prestige 2PRCD 24073
Duke Ellington Carnegie Hall Concerts 1946:
 Prestige 2PRCD 24074
Duke Ellington Carnegie Hall Concerts 1947:
 Prestige 2PRCD 24075
Swing's the Thing (1960): Fantasy OJC-838-2

Jabbo Smith: The legendary Jabbo Smith recorded his finest material in the years 1929–31. He resurfaced in the mid-1960s, had a modest career, and made some recordings, none of which are easily obtainable as CDs.
Rhythm Aces 1929–1938: Classics 669

Maxine Sullivan: The pure voice of Maxine Sullivan was heard on recordings for fifty years. Her early work with John Kirby has been reissued, and there are examples of her artistry available from all the decades of her long career.
With John Kirby (1940–41): Circle CCD 125
Maxine Sullivan Sings (1955–56): Fresh Sounds FSRCD 178
My Memories of You: Empire Music Works
Close As Pages in a Book (1960s): Audiophile AP 203
Loch Lomond: AVS Living Era 5253

Buddy Tate: The young Buddy Tate can be heard to good advantage with Count Basie, and his many subsequent recordings for the next four decades are generally available on CD. Some of the more interesting are from the 1970s.
The Essential Count Basie 1939–40: Columbia CK 40835
The Essential Count Basie 1940–41: Columbia CK 44150
Tate's A-Jumpin': Night Train 7023
Groovin' with Tate (1959): Prestige PRCD 24152
Buddy Tate and His Buddies (1973): Chiaroscuro CR(D) 123
The Texas Twister (1975): New World NW352-2

Billy Taylor: This remarkably enduring artist has made thousands of recordings during his nearly seventy-year career. There are dozens of fine CDs to choose from, but these six cover fifty years of his career.
Billy Taylor 1945–49: Classics 1137
The Billy Taylor Trio (1952): Prestige 24154

Cross Section (1953): OJC 1730-2
Uptown (1960): OJC 1901-2
It's a Matter of Pride (1994): GRP GRD 9753
Music Keeps You Young (1997): Arkadia 71601

Clark Terry: One of the most versatile and respected brass artists in jazz, Clark Terry has recorded extensively with high-profile artists such as Duke Ellington and Count Basie but has made even more recordings as a leader. There are perhaps two dozen fine Clark Terry CDs from the 1950s through the mid-1990s.
Duke with a Difference (1957): Fantasy OJCCD 229-2
Duke Ellington: Blues In Orbit (1960): Columbia CK 44051
Serenade to a Bus Seat (1957): Riverside 30189
The Happy Horns: Impulse GRD 148-2
The Clark Terry Spacemen (1989): Chiaroscuro CR(D) 309
Top and Bottom (1995): Chiaroscuro CR(D) 347

Greely Walton: In the 1930s and 1940s Greely Walton was active in many big bands. There are few examples of his later work because he retired from music in the mid-1950s. Some of his early work is available on CD reissues.
Luis Russell and His Orchestra 1930–34: Classics 606
Louis Armstrong and His Orchestra 1935–36:
 King Jazz KJCD 6165
Cab Calloway and His Orchestra 1943–44:
 Musicdisc MUS 550232

Benny Waters: At ninety-five, Benny Waters continued to amaze audiences throughout the world. His first recordings date from the late 1920s with Charlie Johnson. He played and recorded with vigor until his death in 1998 at the age of ninety-six.
Charlie Johnson and His Orchestra: Jazz Archives 58122
From Small's Paradise to Shangri-La (1987):
 Muse MCD 5340
Memories of the Twenties (1988): Stomp Off SOS 1210
Plays Songs of Love (1993): Jazz Point 1039
Birdland Birthday Live at 95 (1997): Enja ENJ-9321-2

Frank Wess: The earliest performances of Frank Wess were not recorded, and the Billy Eckstine transcriptions on which he appeared are not available as CDs. He is, however, well represented on Count Basie CDs and on many others as the leader of fine ensembles.
Count Basie and His Orchestra: Verve 314-513630
The Best of Count Basie: Roulette B21Y-97969
Opus de Blues: Savoy 0137
Opus in Swing: Savoy 0144
Two for the Blues (with Frank Foster): Fantasy OJCCD
 788-2
Surprise, Surprise (1996): Chiaroscuro CR(D) 350

Bobby Williams: Few of the recordings on which Bobby Williams appeared early in his career are on CD, except for the sides he made with Benny Carter. The recordings he

made in the LP era are not readily available as CDs
Benny Carter and His Orchestra (1940):
 Bluebird 3000-2-RB
Don Redman—For Europeans Only (1946):
 Steeplechase SCCP 36020

Joe Williams: There are countless recordings by Joe Williams available on CD. They document his career from the early 1950s to the present day.
Count Basie & Joe Williams: Verve 835329-2
Count Basie Swings, Joe Williams Sings: Verve 314-519852-2
A Night at Count Basie's: Vanguard VMD 8508
Me and the Blues: RCA 52879-2
A Swinging Night at Birdland (1962): Roulette B21Y-95335
At Newport '63/Jump for Joy: Collectibles 2706

Johnny Williams: Many of the large- and small-band recordings Johnny Williams made in the 1930s and 1940s are available on CD. It is more difficult to find examples of his work in the 1950s–1980s because to date these LP recordings have not been reissued.
Benny Carter and His Orchestra (1938–39):
 Classics 552
The Quintessential Billie Holiday: Columbia CK 47030
Louis Armstrong and His Orchestra (1940–42):
 King Jazz KJCD 6169
Albert Ammons—The Boogie Woogie Man:
 AVS Living Era 5305

The many recordings of the ghosts and the bands with which they played, many of which are noted here, can provide a general overview of the music being made in Harlem during the years under consideration. A thoughtful listener, however, might like to sample the work of some of the men and women who were vital artists in Harlem in the years 1925–35 who were not interviewed for *The Ghosts of Harlem*, because they either were deceased or were unavailable. I offer one selected CD or CD set for some of the more important of these artists. There are, of course, many other artists and hundreds of other recordings. I have also noted

a remarkable anthology entitled *Live at the Cotton Club*. For the serious enthusiast who wants to dig around and has a turntable, I have also listed *The Sound of Harlem*, which has, unhappily, never been reissued but which occasionally turns up on eBay and similar sites. The forty-page book that accompanies the records, including George Hoefer's fine essay, is particularly illuminating. Good listening!

Red Allen 1935–36: Classics 575
Eubie Blake: *Early Rare Recordings:*
 Eubie Blake Music EBM-4
Willie Bryant and His Orchestra 1935–36: Classics 768-2
Charlie Christian at Minton's Playhouse:
 Musidisc MUS 55012
Cozy Cole 1944–45: Classics 085-819-2
Nat King Cole: *Hit That Jive, Jack:* Decca MCAD 42350
Roy Eldridge 1935–40: Classics 725
Duke Ellington: *Jubilee Stomp:* Bluebird 66038-2
Ella Fitzgerald: *The Early Years:* Decca GRD4-654
Lionel Hampton 1937–1938: RCA 66500-2
Coleman Hawkins: *Indispensable:* RCA 66495-2
Fletcher Henderson: *A Study in Frustration:*
 Columbia CK 57596
Johnny Hodges: *Hodge Podge:* Epic 66972
Billie Holiday: *The Legacy:* Columbia C3K-47724
Freddy Johnson 1933–1939: Classics 085-829-2
James P. Johnson: *Snowy Morning Blues:*
 Decca GRD 604
Thelonious Monk: *Genius of Modern Music:*
 Blue Note B21Y-81510
Charlie Parker: *Bird at St. Nick's:* Fantasy OJC 041
Don Redman 1939–40: Classics 649
Willie "The Lion" Smith 1937–38: Classics 677
Art Tatum: *Classic Early Solos:* Decca GRD 607
Fats Waller: *Piano Solos:* Bluebird 2482-2-RB
Ethel Waters 1931–34: Classics 735
Chick Webb: *Spinnin' the Webb:* Decca GRD 636
Mary Lou Williams 1927–1940: Classics 630
Teddy Wilson and His Orchestra 1939–41: Classics 620
Lester Young: *Blue Lester:* Savoy SV 0112
Live from the Cotton Club Plus: Bear Family BCP 16340 BL
The Sound of Harlem (*Jazz Odyssey*, Vol. 3):
 Columbia C3L 33 (LP)

Index

Profiles of ghosts are indicated in bold.
Additional pages containing illustrations are indicated in italic.

Acknowledgments

A number of people assisted me in the initial preparation of *The Ghosts of Harlem* in 1996 and once again in 2008. In more or less chronological order of their help, John Hammond was not only present when the idea for this project first occurred to me, he also encouraged me along the way and provided me with a good deal of advice. My first editor, Les Pockell, had the vision to understand this was a useful endeavor and helped get the project off the ground. My sternest photographic critic, Berenice Abbott, was very supportive in the first stages of the project and would have been pleased that the majority of the formal portraits were taken with a view camera. Jason Nocito and I did the printing of the many images that appeared in the French edition of *The Ghosts of Harlem.* Jason was responsible for printing the 4x5 negatives; I printed the 35mm and 2¼ negatives. Jason did his work in the studio of Tom Caravaglia and Tom, of course, offered support and guidance. Al Ben-Ness provided technical assistance, film developing, and supplies; his three assistants—Malkiel Yadaie, Gloria Bueno-Reynolds, and Johnese R. Wilson—were also of great help. Ben-Ness Imaging still processes my film, but Malkiel Yadaie is now the owner/manager.

In 2008, because of technological advances, no silver prints were used in the production of the book. All reproductions are based on digital scans of the original negatives and prints of archival material. Contemporary silver prints made by Ken Wahl were often used as a guide. New technology enabled us to make use of some material that couldn't be used in 1996 and vastly improved many images that were used in the original edition. Ian P. Clifford did all this work with great care and creativity, and he is also responsible for creating the collage from my nighttime photographs of Harlem that is the final image in the section "Discovering Lost Locations."

One of the hardest jobs in the preparation of *The Ghosts of Harlem* was transcribing the cassettes and DATs on which the interviews were recorded. Ken Siman and Gina Lawson transcribed about one-third of the interviews, and excerpts of the first six transcriptions were featured in Jonathan Abbott's fine UK publication *Jazz on CD* in 1993 and 1994. Ravenna Narizzano did the remaining transcriptions in 1995–96.

Even though I knew the majority of the musicians who eventually took part in *The Ghosts of Harlem* project, I didn't know all the people on my initial list. The late Stanley Dance was very helpful in the early stages of the project, Dr. Al Vollmer was supportive for the duration, and in 1996 Fr.

Peter J. O'Brien, SJ, introduced me to Thelma Carpenter. Inadvertently, the producer/historian Frank Driggs was also of great help because of work he had done in the early 1960s. The Columbia album he produced in 1963, *The Sound of Harlem*, and the accompanying booklet remain a landmark production, the best that exists which deals with the music, people, and places in Harlem in the 1920s, 1930s, and 1940s. I would have been lost without the names and addresses of Harlem clubs that are part of this important record.

Nicolas Hugnet of Filipacchi immediately recognized the significance of this project, and it was he who first assembled all the interviews and photographs into the French edition of *The Ghosts Of Harlem*. Paul Bacon, the noted graphic designer, legendary literary figure, and expert on old-time jazz, read my text and made certain I didn't say anything too outlandish or excessive. A real person like Paul is far more reliable than the various programs that are part of my computer.

I owe a special debt of gratitude to my good friend Arthur H. Barnes, who persuaded his high school classmate Congressman Charles B. Rangel to contribute a foreword to the book. There is no better representative of Harlem, past and present, than Congressman Rangel, who has served New York's Fifteenth Congressional District with distinction since 1971.

The CD that accompanies this book is drawn from the catalog of Chiaroscuro Records. The mastering for this CD was carried out by Chris Norton's skilled staff at WVIA-FM, a PBS affiliate located in Pittston, Pennsylvania. The engineer in charge was Paul Lazar.

Most importantly, sincere thanks are offered to the talented group of editors, designers, and production managers at Vanderbilt University Press, notably Michael Ames, Jessie Hunnicutt, Dariel Mayer, and Bobbe Needham, who took a manuscript and piles of pictures, edited and organized them in a sensible fashion, and shepherded this raw material through to a finished book with unusual skill and aplomb.

The Ghosts of Harlem wouldn't exist without the cooperation of the ghosts, the exceptional men and women who made the music once heard uptown and who gave of their time so willingly. I offer them untold thanks. Finally, there would not have been a book at all if not for Shelley Shier, who aided me with good advice, served as a photographic assistant on numerous occasions, and looked after business matters while I was confined to the darkroom or behind a computer, and so it is to her I am most grateful.

Listening to the Ghosts of Harlem

I was fortunate enough to work with thirty-two of the ghosts at my recording studio or at festivals we produced. Some of the recordings were for labels other than my own, but seventeen of the ghosts appeared on Chiaroscuro recordings between the years 1972 and 1996. I wish there had been more, but many of those I didn't work with were no longer active.

The eleven selections on the CD that accompanies this book illustrate what these great artists sounded like toward the end of their careers. One of the best things about being a musician, particularly a jazz musician, is that you can be as good at seventy as you were at twenty, and often considerably better. The seventeen ghosts prove it time and time again with these timeless jazz standards and originals. The ghosts are noted in **bold**.

1. "Sunday" (from *Buddy Tate and His Buddies*, CR(D) 123): Roy Eldridge, trumpet; **Illinois Jacquet**, **Buddy Tate**, tenor saxophone; Mary Lou Williams, piano; Steve Jordan, guitar; **Milt Hinton**, bass; Gus Johnson, drums. Recorded 1 June 1973. (11:13)

2. "Back on the Street" (from *Back on the Street*, CR(D) 118): **Jonah Jones**, trumpet; **Buddy Tate**, clarinet, tenor saxophone; Earl Hines, piano; Jerome Darr, guitar; John Brown, bass; Cozy Cole, drums. Recorded 22 March 1972. (4:57)

3. "Good Time Charlie" (from *Old Man Time*, CR(D) 310): **Doc Cheatham**, trumpet; **Eddie Barefield**, alto and tenor saxophones; **Buddy Tate**, tenor saxophone; **Red Richards**, piano; **Al Casey**, guitar; **Milt Hinton**, bass; Gus Johnson, drums; **Cab Calloway**, vocal. Recorded 6 March 1990. (3:52)

4. "Girl of My Dreams" (from *Old Man Time*, CR(D) 310): **Dizzy Gillespie**, trumpet; John Bunch, piano; **Milt Hinton**, bass; Jackie Williams, drums. Recorded 21 December 1989. (7:24)

5. "I Ain't Gonna Give Nobody None of This Jelly Roll" (from *Old Man Time*, CR(D) 310): **Danny Barker**, guitar; **Milt Hinton**, vocal, bass. Recorded 30 October 1989. (2:55)

6. "Bloody Mary" (from *Old Man Time*, CR(D) 310): **Doc Cheatham**, trumpet; **Eddie Barefield**, alto and tenor saxophones; **Buddy Tate**, tenor saxophone; **Red Richards**, piano; **Al Casey**, guitar; **Milt Hinton**, bass; Gus Johnson, drums. Recorded 6 March 1990. (5:48)

7. "Firm Roots" (from *Surprise, Surprise*, CR(D) 350): **Frank Wess**, tenor saxophone; Richard Wyands, piano; Lynn Seaton, bass; Winard Harper, drums. Recorded 5 November 1996. (7:39)

8. "Blues in D Flat" (from *Teddy Wilson and His All Stars*, CR(D) 150): **Harry Edison**, trumpet; Vic Dickenson, trombone; Bob Wilber, clarinet and soprano saxophone; Teddy Wilson, piano; **Major Holley**, bass; Oliver Jackson, drums. Recorded 24 June 1976. (6:15)

9. "'S Wonderful" (from *The Return of Mel Powell*, CR(D) 301): **Benny Carter**, alto saxophone; Mel Powell, piano; Howard Alden, guitar; **Milt Hinton**, bass; Louie Bellson, drums. Recorded 21 October 1987. (6:42)

10. "Four or Five Times" (from *Old Man Time*, CR(D) 310): **Clark Terry**, trumpet; Al Grey, trombone; Flip Phillips, clarinet; Norman Simmons, piano; **Milt Hinton**, bass; Gerry King, drums; **Joe Williams**, vocal. Recorded 27 October 1989. (5:10)

11. "The Survivors" (from *Old Man Time*, CR(D) 310): **Eddie Barefield**, **Cab Calloway**, **Doc Cheatham**, and **Milt Hinton**. Recorded 6 March 1989. (13:09)